| Objects of Translation

OBJECTS OF TRANSLATION

Material Culture and Medieval "Hindu-Muslim" Encounter

FINBARR B. FLOOD

PRINCETON UNIVERSITY PRESS *Princeton and Oxford*

Copyright © 2009 by Princeton University Press

Published by Princeton University Press, 41 William Street, Princeton, New Jersey 08540

In the United Kingdom: Princeton University Press, 6 Oxford Street, Woodstock, Oxfordshire OX20 ITR

Cover illustrations: (Front), *Burzuya and the Indian sage, Kalila wa Dimna*, MS. Pococke 400 folio 13 verso. Courtesy of Bodleian Library, University of Oxford. (Back), *An Indian Embassy before Sultan Mahmud of Ghanzna, from the "Majmal al-Tawarikh" of Hafiz-e Abru.* Worcester Art Museum, Worcester, Massachusetts, Jerome Wheelock Fund.

Fifth printing, and first paperback printing, 2018

Paperback ISBN 978-0-691-18074-8

The Library of Congress has cataloged the cloth edition of this book as follows:

Flood, Finbarr Barry.

 Objects of translation: material culture and medieval "Hindu-Muslim" encounter/Finbarr B. Flood

 p. cm.

 Includes bibliographical references and index.

ISBN 978-0-691-12594-7 (hardcover: alk.paper)

1. Material culture—South Asia—History. 2. Ethnic relations—South Asia—History.

3. Cultural geography—South Asia—History. I. Title.

GN635.S57F56 2009

306.40954—dc22 2008051474

British Library Cataloging-in-Publication Data is available

This book has been composed in Adobe Garamond

Printed on acid-free paper. ∞

press.princeton.edu

Printed in the United States of America

10 9 8 7 6 5

Virtually everywhere one looks, the processes of human movement and encounter are long-established and complex. Cultural centers, discrete regions and territories, do not exist prior to contacts, but are sustained through them, appropriating and disciplining the restless movements of people and things.

—James Clifford, *Routes: Travel and Translation in the Late Twentieth Century (1997), 3*

For Josh and Alex

| Contents

| *Acknowledgments*

More than any other project that I have undertaken, this has been a collaborative endeavor, and my debt to colleagues and friends who gave freely and generously of their opinions, time, research materials, and photographs during the decade that it was under way is immense. In addition to the individuals named below, I would like to thank all those whose numerous small kindnesses helped smooth my path, especially during my travels in India, Iran, and Pakistan.

The project would have been impossible without a series of fellowships and grants that allowed me to research and write various sections of the book and to share ideas with colleagues across a range of continents and fields. At various times, the research has benefited from travel grants awarded by the Barakat Trust and the Fondation Max van Berchem, and I am grateful to them both for enabling the fieldwork on which much of the book depends. The intellectual framework of the book was shaped by my experiences as an Ailsa Mellon Bruce Senior Fellow at the Center for Advanced Studies, National Gallery of Art, Washington, D.C., in 2000–2001. Between 2001 and 2002 the research was facilitated by a Smithsonian Institution Fellowship held at the Freer and Arthur M. Sackler Gallery, Washington, D.C. The support of both institutions enabled me to develop my ideas in an atmosphere of true fellowship, and I am enormously grateful to them for indulging my shifting enthusiasms and exasperations. I would like to offer a special thanks to the curators, fellows, and staff at both institutions, especially Zoë Strother, Stella Nair, Faya Causey, Debra Diamond, Massumeh Farhad, and Ann Gunter. The final stages of writing were undertaken in the fall of 2006 and spring of 2007, when I was fortunate enough to be a residential fellow of the Sterling and Francine Clark Art Institute, Williamstown, Massachusetts, and a visiting scholar at the Getty Research Institute, Los Angeles.

I would also like to thank New York University for providing both the means and the opportunity to work on the book during two years of leave in 2004–2005 and 2006–2007, and my colleagues for shouldering the pleasures and pains of my absence. Among the friends and colleagues at NYU who offered advice, conversation, and support of various kinds during the final stages of writing, I would like to offer a special thanks to Priscilla Soucek and Kathryn Smith, and to Everett Rowson for his generosity in sharing with me his as yet unpublished work on the historian al-'Utbi.

This book would not have been possible without the assistance of a remarkable group of librarians scattered across several continents. I am particularly grateful to the librarians at Cornell University for their help at various points between 1998 and 2000, even though I held no formal affiliation there. In London, I profited from the astounding resources, efficiency, and bonhomie of the staff of the Oriental Reading Rooms in the British Library. In Washington, the remarkable librarians of the Library of Congress, the Center for Advanced Study in the Visual Arts, and the Freer & Sackler Galleries showed patience and tenacity with my various requests for obscure publications. The last stages of the project benefited from the help of the librarians of New York University—Tom McNulty and the Interlibrary Loan staff deserve particular mention.

My observations on the numismatic material have benefited greatly from discussions with several distinguished colleagues, who have patiently endured my amateurish queries and theories. In particular, I would like to thank Stan Goron, Dr. Michael Bates of the American Numismatic Society, Prof. Lutz Ilisch of Tübingen University, Dr. Joe Cribb of the British Museum, and Dr. Shailendra Bhandare of the Ashmolean Museum. I would also like to offer my warm thanks to Dr. Mohammad Reza Kargar, director of the Iran Bastan Museum, and Mrs. Zohreh Rouhfar, curator of Islamic material, for permitting me to study the Ghurid Qur'an discussed in chapter 4. Elizabeth Lambourn kindly shared her work on the Indian Ocean trade with me and brought the relevant Sri Lankan material to my notice.

For help with obtaining images and information, it is a pleasure to thank Dr. Anette Kramer, Mr. Manfred Eder, Dr. Raffael Gadebusch, Mr. David Thomas, Prof. Tom Mathews, Dr. Lev Avdoyan, Mr. James Willaman, Dr. Stefano Carboni, Prof. Bernt Glatzer, Dr. Navina Haidar, Dr. Lynn Jones, Dr. Sue Kaukji, Dr. Monik Kervran, and Mr. Derek J. Content. I owe a special debt of gratitude to Dr. Roberta Giunta and Prof. Gherardo Gnoli for their generosity in supplying images of the reliefs from Ghazni and permitting their reproduction. Heartfelt thanks are due to Jaroslav Poncar and Dr. Christian Luczanits for their kindness in supplying and permitting the reproduction of the Alchi images that they will soon publish in all their colorful glory. Particular thanks are also due to Dr. Vandana Sinha at the American Institute of Indian Studies, Gurgaon, for her help with obtaining photographic material from the institute's archives. I would like to offer a special thanks to Max Schneider for his patience and perseverance with the drawings for the book.

ACKNOWLEDGMENTS

Roberta Giunta, Scott Redford, Bernard O'Kane, and Ilyse Morgenstein Fuerst all commented on various chapters of the book while they were being drafted in ways that helped me clarify the presentation and avoid errors. I owe a particular debt to Oleg Grabar and to two anonymous reviewers for their very careful reading and critiques of the draft manuscript, and to my editor at Princeton University Press, Hanne Winarsky, for her insights and suggestions, to Terri O'Prey and Tracy Baldwin, and to Will Hively for the care with which he copyedited the manuscript. These critical interventions have greatly improved the finished product.

Over the years, the development of my thought on the subjects of this book has derived particular benefit from informal discussions with Phillip Wagoner of Wesleyan University and Sunil Kumar of Delhi University, two colleagues and friends who are major innovators in the field of medieval South Asian history. Whether or not it faithfully reflects the content and tenor of those conversations, without them this project would never have assumed some of the forms that it has. I am truly grateful to them both for their encouragement, support, and comments on the manuscript.

Last but by no means least, for keeping me sane during the interminable process of writing, and for tolerating my occasional inabilities to disengage from premodernity, especially warm thanks is due to Nebahat Avcıoğlu, Zahid Chaudhary, Kryzstof Czuba, Kalleen Flood, Irene Leung, Stella Nair, Avinoam Shalem, Vijayanthi Rao, and Satya Pemmaraju. Srinivasan Padmanabhan has, as always, shown patience above and beyond the call of duty and offered unstinting support for this project throughout its history. Without that support this book would never have seen the light of day.

In claiming this project as a kind of collective endeavor, I should end by emphasizing the limits of collectivity—any glitches, quirks, or outright errors are entirely mine.

| A Note on Translations and Transliterations

For the sake of simplicity, diacriticals have been kept to a minimum. Where a foreign word has entered English usage (for example, mihrab, sufi, etc.), it is neither italicized nor provided with diacriticals. However, where a term is transliterated from Arabic, Persian, or Sanskrit, appropriate diacritical marks have been used following the systems used in the *International Journal of Middle East Studies* and *Epigraphia Indica*. For convenience, the plurals of these terms have been formed following the English convention of adding *s*.

Hijrī (Islamic lunar) dates have been given where dealing with Arabic and Persian coins, inscriptions, or texts, and Indic dating systems cited where they are found in texts or inscriptions.

Unless otherwise stated, all translations are mine.

| *Objects of Translation*

| Introduction

Contact is never pure, always about something.

—Per Otnes, *Other-Wise: Alterity, Materiality, Mediation (1997), 38*

| Roots or Routes?

In the spring of 2006, an article appeared in the *Guardian*, a liberal British newspaper, in which an Oxford historian considered the intercultural tensions afflicting contemporary Europe. The problem, the writer concluded, was not cultural difference per se but rather the effect of global mobility, a peculiarly modern inability of human subjects to stay in place or at least to abandon their cultural baggage as they migrate:

> For centuries, there has been a good rule for the coexistence of civilizations. It said: "When in Rome, do as the Romans do." Globalisation has undermined that rule. Because of mass migration, peoples and their cultures are physically mixed up together. Rome is no longer Rome; it's also Tunis, Cairo and Tirana. Birmingham is also Kashmir and the Punjab, while London is all the world.[1]

In both content and spirit, these sentiments resonate with Samuel P. Huntington's idea of a contemporary "clash of civilizations," central to which is a marked contrast between mobile modern populations and their sedentary predecessors.[2] Both writers presuppose a universe in which people and things once had their proper places. Geographic displacement and the cultural complications arising from it are seen as defining characteristics of modernity, a condition in which people and things are increasingly out of place.[3]

By contrast, the material presented in this book suggests that people and things have been mixed up for a very long time, rarely conforming to the boundaries imposed on them by modern anthropologists and historians. Rejecting any notion of a prelapsarian time when people knew their place, the book emphasizes the remarkable mobility of premodern subjects and objects, and considers the nature and effects of this mobility on the identities of both.

Shaped by colonial and postcolonial displacements, global capital, and technological innovation, the patterns and scale of modern mobility are quite different from those that marked premodern societies, in which populations were smaller and mobility was generally associated with specific socioeconomic groups. The idea of mobility is, however, intrinsic to the history and prescriptions of Islam, a religion whose year zero is measured not from the birth of the Prophet but from the migration of the nascent Muslim community from Mecca to Medina. Moreover, the duty to make the pilgrimage to Mecca at least once in a lifetime imbues Islam with an institution that is global in its extent and impact, not least on the circulation of artistic concepts and forms. Without entailing a deterritorialized concept of identity, the need to negotiate between the local and the translocal, the lived experience of the quotidian and the ideal of the *umma*, an imagined community with a global reach, has been a distinguishing feature of Islamic cultures from their inception.[4]

This "double movement" is especially evident in the regions that form the subject of this book: the frontier territories between what are usually described as the Hindu and Muslim polities of South Asia. The rough contours of this amorphous region are delineated in the west by the important eastern Iranian province of Khurasan, in the east by the Ganges River, in the north by the river Oxus, and in the south by the province of Sind, which abuts the Indian Ocean. It thus includes all the territories of the modern states of Afghanistan and Pakistan, and parts of those now integrated into the republics of Iran, Turkmenistan, and India. For the sake of convenience, I will make anachronistic use of these terms, as geographic rather than narrowly political descriptors. Similarly, although in its literal sense—an interlude between high classicism and its revival during the European Renaissance—the term medieval has little relation to South Asian history, since it has entered general usage there I have deployed it alongside the no less problematic "premodern."

Straddling regions with different topographies but entangled histories, the book that follows argues the need for a reconfiguration of premodern cultural geography, moving beyond the linear borders of the modern nation-state and the static taxonomies of modern scholarship. To this extent, it is in agreement with calls for the writing of histories that displace "civilisation-history" and its vertical emphasis on narratives of rise and fall with alternative models emphasizing horizontal dimensions of mobility.[5] As David Ludden put it in a recent article that called for a shift from the stasis of "civilisational" histories, with their boundaries, boundedness, and closures, to a more dynamic emphasis on networks of encounter and exchange, "the idea of civilisation necessarily (if not intentionally) indices a reading back of 'present-national-sentiments' into a timeless past; it thereby prevents history from working against cultural hegemonies in the present by stultifying our analysis of mobility, context, agency, contingency and change."[6]

Analyses of the interlocking and overlapping economic zones and trade networks that emerged in the wake of the Mongol conquests of the thirteenth century (what is now often referred to as the thirteenth-century world system) have demonstrated the productive potential of these sorts of approaches.[7] However, this burgeoning of interest in premodern global trade networks fostered by the Pax Mongolica has to some extent obscured the existence of much earlier but no less complex circuits of exchange linking the Mediterranean, Middle East, and Central and South Asia in the preceding centuries that form the chronological focus of this book.[8]

The chronological scope of the book stretches from the conquest of Sind by Arab armies in the early eighth century to the establishment of the Delhi sultanate in the early thirteenth. In terms of scholarship, the period is enigmatic and obscure.[9] This lacuna reflects not only the paucity of materials that might be used to craft the cultural history of these centuries, or the difficulties entailed in the fact that such a project would cut across national and disciplinary boundaries that have traditionally set the limits of scholarship, but also a more insistent focus on the glories of the Mughal period in South Asian historiography. Long seen as the epitome of Indo-Islamic cultural production, Mughal art and architecture has been consistently celebrated for its synthetic aesthetic qualities, in contrast to the more "hybrid" and less immediately appealing remains from other periods. As one nineteenth-century antiquarian put it: "It is only after the Mughal conquest that the Mahomedan architecture begins to be beautiful."[10] Consequently, there has been a tendency when dealing with the period between 800 and 1250 in South Asia either to ignore it or see it as an undifferentiated monolith within which fragmentary monuments (and even fewer objects) subsist at random.

Despite the dearth of dedicated studies, the centuries covered by this book have occupied center stage in colonial and nationalist constructions of a past that has been cast as a perpetual confrontation between Muslim invaders and Hindu resisters, a Manichaean dyad that has structured and constrained the history of the region for almost a millennium. Within the master narratives of South Asian historiography, the pre-Mughal period unfolds as a series of iconic moments within the "Muslim" conquest of South Asia, a cultural and historical rupture that prefigures the bloody Partition of India in 1947.[11] The notion assumes a unity of identity and purpose among the Arab amirs of Sind in the eighth through tenth centuries, their Arabized Persian contemporaries in Afghanistan, the Ghaznavid Turks who expanded their domains as

far east as the Indus Valley in the eleventh and twelfth, and the Persianized Ghurids who succeeded them. Acting in concert across more than five centuries, these disparate agents—differentiated not only by ethnicity and language but also by intra-Muslim sectarian affiliations—effected a "slow progress of Islamic power" in India, as D. R. Bhandarkar wrote in 1930.[12] Conversely, in a retrojection of the values of the nation-state, the denizens of premodern South Asia have been figured as the noble citizens of "Hindu India" valiantly resisting the Muslim onslaught.

The military conquests undertaken by the sultans of Ghur from their heartlands in central and eastern Afghanistan in the 1190s (the subject of chapter 3) are usually seen as the definitive "Muslim" conquest of India, with later expansion and mopping-up operations left to the Delhi sultanate, which emerged after the collapse of the Ghurid sultanate in 602/1206.[13] In this teleological view of history, the exploits of the Ghurid sultan Mu'izz or Shihab al-Din Shansabani (d. 602/1206, often referred to as Muhammad Ghori) continue and culminate a project of "Muslim" expansion begun by Muhammad ibn Qasim (d. 95/714), the Arab general who conquered Sind several hundred years earlier. As the historian A.B.L. Awasthi put it, "The Turkish conquest of India began with the Arab conquest of Sind."[14] The notion would be farcical had it not proven so tenacious in scholarship and its ramifications in the politics of the present so deadly.[15]

Like most teleologies, these scenarios operate through a collapse of all possible identities into a single monolithic identification, producing as singular, static, and undifferentiated what was often multiple, protean, and highly contested.[16] In an attempt to deconstruct these monoliths, the book traces dynamic patterns of engagement between Hindus and Muslims over several centuries, emphasizing relations rather than essences, "routes rather than roots" to borrow an evocative phrase from the anthropologist James Clifford. Focusing on practices of circulation, displacement, and translation, it aims to demonstrate the contingent and unstable nature of premodern identity. The "Hindu-Muslim" of my subtitle is therefore framed within quotation marks, not only to suggest that sectarian categories of identity are inadequate to the task of representing the phenomena that form my subject, but to call into question the inherent stability

of these very identities. My approach is close in spirit to that of Clifford, who questions the dichotomy between "absorption by the other *or* resistance to the other" that structures many accounts of culture contact, posing a question that is central to my own undertaking: "Yet what if identity is conceived not as [a] boundary to be maintained but as a nexus of relations and transactions actively engaging a subject? The story or stories of interaction must then be more complex, less linear and teleological."[17]

In fact, despite the conventional rhetoric that they employ, medieval Indic inscriptions and texts are more sensitive to ethnic, historical, and regional differences among the Muslims than is modern historiography, generally preferring ethnic or regional appellations to religious categories; it is only in the thirteenth century that one begins to find references to Persians or Turks as *Musalamāna*.[18]

Earlier terms range from those based on caste status and ritual impurity (the ubiquitous *Mleccha*, foreigner) to ethnic labels such as *Yavana* (Greek), *Pārasīka* (Persian or Parsi), and *Tājika* (Arab or Persian), a term first applied to the Arabs of Sind in the eighth century.[19] However reductive, the terminology of alterity was not undifferentiated; on the contrary, it was sensitive to shifts in the constitution of military and political authority. From the tenth century, *Turuṣka* (Turk) became more common, reflecting the ascendancy of Turkic dynasties in the central Islamic lands and eastern Islamic world.[20] More specific terms found in the eleventh and twelfth centuries include *Garjaṇa* (and variants such as *garjaṇaka* and *garjaṇesha*) or *Garjaṇikādhirāja*, and *Hammīra*, generic terms for Muslim kings derived from Ghazni and the Arabic *amīr* (commander) respectively.[21]

That ethnicity was constructed (at least in part) on the basis of contingencies such as custom is suggested by the use of *Turuṣka* to designate those who were neither Turks nor Muslims but who adopted some of their ways. The *Rājataraṅgiṇī*, a twelfth-century Kashmiri royal chronicle, refers to King Harsha (r. 1089–1111) as a *rājaturuṣka* (Turk king) on account of his fondness for Turkic dress and women and occasional bouts of violent image destruction.[22] Once again this suggests that while categories of identity were by definition relational and often oppositional; they were not necessarily immutable. As we shall see

in the final chapter, *Hammīra*, a Sanskritized Arabic term that denoted the Turko-Persian sultans who battled with the Rajput dynasties of north India could, in time, be transformed into a proper name born by the last scions of those same "Hindu" dynasties.

Even the textual sources in which the most radical assertions of alterity are inscribed provide occasional glimpses of human agents who seem curiously impervious to the absolute boundaries between "Hindu" and "Muslim" identities and polities that are axiomatic to modern frontier historiography. Among those that we will encounter in chapters 1 and 2 are Muhammad ibn Shahriyar from Siraf, a mercantile city in the Persian Gulf, who administered a port city on the Konkan coast of western India in the name of the Rashtrakuta rajas, granting permission in his name for the construction of Hindu temples and monasteries, and Tilak, a free Hindu from Kashmir who sought his fortune as a translator at the court of the Ghaznavid sultan Mas'ud I (r. 422–32/1031–41) and rose to become a celebrated commander of the Ghaznavid armies, infamous in South Asian historiography for pillaging northern India.

As this suggests, even the armies through which "Muslim" or "Hindu" victories were achieved were often heterogeneous congeries of different ethnicities and faiths. War is not, therefore, always inimical to the promotion of cosmopolitan identities. On the contrary, it can unite men of different ethnicities and faiths (often against their coreligionists) and engender new patterns of circulation. It follows that to emphasize the historical importance of transregional circulation and transcultural communication is to deny neither the existence nor the perception and representation of cultural, ethnic, linguistic, and religious difference. Recent research has in fact highlighted the importance of frontier contacts for the formation or consolidation of ethnic identities in premodern South Asia, a reminder that rather than being opposed to identity, difference may in fact be central to its construction.[23] The historical formation and transformation of identity through such encounters also underlines that difference was not a constant (except perhaps in the rarefied world of normative rhetoric) but rather was dynamic in its emphases, contingent in its expression, and variable in its meaning.

The entangled histories of contact, conquest, and cosmopolitanism undermine, however, any suggestion that medieval encounters along the shifting frontier between what the Arabic and Persian sources refer to as the *dār al-Islām* (house of Islam, the lands under the control of Muslim rulers) and the *dār al-ḥarb* (house of war) led to the embrace or emergence of a medieval "multiculturalism." With its assumption of reified (and frequently singular) identities, the concept of multiculturalism fails to do justice to the complex and fluid notions of identity that characterize the highly mobile artisans, merchants, and political elites who form the subjects of this book. Equally, however attractive they may be, romanticizing models such as *Convivencia* (cohabitation, a term that has emerged to describe the coexistence of Christians, Jews, and Muslims in medieval Spain) have a tendency to flatten the contours in what were evidently complex, dynamic, and often rapidly changing landscapes, casting premodern societies as the inverse of our own anticosmopolitan dystopias.[24]

In his observations on this period, the historian Shahid Amin has rightly emphasized the dangers of emphasizing either "Turkiana (the Sword of Islam)" over "Sufiana (the gentle ways of the Islamic mystics)," or "syncretism *sans* conflict."[25] I am not therefore seeking to reconstitute a "Convivencia on the Ganges." Neither do I intend to romanticize syncretism (itself a problematic model) or to replace a dystopian narrative with a more upbeat utopian alternative. Rather, my aim is to explore and historicize the dialectic between alterity and identity, continuity and change, confrontation and co-option that shaped transcultural encounters and the ways in which these conditioned and were conditioned in their turn by diplomatic, martial, and mercantile exchange. Past studies of this period have focused on the displacements that accompanied these phenomena as forms of cultural violence. Here I want to emphasize the violence imposed on the past by our own attempts to purify and stratify it in reproduction, while foregrounding the acts of communication and cooperation that accompanied the movement of premodern subjects and objects, and the transformations that they wrought in their turn.

Of course, at one level to highlight the abundant if scattered evidence for the sorts of communicative practices and social mobility that undermine the absolutism of "Indic" and "Islamic" as oppositional cat-

egories is to make a rather banal claim, anomalous only within the highly politicized and polarized discourses of modern historiography. As Sheldon Pollock reminds us, "there exist no cultural agents who are not always-already transcultured"; consequently, "the cultural materials being transferred are *already hybrid themselves*; and like the transmitter the receiver culture too is something always in process and not a thing with an essence. 'Transculturation,' accordingly, turns out to be a misnomer, since it is the real and permanent condition of all cultural life."[26] This is indeed true of the *longue durée*, and goes a long way toward explaining why aspects of premodern culture that seem remarkable to a modern observer often went unremarked by medieval observers, to whom they may not have been manifest in the same way, if at all.

However, while acknowledging the danger of reifying dynamic and heterogeneous cultural systems, one needs to consider not just process but event. In particular, one needs to be cognizant of the way in which sudden shifts in established sociopolitical orders can produce new patterns of circulation and contact or the preconditions for established patterns of encounter and exchange to undergo radical transformations of intensity or scale. As James Clifford notes in *Routes*, his recent book dealing with issues of travel and translation in our own era of globalization and transnationalism: "Contact approaches presuppose not sociocultural wholes subsequently brought into relationship, but rather systems already constituted relationally, entering new situations through historical processes of displacement."[27] Despite its focus on the *longue durée*, much of this book is concerned with periods of cultural shift and historical displacement, moments when the rise of powerful regional dynasties or the eastward expansion of ambitious amirs, governors, and sultans reconfigured the political landscape of eastern Iran and South Asia, providing increased opportunities for transregional mobility.

To highlight the heterogeneous nature of all cultural forms and practices is, moreover, to say little about their potential commensurability. While medieval Persian is (like its modern counterpart) marked by the ubiquitous presence of Arabic loanwords, reflecting a long history of engagement between different ethnic and linguistic groups within the Islamic world, the existence of such loanwords does not erase the significant differences between these two languages (which belong to different linguistic families) and the consequent need for translation to mediate between them in specific historical situations. In the words of one translation theorist, "the mongrelization of languages occurs because their 'interiors' and 'exteriors' are separated by porous, elastic membranes and not by rigid walls; [but] despite such a permeability of boundaries, each language heuristically retains its 'identity' in relation to other languages."[28] The metaphor of permeability or porosity employed here has sometimes been used in analyses of Indo-Islamic cultural forms.[29] Its mechanistic and deterministic overtones occlude, however, questions of agency that are central to understanding the sorts of negotiations that produced these forms both materially and ontologically.

There are similar problems with the biological metaphor of hybridity, although this too has frequently been used to explain the anomalous aggregation of apparently discrete "Hindu" and "Muslim" cultural forms. Metaphors of hybridity presuppose (if not produce) "pure" original or parent cultures, betraying with their roots in nineteenth-century scientific discourses on race, within which culture was a sign or symptom and cultural mixing (like racial miscegenation) was generally frowned on as an uneasy, unnatural, and unstable state of affairs.[30] The alternative model of syncretism is no less redolent of an essential purity to which the syncretic acts as foil, although its genealogy is closely tied to questions of religious practice, shifting the emphasis more decisively from race to culture.[31] In addition, we have to recognize the inevitable privileging of hybridity in product (a tangible index) rather than facture or process, which is less immediately accessible to modern historians.[32] Nevertheless, as we shall see in chapter 5, there may be specific circumstances in which hybridity is a useful category of analysis, but they raise complex questions about artistic style and premodern visual cognition.[33]

| *Networks, Translation, and Transculturation*

Some twenty years ago, the historian Peter Hardy described the refraction of northern Indian culture through the lens of medieval Arabic and Persian histo-

ries as offering "an account of how two people from different worlds of experience were struggling to find a mutually intelligible language." He began his remarks with an inspired choice of quotation from Lewis Carroll's *Through the Looking Glass*, which neatly encapsulates the relationship between agency, power, and the construction of meaning in any intersubjective dialogue:

> "When I use a word," Humpty Dumpty said, in rather a scornful tone, "it means just what I choose it to mean—neither more nor less."
> "The question is," said Alice, "whether you can make words mean so many different things."
> "The question is," said Humpty Dumpty, "which is to be master—that's all."[34]

The topsy-turvy quality that Hardy evokes is exemplified in the Arabic writings of al-Biruni (d. 439/1048), who lived much of his life in what today is Afghanistan, and whose substantial work on Indian culture and religion, the *Kitāb fī taḥqīq ma li'l-Hind* (Book of Inquiry into India), is among the earliest and most remarkable testimonies to the encounter between premodern Indic and Persianate elites. Although al-Biruni's stated intention in writing is to enable an intercultural dialogue, his text oscillates between the assertion and disavowal of alterity.[35] On the one hand, the Pandavas, the protagonists of the *Mahābhārata*, are compared to the heroes of the *Shāhnāma* (Book of Kings), the Persian "national" epic.[36] On the other, the cultural codes governing the conduct of Indians are presented as the inverse of those with which his readers were familiar. Referring, for example, to an Indian penchant for using turbans as trousers (a reference to the wound Indian loincloth or *dhoti*), al-Biruni writes:

> Many Hindu customs differ from those of our country and of our time to such a degree as to appear to us simply monstrous. One might almost think that they had intentionally changed them into the opposite, for our customs do not resemble theirs, but are the very reverse; and if ever a custom of theirs resembles one of ours, it has certainly just the opposite meaning.[37]

This was not the whole story, however. Neither the assertion of difference nor the struggle to control or determine meaning precluded intercultural dialogue. On the contrary, whether in the Mediterranean, Iran, or South Asia, they were often central to it. In a plea for enhanced contacts between Byzantium and the Muslim Arab rulers of Crete, for example, Nicholas I, the Christian patriarch of Constantinople (912–25), acknowledges differences "in lives, habits and religion," even as al-Biruni insists that the Indians "differ from us in every respect, many a subject appearing intricate and obscure which would be perfectly clear if there were more connection between us."[38] However, the text in which this sentiment is inscribed is itself a testimony to the construction of meaning across ethnic, linguistic, and religious boundaries: in writing what is perhaps the most empathetic and sophisticated premodern evaluation of Indian cultural and religious practices ever written by a Muslim, al-Biruni was himself dependent on translated Sanskrit texts and Indian scholars for his information.

Translation is in fact central to the content and context of one of the most popular story cycles of medieval Islam, *Kalīla wa Dimna*, a series of animal fables whose origins lie in the *Panchatantra*, a Sanskrit work on statecraft believed to have been first committed to writing by a Kashmiri scribe sometime around AD 300. The fables reached Iran in the sixth century through the medium of Pahlavi or Middle Persian, and were translated into Arabic by the eighth. From the thirteenth century onward, numerous illustrated copies survive from Egypt, Iran, and Syria, attesting to their popularity; some of the illustrations in these texts are based on those created in India more than a millennium earlier.[39]

The tales begin with a self-conscious celebration of the role of translation in their own dissemination through the agency of the court physician Burzuya. In the opening story, Burzuya is sent to India by the Sasanian ruler Khusrau Anushirvan (r. 531–79) to seek out and bring back to Iran works of Indian wisdom that are hidden in the library of an unnamed Indian king. With the help of a native informant, an Indian sage, Burzuya gains access to the desired texts and, laboring night and day, translates the *Panchatantra* and other manuscripts from Sanskrit into Pahlavi, the language of the Iranian world at this time.

Foregrounding translation as a mode of facilitat-

ing communication between premodern elites, the tale of the Persian physician and the Indian text can be considered paradigmatic of the encounters that form the subject of this book. The deceptively simple tale of Burzuya entails a number of paradoxes, highlighting the ambivalences and ambiguities that often characterized transcultural exchanges. In the first place, the value of the desired texts is related not only to their content but also to their foreignness, to the long and dangerous voyage that their acquisition necessitated. In this regard, it is noteworthy that the texts acquired from India and other lands by the Sasanian kings of Iran were reportedly deposited in the Royal Treasury along with more material riches.[40]

The value ascribed to the texts was equally a product of the chain of transmission through which they circulated westward. Writing in Spain, at the opposite end of the known world, around 1050, the Arab scholar Sa'id al-Andalusi lists the work (one of "noble purpose and great practical worth") among the many great legacies of Indian learning, explaining the circuitous chain of translation by which it circulated from pre-Islamic India to medieval al-Andalus.[41] Many of those who worked or wrote on the text explicitly addressed the problem of translation, taking different approaches to the transformations that it inevitably wrought. In his *Book of Inquiry into India*, for example, al-Biruni laments his lack of linguistic access to the *Panchatantra*, the Sanskrit original of *Kalīla wa Dimna*, noting that "it is far spread in various languages, in Persian, Hindi, and Arabic—in translations of people who are not free from the suspicion of having altered the text."[42] A more expansive notion of translation is found in the *Nuh Sipihr* of Amir Khusrau (718/1318), where the excellence of the *Panchatantra* is said to be reflected in its translation into Arabic, Persian, Turkish, and other languages, which have manifest it in alternative forms.[43]

Premodern linguistic and textual translations were generally multistage endeavors often mediated by a third language and involving not two but three or more agents. Thus, as Amir Khusrau suggests, the translations that facilitated the transmission of *Kalīla wa Dimna* were themselves complex and multiple, the passage from Sanskrit to English (and other European languages) being mediated by Pahlavi, Arabic, Hebrew, and Latin.[44] The first Arabic translation was commissioned by the founder of Baghdad, the 'Abbasid caliph al-Mansur (d. 158/775), one of a number of translations from Greek, Pahlavi, and (more rarely) Sanskrit undertaken at the 'Abbasid court.[45] Truth being stranger than fiction, around 800 the vizier of the 'Abbasid caliph, Yahya ibn Khalid al-Barmaki (whose family were Buddhist converts from northeastern Iran), sent a scholar from Baghdad to India to gather medicinal herbs and knowledge about Indian religions. Translated and transcribed, this information served (directly or indirectly) as a source for numerous later writers on India.[46]

The 'Abbasid caliphs modeled much of their court culture on that of the Sasanian kings whose territories they had inherited, and the 'Abbasid mission to India may have been undertaken in imitation of Burzuya's voyage, reenacting Anushirvan's appropriation of Indian texts through translation.[47] The commission of translations reiterated the original patronage of the Indian king, creating a common bond rooted in the etiquette and rituals of kingship. Indeed, the preface to the greatest Persian royal epic, the *Shāhnāma* or Book of Kings (written in 346/957), explicitly invokes Anushirvan's acquisition of the *Panchatantra*, citing the commissioning of this and other texts (including the Indian epic the *Rāmayāṇa*) by an Indian king and their later translation at the Sasanian and 'Abbasid courts as appropriate ways for royal patrons to perpetuate their memories.[48] Further associations between India, translation, and the self-fashioning of Persian elites are suggested by the fact that the best-known Persian translation of *Kalīla wa Dimna* was undertaken at the court of the Ghaznavid sultan Bahram Shah (d. 546/1152), whose territories included parts of western India. Nasr Allah Munshi, the Ghaznavid translator, emphasizes both the Indian origins of the text and the Indian victories of his patron, whose territories are said to have extended from Isfahan in central Iran to the Ganges.[49]

The production of a Persian translation reflects internal developments that were reshaping the cultural and political geography of the eastern Islamic lands during the eleventh and twelfth centuries, and which were to have significant implications for South Asia. These include the rise of regional courts, who sponsored the production of vernacular literatures written in New Persian (rather than the lingua franca of Arabic)

and the concomitant appearance of local (rather than universal) histories.[50] The rise of Persian as a court language offers interesting parallels for contemporaneous shifts in linguistic usage in South Asia, where, around the beginning of the second millennium CE, vernacular literary codes and forms began to replace the more translocal Sanskritic forms, which South Asian elites had favored from the first few centuries of the Christian era.[51] The simultaneous production of vernacular translations of *Kalīla wa Dimna* and *Panchatantra* in both Spain and southern India in the period between 1000 and 1250 has been noted, but the more relevant appearance of the first Persian translation of the text in northwestern India around 1150 has gone largely unremarked.[52]

With their ability to move through and beyond the limits of political dominion or physical topography, the peregrinations of *Kalīla wa Dimna* and the human agents who effected its transmission exemplify the mobility of routes and networks in contrast to the fixities of roots and territories. First applied to the history of South Asia fifty years ago, the notion of networks has gained currency in our own era of global mobility.[53] The sociologist Bruno Latour explains its utility in the following way: "More supple than the notion of system, more historical than the notion of structure, more empirical than the notion of complexity, the idea of network is the Ariadne's thread of these interwoven stories." Such a thread "would allow us to pass with continuity from the local to the global, from the human to the nonhuman. It is the thread of networks of practices and instruments, of documents and translations." As this suggests, for Latour, networks are closely related to practices of translation and hybridization and opposed to strategies of disaggregation or purification that correspond to what he calls "the modern critical stance."[54]

Latour's interest in translation as a cultural problematic reflects a "translation turn" in the social sciences over the past decades, which has extended the purview of translation from the strictly linguistic to other fields of cultural production, embracing translation as both an explanatory metaphor and a dynamic practice through which the circulation, mediation, reception, and transformation of distinct cultural forms and practices is effected.[55] While acknowledging that translation is an activity that occurs not only between but within cultures ("a mediation between two already constituting worlds"), postcolonial theorists have, for example, sought to theorize the limits and nature of cultural translation and the way in which it facilitates the emergence of new cultural forms.[56] In his work on postcolonial diasporas, for example, Homi Bhabha writes of a "third space" emerging from the interface between hegemonic and subordinate or marginalized cultural forms, the dialectical tensions between alterity and assimilation. This is an arena within which difference is negotiated, through the appropriation, translation, and rehistoricization of cultural signs and their associated meanings, a process that contributes to the emergence of new hybrid identities.[57]

These theoretical approaches have been developed in relation to modern colonial and postcolonial cultures, with the result that historians of premodernity have been slow to appreciate and exploit their implications. Nevertheless, studies of premodern South Asia have not been immune to the "translation turn" that underlies their development. The historian Richard Eaton discusses, for example, the "translation" of Islam into India, a process that necessitated "a broader conception of translation" than word-for-word rendering of Arabic sacred texts into Indian vernacular languages.[58] Extending the idea to material culture, Sheldon Pollock has noted that South Asian coins, monuments, and texts of the eleventh to fourteenth century "demonstrate a sustained and largely successful effort at intercultural translation."[59] Working in the Deccan region of south-central India, Phillip Wagoner has adumbrated the dynamics of these processes, demonstrating the operation of a "cultural hermeneutic" not confined to the realm of spoken communication and its textual traces, but which also pervaded material, performative, and visual aspects of cultural production, and the various "languages" that they employed.[60]

If Bhabha's concept of the intercultural (emblematized in his neologism the "third space," which oscillates between process and place) has been criticized for its nominalism, for its reduction of complex social practices to textual representations,[61] these studies remind us of Jonathan Hay's observation that "*contact between cultures* always brings us back to the geographical transfer of makers, objects or images."[62] In an essay on objects as signs, John Dixon Hunt sees the hermeneutical or interpretive strategies associated

with such transfers as a series of translations, which include the work of the historian him- or herself:

> Is it not more useful to think of teapots and other objects as signs? . . . The study of objects, like discourse, would then focus on a series of translations. And the questions would concern, first, how speakers . . . encode their messages, with certain goals, within given linguistic and other cultural contexts . . . and, second, how hearers decode (in the case of objects this could be a user or a later historian) within different schemas, in fresh contexts that involve both pragmatic and intellectual control. In both encoding and decoding there is an act of translation, finding in one "language" adequate terms to give a reliable account of something in another.[63]

Adopting such a framework, the book that follows also draws attention to the relationship between strategies of translation associated with the circulation of objects and processes of *transculturation*. Coined by the anthropologist Fernando Ortiz, whose work on the sugar and tobacco cultures of postcolonial Cuba is of particular significance for its insistence on the centrality of objects and the practices associated with them, the term *transculturation* denotes a complex process of transformation unfolding through extended contact between cultures. Although Ortiz clearly saw this as a unidirectional process that entailed an initial loss (a "deculturation" that prepares the ground for "neoculturation"), *transculturation* has gained currency as a term that emphasizes the multidirectional nature of exchange.[64] Like the medieval French *trastornée*, with its connotations of a simultaneous movement across and within, this notion of transculturation acknowledges that cultural formations are always already hybrid and in process, so that translation is a dynamic activity that takes place both *between* and *within* cultural codes, forms, and practices.

| *Things and Texts*

This dynamic aspect of translation confounds any attempt to draw hard-and-fast boundaries between cultural formations. The point is eloquently made by the opening image in a fourteenth-century manuscript of *Kalīla wa Dimna* probably produced in Syria (fig. 1). A rather conventional inscription of difference on the bodies of the chief protagonists, Burzuya and the anonymous Indian sage—the latter darker of skin, longer of hair, and scantier of clothing than his Persian interlocutor—is subverted by the content and context of the text itself, exemplifying the ability of translation to bridge the gap between them, to domesticate the foreign. Appreciating this depends, however, on a willingness to engage both media simultaneously, to read between and beyond text and image rather than privileging one over and above the other.[65] If, therefore, "routes not roots" and "networks not territories" are two fundamental themes of this book, a third, related concern might be characterized as "things not texts."

Most previous approaches to the period have relied almost entirely on premodern inscriptions and texts for their narrative reconstructions of the past.[66] Over the past decades, increasingly sophisticated modes of analyzing such documents have been developed, which mitigate the dangers of taking the oppositional categories and rhetorical claims that proliferate within them at face value. Nevertheless, the dominance of a textual paradigm has obscured the semiotic potential of materials and materiality even as they relate to textual sources. For example, the premodern inscriptions that have been central to modern histories of South Asia are rarely read from the monuments on which they were placed but, instead, from modern printed compendia that reduce their communicative potential to semantic content, ignoring haptic and optic dimensions of inscription: the media in which they were carved, their scale and placement, and their precise relationship to the architectural forms on which they were inscribed.[67] This abstraction of semantic content from the material means of its articulation and reproduction illustrates the role traditionally ascribed to artifacts in the writing of medieval South Asian histories: that of props or supplements, wheeled onstage in a supporting role to bolster textualized mediations of the past.

While acknowledging the value of texts as historical documents, by placing an equal emphasis on material culture I seek to challenge their centrality to the writing of South Asian histories. The *material*

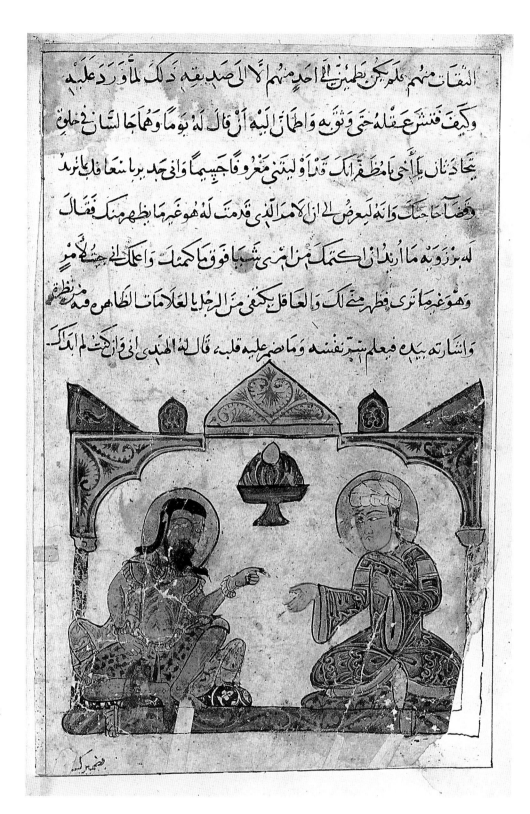

النقات منهم ... لكن بطمئن إلى أحد منهم ... لا إلى يصدقه ذلك لما أورد عليه

وكيف فشرع عقله حتى وثوبه واطمأن إليه أن قال له يوما وهما لشأن في خلوا

نجاذنان يا أخي ما مظفر ألك قد أولدتني معروفا جسيما وإني جد برا سعابة لترد

وقضا حاجتك وإنه لعرض لا إلى الأمر الذي قدمنا له هو غير ما يظهر منك فقال

له برزويه ما أريد أن أكتمك من نفسي شيا فاقر وما كتمك واعلمك إلى جلسام

وهو غير ما ترى فطرحنا جسد لك والعاقل يكتفى من الجلي العلامات الظاهر فيه منظره

وإشارته بيده فيعلم سر نفسه وما صرى عليه قلبه قال له الهندي إني وإن كنت إلك

culture of my book's title is a deliberately expansive term that includes coins, frescoes, modes of dress, texts, manuscripts, monumental architecture, and the more abstract but no less revealing realm of onomastics, royal titulature, and ritual practice. In my narrative there is a loose progression in chronology and scale, from objects and modes of dress to monumental architecture. Although my primary focus is on objects, at various points agricultural technology, taxation, and military tactics are also relevant to questions of material culture and cultural flows.[68] Casting the net broadly, I aim to highlight the ability of artifacts to provide fresh insights and novel perspectives when treated as potentially complementary (rather than supplementary) sources of historical information. I have avoided referring to these artifacts as "art objects," less from any imagined aesthetic inadequacy than from the (perhaps conservative) assumption that art objects are generally ends rather than means. Some of the objects that will be discussed here—among them frescoes, textiles, and temples—would no doubt gain admittance to the exclusive club of objets d'art; others intended to mediate more quotidian interactions would undoubtedly not. Both are, however, equally informative for histories of circulation and consumption.

I am aware of the paradox inherent in adopting linguistic models for a book that champions the value of material culture. I am also aware that, in doing so, I am to some extent swimming against the tide. The dominance of a linguistic model in the social sciences has sustained recent criticism from a number of scholars, among them the art historian David Summers, who has argued that whereas language is conventional, works of art "are embodied under certain *conditions*, and these are only secondarily *conventional*." Summers argues that when it comes to works of art (and by extension any artifact), "what parallels 'grammar and syntax' is the construction of real and virtual space consequent to patterns of human use."[69] That is, unlike the words and sentences of conventional languages, created artifacts have concrete material presence and real spatial relations.

Curiously, however, since it is embedded in what is in effect a universal history of art, Summers' critique of the inadequacy of linguistic models to account for material things is firmly rooted in a Euro-American

milieu. It ignores, for example, conceptions of the effect and meaning of Sanskrit words as substantive rather than representational, imbued with the ability to alter physical substance and thus produce radical spatial effects.[70] This conception of language adumbrates more complex relationships between subjects, objects, words and spaces than those imagined in the post-Enlightenment ontologies that Summers takes for granted.

This observation is directly relevant to Burzuya's own tale, and to his subsequent reception when he returned to Iran with his translated treasures. As one might expect, Anushirvan's envoy received suitable recompense for his efforts in India on behalf of his royal patron, being offered all the riches of the kingdom by his king. What happened next is, from the perspective of a modern reader at least, rather surprising: "Burzuya knelt before Nushirvan and praised his king. He said that since it was the wish of his sovereign that he choose something, he would obey. The physician went to the royal wardrobe and took one of the king's robes."[71] Within the context of a commodity culture, Burzuya's modest choice of reward is almost incomprehensible. In the medieval Islamic world in which this tale was written and read, however, the gifting of robes constituted a metalanguage of power. Beyond material value, the robe incorporates Burzuya into the political structures of the Sasanian court, functioning as a "transactional symbol," a device through which the ruler constituted a chosen subject as a boon companion who shared in his sovereignty. Adopted, adapted, and appropriated by medieval elites, these kinds of artifacts produced networks of affinity not bounded by religious, ethnic, or linguistic identity but by possession, consumption, and display.[72]

The artifacts' ability to function in this way was directly related to their possession of a physical relationship (ranging from full body contact to a passing glance) with the body of the donor. Donning the transvalued apparel (often as part of a ceremonial re-clothing), the recipient not only came to act on the king's authority but functioned as a notional extension of his body, part of what a modern anthropologist would call his "distributed personhood."[73] Burzuya's desire for his patron's castoff above all the riches of Iran thus serves as a reminder that the post-Enlightenment view of subjects as ontologically distinct from (and

prior to) the objects that they create, circulate, and consume is the product of a specific cultural attitude and is neither universal nor natural.[74] This recognition brings us back to Bruno Latour's definition of modernity as a perpetual tussle between practices of translation that create hybrids (of culture and nature as much as culture and culture) and strategies of purification designed to articulate and enforce the ontological distinction between humans and nonhumans that has been naturalized in many post-Enlightenment societies. By drawing attention to the mutual imbrications of animate subjects and inanimate objects, a subsidiary aim of this book is to explore the constitutive relationships between subjects, objects, and political formations, and the ways in which these relationships were implicated in processes of transculturation.[75]

Investigation of these phenomena has been frustrated by sectarian taxonomies institutionalized as an academic division of labor within which Indic art, history, and languages are specializations considered distinct from their "Islamic" counterparts. Essentialist categories of "Hindu" and "Muslim" identity have been projected onto all aspects of premodern cultural production, so that in the representation of the premodern past, Indic modes of architecture, dress, epigraphy, language, and literary production are necessarily opposed to their Islamic counterparts. As the historian Barbara Metcalf noted recently, should a member of the transcultural elites that moved between the "Hindu" and "Muslim" courts of premodern South Asia visit a modern museum, he would find his possessions displayed in different rooms, divided on the basis of a sectarian taxonomy that parses and stratifies the complex products of heterogeneous cultural milieus.[76] The impulse is equally manifest in the practice of splitting coin hoards from South Asia into tokens bearing Arabic or Sanskrit inscriptions, which are then parted to enter different patterns of modern circulation and publication. This frustrates understanding of the heterogeneous cultural milieus in which these tokens circulated but "corrects" perceived anomalies according to modern taxonomic logic.[77]

The past decade has in fact seen significant attempts to combine textual and material evidence in order to develop more complex paradigms for understanding the interrelationships between Muslims and non-Muslims in South Asia. These have demonstrated that the existence of commonalities and homologies between the cultures of elites was often central to the operation of a "cultural hermeneutic," in which the material world was deeply implicated, and which this hermeneutic implicated in its turn.[78] They have, however, focused primarily on architecture, on Gujarat, the Deccan, and South India, and the fourteenth through sixteenth centuries, when the Delhi sultanate expanded into these regions. Despite a heavy debt to these pioneering studies, this book is the first to deal with the crucial formative period of Indo-Islamic culture, with the northern Indian context of this formation, to consider material culture in all its manifestations, and to take a transregional approach to premodern transcultural encounters.

The chapters that follow explore the mechanisms of circulation (among them looting, gifting, and trade) through which specific classes of artifacts constructed and mediated cultural boundaries, and the ways in which meaning and value were translated and transfigured through the mobility of both people and things. Ranging across dynastic, geographic, regional, and temporal categories, the emphasis is on histories of circulation, reception, and translation rather than on strictly dynastic or political history. Histories of this kind invariably risk dehistoricizing and unifying the very protean phenomena that they seek to emphasize. Responding to this danger, Patrick Manning indicates three criteria of analysis that will minimize or obviate its impact, and these criteria have informed my own approach: consideration of a wide range of interactions across a variety of cultural forms and practices (architecture, dress, music, etc.); specificity regarding the agents and criteria of cross-cultural contact; the need to be alive to both continuities and discontinuities, to shifts in the nature of cross-cultural interaction even in the same regions through time.[79]

Situating "thick" synchronic analyses of a wide array of cultural artifacts, encounters, and practices within a "thin" diachronic matrix that ranges over four centuries, the discussion that follows can make no claims to be comprehensive. Nevertheless, any attempt to represent complex social realities through the linear medium of text invariably entails a selective approach, unless like Borges' infamous map it aims for a one-to-one relationship between the representation and the represented. In this sense, the fragmen-

tary nature of the material evidence is both a blessing and a curse, limiting the information available but also frustrating the totalizing approach to the past to which the fixities of "Hindu" and "Muslim" identity are integral.

Chapter 1 begins on the eastern frontier of the 'Abbasid caliphate of Baghdad during the ninth and tenth centuries. It focuses on two of the dynasties whose emergence on the eastern frontier marked a decline in the centralized authority of the caliphate: the Saffarids of Sistan (now southern Afghanistan) and the Arab amirs of Sind (now southern Pakistan). The Saffarids originally governed in the name of the 'Abbasid caliph in Baghdad, but between 873 and 900 the brothers Ya'qub ibn Layth (d. 265/879) and 'Amr ibn Layth (d. 289/902) extended their control over much of Iran and the lands of the Indo-Afghan frontier, eventually going so far as to march on Baghdad itself in 262/876.[80] During the same period, two quasi-independent Arab amirates emerged in Sind, a region peppered with major mercantile emporia connected by sea and land to both the central Islamic lands and India. The Saffarids and Sindi amirs used gifts of Indian exotica, including looted Buddhist and Hindu icons, to negotiate their often fractious relationships with Baghdad. Conversely, the surviving material evidence from Sind highlights that region's role as a nexus between the central lands of the Baghdad caliphate and the neighboring "Hindu" polities of India. Artifactual and textual evidence suggest that 'Abbasid Sind was a major center of ivory and metalworking, whose importance has been overlooked until now. One reason for this neglect is that the "hybrid" products of Sindi artisans resist categorization as Indic or Islamic, posing a significant challenge to the categorical structures on which modern understandings of the past are invariably based.

Chapter 2 focuses on the circulation of items and modes of dress, and its implications for differing conceptions of the body. It builds on the discussion of Sind in chapter 1, considering the ways in which the construction of the royal body among the Arab elites of Sind was informed by contacts with their Indian neighbors. It goes on to consider the adoption of Turko-Persian modes of dress by Buddhist elites ruling the western Himalayas in the eleventh and twelfth centuries, and the gifting of robes of honor by the

Turkic sultans of Ghazni to Hindu rulers that they constituted as vassals during the same period. These exchanges involved both objects and acts, raising interesting questions about the translatability of sartorial codes and ritual practices, questions that will be addressed in varying ways throughout the course of this book.

Chapter 3 deals with the decades after 1150, when the rule of the Ghaznavid sultans was eclipsed by an obscure Persianate dynasty based in the remote mountainous region of Ghur in central Afghanistan. Previously vassals of the Ghaznavids, in the last decades of the twelfth century the Ghurids established a major transregional sultanate that conjoined the former territories of various Rajput kingdoms in northern India with some of the most important cultural centers in the eastern Iranian world for the first time. Although the Ghurid polity endured only for a few short decades, its transregional character was marked by new patterns of mobility between northern India, Afghanistan, and eastern Iran. In spite of the Ghurids' role as the "national" dynasty of Afghanistan, analysis of the material culture of the sultanate and its ability to illuminate the cultural flows that marked the period has been precluded by the remoteness of the Afghan monuments on the one hand and the negative role ascribed to "Muhammad Ghori" (sultan Mu'izz al-Din Muhammad of Ghur) as *the* Muslim conqueror of India in South Asian historiography on the other. Attempting to remedy this neglect, chapters 3 through 5 (that is, the greater part of this book) are concerned with the architecture, coinage, ceremonial practices, and political structures of the Ghurid sultanate, and their often complex relationships with their northern Indian counterparts.

The final chapter (6) focuses on the Delhi sultanate that emerged in the three decades following the collapse of the Ghurid sultanate around 1206. In the wake of this event, India was riven by competition between the Turkic military slaves of the Ghurid sultan, with Delhi finally emerging as the major cultural and political center under the patronage of sultan Iltutmish (d. 633/1236). Although Iltutmish built on the Ghurid legacy, demographic shifts caused by developments in the wider Islamic world between roughly 1200 and 1230 are reflected in significant changes in the content and form of the extensions that he made

to the Friday Mosque of Delhi (1192 onward). Under Iltutmish, the mosque became the locus for an agglomeration of signs that sought to project the authority of the sultanate while shaping the identity of the Muslim community of northern India. The endeavor was intended to construct a genealogy for the sultanate that addressed the dialectical nature of Indian Islamic identity (the double movement referred to above), asserting a relationship with the wider Islamic world while accommodating and appropriating the signs of an Indian past.

It will be clear by now that my own conceptual framework is a bricolage of ideas drawn not only from scholarship on other premodern frontier regions (notably Anatolia, Armenia, Spain, and Sicily) but also from a myriad of disparate disciplines, including art history, anthropology, history, postcolonial studies, and linguistics. Despite my championing of material culture and its value as a historical document, implicit in my use of contemporary theoretical work is a rejection of any notion of a "return to the object" as if it were preexistent or self-subsisting.[81] A subsidiary aim of the book is, therefore, to contribute to a negotiation of the (often-marked) boundaries between empirically driven and theoretically informed scholarship on premodernity, while forging a dialogue between those interested in the relationships between precolonial, colonial, and postcolonial history and historiography.[82]

This engagement with theories of the present in a study of the past will inevitably attract criticism for privileging etic categories of explanation (those drawn from exogenous frameworks of analysis and understanding) over emic (those that would have been recognized by the actors in a given situation): in short,

for anachronism. Like the idolatry discussed in chapter 1, anachronism is a vice located in the eye of the beholder. It is closely related to the critique of politically informed practices of history writing as "interventionist." The charge of interventionism, like that of anachronism, obscures the historicity of history, the fact that all narrative (re)constructions of the past and the methodologies that they employ are historically constituted and thus engage a past that is at once distant and "dialectically continuous with the present," as the anthropologist Nicholas Dirks puts it.[83] This occlusion generally obviates any need to analyze the *content* of such histories, while effectively championing as History the preexisting or hegemonic narratives that they challenge.[84]

Remaining cognizant of emic explanations, our own narrative (re)constructions of historical events must of necessity be in our (etic) terms, since they are being offered not to the participants but to our contemporaries and successors.[85] Moreover, historical narratives are always underdetermined by the evidence on which they depend, and therefore potentially multiple.[86] As the central organizing trope of this study, translation has the advantage of acknowledging this, recognizing that the task of the historian is an open-ended process of negotiating the unstable relationship between past and present.[87] In its appropriation of approaches and concepts from a range of fields and their deployment in contexts far from those in which they may have emerged, and for which they may have been intended, my own approach enacts the phenomenon that is its subject, acknowledging that the translator is always present in and implicated by the translation.

1 | *The Mercantile Cosmopolis*

A marketplace is the epitome of local identity . . . and the unsettling
of that identity by trade and traffic of goods from elsewhere.

—Peter Stallybrass and Allon White, *The Politics and Poetics*
 of Transgression (1986), 27

| *Polyglot Frontiers and Permeable Boundaries*

In the first decades of the eighth century, the armies
of the Umayyad caliphs of Damascus, the first Islamic
dynasty, defeated the indigenous rulers of the Iberian
Peninsula in the west and the Indus Valley in the east.
The subsequent history of Islamic Spain is well known,
manifest in spectacular monuments such as the Great
Mosque of Cordoba, and by the ivories and richly
carved marbles found in European and American
museum collections. By contrast, Arab Sind has been
forgotten, ignored in studies of early Islamic material.
The reasons for this are several. In the first place, there
is the perception of Sind as geographically remote
from the major cultural and political centers of the
caliphate. This quality was apparent even to premod-
ern observers such as the Jerusalem-born al-Muqadd-
asi, whose observations on Sind betray tenth-century
prejudices:

> Here is an elegant metropolis, a noble river, un-
> common things. However, its non-Muslims are
> polytheists, scholars there are few; moreover, you
> cannot reach it except after the dangers of the
> land and the terrors of the sea, after hardships
> and mental stress.[1]

Prejudices of a more modern kind, but no less rele-
vant to this neglect, are apparent in the comments of
Sir John Marshall, director of the Archaeological Sur-
vey of India, writing in the *Cambridge History of India*
in 1928: "With the Arabs, who in the beginning of the
eighth century possessed themselves of Sind, our con-
cern is small. Like other Semitic peoples they showed
but little natural instinct for architecture or the for-
mative arts."[2] This impression of Sind as a cultural
void was reinforced by its ecology. Earthquakes and
constant shifts in the course of the river Indus over
the course of the past millennium have obscured the
material traces of the Arab period, which are known
only through recent archaeological excavations and
surveys.[3]

The neglect of the eastern territories in modern
scholarship belies, however, their importance to the fi-
nancial, moral, and political economies of the caliph-
ate. Between the eighth and tenth centuries, a vast
array of materials, among them coins, natural resources,
manufactured goods, and even looted Buddhist and
Hindu icons circulated westward from the eastern
frontier to the central Islamic lands. In addition to
booty, taxes, and trade, the importation of flora, fauna,
and agricultural technology from Sind permitted the
exploitation of economically marginal regions of Iraq
itself.[4] Although the devastation wrought by the Mon-
gol conquest of Iraq in the thirteenth century makes it
difficult to trace the impact of these eastern imports on
the artistic production of the 'Abbasid heartlands, the
cultural flows of the period were clearly multidirec-
tional, suggesting that the relationship between center

and periphery was considerably more complex than has usually been assumed.

In this chapter I want to explore the role of the eastern territories, particularly Sind, within the trade networks that developed in the heyday of the 'Abbasid caliphate during the ninth and tenth centuries. Connecting regions as diverse as the Atlantic coast of Europe and the Indian Ocean littoral of India, what has been dubbed the "Arab Common Market" fostered the development of supralocal systems of exchange that cut across (while not necessarily transcending) ethnic, linguistic, political, and religious boundaries.[5] These networks and zones of mobility were both maritime and terrestrial. The first connected Sind and western India with an Indian Ocean circuit that linked the maritime emporia of the Red Sea and Arabia in the west with southwestern China in the Far East. Another branch connected Sind and al-Hind with Iraq and the Persian Gulf ports, Basra and Siraf being by far the most important. From the ports of Sind, both riverine and terrestrial routes led into the interior of the Indus Valley, to the landlocked urban centers of Mansura and Multan. From here, merchants, travelers, and goods could connect to the terrestrial corridors that led west, to the desert region of Makran and on to Iran, or travel by the slower but more hospitable routes that led via mountain passes and valleys to Sistan (with its capital of Zarang) or Zamindawar (around Kandahar) in southern Afghanistan or to the emporia and political centers of Ghazni and Kabul farther to the northeast. From here, the journey could be continued to Khurasan, the wealthy and culturally dynamic region of eastern Iran, or north into Transoxiana and Central Asia.[6] Alternatively, merchants might take southeasterly routes that led along the coast from Sind toward the coastal emporia in the domains of the Rashtrakuta rajas of the Deccan, or more northeasterly trajectories to the Gangetic Plain and the territories of the Gurjara-Pratihara rajas of Kanauj.

The maritime and terrestrial routes connecting the central lands of the 'Abbasid caliphate in Iraq and its eastern frontier regions in what today are Afghanistan and Pakistan were conduits not only for raw materials and high-value goods but also for religious and political dogmas, artistic ideas, and for the human agents who made and traded the objects in which they were manifest. Considering the heterogeneous constitution of a world to a remarkable degree in motion,

the three sections into which this chapter is divided address different but interrelated aspects of mobility between Iraq and al-Hind and the circulatory processes through which diverse subjects and objects, men and commodities, were brought into constellation. The first section considers the scale and nature of the trade in commodities between India and the Islamic world, and the human agents who facilitated it. The second outlines the peregrinations of looted Buddhist and Hindu icons from the area of what today is Afghanistan and Pakistan and draws attention to their role in the political and moral economies of the Baghdad caliphate. The third examines the evidence for the material culture of Sind (now in southern Pakistan) during this period, and the insights that this evidence offers into the complexities of cultural and religious identity on its eastern frontier.

According to one of the many hadiths (Traditions of the Prophet), the Prophet Muhammad both prophesied the conquest of India and exhorted believers to travel as far as the subcontinent in search of knowledge.[7] While the first tradition suggests an early aspiration toward the exercise of Arab political hegemony, the second invokes the renown of India as a reservoir of philosophical and technological knowledge, raising the possibility of more profound levels of cultural engagement. The earliest Arab incursions into the Kabul Valley occurred by the 650s, and the northern and western regions of what today is Afghanistan had come under Arab control by the early eighth century. However, the eastern and southern borderlands of Afghanistan were administered by a series of enigmatic rulers known only by their titles—the Zunbil of Zamindawar, the Lawik of Ghazni, the Shir of Bamiyan—whose dynastic temples seem to have enshrined cults with strong Indic affinities.[8] In the ninth and tenth centuries the Kabul Valley was in the possession of the powerful Hindu Shahis, until the eventual eclipse of the dynasty by the Ghaznavids of Afghanistan.

In the course of the ninth, tenth, and early eleventh centuries, Sistan, Zabul, and Zamindawar (what today is southern Afghanistan) were gradually brought under the political control of those who professed the faith of Islam (fig. 2). These developments are closely associated with the Saffarids of Sistan, maverick parvenus who rose to prominence around 860, and the Ghaznavid sultans who succeeded them as the major

power brokers in the east around 1000. The relationship between the 'Abbasid caliph in Baghdad (the titular head of the Sunni Muslim community) and the amirs, commanders, and governors who mounted raids and campaigns of conquest along the eastern frontier was often ambiguous, marked by a consistent and increasing tendency toward religious heterodoxy and political dissent.

By the late tenth century, the eastern extremities of the 'Abbasid caliphate were roughly defined by a series of mercantile emporia along a line stretching from Balkh to Kabul, Gardiz, and Ghazni through the Gomal Pass to the Indus Valley, where access could be had to the more direct sea routes.[9] Along these routes, urban nodes such as Bust, Ghazni, and Kabul are described as metaphorical "ports" of or "gateways" to India. Both Ghazni and Bamiyan, which lay along the trade routes to Khurasan, are described as the treasure-house of Sind (*khazā'in al-Sind*), while Balkh is described as the emporium of India (*bār-kadha-yi Hindūstān*).[10] These frontier towns were polyglot emporia containing ethnically and religiously heterogeneous populations; tenth-century Kabul, then the capital of the Hindu Shahi dynasty, was typical, populated as it was by Muslims, Jews, and Indians (*Hindūwān*).[11] Arab and Persian merchants (among them both Muslims and Jews) also operated in the coastal areas of Sind and western India and in the interior as far as the central Indian city of Kanauj, while Indian merchants traded goods in Sind, Sistan, Zabulistan, and as far west as Kirman in southeastern Iran. The honesty of these Indian traders is a persistent

2

Map showing the major political formations of South Asia during the ninth and tenth centuries.

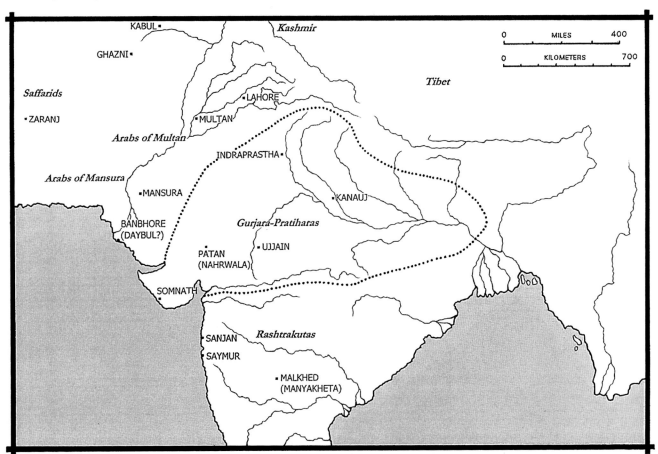

17

topos, as is the extent to which Indian rajas went to protect trade and traders in their realms.[12]

Farther to the south, an expedition under Muhammad ibn Qasim had succeeded in bringing the major settlements of southern Sind under Arab control by the first decades of the eighth century.[13] The possible appearance of the "king of India" (probably Dahir, the ruler of Sind at the time of the contemporary Arab conquest) along with other defeated rulers in a painting executed in a royal bathhouse at Qusayr 'Amra in the Jordanian desert around AD 740 provides a reminder of the "global" resonance of these campaigns of conquest in the east. Dahir's engagements with the Arabs are described in detail by the Arab historian al-Baladhuri (ninth century) and in the *Chachnāma*, a thirteenth-century Persian history of the campaigns in Sind apparently based on a lost Arabic original.[14]

The two most important cities under Arab control were the ancient center of Multan in the Panjab and the city of Mansura in lower Sind, a new Arab foundation located near the ancient settlement of Brahmanabad (fig. 2).[15] The architecture of Arab Multan is an unknown quantity, but both Mansura and Daybul (its dependent port, usually identified with the modern site of Banbhore in the Indus Delta) were walled cities, with gates named after the regions toward which they faced (fig. 3).[16] The port of Daybul

3
Plan of Banbhore, Indus Delta (after A. Khan 1990a).

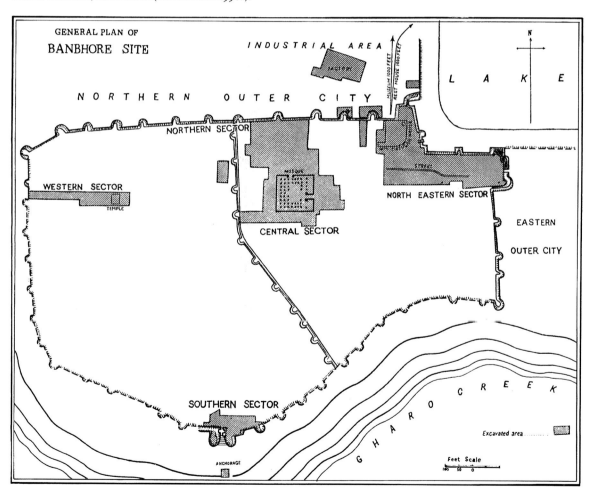

connected Mansura to the maritime routes of the Indian Ocean, linking it with ports in the Red Sea and Persian Gulf in the west and in the east to the emporia on the western coast of India, and ultimately to those on the south coast of China. By contrast, Multan was a landlocked emporium located along the slower east-west trade routes linking Iraq, eastern Iran, Afghanistan, Central Asia, and northern India.[17] Muslims appear to have been a minority in all these centers, and Multan was the site of a celebrated Sun Temple, which continued to operate and to attract pilgrims from all over the subcontinent after the conquest.[18]

The cosmopolitan world of Sind is evoked in the Arabic and Persian accounts of al-Hind left by tenth-century geographers, sailors, travelers, and by the sedentary scholars who derived vicarious benefit from their experiences. The ninth and tenth centuries saw the production of more Arabic geographical accounts of India than any subsequent period, and the dependence of later writers on them attests to Sind's role as a transregional nexus before 1000, when the sultans of Ghazni reconfigured the cultural and political landscape of the eastern Islamic world.

In the accounts, India is depicted as a world of wonders ('ajā'ib), much as it had been to western writers from the time of Herodotus onward. This wonder finds expression in works such as the *Akhbār al-Sind wa'l-Hind* (News of Sind and al-Hind), compiled in 237/851, and the *Kitāb 'Ajā'ib al-Hind* (The Book of the Wonders of al-Hind, ca. 955), compilations of seafaring tales that weave together maritime lore, tales of the fabulous, ethnographic observation, and historical detail.[19] The anecdotalist and geographer al-Mas'udi (d. 346/957) traveled to India, and his firsthand account provides invaluable insights into the nature of the trade that underwrote the economies of Sind and al-Hind, and the cultures of the territories that this trade encompassed and traversed.[20]

These works also provide unique insights into political developments in both regions. Although Sind was administered in the name of the 'Abbasid caliph in Baghdad, from around 850 the caliph's writ obtained erratically. After 850, a series of rebellious governors gave way to self-styled amirs who enjoyed de facto autonomy and struck coins to an Indian rather than an Iraqi standard. The amirs of Mansura claimed descent from Habbar b. Aswad, a contemporary of

the Prophet, and are consequently known as the Habbarids. Similarly, the amirs of neighboring Multan claimed descent from Usama ibn Lu'ayy ibn Ghalib, another contemporary of the Prophet.[21]

This development reflects a decline in the centrifugal authority of the Baghdad caliphate, especially in its eastern territories. Around 354/965, the amirs of Multan abandoned the fold of Sunni orthodoxy, aligning themselves with the Fatimids of North Africa, who espoused the Isma'ili denomination of Shi'i Islam, laid claim to the title of caliph, and installed themselves in Egypt, which seceded from 'Abbasid control in 358/969. This was a period of resurgent Shi'i political activity even in the Iraqi heartlands of the caliphate, which from 344/955 was under the control of the Buyids, Iranian Shi'is based in the Gulf province of Fars, who retained the caliph as little more than a figurehead. Around the same time that Multan came under Isma'ili control, the amirs of Mansura aligned themselves with the Buyids, bringing the two Arab polities of Sind within the Shi'i fold.[22] The heterodox affinities of the amirs led to their demise; they were subject to military chastisement and eventual extinction at the hands of the Ghaznavid sultan Mahmud in the first decades of the eleventh century.

There can be little doubt that maritime connections between Sind, Egypt, and the Persian Gulf played a role in these realignments, facilitating the relatively rapid transmission of potentially seditious ideas and the human agents who propagated them. Patronized by merchants from as far afield as Andalusia, the cosmopolitan port cities of Sind were ideally situated to the promulgation and promotion of intra-Muslim polemics: the Qur'anic texts inscribed in the congregational mosque at Banbhore (probable site of the celebrated port city of Daybul) seem to have been selected for their ability to engage theological debates between rationalist and antirationalist factions that were raging in Baghdad during the reign of the caliph al-Mutawakkil (d. 248/861).[23]

During the ninth and tenth centuries, peninsular India was dominated by two major political formations: the Rashtrakuta rajas of the Deccan, who claimed overlordship of peninsular India as a whole, and the Gurjara-Pratiharas of Kanauj, who between circa 836 and 933 united large areas of northern India, including areas of Gujarat and Rajasthan that abutted the Arab

amirates of Sind (see fig. 2). The Arabs refer to the Pratiharas as the *Jurz* (Gurjara) or *Biruza* (from *biruda*, their epithet), and to the Rashtrakuta maharaja as the *Balharā*, an Arabization of *Ballaha-rāya*, the Prakrit form of *Vallabha-rāja* (the beloved king), one of his titles.[24] The *Balharā* is frequently described as the greatest of the rulers of India, his success attributed to his favorable disposition toward the Arabs, with whom he shared common cause against the Gurjara-Pratiharas.

By contrast, the Gurjara-Pratiharas are reported to have been hostile to Muslims in general and to the Arabs of Sind and their Rashtrakuta allies in particular. The Pratiharas maintained strong armies to be deployed against both, and numerous inscriptions record military engagements between the Arabs and the rajas of Kanauj or their vassals during the course of the ninth and tenth centuries.[25]

Vagaries in the political relationships between Baghdad, Sind, and al-Hind did little to stem the westward flow of agents, artifacts, booty, commodities, information, and texts during these centuries. The remittance of Indian booty or tribute to the early caliphs is documented as early as the late seventh century, but it increased exponentially with the conquest of Sind in the early eighth. Under the Umayyad caliph Mu'awiya b. Abi Sufyan (d. 60/680), the governor of the Indian frontier received the submission of the ruler of al-Qiqan in Sind, who agreed to pay the poll tax (*jizya*) imposed on non-Muslims and forwarded the governor a number of rarities including a fragment of a mirror said to have belonged to Adam, which was selected for dispatch to the caliph.[26] The gift of a golden jeweled camel sent by the "king of India" to al-Junayd b. 'Abd al-Rahman, the governor of Sind during the reign of the caliph Hisham (d. 125/743), ended up in the treasury of the Umayyads, from whence it passed into the possession of their successors, the 'Abbasids.[27] A later governor of Sind, 'Imran b. Musa b. Khalid b. Barmak (d. ca. 226/840), sent the 'Abbasid caliph two thousand Indian prisoners of war, precious raw materials, worked gold and silver objects and weapons, and other curiosities and rarities including birds and animals.[28] Making immanent at the center distant (and sometimes notional) victories at the periphery, these gifts of exotic animals, precious raw materials, rare commodities, and looted curiosities linked the ideal political center of the medieval Sunni world, Baghdad, with regional centers of authority in

the east (Sistan, Sind, Kabul, Ghazni) and the inchoate world of the *dār al-ḥarb* that lay beyond.

In addition to the transmission of booty and tribute, several gift exchanges between the 'Abbasid caliphs and the "king of India" are documented for the ninth and tenth centuries, the result of diplomatic contacts with South Asian rulers established as early as the seventh century.[29] Among the more intriguing reports of such exchanges, Dahmi or Rahmi, described as the great king of India, is said to have sent the 'Abbasid caliph al-Ma'mun (d. 217/833) a letter describing his palace built of aloes wood, its treasury, and the wealth of his court. Accompanying the letter was a vast array of Indian riches and a book whose Arabic title is rendered as *Ṣafwat al-Adhhān* (The Cream of Intellect). In the written response that accompanied the rare gifts with which the caliph reciprocated, the caliph mentions his inclusion of a work titled *Dīwān al-Albāb wa Bustān Nawādir al-'Uqūl* (The Gathering of the Cores of Intellect and the Garden of Rare Minds).[30] The exchange of texts across linguistic barriers may seem unlikely, but the same caliph is reported to have solicited Greek manuscripts from the Byzantine emperor.[31] The letter accompanying the caliph's gifts reportedly referred to the need for its own translation, an activity that was actively pursued at the 'Abbasid court, enhancing knowledge about and from India through the rendering of Indian astronomical, medicinal, and pharmacological texts into Arabic.[32] The association between India and learning was so well established at this period that some Arab observers attributed the ultimate sources of Greek learning to that country. Arabic translations of Sanskrit texts (including the *Panchatantra/Kalīla wa Dimna*) were rarely direct, however, but were usually mediated by earlier Middle Persian (Pahlavi) translations.[33]

Occasionally, the process of translation benefited from the fruits of Arab "scientific expeditions" to India. In a curious echo of the framing tale from *Kalīla wa Dimna* with which I began this book, the 'Abbasid vizier Yahya ibn Barmak (d. 187/803), who was descended from the custodians of a Buddhist shrine at Balkh in northwestern Afghanistan, dispatched a mission to India to gather information on its medicinal plants and religions. The resulting text continued to be an important source for later writers on India.[34]

The presence of Indian informants in Baghdad itself is also well documented. The production of the

Zij al-Sindhind, one of the most important works of medieval Arabic astronomy, was facilitated by the presence of an Indian scholar who came to Baghdad bearing scientific tracts (including a *siddhānta* or astronomical text) as part of delegation sent by a ruler of Sind in 154/771 or 156/773, one of a number of Indian scholars and physicians whose presence is reported at the 'Abbasid court.[35] A perceived relationship between complexion, ethnicity, and cultural achievements led at least one Arab author, writing in Spain around 1050, to explain that the ingenuity of Indians, their genius for astronomy, medicine, and mathematics, was at odds with their dark complexion.[36] Nevertheless, the physical beauty of Indians (both male and female) is also a consistent topos in Arabic and Persian literature, along with their capacity for xenophobia, idolatry, self-mutilation, and the observation that their rulers generally avoided alcohol (a source of cultural kudos in Arab eyes) but had lax sexual mores (a stock monotheistic criticism of idolaters).[37]

Outside the courtly milieu, Indian slaves acquired during military campaigns along the eastern frontier are occasionally encountered in Arabic and Persian geographies and histories, where their fortunes vary considerably. At one end of the spectrum are the Sindi slaves in Iraq or the Indian slave boy encountered near Qazwin in northwestern Iran by the Isma'ili traveler Nasir-i Khusrau in 438/1046; at the other is the Indian slave who governed the Syrian city of Aleppo in the name of the Ayyubid sultan two centuries later.[38] In addition to pirates from Kachch and Kathiawar who raided as far west as southern Iraq as early as the ninth century, the presence of Indian merchants is reported in the ports of southern Iraq, where the construction of Hindu shrines suggests that they enjoyed the freedom to worship openly.[39] As late as the fifteenth century, Hormuz, the successor to Siraf on the Persian Gulf, is said to have had a sizable community of non-Muslims, its inhabitants combining what a contemporary traveler refers to as "the glibness of Iraqis and the mysteriousness of Indians."[40] These merchants were involved in the import of raw materials such as aloe, exotic animals and their pelts, precious stones and tropical hardwoods, and manufactured goods into the 'Abbasid lands from India, including metalwork, worked leather, textiles, and sandals from Cambay (an interesting comment on the portability of premodern fashions).[41]

Later members of the Indian diaspora may have provided the inspiration for the representations of Indian sailors and princes found in Arabic and Persian manuscripts and on ceramics between the twelfth and fourteenth centuries (fig. 4). Some of these Iraqi paintings make use of stylistic details common to earlier western Indian painting, hinting at dimensions of culture contact whose significance awaits further investigation.[42] In these images, Indians are depicted according to fairly consistent visual conventions: darker of skin than their Arab and Persian contemporaries, by comparison with whom they are consistently underdressed (often bare chested and clad only in a *dhoti* or *lungi*), sporting long hair (often tied in a topknot) and long beards.

The corollary of the Indian communities in the Gulf is the existence of sizable communities of Muslim traders in the coastal domains of the Rashtrakuta rajas of southern India. Epigraphic evidence attests to the presence of Persian (either Zoroastrian or Muslim) merchants on the Konkan coast of western India as early as the late seventh century.[43] The geographer al-Mas'udi visited Saymur (modern Chaul south of Mumbai; see fig. 2) in 304/916 and saw there a large community of Muslims comprising merchants from Basra, Baghdad, Oman, Siraf, and Yemen.[44] During this period the denizens of Siraf were active in the maritime trade as far east as China, and the best documented of the Sirafi merchants, Ramisht (d. 537/1142), is said to have made a fortune in the Indian trade, with some of which he endowed and embellished the sanctuary at Mecca.[45]

The Iraqi and Persian Muslims of western India were provided with both neighborhood mosques (*masājid*) and congregational mosques (*jawāmi'* or *masaqit-i ādhīna*) standing in close proximity to idol temples (*but-khāna*) endowed with minarets from which the call to prayer (*adhān*), the *takbīr* (the cry "God is great"), and the *tahlīl* (the statement that there is no god but God) were given.[46] The existence of these diasporic communities is confirmed by inscriptions of the Rashtrakuta and Kadamba rajas found on the west coast of India. The Chinchani copper-plate inscription of Śaka 848 (AD 926) mentions that a *Tājika*, who with the name of Madhumati Sugatipa (Muhammad Lord of the Virtuous) son of Sahiyarahara (Shahriyar) was evidently a Persian Muslim, governed the region of Sanjan (Samyana) on the Karnataka coast of

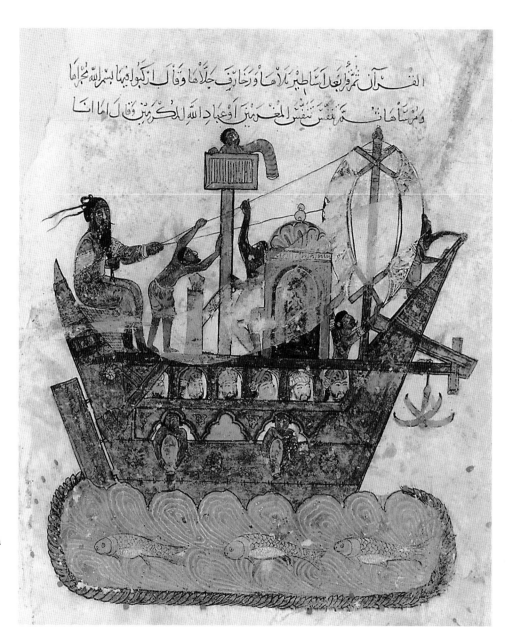

قران ثم ذوابعد اساطير بلاها ورخارف جلاها وقال ازكبوا فيها بسم اللّه مجراها
ومرساها ثم نفس نفر المعمين او عباد اللّه المكربين وقال انا

4
A ship manned by Indian sailors, *Maqāmāt* of al-Harīrī, Baghdad(?), 1237 (Bibliothèque nationale de France, Ms. Arabe 5847, fol. 199v).

western India (see fig. 2) for the Rashtrakutas during the reigns of Krishna II (AD 878–915) and Indra III (915–28), who elsewhere describes his dominion as including the *Tājika*s and *Pārasīka*s (Muslims and Persians/Parsis). The inscription indicates that Madhumati established free ferries and a feeding house and endorsed the establishment of a Hindu monastery and an endowment to ensure its support by a Brahman who was an associate of his minister. The foundation is mentioned in a later inscription of Śaka 956/AD 1034, which also refers to the merchants Alliya ('Ali), Mahara (Mihr), and Madhumata (Muhammad).[47] Recent archaeological finds at the site of Sanjan have produced evidence to substantiate these links between

the Rashtrakuta ports and the Persian Gulf, including significant quantities of tenth-century ʿAbbasid lusterware vessels presumably brought from the port city of Basra in Iraq.[48]

Farther south along the Konkan coast, two inscriptions in the name of the Kadamba ruler Jayakeshin I (ca. 1050–80) found at Panjim in Goa attest to the presence of Muslim communities related to those of the northern coastal cities. The first is datable to AD 1053 and grants permission to an official named as Chadama to collect taxes from ships entering the port in order to fund construction of a *mijigiti* (mosque); the official's father is named as a *Tājika* merchant Madumod (Muhammad). From a second royal inscription of AD 1059 reporting the grant of a village to Chadama, we learn that he was the son of Madhumada (Muhammad), son of Aliyama (ʿAli), a *Tāyika* (*Tājika*) merchant who hailed from the port of Cemulya (Saymur).[49]

The Muslim presence was not confined to the coastal cities and towns of Gujarat and Maharasthtra, for communities of Muslim merchants also existed in the cities of the Gangetic Plain. Al-Muqaddasi reports the existence of a congregational mosque (*jāmiʿ*) serving these communities in the suburbs (*al-rabaḍ*) of Kanauj, the capital of the Gurjara-Pratiharas whom the geographers describe as inherently hostile to Islam.[50] A mihrab datable to the ninth or tenth century survives at Gwalior near Kanauj (fig. 5), confirmation that Muslims and mosques existed not only in the coastal cities of the Rashtrakutas but also within the urban centers of the Gurjara-Pratihara rajas.[51] Adapting a contemporary Indic architectural vocabulary, the stone mihrab anticipates the idiomatic transformations associated with later Indo-Islamic architecture (see chapter 5).

From what we know of them, the administrative arrangements made for minority communities in the domains of the Hindu Shahis of Afghanistan, the Rashtrakutas of the Deccan, and the Gurjara-Pratiharas of the Gangetic Plain were similar. Al-Muqaddasi mentions that the minority Muslim populations of both Kabul and Kanauj were administered by an independent authority. Similarly, Muslims living under Rashtrakuta rule were governed by Islamic law and administered by a *hunarmān* (the equivalent of a *qāḍī* or judge) with the consent and support of the Rashtrakuta maharaja.[52] Among the strangest cases heard

5
A ninth- or tenth-century stone mihrab now preserved on the exterior wall of Gwalior fort, central India.

by one of these officials is that of a Muslim sailor accused of using an idol for sexual gratification. Violations of this kind were apparently common to communities of every faith: the *Arthashāstra*, a Sanskrit manual of statecraft compiled in the first centuries of the Christian era, prescribes a financial penalty for them. In this case, however, the *hunarmān* reasoned that the offence was equivalent to the desecration of a mosque and invoked the harsher standards of the Shariʿa to have the youth executed.[53]

In both Kabul and Kanauj, minority Muslim

communities inhabited the suburbs (*al-rabaḍ*), where the mosque at Kanauj was located rather than the city center, as one would expect in an Islamic city.[54] It would, however, be mistake to see this marginalization as a spatialization of difference, an urban reiteration of the boundaries between "Hindu" and "Muslim" political formations. In the first place, there is nothing to suggest that Muslims were segregated in the suburbs of Kabul. In the second, the boundaries between different polities on the eastern frontier of the Islamic world were themselves less distinct and linear than a modern observer might conclude.

Modern political theorists distinguish between a boundary, "a precise linear division within a restrictive political context," and a frontier, which "connotes more zonal qualities, and a broader, social context."[55] Broadly speaking, the latter seems to correspond to how boundaries were conceived of by the medieval Arab and Persian geographers. The anonymous Persian author of the *Ḥudūd al-ʿĀlam* (The Limits of the World), completed in 372/982, acknowledges the differences between regions, locating them in climatic, cultural (including religions, laws, and beliefs), linguistic, and political distinctions. For him, it is the natural features of the land (mountains, rivers, deserts) that define the limits of countries.[56] The two terms most commonly employed to denote political boundaries are *ḥadd* or the plural *ḥudūd* (boundaries, impediments, limits) and *thagr*, usually used in the plural *thughūr* (breaches, gaps, or openings).[57] The former is used to denote boundaries of political authority between entities both within and without the *dār al-Islām* (that is, both "external" and "internal" frontiers), whereas *thughūr* generally refers to "external" boundaries, including coastal regions subject to hostile attack from non-Muslims.[58]

In contrast to the contemporary frontier between the ʿAbbasid caliphate and its Byzantine neighbor, which was the *thughūr* par excellence, the eastern frontier lacked the *ʿawāṣim*, a defensive buffer zone that preceded the *thughūr* proper.[59] The mobility and mutability of the eastern frontier is one reason for this absence. Rather than a fixed defensive boundary, a Maginot Line or iron curtain, the eastern frontier comprised a series of urban nodes each with its hinterland within which administrative authority was exercised to varying degrees of effectiveness, diminishing in intensity as one traveled away from the center.[60] Imagined collectivities of such administrative centers could define larger cultural and political formations, so that the cities of Sind and their dependencies collectively constituted the frontier of Sind (*thughūr al-Sind*) or the eastern limit (*ḥadd al-mashriq*) of the Islamic world.[61]

At least in the geographical texts, this model of dominant centers, associated peripheries, and diffuse limits operated intraculturally as well as interculturally. Thus, the *Ḥudūd al-ʿĀlam* notes that Ghazni lies on the frontier (*ḥadd*) between Muslims and unbelievers, employing exactly the same term to denote the boundaries between Arab Mansura and its dependency of Daybul.[62] The terminology and manner in which information is conveyed underline a key element common to the imagining of "internal" and "external" boundaries: the assumption that they could be, indeed would be, crossed. This quality of mobility is emphasized by descriptions of cities like Ghazni and Bust as metaphorical gates to or ports of al-Hind, and by the naming of the four gates of Mansura after the regions toward which they led, whether or not they were under the jurisdiction of Muslim rulers.[63]

We are far removed here from the crisply delineated (and heavily policed) borders and boundaries of the modern nation-state, "that product of a legal act of delimitation," which in Pierre Bourdieu's reckoning "produces cultural difference as much as it is produced by it."[64] While Sind and al-Hind are evidently conceptualized as distinct entities—and military conquest could reposition the frontier cities of Hindustan within the Islamic lands—the transition between them is defined by a gradual transition from one sphere of political authority to another, not by fixed points. Rather than bounded (or bordered) space, therefore, we are dealing with cultural and political spheres of authority that intersected at their margins to form "zone boundaries" or "transfrontiers" where the limits of cultural and political authority overlapped and were continuously negotiated, whether by belligerent rulers or itinerant merchants, pilgrims, and travelers. The *ḥadd al-mashriq* was it seems constituted by process as much as by place.[65]

Moving away from a linear conception of premodern frontiers to a more processual or zonal paradigm does not of itself solve the problem of the reified

boundary, however, for if the frontier is neither linear nor stable, neither is it reducible to the exercise of political authority alone. On the contrary, the limits of political power in premodern societies were not necessarily coincident with legal, ethnic, or fiscal boundaries, or with linguistic, commercial, and numismatic frontiers.[66] The point is underlined by the existence of self-governing communities of Arabic- and Persian-speaking Muslims subject to Shari'a law within the coastal cities of the Rashtrakuta polity. Since the *dār al-Islām* is sometimes defined as those territories in which the law of Islam prevails, the existence of these self-governing communities highlights a disjunction between legislative and political frontiers. Elizabeth Lambourn's recent study of these communities suggests that the texts in which they are described may in fact have been intended as contributions to an ongoing debate about the legal status of Muslim residence outside lands under the political jurisdiction of Muslims. As Lambourn reminds us, "the *dār al-Islām* was less a single, centred mass than a network across Asia and its oceans."[67]

In contrast to the *cognitive regions* central to the nation-state, which are characterized not only by shared conceptions of space (mythic/symbolic as well as territorial) but also by language and religious beliefs and practices, the ethnically, linguistically, and religiously heterogeneous communities that comprised the urban nodes of South Asian trade networks constituted *functional regions*, spatial elements of a cultural geography marked by circulations and flows that cut across political boundaries.[68] In her work on the material culture of the medieval Mediterranean, Eva Hoffman has drawn attention to the ways in which the circulation of luxury goods along "pathways of portability" "re-mapped geographical and cultural boundaries, opening up vistas of intra- and inter-cultural encounters and interactions."[69] The idea is an important one that might equally be extended to other kinds of artifacts, most obviously the monetized tokens that facilitated the circulation of commodities and services between Central and South Asia, the Middle East, and northern Europe during the ninth and tenth centuries. A tenth-century Arab traveler in the Rhineland could, for example, remark on the use of silver dirhams minted three thousand miles away in the Samanid amirate of Bukhara, coins that have been found in quantity in northern Europe and were imitated by contemporary Anglo-Saxon kings.[70] The circulatory patterns of these coins delineated monetary spheres of influence that were not necessarily coincident with boundaries of administrative or political authority.[71]

Samanid dirhams circulated alongside silver coins struck by the Hindu Shahis of Afghanistan. Engraved with a mounted rider on the obverse and a recumbent bull usually interpreted as Nandi, the sacred bull of Shiva, on the reverse, these are known as "bull-and-horseman" coins. Like the Samanid dirhams, the "bull-and-horseman" coins were valued for their reliable silver content, traveling east and west along the trade routes emanating from their Afghan homelands, to be found in significant quantities in northeastern Europe.[72] A gradual decline in their silver content did little to curb their use, and by the eleventh and twelfth century billon (alloyed metal) versions of the coin type had been adopted by the Ghaznavids in their Indian territories and by Rajput dynasties such as the Tomars and Chauhans in northwestern India.[73]

The overlapping and intersection of different monetary spheres extended the phenomenon of the transfrontier while facilitating transcultural appropriations of objects and images in ways that may or may not be immediately apparent. An enigmatic version of the Hindu Shahi bull-and-horseman coin issued by the Saffarid governor of Kabul after its capture in 256/870 (fig. 6) is a case in point. The mounted horseman of the obverse is juxtaposed with the Arabic inscription *'adl* (justice), while on the reverse a recumbent bull is framed by the Sanskrit inscription *śrī khūdarayaka* (the fortunate small raja).[74] The presence of the Arabic term may derive from Islamic ideals of kingship in which the dispensation of justice features prominently; a later pretender who arose from among the circle of the Saffarids styled himself *Dār al-'Adl* (The Abode of Justice).[75] The bicultural nature of the coins is not confined to their inscriptions, however, but includes their metrology: they were not struck to the weight standard of contemporary Hindu Shahi coins but to that of 'Abbasid dirhams from Iran and Iraq.[76]

A few decades later, Hindu Shahi coins of the same type circulated westward to Iraq, where they served as models for an extraordinary series of coins

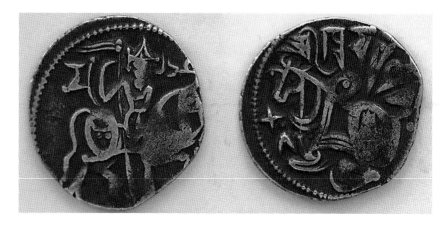

6
Kabul, bull and horseman *jital* struck around AD 870 in the name of Khudarayaka and bearing the Arabic word *'adl* (private collection).

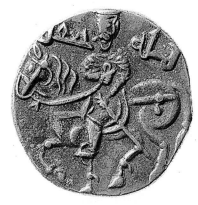
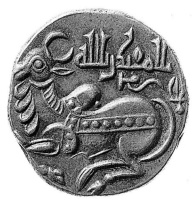

7
Commemorative coin of al-Muqtadir Billah, Baghdad(?), 295–320/908–32 (courtesy of the Ashmolean Museum, Oxford).

issued by the 'Abbasid caliphs al-Muqtadir Billah (295–320/908–32) and al-Muti'lillah (334–363/946–974). In addition to a rare gold version (unrepresented among the Hindu Shahi models) al-Muqtadir struck at least four variant silver forms, on which the caliph's given and regnal names replace the Sanskrit legends of the prototypes.[77] On the obverse of one variant the *trisūl* (trident) appears prominently, displaced from the rump of Shiva's mount but quite legible (fig. 7). Also present is what appears to be the Sanskrit letter *ta* or *da* rotated anticlockwise through ninety degrees, emulating enigmatic letters that appear on the Hindu Shahi prototypes.[78] The use of figural imagery is anomalous on 'Abbasid coinage, which is strictly epigraphic, and these were probably commemorative or donative issues minted in Baghdad perhaps for distribution to the tribes of the Kabul Valley to secure their allegiance, or to commemorate an expedition to Zabulistan in 304/912.[79] The appearance of Shiva's bull and trident on 'Abbasid coins provides a particularly concrete example of how circulation can remap cultural boundaries, rendering even religious imagery available for appropriation in the process.

| *Gifts, Idolatry, and the Political Economy*

The circulations and intersections within the ninth- and tenth-century world system to which the numismatic evidence attests included communities of faith. The construction of mosques for minority communities of Muslims in the territories of the Gurjara-Pratiharas and Rashtrakutas offers one example, and reports that Indian merchants placed an idol of Zhun (whose principal shrine was located in southern Afghanistan) in the Iraqi port cities of Basra and al-Uballa another.[80]

THE MERCANTILE COSMOPOLIS

During the same period, mercantile communities of Hindus and Muslims were constructing temples and mosques in the ports of southeastern China.[81]

Despite these intersections, for medieval Arabic and Persian geographers and historians, distinctions between different communities of faith comprised a cognitive frontier often conceived in spatial terms. In the teleological version of history offered in Arabic and Persian texts, territorial expansion and concomitant Islamization is often signified by the extirpation or repudiation of idolatry, a phenomenon manifest in *shirk*, the association of other gods with God, or a mistaken investment in material objects, what a modern observer might call fetishism.

The association between India and idolatry was firmly established in Arabic and Persian literature from an early date. Muslim polemicists frequently accused those of other faiths of indulging in polytheism and idolatry, however, and it is important to remember that such accusations were a stock-in-trade of medieval monotheist polemics. Even polemical tropes circulated. Indian idolaters could be compared to the pagan Arabs of pre-Islamic Arabia by a Muslim scholar even as a Christian Arab polemicist of the ninth century cast the practices associated with the *ḥajj* (including circumambulation of the Ka'ba and the shaving of hair) in the mold of the idolatrous rites practiced by Indian Brahmans.[82] Ironically, two of the key stereotypes concerning Indians in general and Hindus in particular that were current in the medieval Islamic world—their moral laxity and inveterate idolatry—are precisely those that color Christian representations of Muslims during the same period.[83]

Alongside the stock descriptions of wondrous idols and shocking customs that one finds in the works of the geographers, however, one also finds more extensive treatments of Indian religious practices and iconolatry, topics that were to increasingly preoccupy Arab and Persian writers as the cultural contacts between eastern Iran and India increased in volume between the tenth and twelfth centuries. Among the earliest Arabic writings on Indian religions are those of Ibn al-Nadim (ca. 326/938)—a rare survival among a number of ninth- and tenth-century works on Indian idolatry now lost—and Persian writers such as Gardizi (before 432/1041), Abu al-Ma'ali (484/1092), and Marvazi (ca. 513/1120).[84] These generally treat

"Hindu" religion less as a monolithic category and more as a congeries of sects, which are sometimes accommodated among discussions of the many heterodox (and heretical) groups that proliferated in the eastern borderlands of the Islamic world.

The *Kitāb fī taḥqīq ma li'l-Hind* (Book of Inquiry into India) of al-Biruni (ca. 1030) includes a sophisticated explication of Indian religions, and it later formed the basis for the Indian sections of a universal history produced in Mongol Iran.[85] Al-Biruni accepts that polytheistic religions can have monotheistic adherents. Repudiating the idea that Indians view idols as worthy of worship in their own right, he sees the fundamental fault lines of religious belief as those of class. Just as human need for the concrete (*maḥsūs*) over the abstract (*ma'qūl*) leads uneducated people to crave representations of their objects of devotion (the examples given include images of the Ka'ba and the Prophet Muhammad), so uneducated Hindus embrace idol worship, ignoring the distinction between the material representation and the immaterial reality that it represents.[86] As far west as Cordoba a contemporary of al-Biruni noted that Brahmans accepted the unity of God but denied the possibility of revelation, which was central to Muslim belief. Similarly, the Sicilian geographer al-Idrisi (d. 560/1165) explains in terms worthy of an eighth-century Byzantine iconodule that Brahmans use idols by way of mediation (*al-tawassuṭ*) between God and themselves.[87]

Works like these provided literate audiences with complex theoretical insights into Indian beliefs and practices, but for most observers the theory and practice of Indian idolatry were materialized in their most fundamental object: the idol. The caliph Mu'awiya (d. 60/680) is said to have dispatched to Sind idols seized during the Arab conquest of Sicily, with the certainty that they would find a market there.[88] The report points to a persistent association between idolatry and Sind in the Arabic sources, while underlining the fact that idolatry is a vice located in the eye of the believer-beholder, for whom all idolaters are often alike in their cathexis, whatever its object. Not all Indian idols or icons were undifferentiated, however. During the ninth through eleventh centuries, select objects of Indian exotica, including religious images, acquired through the military exploits of the Habbarids, Saffarids, and Ghaznavids on the eastern fron-

tier were dispatched to Baghdad, where they manifested narratives of conquest and piety, incorporation and renunciation. The incorporation that they materialized was often notional: although the Saffarid ʿAmr ibn Layth sent Indian idols seized during his campaigns around Zamindawar and Bust in southern Afghanistan as gifts to the caliph in 283/896, fifty years later al-Masʿudi noted that this region still constituted the frontier (al-thughūr) and was largely inhabited by unbelievers.[89] Nevertheless, the display of Indian idols in Baghdad and Mecca made distance tangible, signifying a remapping of spiritual and terrestrial frontiers while mediating the relationship between the actual and putative agents of this process.

Entering circuits of conspicuous redistribution within the political economy of the ʿAbbasid caliphate, the icons came to function as "incarnated signs" whose principal use was rhetorical and social, and whose value derived not only from their material properties or former functions but also from the fact and nature of circulation itself.[90] At the end of their peregrinations, looted icons could be sent to Mecca, the spiritual omphalos of the Islamic world, for ritual display and/or destruction and redistribution as alms or coin in a kind of potlatch that accrued further symbolic capital for the donor. Within a loosely but consistently articulated theory of value that valorized circulation over accumulation, such gestures exploited the material instability of the icon to enact practical critiques of idolatry.

Modern commentators have, however, seen these practices as evidence for the reductive approach of medieval chroniclers to Buddhist and Hindu icons, a tendency to emphasize their homogeneous identity as idols, and reduce their cultural value and ontological status to that of their constituent materials.[91] Conversely, leftist scholars have sometimes cast medieval agents in the mold of modern secularists, emphasizing economic utility rather than iconoclastic ideology as a motivation for such acts. Both approaches ignore Anthony Cutler's observation that so far as premodern ritual practice is concerned, "aesthetic, economic, and pious gestures do not inhabit entirely separate universes."[92] During the conquest of Samarqand in 87/705, for example, captured religious images were first despoiled then burned to show their impotence, netting fifty thousand mithqāls (roughly two and a half thousand kilograms) of gold and silver in the process.[93]

According to most traditions of Islamic jurisprudence, the spoils of wars against non-Muslims fall into two basic categories: fay' and ghanīma. In general, fay' accrued from lands taken as the result of unconditional surrender, while ghanīma accumulated as a result of military conquest. Ghanīma was divided into fifths, with one-fifth being mandated to the state and the remainder divided among all those who had fought in battle; a bonus (nafal) might be paid to warriors who distinguished themselves in battle. Specific classes of the remaining booty (referred to by the Arabic term ṣafiyya) were reserved for the ruler; these included precious metals, arms, elephants, and objects of particular monetary worth, rarity, or aesthetic value.[94] The occlusion of particular types of artifact from general circulation as booty is common to South Asian tradition, which awarded a certain portion of the spoils to those who fought in battle, while reserving certain categories of plunder—including gold, silver, land, religious icons, and royal regalia—for the victorious ruler. Corresponding to the ṣafiyya, these spoils were usually dispatched to the victor's capital for display, redistribution, or donation to his temples, thus embellishing and extending the conqueror's power while downgrading and diminishing that of his defeated opponent.[95]

Just as Assyrian kings or Roman emperors might carry off images of autochthonous gods or tutelary deities to hold them hostage, to deprive their homelands of their protective presence, or to avail the metropolitan pantheon of it, so in medieval India religious images could be seized during campaigns of military expansion and installed in the dynastic shrines of victorious monarchs.[96] Alternatively, they might be gifted to a powerful ruler to forestall more aggressive engagements in what Richard Davis has identified as "a metonymic acceptance of ritual subordination," predicated on the icon's ability to stand for both rulers and polities. As Davis notes, these practices were integral to the functioning of a sophisticated semiotics of looting among premodern South Asian elites: "Alive to the identities and mythic backgrounds of the figures, royal looters dislodged select images from their customary positions and employed them to articulate political claims in a rhetoric of objects whose princi-

pal themes were victory and defeat, autonomy and subjugation, dominance and subordination."[97]

In a similar vein, defunct crowns and thrones (signs of political submission) and abandoned idols (signs of religious renunciation) seized from or surrendered by eastern rulers defeated during campaigns of expansion along the eastern frontier of the *dār al-Islām* during the ninth through the eleventh centuries were often dispatched for display in Baghdad, Ghazni, or Mecca. Representing the distant rulers who had abjured or been deprived of their use, the territories over which they had presided, and the amirs through whose agency they had been acquired, these tokens of victory also permitted a vicarious participation in the territorial expansion of the Islamic world, reifying a rhetoric of inclusion and exclusion intrinsic to the construction of an idealized unitary self.

The precedent was established during the lifetime of the Prophet, who is reported to have suspended a copy of the Golden Book of the Zoroastrians within the Ka'ba after it was sent to him by Badhan, the Persian ruler of Yemen, as a sign that he had renounced his former faith. Zoroastrianism itself had undergone an earlier iconoclastic "reformation," so that in the absence of three-dimensional icons the Book served an analogous role, its value no doubt enhanced by reports that it was a polyglot work containing all the known languages and sciences of the world.[98] There is of course a paradox inherent in the enshrinement of defunct idols in the focal sanctuary of a self-avowedly monotheistic religion that had itself been Islamized by the removal of its idols. On at least one occasion, the resulting anxiety was sufficient to merit the removal of a Sasanian gold brazier for fear that it would transform the shrine into a fire temple.[99]

The exclusively monotheistic nature of Islam and its emphatic emphasis on a transcendent and nonimmanent deity meant that the co-option of regional deities into metropolitan pantheons was never an option in the way that it was to conquering Indic kings. Consequently, there are significant differences in the treatment of looted icons in both cultural spheres.

The destruction and display of idols as signs of divine favor, religious ascendancy, and renunciation by caliphs, sultans, and amirs—an incorporation into the fold often inseparable from the pushing back of cultural, economic, and military frontiers—finds broad parallels in their treatment by nineteenth-century European missionaries. An entry from 1826 in the catalog of a missionary museum in London captures both the pedagogical spirit of such displays and the frisson that they occasioned: "the most valuable and impressive objects in this Collection are the numerous and (in some instances) *horrible*, IDOLS, which have been imported from the South Sea Islands, from India, China, and Africa; and among these, those especially which were actually given up by their former worshippers, from *a full conviction of the folly and sin of idolatry*." These objects are described as "trophies of Christianity," manifesting successes that "should act as a powerful stimulus to efforts, far more zealous than ever, for the conversion of the heathen."[100]

Similarly, dispatched to the Ka'ba, pagan images reified idolatry and, by extension, its demise. Much as the *Wunderkammer*s constructed by European princes of a later date brought together diverse objects representative of varied regions, so the foreign gifts and defunct icons housed in the Ka'ba served to construct and reinforce a narrative of conquest and Islamization, a symbolic mastery over the world.[101] Since their very nature ensures a low survival rate for premodern gold and silver artifacts, our knowledge of the nature and fate of the Indian icons discussed here is derived almost entirely from textual sources. Moreover, looted icons were only one (and a relatively minor) source of the Indian gold seized during the eastern campaigns of the ninth through eleventh centuries. Nevertheless, while statistically marginal, their physical treatment provides significant insights into the ways in which discourses of piety and power intersected in the reception of looted Buddhist and Hindu icons. In semiotic terms, objects that had once served as first-order signs of divinity animated by the presence of particular deities were now abducted into systems of second-order signification in which they functioned variously (and often simultaneously) as objects of fascination, negotiation, repudiation, and monetization.

The treatment of the regalia gifted or surrendered by the Kabul Shah around 197/813 provides a concrete example. According to the sources, the *ispahbad* of Kabul (the Kabul Shah) renounced his idols and converted to Islam, reportedly on condition that he should be neither compelled to eat beef nor to commit sodomy—an interesting insight into contempo-

rary perceptions of Muslim practices.[102] As a token of his conversion he brought or sent his crown and bejeweled throne to the governor of Khurasan and future caliph, al-Ma'mun. The crown was sent directly to the Ka'ba, carried there by al-Ma'mun's vizier al-Fadl ibn Sahl in 199/814–15, but the throne was first deposited in al-Mam'un's treasury in Merv in eastern Khurasan before being sent to Mecca. In a letter to Ibn Sahl dated 202/817, al-Ma'mun praises him for "curbing polytheists, breaking idols, killing the refractory" and refers among other victories to his successes both against H-r-m-w-s, the king of Kabul, and *al-Isfahbad*, who is similarly described.[103] Other near-contemporary sources refer to the same artifacts as a golden jewel-encrusted idol (*ṣanam*) wearing a crown and set upon a silver throne, sent to al-Ma'mun either by the Hindu Shahi ruler or by an unnamed ruler of "Tibet" as a sign of his conversion to Islam.[104] Turks and Tibetans are often confused in the Arabic sources, and if (as seems likely) the icon was the tutelary deity of the Kabul Shahs, this might explain its confusion in the sources with the crown and throne of the Kabul *ispahbad*.[105]

Writing of Indian objects displayed in nineteenth-century England, Carol Breckenridge has noted that they were incapable of providing their own narrative but required textual and verbal explication, signs and guides to identify and order them and thus give them meaning.[106] This was equally true of the objects that al-Ma'mun dispatched to the Ka'ba. We are told that the regalia were publicly displayed for three days in the central square of Mecca during the *ḥajj,* or annual pilgrimage, with a silver tablet that read: "In the name of God, the Merciful, the Compassionate. This is the throne of so-and-so, son of so-and-so, king of Tibet. He became a Muslim and sent this throne as a gift to the Ka'ba: so praise God who guided him to Islam." Underlining the ritualistic nature of this event, the proclamation was read aloud day and night "in order to inform the people of God's guidance to the king of Tibet," and presumably to broadcast the triumph throughout the Islamic world through the intermediary of even illiterate pilgrims.[107]

The historian André Wink has drawn attention to the close historical relationship between *jihād* (holy war) and *fitna* (civil war) in the medieval Islamic world, a relationship often relevant to the patterns of

circulation followed by Indian loot.[108] Al-Ma'mun's staggered deployment of the Kabul Shah's regalia—with the crown being sent directly the Ka'ba but the throne resting in al-Ma'mun's treasury for an interval before dispatch at the hands of his trusted vizier—should, for example, be read against his struggle for the caliphate with his brother al-'Amin, from which al-Ma'mun had emerged victorious in 198/813.

Some or all of the Kabul Shah's treasures were melted down and coined within a few decades, but the Meccan historian al-Azraqi (d. 218/834) saw the throne and the inscribed plaque that al-Ma'mun placed upon the crown.[109] The throne bore a text detailing its journey from Kabul to Merv (whence it was apparently carried by the Kabul Shah himself) and thence to Mecca after a three-year interval. The text on the crown (sent to the Ka'ba in the year of al-Ma'mun's victory) referred directly to the civil war between the brothers and to the circumstances in which the covenant between them was broken.[110] This document had also hung in the Ka'ba before being destroyed by al-'Amin. The viewer was evidently meant to contrast al-'Amin's abrogation of his pledge to a fellow Muslim with the truer pledge of the recently Islamized Kabul Shah acquired through al-Mam'un's efforts on behalf of the *umma*, the Muslim community.[111] The text related that al-Ma'mun's campaign against the Kabul Shah pressed 'Abbasid claims as far east as the Indus River (where the Kabul Shah's writ extended) and Tibet, which presumably explains the confusion about the source of the golden objects acquired as a result of his endeavors.

This instrumental deployment of Indian icons, their use in an appeal to piety designed to further the pursuit of temporal power, was by no means unique. A similar rationale is reiterated a century and a half later in a letter written in North Africa by the Fatimid caliph al-Mu'izz and sent to his agent Jalam ibn Shayban after the latter had succeeded in establishing an Isma'ili Shi'i government in Multan around 354/965.[112] Lauding the victory of Ibn Shayban, al-Mu'izz mentions the destruction of an idol temple (probably the celebrated Sun Temple of Multan) and makes the following request: "We would be very much pleased if you could send us the head of that idol (*ṣanam*); it would accrue to your lasting glory and would inspire your brethren at our end to increase their zeal and

THE MERCANTILE COSMOPOLIS

their desire to unite with you in a common effort in the cause of God."[113] This request was made at a time when the Fatimid countercaliph was engaged in an aggressive campaign to extend his purview over the territories of his greatest Sunni rival, the 'Abbasid caliph in Baghdad. Seen in this light, the utility of the idol lay not only in its ability to signify the demise of Hindu idolatry or the territorial expansion of the Isma'ili community but also in its potential to inspire the faithful in their attempts to further this expansion at the expense of their Sunni coreligionists.

The political utility of looted idols was not confined to struggles for the caliphate. As we saw above, select items of booty or tribute were routinely dispatched to the Umayyad and 'Abbasid caliphs following campaigns of expansion during the eighth and ninth centuries. Most theories of the gift assume that the act of giving places the donor in a position of strength vis-à-vis the recipient, but in these cases the line between gift, tax, and tribute is often hard to determine, especially when dealing with gifts sent by Indian rulers, which are often glossed as *jizya* or poll tax. The Indian booty sent to Baghdad constituted the *ṣafiyya*, the ruler's share of booty, and is therefore best understood as a mandated "gift" expressing allegiance in a manner that reified a hierarchical relationship between donor and recipient. Conversely, the robes, standards, and patents of investiture with which these exotica were reciprocated were gifts to a political inferior that consolidated the structures of authority and charisma but within a strictly hierarchical framework.

In the course of the ninth century, these apparently asymmetric exchanges were characterized by mounting ambiguities as the centripetal rhetoric of the Baghdad caliphate was challenged by increasingly centrifugal political tendencies within the caliphate and the demand for honors by increasingly restive provincial governors and regional potentates escalated. As Yasser Tabbaa puts it, what resulted was a series of negotiations between "a center possessing the means of legitimation but lacking power, and a periphery lacking legitimation but wielding real power."[114] Parvenus such as the Habbarids of Sind and the Saffarids of Sistan engaged in a complex pas de deux with the 'Abbasid caliphate, acknowledging its de jure authority while exercising de facto autonomy, sending puta-

tive tokens of deference to elicit caliphal favor and its instantiations in robes of honor, patents of investiture, and honorific titles.

Buddhist and Hindu precious metal images were often central to these negotiations. In 250/864, for example, a number of these were among the Afghan exotica (including elephants) sent from Kabul by Muhammad ibn Tahir ibn 'Abdallah, the governor of Khurasan, who received in return an embassy bringing formal insignia of caliphal investiture.[115] In 271/884, three silver idols (*aṣnām*) were sent to the caliph al-Mu'tamid by Musa ibn 'Umar ibn 'Abd al-'Aziz 'Abd Allah ibn 'Umar, the "lord of Sind" (*ṣāhib al-Sind*) along with rare animals, spices, textiles, and an aloes wood throne.[116] Musa was the amir of Mansura, third scion of the Habbarid dynasty, which had risen to power around 239/854 after overthrowing the 'Abbasid governor.

Similarly, the parvenu Saffarid governors of Sistan, the brothers Yaq'ub ibn Layth and 'Amr ibn Layth al-Saffar, who were to pose a significant threat to the caliphate, both sent gifts of Indian booty, including images, to Baghdad. Accounts of those sent to the caliph al-Mu'tadid in 283/896 by 'Amr b. al-Layth provide a rare insight into the peregrinations of such looted icons, and a sense of the interest that their display aroused. The gifts consisted of one hundred camels, chests of precious materials and bullion, and an enormous brass idol (*ṣanam*) of a four-armed woman on a cart drawn by camels and two smaller idols, all decorated with precious stones. The idol had been brought by the donor from one of the Indian cities that he had conquered in the region between Bust and Zamindawar, possibly from the temple of the goddess Lakshmi or Lakhavati at Sakavand between Ghazni and Kabul.[117] The gifts evidently arrived by the maritime route, for the associates of 'Amr had them publicly displayed in Basra en route to Baghdad. Upon their arrival in the capital, the gifts were first taken to the caliphal palace, then to the prefecture of police (*majlis al-shurṭa*) in the east of the city, a choice of location that reflects their donor's former position as police chief of Baghdad. Here they were put on show for three days. This is exactly the interval for which the idol of the Kabul Shah had been displayed in Mecca eighty years earlier, underlining the ritualized nature of such displays and hinting at the existence of

specific protocols governing them. The intense public interest that the idol aroused is indicated by the nickname it acquired on account of the crowds that were drawn to it: *shugl* (the Distraction).[118]

The protracted multistage peregrinations of the idol as it traveled from southern Afghanistan to Basra and thence to Baghdad, where it oscillated between immurement in the palace of the caliph and ritualized display in the locus of the donor's authority, maps its trajectory between different (and contending) regimes of value. These events provide a graphic illustration of the manner in which Indian loot negotiated the often fraught relationships between center and periphery. In this case, the endeavor was successful, for one year later, in 284/897, the caliph al-Muʿtadid reciprocated ʿAmr ibn Layth's gift with robes of honor and a patent of investiture.[119] The exchange offers an example of what Pierre Bourdieu has termed the "alchemy of symbolic exchanges," the interconvertibility of economic and symbolic capital that characterizes a gift economy.[120]

A century or so later, Indian campaigns and the booty that they generated were no less instrumental to promoting the victories of the Ghaznavid sultans of Afghanistan otherwise commemorated in poetry (a relatively private genre) and also announced in the *fatḥnāma* (letter of victory), which was circulated as far as Baghdad, to be read aloud. Once again, Indian loot materialized these triumphs in the caliphal capital, eliciting signs of favor, insignia of investiture, and bombastic titles proclaiming the sultan as the defender of Islam.

The most (in)famous example of this visual rhetoric of piety concerned the icon of Somnath, a Shiva *linga* housed in a temple on the coast of Gujarat built by the Chalukya or Solanki rajas, which Arabic and Persian chroniclers depict as preeminent among the idols of India. After its destruction by Mahmud in 416/1025, part of the *linga* was thrown into the public square (*maydān*) of Ghazni, where it joined a decapitated bronze idol of Vishnu Cakraswamin that had been taken from Thanesar a decade earlier; the remainder was set at the threshold to the Friday Mosque of Ghazni to be trampled by those entering.[121] The discovery of a one-meter-high marble statue of Brahma (fig. 8) and a Jain *tīrthankara* in the palace at Ghazni confirms that Indian images were indeed carried back

to Afghanistan for recontextualization and display during the various Indian campaigns of the eleventh and twelfth centuries; the pattern of wear on the former (fig. 9) led its excavator to suggest that it had been set into a threshold or pavement.[122] The trampling of the icon-as-metonym conforms to the prescriptions on figuration in the hadith (the traditions of the Prophet), while reiterating practices associated with the Islamization of Arabia.[123] At the same time, it enacts a metaphorical claim to have trampled the defeated underfoot common to the rhetoric of Muslim and Hindu rulers.[124]

A particularly revealing aspect of the Somnath episode is the way in which later writers develop the theme of dispersal, expanding the fragments. For example, Juzjani (fl. ca. 658/1260) relates that while a single fragment was laid at the entrance to the palace and mosque of Ghazni, two others were dispatched to Mecca and Medina.[125] Whether or not such narratives of dissemination were literally true, fragmented and dispersed, the idols seized in the *dār al-ḥarb* had the paradoxical ability to reintegrate the dispersed and disparate centers of political and religious authority within the *dār al-Islām*. Moreover, the peregrinations of the Kabul Shah's throne—which followed a trajectory from Kabul to Merv in Khurasan and thence to the Kaʿba in Mecca—indicate the existence of historical precedents for the reported treatment of the Somnath *linga*.

In fact, looted Buddhist and Hindu icons were prominent among the objects that mediated not only the disjunction between different (and competing) centers of political authority but also their geographical dislocation from the *ḥaram* of Mecca, the spiritual center of Islam. In return for sending the head of the eastern rebel Rafiʿ to the caliph al-Muʿtadid in 284/897, for example, the Saffarid ruler ʿAmr ibn al-Layth demanded to have his authority over specific territories recognized but also the (symbolic) role of guardian of the caliph's palace in Baghdad, the inclusion of his name in the Friday sermon (*khuṭba*), and the right to have coins struck in his name in both Mecca and Medina.[126] The *khuṭba* and coinage were standard modes of articulating political authority in Islam, but the specific desire for representation in Mecca reflects not only the sanctity of the shrine but the utility of the *ḥajj* in disseminating claims to authority. Eight decades

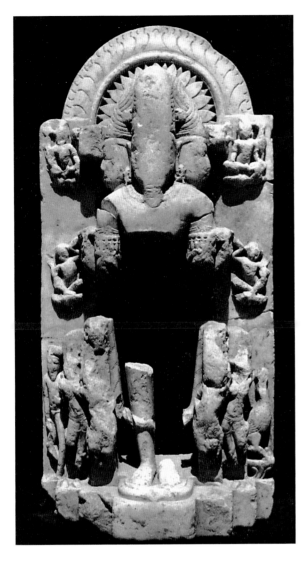

earlier, it was during the annual pilgrimage that al-Ma'mun had orchestrated the tableau involving the treasures of the Kabul Shah. Highlighting the complex disjunctions between centers of authority, power, and sacrality in the *dār al-Islām*, these practices complicate the standard depiction of iconoclasm as the symptom of a struggle between local autonomists and centralizers.[127]

The ultimate fates of some Indian images further deconstruct any simple opposition between economic and religious motivations for iconoclasm. In the spring of 257/871, for example, fifty gold and silver idols (*but*) looted from the Kabul region (perhaps Buddhist images taken from the Shir of Bamiyan) in the previous year were dispatched from Kirman to Samarra, the 'Abbasid capital in Iraq, as gifts to the new caliph al-Mu'tamid from the de facto ruler of Sistan, the Saffarid amir Ya'qub ibn Layth.[128] In this case, however, the donor specifically requested that the precious metal icons be forwarded to Mecca, melted down, and distributed for the welfare of its people, despite their association with the infidels.[129] The piety of Yaq'ub's request ensured that it was unlikely to be denied; his consequent ability to determine the final fate of the objects—ensuring that the caliphal palace was but a

8
Marble image of Brahma excavated from the Ghaznavid palace at Ghazni (by kind permission of the Istituto Italiano per l'Africa e l'Orient, IsIAO Dep CS No. 1524.1).

9
Marble image of Brahma from Ghazni, detail (by kind permission of the Istituto Italiano per l'Africa e l'Orient, IsIAO Dep CS No. 1525.5).

temporary halting place on a circuit of his determination—provided a very public display of an authority only contingently related to caliphal writ.

Muslim amirs or sultans were not unique in exploiting the materiality of representation for rhetorical effect. The silver image of a Tantric deity in the temple of Vajrasana at Bodh Gaya was, for example, destroyed in the eighth or ninth century by Hinayana Buddhist monks who smashed it into pieces and used the metal thus obtained as coin, thereby enacting a classic critique of hylotheism, the confusion of a transcendental God with matter.[130] However, in the Islamic context, the transmutation of the material icon into philanthropic coin constituted a type of potlatch. Like all potlatch ceremonies, it "liberated" wealth formerly occluded from circulation through destruction and redistribution, gestures that are necessarily public.[131] Like the North American gifting ceremonies that gave the potlatch its name, the claim to rank was asserted by an ostentatious redistribution in which the donor accumulated symbolic capital through an excess of consumption.[132]

The shift between registers of consumption intrinsic to the transmutation of icon into coin establishes a relationship between economic, political, and religious spheres of exchange. The specific manner in which this is achieved accords with a number of contemporary charitable practices that also ensured the donor's representation in the spiritual center of Islam. The revenues from a bazaar founded by 'Amr ibn Layth the Saffarid in Zarang, the capital of Sistan, were, for example, distributed among the congregational mosque of the city, its hospital, and the sanctuary of Mecca.[133] Similarly, the bilingual (Arabic and Sanskrit) foundation document of a mosque built in 662/1264 by a Persian merchant resident in the territory of the Chalukya-Vaghelas on the west coast of India specifies that any surplus remaining from the annual income of its *waqf* (endowment deed) was to be sent to the shrines at Mecca and Medina, for which pilgrims embarked at the nearby ports of Gujarat.[134] As Brajadulal Chattopadhyaya notes, the redistribution of excess income enabled this local mosque to be represented at and participate in the sanctity of the sacred center.[135]

Discourses of charity, idolatry, and sacred geography coincide in the rematerialization of looted Indian icons, but neither the impetus toward destruction nor

the context in which it occurred was specific to polytheistic images. Neither facture nor figuration was a necessary precondition of idolatry: Islam accepts that both manufactured images and objets trouvés have the capacity to function as idols, and ritualized destruction was often deployed against any "idolatrous" signs (including those of fellow Muslims) regardless of whether they were figurative or mimetic.[136] In 414/1023, for example, the Ghaznavid sultan Mahmud dispatched to Baghdad a robe of honor and other gifts given by the Fatimid countercaliph of Egypt to Hasanak, Mahmud's general. The robe had been gifted when circumstances obliged Hasanak to lead a caravan through Fatimid territory en route to Mecca, and it was forwarded to Baghdad at the request of the 'Abbasid caliph al-Qadir. Upon its arrival, the caliph had the robe, a synecdoche for the countercaliph, ceremonially burned at the Nubian Gate, one of the palace gates where idolatrous objects were often laid and the heads of dissidents and heterodox Muslims displayed.[137] A significant amount of gold is said to have been recovered from the melted cloth and gathered for distribution as alms to the poor of the Bani Hashim (the tribal group to which the ruling 'Abbasid house belonged) in accord with those hadiths that emphasize the value of giving alms to relatives in order to strengthen family bonds.[138]

As this event suggests, the items considered to be idolatrous could include any object that manifested or promoted religious error, even those of coreligionists; when Mahmud of Ghazni sacked the Iranian city of Rayy in 420/1029, for example, manuscripts associated with the promulgation of heterodox (Shi'i or Mu'tazilite) ideas were burned on the spot, even as the *linga* of Somnath is said to have been broken and then partly burnt where it stood.[139] In addition, the dangers of idolatry were not confined to objects but were also manifest in associated practices, especially any misplaced (or fetishistic) investment in them. Both the hadiths and the opinions of the jurists attest to a taboo on the use of gilded cloth and golden vessels. Citing the hadith "He who drinks in cups of gold and silver, enkindles as it were the fire of Hell in his belly,"[140] the author of the *Baḥr al-Favā'id* (Sea of Precious Virtues), a Persian exemplar of the "Mirrors for Princes" genre of literature that flourished during the eleventh and twelfth centuries, explains:

Kings who use golden censers, vessels, and cups wrong both themselves and their subjects; they bring perdition on themselves and cause a scarcity of gold among the people. The trade of one who makes these (vessels) is unlawful. This has been made unlawful because gold and silver were created to serve as the prices of things and in payment for property. When people make them into vessels, imprison them and put them in treasuries, how can they determine fines and fix prices? Men's livelihoods will become straitened, and God's wisdom will be set at naught.[141]

Such passages indicate that the proscriptions on precious metals circulated outside the realm of arcane theology and should probably be read against the background of the periodic shortages of precious metals that afflicted the medieval Islamic world from the tenth century onward.[142]

The proscription of precious metal vessels is only partly related to a rejection of luxury and ostentation. As the passage just cited suggests, used in ways that inhibit their natural function, gold and silver are themselves capable of assuming the status of idols whether fashioned into potentially animate forms or not.[143] The Persian philosopher al-Ghazali (d. 505/1111) expresses a common view among the jurists when he explains that gold and silver are inherently worthless stones, whose value derives from their ability to mediate exchange, to facilitate dynamic social interactions rather than static accumulation.[144]

The Qur'an specifically forbids the hoarding of gold and silver and its expenditure in ways that do not advance the cause of righteousness:

O believers, many rabbis and priests devour the possessions of others wrongfully, and keep men away from the path of God. To those who accumulate gold and silver, and do not spend in the way of God, announce the news of painful punishment. On the day We shall heat up (their gold) on the fire of Hell and brand their foreheads, sides and backs (and say to them): "It is this you stored up for yourselves: so now taste of what you had stored." (9:34–35)[145]

The association between idolatrous economic practices and the religious identity of nonbelievers implicit in these verses is developed in the hadiths, which identify gold and silver vessels (like silken garments) as the preserve of non-Muslims in this world and Muslims in the next. Exegetical traditions amplify the theme, identifying accumulation as *tabarruj al-jāhilīyya* (conduct of the "period of ignorance," the pre-Islamic period), and establishing an association between hoarding and the economy of unbelief.[146]

Christian, Jewish, and Muslim monotheistic polemics share the belief that idols are material artifacts crafted by human beings and therefore inherently incapable of representing transcendental truths.[147] What distinguishes Islamic polemics on idolatry is their location within a broader theory of value characterized by a valorization of consumption and circulation over accumulation, and a specific emphasis on the need for gold and silver to circulate in order to fulfill their natural function as instruments for the regulation of value. To accumulate gold and silver by fashioning them into object form, hoarding, and thesaurization is to confuse the sign of value with value per se, a displacement that amounts to idolatry. This explains why gold and silver vessels were periodically destroyed (often alongside images) when specific rulers sought to assert their orthodoxy. During a reassertion of orthodoxy by the Delhi sultan 'Ala' al-Din Khalji (d. 715/1316), for example, gold and silver vessels were melted down and coined, and wine bottles smashed along with gilded porcelains were thrown before the Badaun Gate of Delhi, the place of public execution where looted Hindu icons were also sometimes thrown, to be trampled by the populace.[148]

Gold often features in narratives of cross-cultural encounter as a common object of interest. In this sense, the physical portability of the medium itself is emblematic of its ability to translate meaning, value, and (ultimately) social relations.[149] As a corollary, gold as mediator is frequently the subject of misprisions and misapprehensions located in the manner in which its own value is conceptualized.[150] Europeans of the sixteenth century justified the appropriation of New World gold by asserting that the natives did not afford it a proper value.[151] Conversely, Arabic and Persian chroniclers rationalized the seizure of East Indian gold by insisting that Indians valued the material too highly. In Arabic and Persian histories and geographies, India is figured as an economic vortex drawing

Western gold out of circulation and into royal and temple treasuries, which represent the massed accumulation of unproductive capital. Writing in the fourteenth century, the historian al-'Umari explained that for three thousand years India had attracted gold from the rest of the world, none of which was recirculated or relinquished.[152] Not surprisingly, this fondness for accumulation and hoarding is given a negative spiritual gloss: the author of the *Bahr al-Favā'id* contrasts the abundant treasures of the Byzantine emperor and "king of the Hindus" with their poverty vis-à-vis the true faith, exhorting the reader to abjure material wealth in favor of charitable deeds.[153]

The investment of resources in the fashioning of idols thus represents a specifically egregious instance of a peculiarly Indian fondness for accumulation, which is doubly idolatrous. In the first place, it commits the sin of hylotheism, the confusion of a transcendental God with matter. In the second, it fetishizes materiality through accumulation, which displaces value from the mediating function of precious metals onto the materials themselves. Precious metals are not inherently corrupt, however. Consequently, their inherent mutability, their ability to shift their form and function from coinage to containers to architectural embellishment and back again is both a potential source of idolatry and a solution to it.[154] Just as display and recontextualization of the icon effect a demystification of the sacred—revealing to public view what was previously sacrosanct—the dethesaurization of hoarded temple gold, the act of putting the precious metals back into circulation, inverts the sacralization of wealth by its immurement in temple treasuries. The alienation of the inalienable icon has the added advantage of "liberating" the precious metals imprisoned in the products of human artistry and "restoring" them to their natural function as mediators of exchange.

Gold thus obtained might be spent "in the way of God" as Qur'an 9:34 puts it, a deployment particularly evident in narratives of Islamization. In the early eighth century, for example, the Arab conquerors of Multan are reported to have confiscated the accumulated golden treasures of the city's Sun Temple, using them to build congregational mosques and strike coins in the name of the caliph.[155] Similarly, it is reported that an idol of the Hindu Shahi period discovered beneath the foundations of a mosque at Ghazni was destroyed to fund construction of another mosque.[156] In

his description of the mosque that Mahmud of Ghazni ordered on the same site in 409/1018, al-'Utbi contrasts the use of gold in the manufacture of naked idols by polytheist kings and its disposal for the construction of a mosque, which would both benefit the community and perpetuate the piety of the sultan:

> As for the gilding . . . it was not just a matter of gold plate, but also of doorbolts of red gold, cast from the golden images of idols (*al-aṣnām*) that had been broken up and cult statues (*al-bidda-dat*) that had been taken (from India); thus did they find themselves subjected to the fire, after having been worshiped with submissively lowered cheeks and chins. Is not he who spends gold on the walls of the mosques of God, as a lesson for the monotheists and a provocation for the heathen, nobler and more bounteous than he who casts it into an object of worship, which he then sets up as something intended to dole out benefit and harm? We take refuge in God from a lord whose private parts are shamelessly exposed, lacking even a loincloth! And we pray to God that He reward, in the name of Islam, a king who performs such deeds and acts as these, and whose constant habit is to extend his spirit and his gifts for the sake of God![157]

This critique of improper (and ultimately idolatrous) usage finds common ground with many of the texts cited above. However, from the perspective of those jurists that take a hard line, forbidding the golden embellishment of mosques and gilding of the Qur'an, its effusive narrative of transmutation is no less redolent of idolatry than the Hindu images that are its subject.[158]

Nevertheless, the distribution of wasted capital as alms or for investment in the foundational monuments of the faith effects the ultimate "translation" of alien idols, their transmutation into mosques and Muslims, the very materials of the self. The transmutation of the inert objects of idolatry into the living bodies of believers, the alien signs of the other into the embodied self, offers the ultimate demonstration of the ability of precious metals to effect equivalence between relative (if inverse) terms in a transcultural system of exchange.[159] This is an inversion that operates at multiple levels. We should bear in mind, for example, that Hindu icons are understood not as depictions of deities but their

ritually animated bodies.[160] Tales of Hindu icons ground up by Mahmud of Ghazni and fed to the Brahmans who had once ministered to them exploit this quality while alluding to the ultimate fate of the golden calf fashioned by the Israelites.[161] A more positive gloss on the relationship between embodiment, materiality, and spirituality is found in the gesture of King Avantivarman of Kashmir (d. 883), who upon his accession renounced material wealth and transmuted the gold and silver vessels in his treasury into porridge for distribution to the Brahmans. The gesture can be read as a materialization of contemporary poetic metaphors that describe the bodies of the beautiful as covered with a paste of molten gold, a symbolic gilding of the body to parallel the literal adornment of contemporary temples (often with looted gold).[162]

The structural similarities between the treatment of precious materials in both cases serve as a reminder that it is not rematerialization per se that is iconoclastic. Indeed, the material instability of precious-metal Hindu icons is acknowledged in the *shāstra*s (treatises), which prescribe that the appropriate way of disposing of a metal icon that has reached the end of its religious life is by melting, a process that purifies any metal recovered from the operation.[163] Parallels in the treatment of objects deemed idolatrous (whether caliph's robe, gold vessel, or Buddhist icon) and the fate of the precious metals obtained from them also obviate any clear distinction between "secular" and "religious" iconoclasm, or indeed between objects of Hindu and Muslim idolatry.

In a recent discussion of idolatry and the fetish W.J.T. Mitchell observed, "bad objects . . . are not simply bad in some straightforward moral sense. They are objects of ambivalence and anxiety that can be associated with fascination as easily as with aversion."[164] The reception of Buddhist and Hindu images looted during campaigns of conquest on the eastern frontier of the Baghdad caliphate underlines this ambivalence. "The Distraction" (*shugl*), the nickname afforded the four-armed icon sent to Baghdad from Sistan in 283/896, resonates with contemporary discourses on idolatry, in which the notion of gold and silver as originary idols imbued with the capacity to deceive is related to their potential liquidity (their ability to be fashioned) and to their possession of a (false) liveliness and animation. The ability of precious materials and lavish embellishment to distract the worshipper is, for

example, among the reasons given for stripping golden lamps and gilded decor from mosques during the eighth through tenth centuries.[165]

To read reports of the icon's reception in this light alone is, however, to privilege the proscriptive discourses of the *'ulamā'*, the religious classes, over the gaze of the Baghdad citizenry and its embodied response to an object that was clearly regarded as a marvel. Accounting for the slippage between categories revealed by the icon's reception, Stephen Greenblatt's distinction between *resonance* (the ability of the displayed object to reach out to the viewer and represent larger cultural forces and spaces "from which it has emerged and for which it may be taken by a viewer to stand") and *wonder* ("the power of the displayed object to stop the viewer in his or her tracks") is especially relevant.[166] In this sense, *shugl* not only denotes the distraction from the routines of daily life afforded by this ritualized display but also connotes the rapt attention that the icon evoked in the citizens of Baghdad. The reception of this looted image thus opens up a space between the figurative and literal reduction of idolatry and its objects, pointing to more ambivalent and expansive practices of responses, which adumbrate the idea of the golden idol as a sign of fundamental incommensurability, lurching between adoration and denigration as it circulated from east to west. Moreover, in some of the eastern territories of the caliphate, Muslim responses to Hindu iconolatry assumed even more surprising forms.

Heteropraxy, Taxonomy, and Traveling Orthography

The maritime and terrestrial emporia of Arab Sind were among the most ethnically, linguistically, and religiously diverse cities of the 'Abbasid mercantile cosmopolis. At the time of the conquest in the early eighth century, Sind contained a religiously heterogeneous population consisting of Buddhists, Brahmans, Pashupata Shaivites, and some Vaishnavites.[167] A tenth-century bronze image of Surya, the sun god, found at Brahmanabad near Mansura attests to continuity in the cult whose temple at Multan was one of the most important pilgrimage sites of northern India until its destruction by the Isma'ili missionary Jalam ibn Shayban in 354/965.[168] This was only the most celebrated of

a number of Hindu temples that stood within the territories of Arab amirates.[169] The continued existence of certain temples is in line with the reported policy of Muhammad ibn Qasim, the conqueror of Sind, who built mosques in the conquered cities but afforded their non-Muslim populations the de facto status of *dhimmīs* (protected subjects) similar to that enjoyed by the Christians, Jews, Zoroastrians, and other "People of the Book," who paid *jizya* (poll tax).[170] However, the treatment of temples in the postconquest period appears to have been related to the conditions of capitulation or conquest.[171]

In contrast to this impression of religious pluralism, however, a *linga* (an aniconic sign of the Hindu deity Shiva) was set at the entrance to the congregational mosque at Banbhore (see fig. 15), to be trampled by those entering, a common practice of monotheist polemicists, as we saw above (see figs. 8–9).[172] In light of recent research suggesting that the decline and disappearance of the Buddhist communities of Sind was due to voluntary conversion to Islam by a community that had traditionally been involved in long-distance trade seeking to maximize the commercial opportunities that incorporation into the ʿAbbasid caliphate afforded, it is worth noting that elsewhere in the Islamic world, the trampling of religious icons was sometimes associated with the testing of converts to Islam for signs of apostasy.[173]

Freedom of polytheistic practice was therefore by no means incompatible with freedom to indulge monotheistic propaganda: practices of denigration and veneration could and did inhabit proximate spaces, as the find of a nearby Shiva temple (visible in fig. 3) with its *linga* and *yoni* still intact suggests. Unfortunately, the manner in which Banbhore was excavated precludes any certainty about the chronology of the temple, but it appears that the only reason for attributing it to the pre-Islamic period is an assumption that temple and mosque inhabit distinct space-time continua: the "Hindu" and "Muslim" periods.[174] However, fragments of tenth-century sculptures of Shiva and the sun god Surya were recovered from nearby Brahmanabad, and the Buddhist stupas of Sind show signs of continued use after the Arab conquest, perhaps even as late as the tenth century.[175]

The complexity of religious identity within the mercantile emporia of Sind is reflected in the mone-

tized tokens through which the long-distance trade of Sind was enabled. The Hindu Shahi bull-and-horseman coinage that inspired tenth-century ʿAbbasid donative issues (see fig. 7) also greased the wheels of Sindi trade, one among a number of currencies that circulated in the region. In addition to ʿAbbasid and Hindu Shahi coins, a debased silver coin modeled on a pre-Islamic Sasanian design and known to the Arab geographers as the *ṭāṭarī* dirham and to modern numismatists as the *gadhiyā paisā* also circulated in Mansura and Multan, although it was not minted in Sind but in the neighboring Rashtrakuta and Gurjara-Pratihara polities.[176] As Deyell notes, the circulation of these coins as far west as Herat demonstrates "that the tentacles of the western Indian traders did not terminate in southeastern Afghanistan, but reached clear into Khurasan."[177]

Just as linguistic translation was central to the encounters and exchanges that characterized this monetized economy, so the Arab geographers cite conversion rates and equivalences for the various ʿAbbasid, Hindu Shahi, and Pratihara currencies circulating in Sind. However, the epigraphic content of the coins struck in Sind itself points to processes of translation that extend beyond the role of coinage as a medium of commodity exchange, to encompass its potential as a vehicle for the circulation of ideas.

Silver coins were struck by the Arab rulers of Mansura and Multan from the mid–ninth century, when the amirs of both cities assumed de facto autonomy and the flow of ʿAbbasid coins from the central Islamic lands apparently ceased.[178] The tiny coins, known as dammas or dramas (from the Greek *drachm*), weigh around 0.5 gram (fig. 10). Despite their Arabic inscriptions, they bear little resemblance to coins from elsewhere in the Islamic world. Coins of similar size and weight were, however, produced in neighboring Gujarat and elsewhere in northern India during the seventh and eighth centuries, and may even have provided the models for the coins of similar type that are found in the Muslim emporia of southern Arabia and East Africa during the ninth and tenth centuries.[179] The Sindi dammas were evidently struck to an Indian denomination standard and were similarly minted by tally, counted rather than weighed. The absence of dates (which one would expect on Islamic coinage, and which had appeared on earlier Arab coins from

10

Habbarid silver damma from Sind compared
with a modern dime.

II

Silver damma issued in the name of 'Abd Allah, the Habbarid amir
of Mansura, ca. 270/883 (private collection).

Sind) is again reminiscent of the coinage issued by
contemporary northern Indian rulers.

The dammas issued in the name of the Habbarids
of Mansura are inscribed in Arabic with the name of the
ruling amir (fig. 11), the *kalima* (profession of faith),
and doxologies invoking God's help, asserting the amir's
trust in him, and his ability to bring victory. The legend
lā ilāha illā allāh waḥdahu lā sharīk lahu (There is no
god but God alone, no partner to Him), which also ap-
pears on many of these coins, had been used on Islamic
coinage from the late seventh century and appears on
contemporary 'Abbasid silver coinage.[180] The presence
of Arabic script did not, however, prevent the circula-
tion of the Habbarid dammas into the adjacent "Hindu"
regions of Marwar, Ajmir, Mewar, and Saurashtra.[181]

It has been suggested that the appearance of
"Indic" motifs such as lotus flowers, stars, and flowers
on the copper coins issued by the Arab amirs of Sind
indicates the increasing "indigenization" of the ruling
elite.[182] Whether or not this is so, recent finds of pre-
viously unknown dammas minted in the name of the
Arab rulers of Multan provide more pronounced evi-
dence of transculturation, while also pointing to sig-
nificant differences in the public culture of Mansura
and Multan. The coins still await a detailed study;
many of their inscriptions have yet to be deciphered,
and their precise chronology has yet to be established.
Nevertheless, even a preliminary analysis indicates
their singular importance for understanding the cul-
tural and religious life of early medieval Sind. They are
struck to the same denomination standard as the tiny
silver coins from Mansura but differ significantly in
their epigraphic content. On their reverse, the Mul-
tani coins all bear a three-dot motif of unknown sig-
nificance also found on contemporary Indian coins,
and Arabic inscriptions that are only partly legible,
but include proper names such as Harun (important
evidence for the identity of the Multani amirs, only
one of whose name is known) and religious phrases
such as *lillāh muḥammad* (to God, Muhammad
. . .).[183] There are two basic variants of obverse texts:
Arabic inscriptions similar to those on the reverse and
Sanskrit texts written in Nagari script (fig. 12).

The Sanskrit inscriptions invoke a wide array of
Hindu deities. To date, coins with four different San-
skrit texts have been published: *śrī ādivarāha* (the
blessed or fortunate great boar), *śrīmad varāha* (the
boar possessed of fortune), *śrī lakś[mī?]* (the fortunate
laksh[mi?]), and *śrī madhumadī* (the blessed or fortu-
nate Muhammad). Two of the four types thus invoke
Varaha, the great boar incarnation of Vishnu, while
another seems to contain the name of Lakshmi, the
Hindu goddess of wealth. Other unpublished types
reportedly bear the inscriptions *śrī jāyanta rāja* and *śrī
mihira deva*, both of which are allusions to Surya, the
sun god whose celebrated temple was located in Mul-
tan and whose images (along with those of Hindu

39

12
Obverse and reverse of eight bilingual dammas from Multan (private collection).

13
Adivaraha damma struck by the Pratiharas of northern India in the ninth century bearing an anthropomorphized image of the boar incarnation of Vishnu (private collection).

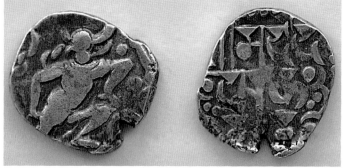

deities) were worshipped in the northern Indus Valley in the seventh and eighth centuries.[184]

The invocation of the primal boar (ādivarāha) was probably inspired by a series of alloyed silver coins issued by the Gurjara-Pratihara ruler Bhoja (ca. AD 836–82), which a tenth-century Rashtrakuta inscription refers to as the śrīmadādivarāha damma (fig. 13).[185] The Rashtrakuta coins differ from the Multani dammas in their metrology but also bear the inscription śrīmad ādivarāha (the biruda or epithet of Bhoja) on their reverse with an anthropomorphic depiction of the boar incarnation of Vishnu on their obverse, replaced by Arabic text on the Multani dammas.[186] This relationship to Gurjara-Pratihara coinage suggests that the dates of the Multani bilingual dammas can be roughly bracketed between around 225/840 (from when the Bhoja coins appear) and 354/965, when the amirs of Multan began minting coins of a different type, inscribed with Arabic texts that advertised their newfound allegiance to the Fatimid Isma'ilis of North Africa.[187] They are thus the earliest bilingual Islamic coins minted in South Asia.

The aniconic adaptation of what were probably Gurjara-Pratihara models on the Multani coins might be compared to the omission of figural carvings on the mihrab of this period that survives in the former Gurjara-Pratihara stronghold of Gwalior, which otherwise conforms to the norms of contemporary northern Indian stone carving (see fig. 5). The adaptive qualities of the Multani coins extend beyond the omission of figuration, however, encompassing an innovative attempt to accommodate the prophet of Islam within the conceptual vocabulary of northern Indian religious tradition. The fourth name among the published Sanskrit texts, Madhumadi, is the Sanskritized version of Muhammad.[188] It is possible that Madhumadi was a contemporary amir of Multan, but the equivalent

Sanskrit texts all invoke Hindu deities or their avatars, with the historical information conveyed in Arabic on the obverse. It seems more likely therefore that the Sanskrit text presents the Prophet Muhammad as an avatar, a representation that, while unorthodox in an Islamic context, was clearly intended to frame Islamic doctrine in a manner consonant with Indic paradigms of manifestation and materialization.

A more explicit use of the same formula is found a century or so later on a series of bilingual coins struck at Lahore by Mahmud of Ghazni in 418/1027 and 419/1028 (fig. 14).[189] The Arabic text on the obverse of these coins (identified as dirhams by their Arabic inscriptions and tankas in Sankrit) contains the kalima, the basic statement of faith (There is no god but God, Muhammad is the messenger of God), the name and titles of Sultan Mahmud, and the name of the 'Abbasid caliph framed by a marginal legend giving the date and mint name. The Sanskrit text inscribed in Śāradā script in the main field of the reverse amounts to a translation of the kalima, which reads: avyaktam ekaṃ Muhamadaḥ avatāraḥ nṛpatiḥ Mahamūdaḥ (There is One Unmanifest [or invisible], Muhammad is the avatar, the king is Mahmud).[190] On the margin, the bismillāh is translated as avyaktīya nāme (in the name of the invisible). This equation of the Prophet with an avatar on the later coins makes explicit a homology that is implicit on the Multani dammas, and frequently employed in later translations of Arabic and Persian religious texts.[191]

The attempt to translate between the concept of avatar and messenger conforms to the absorption and co-option of autochthonous deities as a common part of the process of medieval Indic state formation.[192] It also cuts also both ways, finding a counterpart in some of the earliest surviving Arabic and Persian works on Indian religions, which describe the belief of certain

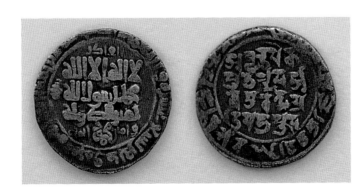

14
Bilingual dirham/tanka struck in the name of Mahmud of Ghazni in Mahmudpur (Lahore) 419/1028 (private collection).

Brahmans in prophethood (*al-risāla*), and refer to Mahadeva and Vasudeva (avatars of Shiva and Vishnu respectively) as the "prophet of God" (*rasūl allāh*), adopting the terminology of envoyship central to Islamic thought.[193] The coinage issued by the amirs of Multan thus combines elements of syncretism (a constellation or juxtaposition of elements belonging to different systems of belief) and translation (an attempt to represent the beliefs of one tradition in terms of another).

Bilingualism and/or polyglossia may in fact have been relatively common phenomena of the South Asian borderlands. A foundation text dated 243/857 from the Tochi Valley in Waziristan, one of the passes that led from Afghanistan to the Indus Valley that was known for its communities of heterodox Muslims, is inscribed in both Arabic and Sanskrit, attesting to an overlap between the dominant Islamic and Indic linguistic ecumenes of the period.[194] The coastal emporia of Sind and western India were also polyglot centers.[195] In addition to Arabic and Sindi, which were spoken in both Mansura and Multan, we are told that comprehensible Persian (*farsīyyat mafhūmat*) was spoken in the latter city in the tenth century, reflecting its position as a terminal for the Khurasan trade.[196] This linguistic heterogeneity was an enduring quality, for in the early thirteenth century a poet from the region around Multan who, with the name of Abdul Rahman, was evidently a Muslim penned an epic romance in the ancient northern Indian language of Apabhraṃśa.[197]

Current interest in the theme of cosmopolitanism is closely linked to contemporary discourses of globalization and modernity, but it is clear that neither the cosmopolitanism nor mobility that characterizes late capitalism are in themselves unique. By drawing attention to the evidence for mobility between currencies, faiths, and languages, I am not, however, suggesting that the amirates of Sind were marked by a touchy-feely multiculturalism; rather, that they entertained a pragmatic attitude to iconolatry and its potential economic and political utility. As the Romans, the Hapsburgs, the Ottomans, and numerous others have discovered, cosmopolitanisms of all sorts can be a useful asset to the state. This is in fact reflected in the Arabic name for Multan: Faraj Bayt al-Dhahab (Frontier of the House of Gold), reflecting the economic importance of the Sun Temple that stood in the city to its Arab rulers, who claimed up to 30 percent of its

revenue.[198] If the empires of imperial Rome and Ottoman Istanbul were marked by what Antonio Gramsci referred to as "imperial cosmopolitanism," the range of phenomena outlined here is indicative of what be dubbed mercantile cosmopolitanism. The two are by no means incompatible: they often went together.[199]

The window that the coins open onto the complex cultural affiliations and religious affinities of the ruling elite conforms with what little is known from textual sources. The tenth-century geographers assert that Muslims were a minority in Multan, but they emphasize the piety of the city's Muslim inhabitants and their pursuit of etiquette (*adab*), knowledge (*'ilm*), and Qur'anic knowledge (*'ilm al-Qur'ān*).[200] However, a letter written from North Africa by the Fatimid caliph al-Mu'izz (r. 341–65/953–75) to his agent in Multan suggests that a rather agglomerative attitude toward idolatry, identity, and religious practice prevailed among the Muslims of Multan, even outside the ruling elite. In his letter, al-Mu'izz criticizes an Isma'ili *dā'ī* (missionary) who was instrumental in converting large numbers of Multani Muslims and Hindus to Isma'ili Shi'ism around 348/960 for fostering heterodoxy in doctrinal matters and permitting the emergence of syncretistic practices, including perhaps continued visitation to the famed Sun Temple.[201]

The pragmatic attitude to idolatry adopted by the envoy whom al-Mu'izz criticizes seems to have prevailed at all levels of society, for al-Muqaddasi (tenth century) mentions a merchant from Khurasan who, being captivated by two idols in Sind, gave himself over to idol worship, only to rejoin the fold of Islam once he returned to Nishapur.[202] Conversely, there are reports of Indic and Turkic rulers in western Afghanistan, the Kabul Valley, and Sind converting to Islam and adopting Arabic names during the eighth and ninth centuries only to apostasize when the appeal or power of the Arab center waned.[203] This circulation between modes of naming and religious affiliation reflects a pragmatic "orientation to power," a reminder that shifts in modes of self-identification often stand at the beginning of a reversible process rather than marking its end.[204]

The fluidity of religious patronage and practice in Sind is consistent with Holly Edwards' observation that, in the premodern Indus Valley, faith "simply fell somewhere in the spectrum of piety, a range which had poles, gradations and distinctions, but few exclu-

sionary boundaries."[205] Like the city of Multan, in which Sunni piety coexisted with sun worship and the missionary activities of Isma'ili Shi'is, the remote frontier areas of the Indus Valley and Sistan were often seen as the resort of heterodox Muslims, a fact that made them vulnerable to attack from Sunni Muslims keen to prove their orthodox credentials.[206] A comprehensive history of the pietistic entanglements between those known to modern historiography as Hindus and Muslims has yet to be attempted, but it could be constructed around shared shrines and ritual practices across the Indus Valley and northern India, including both *ghāzī* shrines (the tombs of Muslims who fell in *jihād*) and Hindu temples.[207] As late as the fourteenth century, Amir Khusrau reports that Muslim pilgrims embarking for the *ḥajj* on the coast of Gujarat were in the habit of stopping to pay their respects at the temple of Somnath.[208] Around the same time we hear a curious tale of a Muslim youth resident in the town of Jurfatan (modern Cananore) on the west coast of India circumambulating a mosque (in emulation of the circumambulation or *pradakshinā* of a temple?) prior to committing ritual suicide.[209]

Pietistic cosmopolitanism is a limitrophe phenomenon, characteristic of other Muslim frontier societies. In his work on the Turkman states of medieval Anatolia during the eleventh through fourteenth centuries, for example, Cemal Kafadar has noted the difficulties of distinguishing between heterodoxy and orthodoxy, suggesting that frontier belief "should be conceptualized in part in terms of a "metadoxy," a state of being beyond doxies, a combination of being doxy-naïve and not being doxy-minded, as well as the absence of a state that was interested in rigorously defining and strictly enforcing an orthodoxy."[210] In both Sind and Anatolia, the absence of a state invested in the enforcement of orthodoxy and the regulation of correct practice was central to the phenomena that Kafadar names. However anathema to the purist boundaries of orthodox stricture and modern historiography, the failure to enforce forms of orthodoxy may have proven useful as a means of fostering social cohesion and potential conversion in areas conquered by force in which Muslims were a minority. One might even go further, to suggest that in both regions the heterogeneous nature of their populations led those attempting to consolidate their authority to foster aspects of pi-

etistic cosmopolitanism. The patronage of the Sun Temple or the minting of bilingual coin, by the amirs of Multan points in this direction, quite apart from their obvious economic benefits. Similarly, the sufi lodges that proliferated in Anatolia during the thirteenth and fourteenth centuries included Christian adherents, and sometimes incorporated Christian rituals.[211] In Sind, at least, the situation seems to have undergone a radical change around 354/965, when the embrace of Isma'ili Shi'ism led the amirs of Multan to demolish the Sun Temple that stood at the heart of their city, responding to the concerns voiced by the Fatimid caliph al-Mu'izz several decades earlier.

Kafadar's approach offers a way of conceptualizing religious affinity that transcends the dyad of orthodoxy/heterodoxy that has tended to structure discussions of regional forms of Islam, including those in pre- and early modern South Asia.[212] The relationship between doxis and praxis, between professed belief and quotidian practice, further complicates the question of religious affiliation. The letter of al-Mu'izz highlights this complex relationship, underlining a desire for both orthodoxy and orthopraxy even within a tradition considered heterodox by the Sunni majority. The subversion of this desire by the relaxed strictures of the caliph's emissary and his converts reminds us that ritual practices (rather than professed belief) often blurred boundaries that textual sources represent as well defined.[213] In this sense, we are dealing with something quite different from the idea of "multiple identities," in which religion is one possible mode of identification.[214] Here clear-cut categories of religious identity are themselves subverted by a complex and constantly shifting dialectic between professions of belief and pietistic practice.

The transgressive nature of heteropraxy means that it is rarely addressed in the medieval sources. It may even be that "ideological silence" is a necessary condition for the emergence of religious toleration, serving to both obscure and reconcile the contradictions that characterized medieval frontier societies. Writing of medieval al-Andalus, Halperin speculates that such omissions and silences permitted medieval frontier societies a space "to practice, albeit temporarily and with considerable difficulty, a type of religious pluralism which many modern societies seem unwilling or unable to imitate or duplicate."[215] Critics of the modern vogue

for cosmopolitanisms of all sorts have argued that the term *cosmopolitanism* historically denoted "an enthusiasm for customary differences, but as ethic or aesthetic model for a unified polychromatic culture—a new singularity born of a blending and merging of multiple local constituents."[216] However, this evocation of an "either or" approach to identity associated with modern notions of the melting pot or multiculturalism fails to do justice to the rather fluid, heterogeneous, and context-specific approaches to religious identity espoused by those who operated in the bustling mercantile cities along the eastern frontier of the caliphate, and/or the western fringe of "Hindu" India.

Like the heterogeneous culture of Multan itself, with its markets and temples attracting pilgrims from all over India, the coinage of the Multani amirs constituted a "contact zone," a portable zone of "copresence, interaction, interlocking understandings and practices," in which faiths and languages commingled.[217] The multilingualism that the coins espouse and the translational gambits that they employ are relevant to the circulation of religious knowledge. Around 270/883 a ruler of the region between Upper and Lower Kashmir reportedly wrote to the Habbarid amir 'Abd Allah requesting an exegesis (*tafsīr*) of the laws of Islam to be rendered into *hindīyah* (perhaps Hindavi or Sanskrit). The translation was undertaken by an Iraqi who was living in Mansura but who had been raised in al-Hind and was familiar with its languages.[218] The tale may be apocryphal, but it coincides with a moment when monism was gaining ground in Kashmir.[219] It also presupposes both the mutability of religious identity and the existence of the polylingual elites mentioned above.

The Multani bilingual coins have not been found in mixed hoards with their more orthodox counterparts from Mansura, suggesting that both types had different circulation patterns. The Sanskrit inscriptions that they bear may therefore have been intended for audiences that lay outside the limits of the amirate, exploiting the portability of the medium that bore them. The Surya cult was well established in neighboring Gujarat and Rajasthan, for example, and pilgrims from these areas may have extended the circulation of the bilingual dammas eastward.[220] To judge from the range of deities represented on the Multani coins, however, this was something more than a local

phenomenon. On the contrary, the parallels with the coinage of the Gurjara-Pratiharas of Kanauj, one of the two great political formations of contemporary India, suggest that the amirs of Multan were constructing their numismatic self-representations with one eye on their powerful eastern neighbors.

The dialectic between the contemporary cultural conventions of both Baghdad and Kanauj to which the coins bear witness is no less apparent in the fragmentary and scattered architectural remains of the ninth and tenth centuries. Chief among these are the congregational mosques that formed the centers of Islamic religious life in the cities of Sind. The basic plans of the mosque in Mansura and the mosque in its associated port at Banbhore (probable site of Daybul) have been revealed by excavation (figs. 3 and 15). Although their chronology is a matter of debate, epigraphic and numismatic evidence indicates that both were active, and probably built, during the ninth and tenth centuries, that is, during the heyday of the Sindi amirs. Measuring 150 by 250 feet, the Mansura mosque was almost double the size of the Friday mosques of Banbhore and Siraf (ca. 209/825), a major trading emporium in the Persian Gulf from whence many traders sailed to the Indian ports.[221]

Both mosques conformed to an "Arab" hypostyle plan, consisting of a pillared prayer hall preceded by a courtyard, surrounded by an irregular two-bay colonnade in the case of Banbhore.[222] The Mansura mosque was distinguished from the majority of wood and clay structures in the city by its construction from baked brick and stone, as the geographers note.[223] In both cases flat wooden roofs were borne on pillars: of wood set on stone bases (some reused) at Banbhore, and fired brick in Mansura.[224] The use of brick piers and the reported use of teak paneling at Mansura might reflect contemporary 'Abbasid trends, for both features appear in the congregational mosques of Samarra, the capital of Iraq from the 830s.[225] As late as the fourteenth century, we hear of the Muslim ruler of Hinawr (Honaur) on the western coast of India fashioning the city's congregational mosque after the style of those in Baghdad.[226]

Despite these likely Iraqi affinities, claims that the Arab architecture of Sind shows little indigenous input are not entirely true.[227] In addition to these large congregational mosques (*jawāmi'*), smaller neighborhood

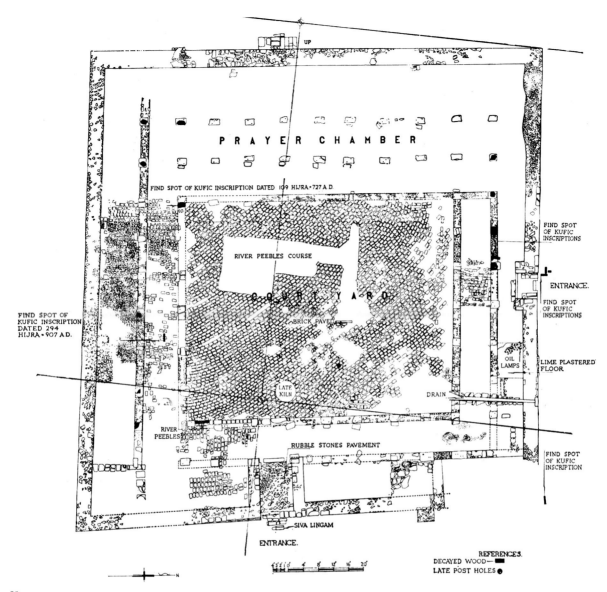

UP

PRAYER CHAMBER

FIND SPOT OF KUFIC INSCRIPTION DATED 109 HIJRA - 727 A.D.

FIND SPOT OF KUFIC INSCRIPTIONS

RIVER PEEBLES COURSE

COURTYARD

ENTRANCE.

FIND SPOT OF KUFIC INSCRIPTIONS

BRICK PAVE

FIND SPOT OF KUFIC INSCRIPTION DATED 294 HIJRA - 907 A.D.

LIME PLASTERED FLOOR

OIL LAMPS

LATE KILN

DRAIN

RIVER PEEBLES

RUBBLE STONES PAVEMENT

FIND SPOT OF KUFIC INSCRIPTION

SIVA LINGAM

ENTRANCE.

REFERENCES.
DECAYED WOOD —
LATE POST HOLES ●

N

15

Great Mosque of Banbhore (probable site of Daybul), plan as excavated, with find of Shiva *linga* marked at main entrance (after Ashfaque 1969).

mosques (*masājid*) constructed from brick and wood, and with two to four columns supporting their roofs, were excavated at Mansura.[228] Recent surveys of the Indus Delta have brought to light a number of these small oratories, built from stone, square in plan and with four interior pillars creating a ninefold division of interior space. The best-preserved Sindi example, that at Thambo Wari or Thuman Jo near Thatta (fig. 16), has been dated to the tenth or eleventh century, al-though it may be slightly later.[229] The mosque was a square flat-roofed trabeate structure raised on a plinth (a feature associated with the medieval temple archi-tecture of western India), with exterior walls about twenty-five feet in length constructed from thin brick courses cased with dressed stone. It had a concave mihrab carved with Arabic texts, and four richly carved stone pillars once supported its roof.

These mosques are regional variants on a type of

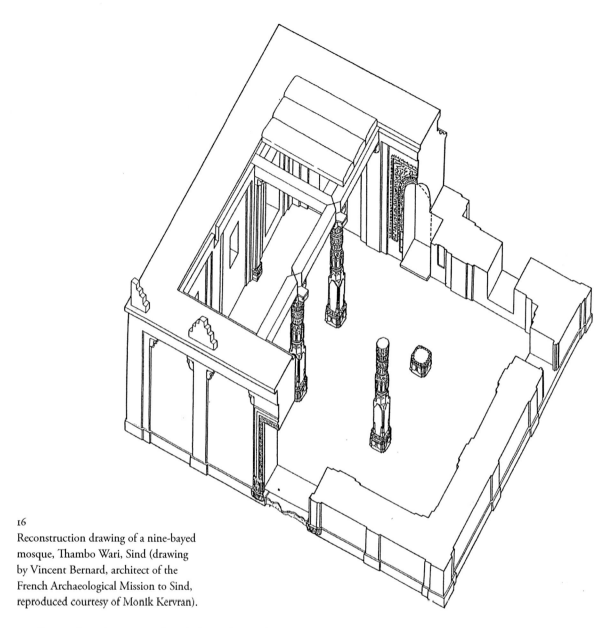

16

Reconstruction drawing of a nine-bayed
mosque, Thambo Wari, Sind (drawing
by Vincent Bernard, architect of the
French Archaeological Mission to Sind,
reproduced courtesy of Monik Kervran).

small nine-bayed mosque found throughout the Is-
lamic world at this date. Its appearance in Sind points
once again to the maritime connections of the region,
for contemporary mosques of similar form are found
in the coastal emporia of Egypt.[230] Those found else-
where, especially in those regions of the Persianate
world where brick was the dominant structural me-
dium, are usually domed. Here, however, the basic
form is executed in the local stone medium and tra-
beate (post and lintel) idiom of the Indus Delta, and

would have originally had a flat roof made of stone
slabs.

Despite these formal affinities to the mosques of
the wider Islamic world, the multisectional pillars and
the carved creeper ornament that frames the entrance
to the mosque are entirely Indic in form and decora-
tion. In this respect, the mosque has more in common
with the stone temples of the region or the twelfth-
century mosques and tombs constructed for maritime
communities of Muslims living within the domains of

46

17
Tomb of Ibrahim, Bhadreshvar,
Gujarat, entrance portico.

18
Tomb of Ibrahim, Bhadreshvar, Gujarat, interior showing
arched mihrab opening and corbeled dome.

the Chalukya rajas at Bhadreshvar on the coast of neighboring Kachch in Gujarat (figs. 17 and 18) than it does with the conventional hypostyle congregational mosques excavated at Banbhore and Mansura. Indeed, when the Thambo Wari mosque was first reported, it was erroneously assumed that it had been constructed from *spolia* taken from the Hindu temples of the region rather than carved de novo.[231]

This mingling of nonindigenous forms and indigenous decorative idioms finds parallels elsewhere in the Indus Valley, notably in the stone temples constructed in the Salt Range (northern Indus Valley) between the sixth and tenth centuries (fig. 19). The temples attest to the emergence of a hybrid or synthetic style that combines the *nāgara* forms of contemporary Indian temples with the classicizing idioms of the early Buddhist architecture of Afghanistan and northwestern Pakistan.[232] Mosque and temple both point to the importance of the Indus Valley as a distinct cultural region, while illustrating a point made in the introduction: circulation cannot be equated with "the simple reproduction across space of already formed structures and notions."[233]

Against this, it must be noted that in all the Sindi mosques, regardless of their plan, the execution of arch forms was clearly a desideratum, although intrusive within the regional idioms of Sind and Gujarat. In Thambo Wari and Bhadreshvar, arched entrances and mihrabs were excavated from stone monoliths (figs. 16, 18, and 20), while the mihrab of the Banbhore mosque

47

19

Hindu Shahi Temple, Kafir Kot, Salt Range Mountains, Panjab, Pakistan.

on the part of Arab patrons. Among the objects recovered from Mansura are four spectacular bronzes that are among the most remarkable examples of both early Islamic art and medieval South Asian metalwork to have survived (fig. 21). Although it would be difficult to exaggerate their importance, these bronzes have been ignored in surveys of Islamic art, confirming the late Michael Camille's observation that works considered liminal in a chronological, geographical, or taxonomic sense rarely achieve canonical status.[235]

The four monumental cast bronze door handles or knockers each measure over half a meter in diameter, weigh around seventy pounds, and consist of three distinct sections soldered or bolted together: a central three-dimensional boss featuring an anthropomorphic or zoomorphic head; an inscribed silver plate;

20

Blocked arched entrance, Chhoti Masjid, Bhadreshvar, Gujarat.

was reportedly provided with a stone frame cut to approximate an arch form, a feature that relates all these monuments to the architectural traditions of a wider Islamic world.[234] The endeavor to evoke the arched form in the mosques and shrines of Muslim communities living on the west coast of India suggests an association between specific formal values and cultural identity. The deployment of Arabic script and a strictly aniconic decorative vocabulary in the early Sindi and Gujarati mosques points in the same direction.

The aniconic decoration of Sindi mosques should not, however, be taken as evidence for the abjuration of the richly figural traditions of northern Indian art

THE MERCANTILE COSMOPOLIS

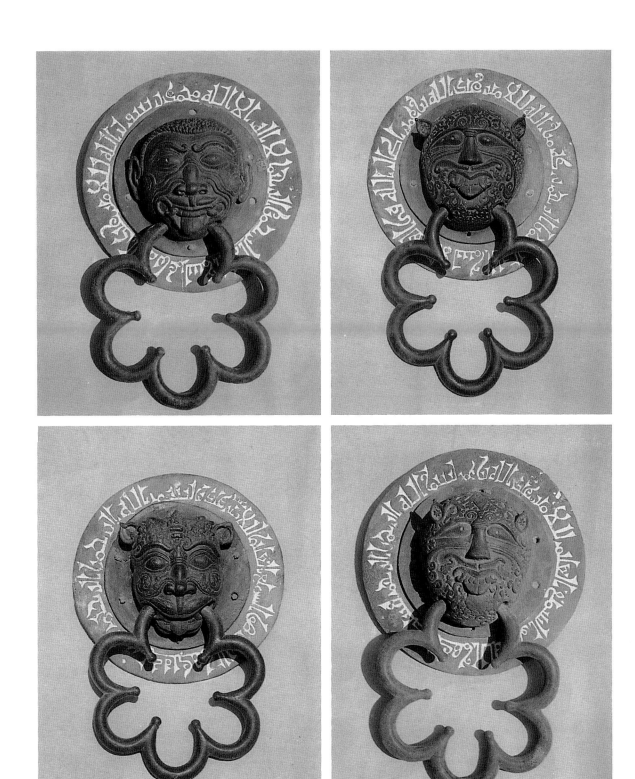

21
Four bronze door knockers excavated at Mansura (after A. Khan 1990a).

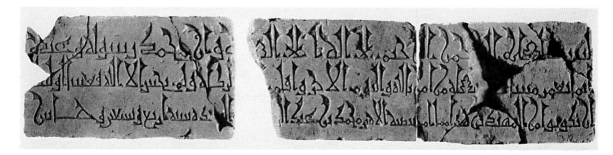

22

Foliated Kufic inscription from the Great Mosque of Banbhore, dated 294/906–7 (after Anon. 1964).

and a hexafoil knocker that hangs from the lower jaw of the face.[236] The rim of each bears an inscription incised in angular Kufic script, which may once have been emphasized by the presence of inlay. The bronzes were recovered from the *dār al-imāra* (gubernatorial palace) of Mansura and are believed to have adorned its entrance. The bronzes fall into pairs—two anthropomorphic and two zoomorphic—with the inscriptions on each type almost (but not quite) identical.

Although they are the earliest surviving examples of a type of door knocker well attested later elsewhere in the Islamic world, as products of a geographically peripheral region of the caliphate it has been assumed that some or all of these works were imported from Iraq, standing on the margins of a series rather than at its beginning.[237] In both quality and scale, there is, however, little to compare with the Mansura bronzes from the contemporary Islamic world. By contrast, the existence of a major metalworking industry in early medieval Sind is indicated by finds such as a three-foot brass Brahma image from Mirpur Khas, and references to the coppersmiths' bazaar in tenth-century Multan suggest that Sind was a major metalworking center before and after the Arab conquest.[238] In addition, the bronze lion faces owe much to contemporary Indic sculptural traditions, specifically the lion-faced *kīrttimukha* or *siṁha* figures that decorated the stupas and temples of Sind.[239]

Despite these local affinities, the form and content of the marginal inscriptions point unambiguously toward a relationship to the wider Islamic world. All the inscriptions on the bronzes bear the name of amir 'Abd Allah ibn 'Umar, who is named on some of the copper and silver coinage of Mansura (fig. 11), and is known from a chance reference in the *Akhbār al-Sind*

wa'l-Hind to have been ruling around 270/883.[240] The bronzes can thus be dated with confidence to the early 880s at the latest. This dating is all the more remarkable since the Arabic legends are executed using a foliated variant of the angular Kufic script normally used for inscriptions, a variant that became common in the Islamic world only in the tenth century. The precocious use of this script in the foundation texts of the amirs of Mansura is confirmed by its use (although with more restrained foliation) in an incised stone foundation (or restoration) text dated 294/906–7 recovered from the congregational mosque at Banbhore (figs. 22 and 23). The amir Muhammad ibn 'Abd Allah referred to in the Banbhore inscription is probably the son of amir 'Abd Allah named on the Mansura bronzes.[241] In contrast to most contemporary inscriptions in the wider Islamic world, which are carved in relief, the Banbhore texts are (like those on the Mansura bronzes) incised, following the standard practice for northern Indian inscriptions. This, combined with the local affinities of the figural ornament, suggests that some or all of the epigraphic plates and figural bronzes comprising the door handles were produced locally.

The earliest documented examples of foliated scripts are found in Palestine and Egypt, where they are employed in stone inscriptions as early as the 820s.[242] The circulation of Egyptian artifacts in Sind is proven by the find at Banbhore of a single dinar minted in Egypt in the name of the 'Abbasid caliph al-Wathiq (227–32/842–47).[243] In addition, the success of North African missionaries in converting the rulers of neighboring Multan to Isma'ili Shi'ism in just six or seven decades later underlines these contacts between North Africa and Sind. The sea route between Egypt and Sind was not a direct one, however, but proceeded via the

23

Details of Mansura bronze and Banbhore inscription showing common use of foliated Kufic script.

ports of Arabia. The appearance of similar scripts in the Hijaz, the coastal region of Arabia containing the holy shrines of Mecca and Medina, by the middle of the ninth century reminds us that territorial contiguity is not a requirement of physical proximity, underlining the importance of maritime connections for the dissemination of artistic forms.[244] The diffusion of these scripts in South Asia may therefore also reflect the role of pilgrimage in facilitating circulation; in 295/908 for example we hear of a merchant from Cordoba in Spain who, having made the *hajj*, traveled on to India to conduct business. A suggested association between foliated scripts and the Isma'ili rulers of North Africa, who were aggressively proselytizing Sind during this period, may also be relevant, although it has been disputed.[245]

The appearance of foliated Kufic script in a series of ninth-century funerary inscriptions from the ports of Sri Lanka confirms the early dissemination of foliated script around the Indian Ocean littoral; it is worth remembering that the Arab conquest of Sind was reportedly occasioned by a Sindi attack on a boat carrying Muslims from Sri Lanka to the Persian Gulf.[246] Found on the route between the royal city of Anuradhapura and the coast, the Sri Lankan example illustrated here (fig. 24) is dated 202/817–18, preceding the Sindi inscriptions by several decades. In addition to their foliated scripts, the epigraphic formulas used on the Sri Lankan stelae are identical to those found on contemporary Arabian and Egyptian tombstones, pointing once again to maritime connections with these regions. The Sindi and Sri Lankan inscriptions represent the sole documented examples of foliated Kufic script outside the eastern Mediterranean and Red

24

Rubbing of a tombstone incised with a foliated Kufic inscription dated 202/817–18, found on the route between Anuradhapura and Puttalam, Sri Lanka (after Kalus and Guillot 2006).

Sea in the ninth century, confirming the role of maritime contacts in the dissemination of contemporary cultural forms. In fact, the circulation of elaborate scripts between the Red Sea, Hijaz, and Persian Gulf probably has a long history. The appearance of a specific type of elaborate Kufic script in the port city of Bhadreshvar on the Gujarat coast of western India around 1150 has, for example, been convincingly related to its contemporary popularity in the Persian

Gulf emporium of Siraf, whence many of the Muslim merchants in Gujarat are known to have come.[247]

If, however, the form of the Habbarid inscriptions on the Mansura bronzes points toward maritime connections with Arabia or Egypt, their content evokes the courtly milieu of ʿAbbasid Iraq. The inscriptions on the anthropomorphic bronzes terminate with a quotation from Qur'an 2:137: "God will suffice you against them, for God hears and knows everything." This was a contemporary slogan of the ʿAbbasid caliphs, inscribed on the iron pole that held their banner.[248] The banner was adorned with other religious texts, including the phrase *lā ilāha illā allāh wahdahu lā sharīk lahu* (There is no god but God alone, no partner to Him), which appeared on ʿAbbasid coins, and on the copper and silver coins minted in the name of the Habbarid amirs of Mansura, including Amir ʿAbd Allah.[249]

This emulation of ʿAbbasid slogans in the public texts of the Habbarid amirs may be related to the particular circumstances of Habbarid rule. ʿAbd Allah was only the second of the Habbarid amirs to have ruled at Mansura. Habbarid rule had been secured by his father, ʿUmar ibn ʿAbd al-ʿAziz al-Habbari, in 240/854.[250] The sources are a little circumspect about the circumstances in which the Habbarids came to power, but the *Ḥudūd al-ʿĀlam* (372/982) bluntly states that ʿUmar ibn ʿAbd al-ʿAziz rebelled and seized Mansura, while the Arab historian al-Baladhuri (d. ca. 278/892) reports that he deposed or murdered the ʿAbbasid governor during one of the many disputes between Arab tribes of Hijazi and Yemeni origin that wracked the province.[251]

Sind was nominally under caliphal control even after this date: the caliph al-Mutawwakil bestowed it on his son in 235/850, in 257/871 its governorship was awarded to the Saffarids of Sistan (although there is no evidence that they took much of an interest in the region), and it was among the territories that the caliph al-Muʿtamid conferred on his brother in 261/875.[252] Despite the circumstances of their accession and the ambiguities of their position, the Sindi amirs continued to give the Friday sermon (*khuṭba*) in the name of the ʿAbbasid caliph, a traditional sign of communal allegiance, although the amirs of Multan are said to have submitted to the sovereignty of no one.[253]

ʿUmar's usurpation of power marked the beginning of the de facto independence of Mansura, and it

may not have been universally acclaimed; the years of ʿAbd Allah's reign were marked by insurgency.[254] In these circumstances, the use of ʿAbbasid slogans on the doors of the amir's palace may have been intended not as a usurpation but as an attempt to obscure the distinction between the de facto autonomy wielded by the Habbarids and the de jure authority of the ʿAbbasid caliph. The rise of the Habbarids is part of a broader ninth-century phenomenon of fragmentation, and it is noteworthy that during the same period the rebellious governor of Egypt, Ahmad ibn Tulun (d. 270/884) modeled the court culture of his breakaway capital (including his architectural patronage) on that of the ʿAbbasid caliphs.[255] Whether this should be understood as an appropriation or an homage is uncertain, an ambiguity that was no doubt relevant to the meaning and reception of these Iraqi forms and media. By contrast, the formal and iconographic heterogeneity of the Mansura bronzes reflects the nature of the city that they adorned, a city whose denizens dressed in the fashions of contemporary Baghdad, while their amirs adopted Indian modes of dress and struck Arabic coins to an Indian denomination.

Among the very few extant artifacts capable of shedding further light on this cosmopolitan world is an enigmatic Indian ivory known as the "Chessman of Charlemagne," now housed in the Bibliothèque nationale in Paris (figs. 25–27). The figure is substantial, standing 15.5 cm high, and is designed to be seen in the round. Tradition identifies it as a gift sent by the ʿAbbasid caliph Harun al-Rashid (786-809) to the Holy Roman Emperor Charlemagne, but since the earliest recorded reference to the object is in a sixteenth-century inventory, this is unlikely.[256] It has been suggested instead that the ivory was brought to Baghdad along with other Indian exotica (some of which were discussed above) in the ninth and tenth centuries.[257] This is more probable, but for present purposes the mechanisms through which the ivory circulated and came to rest in Paris are less at issue than the question of its origin. On stylistic grounds, the ivory has been ascribed dates ranging from the eighth to the fifteenth centuries, and attributed to regions ranging from northwestern India to Gujarat and the Deccan.[258] However, a number of factors suggest that it was in fact produced in either Mansura or Multan during the ninth or tenth century.

The ivory depicts a long-haired mustachioed fig-

THE MERCANTILE COSMOPOLIS

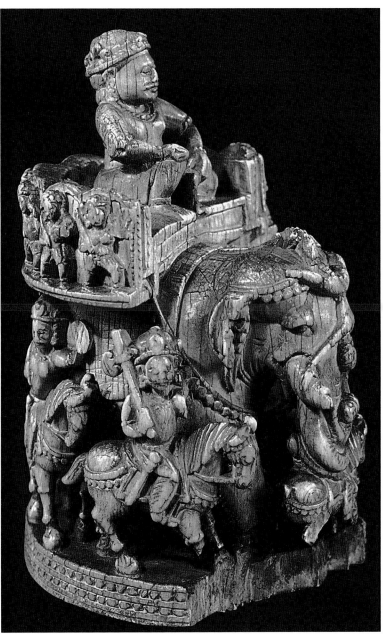

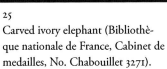

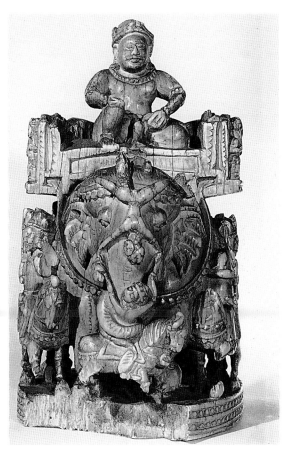

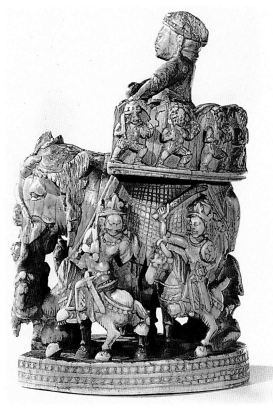

25
Carved ivory elephant (Bibliothè-
que nationale de France, Cabinet de
medailles, No. Chabouillet 3271).

26 and 27
Different views of carved ivory
elephant (Bibliothèque nationale
de France, Cabinet de medailles,
No. Chabouillet 3271, Negs. B46619
and B46620).

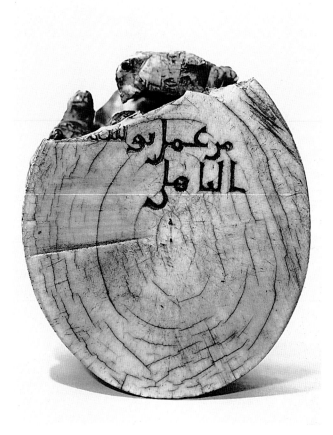

28

Arabic inscription carved on the base of the Bibliothèque nationale elephant (Bibliothèque nationale de France, Cabinet de medailles, No. Chabouillet 3271, Neg. 80.B91023)

ure seated in a howdah atop a richly caparisoned elephant and wearing a *kurta* (a long fitted shirt) and prominent earrings, his head adorned with a narrow fillet bearing a series of trefoil projections (fig. 27). The elaborate dress of the mounted figure (whose crown is studded with drill holes, suggesting that it was once set with jewels) as well as his preeminent position and scale seem to identify him as a royal rider. The semicircular exterior of the howdah is ringed by eight advancing foot soldiers, each wearing a diadem and bearing a raised sword and circular shield. The figures are set within the intercolumnations of an arcade composed of low ovoid arches born on rectangular capitals, a design common to Buddhist stupas and reliquaries from the Gandhara region of northwestern Pakistan.[259]

The base of the elephant is ringed by five horse

riders, who are either bare chested or wearing a *kurta* with baggy trousers and boots. The details of their costume and accoutrements, including stirrups and horse trappings, are carefully delineated. Four of the riders are provided with a sheated sword, and a weapon (including an ax, club or mace, and curved sword), and a circular shield bearing six- or seven-petaled rosettes. Each horseman sports a crown of different form: of the three that are now legible, one consists of a diadem or fillet adorned with a lunar crescent and solar disk; another, a fillet with repeated trefoil projections; and a third, more complex headdress consists of a crenelated diadem surrounding a cylindrical form.[260] Some of the horses' heads are adorned with a single peacock ornament, a motif with royal connotations in South Asia. Finally, a mahout dangles precariously from the head of the elephant in the process of a performing an acrobatic feat intended either to unhorse the fifth rider or to lift him onto the elephant, whose trunk is wrapped around his body. The legs of a less fortunate infantryman are barely visible, disappearing under the rear legs of the elephant.

There is little "Islamic" about the ivory carving in the sense that this adjective is usually employed, and were it not for an Arabic inscription on the base of the piece (fig. 28), one might be inclined to identify it as an Indic artifact that migrated westward as booty, gift, or merchandise. Written in an unusually expansive Kufic script, which has been dated to the ninth or tenth century on paleographic grounds, the inscription reads *min 'amala Yūsuf al-Bāhilī* (from the work—or workmanship—of Yusuf al-Bahili).[261] Whether one should read this as the product of an individual or his workshop (a "brand") is unclear.

The *nisba* or toponymic of the individual named in the inscription indicates that he was a member of the celebrated Bahila tribe of Arabs, many of whom participated in the early conquests of the eastern frontier.[262] During the reign of the caliph 'Umar ibn 'Abd al-Aziz (d. 101/720), 'Amr ibn Muslim al-Bahili oversaw the recently acquired territories in Sind, and it is likely that his descendants settled in the region, as did many of those involved in the conquest, including the ancestors of the Habbarids.[263] The inscription thus suggests a relationship to the eastern frontier of the Islamic world, and northwestern India in particular, an impression borne out by details of the carving.

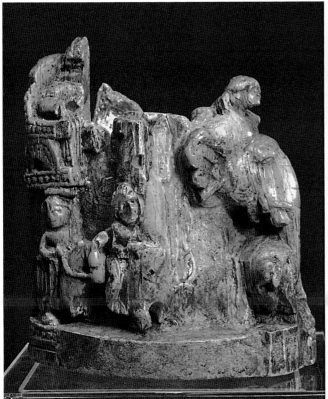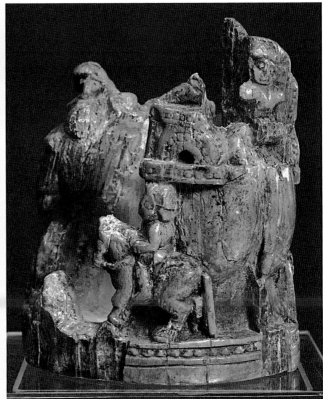

29
Ivory elephant, Sind(?) (courtesy of Museum für Indische Kunst, Berlin).

Some of the details of the ivory suggest affinities with the sculpture of Kashmir, known to have been a center for ivory carving during the eighth and ninth centuries, or with other regions of the western Himalayas.[264] These include the triple projections on the diadems worn by the horsemen, the typical "Kashmiri crown" (the fillet with crescent and disk), and the low crenelated crown worn by the royal figure atop the elephant, which is reminiscent of those worn by bronze Buddha figures produced in Chamba or Gilgit during the seventh through ninth centuries.[265] Despite these affinities, it seems unlikely that the elephant was created in Kashmir, since extant Kashmiri ivories generally depict religious (primarily Buddhist) scenes and are not executed in the round but are almost always designed to be approached from a single viewpoint.[266] If, as I believe, the ivory was worked in Mansura or Multan, its strong Himalayan affinities might reflect contemporary contacts between Kashmir, the Indus Valley, and Gujarat, elsewhere reflected in imports of Kashmiri sculpture and the adoption of characteristic Kashmiri

forms (including trefoil arches and pyramidal roofs) in some of the Hindu temples of the Salt Range.[267]

Confirmation that worked ivory was produced in Sind can be found in Arabic geographies, which list ivory among the manufactured goods and raw materials exported from Mansura.[268] In addition, they mention that the Sun Temple of Multan was located in an enclosure situated between the bazaar of the ivory carvers and the shops of the coppersmiths.[269] A series of ivory plaques depicting *apsarās* (celestial females) and *makara*s (hybrid sea creatures) excavated at Brahmanabad near Mansura have been tentatively dated to this period and identified as an import from the Gurjara-Pratihara kingdom of central India, but it is just as likely that they are products of these Sindi workshops.[270]

Among the other artifacts that may be identified as remnants of the Sindi ivory industry is a small elephant found in the northwest of the Indian subcontinent and now in the collections of the Museum für Indische Kunst (fig. 29).[271] Standing 9.7 cm high, the

Berlin elephant is considerably smaller than that in Paris, poorly preserved and of much cruder workmanship. Nevertheless, the iconography of the piece is very similar to that of the larger and more sophisticated Bibliothèque nationale ivory.

Closer parallels are offered by a Buddhist diptych in the form of an elephant carrying a seated figure bearing a stupa shrine and surrounded by armed infantrymen (figs. 30 and 31).[272] Although different in details, at 15.9 cm high the diptych is almost identical in scale to the Paris ivory. The ivory was found in a cave near Gansu in northwestern China, but the scenes from the life of the Buddha depicted in its interior are closely related to the Buddhist stone sculptures found in the Gandhara region of Afghanistan and northern Pakistan. In a recent study of the Gansu ivory, Diana Rowan suggested that the figure seated on the Gansu elephant is a Shahi, or foreigner from the northwest of India, concluding that "the diptych may represent an unusual commission of a late seventh- or eighth-century Śāhi dignitary who lived on the frontiers of Kashmiri influence—a Buddhist frontier familiar with Gandhāran diptych forms and narrative cycles, Hindu style and Chinese decorative arts; an area located in the midst of trade routes that carried this portable object of worship to its find spot in northwest China."[273] The heterogeneity and Kashmiri affinities of the piece resonate with those of the Paris ivory. In light of the suggested seventh- or eight-century date for the Gansu ivory, and the ninth- or tenth-century date that I am proposing for the Paris elephant, taken together they may offer evidence for continuity in the work of Sindi ivory carvers before and after the Arab conquest of Sind in the early eighth century.

Coincidences between the ideals of Indic kingship, the practices of Indian kings, and the dress of the figure depicted on the Paris ivory only strengthen the case for a Sindi origin. Although the carving has often been taken for a chess piece, recent research casts doubts on this identification.[274] The ivory tableau accords, however, with tenth-century Arabic descriptions of how both Indian kings and the amirs of Mansura deployed war elephants in battle: surrounded by a ring of foot soldiers against the ranks of cavalry.[275] It also conforms to a type of ideal battle formation described in Kautilya's *Arthashāstra* (before the fifth cen-

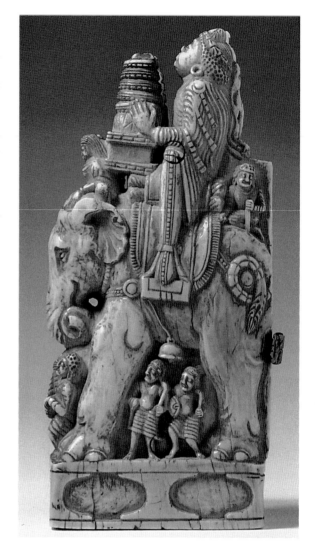

30

Ivory diptych found in Gansu, northwestern China, from the Indus Valley (?), seventh or eighth century (after Weichao 1997).

tury AD), the classic Sanskrit text on statecraft, which stipulates that an elephant should be surrounded by five cavalrymen.[276]

The piece might, therefore, be read as an idealized representation of a contemporary Arab amir. Arab admiration for the elephant was rooted in the military advantage that pachyderm power conferred: in medieval geographies the king of al-Hind is also referred to by the homonym "king of the elephants" (*malik al-fila*), and by the ninth and tenth centuries the iconographic association between elephants and authority

THE MERCANTILE COSMOPOLIS

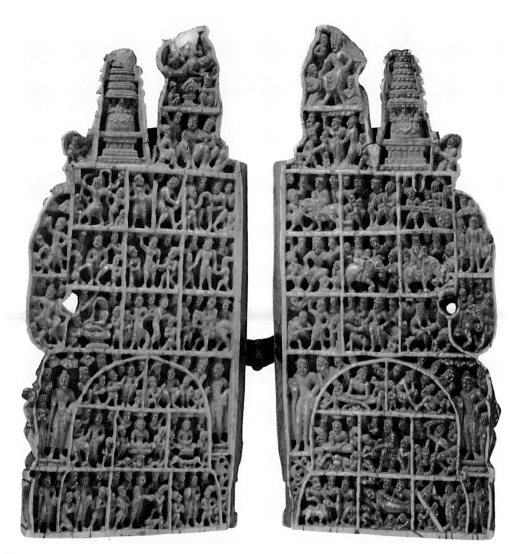

31
Gansu diptych, interior (after Weichao, 1997).

was acknowledged as far west as al-Andalus.[277] The ceremonial and military use of elephants is particularly associated with dynasties that ruled on the eastern frontier, among them the Habbarids, Saffarids, and Ghaznavids. The Habbarid ruler of Mansura possessed eighty war elephants, two of which are named and were celebrated for their size and strength, while the Arab amirs of Multan processed from their palace outside the city to Friday prayers mounted on an elephant.[278] Moreover, as we shall see in chapter 2, the Indic dress of the royal figure depicted on the ivory conforms to reports that the Habbarid rulers of Man-

sura (whom the sources refer to as both *amir*s and *mahārāj*s) dressed in the style of contemporary Indian kings, wearing earrings, long hair (a practice associated with Indians), and sporting a short tunic known as a *kurta*.

A more metaphysical reading of the ivory might see in it a representation of dharmic order: the vassals (*sāmanta*s) surrounding a *mahārāja* or the ideal polity described by Kautilya, central to which is the "circle of kings" composed of the alternating rings of adversaries and allies that form around a *chakravartin* or universal ruler.[279] The concept has something in common

with the "family of kings" depicted in early Islamic images and texts, where the kings of the earth (often reduced to the four or five kings of the Turks and/or Persia, China, India, and Rome) frame the throne of a superordinate ruler.[280]

It is of course possible that the Arabic inscription postdates the creation of the object, but close examination of the base shows that all the fractures on its surface have formed around the incisions of the inscription, suggesting that the text was in place as the ivory began to age (fig. 28). Moreover, the sole reason to assume this is an a priori assumption about the nature of "Islamic" art and the fact that the presence of an Arabic name is somehow at odds with the Indic style of the piece, as the art historian Moti Chandra observes: "As a matter of fact, the purpose of an Arabic inscription on a purely Indian piece is also far from clear. It is difficult to say whether some Arab ivory-carver working in Indian style put his name on the ivory or whether its Arab owner got his name inscribed there."[281] Similarly, a recent study of the ivory dismisses the idea that such a richly figural tableau could be the work of a Muslim sculptor, concluding that it was carved by an anonymous (Hindu) artisan within the workshop of Yusuf al-Bahili.[282]

The "problem" is common to the bronzes from Mansura, which scholars have struggled to locate both geographically and taxonomically. On stylistic grounds they have been divided into an "Indic" anthropomorphic pair and "Islamic" zoomorphic pair, with explanations for this juxtaposition of Indic and Islamic iconography in a single group of artifacts ranging from literally diffusionist (the "Islamic" bronzes were dispatched from Iraq) to absurdly intentionalist. As a recent account of the Mansura bronzes explains, "two different workshops (or two artisans in the same workshop) [may have been] responsible. One worked in a traditional Indian mode, continuing to use the local style connected with the production of Hindu and Buddhist sculpture; the other employed a deliberately Islamic idiom and was well aware of stylistic developments in the central Islamic lands, possibly having emigrated from there."[283] Once again, it should be emphasized that there is nothing comparable to these bronzes from the central Islamic lands at this date, so that the Iraqi stylistic developments taken as a given

are being read backward from the very bronzes that are taken to show their diffusion.

These juxtapositions appear anomalous only by virtue of an attempt to accommodate the artifacts on which they occur within taxonomies that conflate ethnic, territorial, iconographic, and stylistic categories of analysis, privileging notions of "Hindu" or "Muslim" identity that are assumed to be distinct and incommensurate.[284] This categorical approach to identity is apparent, for example, in David Wasserstein's insistence that "the very recognition of a coin as Islamic . . . implies the recognition of boundaries dividing Muslim from non-Muslim, Islamic from non-Islamic as well. Such a coin refers unmistakably to Islamic, as distinct from non-Islamic, territory, in every sense of that word."[285] An understanding of the fabric, script, and scale of coins as constituting a numismatic metalanguage that asserts intercultural difference cannot account for the bilingual dammas from Multan. Their spirit is, however, perfectly in keeping with the intermingling of Arabic text and Indic iconography on a single object, or the combination of siṁha masks and ʿAbbasid religious slogans on the doors of the dār al-imāra of Mansura. In a world in which descendants of the Prophet's tribe could issue coins with Sanskrit texts representing him as an avatar and invoking Hindu deities, a world in which for some temple and mosque seem to have been equally integral to quotidian rituals of devotion, neither "Islamic" nor "Indic" characteristics can be taken as predictive of ethnicity or religious affinity. Instead, the bilingual coins or ivory elephant should be seen as integral artifacts of premodern cosmopolitan cultures rather than disturbing anomalies marginalized by modern taxonomies.

Posing significant challenges to a principle of reading difference, a principle that is intrinsic to modern categories of thought that structure our understanding of the past, the flotsam from premodern Sind that are so marginal to canonical tellings of history (and art history) are immensely productive sites from which to interrogate the categorical structures on which canons themselves depend. They also provide a timely reminder not only of the fact that people, things, and the practices associated with both have been mixed up together for a very long time, but of the violence done to

all cultural forms by attempts to purify and stratify them, to bring them into conformity with our, culturally specific, modes of ordering the universe.

As a coda, it should emphasized that differences in the ethnic and linguistic composition of Mansura and Multan, and in the self-representations of their respective amirs, preclude any attempt to define a unitary Sindi "Arab" culture. Both the use of 'Abbasid slogans on the public art of the Habbarids and the early appearance of foliated Kufic bespeak the impact of maritime connections to Egypt, Arabia, and Iraq. Under the right conditions, the journey from Siraf in the Persian Gulf to Saymur on the west coast of India could take as little as two weeks. By contrast, Multan, the meeting point for caravans to Khurasan, lay two months' journey by the terrestrial routes from Zarang (the capital of Sistan), which was itself remote from Baghdad.[286] The use of Arabic and Persian is indicated at Multan, and the presence of Sanskrit on Multani coins points at dimensions to elite literacy that lay outside the interest or knowledge of the Arab writers on whom we depend for most of our information. By contrast, Arabic and Sindi were the languages of Mansura, hinting at differences in the ethnic composition of the merchants who came to trade in both cities, and patterns of circulation specific to each sphere. Similarly, it is reported that the loincloth (*izār* or *mi'zar*) that was favored by the Muslim and non-Muslim populations of Gujarat also prevailed among the male population of Multan but not among that of Mansura, where Iraqi fashions were the norm.[287] These differences undermine any idea of a unified Arab or Muslim culture in Sind, but it would be mistake to conclude that the cultures of Multan and Mansura were characterized by an exclusively Indic or Islamic orientation, as we shall see in the following chapter.

2 | *Cultural Cross-dressing*

Habit has its abode neither in thought nor the objective body,
but in the body as mediator of a world.

—Maurice Merleau-Ponty, "The Spatiality of the Lived Body
 and Motility" (1970), 266

The Prophet (peace be upon him) said: "He who imitates any people
is one of them."

—Sunan of Abu Da'ud (d. 275/888), *Kitāb al-Libās* (Book of Clothing)

| *Prestigious Imitation*

In a groundbreaking study published in 1996, Phillip Wagoner analyzed the role of dress in the public ceremonial of the Hindu rulers of Vijayanagara, an important political formation in the Deccan region of southern India. At its zenith between the fourteenth and sixteenth centuries, Vijayanagara was surrounded by dominant Muslim polities. From contemporary textual and visual evidence, Wagoner argued that the need to engage with a wider political culture in which sovereignty tended to be expressed within Islamicate frames of reference led its Hindu rulers, who styled themselves "Sultans among the Hindu Kings" (*Hindurāyasuratrāṇa*), to adopt Islamicate modes of rhetoric and dress in their public ceremonial.[1] These were not generalized in the Vijayanagara kingdom but restricted to its elite, the product of a deliberate self-fashioning rather than a general dispersal of Islamicate fashions. Wagoner concluded that "the royal imagery projected by these rulers through Islamicized styles of dress and address was far more complex than the simplistic image in which the communally inspired historiography of our own age has cast them."[2]

In this chapter, I want to demonstrate that the phenomenon identified by Wagoner was also operative (if not, perhaps, as comprehensively articulated) much earlier in the cosmopolitan contact zones of the mercantile cosmopolis, and in the adjacent Hindu and Buddhist kingdoms of northern India. Existing on the margins between the biological and social being, dress renders the body legible according to specific culturally determined categories. Modern cultural historians have drawn attention to the ability of clothing to mold the wearer both physically and socially, to "make the body culturally visible."[3] This capacity was no less apparent to premodern elites who could be positioned, or position themselves, in relation to the dominant social structures of the worlds that they inhabited through the adoption, denial, granting, and imposition of specific modes of dress. Between the tenth and twelfth centuries, these qualities were central to the articulation of a complex interplay between sameness and difference, self and other, in the self-fashioning of northern Indian Buddhist, Hindu, and Muslim elites. During this period we encounter both Muslim elites whose sartorial codes were inspired by those of powerful Hindu neighbors and Buddhist and Hindu elites who adopted Turko-Persian modes of dress that were fashionable during the eleventh and twelfth centuries. The reciprocal or multidirectional nature of the phenomenon suggests that it had little to do with the ethnic or religious associations of dress, and everything to do with its role in the visual articulation of authority.

Nevertheless, the assumption that in premodern South Asia irreducible differences between Hindus and Muslims were reflected in sartorial distinctions is

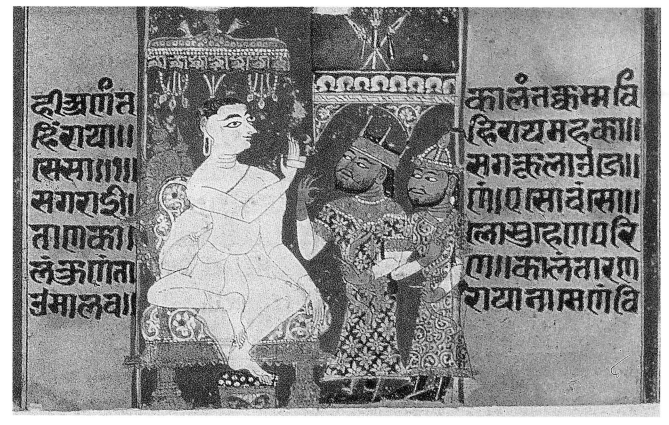

32

The monk Kalaka in conversation with two Shahis, detail of a folio from the *Kālakāchārayakathā*, western India, ca. 1400 (courtesy of the trustees, Chhatrapati Shivaji Maharaj Vastu Sangrahalaya, formerly Prince of Wales Museum of Western India, Mumbai).

widespread in modern scholarship, exemplified by Nirad Chaudhuri's observation that the "conflict of religions had its complement in a conflict of clothes, which in India was only natural."[4] The assumption finds some support in premodern sources, although these tend to emphasize ethnic or regional rather than religious categories of difference. Writing in the early eleventh century about the differences between the inhabitants of al-Hind and those of the Persianate world with which he was familiar, al-Biruni asserts that "in all manners and usages they differ from us to such a degree as to frighten their children with us, with our dress, and our ways and customs."[5] Textual assertions of the relationship between dress and difference find corollaries in thirteenth- and fourteenth-century Islamic painting, where Indians were conventionally depicted as darker of color, longer of hair, and scantier of clothing than the Arabs and Persians that they encountered (see figs. 1 and 4).[6] Conversely, in Northern Indian paintings of the fourteenth and fifteenth centuries, the exotic appearance of Shahis (Persians or Central Asians) compared with their Indian interlocutors is indicated by differences in the style of clothing and its relationship to the body; loosely draped cloth covering part of the body contrasted with fitted robes entirely obscuring it (fig. 32).

This emphasis on difference is a stark reflection of the ability of dress to communicate political power, social status, personal wealth, and ethnic or religious affiliation. The relationship between dress

CULTURAL CROSS-DRESSING

and identity finds its most comprehensive expression in the prescriptive use of sartorial or sumptuary regulations to inscribe difference upon the human body, naturalizing alterity in the process. In the Islamic world, a range of vestimentary restrictions ascribed to the caliph 'Umar (d. 23/644) were both proscriptive and prescriptive, mandating the use of specific types of dress (including belts, headdresses and shoes) by non-Muslims (*dhimmīs*) and precluding the adoption of others. These proscriptions extended to the use of signs of status (such as weapons and saddles) and Muslim names (especially patronymics) by non-Muslims.[7] Complaints about non-Muslims failing to observe these vestimentary codes are common, and the need for periodic reinforcement in Syria and Iran suggests that they were honored more in the breach than the observance.[8] Nevertheless, vestimentary codes were clearly intended to perpetuate a state of differentiation (*ghiyār*) manifest in outward appearance. *Dhimmīs* were for example obliged to wear the *zunnār*, a belt or girdle in fashion at the time of the Muslim conquest of Syria in the seventh century, and forbidden to wear the *minṭaqa*, a belt worn by Muslims.[9]

Developed as part of the seventh-century conquest of Syria (whose sartorial conventions they reflect), the prescripts governing dress in the "Code of 'Umar" were later transposed to other cultural contexts. The differentiation of ethnic or religious groups through the prescription of appropriate hairstyles or modes of facial hair was common to both Indic and Islamic societies, and their homologous use may even have facilitated the adaptation of Islamic vestimentary proscriptions to Indian conditions in the wake of the Arab conquest of Sind.[10] As part of this process we see an adaptation or translation of Middle Eastern terms for the Indian context. For example, the *Ādāb al-Ḥarb* (Etiquettes of War) of the Indo-Persian historian Fakhr-i Mudabbir (writing ca. 616/1220) emphasizes that in the cities in which Muslims were a majority, *dhimmīs* should be distinguished by being forbidden to wear the *jāma*, a long robe favored by Indian Muslims.[11] Similarly, in Ghaznavid poetry and histories, the term *zunnār* translates the *upavita*, the thin sacred thread worn by Brahmans around their body, an example of translation based on perceived functional homology.[12]

The relationship between dress and identity was not merely metonymic but also constitutive: dress and personal adornment constituted the very categories that they signified. Consequently, if the enforcement of vestimentary codes was a boundary-maintaining mechanism designed to occlude the possibility of crossing (or "passing"), those boundaries could be traversed through emulation or imitation.[13] Clothing could serve as a metaphor for political or religious identity,[14] but neither was set in stone. Adopted or bestowed across ethnic, linguistic, or religious boundaries, dress carried the paradoxical ability to incorporate those who formerly stood beyond and without specific categories of identity. After the conversion of Ghazan Khan, the Mongol ruler of Iran, to Islam in 697/1298, for example, the court abandoned Mongol headdresses for Arab turbans.[15]

The potential of dress to effect radical translations in identity is acknowledged in a well-known tradition of the Prophet Muhammad, included in the chapter on clothing in the *Sunan* of Abu Da'ud (d. 275/888): "he who imitates a people is one of them."[16] It is for this reason that, according to some authorities, the adoption of *dhimmī* clothing by a Muslim constituted an act of apostasy. Writing in 986/1577, the Hanafi jurist Muhammad b. 'Abdallah 'Arabi explained the meaning of the hadith thus: "He who intentionally makes himself like the unbelievers or dresses in the manner of the Christians, or belts himself with the *zunnār* or wears the *qalansuwa* of the Zoroastrians, is declared an unbeliever."[17] The translational qualities of dress are taken for granted by al-Biruni, in a tale about an Indian ruler who punished his enemies by compelling them to adopt the Persianate dress current in the Ghaznavid sultanate, an imposition that constituted an ignominious punishment. Musing on this episode, the author expresses his gratitude that the vengeful raja "did not compel us to Indianize and translate ourselves into their ways."[18]

Comparisons between linguistic translation and sartorial transumption are relatively common, so that in eleventh-century al-Andalus, translation from Arabic to Hebrew could be described as a change of clothing.[19] A parallel can be found in early modern England, where "translation" could refer both to linguistic displacement and an act of reclothing.[20] In their study of both the term *translation* and the phenomena that

it names, Jones and Stallybrass emphasize that in order to understand the role of dress in premodern cultures, "we need to undo our own social categories, in which subjects are prior to objects. . . . We need to understand the animatedness of clothes, their ability to 'pick up' subjects, to mold and shape them both physically and socially, to constitute subjects through their power as material memories."[21]

By virtue of its ability to effect translations, dress could serve as a mechanism of incorporation in ways that qualified, confused, or even subverted social categories that sartorial proscriptions were intended to enforce. The incorporative qualities of clothing could lead medieval elites to adopt or appropriate modes of dress associated with the articulation of authority in powerful neighboring polities. The phenomenon represents a desire for legibility or visibility within the dominant modes of articulating authority, a kind of auto-*interpellation*, to use a term developed by the philosopher Louis Althusser to denote the ability of ideology to call the subject into being within specific categories of identity. It also subverts any simplistic attempt to make the frontiers of dress coterminus with ethnic or religious boundaries.

These general points can be illustrated by two case studies taken from different areas of the frontier between the *dār al-Islām* and the sovereign Buddhist and Hindu polities of northwestern India. The first involves the amirs of Mansura discussed in chapter 1, minor players on the western fringes of powerful Indian polities to which they were linked by strong mercantile ties. The other concerns the adoption of Turko-Persian modes of dress by the ruler of a small Buddhist kingdom sandwiched between the Muslim sultanates of Ghazni (modern-day Afghanistan) and the Hindu kingdom of Kashmir, a major cultural and political force in the region during the eleventh and twelfth centuries.

The Arab geographers who write on India display an acute sensitivity to the operation of different vestimentary codes in the regions that they visited, noting when local rulers wear untailored garments or go bare chested, in contrast to those who wear modes of dress familiar to Arab or Persian observers (who generally make a more favorable impression).[22] Outside the courtly milieu, communities of dress are delineated by a respective preference for the unsewn loincloth (referred to in Arabic as *al-izār* or *mi'zar*) or the tailored garments of the central Islamic lands.[23] According to the Arab geographers, the *izār* that was standard among the population of Kanauj, the capital of the Gurjara-Pratiharas, was also worn by both the Muslim and non-Muslim populations of the coastal cities under Rashtrakuta control, whose inhabitants wore their hair long.[24] In some of the hadiths, the Prophet enjoins Muslims to wear the *izār* only in contexts where it serves to distinguish them from non-Muslims, but this is clearly not the case here.[25] The same mode of dress is said to have prevailed among the population of Multan, but interestingly not among that of Mansura, whose population (with the exception of the amir) adopted Iraqi norms of dress.[26]

Multan and Mansura were thus differentiated by their participation in distinct sartorial ecumenes. This should, however, lead us to conclude neither that the population of one region looked west for its sartorial models, the other east, nor that the population of one region was more "Indianized" than that of the other. The associations of dress are not just regional but also hierarchical, operating both horizontally to link the populations of geographically distinct regions and vertically, creating communities of elites within those populations. In contrast to the bulk of their subjects, the rulers of Mansura (variously referred to as *amīrs* or *mahārajs*) are reported to have adopted the dress of contemporary Indian kings (*ziyy mulūk al-Hind*), wearing their hair long (a practice associated with Indians) and sporting a short tunic known as a *kurta* (*al-qurātiq*).[27] The sources emphasize that these modes of dress were not general in Mansura, whose denizens espoused the Iraqi fashions that held sway as far away as Andalusia at this time, reflecting the cultural hegemony of the Baghdad caliphate.[28] Just as the kings of neighboring Kashmir distinguished themselves from their subjects by their hairstyle,[29] the amir and his subjects participated in distinct sartorial ecumenes, underlining once again the complex transregional orientations and transcultural affiliations of Mansura.

The particulars of Habbarid dress—the long hair, earrings, and *qurātiq*—conform to those said to have prevailed in Makran to the west of Sind, whose population is said to have dressed like Indians, but the geographers imply that these modes of self-fashioning

CULTURAL CROSS-DRESSING

were confined to less cosmopolitan areas of Makran; elsewhere the *qamīṣ* (shirt) and *ridāʾ* (cloak) fashionable in Iraq and Fars predominated.[30] It is highly unlikely that the amirs of Sind modeled their dress on that of the rural populace of Makran, which all the geographers depict as an inhospitable backwater. Instead, the Habbarid amirs of Mansura evidently looked to the kings of India, as was apparent to contemporary visitors to the city.

We have seen in the preceding chapter that the Arabs of Sind formed particularly strong cultural and political ties with the Rashtrakutas, a bond forged in part by mutual opposition to the powerful Gurjara-Pratiharas of northern India. In addition to its political expediency, the centrality of trade to this relationship is underlined on the one hand by the circulation in Mansura of the dominant form of specie in the neighboring Indic polities, and on the other by finds of Arab silver coins in Gujarat and Rajasthan.[31] The bilateral nature of the relationship is also indicated by the presence of Muslim elites in the coastal cities of the Rashtrakuta realm. It therefore seems likely that the self-fashioning of the Mansura amirs was informed by, if not modeled on, that of the Rashtrakuta rajas, to whom Arab travelers refer as the kings of those who pierce their ears.[32]

We know far less about the amirs of Multan than about their counterparts in Mansura, but there are hints that Indic modes of self-fashioning may also have held sway among them. Arab travelers report that on the occasion of Friday prayers the amir processed to the congregational mosque of Multan from his palace at Jandrawar (Chandravar) outside the city, mounted on an elephant.[33] The ritualized nature of the event recalls descriptions of the ruler of Nahrwara (medieval Anhilavada or Patan; see fig. 2), the capital of the Solanki or Chalukya rajas of neighboring Gujarat, riding out in procession every Friday, richly clad in a golden crown and robe, surrounded by female courtiers wearing the *qurāṭiq*, the garment favored by the amirs of Mansura.[34]

Although the adoption of Indic dress runs counter to both the spirit and the letter of those hadiths that inveigh against the imitation of sartorial practices associated with unbelievers, the Arab ruler of Mansura was a Sunni Muslim, a *Qurayshī* (a member of the Prophet Muhammad's tribe) who paid at least lip service to the caliph in Baghad. It is clear, therefore, that the self-fashioning of Mansura's Habbarid amir had little to do with religious affinity or antipathy and everything to do with the culturally and politically liminal status of Arab Mansura. Geographically isolated from a Baghdad to which he was nominally subservient, the *amīr* or *mahāraj* of Mansura evidently modeled his dress and public appearances on those of his powerful Indic neighbors, projecting his authority in a manner determined by the dominant political culture of the region. This was a pragmatic gesture, reflecting an "orientation to power" designed to appropriate the dominant modes of projecting effective political authority, regardless of the ethnic or religious associations of those who wielded it. Patricia Crone has famously noted in another context that "Umayyad genealogy was no bar to ʿAbbasid hairstyles." In Arab Mansura, it appears that *Qurayshī* genealogy was no bar to Rashtrakuta lifestyles.

Just as certain Sanskrit terms for textiles had entered Arabic in the centuries following the conquest of Sind (presumably reflecting the circulation of the stuffs to which they referred), so between the tenth and thirteenth centuries Sanskrit absorbed Pahlavi and Persian terms for textiles whose continued circulation between northern India and the eastern Islamic world they attest to.[35] The impact of these developments is apparent in a second, slightly later, case study, this time not a textual description of royal dress but a series of royal scenes painted in a Buddhist temple at Alchi in Ladakh, high in the northwestern Himalayas (marked on fig. 46). Like Sind, Ladakh lay at the intersection of transregional trade routes: a series of Arabic inscriptions from nearby Tangtse datable from the ninth century onward attests to the "international" contacts of the region.[36] In the period between 1150 and 1220, when the paintings are believed to have been executed, Ladakh was sandwiched between two more powerful neighbors: the kingdom of Kashmir to the south, and the Ghaznavid and Ghurid sultanates of Afghanistan to the west (see fig. 46).

The most elaborate of the paintings appears in the interior of the Dukhang shrine in the Alchi complex (fig. 33).[37] It shows a seated ruler with a female figure to his left (perhaps the king and queen mentioned in a nearby Tibetan foundation text) and a male figure, perhaps a son, to his right.[38] Of particular interest is

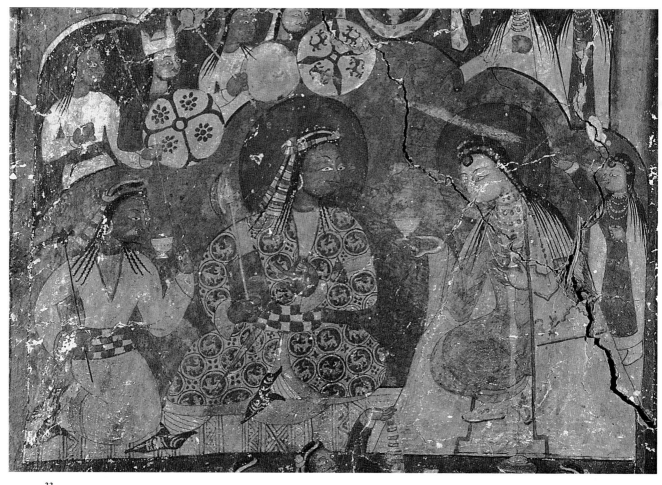

33
A royal scene, Dukhang Temple, Alchi, Ladakh (courtesy of Jaroslav Poncar).

the robe worn by the ruler, for it corresponds to the *qabāʾ*, a type of dress well known in the Islamic world. The *qabāʾ* was a sleeved, tailored, midcalf-length coat, open down the front and closed by one side being fastened across the other; it was often worn above a shirt or undergarment known in Arabic as a *qamīṣ*, and with a thick belt or girdle, baggy trousers, and boots, all of which are present at Alchi.[39] Here the robe is decorated with a repeated pattern of roundels containing rampant lions, a design that may reflect the impact of contemporary Persian textiles.

This form of dress, which is widely dispersed in Central Asia and eastern Iran, is Central Asian in origin, and seems to have been originally associated with if not exclusive to Turkic peoples.[40] A form of *qabāʾ*

was adopted by elites from Baghdad to Tibet as early as the ninth or tenth century. With the ascendancy of Turkic dynasties such as the Seljuqs and Ghaznavids in the Islamic world from the eleventh century a variant form known as the *qabāʾ turkī* or "Turkic *qabāʾ*" became popular in the central Islamic lands.[41] This was a type of coat fastened by overlapping one side across the front of the other (figs. 34 and 35), as seems to be the case at Alchi, where the coat is held in place with a swath of cloth tied tightly about the waist. The fashion of wearing jackets, tunics, and trousers in the Persian manner increased in northern India during the twelfth century as a result of increased contacts with the Iranian world, and the fact that *Turuṣka* (Turkic) costumes tended to cover the body from the

CULTURAL CROSS-DRESSING

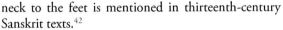

34
Turkic *ghulāms* of the Ghaznavid sultan, drawings after frescoes in the throne room of the palace at Lashkari Bazar, Afghanistan, eleventh century (courtesy of Janine Sourdel-Thomine and the DAFA).

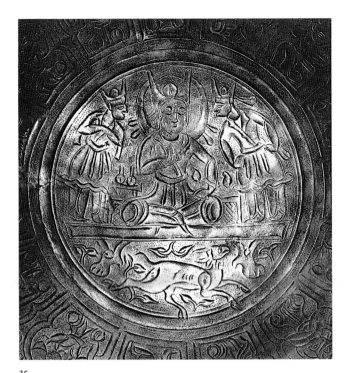

35
Tin-glazed bowl with enthroned ruler, Afghanistan, eleventh century (Metropolitan Museum of Art, 1971.42).

neck to the feet is mentioned in thirteenth-century Sanskrit texts.[42]

An interesting tale told by al-Biruni retrojects eleventh-century norms of kingly self-fashioning associated with the Turks, but may equally indicate an association between Turkic modes of dress and kingship in the Hindu and Buddhist kingdoms of the western Himalayas even before the rise of the Ghaznavids. According to al-Biruni's story, the first of the Hindu Shahi rulers of Kabul rose to prominence in the seventh or eighth century by means of a trick, whereby he hid himself in a sacred cave, from which he emerged in regal fashion, clad in Turkic dress (*ziyy al-ātrāk*), consisting of a *qabā'* and *qalansuwa* (a type of conical hat).[43] We may therefore witness at Alchi a later reinvestment of a type of Turkic robe that had its roots in the sartorial traditions of Central Asia and was adopted by the Turkic and Tibetan elites as early as the eighth or ninth centuries.[44]

The most telling addition, and one absent from earlier representations of Tibetan rulers wearing analogous robes, is the *ṭirāz* or arm bands prominently displayed on the upper arms of the male royal figures in the Alchi frescoes. These bands also appear on the robes worn by two other princely figures depicted elsewhere in the Dukhang, at least one of whom wears a *qabā'* over a white shirt or *qamīṣ* (figs. 36–37). Bands of similar type appear on the robes of Turkic figures depicted in Central Asia as early as the eighth or ninth centuries; their popularity and proliferation in the Islamic world coincide with that of the *qabā'*, and probably also reflect the political ascendancy of the Turks.[45] Often inscribed with blessings or the name and titles of rulers who had gifted the textiles that they adorned, *ṭirāz* bands proliferated on Islamic costume between the eleventh and fourteenth centuries. They appear, for example, on the *qabā's* worn by the *ghulāms* or Turkish slaves of the Ghaznavid sultans as they appear

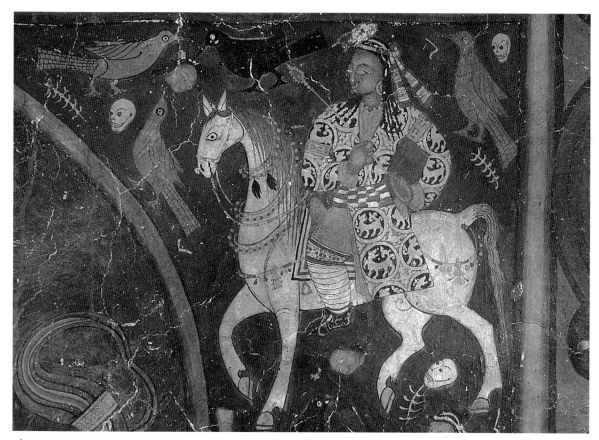

36

A royal rider, Dukhang Temple, Alchi, Ladakh (courtesy of Jaroslav Poncar).

on the walls of the throne room at Lashkari Bazar (see fig. 34), and on at least one relief from Ghazni.[46] *Ṭirāz* bands are also depicted on the *qabā*'s worn by courtly figures found on ceramics, manuscripts, metalwork, and other portable objects that circulated well beyond the boundaries of the *dār al-Islām* (see fig. 35).

At Alchi, *ṭirāz* bands are confined to the robes worn by enthroned or royal figures, suggesting that they were a meaningful element in the articulation of authority and not merely a generic device. The prominent nimbi afforded the Alchi ruler and his queen, and the ax held as a signifier of authority or office, also find parallels in the royal iconography of the eastern Islamic world, as does the role of the drinking vessel that forms the focus of the royal scene.

At least one scholar has rejected the possibility that the dress of the Alchi ruler is modeled on that of the neighboring Muslim courts of Afghanistan on the

grounds that it is difficult to imagine the "iconoclastic Muslims" providing models for a Buddhist prince.[47] Like the a priori rejection of the possibility that a Muslim craftsman could have created the ivory elephant discussed in chapter 1 (see figs. 25–27), this reduction of medieval identities to sectarian religiosity and incommensurate practices may say more about the limits of the modern imagination than about medieval Ladakhi self-fashioning. King Kalasha (r. 1063–89), the Hindu ruler of the neighboring polity of Kashmir, from where those who painted the Alchi frescoes seem to have hailed, had no qualms about employing an artisan from the lands of the Turks (*Turuṣkadeśa*) to gild the parasol (*chatr*) covering the central icon of a Shiva temple that he had erected in the Kashmir Valley.[48]

The employment of this Turk (an itinerant Muslim craftsman?) coincides with a moment when the

CULTURAL CROSS-DRESSING

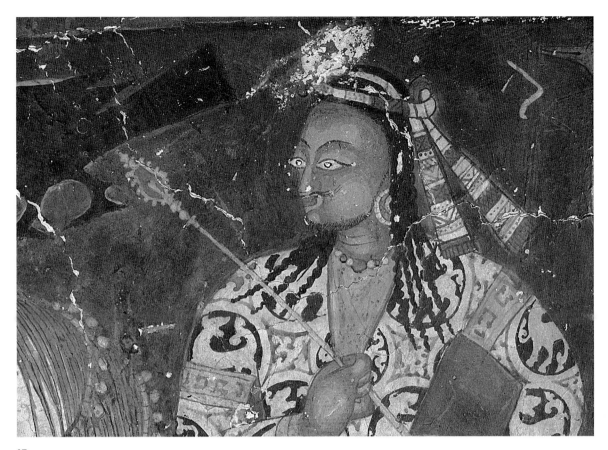

37
A royal rider, Dukhang Temple, detail (courtesy of Jaroslav Poncar).

cultural impact of the Ghaznavid sultanate of Afghanistan was strongly felt in Kashmir.[49] In the decades following the construction of the Shiva baldachin by this itinerant Turk, King Harsha (r. 1089–1111) introduced changes in fashion and personal adornment, including a type of attire that was "fit for a king." We have few details of this attire, but in view of Harsha's other *Turuṣka* leanings (including a fondness for Turkic concubines and soldiery), Aurel Stein noted the likelihood that this was a style of dress associated with the Muslim sultanates to the west.[50] During the eleventh and twelfth centuries, the Turkic amirs and sultans who dominated the eastern Islamic world provided the models for court cultures from Armenia to Afghanistan. The circulation of modes of Turko-Persian dress in northwestern India during this period is indicated by the expanding lexicon of dress and the incorporation of nonindigenous terms (including

qabā') into northern Indian vernaculars.[51] The robes depicted in the Alchi are distinguished from those worn by Tibetan and Ghaznavid elites (see fig. 34) by their lack of a prominent lapel.[52] Given the Kashmiri origins of the artists who worked on them, this detail of the Dukhang paintings may provide graphic evidence for the fashions current in and mediated by the contemporary court culture of Kashmir.[53]

Confirmation that the Islamic world provided the ultimate models for the self-fashioning of Ladakhi elites is provided by the presence of pseudo-Arabic inscriptions using angular Kufic script rotated through ninety degrees on the armbands of the robes worn by royal figures depicted elsewhere in the Dukhang (figs. 36–39). Similar pseudo-Arabic inscriptions are found on numerous portable objects produced in the neighboring sultanates of Afghanistan. The specific form of the Alchi "texts"—repetitions of a single tripartite unit

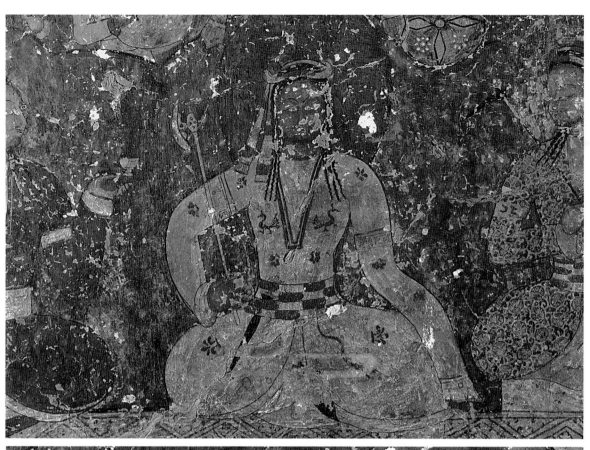

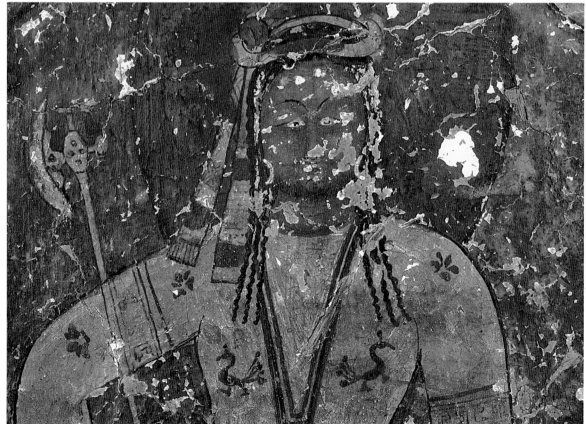

consisting of two uprights joined by a horizontal line—recurs as a border on twelfth-century Ghurid tiles found in Ghazni (fig. 40) and in the brick ornament of a Ghurid tomb near Multan in the Indus Valley, both of which date from the last decades of the twelfth century and are therefore roughly contemporary with the frescoes.[54] In fact, by the twelfth century this is perhaps the most common form of pseudoinscription found in the medieval Islamic world from the Mediterranean to Central Asia, a popularity that may reflect its derivation from the central characters of the Arabic word *Allāh*, even if it had been so abstracted by this date that its origins were no longer apparent.[55]

The affinities of the Alchi fresco (fig. 33) with the royal iconography of the eastern Islamic world have led to suggestions that the Alchi image represents an "Indo-Aryan" or "Turko-Iranian" ruler who married into a local Himalayan royal family.[56] The argument is circular, depending on the identification of the royal figure's dress as Turkic, the underlying assumption being that the primary association of dress in twelfth-century Ladakh was ethnic. During this period, however, depictions of figures of authority wearing types of "Turkic" dress (including the *qabā*) are found on a range of portable luxury objects that circulated in the Islamic world, sometimes depicting individuals who were not ethnic Turks. In her study of this phenomenon, Priscilla Soucek concluded that the dispersal of these modes of dress reflects "a kind of implicit, if not explicit, linking of military power with the costumes and attributes of various Turkish speaking groups." Soucek went on to conclude that "such images would have primarily conveyed a sense of power and only secondarily of Turkish ethnicity."[57] Like the *qabā* that they adorn, the popularity of the inscribed pseudo-Arabic bands on the robes worn by the Alchi rulers may once have been the product of Turkic ascendancy, but by the twelfth century their appearance as far west as Norman Sicily and as far east as Alchi indicates that their significance transcended ethnicity.

38 *(facing page top)*
An enthronement, Dukhang Temple, Alchi, Ladakh (courtesy of Jaroslav Poncar).

39 *(facing page bottom)*
An enthronement, Dukhang Temple, detail (courtesy of Jaroslav Poncar).

Rather than reflecting their hypothetical Turkic ethnicity, the dress of the Alchi rulers is more likely to indicate the adoption of modes of dress associated with the articulation of authority in the powerful adjacent sultanates of Afghanistan. In his study of the Alchi frescoes, Pratapaditya Pal noted that the ruler's dress "was part of a common regal attire in a wide region (from the Panjab in India to the court of Ghazni and beyond in the north and in Ladakh)," concluding that "the model court at the time (mid-eleventh century) was perhaps Ghazni."[58] Subsequent work on the Dukhang frescoes has suggested a slightly later date for them, and the royal portraits may equally reflect contemporary court culture in the Ghurid sultanate, the Ghaznavid successor state.[59] Ghaznavid and Ghurid sultans bestowed gifts of clothing—including the *qabā*—on both their own followers and

40
A twelfth-century tile from Ghazni with a pseudoepigraphic border (after Scerrato 1962) compared with the pseudo-Arabic inscription in Kufic script on the armbands of the royal figure depicted in figs. 36 and 37.

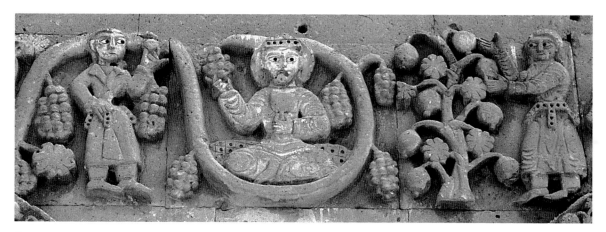

41
A royal scene, Church of the Holy Cross, Aghtamar, 921 (courtesy of Lynn Jones).

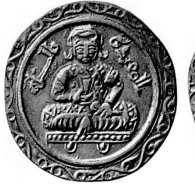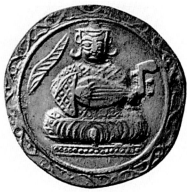

42
Medallion of Caliph al-Muqtadir (now destroyed, image courtesy of the Museum für Islamische Kunst, Berlin).

northern Indian rulers, indicating one possible mechanism for the circulation of this attire in the western Himalayas.

If my reading of the Alchi image is correct, it provides further evidence for a phenomenon witnessed earlier in Mansura and later at Vijayanagara. In all three cases, the adoption of Indic, Persianate, or Turkic dress was not part of a general sartorial trend but exclusive to elite self-fashioning: in Alchi, only the ruler and his deputy or son wear the *qaba'*, and only the robes of the ruler figures bear *ṭirāz* bands. In contrast to the type of *qaba'* favored by the later rulers of Vijayanagara, which had its origins in the Arab world, that worn at Alchi is a "Turkic *qabā*," reflecting the cultural orientations of northwestern India around 1200. Whether the use of Islamicate rhetoric at Alchi extended beyond the realm of royal portraiture and into the domain of royal ceremonial (as at Vijayanagara) is uncertain, but this seems likely.

Despite differences in the specific terms that they employ, the phenomena witnessed in Alchi and Man-

sura exemplify "cultural cross-dressing." The term derives from the intersection of gender studies and postcolonial studies, where it was developed in analyses of eighteenth-century portraits of Europeans dressed *à l'orientale*. Denoting transcultural modes of self-fashioning (and self-representation), the term emphasizes both the constructed nature of identity and its performative aspect as something that is fashioned dynamically and not an inherent characteristic of the biological body.[60] Occurring at the intersection between two or more sign systems, cultural cross-dressing is the negotiated product of circulation, both of representations and their signifying potential, "firmly embedded in relations of production and trade, of circulation of imagery."[61] To be effective, cultural cross-dressing needs to distinguish the subject from his immediate cultural peers while associating him with an alternative cultural identity; as a consequence, it is often characterized by a simultaneous assertion and disavowal of alterity.[62] Both aspects of the phenomenon are relevant to the self-fashioning of Sindi and Lad-

CULTURAL CROSS-DRESSING

kahi elites, and to the later rulers of Vijayanagara, who adopted the *qabāʾ* as their public dress in contrast to the bulk of the populace, who continued to wear the traditional *dhoti*.[63]

In fact, cultural cross-dressing was common among medieval elites in polities that existed on the margins of, or in the interstices between, larger, more powerful neighbors. A comparable phenomenon existed on the western fringes of the central Islamic lands, where between the tenth and eleventh centuries the Christian kings of Armenia modeled some of their self-representations on those of the caliph in Baghdad. The Armenian rulers were subject to the caliph, from whom they received robes of honor and investiture, and were sometimes depicted wearing the *qabāʾ* in similar fashion to the rulers depicted in the Himalayan frescoes. The debt to caliphal prototypes is evident in the representation of Gagik Artsruni on the façade

of his palatine church at Aghtamar in eastern Anatolia, completed in 921 (fig. 41). The depiction of the Armenian king echoes that of the ʿAbbasid caliph al-Muqtadir (295–320/908–32) on a well-known commemorative medallion (fig. 42), a further reminder that images of royal authority circulated widely in a variety of portable media.[64] It is not clear, however, if Gagik wears the *qabāʾ* here, as do the Armenian princes depicted elsewhere on the façade of the church.

Slightly later, a fragmentary portrait page from a gospel manuscript commissioned by Gagik-Abbas, the Armenian ruler of the border state of Kars around 1050, provides a striking counterpart for the Alchi image of a century or so later.[65] In it we see Gagik-Abbas enthroned along with his wife and daughter, who occupies the place of honor (fig. 43). The ruler is cross-legged and wears a Turkic *qabāʾ* made from a textile with prominent roundels containing elephants

43
Frontispiece from a manuscript commissioned by Gagik-Abbas, Kars, ca. 1050 (courtesy of the Armenian Patriarchate, Jerusalem, No. 2556, fol. 35v).

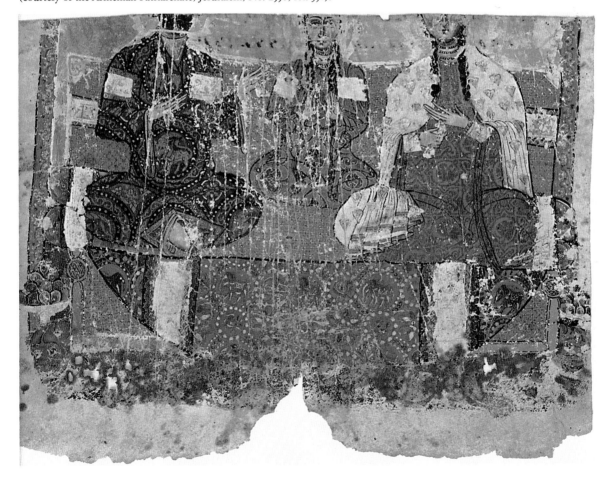

and bearing the *ṭirāz* bands also found at Alchi. Whether or not the garment worn by Gagik-Abbas was a caliphal gift, its appearance reflects the continuing impact of ʿAbbasid modes of self-representation on Armenian courts into the eleventh century, when use of the *qabāʾ* had become widespread in the central Islamic lands.

The cultural cross-dressing that we see in Alchi or Armenia employs a mode of dress that may once have had very particular ethnic associations but came to be representative of political authority by virtue of a relationship to those who exercised it. This relational aspect of elite self-fashioning is well captured by Helen Evans' observations on Armenian royal portraits, which are equally relevant to the self-representations discussed here: "Royal portraits are indicative of how those who rule perceive themselves in relationship to their own people and those powers which surround them. The format selected for the royal images, the pose and dress are all significant indicators of the internal and external forces which the royal figures recognize as validating their power."[66]

Like the appearance of Byzantine royal robes in other representations of medieval Armenian rulers, or indeed the use of ʿAbbasid slogans by the amirs of Mansura, the adoption of contemporary Islamicate modes of dress in Alchi should be understood as a "device to enhance prestige," and not necessarily as an attempted usurpation of Byzantine or ʿAbbasid power.[67]

In his magnum opus on early modern patterns of consumption, Fernand Braudel suggested that the circulation of particular modes of dress in Europe and the Islamic world often reflected estimation based on admiration rather than the brute exercise of military or political hegemony.[68] An interesting example of the way in which admiration could subvert sartorial norms in another contemporary contact zone is provided by the historian Ibn al-Athir (d. 630/1233), who reports that Henry, Count of Champagne (d. 594/1197), ruler of the Latin Kingdom of Jerusalem, wrote to Salah al-Din Ayyub, counter-crusader and chivalric paradigm, requesting a *qabāʾ* and a *sharbūsh* (a type of hat). In making his request, Henry is reported to have written: "You know that to put on the *qabāʾ* and the *sharbūsh* is not approved of among us, but I would put them on if they came from you, because of the regard I have for you."[69]

The adoption of the *qabāʾ* by minor Christian and Buddhist rulers on the peripheries of the Islamic world offers a good example of what the sociologist Marcel Mauss has dubbed "prestigious imitation," a process that typically occurs in relation to figures who have authority over the imitator, or who inspire his admiration.[70] Although Mauss developed the idea in relation to techniques of the biological body, it is no less relevant to the socially constructed body. Whether in Arab Mansura, Buddhist Alchi, Christian Armenia, or Crusader Jerusalem, prestigious imitation was less a question of ethnicity or religion than a reflection of localized endeavors to enhance status and authority by adopting more "universal" norms of self-representation. They say much about the porosity of elite cultures and little about distinctions in religious belief or practice.[71]

The point is driven home by the existence of two distinct ceremonies of investiture in medieval Armenia: one corresponding to a conferral of religious authority that followed indigenous Christian models, another an investiture of earthly dominion very much in the Islamic mode.[72] Similarly, representations of the Norman rulers of Sicily in Byzantine or Islamic garb are contextually specific, with the latter relegated to the sphere of secular art and the pleasures of the palace.[73] Although the evidence is too meager to demonstrate similar distinctions in the rituals and self-representations of Ladakhi or Sindi elites, the pattern is repeated later in Vijayanagara, where the use of Islamicate modes of royal rhetoric is restricted to the performative sphere of public rhetoric.

The adoption of Indic modes of self-fashioning by the amirs of Mansura demonstrates, however, that prestigious imitation and its sartorial correlates cannot be attributed to the attractions or resonances of Islamic courtly culture alone. Instead, it is best seen as a more generalized phenomenon of contact zones. The visual languages and the terms employed by cultural cross-dressers were contingent, varying in time and place, but like the code switching studied by modern linguists, their adoption and deployment reflects a belief in their ability to facilitate access to symbolic and material resources.[74] For this reason, the cultural cross-dressing of premodern Indic elites has been compared to attempts by various "little communities" to bolster their standing through participation

in the Sanskrit ecumene that dominated literary production and royal self-representations during the first millennium.[75] As Pollock notes, "What transpired seems to have happened according to some cultural process of imitation and borrowing less familiar to us as causative than conquest or conversion, some impulse towards transculturation that made it sensible, even desirable, to adopt the new Sanskrit cultural-political style as an act of pure free will."[76]

The adoption of common modes of self-representation reflects not only their ability to render adoptees legible according to hegemonic or valorized cultural codes, but also the conferral of status that this implies. It is worth noting here that fifteenth- and sixteenth-century Arab and Persian visitors to the courts of southern India distinguished between the importance of the local rulers that they encountered based on their appearance, affording higher status to those who had adopted Islamicate modes of dress. [77]

A notable aspect of cultural cross-dressing that is not perhaps as pronounced in processes of Sanskritisation is its dependence on a complex interplay between sameness and difference that resonates both inter- and intraculturally, distinguishing elites from their subjects and some contemporary peers while forging an association (however notional) with others. Occurring at what Stephen Greenblatt, writing of self-fashioning in early modern Europe, calls "the point of encounter between an authority and an alien," the resulting self-representation necessarily partakes of the nature of both, and gives rise to a synthetic identity that "always contains within itself the signs of its own subversion or loss."[78] A similar idea permeates discussions of mimicry in the work of postcolonial theorists such as Homi Bhabha, who notes that "mimicry is like camouflage, not a harmonization of repression of difference, but a form of resemblance, that differs from or defends presence by displaying it in part, metonymically"; consequently, "in order to be effective, mimicry must constantly produce its slippage, its excess, its difference."[79] Prestigious imitation differs from the phenomenon of colonial mimicry in that it tends to reflect cultural rather than political hegemony, but it shares with it the quality of wanting to improve one's lot.

Uniting all the instances of cultural cross-dressing discussed so far is the desire of medieval elites for auto-interpellation within the dominant modes of projecting authority. When it came to the use of dress as an incorporative mechanism, however, elite agency could also manifest itself in the gifting of apparel, or in the acceptance and rejection of such a gift. The gifting of robes of honor (Arabic pl. *khila'*) was central to the visual articulation of power in the medieval Islamic world. The robe was given to one who was inferior not by virtue of his ethnicity or religious affiliations but by virtue of his standing within a hierarchical political structure, into which he was subsumed by acceptance of the gift; hence, investiture constituted a metalanguage of power that could be used to interpellate those "outside" the system. However, although the transcultural nature of the phenomenon is often stressed,[80] so far there has been little attempt to explore the implications (cultural, political, practical, theoretical) of extending gifts of clothing across cultural, linguistic, or religious boundaries.

In contrast to the examples of cultural cross-dressing discussed so far, which reflect the voluntary adoption of modes of dress associated with powerful authority figures by Buddhist and Muslim elites, the encounter to be considered below concerns the gifting of a *qabā'*, a robe of similar type to that worn at Alchi, by a Ghaznavid sultan to the Hindu ruler of a major northern Indian polity. Although the *qabā'*, the coat-like garment worn by the Buddhist ruler of Alchi (see fig. 33), was specifically forbidden to *dhimmīs*,[81] this type of robe was gifted to Rajput chiefs by Ghaznavid sultans attempting to incorporate them into the Ghaznavid body politic as vassals. Political expediency thus often mitigated religious proscriptions on dress or rendered them entirely redundant. In this case, the adoption of the *qabā'* at Alchi found a corollary in attempts to refuse or resist the robe and the incorporation that it implied. The resulting exchange provides important insights into the role of translation in mediating encounters between medieval elites and the ritual practices associated with them.

| *Fractal Kingship and Royal Castoffs*

The common use of transactional symbols by Indic and Islamic kings was remarked on some twenty years ago by the historian Peter Hardy, who noted the exis-

tence of "homophones" and "homonyms" in what he termed the "very different" languages of Hindu and Muslim kingship.[82] These included certain symbols of royal authority such as the crown (*tāj*), kettledrum (*kūs* or *bhērī*), and parasol (*chatr*).[83] The distribution of such honors established assymmetrical relations of dependence often characterized by a disjunction between authority and power.[84] Developing his linguistic analogy, Hardy concluded, however, that the existence of such homonyms did little to facilitate mutual understanding and cross-cultural communication, since there is little in the sources to suggest that the protagonists possessed the "necessary linguistic knowledge to become aware of that language of ideas."[85] By contrast, I would like to draw attention to a curious tale concerning royal gifting ceremonies that highlights the role of translation in mediating between these apparently incommensurate languages.

Despite the homonyms and homophones noted by Hardy, there were undoubted terminological and syntactic differences in the languages of kingship in both domains. While some of the artifacts that instantiated authority (such as banners, drums, and parasols) were common, others (among them chowries, copperplate texts, and stitched garments) were not. Moreover coins, one of the triumvirate of *khil'a*, *khuṭba*, and *sikka* (robe, sermon, and coinage) central to the articulation of authority in the Islamic world, did not fulfill the same function in northern India.[86] Even similar honors might carry different meanings: the titles distributed from Baghdad aggrandized the ruler by emphasizing his role as defender of the *Sunna* or his personal relationship to the caliphate, but they did not constitute a sharing of the caliph's selfhood or substance in the same way that the bestowal of a maharaja's *biruda* (epithet) did.[87] Incorporation through the use of objects that stood in metonymic relationship to the donor and permitted a subordinate sharing in his sovereign substance was not unknown in the Islamic world, but was achieved through the gifting of transvalued objects rather than the sharing of substantive words and sounds.[88] The robe of honor is the obvious case in point: more than a symbol of authority, it functioned as an incarnated sign of sovereign authority.

Just as in premodern Europe the emperor was an idea, not a person, so in the medieval Islamic world the individual was constituted as the instantiation of the idea by means of investiture, so that the office was often conflated with the robe that conferred and constituted it.[89] Accompanied by other items of clothing, such as belts, hats, richly caparisoned mounts, and even cash, robes were gifted from the caliph in Baghdad to bind regional (and potentially rebellious) rulers to his authority, and gifted by regional rulers to their own subordinates in a devolution of "*khil'a* culture" that consolidated the internal political structures of the *dār al-Islām*. The display that such ritualized gifts occasioned is described by al-Qalqashandi (d. 821/1418):

> If the person whom the Caliph appointed was a prince of regions far from the court, the robe of honor [termed *tashrīf*, or "mark of honor"] was carried to him by a messenger of the caliph. It consisted of a robe [*jubba*] of black satin with an embroidered border, a collar, two bracelets of gold . . ., a sword and a horse with a golden saddle, as well as a black flag with the name of the Caliph written in white. . . . When the robe was granted to the prince of the region, he put on the robe and the turban ('*imāma*), grasped the sword, mounted the horse, and paraded to the palace at the head of his retinue.[90]

A scene of this type is captured in the early fourteenth-century *Compendium of Chronicles*, where a description of Mahmud of Ghazni receiving a robe of honor from the envoy of the 'Abbasid caliph in 389/999 is imaginatively re-created (fig. 44).

In his seminal work on the gift, the sociologist Marcel Mauss famously argued that in contrast to the distinction between persons and things, which is a necessary function of commodity exchange, some of the objects that circulate in gift economies should be understood as "parts of the donor."[91] The implications of Mauss' observation for South Asian gift economies have been noted by Jonathan Parry: "It is because the thing contains the person that the donor retains a lien on what he has given away and we cannot therefore speak of an alienation of property; and it is because of this participation of the person in the object that the gift creates an enduring bond between persons."[92] This is particularly true of textiles (and even their threads), which in circulation can extend the presence of those with whom they are associated.[93] The *khil'a* is exem-

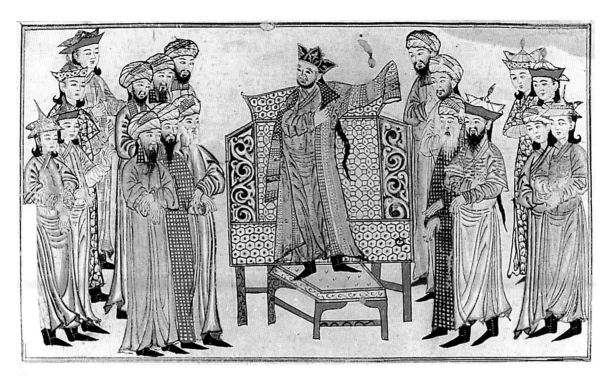

44
Mahmud ibn Sebuktegin donning a robe of honor from Caliph al-Qadir Bi'llah in 389/999, *Jāmiʿ al-Tawārīkh*, Iran, ca. 1315 (courtesy of Edinburgh University Library, Or. Ms. 20, fol. 121r).

plary, a crafted textile whose value is reducible neither to the intrinsic worth of its constituent materials nor to the artisanal skill that it displays, but to the fact that it is transvalued as a result of a relationship with the body of the donor. The idea is inherent in the etymology of *khilʿa*, which derives from the Arabic *khalaʿa*, "to divest oneself of one's robe," originally as a sign of honor and a pledge of security (*amān*).[94]

The gifting of a *khilʿa* was predicated on the (sometimes fictive) notion that the robe was gifted from the wardrobe of the donor.[95] Transvalued by contact (ranging from full body contact to a passing glance), the gifted robe carried with it something of the donor's essence and was valued for its synesthetic properties, including (on occasion) its olfactory qualities, which further charged the robe with the presence of its donor.[96] The public destruction of the Fatimid counter-caliph's robe in Baghdad in 414/1023 offers a particularly striking example of the ability of personal clothing to "represent" its former owner (ei-

ther positively or negatively), an example that is by no means unique.[97]

By virtue of the robe's role as an index, a sign with a causal relationship to its referent, by donning it the vassal not only came to act on the king's authority but also functioned as a notional extension of his body, part of what a modern anthropologist would call his "distributed personhood."[98] The relationship between donor and robe was both indexical and metonymic; deriving from a sovereign individual, the *khilʿa* represented legitimate authority itself. Thus the gifting of the robe not only betokened personal largesse but also constituted a ritual incorporation into the body politic effected through a mediated encounter with the royal body. Just as select individuals might be invited to partake in the royal presence in a particularly intimate way through the sharing of food taken from the ruler's plate (a practice documented for medieval Indic and Islamic courts), so the gift of a "castoff" was considered to transfer something of the

donor to the recipient, permitting him to share in the donor's authority.[99]

The cultural value attached to royal robes meant that they shared the inalienable quality of royal insignia, symbolic repositories of genealogies and histories that stand outside the operation of quotidian exchange mechanisms and generally circulate only as gifts or loot.[100] The *burda*, or cloak of Prophet Muhammad, is paradigmatic, although gifted in the first place to a poet rather than a politician. After the Prophet's death, the robe was hotly contested between rival claimants to the caliphate.[101] Possession of the cloak (along with other relics of the Prophet such as his ring and staff) conferred a degree of legitimacy on its possessor by virtue of an indexical relation to earlier owners and ultimately to the Prophet himself. The tradition was revived recently by Mullah Omar, the leader of the Taliban, the only known photograph of whom shows him at a pivotal moment in his rise to power standing on a Kandahar rooftop donning what was believed to be the Prophet's robe.[102] In this way the robe functioned as a kind of visual manifestation of an *isnād*, a chain whereby the authority (usually of a text or a tradition) is secured by a cumulation of indexical links to previous authoritative figures, a point underlined by the "regifting" of castoffs received from caliph or sultan.[103]

As this suggests, the articulation and devolution of authority in both Islamic and Indic theories of kingship were marked by a common fractal dimension, with the insignia of an amir or sultan, raja, or *sāmanta* replicating those of an overlord, albeit often on a smaller or less lavish scale. This enchainment of power through practices of redistribution, reiteration, and reproduction articulated an authority that was derivative and relational, operating both horizontally and vertically.[104] The receipt of insignia from the center was often celebrated by reclothing ceremonies of subinfeudation through the distribution of analogous honors to the vassals of the recipient: in 389/999, for example, when Mahmud of Ghazni received a robe of honor and honorific titles from the 'Abbasid caliph al-Qadir Billah, he donned the robe publicly, with the nobles of the realm ranked in rows before him swearing an oath of loyalty and receiving robes and other gifts in their turn (see fig. 44).[105] The links in the chain of political authority thus created

were marked by self-similarity or fractality: the constituent parts reproduced the whole comprised by their aggregation.[106]

These homologies in the articulation of authority within Indic and Islamicate cultures were among the factors that permitted the transcultural extensions of incorporative devices by the Ghaznavid sultans. Medieval historians and their modern successors portray the Ghaznavids in general and sultan Mahmud ibn Sebuktegin in particular as staunch upholders of Sunni orthodoxy, and consequent scourges of Hindu idolatry. Despite the normative rhetoric, however, even contemporary historical texts suggest that the Ghaznavid relationship with India was considerably more complex than it at first appears.[107] To present this as a "clash of civilisations" is, for example, to ignore the multiethnic constituency of Ghaznavid armies and the presence within them (as in Saffarid armies of the ninth and tenth centuries) of an Indian contingent, the *sālār-i Hindūyān*.[108]

The Indian contingents also included Hindu generals, some of whose names we know. These participated in the annual Indian raids of the Ghaznavids, enjoyed an exalted rank at the Ghaznavid court, and were granted honors associated with royal favor in the Islamic world. The best documented, Tilak, seems to have been a free man rather than a slave, who made his way to Ghazni from Kashmir, seeking patronage at the court of sultan Mas'ud I (r. 422–432/1031–41). Tilak, who is said to have written excellent Hindavi and Persian, began his career at the court as a translator (*mutarjim*) with the Indians before rising to become the commander of the Indian contingent (*sipahsālār-i Hindūyān*). He reached high office and was conferred with honors including a *khil'a*, banners, a parasol, and drums.[109] Tilak not only led Ghaznavid campaigns against his co-religionists (thus confounding any simple equation between ethnic or religious identity and Ghaznavid expansion) but in 424/1033 undertook punitive expeditions against rebellious Muslim Turks on behalf of the Ghaznavid sultan.[110]

Some of the Indian generals had families in Ghazni, which had an Indian quarter. These Indian communities were apparently free to follow their own cultural practices, for a chance reference in a contemporary Syrian text mentions the practice of *satī* or self-immolation in Ghazni, informing us that the wives of

Indian soldiers there would commit themselves to the flames when their husbands were lost in battle.[111] The presence of Hindu temples serving this Indian community can probably be assumed, even if the sources do not herald their existence. Writing of the relationship between Byzantine Christians and Muslim Turks in medieval Anatolia, Kafadar notes "the possibility of cooperative ventures by people of different identities . . . even if those identities may be seen to be engaged in a conflict in a larger setting," while reminding us "we should not . . . assume that because the gazis were able to embrace the infidels, they would proudly have all such embraces announced and recorded."[112] Studies of other medieval frontier societies have demonstrated that silence often served to obscure the realpolitik that operated in the gap between idealism and opportunism.[113]

In addition to their Indian soldiery, the Ghaznavid sultans also reached accommodation with northern Indian rulers when it suited their broader political ends. The almost annual raids into the Indic polities to the east benefited the royal coffers and accrued symbolic capital for the sultan, but they also led to enhanced opportunities for cultural, diplomatic, and economic exchange between eastern Iran and northern India. These new patterns of contact included the establishment of tributary relationships with Rajput chiefs. The Arabic and Persian sources refer to these rulers requesting to enter into a state of treaty (*amān* or *ṣulḥ*) with the Ghaznavid sultan, and offering to pay *jizya* (poll tax) or *kharāj* (land tax).[114] Although it is highly unlikely that Indian rulers actually used this legalistic terminology, its use in the chronicles suggests that Hindu rulers were perceived as de facto *dhimmī*s, pointing to an accommodation of these relationships within conceptual categories that blurred the distinction between the *dār al-Islām* (the house of Islam) and the *dār al-ḥarb* (the house of war). Indeed, certain traditions of Islamic jurisprudence governing the conduct of war (including those of the Shafiʿi school that was predominant in India) allow for the creation of an intermediate space between these poles. The land of the covenant or treaty (*dār al-ʿahd* or *dār al-ṣulḥ*) is the temporary product of a treaty concluded between a Muslim ruler and an undefeated sovereign foe in situations that are advantageous to the Muslim opponent. In return for submitting to his Muslim opponent and

paying tribute, the non-Muslim vassal retains the territorial integrity of his kingdom; the jurists often gloss this tribute (variously designated as *jizya* or *kharāj*) as a type of booty.[115]

Such treaties were often concluded in situations of military superiority and numerical inferiority, as was the case in India, where the stipulated signs of submission included bullion, specie, rare objects, and elephants. As booty, elephants bespoke the military might and wealth of Indian kings, and enhanced the prowess and prestige of those who defeated them. Indian elephants were often "regifted" westward as part of ritualized gift exchanges between Arab, Persian, and Turkic governors, generals, and sultans exercising authority on the eastern margins of the Islamic world and the ʿAbbasid caliphate in Baghdad, the nominal source of their authority.[116] Baghdad might not even be the end of the line. Gifted onward, Indian elephants served to advertise the global reach of ʿAbbasid imperium and its military might; the most remarkable case is that of Abu'l-ʿAbbas, the elephant gifted by the ʿAbbasid caliph Harun al-Rashid to the court of Charlemagne at Aachen (now in western Germany) in 802.[117]

Among the many examples of the routes through which elephants were obtained is the embassy sent in 400/1009 by the Hindu Shahi ruler Anandapala to Mahmud of Ghazni, who accepted peace on payment of an annual bullion tribute, fifty of the best elephants, two thousand horses, and the right to Ghaznavid armies of free passage through Anandapala's territories.[118] In the same year, the Raja of Narayanpur in Rajasthan agreed to pay an annual tribute, along with a gift of fifty elephants and two thousand soldiers to fight for Ghaznavid arms, establishing a peace that is said to have facilitated trade between Khurasan and northern India.[119] The arrival of Indian emissaries bringing Mahmud elephants as tribute (probably from the raja of Narayanpur) is depicted in a folio from a copy of the *Majmuʿ al-tawārīkh* (Assembly of Histories) painted in Herat around 826/1423 (fig. 45). Just as medieval Hindu rulers might confer honors and insignia on non-Hindu subjects, these "gifts" were reciprocated by the bestowal of robes of honor (*khilaʿ*) by the Ghaznavid sultans, reflecting their value as a mechanism for negotiating sociopolitical relationships both intra- and interculturally.[120]

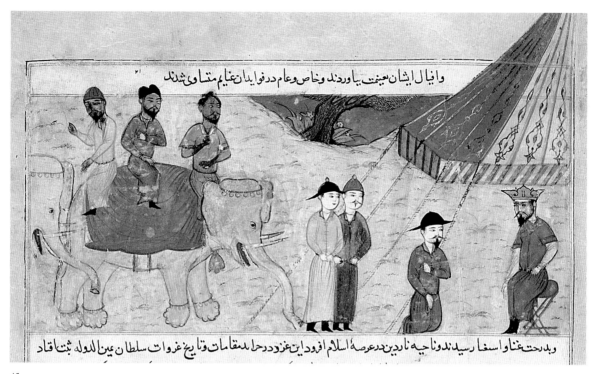

وايال ايشان معيفت يياورذنذ وخاص وعام درفوايذان عنايم متساوى شذذ

ويدحت غناو اسفنا رسيدندونا حيه ناردين درعرصهٔ اسلام افرودايت عزوذرحا ندمقامات وقتايخ غروات سلطان عين الذوله ثبتا قاد

45

Mahmud of Ghazni receiving Indian elephants as tribute, detail of a folio from the
Majmuʿ al-tawārīkh of Hafiz-i Abru, Herat, ca. 829/1425 (courtesy of the Worcester
Art Museum, Jerome Wheelock fund, Accession No. 1935.20).

Perhaps the best documented of these exchanges took place between sultan Mahmud of Ghazni and the Raja of Kalinjar, a fortified stronghold of the powerful Chandella dynasty whose territories extended over what today is the state of Uttar Pradesh in northeastern India (fig. 46). The events in question took place in 413/1023 according to Gardizi and al-ʿUtbi (our earliest sources for these events), a year later according to others, and was the final and most definitive in a series of encounters between the two rulers.[121] The raja is known variously to the Arabic and Persian sources as Nanda, Ganda, or Bida. These variants could result from scribal error, but Bida may also be a corruption of the Sanskrit Vidya, so that the raja in question is probably the Chandella ruler Vidyadhara, son of Ganda, both of whom are named in two eleventh-century inscriptions.[122] In these inscriptions, Vidyadhara is said to have brought about the demise of the raja of Kanauj, an event that precipitated Mahmud's

punitive raid on Kalinjar in 413/1023 according to the Arab historians.

Located at the eastern end of the Vindhya mountain range at an elevation of 1,200 feet, the fort of Kalinjar was renowned for its impregnability. Al-Biruni describes Kalinjar and the nearby fortified stronghold of Gwalior (in the possession of the Kachwaha feudatory of the Chandellas) as two of the most celebrated forts in India, while later authors compare the strength of Kalinjar fort to that of the famous Wall of Alexander, built to separate the realms of Gog and Magog.[123] Kalinjar fort protected the north of the Chandella domains and its religious center at Khajuraho, of which Ibn al-Athir makes Bida (reportedly the greatest of all Indian kings) the master. The importance attached to Kalinjar is suggested by Chandella use of the title Lord of Kalinjar (*kālañjarādhipathi*), claiming its celebrated strength as the dynasty's own.[124]

CULTURAL CROSS-DRESSING

According to Gardizi, the raja of Kalinjar was besieged by the army of Mahmud and offered to make peace by paying the *jizya* and three hundred elephants. He also sent the gift of a poem in Hindavi (*Lughat-i Hindavī*), the precursor of Hindi, celebrating the prowess of the Ghaznavid sultan, which sufficiently impressed Mahmud that he sent the raja gifts, including robes of honor (*khil'athā*) and jewels, and issued a *farmān* bestowing on him the government of fifteen forts.[125] The gifting of eulogistic Arabic and Persian poems between medieval Persianate elites is well documented, but this gift of a poem written in an Indic vernacular raises interesting questions about intercultural literary reception.

In legal terms, the treaty concluded between the Ghaznavid sultan and the raja of Kalinjar reconstituted the polity as an interstitial space, the *dār al-'ahd*. Notionally at least, the Chandella polity of Kalinjar was no longer sovereign, but neither was it incorporated territorially into the *dār al-Islām*. Instead, Kalinjar was repositioned at the interstices of the Ghaznavid sultanate of eastern Iran and the sovereign polities of northern India. Since the jurists envisage that the lands of the *dār al-'ahd* will ultimately be incorporated into the *dār al-Islām*, politically at least the Kalinjar kingdom entered a state of liminality. The full cultural implications of such a scenario remain to be explored, but it inevitably brings to mind the "third

46
Map showing the approximate extent and location
of the Ghaznavid and Chandella polities.

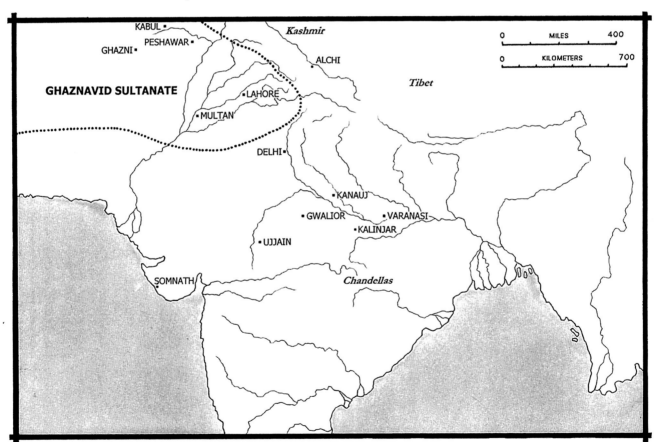

space" of postcolonial theorists. In Homi Bhabha's classic formulation, the third space is the place where cultural frontiers are expanded and "the superposition of cultural layers negotiates the appearance of a new hybrid subject."[126]

Central to the process of reconstituting the raja of Kalinjar as "a new hybrid subject" was an act of translation that was at once metaphysical, metonymical, and material. This aspect of the exchange is detailed in the more extensive treatments of the same encounter found in early thirteenth-century Arabic historical texts, among them the chronicles of Ibn al-Athir, Ibn Zafir, and Sibt ibn al-Jawzi, and in the Syriac *Chronography* of Bar Hebraeus (d. 1286). All these agree on the essential details, suggesting that they are based on a common earlier source. In all of them, Mahmud invites the raja of Kalinjar to convert to Islam or to pay gold and elephants as tribute. In the most narrative account, that of Bar Hebraeus, the response of the raja to the sultan's ambassador reads as follows:

> And having sent with the envoy one of the learned men of the Arabs, who went into the Citadel and spoke with them by means of an interpreter, they replied, "We shall not change our Faith, and the gold which you demand we do not possess, but we have silver in abundance." And they agreed to give them three hundred elephants, and a vast quantity of silver, and costly apparel, and perfumes. And Mahmud replied, "I agree, but though the king will undertake to wear our apparel, and to gird a sword and belt about his loins, he must cut off the top of his finger in confirmation of the oath according to the custom of the Indians."
>
> The Arab ambassador said, "When I went into the presence of the Indian king, I found a splendid youth of great beauty, glorious in blackness, on a silver throne, wearing a cloak and trousers of cloth, with a turban on his head. When I saw him I clapped my hands together violently and bowed over them according to their custom. I spoke of the dress he was to wear and entreated him much (to wear it). He said: 'I beg you to excuse me from wearing it and tell your lord that I have put it on.' And when I re-

plied that it was impossible for me to deceive my Lord, with great reluctance he put it on. And he girded on the belt and hung the sword by his side."[127]

As we have seen, within the Islamic world, the robe of honor was a standard transactional symbol, used to articulate and consolidate the hierarchical relationship between a ruler and his subjects or vassals. The bestowal of a robe was an offer that could not be refused, however, since to do so implied the rejection of overlordship and constituted a de facto act of rebellion.[128] The refusal to don a *khil'a*, or even the public desecration of such a gift (the alienation of the inalienable) was used on more than one occasion by those wishing to demonstrate their rejection of the donor's authority.[129]

Charged with the cumulative authority of their primary and secondary donors, robes partook of a political economy of redistribution in which they instantiated a chain of authority that bound the recipient to the donor. For this very reason, envoys from realms not wishing to enter the Mongol "family of nations" necessarily avoided accepting gifts of clothing from the Mongol khan.[130] In this sense, the *khil'a* was a type of "symbolic violence," to borrow Pierre Bourdieu's term. In Bordieu's formulation, this is a characteristic of exchanges that convert "brute power relations, which are always uncertain and liable to be suspended, into durable relations of symbolic power through which a person is bound and feels bound."[131] The literal and metaphoric aspects of this binding coincide in the institution of robing. The text accompanying the previously mentioned fourteenth-century image of Mahmud of Ghazni donning a caliphal *khil'a* (see fig. 44) explains that during the robing ceremony the Ghaznavid elite stood in line and fastened the belt of allegiance to caliph and sultan, the belt and belting long being associated with ceremonies of submission and subordination.[132]

As Bourdieu notes, the act of binding implicit in the gift presupposes both a willingness and ability on the part of both participants and, by extension, some sort of shared cognitive framework permitting the interlocutors "to see themselves as they are seen."[133] That the chain of authority manifested by the gifted robe was both connecting and constraining was evidently

CULTURAL CROSS-DRESSING

apparent to the raja of Kalinjar, for several versions of the encounter between him and Mahmud indicate a resistance to donning the robe and fastening the belt sent by the sultan.

Ibn al-Athir explains that while the raja put on Mahmud's *khil'a*, he refused to wear the belt that it included, until it was made clear that his refusal threatened the treaty of vassalage.[134] Al-Qalqashandi puts it rather more bluntly: "The king wanted to be excused from wearing the belt around his waist, but he was not excused; so he put on the belt unwillingly."[135] As we saw at the outset, dress played a central role in contemporary constructions of cultural difference. This may be one reason why the raja of Kalinjar was reluctant to wear the sultan's apparel, but it was surely not the only one.

The *khil'a* was an expression of hierarchy characterized by asymmetric reciprocity, a gift invariably made to one who was subordinate, not by virtue of his ethnicity or religious affiliations, but by virtue of his standing within a hierarchical structure into which he was subsumed and within which he was positioned by acceptance of the gift.[136] An ethnographic parallel for the way in which the *khil'a* functioned in gift exchanges between the Ghaznavids, Ghurids, and their Indian adversaries may be found in the Inca Empire, where gifts of clothing to citizens of areas newly incorporated into the empire represented "a coercive yet symbolic reiteration" of the recipient's obligations and conquered status.[137] A major difference, however, lies in the fact that the institution of *khil'a* was first and foremost one that articulated hierarchical relationships *within* the Islamic world, but which could be extended on occasion to peripheral non-Muslim vassals. Nonetheless, the insistence on the wearing of Mahmud's "gift" on the one hand, and the raja's refusal on the other, suggests a transparent understanding of the robe's ability to bind its recipient as a subordinate. Similarly, there are later instances of Rajput chiefs or their envoys refusing gifts from Muslim rulers on the grounds that to do so would constitute an insult to their overlord.[138]

The raja's understanding of the implications of robing was no doubt facilitated by the fact that the general principle of incorporation through royal gifting was common to both Islamic and Indic royal ritual. The constitutive potential of certain gifts would also have been clear, for within the redistributive practices of medieval Indian kings, "What the king gave out in the form of land grants, titles, emblems, honours, and privileges of service, was some part of his own sovereign substance by which he conferred on the recipients a subordinate share in his sovereignty and bound them to him."[139] Cloth and textiles were among the transactional symbols deployed to this end and were sometimes transvalued not only by contact with the royal body but also by use in the context of rituals of worship. Objects of personal adornment could thus assume a religious significance rooted in the homologies between the rituals of temple and palace, lending them further valences not common to their Islamicate analogs.[140] There is also a general preference for the use of cloth or textiles (as opposed to stitched robes) in Indic gifting rituals, although the institution of robing became more canonical in South Asia as a result of increased contacts with Islamic courts in the twelfth and thirteenth centuries.[141] In the fourteenth century, southern India was one of the few regions visited by the inveterate traveler Ibn Battuta that lay "beyond the edge of the known world of robes of honour."[142] Descriptions of ninth- and tenth-century Hindu rulers gifting *khila'* in Arabic and Persian histories of the sultanate period are therefore likely to reflect prevailing expectations of how a ruler should or would behave rather than the historical realities of the cultures that they described.

Even if the phenomenon of robing was not canonical in eleventh-century South Asia as it was in the Islamic world, the idea of cloth as a medium capable of transmitting both spirit and substance, a condition as well as an essence, was common to both Indic and Islamic traditions.[143] A further factor to be considered in the raja's reluctance to wear the robe, therefore, is the question of ritual pollution through contact with the body of a noncaste sultan. The ability of clothing to both absorb and transmit ritual impurity through physical contact underlies the recommendation in the *dharmashāstras* to bathe one's person and clothing after coming into contact with those of noncaste status, including *Mlecchas* (foreigners) and *Pārasīkas* (Persians).[144] Although stitched garments were known in India before the sultanate period, the advent of Persianate modes of dress greatly increased the volume of

83

stitched garments, which were considered more permeable to pollution than uncut unstitched cloth.[145]

The raja's resistance to Ghaznavid modes of dress may also be understood as a resistance to the coercive transculturation implicit in their adoption. By virtue of their constitutive qualities and their ability to move between persons, in many premodern societies clothes had the ability to confound, alter, transform, and translate the wearer: as Stallybrass notes of Renaissance England, "'translations' of clothing . . . enact the power of clothes to shape and to resist social identities."[146] This is no less true of the *khil'a*, which constitutes the bonds that it advertises and thus acquires the paradoxical (if sometimes notional) ability to dissolve the cultural boundaries that it crosses by affirming a relationship to a hegemonic center. The removal of items of clothing associated with a specific cultural identity may have been equally instrumental to the articulation of political relationships between the Ghaznavids and the Indic rulers that they defeated: in a later encounter, we hear of the Hindu ruler of Agra offering obeisance to the Ghaznavid prince Sayf al-Dawla Mahmud by removing the sacred thread that he wore around his body.[147]

If "clothes make the man," in Kalinjar they were clearly understood as remaking him in the image of his Ghaznavid overlord. This ability of clothing to effect the transnaturation of the wearer was positively exploited in the self-representations of the Arab amirs of Mansura and the Buddhist ruler of Alchi. But unlike Alchi, the Chandella polity was not a marginal player on the periphery of the Ghaznavid sultanate; it was a powerful sovereign polity far from Ghazni, a major force in a region where political authority and territory were hotly contested between different Rajput polities. In these circumstances, the adoption of Ghaznavid modes of dress conferred few advantages on the raja of Kalinjar. On the contrary, as the objectification of an identity that was at once cultural and personal, the gift of clothing was doubly undesirable and consequently resisted. Vidhyadhara's resistance to the *qabā'* thus reflects the quite different conditions prevailing in Bundelkhund and Alchi, a reminder that premodern elites exercised their agency in dynamic ways that were informed by historical contingencies rather than ahistorical essences.

| *The Raja's Finger and the Sultan's Belt*

Whether desired or not, the robe that effected incorporation into the Ghaznavid body politic was part of a *reciprocal* gift exchange in which sultan Mahmud demanded a part of the raja's physical body. In his *Chronography*, Bar Hebraeus describes how the ambassador of the Ghaznavid sultan, having complied with the first part of his master's request—to force the raja to submit by donning his gifted robes—proceeded to implement the second demand, that the compact be sealed by the amputation of the raja's fingertip:

> And when he had dressed himself I was ashamed to say to him, "Cut your finger," and so I only said, "Swear an oath of fealty to us." And he replied, "Our oaths are [taken] by images and by fire, and they would not be acceptable to your folk. By what shall we swear to you?" Then I said, "You know how to swear an oath to us." And straightway he commanded a slave to bring a razor, and he brought it, and he took it in his right hand and cut off with it the tip of his left thumb without his color changing in the slightest degree. And he sprinkled some powdered drug over the finger and tied it up. And they washed the portion that had been cut off with water and placed some camphor with it in a bag, and they gave it to me with some clothes, silver and two horses.[148]

However bizarre, this account is consistent with those found in Arabic histories, although these specify the little finger rather than the thumb. According to Ibn al-Athir's account, after tying the belt, the raja of Kalinjar amputated his own little finger and dispatched it to sultan Mahmud to seal the treaty.[149] Similarly, the account of the Arabic historian Sibt Ibn al-Jawzi (d. 654/1257), who had access to the lost chronicle of the Ghaznavid historian Hilal al-Sabi', reiterates the motif of the finger. In return for a payment of five hundred elephants and three thousand cows, Mahmud sent the raja a *khil'a* consisting of a *qabā'*, a turban, a dagger, a belt, a gold-caparisoned horse, and a ring inscribed with the sultan's name. The resulting compact was sealed as follows: "According to the ceremony which ensured the observance of a compact among

the Hindūs, the Sulṭān ordered the small finger of the Rājā to be cut off. Maḥmūd thus had numerous finger-tips of those who had made peace with him. The Rājā put on the dress, took out the knife and cut off his little finger with it without changing colour. He then applied an ointment to the wound to stop bleeding."[150] The Arab historian Ibn Zafir (d. ca. 622/1226) tells us that this was the standard mode of sealing a compact among Indian rulers, again adding rather ominously that sultan Mahmud had numerous fingertips of the Hindu rajas whom he had defeated.[151]

The gruesome detail of the finger (or fingertip) represents a strikingly literal take on Mauss' idea that gifts are "parts of persons." It also recalls descriptions of finger sacrifice found in early Arabic accounts of al-Hind. The practice is mentioned, for example, in the ʿAjāʾib al-Hind (Wonders of India), a tenth-century compendium of tales written by the Persian sea captain Buzurg ibn Shahriyar: "When the kings of India ascend the throne, men come to them, in numbers that vary with their rank and power, and say to the king: We are your balawajirs. With his own hand he gives them rice and betel, and each one of them cuts off a finger, and sets it before the king. Thereafter they follow him everywhere."[152] Although presented as a generic occurrence, this scene is clearly set at the court of the Rashtrakutas, rulers of the Deccan, for Balawajir seems to be a corruption of Vallabha-rāja (the beloved king), the honorific by which the Rashtrakutas were known. Food was a transactional symbol common to Islamic and Indic kings,[153] and the ceremony desribed here clearly constitutes a ritual of incorporation in which a transactional symbol transvalued by contact with the ruler's body is exchanged for a part of the vassal's physical person. Confirmation that finger sacrifice (entailing the last joint of the forefinger) was indeed known among the Rashtrakuta rulers (at least in the context of religious ritual) is found in a number of medieval temple inscriptions from the Deccan, where the finger was gifted to seal a vow or to ward off a threat to the devotee.[154]

More germane both chronologically and geographically to the Ghaznavid context, however, is the evidence offered by the Rājataraṅgiṇī (Sea of Kings), a Kashmiri Sanskrit chronicle composed by the court poet Kalhana around 1150 AD. The text (which men-

tions one of Mahmud's incursions into Kashmir) contains numerous references to ritual finger sacrifice, and in precisely those circumstances described by the Arabic and Syriac histories: as an offering to a more powerful adversary signifying surrender and invoking the protection of the victor. Among the many examples of this practice mentioned in the Rājataraṅgiṇī, we hear of the defeated rebel brother of King Jayasimha (1128–49) approaching the king after his capture, carrying his own cut finger in a clay vessel as a token of submission.[155]

The ideals of Indic kingship were shaped by the idea of a constitutive relationship between the body of the ruler and the integrity of the polity. Hence bodily deformity or mutilation precluded rulership, a taboo known in the medieval Arabic sources on India.[156] Discussing the campaign of Sankaravarman of Kashmir (r. 883–902 AD) against the Gurjara-Pratiharas of northern India, Kalhana relates how the Gurjara ruler ceded some territory to the Kashmiri in order to preserve the integrity of the remainder of his kingdom. The poet compares this gesture to that of a man who gives up his finger to save his life, suggesting that the finger not only served as a synecdoche for the person of the vanquished or vassal but could stand in metonymic relationship to the polity over which he governed.[157]

In the Sanskrit texts and inscriptions referring to finger sacrifice, the finger is clearly understood as a surrogate for the person, even as, in Islamic tradition, the robe infused with the sultan's essence substitutes for the man himself. The gift exchange between raja and sultan may thus be understood as a ritual incorporation mediated by the bodies of donor and recipient, in which a metonymic part of the royal body was exchanged for the synecdochic fingertip of a vassal. In view of the relationship between the gift, the royal body, and the body politic, their reciprocal exchange can be understood as not only constituting the new relationship between their respective polities but also, quite literally, embodying it.

The royal body (and its synecdochic representation by the hand) was especially well situated to index alterations in cultural geography and political topography, and has been central to rituals of investiture and vassalage that operate both intra- and interculturally. In 449/1057, for example, after his investiture by

the 'Abbasid caliph, the Seljuq sultan Tughril took the caliph's hand and laid it upon his own eyes.[158] Similarly, in the sultanate period the submission of a prince was often confirmed by the sultan or his agent placing a hand on the back of the submitting raja or his agent.[159]

However, the meaning of such gestures was dependent on access to culturally determined codes and hence mitigated by contingency. In cross-cultural contexts, the representational excess stemming from this contingency could be productive for one or another party, satisfying the expectations of multiple constituencies simultaneously, saving face, avoiding open conflict, or even imbuing the exchange with ironic qualities.[160] The tenth-century Muslim ambassadors to Constantinople who were "honored" by being dressed in pearl-studded costumes normally reserved for eunuchs find a literary counterpart in the letters to the Fatimid sultan penned by Michael Psellus on behalf of the emperor Constantine IX (1042–53), which the secretary boasts were rife with ambiguities and subtly inverted meanings, so that what he wrote "had one meaning for Constantine and another for the sultan."[161]

Psychoanalysts have argued that misprision or *méconnaisance* is a necessary stage in the development of a sense of self that is constituted relationally,[162] but the misprisions that accompanied cross-cultural encounters could also threaten the very compacts that they were intended to confirm. In this respect, it is worth contrasting the exchange between the Ghaznavid sultan and Chandella raja with a slightly later attempt to seal a treaty in another contact zone, this time the eastern Mediterranean. The encounter between the Fatimid caliph of Egypt al-'Adid (r. 555–67/1160–71) and the Crusader Hugh of Caesarea is described by the Crusader historian William of Tyre as follows:

> The Christians then requested that he confirm this statement with his own hand as the king had done. At first, the courtiers who surrounded him, as well as his counsellors and gentlemen of the chamber, on whom rested the responsibility of the royal plans, were shocked at the suggestion, as a thing utterly beyond comprehension. Finally, however, after long deliberation, at the persistent urging of the sultan [i.e., al-'Adid's vizier, Shawar], he very reluctantly extended his hand covered. Then, to the consternation of the Egyptians, who were amazed that anyone should talk so freely to their supreme lord, Hugh of Caesarea said to him: "Sire, good faith has nothing to conceal; and when princes bind themselves together in true loyalty everything ought to be open; and everything which is inserted in good faith in any pact should be confirmed or refused with frank sincerity. Therefore, unless you offer your hand bared we shall be obliged to think that, on your part, there is some reservation or some lack of sincerity."
>
> Finally, with extreme unwillingness, as if it detracted from his majesty, yet with a slight smile which greatly aggrieved the Egyptians, he [al-'Adid] put his uncovered hand into that of Hugh.[163]

Once again the body of the ruler (and his hand in particular) is central to the mediation of difference, but the cognitive dissonance that characterizes this meeting stands in marked contrast to the exchange between sultan Mahmud and the raja of Kalinjar. In one case ritualized submission is forced by conformity to an alien ritual, the hegemonic extension of an aggressive universalizing practice, in another by the coercive iteration of what is understood as indigenous custom. Although reports of both ceremonies mention an element of resistance, in one case that resistance is the product of incomprehension or incommensurability, in the other a function of transparent understanding facilitated by the homologous use of transactional symbols. At first sight the exchange of finger for robe may seem bizarre, since it violates our sense of the inalienability of body parts, if not the fundamental subject-object distinction on which post-Enlightenment ontology hinges. It results, however, from an endeavor to find equivalents within complex, culturally determined rituals of incorporation common to which is the use of (literally) incarnated signs of subordination and vassalage.[164] Within this transaction, the raja's body can be understood as both the site and sign of a translation signified by a sartorial transformation.

In his study of cross-cultural encounters in the Vijayanagara polity with which I began, Joan-Pau Rubiés

CULTURAL CROSS-DRESSING

has argued that "symbolic representations of power could be 'translated' on the basis of cross-cultural analogies."[165] According to Rubiés, the legibility or translatability of these symbolic representations derived from the shared centrality of ritual and ceremony to the elites of the various cultures (Arab, Persian, Central, East, and South Asian, and European) that interacted in the Vijayanagara Empire, and the existence of mutually intelligible homologies in the projection of power. Similarly, the adoption of Islamicate modes of self-representation among the Hindu rulers of the same kingdom has been attributed by Phillip Wagoner to "the operation of an underlying cultural hermeneutic, that is, an act of interpretation in which the specific signs and practices of one culture are understood in the terms of another."[166]

The exchange between Vidyadhara of Kalinjar and Mahmud of Ghazni suggests that a similar cultural hermeneutic was operative in Hindu-Muslim encounters at much earlier periods, even under the most unlikely of circumstances. It presupposes, however, not only the ability to find homologies within different cognitive frameworks, but also reciprocal acts of cognition, an understanding of the practices of contemporary adversaries. Thus the historians cited above indicate an awareness of the robe's meaning on the part of the Chandella raja as well as the fact that oaths sworn to idols were not acceptable to Muslims; conversely, knowledge of finger sacrifice and its significance in the ritual practices of northern Indian elites is attributed to the Ghaznavids and their agents.[167]

Transcultural extensions of *khil'a* culture in other contact zones remain to be explored, but the strange story of Sultan Mahmud and the raja of Kalinjar demonstrates that worlds often represented as contiguous but incommensurate were in fact imbricated in complex and surprising ways. A coda to the tale underlines the points made in chapter 1 about the way in which the transregional circulation and redistribution of Indian exotica served to articulate the internal political relationships of the Islamic world. A marvelous poison-detecting bird sent to Mahmud by the raja of Kalinjar along with tribute and the Hindavi poem mentioned above was later dispatched by the Ghaznavid sultan to the 'Abbasid caliph in Baghdad.[168] In addition, the memory of Mahmud's encounter with the raja of Kalinjar provided a paradigm for those who chronicled later encounters between Turko-Persian elites and their Indic counterparts. In 599/1202 when the Turkic general Qutb al-Din Aybek moved against Parmaldeva, the Chandella ruler of Kalinjar, Hasan Nizami (ca. 626/1229) tells us that the raja submitted and paid tribute, recalling the benevolence with which Mahmud had treated his ancestor almost two centuries earlier.[169]

Apocryphal or not, the tale reminds us that the outcomes of encounters between Buddhist, Hindu, and Muslim elites in eastern Iran and western India were determined not by incommensurable essences but by historical agents responding to aesthetic, cultural, economic, and political concerns. Whether the result of transcultural gifting or less formalized modes of cross-cultural exchange, common to all the instances of cultural cross-dressing presented here is the desire for (or fear of) *incorporation*, underlining a point made by Cemal Kafadar in relation to the frontier cultures of medieval Anatolia: "Historians tend to overlook the fact that (America is not the only case where) one is not necessarily born into a people; one may also become of a people, within a socially constructed dialectic of inclusions and exclusions."[170] As we will see in the following chapter, the malleability and mutability of identity enabled it to function as a strategy rather than a fixity, susceptible to radical shifts over relatively short periods of time.[171]

3 | *Accommodating the Infidel*

Political dominators always seek the support of the dominated,
hence are always constrained by them.

—Henry Orenstein, "Asymmetrical Reciprocity" (1980), 69

| *Sunni Internationalism and the Ghurid Interlude*

In 545/1150 the armies of 'Ala' al-Din Husayn, chief of the Shansabanid clan of Ghur, a remote mountainous area of what today is west-central Afghanistan, sacked and burned Ghazni, eponymous capital of the sultanate that had dominated the eastern Islamic world for a century and a half. Over the course of a week the city was ransacked, its monuments destroyed, and the tombs of the Ghaznavid sultans desecrated, their remains exhumed and burned. Only those of the dynasty's greatest scions—Mahmud, Mas'ud, and Ibrahim—were spared.[1] This carnage, undertaken to avenge the death of 'Ala' al-Din Husayn's two brothers at the hands of the Ghaznavid sultan, earned its perpetrator the sobriquet *Jahān-sūz* (World-burner). It also marked the abrupt entry of the Ghurid *malik*s or chiefs onto the political stage.

As minor chieftains of a rather obscure and inaccessible mountain region, famous primarily for its weapons and large hunting dogs, the Shansabanids were by no means obvious heirs to the Ghaznavid legacy. Forming a buffer zone between the Ghaznavids to the east and the Great Seljuqs of Iran to the west, and subject to both, the inhabitants of the region had converted to Islam only a century or so before these tumultuous events.[2] Nevertheless, the Shansabanids were quick to exploit the power vac-

uum left by the decline of Seljuq power in Iran on the one hand and their symbolic erasure of Ghaznavid sovereignty on the other. A rapid expansion of their authority and dominion over the next five decades saw the territories of the Ghurid chieftains extend from eastern Iran to Bengal, uniting the remote mountain valleys of Ghur with Khurasan to the west, and Ghazni and the Hindu Kush with the Indus Valley and Gangetic Plain to the east, and effecting a major reconfiguration in the political geography of the region.

The apogee of Ghurid power was reached during the reign of the brothers Ghiyath al-Din Muhammad ibn Sam (r. 558–99/1163–1203) and Mu'izz al-Din Muhammad ibn Sam (r. 569–602/1173–1206). The brothers ruled in a condominium, the former overseeing the westward expansion of the sultanate from Firuzkuh in west-central Afghanistan, the latter expanding Shansabanid dominion eastward from the former Ghaznavid capital.[3] A third line based in Bamiyan was celebrated for its patronage of Persian literati, but has less relevance to the conquest of northern India. This unusual arrangement reflects clan-based structures within which rights of succession were horizontal rather than strictly vertical, fostering a system of appanages consolidated by intermarriage and affinal ties. As Sunil Kumar observes, the system fostered a sense of "corporate egalitarianism" within "a loose patrimony of autonomous principalities led by a senior kinsman."[4]

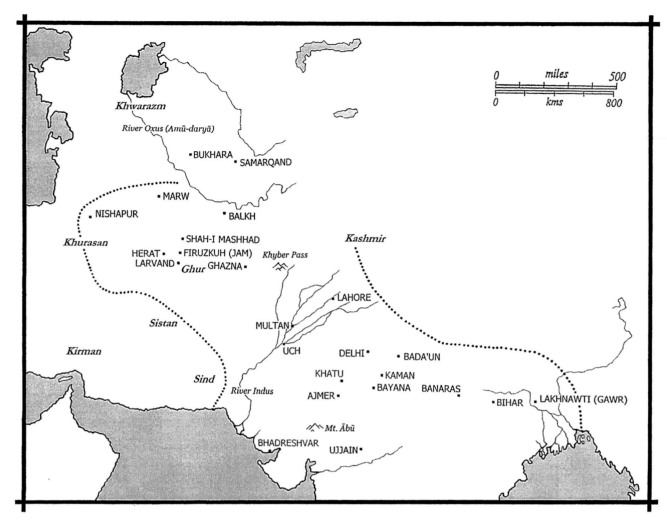

47
Map showing the approximate eastern and western boundaries
of the Ghurid sultanate at its zenith.

The remarkable scale and rapidity of Ghurid expansion recall the Arab conquests of the early Islamic period, and they prefigure the Mongol invasions that were to irrevocably alter the ecological and political landscape of Afghanistan and Iran only a few decades later. In 571/1175, Herat was wrested from the Seljuqs, initiating a process of expansion into eastern Iran, which saw Ghurid imperium reach as far west as the important Khurasani city of Nishapur by 596/1200. Expansion in the east began in the same year, and by 582/1186 the capture of Lahore effectively ended the last bastion of Ghaznavid dominion, establishing the Ghurid sultanate as the de facto successor state. Several encounters between Ghurid armies and those of northern Indian Rajputs followed, including a Ghurid victory in 588/1192 over a coalition led by the Chauhans of Shakambarī at Tara'in (Taraori) in Haryana.[5] Although the Ghaznavid sultans had continued to raid northern India until well into the twelfth century, their Indian territories were confined to the western Panjab and Indus Valley. By contrast, the Ghurid victory at Tara'in opened the way to the conquest of northern India.

By the time that Mu'izz al-Din fell victim to an assassin in 603/1206, Ghurid armies were engaged from Khurasan in the west to Bengal in the east, and from the steppe of Central Asia in the north to Sind and the Indian Ocean in the south (fig. 47). The death

ACCOMMODATING THE INFIDEL

of Mu'izz al-Din effectively marked the end of Ghurid sovereignty, for in its aftermath the neighboring Khwarazmshahs of Central Asia incorporated the western Ghurid territories into their domains, while in the east the Turkish slave generals on whom the Ghurids had relied during their Indian campaigns assumed power, creating the conditions for the emergence of an independent sultanate based in Delhi, which will be discussed in chapter 6.

Although ultimately ephemeral (and thus largely ignored by historians and art historians alike), what the historian C. E. Bosworth dubbed and Holly Edwards later popularized as the "Ghurid interlude" in the eastern Islamic world is one of the most fascinating moments in world history.[6] Conjoining northern India with large swaths of eastern Iran and Afghanistan for the first time, the expansion of the Ghurid polity created the conditions for mobility between these contiguous realms on a previously unimaginable scale. The expansion of the Shansabanid lands to include vast areas that had traditionally fallen outside the *dār al-Islām* presented the parvenu Ghurids and their agents with a double imperative: to project their authority and legitimize their position within the *dār al-Islām* and to provide effective governance in the newly acquired Indian territories that had formerly stood without it. The self-representations of the Ghurids were sensitive to both these imperatives and to the need to negotiate their own rapidly evolving status within a wider Islamic world that was itself in flux.

The Ghurid sultans made their entry upon the world stage at a pivotal moment in the history of the eastern Islamic world, a period that some scholars see as foundational to the emergence of a "world system" linking Europe with the Middle East, South Asia, and China in the wake of the Mongol invasions of the 1220s.[7] Just decades before the Ghurids' decisive victory over their Indic opponents in 588/1192, a victory that was to transform the political landscape of the eastern Islamic world, major shifts in the balance of power were occurring in the eastern Mediterranean. In 567/1171 Salah al-Din Ayyub (better known to Western historiography as Saladin) had succeeded in ending the rule of the Fatimid caliphs over Egypt, Palestine, and Syria, returning these lands to the nominal control of the Baghdad caliphate after two centuries of serious Shi'i challenges to it. Heterodox Muslims were not the only threat, however, for the Syrian heartlands of the first Islamic caliphate had been occupied by Crusader armies since 492/1099. In 582/1187, Salah al-Din struck a decisive blow to Crusader ambitions, recapturing Jerusalem for Islam in an act celebrated by Arab historians, poets, and theologians.

The eclipse of the Fatimids and the recapture of Jerusalem presaged the revival of the fortunes of the 'Abbasid caliphs, who had been little more than figureheads or puppets of powerful Shi'i and Sunni amirs for the previous two centuries. The historian Marshall Hodgson saw the period between 1150 and 1250 as characterized by what he called a spirit of "Sunni internationalism," a recrudescence of caliphal fortunes central to what has come to be known (not unproblematically) as the Sunni Revival.[8] The period saw the emergence of major schools of manuscript production in Iraq, of luxury ceramic production in Iran, and of an inlaid metalwork industry in Khurasan (especially Herat). Politically, it was characterized by the emergence of three great Sunni powers in the eastern Islamic world—the Ayyubids of Syria, the Ghurids of Afghanistan, and the Khwarazmshahs of Central Asia—each of whom engaged and was engaged in its turn by a revivified caliphate. In 567/1171–72, for example, the Ghurid sultan Ghiyath al-Din Muhammad sent an envoy to the caliph al-Mustadi' in Baghdad, after which the caliph's name appears on Ghurid coinage minted outside the new Indian territories of the sultanate. During the lengthy reign of the caliph al-Nasir li-Din Allah (r. 575–621/1180–1225) several embassies were exchanged between Baghdad and the Ghurid courts at Firuzkuh and Ghazni, bearing robes and other honors. At the same time, the Ghurid sultan was inducted into the caliphal *futuwwa* order, a kind of elite pan-Islamic Sunni fraternity designed to foster common bonds of loyalty.[9]

A common Sunni heritage did not ensure fraternal harmony, however. On the one hand, the 'Abbasid caliph sometimes encouraged or exploited the enmity between the Ghurid sultans and their rivals, the Khwarazmshahs of Central Asia, possibly to stem the potential emergence of a powerful duumvirate capable of manipulating the caliphate.[10] On the other, the cities of the eastern Islamic world were often riven by violent confrontations not only between Sunni Muslims and their Shi'i coreligionists but also between adherents of different Sunni sects and schools of jurisprudence. The

intensity of this factionalism deconstructs notions of Sunni doctrinal consensus and pietistic unity that are themselves cultural artifacts. As the historian Richard Bulliet notes, "The mutual tolerance of different legal and doctrinal interpretations of Sunni Islam that characterizes the later [i.e., post-thirteenth-century] centuries belies the bitter factional conflicts between Sunni law schools that mark the tenth, eleventh, and twelfth centuries." As Bulliet suggests, the absence of detailed synchronic studies of local or regional conditions facilitates the retrojection of an image of Sunni homogeneity that belies the "particularism and localism" that characterized specific forms of orthodoxy, especially in eastern Iran and Afghanistan.[11] Seen in this light, the so-called Sunni Revival is perhaps better understood not as a reassertion of a common religious orthodoxy (or even orthopraxis) but as a standardization of Sunni Islam after a period of internecine tensions. These tensions are directly relevant to understanding the shifting self-representations of the Ghurid sultans as their fortunes rose and their territories expanded.

The manufacture of legitimizing genealogies was a stock-in-trade of the arriviste eastern Iranian dynasties that emerged after the weakening of centralized caliphal authority. Intended for consumption both at home and in the wider Islamic world, these genealogies addressed the heterogeneous nature of that world, on occasion asserting descent from both the Arab tribes of early Islamic Arabia and the Persian heroes of the *Shāhnāma*, the *Book of Kings*.[12] Although their precise ethnic origins are obscure, the Ghurids (unlike their Ghaznavid predecessors) were of Persianate, probably Tajik, ethnicity. Treading a path worn by earlier eastern parvenus, they claimed a genealogy that invested them with august secular and sacral antecedents, rooted simultaneously in the heroic past of pre-Islamic Iran, the hallowed milieu of the early caliphs, and the glories of the Baghdad caliphate at its zenith. On the one hand, the Ghurids asserted descent from Zahak, a tyrant memorialized in the *Shāhnāma*, whose family reportedly took refuge in Ghur after his overthrow. On the other, they claimed conversion to Islam at the hands of the fourth caliph 'Ali, from whom the eponymous founder of the dynastic line is said to have a patent (*'ahd*) and a standard (*liwā'*), which were transmitted through the generations.[13]

As this founding myth suggests, legitimizing genealogies and conventional assertions of sovereign authority were often materialized in object form. The incorporative qualities of clothing, its peculiar ability to mediate between origins and aspirations, have been discussed in the preceding chapter and are central to a third strand in these founding myths. Describing how the Shansabanid family triumphed over its rivals to become preeminent in Ghur, Minhaj al-Din Juzjani—a historian who was raised at the Ghurid court in Firuzkuh—relates a tale about Amir Banji ibn Naharan Shansabani, the first of the Shansabanid line to rule, and his elevation at the hands of the fabled 'Abbasid caliph Harun al-Rashid (d. 193/809).[14] This success was obtained through the intermediary of a Jewish merchant, resident in Ghur but wise to the ways of the wider world outside this isolated region. In return for a promise of land on which to found a small community of Jews, the unnamed merchant undertook to secretly instruct the handsome but rather uncouth Amir Banji in the etiquette (*adab*) and conduct (*ḥarakāt*) becoming to a figure of substance and authority.

A central part of the transformation of this Ghurid Eliza Doolitle entailed a change of dress. In place of the rough, short garments common in the region, the Jewish adviser of Amir Banji dressed him in a *qabā'* (robe), *kulā* (hat), and *mūza* (boots), three standard components of the princely "Turkic" dress discussed in chapter 2. When the rival claimants for rulership of Ghur eventually appeared before Harun al-Rashid, he immediately recognized Amir Banji for the ruler that he was through his dress and bearing; clad in the *qabā'* and *kulā*, the Ghurid neophyte was "translated," appearing to the caliph as the ruler that he aspired to become.[15] Accordingly, he was invested with rulership (*imārat*) over the territory of Ghur, while his rival was granted jurisdiction over its military forces (*pahlavānī*).

Juzjani's tale underlines a point made in chapter 2: dynasties no less than individuals can undergo political transitions, rites of passage designed to incorporate neophytes into new, socially advantageous arrangements. Indeed, the three stages of Amir Banji's transformation—abandonment, secret adoption, and public display—recall the tripartite structure of rites of passage in the classic formulation of the an-

thropologist Victor Turner: separation, liminality, and aggregation.[16]

Somewhat anachronistically, the transformation of Amir Banji was effected through the adoption of the Turkic modes of dress that had become established at the courts of the eastern Islamic world only in the eleventh and twelfth centuries. As this implies, it is in the highest degree improbable that Juzjani's genealogy offers transparent insights into Ghurid court culture of the eighth or ninth century, if in fact there was such a thing. It does, however, highlight the contingent and constructed nature of medieval elite identity in what is evidently an attempt to allegorize the rise of a rather obscure dynasty with strongly localized affinities.[17] Indeed, despite the ostensive eighth-century setting of the tale, certain of its details resonate with what we know of Ghur in the twelfth.

Jewish advisers and merchants are a common trope in accounts of medieval court life from the eastern Islamic world and Hindu Kush, and a Judeo-Persian rock inscription of 752–53 at Tang-i Azao near Chisht, on the northwestern edge of Ghur, confirms a Jewish presence in the region as early as the reign of Harun al-Rashid.[18] The existence of a later community of Jews is documented by a series of tombstones recovered from the vicinity of Jam, the assumed site of Firuzkuh, the Ghurid summer capital, which bear Judeo-Persian inscriptions ranging in date from 508/1115 to 610/1214.[19] Eighty-five percent of these inscriptions date from the period of Ghurid ascendancy between 1150 and 1200. An epitaph of 568/1173 indicates that at least one member of this community was a *peqīd* (an intermediary or *wakīl*), a term used elsewhere to refer to the merchants' representatives active in the trade with India.[20] It thus appears that some among the Jewish community of Ghur were intermediaries transporting to Ghur the luxury products of the wider Islamic world, the rare foreign textiles (*qimāshāt-i gharīb*) or imported precious wares (including perfumed leather) mentioned as imports by thirteenth-century historians, or the luxury enameled and glazed ceramics and tiles from central Iran, fragments of which can still be found in Jam/Firuzkuh.[21] The export of costly and fragile wares over such long distances, and the retrieval of their remains (even in small numbers) from such a remote site, are indicative

of a market for luxury goods that confirms the elite associations of the site and reminds us that difficulties of access are not necessarily the same as isolation.[22]

Perhaps the most notable aspect of the Ur-Ghurid's attempt to recast himself as a suave global player rather than an uncouth mountain chief is the attention it draws to the self-consciousness of the Ghurids vis-à-vis the wider Islamic world, and the court cultures of their contemporaries in particular. Stephen Humphreys has noted that in the political games that prevailed among the Sunni elites of the eastern Islamic world during the eleventh and twelfth centuries, rival factions defined themselves "by varying, often rapidly shifting criteria."[23] This is especially true of the Ghurids. Toward the end of the twelfth century, the changing fortunes of the Ghurid polity, its shift from rural chiefdom to global sultanate, threw into high relief underlying tensions between the strong regional associations of the Ghurid *malik*s and their increasingly transregional pretensions. The period is marked by convulsive sectarian disputes and changing patterns of religious patronage within the Ghurid heartlands, developments that can be directly correlated to the shifting self-representations of the Ghurid elite. Contemporary as they are with Ghurid expansion into northern India, these shifts undermine the notion of a singular and stable self, defined through religious affinity, while confirming Sunil Kumar's observation that "elite strategies of framing self and collective identities were intrinsically violent and hierarching exercises that had their own local contextual politics."[24]

| *From King of the Mountains to the Second Alexander*

In a study of Sanskritic self-representations, Sheldon Pollock has noted the constitutive character of medieval Indic royal titles, which accomplished "the creation of the fame and virtue of the king through a celebration of his fame and virtue."[25] This is no less true of medieval Persianate royal titles, complex modes of self-identification that sought to locate the rule of specific potentates within the universalizing rhetoric of Islamic authority. According to the historian Juzjani, as part of this investiture by Harun al-Rashid, Amir Banji acquired the title of *qasīm al-amīr al-muʾminīn*

(the partner of the Commander of the Believers, the 'Abbasid caliph).

Claims to caliphal partnership may have conferred impeccable religious credentials on the Ghurids, but were at odds with their rather unpretentious traditional claim to political authority as *malik al-jibāl* (king of the mountains). Accordingly, the political status of the Shansabanids was enhanced around 545/1150, when they assumed the use of the title *al-sulṭān al-muʿaẓẓam* (the great sultan), a title also held by the Ghaznavids and Seljuqs, to whom the Ghurids had previously been subordinate.[26]

The aggrandizement of the Shansabanid *malik*s and the burgeoning of their titulature reached their zenith under Ghiyath al-Din Muhammad ibn Sam (r. 558–99/1163–1203) and Muʿizz al-Din Muhammad ibn Sam (r. 569–602/1173–1206), the brothers whose joint rule came to define the apogee of Ghurid power. Born three years apart, both brothers shared the given name (*ism*) Muhammad, being distinguished by the formal names (*laqab*s) Shams al-Din (the sun of religion) and Shihab al-Din (the shooting star of religion) respectively.

Upon assuming the sultanate of Ghur in 588/1163 (or shortly thereafter), Shams al-Din changed his *laqab* to Ghiyath al-Din (succorer of religion), the title by which he was known for the rest of his life.[27] Similarly, around 569/1174, Shihab al-Din changed his *laqab* to Muʿizz al-Din (honorer of religion), the name by which he is generally known.[28] Once again, the change in *laqab* can be directly correlated to a change in status, for it follows Muʿizz al-Din's capture of Ghazni from the Ghuzz Turks in 569/1174, after which he was elevated from the rank of *malik* to sultan, having progressively borne the titles *malik al-muʿaẓẓam* (the great chief) and *malik al-ʿaẓam* (the greatest chief).[29] That Ghiyath al-Din remained the elder statesman of the pair is clear from his retention of the title *al-sulṭān al-ʿaẓam* (the greatest sultan) in comparison to Muʿizz al-Din, *al-sulṭān al-muʿaẓẓam* (the great sultan), who acquired the former title only after Ghiyath al-Din's death in 599/1203.[30]

These conventional assertions of sovereign authority were not made in a vacuum but were intimately associated with the objects and media that bore them, and which served to reinforce the claims that they made. For example, the adoption of the *chatr* (parasol) was as intrinsic to ʿAlaʾ al-Din's investment of the new office of sultan as his assumption of the title itself, the former serving as an instantiation of the authority associated with the latter.[31] Other objects displayed a more literal association with the inscription of authority, among them architectural monuments and gold coins, which were struck in the name of ʿAlaʾ al-Din in Ghazni, Herat, and Firuzkuh.[32] With the exception of coins—a relatively abundant if understudied source for Ghurid history and art history—few surviving portable objects can be definitively associated with Ghurid patronage, however.[33] Among them are two unpublished gold amulet boxes ornamented with repoussé harpies and rosettes and inscribed with the names and titles of sultan Ghiyath al-Din in Arabic. The boxes are said to have been found near the minaret of Jam, the assumed site of the Ghurid summer capital, Firuzkuh, from whence some carved wooden doors of the same period have also been recovered.[34]

In the absence of further studies to confirm the claims made for these objects, only a single artifact can be confidently ascribed to the patronage of sultan Ghiyath al-Din. This is a four-volume leather-bound Qurʾan completed on 8 Rabiʾ al-Akhir 584/6 June 1189. With a page size of approximately 39 by 29 cm, it is among the largest Qurʾans of the period, a superlative example of the arts of binding, calligraphy, and illumination, and perhaps the most spectacular Qurʾan manuscript to have survived from pre-Mongol Iran (fig. 48).[35] Unusually for Qurʾans of this period, which tend to be single volume or divided into thirty, seven, or (more rarely) six or two volumes, the manuscript is divided into four, each volume bearing some or all of its original tooled leather binding. The manuscript is unusual in a number of respects, not least in possessing a lengthy colophon that provides a considerable amount of information about the circumstances of its own production, which took a scribe from Nishapur five years to complete. The colophon (fig. 49) also gives the most extensive rendition of sultan Ghiyath al-Din's titles to have survived, providing a unique insight into Ghurid self-representations in the decade before the conquest of India:

> The chief and great sultan, the greatest king of kings, ruler over the necks of nations, sultan of

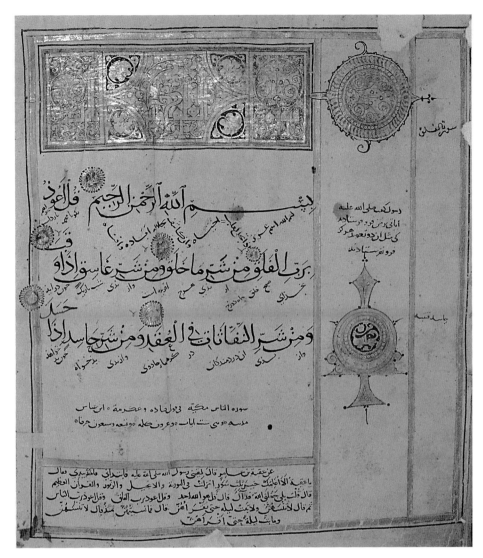

48
Ghurid Qur'an of
584/1189, *sūra* 113, the
penultimate chapter of
the Qur'an, with the
exegetical text of al-
Surabadi in the lower
panel (courtesy of Iran
Bastan Museum, Teh-
ran, manuscript no.
3507, fol. 194b).

49
Part of the colophon of
a Ghurid Qur'an dated
584/1189 (Iran Bastan
Museum, Tehran, man-
uscript no. 3507, fol.
198a).

the sultans in the world, succorer of the world and religion, the glory of Islam and the Muslims, victor over the unbelievers and the heretics, suppressor of heresy and the seditious, the supporting arm of the victorious state, crown of the radiant people, glory of the shining nation, order of the world, Father of Victory, Muhammad ibn Sam, partner of the Commander of the Believers [i.e., the 'Abbasid caliph].[36]

Even in an era in which titles were routinely inflated, this is a remarkably bombastic document, combining once again titles used earlier by both the Seljuq and Ghaznavid sultans.[37] The intrinsic association between the suppression of heresy and the chastisement of unbelievers in these titles is worth emphasizing, providing a cogent reminder that, especially along the eastern frontier, Sunni royal rhetoric in this period was as concerned with the promotion of orthodoxy and the extirpation of heterodoxy as it was with the punishment of unbelief and polytheism.[38]

Rhetorical claims to have championed orthodoxy found a counterpart in repeated campaigns against the Isma'ili Shi'is.[39] Antipathy toward heterodox Muslims may have been fostered by the Ghurid involvement with the Karramiya, a somewhat enigmatic Sunni pietistic sect with distinct modes of prayer, ablution, and burial.[40] Although one tenth-century writer describes the characteristics of the sect as "piety, fanaticism, baseness, and beggary," the preaching of the eponymous Muhammad ibn Karram (d. 255/869) is said to have been instrumental in converting Ghur from paganism to Islam.[41] The Karramiya were dominant among the population of Ghur in the second half of the twelfth century, enjoying the patronage of the Ghurid sultans.[42] Their disappearance in the wake of the Mongol invasions of the 1220s has led scholars (especially those concerned with material culture) to overlook them, but during the eleventh and twelfth centuries Karrami madrasas (religious schools) and khanqahs (convents) were established in all the major cities of eastern Iran and Transoxiana.[43] The sect (itself comprising as many as twelve different subsects) competed for patronage, material resources, and spiritual adherents with representatives of other legal and theological traditions, chief among them the Hanafi and Shafi'i madhhabs

(schools of jurisprudence), two of the four canonical law schools of Sunni Islam.[44]

The Sunni opponents of the Karramiya depict them as anthropomorphists who took at face value a number of Qur'anic verses that seem to imply divine possession of corporeal attributes and qualities, apparently contradicting or undermining the notion of an eternal and uncreated deity, which was central to Islamic thought.[45] As a result, they were sometimes known as mujassima, those who ascribe jism (body) to God, and were even accused of harboring quasi-Christian beliefs concerning an embodied Godhead.

Recent scholarship has drawn attention to the survival of several copies of Karrami texts, ranging from works on fiqh (jurisprudence) and qiṣāṣ (prophetic stories) to a Qur'an commentary.[46] The possibility that extant material remains can be associated with the Karramiya has not been addressed, although we are told that sultan Ghiyath al-Din founded madrasas and khanqahs for the Karramiya and other groups and provided them with waqfs (endowment deeds) and Qur'ans.[47] A number of factors suggest that the unique Ghurid Qur'an of 584/1189 was in fact a royal commission for a Karrami institution. The presence of an interlinear Persian translation of the sacred Arabic text is not unique (although this is one of the earliest dated occurrences), but the inclusion of a Qur'anic commentary (tafsīr) at the end of each chapter (see fig. 48) is unusual in a Qur'an of this period. The commentary is that of Abu Bakr 'Atiq ibn Muhammad al-Surabadi (d. ca. 495/1101), a leading Karrami of Nishapur.[48] The unusual form of the manuscript and the presence of this Karrami exegetical work suggest that this was among the manuscripts commissioned by the Ghurids for a Karrami madrasa.

In fact, a number of surviving Ghurid monuments may have been constructed for the sect, although their significance as such has escaped notice. These include a richly decorated brick madrasa at Shah-i Mashhad in Gharjistan (571/1175–76; fig. 50) and the most spectacular example of Ghurid architectural patronage, the 65 m high minaret at Jam (roughly midway between Herat and Kabul; fig. 51).[49] Isolated today, the minaret was once associated with a mosque built of more ephemeral materials. Despite the topographic limitations of the valley site (including difficulties of access and susceptibility to flooding), the minaret is

50
Shah-i Mashhad Madrasa, Gharjistan, 571/1176, general view
from the south (courtesy of Bernt Glatzer).

generally believed to mark the site of Firuzkuh, sultan Ghiyath al-Din's summer capital. Recent illegal excavations on the hills surrounding the site have reportedly uncovered evidence for a great density of occupation in small multistoried structures, recalling medieval accounts of Firuzkuh as heavily populated.[50] However, although this was a mint city in which both gold and silver coins were struck, the nature of the site renders it unlikely that it was an imperial "city" in the usual sense. The geographers refer to it as a fort (*qal'a*) rather than a city (*madina* or *shahr*), and it has recently been suggested that the site functioned as a symbolic center intimately connected to the ruling Shansabanid family and the Ghurid elite, rather than an imperial capital.[51] The nature of the capital perhaps reflects that of the sultanate itself, "a loose patri-

mony of autonomous principalities led by a senior kinsman."[52]

The name of the architect (*mi'mar*) responsible for the minaret's construction is inscribed on the structure and has recently been read as 'Ali ibn Ibrahim al-Nishapur, suggesting that he hailed from Nishapur, the same city as the scribe responsible for the Qur'an of 584/1189.[53] The minaret bears a foundation date, but ambiguities in the Arabic script mean that scholarship has long been divided about its interpretation, with opinion split between a reading of 570/1174–75 and 590/1193–4. The latter date has long been accepted by most scholars, with the minaret consequently identified as a victory monument, commemorating Ghurid victory over the Chauhan rajas of Ajmir in 588/1192, which paved the way for the conquest of northern

51
Minaret of Jam, general view from the southeast (courtesy of MJAP 2005).

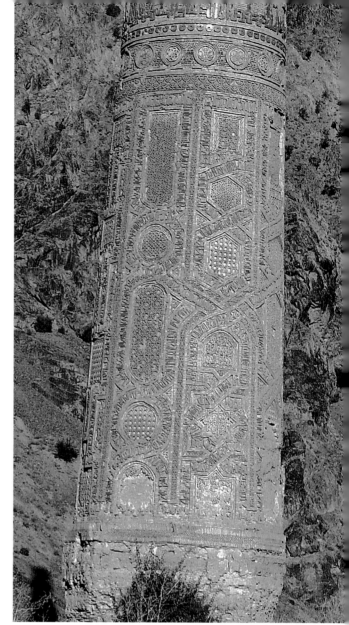

52
Minaret of Jam, detail of lower shaft showing arched panel with rhomboid knot above and star below (courtesy of MJAP 2003).

India. Recent research has demonstrated that the correct reading of its date is 570/1174–75, however.[54] Redated to 570/1174–75, the minaret is shorn of any obvious Indian associations, since it antedates the first Ghurid incursions into the Panjab (against the Isma'ilis of Multan and the Hindu ruler of Uchch) by at least a year.[55] Instead, it may commemorate the capture of Ghazni from the Ghuzz Turks in 569/1174 and Mu'izz

al-Din's elevation to the sultanate. This was a pivotal moment for the development of the Ghurid sultanate, one that resonated as far away as India.[56]

In addition to bearing historical texts and the titles of the sultan, the surface of the minaret is covered with the entire ninety-eight verses of Surat Maryam, Qur'an chapter 19, the *sūra* (chapter) of Mary the mother of Jesus. The Qur'anic verses appear

ACCOMMODATING THE INFIDEL

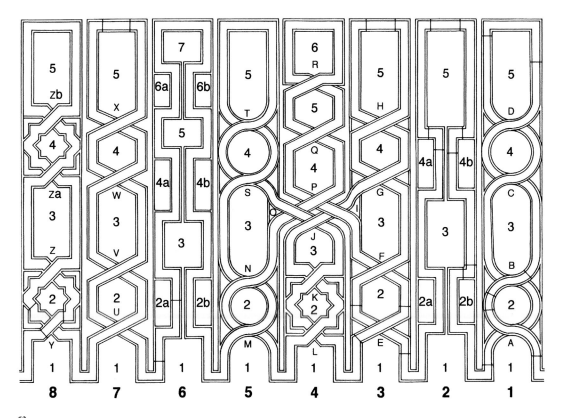

53

Minaret of Jam, schematic diagram of the epigraphic bands containing Surat
Maryam (drawing by Claire Hardy-Guilbert, reproduced with permission from
Sourdel-Thomine, *Minaret*, fig. 55).

in a series of narrow ribbonlike bands that overlap
and intersect each other to form panels filled with
geometric ornament that fill each of the eight faces of
the lowest shaft (fig. 53). Both the form and the con-
tent of the inscription are unique in the Islamic
world, and it has long been recognized that the un-
usual choice of inscriptions must have held a particu-
lar significance for the patrons of the minaret. In
keeping with its identification as a commemorative
monument to Ghurid victories in India, references to
idolatry and unbelief in the Qur'anic verses have
been read as allusions to the conquered Hindu sub-
jects of the sultan. Epigraphy has thus come to play a
central role in constituting the minaret as a symbol of
"Muslim" victory over the conquered "Hindus," tak-
ing it as a given that references to idolatry and unbe-
lief in the chosen verses were intended as allusions to
those who were literally outside the fold of Islam.[57]
However, since we now know that the minaret pre-
dates Ghurid expansion into India, this interpreta-
tion is no longer viable. Instead, close examination of
the content and spatial arrangements of the verses
suggests that their audience and referent lay closer to
home.

The decoration of the eastern face of the minaret
is distinguished by its richness, containing several
unique features delineated by narrow epigraphic
bands (figs. 52 and 53, face 4). These include an arched
panel with an eight-pointed star directly below
(marked 3 and 2 on face 4). Since one would have
faced this side of the minaret while oriented toward
the *qibla* or direction of prayer, the arched panel
should be recognized as a mihrab, which may have
been visible from the adjacent mosque. The associa-
tion with a star motif supports this identification, for
the star is part of an extended reference to the imagery
of light that pervades the decoration of contemporary
mihrabs.[58]

Directly above the apex of the mihrab another
unique design appears, a knotted rhomboidal pattern.

The inscriptions from Surat Maryam that begin here and frame the mihrab and star below (fig. 53, face 4, panel 3, between I and L) read:

> This was Jesus, son of Mary:
> A true account they contend about [34].
> It does not behoove God to have a son.
> Too immaculate is He! When He decrees a thing
> He has only to say: "Be!" and it is [*kun fayakūn* (35)].
> [Jesus only said:] "Surely God is my Lord and your Lord,
> so worship Him.
> This is the straight path" [36].
> Yet the sectarians differed among themselves.
> Alas for the unbelievers when they see the Terrible Day! [37]

The same verses had appeared in the interior of the Dome of the Rock in Jerusalem (72/692) almost five centuries earlier.[59] There, the emphasis on the mortality of Jesus had a literal relevance, revisiting a locus classicus of doctrinal difference between Islam and the Christian majority of the city, since Muslims believe in the prophecy of Jesus but not his divinity. There is, however, no evidence for the existence of a Christian community in Ghur. Moreover, to read the verses inscribed upon the minaret of Jam as a literal address to Christians is to ignore the complex valences acquired by specific verses in particular historical contexts, not only within contemporary (and sometimes contrary) exegetical traditions, but also within *kalām* (speculative theology) and other types of polemic.[60]

Significantly, medieval heresiographers tell us that the Qur'anic phrase *kun fayakūn* (Be! And it is) that falls within the privileged section in the design of the minaret occupied a central position in Karrami attempts to distinguish between the eternal attributes of God and his temporal acts, a distinction central to the contentious issue of anthropomorphism.[61] According to these accounts, the Karramiya believed that God's power extends only over those created things and temporal events that originate in His essence. These are called into being not through power, which is an eternal attribute, however, but through the temporal act of uttering the divine command *kun*! (Be!), an imperative that illustrates the creative power of God but exists in time, and thus proves the temporality of the

creative act itself. God's power to speak and his divine utterances thus constitute two temporally and ontologically distinct occurrences.[62] The former is eternal; the latter originated as a *reflection* of power (an enduring attribute) and are composed of phenomena such as the words of the Qur'an and revealed commands, promises, prophetic stories, and warnings. All these themes feature prominently in Surat Maryam, the Qur'anic chapter inscribed on the minaret. Moreover, there are only eight occurrences of the key phrase *kun fayakūn* (Be! And it is) in the Qur'an, one of which is found in verse 35 of Surat Maryam.[63] The verse is not the median point of the chapter but the thirty-fifth verse in a series of ninety-eight; considerable care was thus taken to ensure that it fell around the mihrab on the eastern face of the minaret at Jam.

While the occurrences of the phrase *kun fayakūn* in the Qur'an all appear amid elucidations of God's creative abilities, the linkage between the person of Jesus and the creative power of the divine command *kun*! illuminates these issues, since the Virgin Birth (in which Muslims believe, and which is alluded to in verse 20 of Surat Maryam) offers one of the ultimate proofs of God's ability to call into being with His command *kun*![64] However, the highlighted verses also reject Christian belief in Jesus' divinity, which contradicts the notion of *tawḥīd*, the oneness of God, central to Islamic thought. Indeed, four of the eight Qur'anic occurrences of the phrase *kun fayakūn* (including that in Surat Maryam) relate specifically to the creation and nature of Jesus, asserting his mortal character despite the unusual circumstances of his conception, and denying his divinity.[65]

Here the royal Qur'an manuscript of 584/1189 can help shed some light on the epigraphic program of the minaret, for its inclusion of the Karrami exegetical text of al-Surabadi indicates the currency of this commentary at the Ghurid court. In his exegesis of Qur'an 19:35, al-Surabadi links the phrase *kun fayakūn* with the creative power of God, while emphasizing that the verse contains a rebuttal to those who assert that Jesus was His son.[66] Considered within the frame of Karrami theology (or at least what we can reconstruct of it), Qur'an 19:34–35 thus addresses the relationship between God's eternal essence and His temporal creative powers, while underlining that the latter did not extend to the production of divine progeny.

This emphasis on the mortality of Christ highlights the issue of anthropomorphism while establishing its appropriate limits, providing a rebuttal to those critics of the Karramiya who insinuated that the anthropomorphist views of the Karramiya had a Christian origin.[67]

The discursive deployment of Qur'anic citation on the minaret reflects the ability of the timeless text to acquire specific valences that inflect its deployment in particular historical contexts. The assumption of modern historians that the "idolaters" (*mushrikūn*) referred to in the texts inscribed on the minaret were literally outside the fold of Islam ignores the polemical qualities of the term and its consequent ideological value as a weapon against *both* fellow Muslims and nonbelievers. Within the historical context of the verses' deployment, the unbelievers referred to in the Qur'anic text chosen to adorn the preeminent monument of the Ghurid capital are far more likely to be the Muslim opponents of the Karramiya (who depicted them in turn as heretics and spreaders of sedition)[68] than the distant Hindus with whom the Ghurid sultanate had yet to engage militarily. In other words, rather than an address to some nebulous polytheist "other," the epigraphic program of the preeminent Ghurid monument should be understood instead as an attempt to engage a Sunni "self" that in fact comprised multiple complementary or competing selves constituted dynamically and relationally in response to shifting cultural, historical, and political conditions.

Events in the decades following the minaret's construction demonstrate just how protean religious identity might be, for in 595/1199 the sultans of Ghur abruptly terminated their association with the Karramiya, embracing the orthodox *madhhab*s (law schools) of Islam instead. While Ghiyath al-Din embraced Shafi'ism, Mu'izz al-Din became a Hanafi, aligning himself with what was in effect the preeminent *madhhab* among the population of Ghazni.[69] Civil strife between different Sunni factions was a commonplace in the cities of eastern Iran during the eleventh and twelfth centuries—as late as the 1150s mosques and madrasas were destroyed in conflicts between the Shafi'is and Hanafis in Nishapur[70]—and these changes in Ghurid pietistic affiliations occasioned a *fitna azima* or great civil disturbance in Firu-

zkuh, the Ghurid capital. In Gharjistan, an area with historical links to the Karramiya, a leading member of the sect penned a series of polemical verses criticizing sultan Ghiyath al-Din's shift in allegiance, which were sufficiently inflammatory to earn the writer a year's exile to Nishapur.[71]

However unpopular at home, the events of 595/1199 coincide with the emergence of the Ghurid sultans as major players on the world stage, the result of rapid territorial expansion westward into Khurasan and eastward into northern India. Juzjani, the historian of the Ghurids, attributes the shift in pietistic orientation to a dream in which the eponymous founder of the Shafi'i school of jurisprudence appeared to the sultan. By contrast, the historian Ibn al-Athir (d. 630/1233) attributes the shift to the mediation of a celebrated Shafi'i *faqīh* who was invited to Firuzkuh by the court poet Fakhr al-Din Mubarakshah.[72]

The notion of a reinvention of the royal persona resulting from the agency of a single individual (visionary or incarnate) is suspect, but the general idea of mediation by individuals with strong connections to a wider Islamic world is quite plausible. The concentrated presence of major Shafi'i theologians in Firuzkuh toward the end to the twelfth century is striking. These included the Shafi'i theologian Fakhr al-Din al-Razi, who had come to preach in Firuzkuh and Ghazni at the invitation of Sultan Ghiyath al-Din and later served as *malik al-kalām* (chief of speculative theology) and as an envoy to India. Al-Razi was a fierce adversary of the Karramiya and succeeded in raising the ire of sultan Ghiyath al-Din's son-in-law, a partisan of the sect.[73] In addition, just one year before these events, in 594/1198, the 'Abbasid caliph al-Nasir (d. 622/1225) had dispatched a Shafi'i envoy from the celebrated Nizamiyya Madrasa in Baghdad to Ghur, where he remained for four years.[74] During the same period, the Ghurid sultans patronized the sufi *shaykhs* at Chisht near Jam (fig. 54), whose founder, Abu Ishaq, had come to Afghanistan from his homeland in Syria, one of a number of scholars that moved between Syria and Afghanistan in the ninth, tenth, and eleventh centuries.[75] Although sufi *shaykhs* developed strong local associations, the orders (*tarīqas*) that they founded or to which they belonged also developed significant transregional networks. Moreover, their function as highly mobile "portable vessels" of a potentially

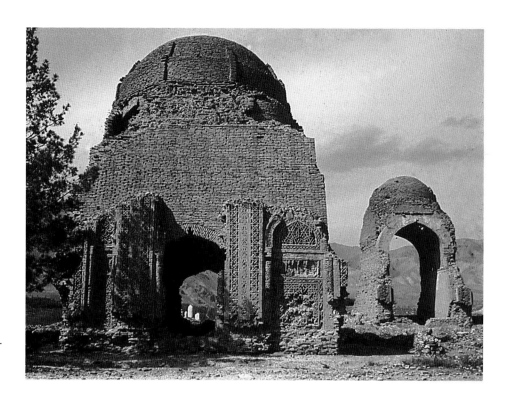

54
Chisht, domed struc-
tures (courtesy of
Bernt Glatzer).

unlimited spiritual sovereignty often attracted the pa-
tronage of medieval rulers in the newly conquered
lands of the east.[76]

This association of sufi *shaykh*s and Shafi'i or
Hanafi *faqīh*s with transregional networks of piety and
political authority was undoubtedly relevant to the
dramatic shift in the religious orientation of the Ghu-
rid sultans. In a speech against sultan Ghiyath al-Din's
guest (the Shafi'i theologian Fakhr al-Din al-Razi),
Ibn al-Qudwa, the *qāḍī* of the Firuzkuh Karramiya,
denounced him for espousing the unbelief of Ibn Sina
and the philosophy of al-Farabi, two of the great
thinkers of the wider Sunni world whose work al-Razi
had studied and commented on. In the end, al-Razi
was expelled from Firuzkuh, moving instead to Herat,
where the sultan had a madrasa built for him.[77]

As a religious faction with strong regional ties,
the Karramiya were evidently opposed to the sorts of
theological cosmopolitanism that the Shafi'is and
sufis represented. The timing of the switch to a less
localized and more transregional form of Sunni Islam
suggests, however, that it was this very cosmopolitan-
ism that attracted the Ghurids to the orthodox schools
of jurisprudence. As Bosworth remarks: "They burst
out of the confines of Ghūr, where the Karāmī di-

vines had had paramount authority in religion, into
the wider world. They came into contact here with
the two chief law-schools of Sunnī Islam in the east,
and they may have felt that the Karāmī tenets were
intellectually somewhat disreputable and too closely
linked with their backwoods origins." [78] The capacity
of the Ghurid sultans for self-fashioning was already
apparent to medieval observers, for Ibn al-Athir (d.
631/1233) observes that when they became rulers of
Khurasan (i.e., the wider Iranian world), they came
to know that the Karramiya were considered theo-
logically unsophisticated and therefore decided to
alter their doctrinal allegiances and embrace
Shafi'ism.[79] In addition, it seems likely that Karrami
asceticism and material egalitarianism were consid-
ered inappropriate to the burgeoning self-aggrandize-
ment of the Ghurids.[80]

Coinciding with the apogee of Ghurid expansion,
this pietistic realignment suggests itself as a spiritual
counterpart for the purported change of clothing that
announced Amir Banji, the rude ancestor of the Ghu-
rid sultans, as a ruler worthy of taking his place in the
'Abbasid hierarchy. In both cases, the embrace of cos-
mopolitanism had much in common with the exam-
ples of prestigious imitation discussed in chapter 2,

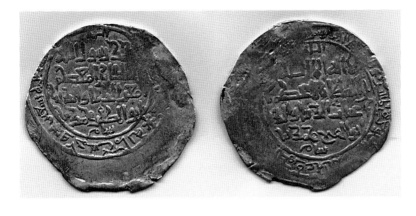

55
Ghurid epigraphic dirham struck at Ghazni in 590/1193–94 (courtesy of Tübingen University Collection, 2003.16.177).

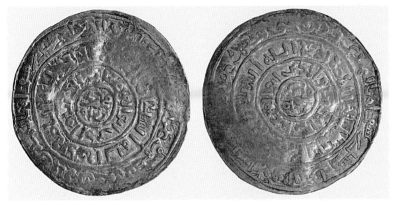

56
Ghurid dirham of "bull's-eye" type, struck at Ghazni in 596/1200 (courtesy of the American Numismatic Society, ANS 1991.40.2).

while the resistance that it engendered should be noted as the flip side of the more fluid attitudes to identity (religious and otherwise) considered in chapter 1.

The tale of Amir Banji also underlines the fact that shifts in identification and self-representation were closely related to the objects in which newly fashioned images were instantiated and through which they circulated. It will come as no surprise then that the shifts in the pietistic and political orientations of the Ghurid sultanate after 595/1199 were not confined to the abstruse realm of theological philosophy but were also reflected in the more tangible (and public) realm of coinage, a medium whose semiotic potential the Ghurids appear to have been especially sensitive to.[81] Previous to 595/1199, in addition to the ubiquitous "bull and horseman" coins of northwestern India, Ghurid mints had also issued coins of traditional epigraphic type, consisting of a central field with superimposed horizontal lines of Arabic script and a circular marginal legend (fig. 55).[82] From 596/1200, these were supplemented by a new coin type struck at Ghazni in both gold and silver, which bore a radically

new design based on a distinctive motif of three concentric circles surrounding a central epigraphic medallion (fig. 56). On the obverse, the coins bore a Qur'anic inscription, the *kalima* (profession of faith), and the names and titles of Ghiyath al-Din; the reverse contained the caliph's name and titles, those of Mu'izz al-Din, and mint information. The concentric design had the advantage of framing the identical name of each brother—Muhammad ibn Sam—in a central medallion on obverse and reverse, evoking in visual terms the dual imperium that characterized the sultanate. This new circular design was followed in 598/1201 by a second new coin type, consisting of a square epigraphic field inscribed in a circle (fig. 57).[83]

The ultimate origins of both new coin types lie in the Fatimid and Almohad polities of North Africa, but by the twelfth century they had been adopted by the Sunni rulers of the eastern Mediterranean.[84] It is possible, likely even, that the contemporary coinage of Egypt and Syria provided the particular models for the new Ghurid coin types.[85] Both regions were under the control of the Ayyubid sultan Salah al-Din (known to

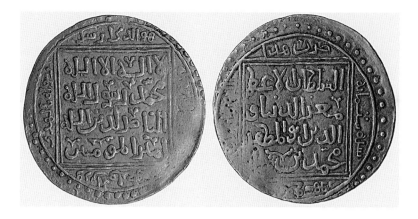

57
Ghurid dinar of "square in circle" type, struck at Ghazni in 600/1203–4 (courtesy of the American Numismatic Society, ANS 1922.216.7).

Western sources as Saladin), whose successes in ending the rule of the Fatimid Shiʿis over Egypt in 567/1171 and recapturing Jerusalem from the Crusaders in 582/1187 were irrevocably altering the balance of power in the eastern Mediterranean even as the Ghurids were reconfiguring the political landscape of the eastern Islamic lands. Although Ayyubid Syria was geographically remote from the mountain fastness of Afghanistan, the movement of merchants, travelers, and religious scholars between the wider Islamic world (including Syria) and eastern cities such as Firuzkuh and Ghazni is well documented.

Historians of the Ghaznavids and Ghurids have a tendency to calibrate their protagonists' achievements against those of celebrated Syrian precedents, and the historian Juzjani (raised at the Ghurid court in Firuzkuh) makes an explicit comparison between the military victories of Salah al-Din against the Fatimids and Christian Franks in the west and those of the Ghurid sultan Muʿizz al-Din against the Ghaznavid and Hindu kingdoms of northern India in the east during the same period.[86] The Ayyubids also championed the cause of the Shafiʿi law school, promoting themselves as upholders of Sunni orthodoxy and making prominent use of Qurʾanic inscriptions to this end.[87]

Like the sudden embrace of the orthodox Sunni law schools, these numismatic changes linked the Ghurids more directly with their Sunni contemporaries in the wider Islamic world, while also facilitating and promoting long-distance trade with regions outside the sultanate. There is a general improvement in the quality and appearance of Ghurid coins, especially gold issues, from 596/1200 onward, which probably reflects an influx of Indian gold into the coffers of Ghazni; the confidence that these coins engendered is reflected by their continued use in Iran decades after the fall of the sultanate and by their circulation as far west as England.[88]

Both of the new Ghurid coin types bore the same Qurʾanic verse—9:33—which asserts the superiority of the true faith (dīn al-ḥaqq) despite the opposition of the polytheists (al-mushrikūn). The verse is a common one on Islamic coinage, perhaps by virtue of its use on the banner of the ʿAbbasid caliphs, but this appears to be the first time that a Qurʾanic text appeared on any Ghurid coin.[89] It is tempting to relate its appearance and content to the Indian campaigns that were taking place at this time, and which probably provided much of the gold from which the new issues were coined. However, this Qurʾanic assertion of orthodoxy is associated with the new "international" coin types, whose introduction followed hard on the heels of the Ghurids' radical shift away from the Karramiya and toward the more mainstream schools in 595/1199, and is likely to be related. Coins minted by the Ghaznavid and Seljuq predecessors of the Ghurids were sometimes inscribed with Qurʾanic citations chosen for their ability to promote the position of a particular Sunni faction over its rivals, providing a precedent for the deployment of scriptural quotation as part of an intra-Muslim polemic.[90]

As Juzjani's comparison between the Ghurid sultan and Salah al-Din suggests, campaigns against heterodox Muslims and Hindu unbelievers were equally useful in acquiring a religious pedigree for parvenu potentates. An intrinsic association between the suppression of heresy and the chastisement of unbelievers, apparent in the titles of the Ghurid sultans, re-

ACCOMMODATING THE INFIDEL

flects ideals of kingship marked by the perception of a close relationship between disorder in religious affairs and disaffection and instability in the polity, a relationship that pervades the "Mirrors for Princes" genre of literature that proliferated in the eastern Islamic world during the eleventh and twelfth centuries.[91] In a frontier variant of the genre dedicated to the Delhi sultan Iltutmish (d. 633/1236), Fakhr-i Mudabbir states that one of most important duties of the ruler is to wage war on unbelievers, the seditious, and the enemies of religion (*kāfirān wa mufsidān wa khuṣmān-i dīn*), echoing the titles and encomiums of sultan Ghiyath al-Din.[92]

Similarly, in his effusive praise of the Seljuq sultans of Anatolia, Najm al-Din Razi (d. 654/1256) lays out the ideal duties of a king. In addition to the subjection and punishment of infidels, evildoers, and heretics, the ruler's duties include

> raids and conquests in the lands of unbelief; the capture of citadels and castles from the heretics (*mulāḥida*); the building of colleges and hospices, mosques, small and great, and their pulpits, bridges, caravanserais, hospitals, and other pious foundations; the honoring and patronage of the scholars of religion; the cherishing and veneration of ascetics and devout men; the care and compassion shown to all the subjects of the king.[93]

There could be no better summary of the activities of the Ghurid sultans (with whom the sufi author of this text had briefly sojourned) and their subordination of both architecture and epigraphy to the promotion of orthodoxy in the last decade of the twelfth century. At this time a major architectural program was undertaken in the name of the Ghurids in Afghanistan and India. Like the new coin types introduced around the same moment, this program is intimately related to contemporary shifts in religious patronage. As Sheila Blair notes: "These royal sponsored monuments show not only that the Ghurids were lavish patrons of architecture, but also that their architectural endowments were part of a coordinated campaign to champion Islam. In part, this was done through the patronage and endowment of mosques and madrasas, both to convert the heathen and to counter internal heresies."[94]

When Ghiyath al-Din embraced Shafi'ism, he commissioned Shafi'i madrasas and a mosque at Ghazni, which was not finished until after his death. In 597/1201, a fire provided him with the opportunity to undertake a major renovation or rebuilding of the congregational mosque of Herat (fig. 58), at which time the imamate of the rebuilt mosque was taken away from the Hanafis and became the perpetual preserve of the Shafi'is.[95]

Firuzkuh is usually described as the Ghurid "capital," but as the geographers emphasize, it was located between Herat and Ghazni, which were more important to the exercise of Ghurid imperium and artistic patronage than was their remote mountain stronghold. A major metalwork school was centred in Herat during this period, when stylistic and epigraphic evidence attests the participation of its denizens in Ghurid architectural projects as far away as the Indus Valley and the northern Indian city of Ajmir. The Ghurids did not secure their control over Herat until 571/1175, but it was here that Ghiyath al-Din was buried, in a tomb adjacent to the mosque that he rebuilt. The Mongol historian Juvayni (d. 681/1283) refers to the city as Ghiyath al-Din's ancestral power base, an assertion that, while erroneous, is nonetheless revealing.[96]

Although the remnants of Ghiyath al-Din's tomb in Herat were swept away in the 1940s, portions of the Friday Mosque that it adjoined are still preserved.[97] Unfortunately, its once extensive epigraphic program survives only in very fragmentary form, but a noteworthy feature of the foundation text preserved in the glazed terracottas of the eastern *īwān* (see fig. 58) is its assertion that sultan Ghiyath al-Din financed the mosque from his own money (*min khālis mālahu*), that is, from the privy purse rather than the state treasury (*bayt al-māl*).[98] Although not stated in the inscription, the public insistence on (and memorialization of) the origin of the capital may reflect the fact that at least some of it derived from Ghiyath al-Din's share of the golden booty taken after the fall of Ajmir, the capital of the Chauhan rajas of Rajasthan in 588/1192.[99]

The use of Indian booty to underwrite an architectural program designed to foster Sunni orthodoxy reflects the increasingly complex imbrications between the newly conquered Indian territories and the Afghan heartlands of the sultanate. Kafadar has noted in another context that championship of the faith constituted "a form of symbolic capital that could turn a title into (political and economic) entitlement."[100] As

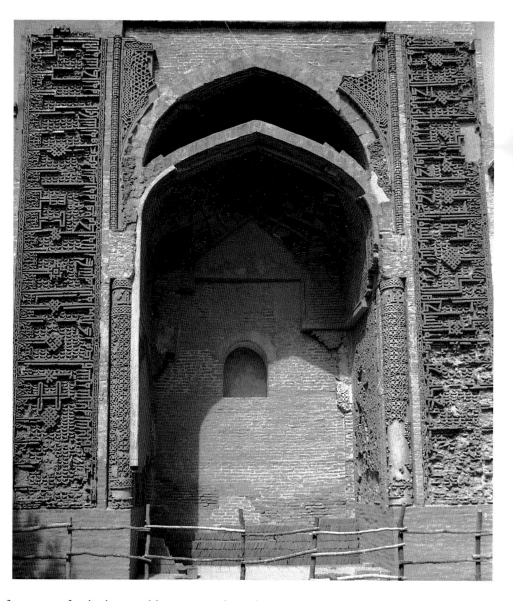

Bosworth quips, "the enforcement of orthodoxy could have its profitable side."[101] The relationship of the Ghurid sultans to the *dār al-Islām* was inseparable from their engagement with the territories of the *dār al-harb*, which provided both the financial and the symbolic capital essential to the Shansabanids' efforts to refashion and reposition themselves in the late twelfth century. Framed within the rhetoric of idolatry, the Ghurids' victories in India were useful for bolstering their orthodox credentials in Baghad and the wider Islamic world. The historians aggrandize Mu'izz al-Din's role as champion of the faith, identifying him as *sulṭān-i ghāzī* (sultan of the holy warriors) and depicting the Indian campaigns of the sultan as a confrontation between the army of Islam (*lashkar-i Islām*) and the army of unbelief (*lashkar-i kuffar*).[102]

Among the resonant titles claimed by Sultan Mu'izz al-Din was that of the Second Alexander (*Sikandar al-thānī*), a title later taken up by the Delhi sultans and even the Khwarazmshah successors of the Ghurids, who never set foot in India.[103] Invoking the other celebrated conqueror of northern India who came from the west, the title integrated the Ghurid sultan into an Iranian tradition of conquest vis-à-vis India, much as his claim of descent from the tyrant Zahak (a denizen of the *Book of Kings*) served to locate

ACCOMMODATING THE INFIDEL

him (albeit somewhat oddly) within the legitimizing tradition of Iranian monarchy. The fluidity of Ghurid titles and epigraphic self-representations, and the responsiveness of their religious patronage to the exigencies of rule within and without their mountain homeland, bespeak a pragmatism that is no less relevant to the other imperative that faced the newly ascendant mountain chiefs: the projection of authority in their newly acquired Indian territories.

| Homology, Ambiguity, and the Rule of Śrī Hammīra

Ghurid expansion into northern India in the 1190s has traditionally been depicted as a (or indeed *the*) "Muslim" or "Islamic" conquest, a confrontation between a reified Muslim self and a hypostatized Hindu "other" constituted as its opposite. The notion is problematic, not least because it assumes (and produces) two monolithic entities that never existed. On the one hand we have the antagonistic engagements between Sunnis and Shi'is of various sorts that were integral to the self-fashioning of the Ghaznavid and Ghurid sultans; on the other, the competition among Sunni factions for architectural, intellectual, and political patronage in eastern Iran and Afghanistan reflected in the protean nature of Ghurid self-identification. In addition, the titulature of the Ghurid sultans assumes an intrinsic identity between the dangers posed by unorthodoxy and unbelief. It should be borne in mind that the eastward expansion of the sultanate began not with an attack on the Rajput kingdoms of India but with a campaign against the Isma'ili rulers of Multan.

Intrinsic to the idea of a Muslim conquest of India is not only the assertion of singular sectarian identities but also the assumption that eastern Iran and northern India constituted distinct cultural spheres. As we saw in chapters 1 and 2, however, the supposedly incommensurate worlds of the *dār al-Islām* and *dār al-ḥarb* were already imbricated in a variety of ways long before northern India came under the sway of the Ghurids in the late twelfth century. During the eleventh and twelfth centuries, Persian texts and Sanskrit inscriptions attest to continued Indian raids by the Ghaznavids, including assaults on Ajmir in Rajasthan and Ujjain in Malwa, capitals of the Chauhan and Gahadavala rajas of Madhyadesha.[104] Although these raids were evidently intended to replenish the dwindling coffers of the sultanate, a more long-term cultural impact is possible. Nagaur in Rajasthan is said to have been captured by the Ghaznavid rebel Muhammad Bahalim during the reign of Bahram Shah (d. 552/1157), and it is possible that a small community of Muslims existed there from this date.[105] Similarly, describing the Ghurid conquest of Benares in 590/1194, Ibn al-Athir states that there had been a Muslim community following the Shari'a in this region since the days of Mahmud of Ghazni.[106]

Our knowledge of medieval Ghur is limited, but there are also hints at mercantile and other connections with northern India even before the sultans of the region embarked on their campaigns of expansion. Al-'Utbi (d. ca. 431/1039) refers to Muhammad ibn Suri, a Ghurid chief defeated by sultan Mahmud of Ghazni, as a Hindu, while Fakhr-i Mudabbir states that only those of sultan Mu'izz al-Din's subjects who had not a "base Hindu" (*razālat-i Hindū*) or a fool among their ancestors could acquire slaves, horses, and camels. Although Hindu was probably a generic term for a person of dark complexion or an unbeliever, the choice of the pejorative is itself indicative of contact and proximity.[107] In addition, several later sources mention that Muhammad ibn Suri's grandson fled to India, took up residence in a temple there, and became a merchant, transporting commodities between Delhi and Ghur.[108]

Commercial activity between eastern Iran, Afghanistan, the Indus Valley, and the Gangetic Plain was not necessarily incompatible with (or even inhibited by) military engagement. Despite the bloody battles on which it was predicated, Ghurid expansion in the late twelfth century may even have fostered mercantile contacts along the terrestrial trade routes. During this period the Jewish and Muslim traders whose presence is reported in Anhilawad or Patan, the capital of the Solanki or Chalukya rulers of Gujarat, find counterparts in the Indian merchants from the same city who traded in Mu'izz al-Din's capital of Ghazni, and as far west as Bardasir, Jiruft, and Kirman in Iran.[109] When Ghurid troops entered Bengal, they were taken for Turkic horse traders, who evidently operated this far east well before the Ghurid conquest; the interesting possibility of an emergent relationship

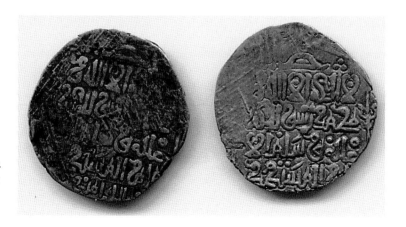

59
Ghurid pale gold dinar minted at Firuzkuh
between 558/1163 and 565/1170 with trident
motif on obverse (courtesy of Tübingen
University Collection, XIVd.809).

between Turkic horsemen or horse traders and local
northern Indian pastoralists in the eleventh and twelfth
centuries has recently been raised.[110]

Under the Ghurids, the trade with northern India
was facilitated by the reintroduction to Afghanistan of
the bull-and-horseman coin (the most common form
or northern Indian currency) for the first time since
the demise of the Hindu Shahis in the early eleventh
century. Whether this was the result of a revival of
Hindu Shahi coin types, a borrowing from earlier
Ghaznavid coins of the same type minted in the Indus
Valley, or an inspiration from contemporary northern
Indian coinage is unclear, but the possibility that In-
dian mint masters were brought to Afghanistan to
work in Ghurid mints has been raised.[111]

A more concrete reflection of these hypothetical
cultural flows manifests itself in the prominent appear-
ance of the trident or *trisūl* on a pale gold dinar struck
at Firuzkuh, Ghiyath al-Din's summer capital, between
558/1163 and 565/1170 (fig. 59). The trident is a variant
on the pictograms of bows, maces, spears, and swords
inscribed as symbols of authority on the eastern coin-
age of Turkic dynasties (Qarakhanids, Ghaznavids,
and Seljuqs) from the late tenth century onward. It
had been used as a metonymic representation of Shiva
emblazoned on the rump of Nandi, his bull mount, on
the ninth- and tenth-century bull-and-horseman coin-
age of the Hindu Shahis whose territories included
much of central and eastern Afghanistan (see fig. 6).
The appearance of the motif on Ghurid coins may
therefore derive from earlier Afghan precedents rather
than direct contacts with contemporary northern

India.[112] Nevertheless its deployment on Ghurid coin-
age serves as a reminder that in some aspects of its cul-
ture at least, Ghur participated in an Indic world well
before Ghurid expansion into northern India.[113] Fur-
thermore, the assimilation of the trident to the martial
imagery of Turko-Persian kingship, and its appearance
alongside the caliph and sultan's names and titles,
points to a capacity for adaptation, appropriation, and
translation writ large in the monuments of the period,
as we shall see in chapters 4 and 5.

In addition to mercantile contacts, texts and in-
scriptions suggest that diplomatic and military en-
gagements between the elites of the Ghaznavid and
Ghurid sultanates and the Rajput polities of north-
western India increased in volume and tenor in the
second half of the twelfth century. These are best doc-
umented for the Chauhan or Chahmana rajas of
Shakambhari who ruled from Ajmir (Ajayameru) in
Rajasthan. In the second half of the twelfth century,
Vigraharaja IV expanded the area of Chauhan domin-
ion, with both Delhi and Hansi being seized from the
Tomars; an inscription of this ruler incised upon an
ancient Ashokan pillar speaks of him extending the
dynasty's sway from the Himalayas to the Vindhyas,
and lauds his victories over *Mleccha* (foreigner) armies
(fig. 180).[114] The Ghurid sultans continued these en-
gagements even before their final defeat of the Ghaz-
navids in 581/1186, and they increased in pace after
Mu'izz al-Din's installation at Ghazni as sultan in
569/1174.

At some point during this period Mu'izz al-Din is
reported to have sent at least one envoy to Prithviraja

ACCOMMODATING THE INFIDEL

Chauhan III, raja of Ajmir, inviting him to convert to Islam or submit to the sultan's authority. The sultan's behavior conforms to orthodox Islamic practice, reiterating similar invitations extended by the Prophet Muhammad to the Byzantine, Sasanian, and Abyssinian rulers of his day.[115] It also conforms to Ghurid treatment of their coreligionists, recalling an invitation to Khusrau Malik, the last Ghaznavid sultan of Lahore to accept Ghurid sovereignty.[116] Two near-contemporary descriptions of the embassy to Ajmir are preserved, one in a Sanskrit text, the other in a Persian history; they make an interesting comparison. The description of the mission in the *Prithvīrājvijaya* of Jayanaka (ca. 1192), a chronicle of the last Chauhan raja, makes the body of the Ghurid ambassador a legible tablet of differences perceived in strictly negative terms:

> His head was so bald and his forehead so broad that it was as if God had intentionally made them thus to inscribe [as on a copper plate] the vast number of cows he had slain. The color of his beard, his eyebrows, his very lashes was yellower than the grapes that grow in his native region [of Ghazni]—it was almost as if even the color black had shunned him for fear of being stained by his bad reputation. Horrible was his speech, like the cry of wild birds, for it lacked cerebrals; indeed, all his phonemes were impure, impure as his complexion. . . . He had what looked like skin disease, so ghastly white he was, whiter than bleached cloth, whiter than the snow of the Himalayan region where he was born.[117]

Both figuratively and literally, the messenger is a pale reflection of his Ghuri overlord, whose very name, punningly glossed in the Sanskrit as "cow-enemy" (*go-arī*), evokes his inversion of the natural order.[118] The emphasis here on the guttural speech of the Afghan envoy and its impure phonemes asserts a generic quality of *Mlecchas* echoed in a description of the Afghans employed at the court of the Delhi sultans less than a century later, whose voices are compared to those of jackdaws, their tongue to a battering ram assailing the ears of the listener.[119]

A more upbeat assessment of the same mission appears in the *Tāj al-Maʾāthir* (begun ca. 602/1205–6),

from which we learn that the envoy was the sultan's chief vizier (*sadr-i kabīr*), Qiwam al-Mulk Rukn al-Din Hamza:

> On reaching Ajmer the envoy set about his diplomatic obligations according to the royal decree. He conveyed the message of the king to the raja in a refined and graceful manner, putting subtle ideas in an elegant language. He strung the pearls of counsel and admonition in the thread of fine phraseology. But, it seems the language of reproof and threat produced no impact on the mind of the ill-advised ruler.[120]

Just as the ambassador conforms to a set of negative stereotypes in the Sanskrit text, so in the Persian he conforms to an ideal ambassadorial type: handsome, scholarly, and mellifluous of tongue.[121] Neither source specifies the language in which the ambassador spoke, but the *Lalitavigraharāja*, a drama written around 1150 CE at the court of the Chauhan raja Vigraharaja IV, mentions Turkic prisoners who spoke Magadhi (suggesting that they were native to northern India) and an ambassador from *Hammīra* (i.e., *Amīr*, probably the Ghaznavid sultan), who is said to have spoken Sanskrit.[122] In whatever language the later embassy was conducted, however, something was clearly lost in translation, even allowing for the rhetorical frames within which these encounters were inscribed.

Tropes of incommensurability were central to the act of framing and proliferate in the Persian chronicles, which depict the military engagements that followed the failure of these diplomatic overtures as a confrontation between the army of Islam (*lashkar-i Islām*) and the army of unbelief (*lashkar-i kuffār*).[123] Similarly, representing their engagements with Ghaznavid and Ghurid armies, Rajput rulers adapted dyadic tropes of good and evil, the demonic and the virtuous, in order to both denigrate their opponents and aggrandize their own role. Among many examples, a *praśasti* (inscribed eulogy) of the Chauhan raja Prithviraja II found at Hansi in the Panjab and dated Samvat 1224/AD 1168 describes his *Turuṣka* foes as *rākṣasas* (demons).[124]

Most modern historians have followed the rhetorical categories of the medieval chroniclers on whom they draw, reducing complex historical processes to a confrontation between two incommensurate and op-

posed traditions. As one scholar notes, "In the predominance of a constantly replenished slave aristocracy, the adoption of a Persian idiom of rule, and in its profound iconoclasm and insatiable appetite for precious metals, the Turkish state of the eleventh to thirteenth centuries introduced an Islamic pattern, familiar in the Middle East, but alien in India."[125] Central to this scenario is the notion that the defeat of the major Rajput houses of northern India by the Ghurids created a cultural and political tabula rasa:

> With the conquest, Muslims became the ascendant power and the new kings, unlike their Muslim predecessors in the subcontinent, viewed the world more clearly in terms of *dār al-Islām* and *dār al-Ḥarb*. Emphatically bent on the expansion of Islamic authority, often through violently iconoclastic conquest, they sought to create an entirely new and Islamic dispensation. In this endeavour, which tried to sweep away all before it, adaptations of the old order of things could find little place.[126]

In such figurations, the "Islamic dispensation" stands in opposition to the Indic or "Hindu" modes of governance that it supplanted. Marxist historians might interpret the radical shift from one to the other positively as "a revolution of Indian city-labor led by the Ghurian Turks," but the majority of commentators have been less enthusiastic about what they have interpreted as a shift from a model of incorporative kingship and ritual hegemony to a radically different paradigm, in which a unitary Indo-Persian superstate was created through the subjugation of pagan polities.[127] Common to both interpretations, however, is the a priori assumption that the "new world order" initiated by Ghurid victories was incapable of adapting to or reaching accommodation with "the old order of things."

Things were rarely so black and white, however, and as numerous studies of the role of ideology in modern and premodern societies have demonstrated, accommodation, co-option, and negotiation were often as central as force or imposition in struggles for authority and dominion, even if they were not signaled as such. Among the rare acknowledgments that this was so is Peter Jackson's observation that in their use of elephants, astrologers, and horoscopes, the Delhi sultans who succeeded the Ghurids adopted Indic customs. There is, however, a crucial caveat, namely that "cultural borrowings of this kind by Muslim rulers cannot be taken, of course, as a sign of accommodation with the infidels; they represent merely an adaptation to Indian conditions."[128] The criterion for distinguishing between accommodation and adaptation is unclear, but it appears to lie in a differentiation between active engagement and passive reception. As an a priori attempt to set the parameters of transculturation, the distinction recalls Peter Hardy's earlier insistence that the Ghurids and early Delhi sultans could not have exercised authority (defined as "enjoying voluntary cooperation") over conquered Rajputs but only "power" and "influence."[129] This depends on an especially restrictive definition of "authority," which other political theorists define more broadly as "an exchange phenomenon in which loyalties and other resources are provided in return for value satisfaction (or relief from value deprivation)."[130]

Moreover, this a priori denial of accommodation runs counter to the impression conveyed by studies of the cultural and political relations between Muslims and non-Muslims in other frontier regions of the medieval Islamic world, which have emphasized that "pragmatic relations with infidels" were often the norm, whether or not they were signaled as such in contemporary histories.[131] Even the worldview of the medieval jurists was not a binary one. Hence, as we saw in chapter 2, Turkic sultans frequently reached accommodation with Rajput rulers when it suited their broader political ends. This is no less true of the Ghurids.

Following the defeat of a Chauhan-led coalition at Tar'ain in 588/1192, the armies of the Ghurid sultan ranged as far south as Gujarat and as far east as Benares. By 599/1203 they had defeated the Chalukyas at Mount Abu, the Parīhars of Gwalior, the Gahadavalas of Kanauj, and the Chandellas of Kalinjar.[132] However, although the events of this decade are traditionally seen as figuring a radical rupture in the cultural fabric of northern India, in many ways the new political order instituted there in the wake of the conquest looked very much like the old. In several cases, scions of defeated dynasties were reinstated as tributary subjects of the Ghurids. Serendipitously or not, the accommodations reached with these Rajput chiefs conform to the normative ideals of Indic kingship.

Postconquest arrangements are best documented for Ajmir, where the survival of a "bull-and-horseman" coin bearing the names of both Prithviraja Chauhan III and Muhammad ibn Sam has led to speculation that the Chauhan ruler accepted Ghurid suzerainty.[133] According to most sources, however, Prithviraja was killed in battle, or captured and executed after plotting against the Ghurids; it is now generally assumed that the coin is a "mule," whose hybrid form reflects the availability of obsolete dies in the mint of Ajmir, which continued to operate unhindered after the conquest.[134]

Nevertheless, the death of Prithviraja did not signal the extinction of the Chauhan line, for we know from several sources that his son, Govindaraja, was reinstated as a tributary of the Ghurid sultan, ruling over Ajmir and the important fort of Ranthambhor.[135] The same pattern seems to have been followed in Delhi, whose ruler (or his son) accepted Ghurid suzerainty, paying tribute and dispatching gifts to the Ghurid sultan Mu'izz al-Din.[136] In Gwalior, the Parihars apparently retained their fort after an initial siege in 592/1196 by paying annual tribute to the Ghurids.[137] The evidence for Kanauj is more tenuous, but Hasan Nizami reports that after the defeat of the Gahadavala raja Jayachandra, Aybek installed "a *rāna* in every direction," and there is epigraphic evidence that a scion of the defeated Gahadavala dynasty continued to rule after his father's defeat.[138] In this way, some local elites remained entrenched but subservient (however nominally) to their new Ghurid overlord or his local Turkic representatives.

How long these arrangements lasted is not clear, for the chronology of the immediate postconquest period is murky. However, Hariraja, the brother of the defeated Prithviraja III Chauhan, led a revolt against Ghurid rule in or shortly after 589/1193 and briefly succeeded in regaining Ajmir, apparently damaging Muslim mosques or shrines there.[139] Chauhan revanchism seems to have destabilized most of northwestern India, for the *Tāj al-Ma'āthir* indicates that Delhi was finally occupied by the armies of the sultan after the involvement of its ruler in the revolt of Hariraja. Gwalior was taken by Qutb al-Din Aybek slightly later, in 597/1200–1201.[140] The Chauhan prince of Ajmir fared better, for he was still in power in 1194 or 1195, when he was rewarded with a robe of honor

(*khil'a*) for his continued loyalty in the wake of his uncle's failed revolt, a very public affirmation of his incorporation into the Ghurid body politic.[141]

These accommodations call into question the well-established distinction between the ritual hegemony exercised by "Hindu" kings and the military force through which their Muslim contemporaries exerted their authority.[142] Moreover, the reinstallation of the scions of defeated non-Muslims runs counter to the prescriptive norms of Turko-Persian kingship articulated in numerous "Mirrors for Princes" texts, which rail against the practice of reaching accommodation with weaker unbelievers as an inversion of the moral order.[143] The reinstallation of the son of the defeated Chauhan king as a Ghurid vassal also appears somewhat anomalous within classical Islamic theories of war. These allow for the recognition of a non-Muslim foe who capitulates to a Muslim and for a Muslim ruler to enter into a treaty relationship with an undefeated non-Muslim foe, reconstituted as a tributary.[144] This arrangement was a convenient means both of precluding unnecessary conflict and of obtaining useful revenues in the form of tribute payments. As we saw in chapter 2, the practice had been followed by the Ghaznavids and the Arabs of Sind before them in their dealings with their Indian adversaries. The reconstitution of the raja of Kalinjar as a Ghaznavid vassal almost two centuries earlier is a textbook case: the latter had not been defeated militarily but had capitulated and was thus permitted to retain his sovereignty, however diminished by his acceptance of a tributary status.

By contrast, the Chauhan house had not capitulated but had resisted and been decisively defeated in battle, its celebrated chief Prithviraja killed. Jurists belonging to the Hanafi school to which sultan Mu'izz al-Din subscribed are a little more equivocal on the status of conquered land, permitting its remittance into the hands of non-Muslims on payment of the land tax (*kharāj*), but without any indication that it should remain under the administration of a non-Muslim ruler who has been roundly defeated in battle.[145]

The reinstallation of the sons of defeated foes is, however, perfectly consonant with the normative ideals of *dharmavijaya*, or righteous conquest, an ideal common to both Buddhist and Hindu codes governing the conduct of conquest and warfare. According

to the *Arthashāstra,* the classic Sanskrit text on state-craft (compiled before the fifth century AD), in order to secure peace after a victory, a conqueror "should install in the kingdom the son of the king killed in action; all conquered kings will, if thus treated, loyally follow the sons and grandsons of the conqueror" (VII.16).[146]

Righteous conquest has as its defining characteristic not the annihilation but the subordination of a conquered king in conditions that encourage continuity in the cultural, economic, and religious life of a defeated polity. The *Arthashāstra* advises a righteous victor to ensure this by adopting the mode of life, dress, language, and religious practices of the conquered population.[147] Such subordinated rivals conform to the category of *sāmanta,* or vassal king, that is well known from Sanskrit historical texts and inscriptions; *sāmanta*s retained their right to rule over their territories providing they acknowledged the suzerainty of the overlord, acquiring a status equal to that of a governor.[148] The practice was directly related to the polycentric ideals of Indian kingship in which the incorporation of smaller regional centers into larger hierarchical political structures was essential to the process of state formation.[149] These arrangements were often cemented by intermarriage, a practice that might explain a curious assertion by the historian Ibn al-Athir that sultan Mu'izz al-Din married the daughter of the Hindu ruler of Aja (Uchch) in the Indus Valley as part of the arrangements that led to the surrender of that city in 569/1174; the princess is reported to have been brought to Ghazni, where her tomb later became a popular shrine.[150]

From what we know of them, therefore, the political arrangements made in the aftermath of the Ghurid conquest were perfectly congruent with Indic norms of conquest and the practices of preconquest Indic kings, as Peter Hardy has noted. In many respects they appear closer in spirit (and indeed in detail) to the ideal model for incorporative kingship prescribed in the *shāstra*s than to the theory or practice of warfare in the contemporary Islamic world.[151] This congruence with the norms of *dharmavijaya* may be fortuitous, but the reinstallation of the sons of defeated rivals is noted as a peculiarity of Indian kingship by Muslim travelers as early as the tenth century.[152] It should be noted, however, that there were occasions when the Ghaznavids and Ghurids rein-

stated the sons of their defeated Muslim foes.[153] It is therefore perfectly possible that this system represents the extension of established practice to India, facilitated perhaps by homologies in Indic protocols of warfare and governance. In any case, seen from the perspective of established Indic norms, sultan Mu'izz al-Din appears much as a paramount king ruling over his *sāmanta*s, as Peter Jackson observes: "The Ghurid Sultan's position was that of an over-king presiding over a number of tributary princes, the *rāīs* and *rāna*s who came, in Ḥasan-i Niẓāmī's words, 'to rub the ground of the exalted court of Aybeg [Mu'izz al-Din's Turkic general].'"[154]

Political theorists have noted that polities are more durable to the extent that they co-opt or incorporate competing ideologies and identities. For this reason, in the expansion of political dominion over newly conquered territories (especially those located at a remove), local contexts and structures often shape the role and nature of incorporation.[155] These imperatives are given additional impetus in conditions of military superiority and demographic inferiority, a state of affairs reflected in an early thirteenth-century image of the Muslims scattered across India like grains of salt in a dish.[156]

Reinstated Rajput bloodlines were only one element in the postconquest administration of northern India, however. A second (and statistically more significant) factor was the introduction to India of the administrative *iqtā',* a type of land and/or revenue assignment that might or might not be hereditary and that carried with it military (or, more rarely, financial) obligations to the state. The arrangement obviated the need to find funds to pay the army while also generating revenue for the state. It had become the dominant form of land grant in the eastern Islamic world during the eleventh and twelfth centuries.[157]

The territories ruled by Mu'izz al-Din from Ghazni appear to have been considered as part of his personal appanage, and most of the *iqtā'*s created in India were assigned not to the *malik*s of Ghur (who played a negligible role in the administration of the Indian territories) but to the *mamlūk*s or manumitted Turks, on whom fell the lot of consolidating and securing the eastern marches of the sultanate.[158] Captured or purchased from Central Asia (an undertaking facilitated by Indian wealth), these slaves were alienated from their homelands and underwent a breaking down and

remaking of social identity before manumission.[159] The most significant among them were the *bandagān-i khāṣṣ*, an elite cadre educated in *adab* (etiquette), Islam, and the arts of war. Unlike the potentially recalcitrant nobles of Ghur, the *bandagān* owed a personal fealty to the sultan, a relationship reflected in their assumption of possessives such as *al-sulṭānī* (of the sultan) or *al-Muʿizzī* (of Muʿizz [al-Din]).[160]

The historian Irfan Habib assumes that the introduction of the mamluk institution to India reflects the inability of traditional clan-based Ghurid political structures to offer a "framework for empire."[161] By contrast, Sunil Kumar has offered a more complex reading that sees the role of the Indian *bandagān-i khāṣṣ* as an adaptation for the frontier environment, an extension of the horizontal clan system of the Shansabanids to those bound to the sultan by ties of loyalty and patronage rather than blood and family: "The organization and deployment of the Muʿizzi slaves [those belonging to sultan Muʿizz al-Din] was conflated with the political practice of the Shansabanid family where together with the tradition of corporate egalitarianism there was the recognition of a nominal senior."[162]

As within the Shansabanid family itself, affinal ties between the *bandagān* were created and reinforced by intermarriage, with the elite corps of the sultan reiterating and replicating not only the political structures of the Ghurid sultanate but the institution of mamlukage itself. This adaptive extension of the clan-based system of Ghur and the flexibility toward administration of the Indian territories that it implies are in keeping with the simultaneous reconstitution of Rajput scions as Ghurid vassals.

The arrangements made in the immediate aftermath of the Ghurid conquests thus saw sultan Muʿizz al-Din ruling over an eclectic combination of subordinate Turks collecting revenues and providing service, and vassal Hindu princelings ruling all or part of their ancestral territories reapportioned as appanages. In effect, the decade following Ghurid expansion was marked by the practice of an eclectic, transcultural form of kingship resulting in the emergence of what Khaliq Ahmad Nizami referred to as "a type of polity, half-Ghurid, half-Indian."[163]

As I noted above, the reinstatement of the sons of the defeated conforms to the norms of Indic kingship but also finds precedents in Ghurid treatment of their defeated Muslim foes. It is possible, therefore, that the emergence of hybrid modes of governance was facilitated by homologies in the exercise and devolution and authority in both domains. Mohammad Habib has, for example, drawn attention to similarities between the distribution of land assignments by paramount kings within Rajput clan structures and within the clan-based structures of Ghur.[164] In addition, the *iqṭāʿ* system might be compared to the structures of the Rajput polities that it displaced. The granting of towns or villages as remuneration to both subordinate chiefs (*sāmanta*s or *rānaka*s) and military officers (*rāuta*s), sometimes with the right to a share in their revenues, is for example attested to among the superordinate kings of preconquest northern India, among them the Chauhans of Shakambhari, whom the Ghurids succeeded.[165] Just as the subordinate chieftain had a status comparable to that of a governor, deriving his authority from an overlord to whom he rendered certain dues, so the role of the *muqṭaʿ* or *iqṭidār* (holder of an *iqṭāʿ*) was essentially that of a provincial governor to whom some of the sultan's authority had been delegated and who shared in his overlord's sovereignty.[166] Whether the Indian vassals of the Ghurids were obliged to supply an annual levy of cavalry or infantry, a duty of the *sāmanta*, is unclear, but these might account for some of the Indian contingent (*hashm-i Hindūstān*) in Qutb al-Din Aybek's armies, which included varieties of *sāmanta*s including *rāutagān* (or *rānāgān*) and *thākurān* (petty chiefs and military grantees).[167] That Hindu petty chiefs and military grantees were among the military clients of the Ghurids' Turkic generals by 1206 suggests a degree of continuity not only among the ruling houses but among the lower strata of the elite also.

On the Indian frontier, as in medieval Anatolia, the *iqṭāʿ* may have been more protean in nature than in the central Islamic lands.[168] Moroever, an *iqṭāʿ* could consist of the fiscal rights to conquered lands that remained in the hands of their former owners, the holder of the assignment benefiting from the collection of the land tax (*kharāj*), part of which was remitted to the state coffers.[169] In these circumstances, it is conceivable that homologies between the offices of *sāmanta* and *muqṭā* permitted *both* lands given as appanages to Indian vassals and those assigned to Turkic mamluks to be conceptualized as types of *iqṭāʿ*, producing revenue and tribute for the coffers of the sultanate. Here the lack of overlap between both

types of assignment is striking and surely relevant: for example, Ajmir, the seat of the reinstated Chauhans, is never listed among the *iqtā*'s of northern India, unlike the nearby former Yadava center of Bayana, whose rulers were not reconstituted as Ghurid vassals.

The scenario outlined here finds later parallels in the Deccan, where homologies between Indic and Islamic cultural forms and practices (what Wagoner terms "fortuitous convergences") permitted their mutual adaptation and assimilation after the Delhi sultans expanded their reach there in the fourteenth century. In the aftermath of this expansion, the minor chiefs of the Deccan were incorporated into the sultanate as either *iqtidār*s or *amīr*s depending on their status in the Hoysala and Yadava political structures displaced by the expansion of the Delhi sultanate.[170] The process was facilitated by the *nāyaṃkara* land tenure system of the Deccan and southern India, which Wagoner sees as an Indic adaptation of the *iqtā*' system, one of a number of political and technical innovations (ranging form the use of cavalry and certain sorts of stirrups to new types of manuals on statecraft) that derived from the "sustained, creative interaction between Indic and immigrant Turkic/Islamicate military-political elites which occurred in the Deccan between the thirteenth and sixteenth centuries."[171]

The adaptation of homologous systems of administration after the Ghurid conquest suggests that the process of reimagining indigenous systems of distributing honors and land under the impact of the *iqtā*' system may actually have begun a century or two earlier in northern India. A further example of the adaptive reception of Islamic administrative and economic institutions, even before the Ghurid conquest, might be sought in references to a "Turk tax" (*Turuṣkadaṇḍa*, literally "Turk stick," figuratively "Turk punishment") in twelfth-century inscriptions of the Gahadavala rajas of Kanauj. The meaning of the term is disputed, with suggestions ranging from a tax to support defensive measures against the Turks to a tax levied on the Muslim communities in Gahadavala territories.[172] It seems likely, however, that *Turuṣkadaṇḍa* was an Indic adaptation of the *jizya*, the poll tax imposed on non-Muslims living under Muslim rule, a premodern variant of a game played in modern consulates and embassies, whose punitive fees for visas

and other services are calibrated reciprocally. A contemporary parallel can be found in twelfth-century Sicily, whose Norman conquerors adopted the system of *jizya*, compelling their Muslim subjects to pay the tax formerly leveled on Christians.[173]

Unlike postconquest adaptations of existing modes of administration, *Turuṣkadaṇḍa* represents the preconquest adoption of a novel institution, a cultural borrowing that reflects the shifting patterns of contact between northern India and Afghanistan. Nevertheless, both adoptions and adaptations are marked by ambiguities that are likely to have fostered the cross-cultural reception of specific forms and practices. Indeed, Wagoner's work on the premodern Deccan has demonstrated that both "fortuitous convergences" and "essential ambiguities" were of equal importance to this process.[174] Similarly, Peter Hardy has noted the productive value of ambiguity in the postconquest administration of northern India:

> Muslim chiefs acted as if they had some authority over Hindu chiefs, and Hindu chiefs, when they could, acted as if the Muslims had no authority; neither party seemed eager, from the evidence available, to force public avowal or disavowal. It was as if, provided the Muslim conquerors offered certain tokens publicly that they were not going to introduce a wholly new language and vocabulary of politics, but rather to add new words to the stock of existing words or new layers of meaning to old words, then (while not going out of their way to be sociable) the conquered chiefs would not refuse conversation.[175]

This ambiguous détente was manifest in the Indian coins minted in sultan Mu'izz al-Din's name, which also confirm that the degree of continuity in projecting royal authority was much greater than the medieval chroniclers and many of their modern successors would have us believe. With a typical rhetorical flourish, Hasan Nizami, our earliest source for the Ghurid conquest of northern India, informs his readers that after the conquest of Benares in 590/1193 temples were converted into mosques and *khanqah*s, the law of Islam was promoted, and "the face of dinars and dirhams gained fresh luster from the name and titles (*nām wa alqāb*) of the king."[176] It is indeed true that

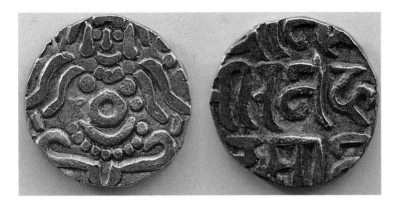

60
Gold coin minted at Bayana in the name of Sultan Muʿizz al-Din Muhammad ibn Sam, with a stylized image of Lakshmi on the obverse (private collection).

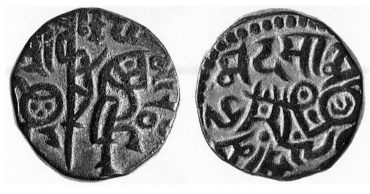

61
Bull-and-horseman billon coin bearing the name of Sultan Muʿizz al-Din Muhammad ibn Sam in Sanskrit (courtesy of the American Numismatic Society, ANS 1920.153.22).

the name of the Ghurid sultan appeared on gold coins issued from Benares or nearby Kanauj after the conquest, but it did so in Sanskrit, the language of the northern Indian literate elite, shorn of its bombastic Islamic titles; indeed, until the early thirteenth century, not a single coin bearing Arabic script seems to have been minted east of the Indus. Moreover, any idea that these coins were part of a comprehensive program to promote the faith of the conquerors is further undermined by the presence of a stylized image of the Hindu deity Lakshmi on their reverse.

With the exception of Bengal, where the lack of a preexisting coinage led to the introduction of "Islamic" coin types, Ghurid coin issues from India not only continued existing iconographic types but also conformed to indigenous standards of weight and metallic purity, in contrast to the issues from Ghazni, which conformed to the numismatic norms of the wider Islamic world. The earliest Ghurid gold coinage from Kanauj emulates the last issues of the defeated Gahadavala rajas, replacing their names and titles with

the legend śrī mahamada bini sāma, the Sanskritized name of the new Ghurid ruler preceded by the Sanskrit honorific śrī or śrīmad (possessed of śrī or fortune). This iconographic continuity is reflected in Ghurid coin issues from all the major mints of northern India, which continued to operate into the postconquest period. Ghurid gold coins bearing the image of Lakshmi were also minted at Bayana, for example (fig. 60), continuing preconquest Yadava coin types, while mints in Delhi, Badaʾun, and elsewhere continued to produce bull-and-horseman billon coins identical to those that had been minted for the Chauhan and Pala rulers of these cities, with sultan Muʿizz al-Din's Sanskritized name juxtaposed with images of Nandi, Shiva's mount (fig. 61).[177]

The numismatic evidence is at odds with the uncompromisingly iconoclastic rhetoric of the Arabic and Persian sources for the conquest, in which the destruction of images of Hindu deities is repeatedly stressed. These texts were, however, intended to sell the virtues of the Ghurids to a wider Islamic world: in

the subcontinent, the need to address their Indian subjects in an intelligible language (both textual and visual) evidently led Ghurid sultans to respect existing precedents even at the expense of orthodox practice. Writing in Delhi in the early seventh/thirteenth century, Fakhr-i Mudabbir notes that one of the duties of a ruler in ensuring the welfare of his subjects is the maintenance of a stable currency.[178] The dissemination of coins bearing the names of the Ghurid sultans juxtaposed with Hindu iconography reflects a pragmatic attitude toward economic realities whose success can be measured by reports that during this period the Hindu traders of Patan in Gujarat, capital of the Chalukya rajas, were investing considerable amounts of their capital in Ghazni.[179]

Nowhere is the fault line between the rigidity of rhetoric and fluidity of practice more clearly revealed than in this contrast between textual and visual assertions of authority, a fault line that is crucial to understanding continuities in the material and political culture of northern India after 588/1192. The dialectical qualities of Ghurid engagements with northern India in the aftermath of the conquest are well represented by Sunil Kumar's observation that "plunder and trade, military engagements and negotiating alliances, iconoclasm and figural depiction on coinage were adroitly reconciled by the Mu'izzī governors [i.e., the Turks belonging to the sultan] in their efforts to expand and consolidate their territories."[180] Coins represent not just economic capital, however, but have a cultural value related to, yet distinct from, their purchasing power. In addition to fostering economic stability, the continuance of indigenous coin types (no less than indigenous modes of administration and conquest) was also a means of legitimating Ghurid rule by casting it in a familiar mold.[181] The value of *sikka* (coinage) as a means of legitimation and self-representation was evident to the Ghurids, who, as we have seen above, placed a considerable emphasis on coinage in the construction of a dynastic image. In order for such a vehicle to be effective, however, it had to conform to the expectations of those among whom it circulated: hence the retention of Byzantine and Sasanian coin types for decades after the Arab conquests of the Near East in the seventh century, and the appearance of Arabic texts and *hijrī* dates on Crusader coins minted in the Levant in the twelfth and thirteenth.[182]

More instructive than the brute fact of numismatic continuity and the pragmatism that it implies, however, are notable absences and innovations in the epigraphic content of Indo-Ghurid coins. In common with contemporary Crusader coins, which adopt Islamic models but are selective in the content of their Arabic legends, the omission of obscure or potentially tendentious material was as integral as ambiguity to continuities in the transcultural communication of authority.[183] The name of the 'Abbasid caliph, a figure difficult to accommodate within the normative framework of Indic kingship (and whose name is also omitted from the earlier bilingual coinage of the Habbarids and Ghaznavids; see figs. 11 and 14) is, for example, omitted from the inscriptions on Indo-Ghurid coins, on which the sultan's name is Sanskritized in a very circumscribed form. In fact, contrary to Hasan Nizami's assertion, one of the striking things about these coins is the very absence of the sultan's elaborate *laqab*s, or any other of his "Islamic" titles, which are eschewed in favor the simple Muhammad ibn Sam, Sanskritized as *mahamad sām, mahamada sāme,* or *mahamada bini sām.*

Shorn of its bombastic Islamic titles, the name of sultan Mu'izz al-Din appeared on the Indian coins of the Ghurids usually preceded by the Sanskrit honorific *Śrī* but generally not by the previously common *Śrī deva* or *Śrī sāmanta deva.* The reason for the apparent reluctance to use these titles is not clear, but the title of *sāmanta* (feudatory chief) or *sāmanta deva* (feudatory chief of the king or lord) may have been thought inappropriate for the Ghurid sultan, and an ambiguity in the term *deva*, which can denote either lord or god, may have added to this reluctance. Evidently some aspects of an Indic honorific vocabulary were more susceptible of translation than others.

The coins were marked not only by absences and continuities, however, but also by innovations. On Indo-Ghurid coins, the sultan's name is generally preceded by *Śrī* or *Śrīmad Hammīra*, a composite title derived from the Sanskrit honorific *śrī* (radiant fortune or prosperity), or *śrīmad* (one possessed of *śrī*) and a Sanskritized derivative of the Arabic *al-amīr* (the commander). The image of Lakshmi (also known as *Śrī*) on the obverse of Ghurid gold coins struck at Bayana and Kanauj (see fig. 60) should probably be understood as a manifestation of the consort of the

ruler as embodied deity, or the *śrī* believed to reside in the body of the king, pointing to further continuities in the iconography of Indic kingship.[184] The appearance of the hybrid title *Hammīra* or *Śrīmad Hammīra* on postconquest coins is, however, a synchronic innovation born of diachronic engagements, reflecting the use of the latter term in northern Indian texts and inscriptions to designate the Ghaznavid and Ghurid sultans since the early eleventh century.[185]

A variant of this title, *śrīmad hamīr mahamad sām* (not found on Indo-Ghurid coins), appears in the interior of a curious gold ring of the twelfth or thirteenth century set with a ruby and diamonds (figs. 62 and 63).[186] It is not certain that the inscription is contemporary with the object on which it appears, but even if this is the case, there is no reason to assume that the ring was a personal possession. Signet rings were among the items gifted by Turko-Persian rulers

to their subordinates, including Rajput chiefs; as we saw in the last chapter such a ring was among gifts sent by Mahmud to the Chandella raja of Kalinjar as part of a *khil'a*.[187] Signet rings could also serve as a personal pledge: according to the historian Juzjani, when the Ghurid ruler of Bamiyan, Baha' al-Din Sam (d. 602/1206), sent an invitation to his father to join his court, he dispatched to him a seal ring (*angushtarīn*) set with a turquoise stone, upon which the family name *Sām* was engraved in Arabic script.[188] It is therefore conceivable that this ring inscribed with the Sanskrit name and title of the Ghurid sultan was intended for dispatch to one of the Indian petty chiefs (*rānās* or *thākurs*) who accepted Ghurid suzerainty in the interval between the defeat of Prithviraja Chauhan III in 588/1192 and sultan Mu'izz al-Din's death in 603/1206. If so, it provides a rare tangible reminder of the hybrid constitution of Ghurid authority in northern India.

Mirroring these heterogeneous political arrangements, Sultan Mu'izz al-Din's coins follow distinct numismatic conventions, with consequent divergences in content and emphasis, including differences in design (Afghan coins are generally aniconic, while the Indian issues bear figural iconography), language (Arabic versus Sanskrit), script (Kufic versus *devnagari*), and semantic content. By a subtle juxtaposition, in both cases the appropriate names and titles of the Ghurid sultan are brought into constellation with the deities germane to each realm, manifesting his authority in quite different ways to different constituencies. To his Ghurid *maliks* and Turkic mamluks he ap-

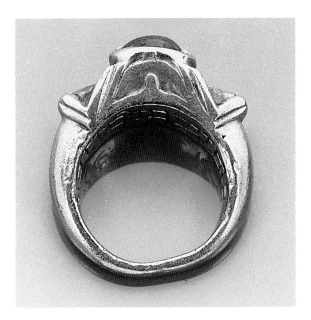

62
Ruby- and diamond-set gold ring with the name of Sultan Mu'izz al-Din ibn Sam inscribed on the interior in Sanskrit (Ex Collection Derek J. Content, by permission).

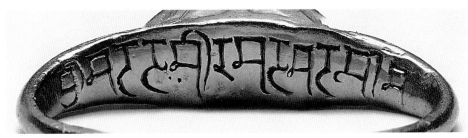

63
Detail of inscription visible in fig. 62 (courtesy of Derek J. Content).

peared as the great sultan (*al-sulṭān al-muʿaẓẓam*), the title given to him in the Arabic texts inscribed on Afghan and Indian monuments but not on Indian coins. To his de facto *sāmanta*s and Indian subjects he was manifest as *Hammīra*, a title confined to the Sankrit texts inscribed on Ghurid coins minted in India (and perhaps other artifacts, to judge from the signet ring).

Much as ancient Assyrian kings presented distinct royal personae to subject groups in different regions of the empire through their inscriptions, or as the sultan's apparent role model, Alexander the Great, manifested himself in different ways to different subjects groups— appearing as pharaoh in Egypt and an Achaemenid potentate in Iran—Muʿizz al-Din's coinage is characterized by a cultural specificity related to the exigencies of transregional and transcultural kingship.[189] In linguistic terms, the numismatic representations of the Ghurid sultan employed a functional diglossia; put more colloquially, the Ghurid sultan was effectively speaking out of both sides of his mouth at once.

The need for rulers presiding over culturally heterogeneous polities to engage the cultural expectations of distinct constituencies in an appropriate language was hardly new. Farther to the west, contemporary Muslim Turkman chieftains who were engaged in the business of carving out kingdoms for themselves from Byzantine territory drew on dual modes of self-representation, "crafting their cultural identity loosely out of a state of flux" and choosing their symbols from "an ongoing process of encounter."[190] The Danishmendids of central Anatolia (463–573/1071–1178) for example adopted both Byzantine Greek and Persianate Islamic modes of self-identification, styling themselves emperors of Byzantium and issuing bilingual coins with Arabic and Greek titles that featured images of Christ. As in India, this cultural polyglossia was associated with the earliest phase of expansion—bilingual coins were phased out by the Seljuq successors of the Danishmendids—and was thus a limitrophe phenomenon associated with the initial phase of expansion and consolidation.[191] As Kafadar notes, "Muslim conquerors . . . were well aware that if one wanted to achieve victory over a rival or alternative system of meanings and values, one needed to enter into that system, turn it into 'a manipulable fiction,' and thus subvert and appropriate it."[192]

Criticized for dressing like a Byzantine emperor, one early caliph is said to have insisted on the need to fulfill the expectations of his (mainly Hellenized Christian) subjects as to how a viable potentate should appear.[193] The undertaking (and the self-consciousness it points to) brings us back to the figure of Amir Banji standing nervously before the ʿAbbasid caliph in Baghdad, in the hope that his informed self-fashioning will qualify him to join the family of kings. The apocryphal endeavor prefigures the internationalist turn of the late twelfth century, when the Shansabanid sultans sought to shake off their rather backwoods image and reinvent themselves as global players. In order to do so, however, the Ghurids not only had to appear as rulers in the eyes of the wider Islamic world but also had to project their authority in their newly acquired Indian territories. The peculiar political and spatial geography of the Ghurid sultanate thus lent a regional specificity to the dual systems of legitimation on which the sultans drew.

However, the eastward expansion of the Ghurid sultanate afforded increased opportunities for circulation between South Asia, Afghanistan, and eastern Iran, cultural flows that complicate the neat picture of discrete administrative and representational systems that I have just painted. Again, coinage provides a useful index of these circulations, for Ghurid and pre-Ghurid coins minted in India (including gold coins of the Lakshmi type; see fig. 60) not only circulated side by side but also flowed westward to Afghanistan, probably as booty and revenues remitted from the conquered territories or as a result of trade and the migration of troops paid in local coinage.[194] In this way the various numismatic systems of the Ghurids came into contact and overlapped. The quantities of Indian specie in Afghanistan were such that it became a de facto medium in the region, a parallel currency to the aniconic Arabic coinage minted by the Ghurids. Ghurid issues from Bamiyan even copy the bull-and-horseman coins of Prithviraja III, the defeated Chauhan ruler of Ajmir, or combine elements of Chauhan coins with those copied from issues of Sultan Muʿizz al-Din. On these issues, Afghan engravers lacking knowledge of *devnagari* attempted to reproduce the Sanskrit inscriptions found on the Indian issues with varying degrees of success. In their rendering of the familiar *śrī mahamada sāme* as the incomprehensible

ACCOMMODATING THE INFIDEL

mavīmrīda sīma, the "Sanskrit" texts on these imitative coins recall al-Biruni's vexed observation that "we have sometimes written down a word from the mouth of Hindus, taking the greatest pains to fix its pronunciation, and . . . afterwards when we repeated it to them, they had great difficulty in recognizing it."[195] The coins also offer a textual counterpart to the garbled speech of the Ghurid envoy to the Chauhan court ridiculed in the passage from the *Prithvīrājvijaya* in the passage cited above.[196]

Even these recalcitrant inscriptions remind us, however, that the cultural flows occasioned by Ghurid expansion in the east were multidirectional. The flow of gifts and tribute from subject Indian princes that circulated exotic, highly crafted objects westward was, for example, sometimes reciprocated by the distribution of honors eastward. In 1194 or 1195, for example, sultan Mu'izz al-Din dispatched a robe of honor or *khil'a* (perhaps his own, since he was in the habit of bestowing royal castoffs on his Turkic mamluks) to Govindaraja, the Chauhan prince of Ajmir, to recement the political bond between the de facto Chauhan *sāmanta* and his Ghurid overlord in the aftermath of a serious revolt by the former's revanchist uncle, Hariraja.[197] An arrangement that was perfectly congruent with Indic ideals of *dharmavijaya* or righteous conquest was thus confirmed by a gesture that had been central to the visual articulation of power in the Islamic world for centuries.

If it is true (as the evidence presented in chapter 2 suggests) that "prestations and acceptances take place within a shared semantic universe," then the existence of homonyms or homologies in the articulation of power seems to have permitted the exercise of what was in effect a type of ritual hegemony commensurate with the expectations of both Chauhan prince and Ghurid overlord.[198] These attempts to foster continuity by adopting indigenous modes of self-representation (including the reinstatement of Rajput chiefs and the minting of existing coin types) were associated with the immediate aftermath of the Ghurid conquest and did not survive it. Nevertheless, both phenomena demonstrate the degree to which accommodation was an option, undermining the simple opposition between a "Persian idiom of rule" and "Hindu" modes of governance with which I began. However ad hoc and short-lived these postconquest arrangements, "ac-

commodation with the infidel" is precisely what the induction of the reinstated scion of the Chauhan house into the *khil'a* system implies, an implication that was perfectly clear to a Hinduphobe like the historian Ziya' al-Din Barani (mid-eighth/fourteenth century), who was later to chastise the Delhi sultans for conferring banners, horses, robes, and other honors on Rajput chiefs.[199]

Just as elements of dress had reportedly served to integrate the Ghurid *malik*s into transregional structures of authority at the outset of their rise to power, so now at the apogee of the sultanate their transcultural extension served to bring the most significant of the Ghurids' foes into the fold. Both phenomena underline the protean nature of elite self-fashioning, while reminding us of Stephen Greenblatt's observation that "the power to impose a shape upon oneself is an aspect of the more general power to control identity—that of others at least as much as one's own."[200]

The tendency of superordinate courts to shape the behavior of clients, retainers, and vassals by the distribution of "morally instructive regalia" has been noted by historical anthropologists and social theorists. The perceived success or failure of the endeavor is often dependent on reciprocity, as Mary Helms notes:

> The success or benefit of this mission is tangibly evidenced, in turn, by the center's acquisition of exotic, naturally endowed foreign things from the cosmographical outside realm; things that not only bespeak the center's continued outreach but also serve to increase its ideological and political potency by virtue of the autochthonous powers believed to be inherent in that which is exotic, curious or different.[201]

In this case the Ghurid sultan was not disappointed, for Govindaraja reciprocated with a series of exotic golden sculptures. These were sent to sultan Mu'izz al-Din in Ghazni and thence to Firuzkuh, the summer capital of the paramount sultan Ghiyath al-Din in the ancestral center of the sultanate. The prominent display of these objects in Firuzkuh reflected their ability to reify the entanglements between the Ghurid sultans and India, highlighting a familiar coincidence between ritualized relationships, political structures, and material things that will be explored further in the following chapter.

4 | *Looking at Loot*

Removed from its context, the exotic souvenir is a sign of survival—not its own survival, but the survival of the possessor outside his or her own context of familiarity. Its otherness speaks to the possessor's capacity for otherness: it is the possessor, not the souvenir, which is ultimately the curiosity.

—Susan Stewart, *On Longing: Narratives of the Miniature, the Gigantic, the Souvenir, the Collection* (1993), 148

| *Signs of Sovereignty*

The opening passage of Rudyard Kipling's *Kim* sees the eponymous hero sitting in front of the Lahore Museum astride an object that still stands in the same location today. Zamzama, a great bronze cannon, was one of two large guns made from the metal of vases produced by the inhabitants of Lahore in payment of a poll tax (*jizya*) levied on non-Muslims by the Afghan ruler of the city in 1757. Captured by the Sikh ruler Hari Singh in 1762, the gun was subsequently looted no less than eight times by a succession of Panjabi chiefs. It came to rest in its present location in 1870, when it was placed next to the museum to commemorate the visit of the Duke of Edinburgh to Lahore.[1]

The history of the gun is inextricably linked to that of the city itself, and to the history of the land beyond. As Kipling notes, "Who hold Zam-Zammah, that 'fire-breathing dragon,' hold the Punjab, for the great green-bronze piece is always first of the conqueror's loot."[2] Kipling's remark is more than an aside on the historical vicissitudes that the Panjab underwent in the early modern period; it is a significant observation on the role that certain objects assume in both articulating and mediating cultural and political change. The history of the gun, its peculiar genealogy, was an intrinsic part of its meaning, which was not reducible to its utility as a weapon. The material trans-

mutation through which the gun came into being, its recontextualization and public display, all had the paradoxical ability to signify an alteration in the political order while invoking a continuity constructed using selected fragments of the ancien régime. The gun thus assumed the ability to act as a synecdochic expression of dominance over the urban landscape of which it formed part.

Despite a contemporary interest in the cultural biography of things, the phenomenon of looting in the medieval Islamic world is a relatively unexplored subject, traditionally the preserve of legal historians rather than historians of material culture.[3] In this chapter and the following, I want to explore the ways in which the seizure and recontextualization of artifacts taken as loot and booty, given as gifts and tribute, or appropriated from earlier Indian monuments served to articulate the political reconfiguration of northern India after the Ghurid victories of the late twelfth century. In keeping with the theme of this book, my particular interest lies in the ways in which both objects and the practices associated with them were translated and transfigured in the process.

As we saw in chapter 2, despite differences in concepts of kingship, the selective use of objects as nuanced expressions of complex power relations was common to medieval Indic and Persianate discourses of kingship, which included homologous terms such as parasols and drums. Common to many of the objects in

this category is the fact that they constitute *inalienable possessions*, objects that circulated outside the mechanisms of quotidian exchange. As the cultural anthropologist Annette Weiner notes:

> In societies with complex political hierarchies, precious possessions such as gold crowns, jewelry, feathered cloaks or fine silks may accumulate historical significance that make their economic and aesthetic values *absolute* and transcendent above all similar things. . . . In this way, certain possessions become subjectively unique, removing them from ordinary social exchange as they obtain absolute value rather than exchange value. The paradox, of course, is that such possessions, from time to time, are exchanged, lost in warfare, destroyed by rivals, sold, or are unclaimed, thus undermining the ability of rulers or families to keep intact the material symbol that legitimates their rank, status, or uniqueness.[4]

As signs of sovereignty, inalienable objects often refer metonymically or synecdochically to the body politic: the robes discussed previously are a case in point, entailing as they do the power to transform the body natural into the body politic.

Through circulation, inalienable objects can acquire complex genealogies that connect them with those who possessed them and among whom they circulated: the Tibetan crown and throne discussed in chapter 1 are good examples. Like certain works of art, such artifacts function as a "congealed residue" of the performance of sovereign authority: by the very act of possessing such signs, their possessor becomes what they embody.[5] These objects can embody both an abstract authority only contingently related to their present owners and a genealogical connection to the historical exercise of power. Although the parasol (*chatr*) of a sultan was normally interred with him, indicating its role as a personal artifact, on occasion it could be removed from the tomb to invest a successor. When Ziya' al-Din, the son-in-law of the Ghurid sultan Mu'izz al-Din, was invested as sultan of Firuzkuh after the latter's death in 603/1206, for example, the parasol of the dead sultan was removed from his tomb in Ghazni, brought to Firuzkuh, and raised over the head of the new sultan.[6]

If possession of signs of sovereignty conferred authority by virtue of their constitutive and genealogical character, the converse was also true: the loss of royal insignia signified a loss of dominion, while damage or injury to them presaged the demise of the ruler or the royal house in whose possession they lay. Similarly, the capture, appropriation, or usurpation of a royal standard or parasol could signal defeat, or rebellion. Consequently, Persian and Sanskrit texts refer to incidents in which these objects were deliberately targeted during campaigns of warfare, and on more than one occasion a pretender was inspired to make a bid for sovereign dominion when the royal insignia fell into his hands.[7]

What happens, however, when such objects are looted across cultural boundaries? How do their identities change, and how do they affect the identities of those into whose possession they fall? In chapter 2, I explored transcultural gifts of one class of inalienable object—royal robes—and their implications for the conceptualization of "Hindu" and "Muslim" elite identities. Here I want to analyze the role of looting in circulating objects and their associated meanings and practices between Indic and Islamic elites in the last decade of the twelfth century.

Existing interpretations tend to assign fixed sectarian identities to looted objects, with the consequent assumption that "Indian" or "Hindu" objects were looted by Ghaznavid, Ghurid, and Delhi sultans either for their intrinsic economic value or to derogate the broader cultural traditions that the reused objects are assumed to have represented. Meaning and identity are not static qualities that inhere in objects, however, but are constructed dynamically by those who own, use, or even view them. The practices associated with objects are central to this process of producing meaning, a process that can be especially complex when it involves the circulation of objects across cultural boundaries. An observation made by the anthropologist Nicholas Thomas in relation to transcultural encounter in colonial Polynesia captures something of this complexity:

> Objects have been central in . . . transcultural histories; they have often marked alterity and particular strategies for dealing with it—through appropriation and incorporation or distancing and recontextualizing. Some things mark the

(partial) acquisition of the capacities or attributes of the other; others express indeterminacy and a bridge between apparently incompatible systems; others now stand for totalities formerly unrepresented, which are discovered, as explicit forms, through the process of contact.[8]

To focus therefore on the innate qualities of looted objects (their constituent materials, or their formal characteristics) or even their meanings in primary contexts is to ignore the shifting narratives through which new meanings are constructed and transmitted, and the capacity of gifted or looted artifacts to develop novel sets of relationships with new communities of subjects and objects.

As we saw in chapter 1, in trying to understand this process, the bare fact of reception is less informative than the manner in which the objects of transcultural circulations were redefined, redeployed, and reimagined. The point has been made in Kopytoff's now classic essay on the cultural biography of things, where he notes that "what is significant about the adoption of alien objects—as of alien ideas—is not the fact that they are adopted, but the way in which they are culturally redefined and put to use."[9] If inalienable possessions such as insignia "are the representation of how social identities are reconstituted through time,"[10] then their fates offer insights into the ongoing process of reconstitution.

| Looting and Difference

Several decades ago Philip Grierson noted that, in medieval Europe, gifting and thieving (including looting, its ritualized variant) were more significant modes of circulating commodities among elites than trade.[11] The negative way in which we view the practice of looting today is a relatively recent phenomenon, largely contingent on the rise of the nation-state. Whereas in 1500 the seizure of booty by European armies was taken as a matter of course, distinguished (at least in theory) from theft by the context in which it occurred, by 1815 this differentiation had in large measure disappeared.[12]

If the eradication of the practice in Europe became a milestone on the road to modernity, its continuation in the colonies served as the benchmark of a cultural or racial difference frequently conceived of in evolutionary terms. Even if wars of colonial expansion in South Asia revealed a somewhat ambivalent attitude toward looting on the part of colonial armies, these practices were mitigated by the development of elaborate mechanisms for transmuting loot into liquid capital and private property.[13] By contrast, the term *loot* was linked to contemporary perceptions of the colonial subject, referring to the capacity of certain sections of the Indian population for theft, plunder, and wanton destruction. Nineteenth-century commentators on the proclivity for looting among Indians often note the "Eastern" origin of the word, which was adapted from Hindi into English by the early nineteenth century.[14]

The idea of looting as an index of cultural difference between Indians and British soldiers crystallized after the Sepoy Revolt of 1857; those writing of the looting that characterized its aftermath were often at pains to emphasize the role of Indian soldiers, among whom looting and rapine were naturalized "through long racial memory."[15] The conception and representation of this "long racial memory" were shaped by memories of recent turmoil, which proved instrumental in shaping both the reception of precolonial histories and the writing of colonial histories in the decades that followed 1857.[16] In subsequent historiography, it was taken as axiomatic that looting was a defining characteristic of Oriental despotism, particularly characteristic of Indo-Muslim rulers. Shaped by essentialist figurations of Islam, looting was thus ranged among a number of practices (including idol destruction and temple desecration) that indexed a violent rupture in the cultural fabric of South Asia with the advent of the Ghaznavid and Ghurid sultans in the eleventh and twelfth centuries.[17] On occasion, colonial officials even went so far as to renegotiate the past by appropriating and redistributing medieval "Muslim" loot, thereby attempting to suture a perceived rupture in the natural order caused by the wanton expropriation of "Hindu" property by a Muslim ruler.[18]

Subsequent scholarship has been largely content to reiterate the standard tropes of the colonial era. Thus the early Muslim rulers of India have been characterized as either iconoclastic zealots, canny pragmatists, or both, plundering India to pay for military

adventures in eastern Iran or to underwrite the cost of extravagant building programs at home. In its most extreme manifestations, this tendency figures Indo-Muslim looting practices as the (almost inevitable) product of a cultural predisposition toward the despotic accumulation of capital. Mahmud of Ghazni in particular has passed into South Asian history as a great plunderer, to such an extent that his activities are the touchstone against which the predations of modern Indian politicians are often measured.[19]

Discussing the economic implications of Muslim expansion into South Asia, the historian J. F. Richards wrote:

> The signs and tangible symbols of victory included plunder: long lines of enslaved captives, who had not accepted Islam; files of horses, elephants, camels; arms, but above all else jewels and precious metals. Preferably the latter were ripped from the desecrated temples of the enemy. Captured treasure heaped in the courtyard of the raiding Sultan was used for largess, for strengthening his currency, and for augmenting his own vaults. Wealth taken in this manner was a tangible sign of God's favor towards the faithful.[20]

This and other essentialist figurations of Indo-Islamic looting effectively ignore the similarities between looting practices within and without the *dār al-Islām*, while eliding important (if somewhat opaque) differences in the activities of different Muslim rulers, which further complicate the picture of an essentially "Islamic" mode of looting. Perhaps more significantly, they ignore the fact that looting was a fundamental part of the economics of premodern warfare, common to Turkic and Indic rulers as a means of accumulating both financial and symbolic capital.[21] Whether in Afghanistan or northern India, medieval rulers used booty seized during campaigns of conquest or looting to embellish their own capitals. Compare, for example, these two eleventh-century accounts of the display of loot in the wake of successful military campaigns. The first concerns Indian booty seized by Sultan Mahmud of Ghazni during the capture of Bhimnagar, around 400/1009:

> [the Sultan] returned to Ghazni in triumph; and, on his arrival there, he ordered the court-
> yard of his palace to be covered with a carpet on which he displayed jewels and unbored pearls and rubies. . . . Then ambassadors from foreign countries . . . assembled to see the wealth which they had never yet read of in books of the ancients, and which had never been accumulated by kings of Persia or of Rum.[22]

The second is a description of the events that followed the victorious return of the Chola ruler Virarajendra to his capital after a raid on the neighbouring Chalukya kingdom in the 1060s:

> Seated on a throne of bright jewels, Virarajendra exhibited in orderly rows the great heaps of treasure he had seized in the Vengi territory, while all the kings on earth did homage at his feet and praised him.[23]

The parallels in the nature of the precious commodities involved and the manner in which the rhetoric of display is orchestrated in both palace and text do little to support the picture of cultural discontinuity that scholars have articulated around the issue of "Turkic" or "Islamic" looting practices.

Within the orthodox Sunni dispensation to which the Ghaznavids ostentatiously subscribed, the chastisement of heretics and the heterodox were no less meritorious than campaigns against idolaters. Consequently, the sorts of looting practices and ritual desecration that characterize accounts of Ghaznavid incursions into India on the eastern frontier of the sultanate are indistinguishable from those found in connection with the contemporary westward expansion of the Ghaznavid polity into areas where fellow Muslims constituted a majority. We are told, for example, that when Mahmud looted a temple in the fort of Nagarkot in 399/1008–9, he obtained seventy million dirhams in specie, seventy thousand manns of gold and silver ingots, rich clothing, a collapsible pavilion made of silver (perhaps silver plates), and a throne.[24] Similarly, in 420/1029 the eastern Iranian city of Rayy was sacked and Mahmud seized jewels worth 500,000 dinars along with gold and silver vessels worth 30,000 dinars, 5,300 richly woven garments, and large numbers of manuscripts, which were carried off to Ghazni.[25] As the military strength and political authority of the Ghaznavid sultanate eroded in the

twelfth century, many of the riches with which Ghazni had been embellished were themselves carried off by invaders from the west; in 510/1117, for example, the soldiery of the Seljuq sultan Sanjar looted the city, stripping the precious metal sheets with which its monuments had been embellished.[26]

In addition to its failure to consider analogies in contemporary South Asian looting practices and the fact that these practices were common to campaigns against Muslim and non-Muslim foes, Richards' characterization of the behavior of Turkish sultans assumes that the meaning of the Indian booty listed in Arabic and Persian sources is reducible to its economic value. This assumption is widespread among scholars and, somewhat paradoxically, has been reinforced recently by an exciting and innovative study that seeks to rescue the looting practices of medieval Indian rulers from the opprobrium of colonial historians and their successors. In *Lives of Indian Images* and a number of other publications, Richard Davis has highlighted the importance of looting as an instrument of state policy in medieval South Asia. Taking a diachronic approach to the study of Indian religious icons, Davis demonstrated that these were routinely looted from royal temples and installed in the dynastic shrines of conquering monarchs.

Davis also illustrated how specific types of objects, which functioned as royal insignia, were targeted for looting during campaigns of warfare.[27] These signs included banners, fly whisks, parasols, crowns, fans, thrones, musical instruments, and certain architectural elements, many of which had a metonymic relationship to the exercise of sovereignty.[28] Like the looting of religious icons, the seizure and display of these objects was closely related to processes of medieval Indian state formation, for they were not merely emblematic devices but "physical manifestations of a king's authority, inseparable from his capacity to rule rightfully."[29] Recontextualized in the victor's capital, these objects signified the incorporation of lesser rulers (and their territories) into a larger imperial formation and their role as subordinate sharers in their overlord's sovereignty.[30] Like Kipling's gun, the meaning of these objects in secondary contexts was directly related to their possession of a history, to the existence of a genealogy that was memorialized in contemporary narratives (both oral and textual) and sometimes even inscribed

upon the objects themselves and the buildings that housed them.[31]

Despite the existence of homologous terms in the articulation of Indic and Islamic kingship and similarities in the textualized protocols of looting in Islamic and Indic societies, Davis specifically excludes the Turko-Persian sultans of Afghanistan from participating in the complex ritual looting practices that he so skillfully reconstructs. Invoking familiar tropes of rapacity and rupture, Davis posits a change in established practices with the advent of the Muslim sultans in the eleventh and twelfth centuries. These, he concludes, gave themselves up to a more generic form of looting and "demonstrated little awareness of this existing discourse of royal objects, or little interest in participating."[32] In other words, invading Muslim sultans ignored or failed to understand the sophisticated ritual looting practices of their Indian adversaries, giving themselves up to a more generic form of looting that concentrated on gold, silver, jewels, elephants, and slaves. In short, the natural rapacity of the Muslim sultans triumphed over their ability to recognize the semiotic capacity of the objects that they looted.

Like its more schematic predecessors, such a reading of the historical sources effectively contrasts the highly structured looting practices followed by Hindu rulers of the period with the apparently more random and fiscally driven approaches of their Muslim successors. In this way, Davis' innovative study serves to reinforce the idea of looting as an index of cultural rupture, an essential sign of difference between medieval Hindu and Muslim elites. We have seen in chapter 1, however, that the meaning and treatment of the looted Buddhist and Hindu precious-metal icons that circulated among Muslim elites during the ninth through eleventh centuries was considerably more complex than the dyadic paradigms of traditional historiography would admit. Despite a rhetorical emphasis on iconoclasm and idolatry, the reception of such booty was shaped by a range of concerns that may have encompassed but certainly extended beyond a desire to strike a blow for monotheistic values. A representative selection of looted Indian icons circulated within a complex redistributive network, a political economy informed by a broader theory of value that served to consolidate the internal political coherence of the *dār al-Islām*.

In addition, the ritual looting of premodern kings was intrinsically linked to the ideals of incorporative kingship that were central to the process of state formation in medieval South Asia. The apparent failure of invading Muslim sultans to engage with an indigenous semiotics of looting has therefore been correlated to essentially incommensurate notions of kingship: in one case polycentric and incorporative, in the other unitary and reductive. As I have been at pains to emphasize, however, along the shifting frontier between the Turko-Persian sultanates of Afghanistan and their Indian adversaries, practice was often fluid and rarely prescriptive. As I demonstrated in the preceding chapter, the political reconfiguration of northern India in the immediate aftermath of the Ghurid conquest amounted to a hybrid articulation of authority, to which the concept of *dharmavijaya* and the institution of *iqtāʿ* proved equally instrumental. In their dealings with the Chauhans of Ajmir, the Ghurid sultans produced an arrangement with remarkable similarities to the polycentric hierarchy of subordinated polities that characterized transregional political formations in medieval South Asia, even if this fact was not explicitly noted in the Arabic and Persian sources. In what follows I hope to demonstrate that the looting and display of certain Indian objects served to articulate the Ghurids' political relationships with conquered Indian rulers in a manner that was perfectly congruent with the looting practices of South Asian kings. Far from being symptomatic of cultural rupture, these practices suggest continuity in South Asian royal looting protocols, and may even provide early instances of transculturation in Indo-Muslim royal ritual.

| *Trophies and Transculturation*

Although generic categories of booty such as slaves, livestock, gold, and jewels (occasionally distinguished by their size or source) are frequently mentioned in Arabic and Persian histories dealing with South Asian campaigns, with the exception of the Buddhist and Hindu icons discussed in chapter 1 there is a notable dearth of information on particular artifacts. This is true even of those texts written in the wake of the Ghurid conquest, which directly address the issue of looting.[33] It seems that medieval historians were more

intent on impressing their readers with the value of Indian booty, or the enormous quantities in which it was seized, than on providing descriptions of specific objects.[34] Some idea of the bounty harvested from India can be gleaned from reports that when the treasury of the Ghurid sultan Muʿizz al-Din of Ghazni was dispersed after his death in 602/1206, that part removed to Bamiyan alone consisted of 250 camel loads of gold and precious metal vessels, some gem encrusted.[35]

A rare exception to this tendency to abstract and generalize occurs in a passage of the *Ṭabaqāt-i Nāṣirī* (ca. 658/1260), our main source for Ghurid history, rendered all the more valuable from the fact that its author spent the early part of his life in the Ghurid court at Firuzkuh, sultan Ghiyath al-Din's summer capital in Afghanistan. In it we find the only surviving description of the royal palace (Baz Kushk-i Sulṭān) in that city:

> Over the palace (*qaṣr*) are placed five golden pinnacles (*kangura-yi zarīn*), each of them three *gaz* and a little over in height, and in breadth two *gaz*; and also two golden *humā*s, each of about the size of a large camel. Those golden crenellations (*shurafāt-i zarīn*) and those *humā*s, the Sultan-i Ghazi Muʿizz al-Din had sent to [his brother] sultan Ghiyath al-Din b. Muhammad Sam, after the victory at Ajmir, in token of service and as valuable presents, along with many other articles of rarity, such as a ring (*ḥalqa*) of gold, with a chain (*zanjīr*) of gold attached, and melons (*kharbūza*) measuring five *gaz* by five *gaz*, and two golden kettledrums (*kusāt*), which were carried on carriages. Sultan Ghiyath al-Din ordered that the ring and chain and those melons should be suspended within the monumental entrance (*pīshṭāq*) of the Friday Mosque at Firuzkuh; and, when the mosque was destroyed by flood, the sultan sent the ring, chain, and those melons to the city of Herat, so that after the Friday Mosque of that city had been destroyed by fire, they rebuilt it by means of those gifts.[36]

Although modern commentators have assumed that the drums are identical with the melons (the shape of the former evoking the latter), earlier sources indicate that golden melons were indeed sent from Ajmir,

and mention the circumstances in which they were acquired. The *Tāj al-Ma'āthir* of Hasan Nizami (ca. 613/1217) relates that golden melons (three in number) were part of a reciprocal gift exchange between the Ghurid sultan and the Chauhan prince ruling as a Ghurid vassal at Ajmir. This was in recognition of the latter's loyalty during a revolt by his revanchist uncle, who had attempted to reestablish an independent Chauhan line sometime around 591/1195:

> About this time, the son of Rai Pithora (Prithviraj III Chauhan) was singled out for a robe of honour (*khil'a*) and other favors as he had won the general faith and confidence of the king. To demonstrate his sincerity he sent the king numerous presents (*khidmat*), which included three watermelons of gold (*kharbūzat-i zarīn*), which had been ingeniously molded into the shape of the full moon. Their crescent-like ribs had been arranged with subtle craftsmanship.[37]

The ultimate fate of these marvelous fruits is expanded upon in the introduction to Fakhr-i Mudabbir's *Shajara-i ansāb*, a royal genealogy composed at Lahore in 602/1206. Speaking of Qutb al-din Aybek, the Turkic mamluk of the Ghurid sultan, the author remarks:

> And this good luck happened to him in 588 [AD 1192–93], and in that same year he defeated the army of Kolah [Prithviraja, the Chauhan raja] and captured the Rai of Ajmir, 14 elephants fell into his hands, he conquered the forts of Dehli and Ranthambor, he carried off four golden melons weighing 300 manns. He sent all four golden melons to the sultan (Mu'izz al-Din) and the Sultan of Islam sent one of them to Sultan Ghiyath al-Din. Sultan Ghiyath al-Din gave orders for it to be taken to Herat, and to make out of it a Friday Mosque (*masjid-i ādhīna*) and a monumental arch (*ṭāq*) and a prayer-hall (*maqṣūra*),[38] so that whoever should pray in that mosque or recite the Qur'an, or study, or contemplate, whatever reward that person should earn, so much reward should go to the treasury of that king.[39]

Extant inscriptions in the Great Mosque of Herat (fig. 58) indicate a major Ghurid rebuilding program around this time, and the veracity of the particulars given here are confirmed by a reference in al-Isfizari's chronicle of Herat to a vanished foundation text in the name of Ghiyath al-Din dated 597/1200 located at one of its *īwān*s (monumental arches).[40]

What the sources tell us, in other words, is that a select group of objects from Ajmir and Ranthambor in Rajasthan was sent back to the Ghurid sultan in Ghazni, from where a portion was carried by chariot to Firuzkuh and subsequently displayed in the two principal dynastic shrines of the Ghurid summer capital: its palace and Friday Mosque (neither of which survive). Some of these objects were eventually sent to Herat to pay for part of the Great Mosque constructed there under the patronage of Sultan Ghiyath al-Din Muhammad. Since construction of the Herat mosque began in 597/1200, we can conclude that the Indian loot was displayed in the Friday Mosque of Firuzkuh for between five and eight years.[41] The palace was presumably destroyed during the sack of Firuzkuh by the Mongols in 619/1222, if not earlier, so the interval during which this select group of Indian loot remained on display was relatively short.[42]

The golden objects dispatched to sultan Ghiyath al-Din by his brother evidently constituted the *ṣafiyya*, the share of loot mandated to the sultan under orthodox Islamic law.[43] The *Tāj al-Ma'āthir* describes the melons at least as gifts from the Chauhan vassal of the Ghurids, raising the possibility that the ensemble derived from two different moments: the initial conquest of Ajmir in 588/1192–93, and the reassertion of control a year or two later, after a revanchist revolt. The confusion may also have its roots in a legal distinction between *ghanīma*, which is seized in warfare, and *fay'*, which (according to the Hanafi and Shafi'i law schools to which the Ghurids subscribed) includes capitation or land tax (*jizya* or *kharāj*) paid by non-Muslims in the treaty lands (*dār al-ṣulḥ*), which in effect included the Chauhan vassal state of the Ghurids.[44] The booty, gifts, and tribute sent by Hindu rajas to seal treaties of vassalage with Afghan sultans are frequently described as *jizya* or *kharāj*.[45] Whether in Iran or India, the distinction between gifts, booty, and tribute was often rather fluid, all three being a highly visible product of victory; tribute might best be conceptualized as a type of "institutionalized plunder" in which the victim plunders himself while salving his pride by representing such payments as gifts.[46]

Where modern historians have made reference to the golden objects displayed in Firuzkuh, it has been assumed that their value was directly related to their precious metal content, that their status as war booty was little different from the golden coins that flowed back from India to fill the coffers of the Ghurid sultan.[47] These objects certainly had a monetary value; the eventual liquidation of some of them to pay for the renovation of the Herat mosque is proof enough of that. However, their public display and ostentatious incorporation into the palace and mosque of the Ghurid capital, no less than their memorialization in contemporary textual (and presumably verbal) narratives, indicate that a particular importance was attached to them. There is in fact evidence to suggest that, like Kipling's gun, their value was not reducible to either their economic worth or their practical utility, but derived instead from their historical pedigree and signifying function within the discourses of medieval Islamic and Indic kingship. Three aspects of the Chauhan booty suggest this: the origin of the golden objects, their nature, and the manner in which they were displayed. I am ignoring their aesthetic value here, but it may be assumed; for, as we shall see in the following chapter, at this very moment Indic modes of ornament were proliferating in the Ghurid monuments of Afghanistan.

Most of the objects came from Ajmir, the dynastic center of the Chauhans in Rajasthan, in which a monumental Friday Mosque making use of material taken from Chauhan buildings was built after the conquest.[48] Others seem to have come from the Chauhan fort at Ranthambhor (Ranastambhapura). Just as Kalinjar was central to the projection of Chandella authority a century earlier, so possession of Ranthambor served to advertise the power and prowess of the Chauhans; it is lauded in medieval Persian sources as one of the most impregnable fortresses in the world.[49] Epigraphic and textual evidence suggests that Govindaraja, the son of the defeated Chauhan ruler Prithviraja, held both Ajmir and Ranthambhor as a Ghurid vassal after the conquest, which might explain the dual genealogy for the objects.[50] Lost to the Ghurids soon after it was captured, the fort was contested between Indo-Muslim rulers and Rajput chiefs well into the Mughal period.[51] Subsequent history notwithstanding, the choice of objects from Ajmir and Ranthambor for display in Firuzkuh was not a random

one. In one instance we are dealing with the ultimate symbol of the Chauhan dynasty's political might, its dynastic center; in the other a symbol of its military strength, a fort celebrated for its invulnerability.

Certain of the objects brought to Afghanistan are somewhat mysterious in nature, and evidently play on the age-old topos of India as a land of wealth and wonder. The eleventh-century writer Marvazi refers to India as *zamīn-i zar*, the land of gold, where gold grows like grass, repeating Herodotus' story about gold-gathering ants in barely altered form.[52] However, in both their nature and their donation to the Friday Mosque of Firuzkuh, the looted objects also suggest an association with the iconography and ritual practices of medieval Indian kingship. The golden chain, for example, may have been among those frequently described as adorning the necks of South Asian rulers, or may have been among the golden chains described in medieval temples (some of which were royal donations) and mentioned as items of booty in Arabic and Persian sources.[53] Similarly, if taken as booty, the golden melons may also have been removed from a temple, since golden fruits (especially those associated with royalty) are among the objects mentioned in temple inventories.[54] Alternatively, it is possible that these were in fact golden *āmalaka*s (*embelic myrobalan*, also a kind of fruit connected with royal patronage), which once crowned the summit of a palace or temple; the passage from the *Tāj al-Ma'āthir* cited above emphasizes their ribbed appearance, further heightening the analogy with *āmalaka*s.[55]

The display of these objects in the Friday Mosque of Firuzkuh, where the community assembled to affirm its allegiance to sultan and caliph, memorialized the conquests through which they had been acquired. The significance attached to the appropriation and recontextualization of the drums with which the golden melons were associated would have been mutually intelligible to both the Ghurids and their Indian adversaries, for in medieval India, no less than in the Islamic world, the trappings of power were not just visual but aural. The monumental scale of kettledrums (Sanskrit *bhēri or bājā*) rendered them particularly appropriate to the projection of royal authority, and they are frequently mentioned in inscriptions and texts as part of the insignia of Hindu and Jain kings.[56] A passage in Fakhr-i Mudabbir's *Ādāb al-Ḥarb* (seventh/thirteenth century) describes how the soldiers of the

tenth-century Hindu Shahi ruler Jaipal covered his absence from the battlefield by beating a drum that usually signaled Jaipal's presence: the drum was called the "the Lion's Roar" (*Sankhnād,* i.e., *Singhnād*).[57] The drums gifted by the Ghaznavid sultan Mas'ud I (r. 422–32/1031–41) to his Indian general Tilak, along with other honors, are said to have been beaten in the manner (*rasm*) favored by Indian chiefs (*mān-i hindūwān*), hinting at cultural differences in the deployment of common elements of insignia.[58] Nevertheless, as a shared element in the insignia of Hindu, Jain, and Muslim kings, kettledrums were specifically targeted as desirable items of loot during campaigns of conquest: vernacular histories of the postconquest period specifically note the targeting by invading Muslim armies of drums and other musical instruments associated with temples.[59]

Kettledrums were also among the insignia of Islamic rulers, part of the duo of banner (*'alam*) and orchestra (*naubat*) that signified political status within and without Islamicate South Asia until the colonial period.[60] Their ability to effect transformations of nature and status is implicit in a tenth-century writer's quip that possession of a drum, a standard, and a prince (*ṭabl wa 'alam wa amīr*) was sufficient to invest a city with sovereign authority.[61] Prior to the tenth century, the beating of drums was the prerogative of the caliph, part of his official insignia. With the weakening of caliphal authority from the Buyid period onward, the various petty potentates who had come to exercise de facto political authority in the eastern Islamic world appropriated the use of drums as part of a broader effort to confer legitimacy on their rule. In the following century this dispersal of insignia increased exponentially, with rulers arrogating the right to confer drums along with other emblems of office on their vassals and successors.[62] Ghaznavid sultans followed established practice, but the Ghurid sultan Ghiyath al-Din Muhammad assumed the prerogative of having drums sounded at his gate five times daily only *after* receiving a robe of investiture from the caliph in Baghdad. This curious reticence suggests that royal drums (*naubat-i pādshāhī*) were afforded a particular significance in the articulation of Ghurid sovereignty.[63]

The theme of sovereignty was reprised in the adornment of the Ghurid palace. Serendipitously or not, the golden appearance of the palace pinnacles (*kangurahā* or *shurafāt*) echoed descriptions of the gleaming pinnacles of palaces and temples in contemporary Sanskrit sources.[64] In medieval Persian usage, *kangurahā* and *shurafāt* are interchangeable, although the former usually refers to parapets upon which one can walk, while the latter tends to denote the decorative merlons or crenellations known in Ghaznavid and Ghurid architecture.[65] The use of the two terms as synonyms in the passage from Juzjani cited above may reflect a degree of uncertainty as to how to categorize the crowning ornaments of the palace. Well documented in premodern South Asia, the practice of using royal booty to decorate the palace roof of a victor offers a possible explanation for this ambiguity. Consider the following threat supposedly issued to the Pandya kings of southern India in the twelfth or thirteenth century by a minor king refusing to give his daughter in marriage:

> The fates of other kings who have made such an offer are well known. If you do not know this, you can see that we Maṟavars have captured their weapons and keep them on the outskirts of our country, their crowns are being looked after, their possessions are used as borders in decorating the rooves of our houses, and their umbrellas are folded and kept aside.[66]

Although preserved in a much later text, the same practice is attested in classical Tamil literature. If we assume that these objects formed a decorative border along the edge of the palace roof, then their designation as both parapet and crenellation makes perfect sense.

The integration of the *shurafāt* from Ajmir into the Ghurid palace should be considered in relation to the complex relationship between the exercise of effective sovereignty and the architectural adornment of palace and temple. The palace towers of the Solanki or Chalukya rajas at Anahilavad in Gujarat were decorated with crenellations that, like their Ghaznavid counterparts, assumed fantastical shapes.[67] The *śikhara*s of medieval temples were also richly adorned with golden ornaments. The pinnacle, crowned by a golden parasol or ribbed *āmalaka*, pot (*kumbha* or *kalaśa*), finial (*stūpika*), and flagstaff (*dhvajastambha*; fig. 154), was an iconographically significant part of the temple, closely associated with royal patronage in both the Hindu and Jain traditions. Numerous inscriptions and texts record the donation of these ornaments and

their ritual installation in the temples erected by the Chauhan and Chalukya rajas of Rajasthan and Gujarat during the eleventh and twelfth centuries.[68] As an instantiation of royal authority, the *dhvaja* or banner crowning the ensemble was directly correlated to the health of the polity: its destruction was said to herald the death of the ruler, who participated in a ritual hoisting of the *dhvaja* on newly constructed temples. The *Bṛhat saṃhitā* (fifth–sixth century) puts it succinctly: "if the *chatr* [crowning a royal temple] should break and fall down, the king will die."[69]

This indexical connection between sovereignty, the *śikhara,* and its crowning ornaments may explain why, during the conquest of Sind in the early eighth century, the *dhvajastambha* of the main Shiva temple in the key city of Daybul was specifically targeted in the belief that its fall presaged the capture of the city and the end of the raja's rule.[70] A perceived association between the sovereignty exercised by Indian rulers, the temples or palaces that they built, and the golden ornaments that crowned them would render the latter highly desirable as items of booty. It is presumably for this reason that a Rajasthani description of 'Ala' al-din Khalji's sack of the temple of Somnath in 1299 refers to Khalji troops scaling the *śikhara* of the temple to remove its golden *kalaśa*.[71]

Gathering to the center the insignia of defeated (and thus implicitly lesser) rivals, the targeting of roof ornaments provides a particularly graphic illustration of the way in which looting inverts the metonymic order by which signs of authority devolve from the center of a higher authority to a lesser. The same idea was often expressed by the redistribution of looted royal insignia to the vassals of a conquering ruler, the alienation of the inalienable.[72] We hear, for example, of a white elephant captured by the Turkic general Qutb al-Din Aybek from the raja of Kanauj in 588/1192, which was sent to the Ghurid sultan Mu'izz al-Din in Ghazni in eastern Afghanistan and thence along with other examples of Indian booty to his brother, sultan Ghiyath al-Din, in Firuzkuh. After the latter's death, his nephew and successor presented it to the Khwarazmshah, his overlord, as a token of his submission to this Central Asian ruler.[73] A sign of Ghurid victories in India was thus transformed into a token of submission, signifying not only the changed fortunes of the Ghurid royal house but also the way in which the

meaning of Indian exotica could be transfigured and transformed by circulation. In the earlier use of Chauhan gold ornaments to adorn the Ghurid palace at Firuzkuh, what was once central to the exercise of Chauhan imperium came to function as peripheral adornments for the locus of Ghurid sovereignty.[74]

The two enormous golden *humā* birds mounted upon the looted roof ornaments only served to underline the point, for in the Iranian world the *humā* was a bird of good omen, whose shadow designated royalty.[75] A work written by the Persian sufi Najm al-Din Razi (b. 573/1177), who spent time in Firuzkuh as the guest of sultan Ghiyath al-Din, provides an insight into the qualities ascribed to the bird among the elite of contemporary Khurasan. In an extended metaphor, al-Razi compares the ruler to God's shadow on earth, just as the shadow cast by one standing on a roof acts as the vice-regent of his terrestrial essence: "When God Almighty placed as a trust one of the mysteries of His favor in the *homā* bird, see what effect it produced, and what property arose. If the *homā* cast its shadow on someone's head, he would gain the dignity of kingship and the good fortune of monarchy."[76]

The image of the *humā* of the Ghurid sultan spreading its auspicious wings over his subjects is frequently invoked in the *Tāj al-Ma'āthir,* a near contemporary account of Ghurid campaigns in India. The conceit was expressed in numerous aspects of the regalia that surmounted the head of medieval Turko-Persian rulers. Not only was the royal crown sometimes adorned with feathers, purporting to be those of the *humā,* but jeweled representations of the bird often sat atop the throne and *chatr,* the umbrella that shaded the head of the ruler.[77] More visible than a crown, and more portable than a dome, the *chatr* combined qualities of both. Although no details of the Ghurid *chatr* have come down to us, the Ghaznavid predecessors and sultanate successors of the Ghurids bore *chatr*s that were topped with a royal bird; for this reason the royal parasol of the Delhi sultans was often described as the *chatr-i humā* (the parasol of the *humā*) and was frequently compared to the spread wings of the bird.[78] It is presumably for similar reasons that the Persian historian al-Qazwini (d. 682/1283) refers to the presence of Ghurid standards in the form of golden birds and other animals in Firuzkuh, perhaps those set on the roof of its palace.[79]

The longevity of the association between *humā*, *chatr*, throne, and royalty in South Asia is indicated by the throne of the eighteenth-century southern Indian ruler Tipu Sultan (fig. 64).[80] The jeweled *humā* bird that sat atop the canopy is today preserved in the collections of Windsor Castle (fig. 65), another reminder of royal looting practices, for it was seized during the British sack of Sri Rangapatan, Tipu Sultan's capital, at the end of the eighteenth century and subsequently served as an adornment at British state banquets.[81]

In his study of cultural circulation in colonial Oceania, Nicholas Thomas has noted how "both sides have creatively changed the purposes of abducted treasures, represented the other, and imagined a narrative of contact objectified in artifacts of alterity and artifacts of history."[82] This is equally true of some (if not all) of the Chauhan objects displayed in Firuzkuh, which provided a visible reminder of the link between the auspicious destiny of the Ghurids and their successes, the memory of which was also inscribed on the landscape of the city in other ways. One of the gates of the city had, for example, been renamed the Tara'in Gate to commemorate the victory of Sultan Ghiyath al-Din in 588/1192, a victory that both avenged an earlier defeat at the hands of the Chauhans and their allies, and finally opened up northern India to the armies of the Ghurids.[83] No less than the looted Indian icons displayed earlier in Baghdad, Ghazni, and Mecca, Chauhan gold made the Indian victories of the Ghurids manifest in a manner that underlined the wealth of the defeated and the economic benefits of victory. The prolific flow of gold and silver coins from Ghurid mints after 590/1194 (figs. 56 and 57) made the point in a more tangible manner, and it can hardly be doubted that some of this specie was used, like the Chauhan booty, for the embellishment of Firuzkuh and Herat.

Providing a serendipitous echo of the fabulous bronze creatures looted from Muslim lands and set atop the cathedrals of contemporary Christendom,[84] Ghurid treatment of the looted birds from Ajmir sets to rest two common assumptions about the reception of Indian artifacts by Indo-Muslim rulers: that they were implacably opposed to figuration, and that they valued looted golden artifacts (especially those featuring figural imagery) for their precious-metal content alone.[85]

More significantly, perhaps, the reception of the Chauhan booty reveals strategies of conceptual and iconographic translation inseparable from the physical translocation of the looted objects. This process of translation seized on formal similarities, which enabled potentially alien objects to be interpreted as known quantities through categorical assimilation: an example of this is the interpretation of what were probably *āmalakas* as golden melons.[86] Similarly, where the precise function or meaning of a zoomorphic image was unknown in the medieval Islamic world, it was often assumed by a process of cognitive assimilation: examples include the identification of the bas-reliefs of winged bulls in the Achaemenid palace of Persepolis with Buraq, the composite steed of the Prophet Muhammad.[87] Comparable processes of analogic reasoning are manifest in medieval discussions of Indian religions in which Garuda, Vishnu's eagle vehicle, is identified as a *simurgh* or *'anqā*, fabulous birds of Persian mythology.[88] In the same way, the birds (possibly Garuda eagles) brought from Ajmir were equated with the *humā* of Persian royal iconography, whether or not they had ever formed part of Chauhan insignia.[89] The identification of the birds illustrates the role that naming plays in effecting equivalence, reconstituting the pretaxonomic thing, producing it culturally as a specific type of object. As Nicholas Thomas reminds us: "The circulation of objects, especially across the edges of societies, civilizations, and trading regimes, is not merely a physical process but is also a movement and displacement of competing conceptions of things, a jostle of transaction forms."[90]

The translated birds were incorporated into an ensemble in which looted elements were used to replicate the royal parasol or *chatr* on a monumental scale. These interrelationships between monumental architecture and royal regalia in the adornment of the Ghurid palace anticipate the practices of later Indo-Islamic rulers, but they also find parallels in the rhetoric of medieval Indian kings.[91] In addition, the translation of the Chauhan gold established a relationship between palatial architecture and political formations: incorporating the signs of their defeated Chauhan rivals, the palace of the Ghurid sultans was transformed into a type of *tropaion*.[92] *Pars pro toto*, the recontextualization of the golden pinnacles and birds signaled the incorporation of the Chauhan polity itself into the

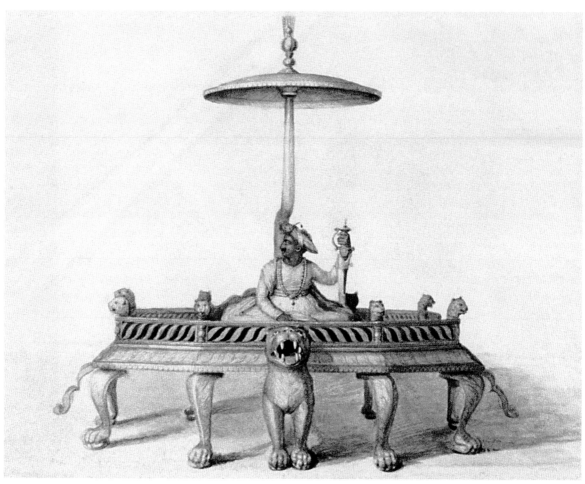

64
Anna Tonelli, *Tipu Sultan enthroned*, 1800, with *humā* bird atop the royal parasol or *chatr* (Clive Museum, Powis Castle, courtesy of the National Trust).

65
Jeweled *humā* bird from the throne of Tipu Sultan, late eighteenth century (The Royal Collection © 2005, Her Majesty Queen Elizabeth II, RCIN 48482).

Ghurid sultanate and the accommodation of the reinstated Chauhans under the aegis of Ghurid imperium. By means of a metonymy, the treatment of the golden objects thus reflected the fate of medieval rulers and the polities that they represented; as a likely mix of gifts, loot, and tribute derived from the defeated Chauhan rajas reconstituted as Ghurid vassals, the golden objects displayed in Firuzkuh were ideally suited to making the point.

The gesture has much in common with the ritual hegemony exercised by medieval Indic rulers over their defeated rivals through the use of looted signs of sovereignty to enhance the victor's status (and often his palace). Moreover, as a locus for the display of looted insignia, the Ghurid palace bears comparison with the complex signs of incorporation favored by some medieval Indian rulers, in which objects that functioned as signs of sovereignty were deployed as component elements within the composite signifier of a greater kingship. Examples include the *palidhvaja* of Chalukya and Rashtrakuta kings, a composite royal banner (sometimes crowned by a *Garuda* eagle) into which the captured banners of defeated kings were assimilated to signal their incorporation into a polycentric political formation.[93] Closer to the Ghurid sultanate both geographically and temporally is the throne of the Chalukyas of Gujarat in the twelfth century, as "a complex sign, incorporating the signs of all the grades of kings into one, the throne of the overlord of the earth, visible at a glance, cognisable at once as encompassing all of the parts of his imperial domain into a single ensemble of which he was the lord."[94]

When it came to looting India, Ghaznavid and Ghurid sultans certainly displayed something of a "get rich quick" mentality. Indo-Muslim sultans were hardly unique among medieval rulers in desiring to bolster their economy by infusions of booty, however, and to present this as the whole story is to flatten the relief in what was clearly a highly contoured landscape.[95] There are instances in Indo-Muslim history where we not dealing with generic plunder, a lust for golden booty, but with a careful selection and ritualized display of artifacts that functioned as homologous royal insignia within the discourses of medieval Persian and Indian kingship. In contrast to the accepted image of Turkic sultans as motivated by a crude financial opportunism alone, the evidence presented here suggests that the Ghurid sultans understood the value of looting as a mode of making and displaying rhetorical claims concerning victory, sovereignty, and territorial integrity. Moreover, the nature of the objects deployed in Firuzkuh and the manner of their display have more in common with the ritualized display of looted insignia as tangible expressions of complex power relations in contemporary South Asia than with contemporary "Muslim" looting practices.

As I stated at the outset, royal looting practices are a largely unexplored aspect of medieval Islamic kingship, best documented in the context of 'Abbasid-Fatimid rivalry, where objects such as the cloak (*burda*) of the Prophet or Zhu'l-fiqar, the sword of 'Ali, were targeted more than once. We also hear of a silver prow in the shape of a lion being stolen from the boat of the Buyid ruler 'Adud al-Dawla by agents of the Fatimid caliph in 371/981.[96] There are, therefore, occasions when objects that signified authority (or were understood as doing so) were targeted for looting. Similarly, there are instances in the Islamic world when one can discern the general principle of architectural metonymy in the incorporation of looted *spolia* into architectural structures.[97] Nevertheless, none of these cases deals with specific classes of artifacts; instead, the looted items were inalienable possessions that were unique by association with particularly charismatic individuals. In the present state of our knowledge these appear more like opportunistic grabs than ritualized practices integral to a widely recognized protocol of looting, with its own grammar and syntax.

Added to this is the fact that the medieval Islamic world offers few obvious precedents for the manner in which Indian booty was displayed in the palace and mosque of Firuzkuh. The Dome of the Rock in Jerusalem and the Ka'ba in Mecca are exceptions, for both functioned as the repositories of a bewildering number of exotic or antique trophies between the seventh and tenth centuries.[98] However, in terms of their function, history, and religious significance, these structures were unique. There are cases of Syrian mosques being used as temporary collection points for booty in the twelfth century, but there is nothing to suggest that these were long-term or permanent repositories of loot.[99] In general mosques, unlike temples (or even churches), do not seem to have functioned as long-term storehouses for the display of booty. Significantly, exceptions are

found in other frontier zones such as southern Spain, where both churches and mosques housed looted objects, including bells and drums.[100]

The seizure, transport, and public display of Chauhan loot may have recalled earlier Islamic precedents (Saffarid use of looted icons being a case in point), but in the terms that they employed, their syntactic structure, and the range of messages that they conveyed, the looting practices documented for Firuzkuh were perfectly congruent with those of contemporary Indian kings. The appropriation of selected objects, their display in the victor's capital, incorporation into dynastic shrines, donation to religious sanctuaries, or disposal to pay for their embellishment all find numerous parallels in the annals of Indian kingship during the eleventh and twelfth centuries.[101] Far from orchestrating a rupture in the cultural and political life of the subcontinent, Ghurid looting practices suggest an engagement with the very discourses that the sultans are supposed to have ignored, extending the purview of those discourses into the eastern fringes of the *dār al-Islām*. The circulation and imitation of Indo-Ghurid coin types in contemporary Afghanistan has been noted in chapter 3, and we shall see in the following chapter that the stone carving produced in Afghanistan during this period indicates the presence of northern Indian stonemasons in Ghazni and elsewhere. If we accept the ability of objects to move across cultural boundaries, even where embellished with culturally specific signs such as script, then we should also consider the mobility (or translatability) of the practices associated with them and be open to the possibility that circulation might encompass less tangibles spheres of ritual practice and elite self-representation. The recuperation of such practices is inevitably dependent on the flotsam of history, and can only ever be tentative, but the phenomenon of transculturation in royal ritual is well documented for the thirteenth and fourteenth centuries, as is the manipulation of semiotically charged objects for legitimizing ends by the Delhi sultans.[102]

The idea of ritualized looting practices as a realm of commonality or even an arena for cultural borrowing may seem paradoxical, to say the least, but the rhetoric of victory may have been a particularly fruitful arena for cross-cultural exchange.[103] As with other instances of cultural borrowing—the adoption of Indic modes of dress by Habbarid amirs or the use of elephants by the Ghaznavid and Ghurid sultans, for example—engagement with an existing royal discourse was desirable because it was useful, and possible because it was consonant with the expectations of subjects, whether Indian or Persian, Hindu, or Muslim.[104] Rhetorical gestures involving loot were multivalent and therefore capable of addressing multiple audiences simultaneously, an advantage in light of the imperatives that stemmed from the peculiar nature of the Ghurid state and the rapidity of its eastward expansion. The presence of elements of looted insignia in Firuzkuh conveyed a message to the population of that city and the wider Islamic world, while their absence from their original settings projected the rhetoric of Ghurid victory within northern India in a manner that accorded with indigenous precedent.[105]

Apparent differences in the nature of Ghaznavid and Ghurid looting practices as revealed by the medieval sources may reflect the changing political relationship between India and eastern Iran between the eleventh and late twelfth centuries. On the one hand there is a notable dearth of references to religious images being transported back to Afghanistan by the Ghurid sultans for ostentatious display in the Ghaznavid mode. On the other there are, to the best of my knowledge, no analogies for the birds, finials, drums, and other golden objects mentioned in the *Ṭabaqāt-i Nāṣirī* in comparable sources dealing with the Ghaznavid period. These differences also seem to extend to the mode of display. When Indian loot was displayed in Ghazni by Sultan Mahmud, this was a temporary spectacle designed to impress both residents of the city and foreign envoys with the wealth acquired as a result of the Indian expeditions. With the exception of the religious images discussed in chapter 1, there are no indications that objects selected from among the Indian booty were permanently displayed in the Ghaznavid capital as they were in Firuzkuh.

It is difficult to know what to make of these differences; they may just highlight idiosyncrasies or lacunae in our source materials for the period, but it is conceivable that the contrast between temporary displays and permanent incorporation reflects the different nature of the relationship with India in the Ghaznavid and Ghurid sultanates. As Eaton has pointed out, "the Ghaznavid sultan never undertook the re-

sponsibility of actually governing any part of the sub-continent whose temples he so wantonly plundered."[106] Temporary displays of booty were favored by a sultanate that conducted periodic raids into the territories of Indian rajas but otherwise more or less left them to their own devices. The transformation of Rajput chiefs from convenient sources of Ghaznavid booty to clients or vassals of the Ghurid sultans, accommodated within rather than raided from without, may have been reflected in the transformation of the Ghurid palace into a microcosm of the new transcultural sultanate.

The treatment of Chauhan booty highlights a relationship between persons, polities, things, and monuments, elsewhere reflected in discussions of the relative value of texts, treasures, and monuments in perpetuating the memory of rulers and dynasties, a common trope in medieval Persian literature. Writing about the architectural patronage of the Delhi sultan Shams al-Din Iltutmish (d. 633/1236) in the early thirteenth century, for example, Sadid al-Din 'Awfi notes that the treasures accumulated by rulers are ephemeral and perish, while the monuments that they erect serve as durable memorials of their rule.[107] The Ghurids illustrate the principle, for while none of the gifts and treasures discussed in this and the preceding chapter survives, significant products of their architectural patronage can be found scattered across Afghanistan, Pakistan, and India. Although modern aesthetic, disciplinary, and national boundaries have worked to sunder the Indian monuments of the Ghurids from this corpus, they manifest processes of conceptual assimilation similar to those that informed the reception of Indian artifacts in Afghanistan. In the following chapter, I will argue that both should be understood as part of a transregional phenomenon characterized by the movement of artifacts, artisans, and patrons between the heartlands of the Ghurid sultanate and its Indian territories in the late twelfth century. The development can be directly correlated to the increased contacts and enhanced cultural flows between the two regions facilitated by contemporary political developments.

5 | Remaking Monuments

*A building, more than most works, alters our environment physically;
but moreover, as a work of art it may, through various avenues of
meaning, inform and reorganize our entire experience. Like other
works of art—and like scientific theories, too—it can give new in-
sight, advance understanding, participate in our continual remaking
of a world.*

—Nelson Goodman, "How Buildings Mean"(1985), 652

| Taxonomies, Anomalies, and Visual Pidgin

The idea that temple and mosque represent two ex-
tremes of a bipolar cultural history is an axiom of
South Asian historiography. The current entry on al-
Hind in *The Encyclopaedia of Islam* explains, for ex-
ample, that idol temples "were not only anathema to
Islam but were its direct antithesis."[1] On occasion, the
two modalities have been identified not only with an-
tithetical cultural values but with incompatible psy-
chological dispositions: the clarity, openness, and in-
telligibility of the mosque embodying the realist
formalist "mind of the Musulman," in contrast to the
mysterious domain of the temple, its "introspective,
complex and indeterminate" nature indexing the ide-
alist, rhythmic "mind of the Hindu."[2]

The reception of the mosques erected by the Tur-
kic agents of the Ghurids following their conquest of
northern India in the 1190s is especially marked by
these assertions of alterity. Writing in 1953 of artistic
production in the wake of Ghurid expansion, Her-
man Goetz expressed a view that has been oft re-
peated, when he suggested that "the conquest in its
turn created a 'colonial' mentality which looked with
contempt on all things Indian and excluded, for the
time being, a further influx of types and concepts
from Indian art."[3] A decade or so later, the Indian
scholar Ziya al-Din Desai noted that "it is this con-
flict between the two styles, foreign and local, that

marks the first phase of Indo-Islamic architecture as a
whole, of which mosque architecture is an important
part."[4]

Despite these assertions of difference, Ghurid
monuments conform to regional architectural con-
ventions. Ghurid monuments in Afghanistan and the
Indus Valley conform to Persianate norms, and are
closely related to their Ghaznavid and Seljuq prede-
cessors. Their baked brick forms, terra-cotta, and blue-
glazed elements are characterized by a dryness and
rigidity, a geometrization even of vegetal motifs exe-
cuted in stucco or brick, which is detached from a
structural function and treated as applied ornament.[5]
There is an abundance of script (especially knotted
scripts), splashes of color (glazing or paint), and ef-
fects of light and shade created by incision, projec-
tion, and recession (figs. 50–52, 54).

By contrast, Ghurid monuments in India make
use of the carved stone medium, trabeate (post and
lintel) structural forms, and deeply carved ornament
standard in the Gangetic Plain. Nevertheless, the In-
dian monuments are integral to the broader late
twelfth-century campaign of architectural patronage
discussed in chapter 3. The scale of Ghurid architec-
tural patronage in northern India is evident from
extant remains, inscriptions, and texts. Textual evi-
dence attests, for example, to the refurbishment or
reconstruction of the Friday Mosque of Multan
in the Indus Valley and its provision with a royal

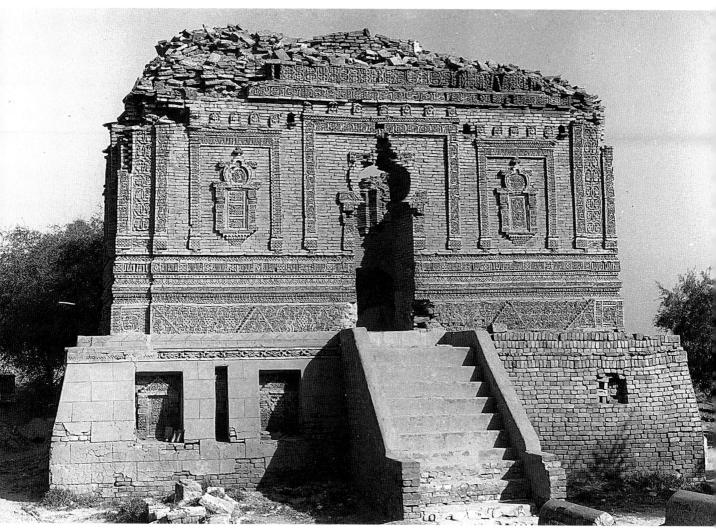

66
Tomb of Shaykh Sadan Shahid near Multan, ca. 1200.

endowment deed (*waqf*).[6] Two Ghurid funerary monuments survive nearby (fig. 66); their brick forms and ornament blend local idioms with those that find close analogies in the brick architecture of contemporary Herat, suggesting that they represent a collaborative endeavor between local artisans and those who migrated eastward in the wake of the Ghurid conquest.[7] In light of the relationship between architectural patronage and the promotion of orthodoxy discussed in chapter 3, Ghurid patronage of mosques and shrines in the Indus Valley may have been intended to encourage outlets for expressions of

Sunni piety in an area known for its strong Ismaʿili sympathies.

The erection of congregational mosques in the newly conquered territories also bolstered the credentials of the Ghurid sultans as promoters of Sunni orthodoxy. The foundation texts of two Ghurid congregational mosques are preserved at Hansi, an important fortified center northwest of Delhi (figs. 67 and 68), and an inscription in the name of Sultan Muʿizz al-Din dated 594/1197–8 now embedded in the walls of Nagaur fort in Rasjasthan may also have come from a mosque.[8] In addition, at least four

REMAKING MONUMENTS

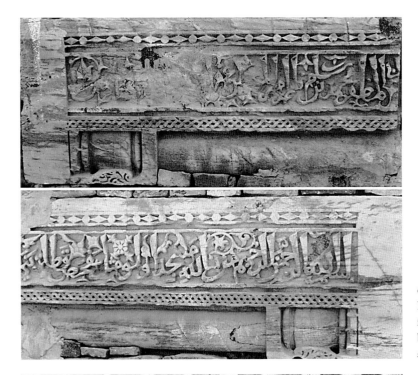

67

Hansi, two fragmentary stone foundation texts of a mosque bearing the name of the Ghurid sultan Muʿizz al-Din.

68

Hansi, Ghurid foundation text, detail.

mosques of the immediate postconquest period survive in northwestern India (for their locations see fig. 47).[9] All four are congregational mosques—that is, mosques designed to accommodate the entire male population of the community for Friday prayers—built in urban centers. The best-known of the four, the "Quwwat al-Islam" or Qutb Mosque at Delhi (fig. 69), bears a series of inscriptions informing us that it was built by the Turkish commander Qutb al-Din Aybek on the orders of the Ghurid sultan. The foundation text above the eastern entrance of the mosque (fig. 70) gives the date of 587/1191–92, the northern entrance 592/1195, while the arched screen preceding the pillared prayer hall (now mostly ruined) seems to have been completed in 594/1198 (fig. 78).

The second of the Ghurid mosques, the Arhai-din-ka-Jhompra Mosque at Ajmir in Rajasthan, was

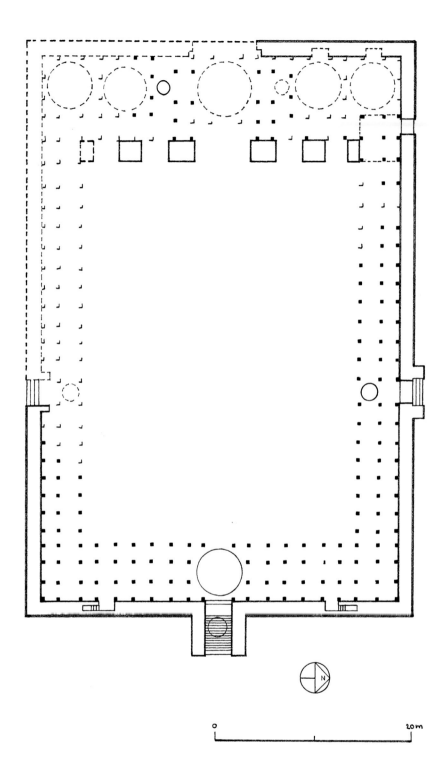

69
Qutb Mosque, Delhi, schematic
plan (drawing, Max Schneider).

REMAKING MONUMENTS

70
Qutb Mosque, Delhi, eastern
entrance.

built in the former capital of the Chauhan rajas after
their defeat in 588/1192; its mihrab gives a date of
Jumādā II 595/February–March 1199 (fig. 71).[10] A
third mosque, the Shahi Masjid at Khatu in Rajast-
han (fig. 72 and 155) roughly sixty miles northwest
of Ajmir, lacks a date, although a foundation text
dated *Jumādā* I 599/January–February 1203 was found
nearby. It is, however, provided with a mihrab of vir-
tually identical form to that in the Ajmir mosque,
with which it shares many formal features (compare
figs. 71 and 73). It can thus be confidently ascribed to
the turn of the twelfth century, if not the same work-
shop. Opinions differ on whether the mosque is con-
structed upon the platform of an earlier temple or
newly built, although making extensive reuse of ar-
chitectural materials.[11]

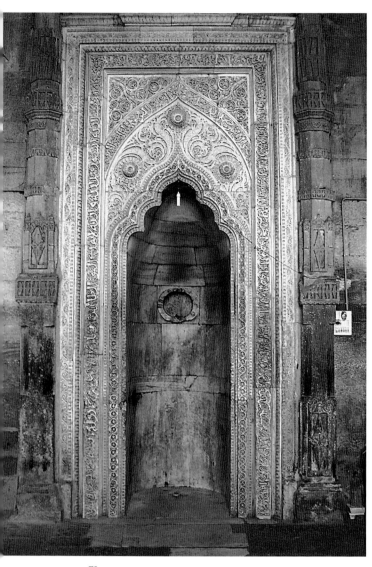

71
Arhai-din-ka-Jhompra Mosque, Ajmir, marble mihrab.

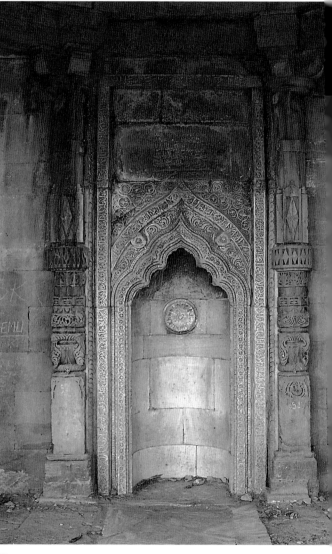

73
Shahi Masjid, Khatu, marble mihrab.

REMAKING MONUMENTS

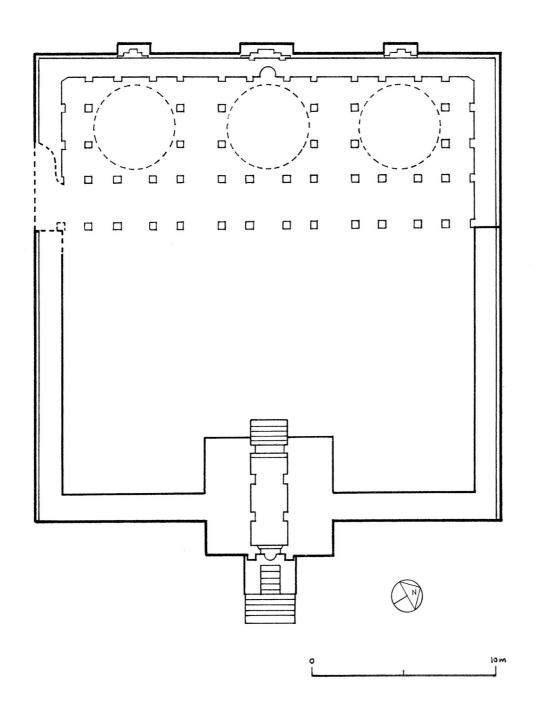

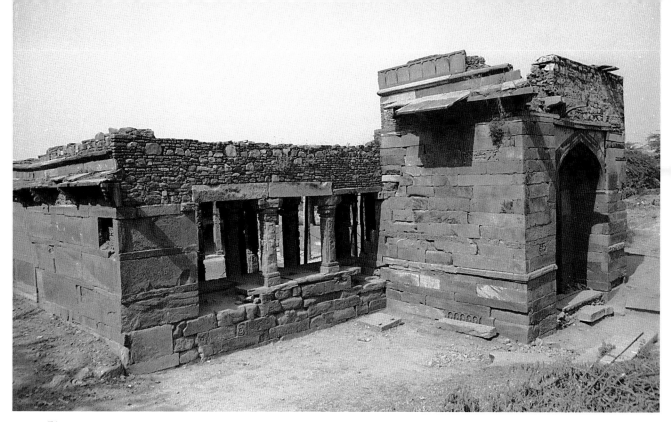

74
Chaurasi Khambha Mosque, Kaman, main entrance from the southeast.

The fourth of the group, the Chaurasi Khambha mosque at Kaman in Rajasthan (figs. 74 and 75), about sixty miles south of Delhi on the route between Ajmir and Sind, bears a damaged foundation text ascribing the mosque's foundation to Baha' al-Din Tughril, a mamluk of the Ghurid sultan who held the *iqṭāʿ* of Bayana between 1195 and 1210.[12] Since Baha' al-Din claims the title of sultan, the text probably dates from around 602/1206, when Ghurid authority in India began to wane after the death of sultan Muʿizz al-Din. The mosque contains the earliest surviving stone *minbar* (pulpit) in India, known locally as "Krishna's swing."[13]

The basic form of the four mosques is similar, with a monumental rectangular projecting entrance (elevated at Ajmir, Delhi, and Khatu) leading to a central courtyard, a multibayed prayer hall at its western end and (at Delhi and Kaman) a narrow arcade or *riwāq* surrounding the remaining three sides. The interior spaces are covered by means of corbeled domes (fig. 76) and flat slabs supported on trabeate beams borne by pillars composed of discrete sections set ver-

tically on end to achieve the required height. Many but not all of these elements have been reused from earlier preconquest monuments. With the exception of the Delhi mosque, where the main mihrab no longer survives, all four structures are provided with a single elaborately carved concave mihrab on the central axis of the building: white marble at Ajmir and Khatu, red sandstone at Kaman (figs. 71, 73, and 109–10)

The Qutb Mosque in Delhi is further distinguished by the presence of a massive tapering red sandstone seventy-five-meter-high minaret, the Qutb Minar, outside its southeast corner (fig. 77). The minaret is composed of alternating angled and convex flanges, a design that has its origins in the earlier minarets of eastern Iran and Afghanistan, including the minaret of Jam in the Ghurid summer capital (figs. 51 and 52). Three Sanskrit graffiti dated Samvat 1256 (AD 1199) on the first story and the presence of Ghiyath al-Din's titles on the fourth band of the same story (their only extant occurrence on monumental architecture east of Ghazni) indicates that the minaret stood up to this height by at least 599/1203, the date of the

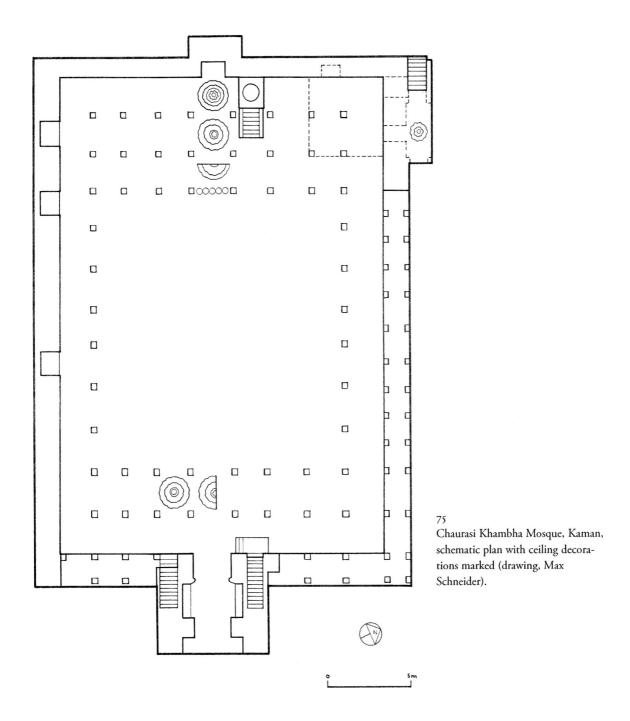

75
Chaurasi Khambha Mosque, Kaman, schematic plan with ceiling decorations marked (drawing, Max Schneider).

sultan's death.[14] Work on the minaret seems to have begun around the same time as an arched screen was added to the façade of its prayer hall (fig. 78), a feature that reiterates the arcades and *iwān*s found in the courtyards of contemporary Iranian mosques in a stone medium and trabeate idiom (fig. 79) but may also memorialize types of ephemeral victory monuments now long-since vanished.[15] The screen was extended in the 1220s under the Delhi sultan Iltutmish, when the Ghurid mosque at Ajmir was also remodeled and provided with a spectacular carved stone screen (see fig. 168), which will be discussed in chapter 6.[16]

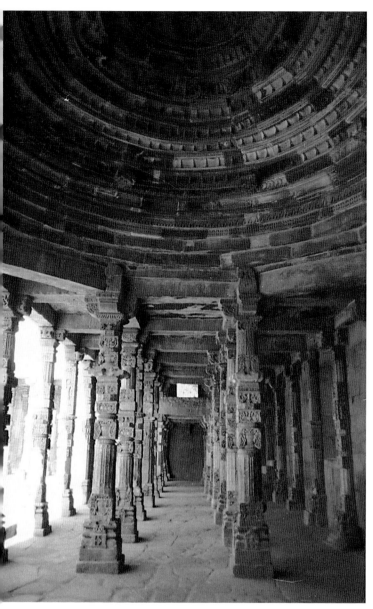

76
Qutb Mosque, Delhi, corbeled dome at eastern entrance.

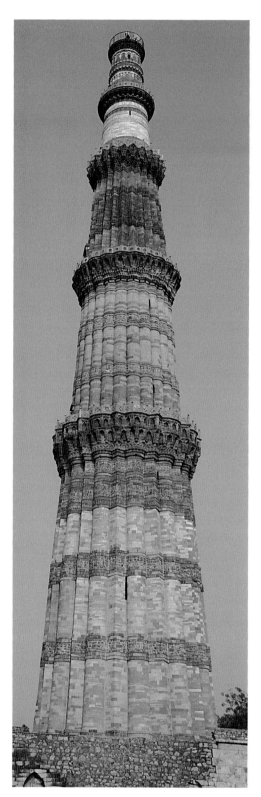

77
Qutb Minar, Qutb Complex, Delhi.

Despite the recurrence of common features, the four mosques can be divided into two distinct groups, based on the absence or presence of specific formal and iconographic features. At Delhi and Kaman, for example, a richly decorated entrance at the northwestern corner of the mosque led to mezzanine enclosure, a royal chamber provided with its own mihrab, a feature that is notable by its absence from the mosques at

REMAKING MONUMENTS

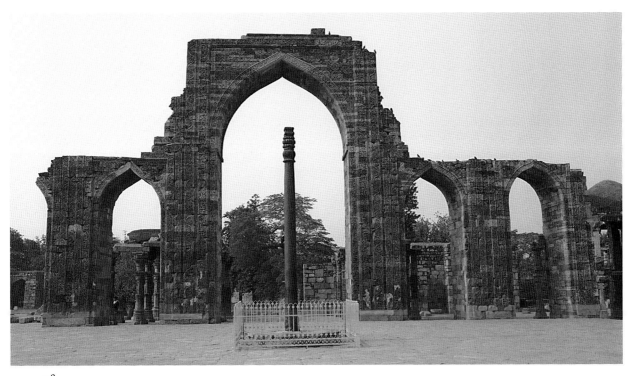

78
Qutb Mosque, Delhi, screen added to the façade of the prayer hall in 594/1198.

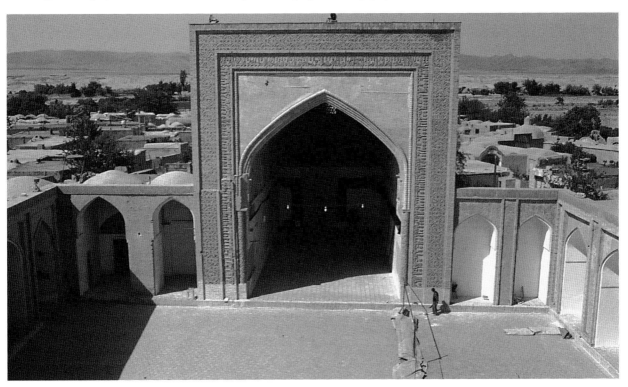

79
Friday Mosque of Gunabad, Khurasan (ca. 1200), view of prayer hall and main *īwān*.

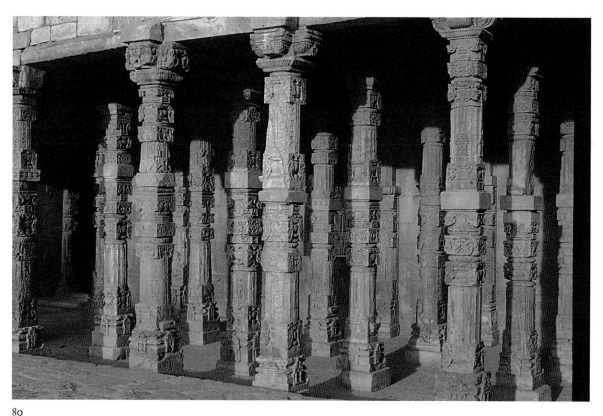

80

Qutb Mosque, detail of northern *riwāq* showing reused, richly carved columns.

Khatu and Ajmir and will be considered below. The latter mosques are distinguished from those at Delhi and Kaman by the absence of a colonnade (*riwāq*) around the courtyard and the presence of identical white marble mihrabs with a semicircular profile, in contrast to the rectangular profile of the mihrab at Kaman (the main mihrab of the Delhi mosque does not survive). The mosques at Ajmir and Khatu are also the most elevated of the four, approached by means of a monumental staircase and projecting rectangular entrances. The Khatu mosque has an unusual entrance consisting of a narrow stepped passage crowned by a pillared pavilion similar to those found at the entrances to certain Jain temples (fig. 155). In both Ajmir and Khatu, the treatment of pillars and lintels represents the most radical expression of aniconic and iconoclastic impulses that are much more muted in Delhi and Kaman (compare figs. 80 and 81).

The distinctions between the two groups may reflect the persistence of local workshop practices, or even differences among the mosques' patrons.[17] It is even conceivable that they preserve something of pre-Ghurid mosque construction among minority communities of Muslims living in Rajput polities, otherwise attested only by two twelfth-century mosques and a tomb at Bhadreshvar on the coast of Gujarat (figs. 17, 18, and 20). Although the content and style of inscriptions from Bhadreshvar indicate close ties with the port of Siraf in the Persian Gulf (underlining a point made in chapter 1: even fancy scripts circulate), the stone medium and Indic forms and iconography of these monuments demonstrate that Indian stonemasons had adapted their repertoire to serve the requirements of Muslim patrons well before the Ghurid conquest.[18] At Nagaur, the survival of a tombstone dated 545/1150 belonging to the son of an Isma'ili missionary (*dāʿī*) indicates the presence of Muslim communities in Rajasthan in the decades before the Ghurid conquest, and serves as a reminder that these did not necessarily share the confessional

REMAKING MONUMENTS

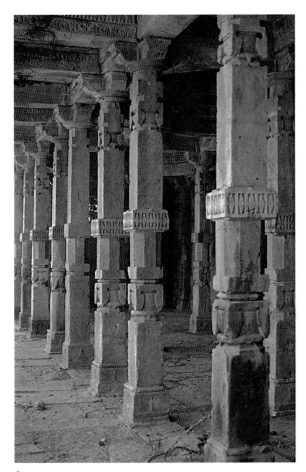

81
Shahi Masjid, Khatu, detail of prayer hall showing plain columns.

affinities of the Ghurids or their Turkic soldiery.[19] As this suggests, the preconquest Muslim presence was not confined to the coastal regions of northern India: in his account of Qutb al-Din Aybek's campaign against the Gahadavalas of Kanauj, the historian Ibn al-Athir notes that Muslim communities had existed in the area since the time of Mahmud of Ghazni and were steadfast in their adherence to the Shari'a, prayer, and the giving of charity.[20]

Despite their common use of a stone medium and trabeate idiom, there are significant formal differences between the mosques erected in the wake of the Ghurid conquest and those built earlier for minority communities of Muslims living in Sind and Gujarat.[21] For example, the round-arched forms found in the ninth- through eleventh-century mosques of Sind

(fig. 16) and at Bhadreshvar (fig. 20) are absent in Indo-Ghurid mosques, whose pointed arches evoke instead the forms favored in the contemporary architecture of eastern Iran and Afghanistan (figs. 78 and 79).

Perhaps the most striking difference between mosques erected before and after Ghurid expansion, however, is the ubiquitous reuse of architectural materials in the latter. The range of styles among the constituent materials indicates a synthesis of antique stones and reused twelfth-century materials with newly carved stones that often emulate the style of the reused material. In Kaman, much of the material reused in the mosque once belonged to pavilions and monasteries of the late eighth or early ninth century AD.[22] Some of the reused materials in the Qutb Mosque are comparable in style to those used in Hindu temples of similar date at Abaneri in Gujarat and Vasantagadh in Rajasthan, or derive from Jain temples of similar date, whereas others seem to date from the period of Tomar rule over Delhi in the eleventh century.[23] Other of the materials reused in Delhi, Ajmir, and Khatu are of more recent date; at Ajmir, these include slabs carved with a series of mid-twelfth-century Sanskrit plays (one dated Vikrama 1210/AD 1153) recording the history of Ajmir and the battles that its rajas fought against Ghaznavid and Ghurid armies.[24] That the materials reused in Ajmir were taken from a Jain temple that stood on the site is an *idée reçue* in writing on the mosque, but has a very slim evidential basis. The Chauhan rulers patronized Shaivite, Vaishnavite, and Jain temples in Ajmir; the find of a white marble Shiva *linga* in the courtyard of the mosque confirms that the sources of materials were not confined to Jain temples.[25]

The reuse of structural materials was widespread in medieval Islamic societies, and included both stones drawn from both pre-Islamic structures and those built by fellow Muslims.[26] Examples include a stone slab bearing a ninth-century Arabic foundation text, later inverted and reused as a base for a wooden pillar in the Great Mosque of Banbhore in Sind during an eleventh- or twelfth-century refurbishment.[27] Similarly, numerous extant northern Indian temples integrate older carved stones in their construction.[28] However, the consistency and scale of reuse in the postconquest mosques of northern India

is remarkable. Skilled stonemasons were surely available in major urban centers such as Ajmir and Delhi after the conquest and, as we will see, are likely to have been involved in the construction of Ghurid mosques. The recycling of architectural materials even when alternatives were available thus seems to represent a conscious choice. Speed may have been a factor, but the same pattern is repeated later after the expansion of the Delhi sultanates into Gujarat and the Deccan in the thirteenth and fourteenth centuries, although by this date the contemporary mosques and shrines of Delhi were being constructed from newly carved rather than reused materials.

This apparent preference for *spolia* and the recurrence of certain formal features in the Ghurid and early sultanate mosques of Delhi, the Deccan, and Rajasthan has led to suggestions that they constitute a distinct "conquest mosque" type constructed with materials garnered from temples destroyed after the expansion of Indo-Islamic polities.[29] Formal and iconographic differences between the four mosques under consideration here complicate this scenario, however. Indeed, one of the dangers of the "conquest mosque" paradigm is its insistence on the imposition of a normative template while ignoring the way in which its implementation was inflected by regional architectural idioms and local workshop practices.

Most scholarship assumes a metonymic relationship between the architectural elements recycled in Indian mosques and the broader cultural formations that they are made to stand for.[30] The static identities on which such roles depend are invariably sectarian, with the inevitable result that the presence of "Hindu" material in a mosque has been read as both a sign of "Muslim" victory over the defeated Hindus and an expression of contempt for the aesthetic and cultural values materialized by reused elements. The resulting emphasis on disjunction and disruption is plainly manifest in the earliest discussion of any Ghurid monument by a modern scholar, James Tod's description of the Arhai-din-ka-Jhompra Mosque at Ajmir in his *Annals and Antiquities of Rajast'han* (1829). Writing only three decades after the censorious use of the term *vandal* had gained currency in the aftermath of the French Revolution, Tod condemns the Turks, the "Goths and Vandals of Rajasthan":

Whatever time had spared of the hallowed relics of old, bigotry has destroyed, or raised to herself altars of materials, whose sculptured fragments serve now as disjointed memorials of two distinct and distant eras: that of the independent Hindu, and that of the conquering Muhammadan.[31]

Tod's emphasis on architectural destruction, his consequent portrayal of Muslim patrons as "spoilers of art" rather than active participants in its production, and his insistence that temple and mosque belong not only to two different modalities but distinct temporalities initiated a trend that resonates in scholarship until today. Within such a view, mosque construction and temple destruction are mutually conditioning activities, figuring a complete rupture in the cultural life of the subcontinent.[32] Especially after the Sepoy Revolt of 1857, the perceived violence of the past was often conflated with the memory of more recent strife, so that medieval mosques such as the Qutb Mosque in Delhi could be invoked to demonstrate the potential future of the subcontinent, should India ever slip the bonds of colonial rule.[33]

If the Ghurid mosques of India were destined to function as signs of alterity in modern scholarship, their juxtaposition of recyled "Hindu" materials with those newly carved for Muslim patrons complicated the neat sectarian distinctions on which that scholarship was predicated. The consequent attempt to negotiate the question of "hybridity" has been a feature of scholarship since its inception. Contrasting the gate of the Ajmir mosque (composed of newly carved elements) (fig. 171) with its prayer hall (constructed from reused columns, figs. 94, 103, and 104), for example, Tod draws from the repertoire of classicizing imagery that both informed and structured colonial responses to the South Asian past:

Separately considered, they are each magnificent; together, it as if a modern sculptor were (like our actors of the last age) to adorn the head of Cato with a peruke. I left this precious relic, with a malediction upon all the spoilers of art—whether the Thane who pillaged Minerva's portico at Athens, or the Turk who dilapidated the Jain temple at Ajmer.[34]

This image of a Roman portrait bust capped with an eighteenth-century wig (peruke) is firmly rooted in an iconography of incongruity, conjuring the quintessential figure of Indian hybridity, the nabob, a turban perched precariously on his bald pate.[35] The negative tone of Tod's pioneering work also inflects the perceptions of most subsequent commentators, for whom the early Indo-Islamic monuments were (like the nabob) a kind of duck-rabbit, an improbable, unstable, and unsatisfactory hybrid cobbled together from mutually incommensurate traditions.

The negative emphasis on the mixing of apparently distinct cultural forms is not merely the product of a particular aesthetic attitude but of a general epistemological position. There is a demonstrable relationship between the incipient disciplines of colonial ethnology and architectural history in nineteenth-century South Asia.[36] Both were dependent on the ability to read visual signs of (cultural, racial, and/or sectarian) difference, an endeavor that colonial scholars believed the caste system, with its rigid taxonomies, could facilitate. In light of the ability of cultural mixing to undermine the parsing or stratification of complex cultural forms and group identities, nineteenth-century ethnologists were often at pains to emphasize the absence of "the disturbing element of crossing" in the objects and subjects of their study.[37]

The biological metaphors of hybridity and syncretism that are often used to explain the unlikely union of opposites found in Indo-Ghurid mosques draw on notions of essence and purity that are embedded in colonial theories of the relationship between culture and race. Writing in 1870, for example, Lord Napier decries the mixing of Hindu, Mussulman, and European styles in India since Mussulman is "a perfect style, which can only be debased by alliance."[38] Concomitant anxieties about architectural miscegenation, with its dilution of pure essence, often have distinctly sexual overtones, manifest for example in the view of one Islamicist that the Ajmir and Delhi mosques show how "the developing Muslim style was being penetrated by the Indian tradition."[39] Similar sentiments could be inflected with a different meaning in nationalist histioriography: S. D. Sharma's 1937 history of Islam in India attributes the decline of the Ghaznavid sultanate that dominated the eastern Islamic world between 1000 and 1150 to a heady mix of architectural hybridity, transculturation, and sexual intermingling:

> Indian architects suggested some of the motifs that Indian artisans forcibly carried off to Ghazni executed for their Muslim masters; Indian captives that were taken in their thousands served to breed enervating habits among the restless and energetic Turks, Afghans, Arabs and Persians who formed the population of Ghazni; and lastly, Indian women abducted and enslaved also in large numbers sapped the vigour of their ravishers and contributed to their downfall.[40]

In this narrative, hybridity functions as a secret weapon of the "Indian" resistance, anticipating the recuperation of the concept in postcolonial and postmodern narratives of subversion and (re)appropriation.[41]

The close relationship between notions of hybridity and the discursive production of "pure" architectural styles has often been noted, as have the strongly ideological motivations underlying the promotion of the latter.[42] On occasion, concerns about the mixing of cultural forms led colonial officials to remove "Hindu" materials reused in Ghaznavid and Ghurid monuments and "restore" them to an ambivalent Hindu populace.[43] The endeavor highlights the utility of medieval monuments as sites for the construction and negotiation of historical memory, anticipating the "historical rectifications" of Hindutva, the militant Hindu nationalist ideology that seeks to "restore" temples whose sites medieval mosques are believed to have usurped.

The relative weight given to indigenous and alien elements in evaluations of the dystopian style of the Indo-Ghurid monuments has generally depended on the disciplinary affiliations and/or political proclivities of the writer. In effect, the monuments have been subject to a scholarly gestalt in which Islamicists have recognized what is familiar from the central Islamic lands, while South Asianists have emphasized a relationship to the preconquest architectural traditions. In their most strident manifestations, these divergent emphases constitute two distinct paradigms, one indigenizing, the other foreignizing. The first sees the mosques as variants of indigenous architectural forms, characterized by a domestic inscription of alien formal and spatial values. This paradigm, the older of

the two, led to confusion and a lively debate about whether or not the Qutb Mosque in Delhi was in fact a converted Hindu temple, a debate that survived well into the twentieth century and has recently been revived by Hindu nationalists.[44]

The second, "foreignizing" paradigm emphasizes the formal affinities of the mosques to the monuments of the eastern Islamic world (despite their inevitable concessions to Indian idioms and media). It developed toward the end of the nineteenth century but really gained ground only in the twentieth, with the availability of published comparanda from Afghanistan and Iran. Proponents of this approach generally see the mosques as epigonous reflections of the brick idiom and vaulted forms favored in the eleventh- and twelfth-century Seljuq architecture of Iran, products of a grudging compromise between the desires of Turkic patrons and the abilities of Indic craftsmen. The tensions between an ideal Seljuq mosque type and its deficient materialization in India figure the mosques as examples of what might be termed a visual pidgin, "not creative adaptations but degenerations; not systems in their own right, but deviations from other systems."[45] For this reason, they are generally considered evolutionary dead ends in a teleological narrative that culminates in the aesthetic glories of Mughal architecture.[46]

The oscillation between indigenizing and foreignizing poles finds parallels in art historical discourse on other medieval monuments that are considered "hybrid" or "transitional." In his work on the reception of "French" Gothic styles in England and the Rhineland, for example, Willibald Sauerländer has noted how the classification of early Gothic monuments as transitional (and thus in process) or regional (and thus constant) depends on whether evolutionary or geographic criteria predominate in their analysis.[47] Similarly, the indigenizing and foreignizing approaches to the monuments have operated as mutually exclusive paradigms, so that past studies of Ghurid monuments in India have emphasized *either* their filiations with the monuments of the Islamic lands *or* their affinities with the regional architectural traditions of northern India.

By contrast, I want to emphasize here the need to consider the monuments in *both* regional and transregional frames, taking a lead from Ajay Sinha's work on another group of "hybrid" monuments from premodern South Asia: the eleventh-century Vesara temples of the Deccan. These drew on both the Nagara forms favored in northern Indian temples and the Dravida forms of the south; in his analysis, Sinha demonstrated the need to locate them within "networks of architectural practice" in which regional and transregional forms, idioms and modes, interacted and intersected.[48] Similarly, in what follows I would like to investigate first the way in which the Indian mosques of the Ghurids reflect the negotiation of Persianate forms and modalities by northern Indian masons—their inscription within the established categories, idioms, and styles of Indic architecture—before going on to demonstrate the contemporaneous reception of Indic forms in the architecture of Afghanistan itself. I will conclude by considering the interrelationships between both phenomena, and their implications for our conceptualization of South Asian cultural geography at the end of the twelfth century.

Rupture and Reinscription

Implicit (and sometimes explicit) in both indigenizing and foreignizing approaches to the early Indian mosques is a broader debate about the degree and nature of the changes wrought by the eastward expansion of Ghurid imperium. As we saw in chapter 3, modern historiography has assumed that the defeat of the major ruling houses of northern India produced a political *tabula rasa*. The congregational mosques built in the immediate aftermath of the conquest are assumed to materialize this rupture, built as they are from from recycled materials, in many cases on sites formerly occupied by the temples of the defeated. However, just as closer inspection of the postconquest administrative arrangements reveals both continuities and discontinuities in the political life of northern India—the reinstatement of ruling houses and continued operation of coin mints alongside the appropriation of conquered lands and their redistribution according to the alien *iqṭāʿ* system—so the mosques are marked by a dialectical interplay between continuity and discontinuity, tradition and innovation. In modern scholarship, this dialectical quality has, however, been obscured by an overwhelming emphasis on discontinuity.

Despite efforts to foster a degree of economic and political continuity in northern India after the Ghurid conquest, the exclusively monotheist nature of Islam meant that the new dispensation could not consolidate its authority through the incorporation of regional deities or appeals to a common ideology of sacral kingship manifest in temple cults. Medieval Arabic and Persian narratives of conquest and expansion generally espouse a binary and teleological vision of history as an unfolding struggle between believers and unbelievers. In these narratives, the act of destroying "pagan" shrines and constructing mosques in their stead functions as a synecdoche for broader processes of Islamization. Textual histories of Ghur itself conform to this pattern, for we are told that when the region was Islamized in the tenth century, mihrabs and *minbars* (prayer niches and pulpits, a shorthand for congregational mosques) replaced idol temples, "and the laws and canons of Islam were promulgated to the very extremity of the region of Hindustan which adjoins that of Chīn."[49] Similarly, early thirteenth-century accounts of Ghurid expansion into India refer to the destruction of idols (*aṣnām*) and idol houses (*but-khāna*s), and their replacement by mosques, madrasas and *khanqah*s.[50] The rhetorical function of such claims mitigates taking them at face value. However, while the existing urban fabric of cities such as Delhi was maintained (perhaps because the combination of fortified city and citadel was consonant with Persianate modes of urbanism), some of the postconquest mosques do appear to have been constructed on the sites of earlier temples destroyed in the wake of the conquest, and all make use of materials garnered from earlier structures.[51]

The dearth of evidence for the conversion of Hindu or Jain temples into mosques may be explained by the architecture of the temple, and its role as a focus for individual rather than congregational prayer. Unlike Syrian basilical churches, which could be converted into mosques by the simple expedient of internal reorientation, or fire temples, which offered a domed chamber that might be adapted for communal prayer, temples with a *garbhagriha* (inner sanctum) designed to house a cult image and narrow corridors designed to accommodate small groups of worshippers were not well suited to communal prayer.

In addition, the political utility of architectural iconoclasm can hardly be doubted. The destruction of tutelary temples reflects their role as a nexus between deity, icon, and ruler, a relationship often expressed through common nomenclature and ritual. These shared attributes manifested a constitutive relationship between the images that temples housed, the ruler who installed them, and the polities over which both presided.[52] The link between the exercise of political power and its constitution in temple cults is evident in a *farmān* (edict) issued by the Delhi sultan Iltutmish (d. 633/1236), in which he states that those who consistently oppose the state should be punished by the destruction of their icons and the temples that house them.[53] Destruction of tutelary temples and the seizure of their icons enacted the destruction of the polities to which they were related. Their replacement with congregational mosques inscribed a dialectics of absence and presence, a rewriting of urban space that was both pragmatic (providing the Muslim community with a space to fulfill the requirements of ritual prayer) and ideological (signifying the supersession of the old political order and the permanence of the new).

Anthropological studies of monumental architecture emphasize its ability to facilitate the consolidation of emergent social, political, and economic formations, an idea anticipated by Ibn Khaldun's (d. 808/1406) observation that the perceived strength of a dynasty resides in its monuments, and their ability to endure and proliferate.[54] As in earlier contexts in which Muslims exercised political hegemony as a statistical minority, patronage of large-scale urban mosques formed part of what the art historian Oleg Grabar has dubbed a "symbolic appropriation" of the land.[55] The role of architecture in translating the land of India is already a theme in Ghaznavid poetry, witnessed for example in Mas'ud-i Sa'd-i Salman's (d. 514/1121) exortation of Sultan Mas'ud: "May you establish a thousand forts like Iran in India."[56]

The architecture and siting of the Indo-Ghurid mosques suggests ambivalence toward the likelihood of perdurance. In Bada'un, Delhi, Hansi, and probably Multan, Ajmir, and Kaman, the first congregational mosques were sited within preexisting forts, a practice followed later as the Delhi sultanate expanded southward. While the choice of locale represented continuity in sites of administrative and military significance, it also suggests a concern with security. Visually (although not necessarily functionally), this

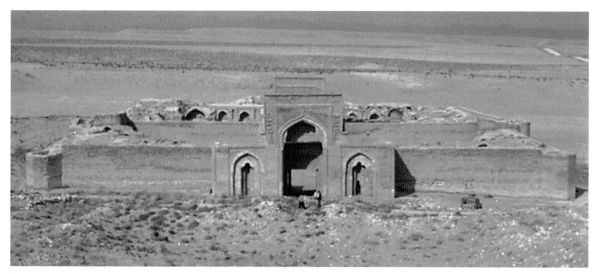

82
Ribat-i-Sharaf, Khurasan, twelfth century.

may also be reflected in the defensive appearance of the mosques at Ajmir, Delhi, and Khatu, and the presence of large projecting rectangular entrances (figs. 70, 74, 155, 171) like those found in the twelfth-century *ribāṭ*s or fortified halting places along the trade routes of eastern Iran (fig. 82).

With the benefit of hindsight, the permanency of Turkic hegemony appears inevitable, but this was not a given at the time that the mosques were constructed. In the unsettled conditions of the 1190s dynastic revanchism posed a real threat. In or shortly after 589/1193, Hariraja, the brother of the defeated Prithviraja Chauhan, led a revolt against Ghurid rule, briefly succeeding in retaking Ajmir, the dynastic capital, and apparently damaging Muslim shrines there. One is left to piece together what one can about these events from a combination of florid allusions and tantalizing inscriptions, but it is clear that this was an important event that destabilized most of northwestern India: it was only after the failure of the revolt that Delhi was finally occupied by the armies of the sultan as a consequence of its ruler's involvement.[57]

The jurists distinguish between non-Muslims who capitulate voluntarily (*ṣulḥan*) and those defeated by force (*'anwatan*), with the former generally receiving more generous terms than the latter. The fate of the principal temples of each city may therefore have varied according to the specific circumstances in which it

fell into Ghurid hands.[58] In Gwalior, for example, the Parihars apparently retained their fort by paying annual tribute to the Ghurids and agreeing to the destruction of the main temple of the city and its replacement with a mosque.[59] Although Ajmir was taken in 588/1192, the earliest dated inscription in its congregational mosque hails from 595/1199; the persistence of the temples of Chauhan tutelary deities on the site during the period when Prithiviraja's son ruled as a Ghurid vassal might explain the time lag. If so, it seems likely that the tutelary temples of the Chauhans were destroyed in the wake of Hariraja's revolt.

Although largely ignored, the role of architectural destruction and desecration in contemporary intra-Muslim struggles for authority and territory has an obvious relevance to the meaning of such acts. As we saw in chapter 3, the category of unbelievers (*mushrikūn*) encompassed both non-Muslims and heterodox Muslims identified as heretics. For those who sought to assert their role as champions of orthodoxy, the destruction of "pagan" temples and the mosques of "heretics" was equally instrumental. The destruction of mosques and madrasas was a feature of the factional rivalries between the different sectarian strains of Sunni Islam in the eastern Islamic world during the eleventh and twelfth centuries. These events were not instruments of state policy but effects of sectarian conflicts with political overtones, in which the protagonists were vying for authority and

often control of urban space.[60] Nevertheless, they find analogies with "official" acts of selective destruction during periods of political conflict. Around 354/965, for example, the Isma'ili rulers of Multan destroyed the Sun Temple of that city and erected a new congregational mosque on its site, abandoning the long-established Sunni Friday Mosque.[61] When Mahmud of Ghazni, an implacable enemy of the Isma'ilis, captured Multan in 395/1005, he destroyed the Isma'ili Friday Mosque, leaving its site vacant (a kind of antimonument signifying supersession) and restoring the original Sunni congregational mosque to its former preeminence.

If Sunni commentators routinely lauded the destruction of heterodox mosques as a victory for the faith, for obvious reasons, the destruction of mosques belonging to Sunni coreligionists was seldom heralded in the chronicles of those whose armies carried out such acts; instead, we tend to hear of them either in regional histories or in those written by non-Muslims. The destruction of the Friday Mosque of Zarang, the rebellious former Saffarid capital of Sistan in 394/1003, by the Indian troop contingents (the *salār-i Hindūyān*) of Sultan Mahmud provides an example at odds with Mahmud's role as a champion of orthodoxy.[62] Similarly, from a Syriac chronicle, we learn that when the Seljuq sultan Tughril Beg, a Sunni, sacked the rebellious city of Sinjar in the Jazira region of northern Iraq in 449/1057, he not only destroyed its palaces but burnt the Friday Mosque to the ground.[63] During the sack of Ghazni in 545/1150, the Ghurid *malik* 'Ala' al-Din Husayn razed many of its monuments (including perhaps the celebrated Friday Mosque, the "Bride of Heaven"), sparing only the tombs of Mahmud and two of his admired successors.[64] These actions are best understood as both revenge and a means of destroying the traditional power base of the Ghaznavids.

In addition to its utility in intra-Muslim warfare, the destruction of a rival's cities, forts, and palaces was in no way outside the pale of medieval Indian kingship. Royal temples were not immune to such conduct, but instances of preconquest temple desecration are generally dismissed as aberrations or anomalies within a historiographic tradition that pits Hindu iconolatry against a theologically motivated Islamic iconoclasm.[65] Nevertheless, epigraphic and textual evidence indicates that temple desecration was undertaken by all the major political formations of preconquest India, north and south: Chalukyas, Rashtrakutas, Pratiharas, Cholas, and Pandyas. A brief overview of the epigraphic and textual evidence suggests that acts of temple desecration or destruction in pre-Ghurid South Asia can be associated with three broad types of phenomena, which are not mutually exclusive: territorial expansion and dynastic change; new accessions within the same dynastic line; and rivalry between different sectarian groups competing for converts, political patronage, or control of sacred sites and the material and spiritual benefits that flowed from this.[66] In certain cases, architectural materials were carried off and incorporated into structures erected by the victor or by a rival sect, anticipating the reuse of materials in Indo-Ghurid mosques.[67] In other words, whether practiced by Muslim sultans or Hindu rajas, image destruction, temple desecration, and the conversion of sacred space were often associated not only with territorial expansion or political ascendancy but also with the exercise of religious hegemony.

The rhetorical frames within which acts of temple desecration were inscribed predate the arrival of the Ghurids and their Turkic mamluks. The demonization of Buddhists, Jains, materialist sects, or those who denied deities such as Vishnu is a commonplace of Sanskrit epics, prefiguring the casting of the *Turuṣkas* or Turks in the role of the demonic "other."[68] Similarly, narratives of bleeding statues that occur in Jain texts written as a response to acts of iconoclasm by Ghaznavid or Ghurid armies reiterate tropes deployed elsewhere to demonize Vaishnavite desecrations of Shaivite icons.[69] Taken together, these phenomena highlight the role of epic and myth as vehicles for mediating shifting patterns of encounter and establishing narrative continuity in the face of political change.[70] Paradoxically, the portrayal of temple desecration as part of a timeless Manichaean struggle between good/light and evil/dark in Sanskrit and vernacular texts mirrors the rhetoric employed in Arabic and Persian texts relating the desecration of Hindu and Jain temples.

Whether continuity in the representation of such acts also implies continuity of meaning is debatable. In a recent controversial article, the historian Richard

Eaton emphasized that temples had been sites for contestations of kingly authority long before the advent of the Muslim Turks, concluding: "by targeting for desecration those temples that were associated with defeated kings, conquering Turks, when they made their own bid for sovereign domain in India, were subscribing to, even while they were exploiting, indigenous notions of royal legitimacy."[71] Implicit in this evaluation is the suggestion that, as a tool of military and political expansion, temple desecration represents a point of continuity rather than rupture with preconquest royal practices.

While it is clear, however, that architectural destruction, including the razing of religious monuments, was an integral part of premodern warfare in India and the Islamic world, it is also important to highlight differences in the meanings of such acts and the contexts in which they occurred. The destruction of tribal icons and the appropriation of their shrines were integral to the Islamization of Arabia, providing a powerful precedent to which the reiterative rhetoric of later dynasties, including the Ghaznavids, often laid claim. Although image destruction and temple desecration were also known in preconquest South Asia (and may even have been considered religiously meritorious in certain circumstances[72]), they lacked the powerful imprimatur of a historiographic tradition in which iconoclasm was a defining act of a newly emergent religion. Image destruction was among a range of practices that led to Harsha of Kashmir (1089–1111) being referred to as a *rājaturuṣka* (Turk king), suggesting a perceived association between image desecration and Turks.[73]

Although the rapid proliferation of temple desecration at the end of the twelfth century may reflect the unprecedented scale and speed of Ghurid expansion rather than the novelty of the practice itself, the shock of these events must have resounded through all levels of society. The Jain writer Jinapala Suri, who was present at the fall of Ajmir to the Ghurid armies in 588/1192, captures something of the chaos and dislocation of that moment.[74] The impact of the postconquest arrangements on the population, their daily rituals, and experience of familiar cityscapes can hardly be doubted. As early as the eleventh century, Jain texts tell of icons attacked by Ghaznavid iconoclasts avenging the blows of their attackers, or decamping of their own volition (auguring the end of

the polities over which they presided), but such supernatural prophylaxis and protection could not always be relied on, and the practice of burying or concealing sacred images to protect them from marauding armies is well documented.[75] A Sanskrit inscription carved in the name of the nephew of Jayachandra, the Gahadavala ruler of Kanauj defeated and killed by the Ghurids in 1193, provides a rare insight into the emotional impact of these events, albeit one framed within the conventions of royal rhetoric. The text commemorates the protective concealment of a Durga icon from Etawah fort by a priest (*ācārya*) in the service of Jayachandra:

> My rationality has been destroyed because of my fear of the *Mleccha*s. With great sorrow, touching her with my head (to honour her), I place this Durgā, the dweller of the fort and destroyer of bad luck, into this pit, till the god Skanda turns their glory (Sun) to dust. When ill fate meets the Yavanas [literally, Greeks, and, by extension, foreigners], she might re-appear, or manifest herself again amidst uproar.[76]

Highlighting elements of congruence in the instrumentalization of architectural destruction by north Indian rajas and their Ghurid successors should not therefore obscure significant disjunctions in the relationship between the exercise of political authority and the patronage of monumental religious architecture. In a recent essay on the Qutb Mosque, Sunil Kumar strikes a delicate balance between continuity and discontinuity, acknowledging the common utility of temple desecration but differentiating its meaning in pre- and postconquest contexts:

> When "Hindu" rajas pillaged each other's temples, the authority of the vanquished lord was either appropriated or reconstituted within the temple shrine of the conqueror. The statements of conquest embodied in the process of destruction and reconstruction of imperial temples, was carried out within ritually homologous forms of Hindu kingship. By contrast, Qutb al-Dīn's statements of conquest in the masjid-i jāmiʿ redeployed temple spoils, but there was no sense of appropriation of authority. It signified instead the arrival of alternate traditions of governance in Delhi.[77]

While one might quibble with the degree to which the decade following the conquest was in fact marked by dramatic changes in governance, the point is well taken.

This dialectic between continuity and discontinuity that was so central to the exercise of Ghurid hegemony in northern India is in fact evoked by a foundation text carved on the inner lintel of the principal (eastern) entrance to the Qutb Mosque in Delhi (fig. 70), half-obscured in the gloom:

> This fort was conquered and this congregational mosque built in the months of the year 587 [1191–92] by the amir, the great general, commander of the army (*isfahsalār ajil kabīr*), Pole of the World and Religion (*Quṭb al-dawlat wa'l-dīn*), the *amīr al-umarā* Aibek *sulṭānī* (i.e. slave of the sultan) may God strengthen his helpers. [The materials of] twenty-seven idol temples (*but-khāna*), on each idol temple two million *dilīwāls* had been spent, were used in this mosque. May God the Great and Glorious have mercy on that slave who prays for the faith of the good builder.[78]

The foundation text constitutes the mosque as a *lieu de mémoire* inscribed with the conditions of its own production. It is, however, marked by several idiosyncrasies, including the early use of Persian. The commemoration of reuse is also unusual in a foundation text of this period, even if the practice was common. In addition, the date given for the foundation is at odds with that of 588/1192, which early thirteenth-century Persian histories give for the capture of Delhi. It is possible, therefore, that the Persian text was in fact set in place later than the date that it cites, perhaps during the reign of Iltutmish (d. 633/1236).[79] Nonetheless, the bald facts communicated to those entering the mosque point to a disjunction in the established order encapsulated by the seizure of the fort, the appropriation of the site, and the reuse of materials to construct a new place of worship for the new Turkic overlords.

Conflating historical events with epigraphic or textual representations of them, the text at the entrance to the Delhi mosque has been read as a transparent statement of historical fact, a triumphal statement of disjunction and disruption that locates the

reuse of materials within a theology of iconoclasm. In fact, despite its emphasis on discontinuity, closer inspection of the foundation text and its content reveals a rather complex relationship between the old and new orders. Most commentators have taken the figure of twenty-seven temples mentioned in the inscription quite literally, at least one demonstrating its veracity by correlating the number of reused pillars in the mosque to the number used in a "typical" Hindu temple.[80] The figure coincides, however, with the traditional number of *nakṣatra*s or lunar mansions in Indic cosmology.[81] Descriptions of Ghurid monuments in Afghanistan and India sometimes stressed their cosmological significance in numerological terms. For example, an earlier Ghurid *malik* reportedly built a palace with twelve towers in each of which there were thirty openings, corresponding to the zodiacal mansions, so that the sun would appear each day in its appropriate house; similarly, the Qutb Minar is often said to have 360 steps.[82] Here, however, a similar idea is expressed using the norms of Indic cosmology. The manner in which the cost of materials is coded—in the local currency of *dilīwāls* rather than the dirhams used in Afghanistan and the central Islamic lands—represents another point of continuity with indigenous cultural norms.

The citation of a figure for the value of the constituent materials (re)used in the mosque is highly unusual among Islamic foundation texts. The commemoration of cost is integral, however, to descriptions of temples encountered in Arabic and Persian texts even before the Ghurid conquest, in which the citation of a monetary value for the architectural materials establishes a relationship with the images that they contained, and whose constituent metals are similarly parsed.[83] It also conforms to the way in which certain kinds of religious patronage were memorialized in pre-Ghurid Sanskrit texts. For example, the *Rājataraṅgiṇī*, the royal chronicle of the Kashmiri kings compiled just decades before the Ghurid conquest, often enumerates the quantities of precious materials used in the facture of icons, informing us for example that Lalitaditya of Kashmir (d. 760) expended 84,000 *tolas* of gold on an icon of Vishnu.[84] Once again, it seems likely that the figure should not be taken literally but was chosen for its auspicious connotations. Employing tropes associated with the representation of royal patronage in preconquest Sanskrit texts, the content of

this Persian inscription therefore raises questions about cognition and transmission that are no less relevant to the adjoining mosque.

Although the historical inscriptions of Indo-Ghurid mosques have usually been considered as distinct from the prolific religious texts that they bear, the content of the historical text on the inner lintel of the eastern entrance suggests that it was intended to be read along with the Qur'anic text that accompanies it:

> From those who deny and die disbelieving will never be accepted an earthful of gold if proferred by them as ransom. For them is grievous punishment, and none will help them. You will never come to piety unless you spend of things you love; and whatever you spend is known to God (Qur'an 3:91–99).[85]

The juxtaposition is of considerable importance, for it would appear to locate the reuse of architectural materials within the "economy of piety" discussed in chapter 1, according to which hoarding and accumulation of gold was proscribed in favor of its circulation for the benefit of the *umma*, the Muslim community.

If the figures cited in the accompanying historical text should be understood metaphorically, so too the gold referred to here can be understood as a metaphor for materials that should be valued not in themselves but for their ability to advance the welfare of the community using the mosque. Just as the material resources encapsulated in looted icons could be freed for circulation in the service of Islam (often by funding the construction of mosques, as we saw in chapter 1), so the constituent materials of demolished temples or derelict structures could be recycled to the same end. However, the emphatic stress on the need for this to be a gesture made not under duress but from belief and renunciation is striking and (questions of linguistic access notwithstanding) may have been intended as an invitation to conversion.

Like the texts that greet the visitor or worshipper at its entrance, the architecture of the Delhi mosque (indeed, of all four mosques considered here) is characterized by a complex interplay between past and present, tradition and innovation, that also characterized both Indo-Ghurid coinage and the political arrangements made in the wake of the conquest.[86] This aspect of the mosques has, however, been occluded by a schol-arly tradition that has generally denied the very possibility that temple and mosque might share any aesthetic, formal, or iconographic values. Failing to consider reuse as a positive mode of reception, for example, nineteenth- and twentieth-century observers who lauded the quality of the carvings from which the Indo-Ghurid mosques were constructed generally denied the same appreciation to their Muslim patrons. On the contrary, the act of reuse was even portrayed as an anti-aesthetic gesture. An account of the Qutb Mosque complex in Delhi written by J. D. Beglar of the Archaeological Survey of India and quoted to the Second Congress of Orientalists in London in 1874 makes clear the contemporary reasoning: "Indeed, on *à priori* grounds, we should expect this want of appreciation of truthful ornamentation among the Mahomedans, a barbarous and warlike people, whose religion narrowed their minds, naturally none of the most liberal, and demanded the suppression of aesthetic feelings. . . . It is only after the Mughal conquest that Mahomedan architecture begins to be beautiful."[87]

Twentieth-century scholarship took this idea one step further, identifying the screen added to the Qutb Mosque at Delhi in 594/1198 (and that added to the Ajmir mosque three decades later; figs. 78 and 168) as an unsuccessful attempt to veil the alien appearance of the earlier prayer halls that lay behind them, composed as they were of "Hindu" materials. Indeed, the Delhi screen (rather than the mosque with which it is associated) has been hailed as the true beginning of Islamic architecture in India, although its corbeled arches and domes are routinely described as false or pseudo versions of the real (Iranian, arcuate) thing.[88] The language of truth and falsity employed in these appraisals bring us back to the image of Cato and his wig in Tod's pioneering description of the Ghurid mosque at Ajmir.

As Carl Ernst has pointed out, however, Muslims who wrote about Hindu temples (and presumably also those observers who never committed their impressions to paper) "had complex reactions based as much on aesthetic and political considerations as on religion."[89] Although it may seem counterintuitive, the instrumentalization of iconoclasm does not preclude an aesthetic appreciation for its objects. Mahmud of Ghazni's victory communiqué (*fathnāma*) after his sack of Mathura, an important northern Indian pil-

grimage center, in 409/1018, eulogizes that city's main temple, prior to ordering its destruction:

> Neither authors with their pens and inkwells nor artists with their brushes could hope to succeed in representing its elegance and ornament, or the eye-dazzling sparkle of the its carved decoration. As the sultan (himself) said in his (victory) letter: "Should anyone wish to build the equivalent of these edifices, he would be unable to, even if he spent a hundred million dirhams over the course of a hundred years, employing master workmen and craftsmen of magical skill."[90]

The importation of (wooden?) beams or columns (*judhūʿ*) from Sind and al-Hind for the Friday Mosque begun by Sultan Mahmud in his capital just before this campaign suggests that the admiration voiced here found practical expression in the sultan's architectural patronage.[91] The ambivalence that relates perception and response is common to the cross-cultural reception of art and architecture in other frontier zones. In medieval Spain, for example, a fascination with the aesthetic values and opulence of specific architectural forms and idioms associated with mosques and Islamic palaces led to their adoption for Christian depictions of Babylon in all its corrupt but seductive lavishness.[92]

Nevertheless, the recycling of architectural materials in Indo-Ghurid mosques has generally been taken as both a sign of "Muslim" victory over the "pagan" Hindus and an expression of contempt for the broader aesthetic and cultural values that recycled materials are assumed to represent.[93] As in other contemporary contact zones, however, architecture needs to be seen as integral to more extensive processes of appropriation, confrontation, and mediation.[94] In common with examples of architectural reuse in other areas of the contemporary Islamic world (including Anatolia, Egypt, and Palestine), at Ajmir, Delhi, and Khatu reused materials were integrated with newly carved stones emulating their style.[95] If this suggests that there was nothing objectionable about the style of the carvings from which the mosques were constructed, the specific modes of reuse and the contemporary reception of an Indic architectural vocabulary in Afghanistan (a phenomenon considered below) indicate a more active reception. Despite this, there has been an overwhelming focus on the *fact* rather than the mode of reuse, an emphasis compounded by a widespread assumption that the identities of cultural artifacts are fixed, an inherent quality of form and structure rather than circulation and use. The issue is not merely academic, for the case of the golden birds discussed in chapter 4 indicates that the manner in which artifacts are redeployed illuminates the meanings and values ascribed to them by secondary and tertiary consumers. The birds are known only from texts: by contrast, the mosques under discussion here have an existence independent of the texts in which they are described. The physical manipulation of the carved stones comprising them thus offers the historian of material culture a practical way of building on what might otherwise remain platitudes about the social life of things.

Paradoxically, perhaps, an empirical approach to the postconquest mosques also enables us to transcend a focus on origins, permitting the historian to address questions of agency and process otherwise occluded from analysis. As Anthony Cutler notes,

> By focusing on the act of reuse we shift the emphasis from the object (and prevailing concerns with its origin) to the agent who reemploys it. This individual becomes the subject in the relationship, rather than the lucky successor to something much older and, by implication, more important than he or she is.[96]

In short, a reorientation from the fact of reuse *tout court* (and the inevitable source mongering toward which it leads) to the specific strategies that inform it refocuses our gaze on agent and process rather than artifact and product, illuminating the ways in which reused artifacts developed novel sets of relationships with new communities of artifacts and users. Instead of considering the Indo-Ghurid monuments as random collections of mutilated fragments, or deficient reproductions of an ideal Persian mosque type, we might instead approach them as *Gesamtkunstwerks* (total art works), with their own aesthetic and iconographic values. Seen in this light, the monuments illuminate the mediation of regionally distinct architectural idioms and styles in ways that destabilize the fundamental dichotomy between "Indic" and "Islamic" traditions on which many previous analyses have been predicated.

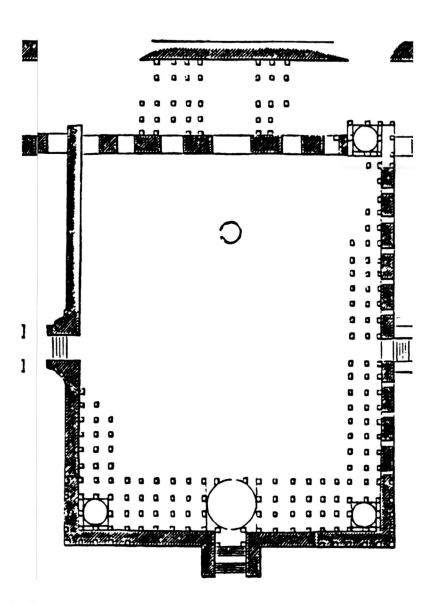

83

Qutb Mosque, Delhi, schematic
plan showing domed chambers
(bottom left and right) and the
royal chamber (*mulūk khāna*), top
right (after Fergusson 1876).

| Noble Chambers and Translated Stones

More than three decades ago, Muhammad Mujeeb be-
moaned the search for borrowed elements (both phys-
ical and metaphysical) in the Qutb Mosque, and the
way in which it detracted from aesthetic appreciation
and empirical analysis of the mosque itself.[97] Despite a
scholarly fixation with reuse and with the various ways
in which the Indo-Ghurid mosques diverge from a
postulated Persianate norm, the presence of several
unusual formal features in the Delhi mosque has gone
unnoticed and unremarked, although they provide
significant insights into the social organization of its
interior spaces. The elevated domed chambers at the
north- and southeastern corners of the mosque (visible

in fig. 83), for example, may have housed madrasas or
religious schools before a dedicated structure was com-
missioned, a practice well documented in other re-
gions of India.[98] Formal antecedents can be found in
the madrasas of Afghanistan or in the mosques built
for minority communities of Muslims living in Hindu
polities, a reminder that the formal genealogies of the
Indo-Ghurid mosques may have been multiple.[99]

Equally informative is a small, elevated cuboid
chamber measuring roughly six meters a side located
at the northern end of the prayer hall in Delhi (figs.
83 and 84). A feature of similar form and dimensions
occurs in the same location in the Chaurasi Khambha
Mosque at Kaman.[100] In both cases, the mezzanine
enclosures were located in the northwestern sector of

160 REMAKING MONUMENTS

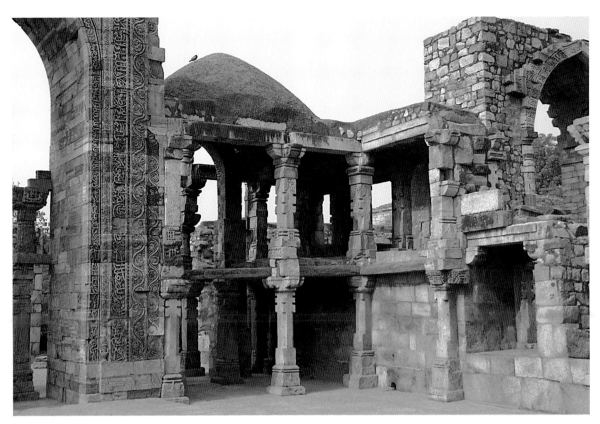

84
Qutb Mosque, Delhi, remains of the royal chamber (*mulūk khāna*) in the northwestern corner of the courtyard.

the mosques (visible in plan in figs. 69, 75, and 83) abutting its north wall and were probably once screened with stone lattices.

These chambers are innovations absent from earlier mosques in Sind and Gujarat, but they have either been ignored in discussions of Indo-Ghurid architecture or misidentified as a *zenāna* (women's gallery).[101] Their significance can hardly be underestimated, however, for they are the earliest extant examples of a feature first encountered in descriptions of the 'Arūs al-Falak (Celestial Bride), the Friday Mosque built by Sultan Mahmud ibn Sebuktegin in his capital of Ghazni around 409/1018. An eyewitness account preserved in the *Ta'rīkh al-Yamīnī* of al-'Utbi (d. ca. 422/1031) describes this as an elevated square chamber distinguished by its decoration and by the provision of a private entrance leading to the adjacent palace:

> The sultan set apart for his personal retinue a chamber (*bayt*) in the prayer hall, looking out over it, cubical (*muka''ab*) in construction, spacious, with regular corners and sides, and pro-

vided with a floor and dado *(izār)* of marble which had weighed heavily on the backs (of the beasts) that bore it from the land of Nishapur. . . . A route was cut through from the royal palace to the chamber that I have described, giving access to it with security from the indignity of prying eyes or the interference of men either virtuous or vicious. Thus the sultan could ride to this chamber with complete dignity and peace of mind in order to perform his prescribed religious duties and claim his wages and reward for them.[102]

Few Ghaznavid or Ghurid mosques survive in Afghanistan, and the subsequent history of this *bayt* is therefore difficult to trace. Nevertheless, archaeological evidence suggests that it was incorporated into later congregational mosques in Afghanistan and first introduced to northern India in the wake of the Ghurid conquest, where the form of the chamber drew on the enclosed hall (*gūḍhamaṇḍapa*) associated with the temple.[103] In contrast to the mosques of the Iranian

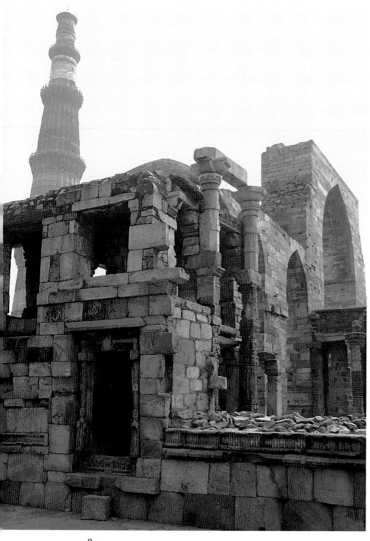

85

Qutb Mosque, Delhi, exterior of the entrance to the royal chamber (*mulūk khāna*) with the Qutb Minar and *qibla* screen visible in the background.

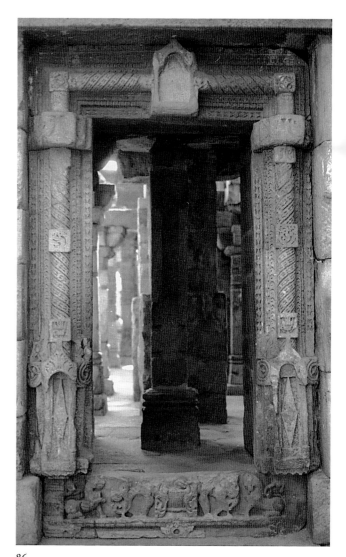

86

Qutb Mosque, Delhi, entrance to the royal chamber (*mulūk khāna*).

world, on which it left little trace, this royal chamber was to enjoy a long history in the mosques of South Asia. Referred to in later Indo-Persian texts as a *mulūk khāna* (royal chamber) and in Bengal as the *takht-i shāhī* (royal platform), subsequent appearances include the royal mosques at Begampuri in Delhi (ca. 743/1343) and Pandua in Bengal (776/1374).[104]

The presence of this royal chamber illustrates one of the problems inherent in the notion that Indo-Ghurid mosques reflect the deficient efforts of northern Indian masons to reproduce a normative Iranian mosque. The latter is almost always imagined as a variant of the vaulted mosques built during the period of Seljuq rule in Iran (ca. 1040–1190), a period of prolific patronage from which a great number of Iranian monuments survive. However, the hegemony of an ideal Seljuq mosque type obscures the appearance of features that were *not* standard in the Seljuq architecture of Iran but were instead innovations introduced in the Ghaznavid and Ghurid mosques of Afghanistan, few of which survive.

While its presence and siting provide insights into

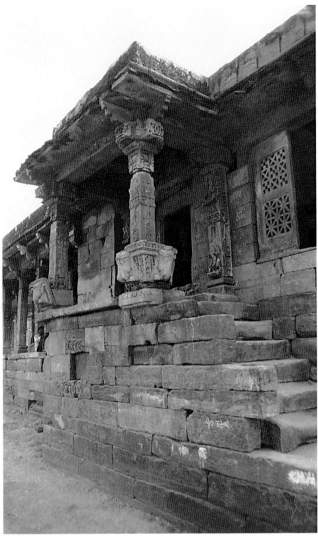

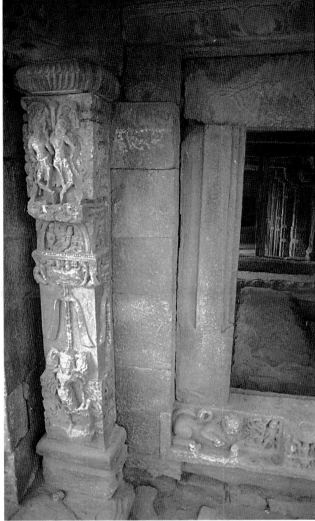

87
Chaurasi Khambha Mosque, Kaman, northern wall, projecting porch of the royal chamber (*mulūk khāna*).

88
Chaurasi Khambha Mosque, Kaman, detail of entrance to royal chamber (*mulūk khāna*).

the social function and hierarchization of space within the mosques, the treatment of the *mulūk khāna* also illuminates the cross-cultural reception of Indic carving, for the royal chambers at both Delhi and Kaman are distinguished by the massing of figural sculpture around their exterior entrances. In Delhi, an entire door frame appears to have been appropriated and reused in toto to emphasize and embellish the entrance (figs. 85 and 86), a pattern repeated in later mosques of the sultanate period.[105] By contrast, in Kaman we are dealing with a collage of figural mate-

rials reused to frame the entrance to the *mulūk khāna* (figs. 87 and 88). The selective treatment of this figural vocabulary is striking: while zoomorphic images remain intact at Kaman, the accompanying images of guardian figures (reused in an appropriate location) have been defaced. Similarly, the image of the deity in the *lalāṭa* above the reused entrance to the Delhi enclosure has been erased (fig. 86). In both cases, images of the *kīrttimukha* (horned or radiant lion face) on the same elements are untouched, while antique slabs carved with undamaged lions guard the threshold

163

89
Qutb Mosque, Delhi, carved lion on threshold of the royal chamber (*mulūk khāna*).

90
Chaurasi Khambha Mosque, Kaman, carved lion on threshold of the royal chamber (*mulūk khāna*).

(figs. 89 and 90). In addition, at Kaman large elephant capitals project from the elevated porch that leads to the royal enclosure (fig. 91). The theme is reprised in the interior space of the *mulūk khāna* of the same mosque by the reuse of a pillar on which the image of an elephant is clearly visible (fig. 92).

The embellishment of the entrances to the royal chambers in the Delhi and Kaman mosques prefigures the iconography of early sultanate palaces: the entrance to the palace of the Delhi sultan Iltutmish (r. 607–33/ 1210–36) was, for example, guarded by a pair of marble lions.[106] Elephants and lions (both of which appeared on Ghurid copper coins) were the royal beasts par excellence in both Indic and Persianate cultures. Like the golden birds discussed in chapter 4, looted from Ajmir

to grace the Ghurid palace in Firuzkuh and identified as *humā*s, the reception of such carvings was undoubtedly predicated on perceived commonalities in the iconography of kingship.[107] The content of the reused carvings and their selection for display at such an iconographically significant location thus implies a carrying over not only of material but also of meaning, highlighting a hermeneutical dimension to reception that will be explored further below.

The prominent display of Chauhan gold sculptures upon the roof of the Ghurid palace in Firuzkuh even as Indic zoomorphic carvings were being selected to guard the entrance to the royal chambers in the mosques at Delhi and Kaman calls into question the opposition between a monolithic Hindu iconophilia

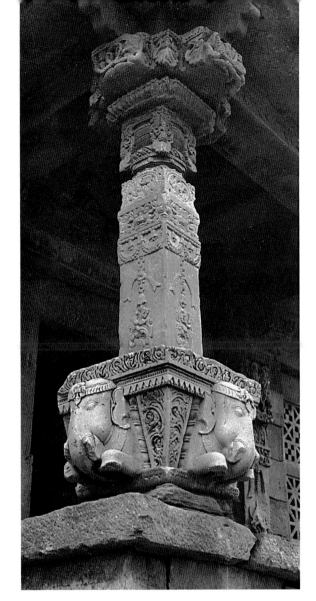

and an Islamic iconophobia constructed as its foil. The period of Turkic domination of the Eastern world saw an increasing interest in the representation of the human figure, an interest that extended even to the production of life-size images to guard the throne of the Ghaznavid sultans (fig. 34).[108] Both anthropomorphic and zoomorphic imagery featured in the frescoes, glass, and glazed tiles that decorated Ghaznavid and Ghurid palaces.[109] However, despite the proliferation of figural imagery in palaces and on portable objects, it was generally avoided in the embellishment of mosques.[110] The construction of mosques from richly carved architectural materials that proliferated with a myriad of celestial nymphs (*apsarās*), dwarfs (*pramathas*), radiant lion faces (*kīrttimukhas*), and deities (*mūrtis*) thus presented their patrons and builders with a problem. The issue had not arisen in pre-Ghurid Indian mosques or in the brick monuments built for Ghurid patrons in the Indus Valley, which adopted the simple expedient of substituting vegetal ornament and inscriptions for the anthropomorphic and zoomorphic imagery favored by Hindu and Jain patrons.[111]

It has usually been assumed that this problem was solved by the systematic defacement and/or erasure of the figural imagery on materials reused to build Ghurid mosques in India, or that the reused materials were plastered in order to obscure the offending images.[112] Neither view is correct. In the first place, alterations to images presuppose that they were visible and not obscured beneath a coat of plaster, an impression confirmed by the orchestration of polychromatic effects within the mosques (especially in Delhi) by alternating different colored stones. In the second, while it is true that many of the images on the piers and pilasters of the mosques have been defaced in accordance with practices prescribed for images of

91 *(above, left)*
Chaurasi Khambha Mosque, Kaman, detail of elephant pillar in *mulūk khāna* porch (visible in fig. 87).

92
Chaurasi Khambha Mosque, Kaman, detail of elephant carving on an interior pillar of the royal chamber (*mulūk khāna*).·

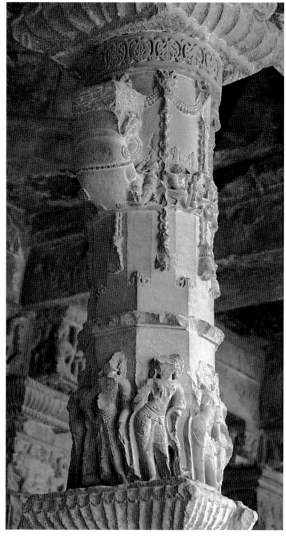

93
Qutb Mosque, Delhi, defaced anthropomorphic and zoomorphic carvings on column reused on the eastern *riwāq*.

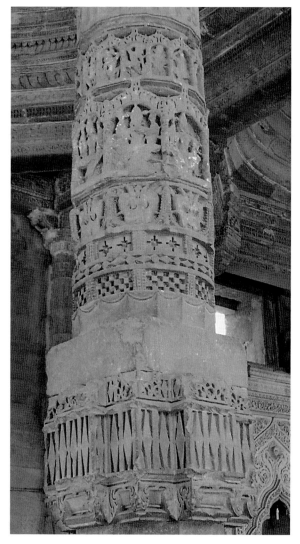

94
Arhai-din-ka-Jhompra Mosque, Ajmir, prayer hall: detail of richly carved column of upper register showing erased figural bands.

animate beings in the hadiths (the traditions of the Prophet Muhammad), these alterations are not uniform.[113] On the contrary, the selectivity manifest in the treatment of reused figural scupture at the exterior entrances to the royal chambers in the Delhi and Kaman mosques also characterizes its treatment in their interiors.

The alteration of anthropomorphic imagery is the closest one gets to a monolithic iconoclasm (figs. 93 and 94). Invariably concentrated on the most

affective aspects of the images—their face and eyes— these alterations conform to the spirit and letter of proscriptions on figuration in Islam and to iconoclastic practice in other areas of the medieval Islamic world.[114] In sultanate India, as in preconquest South Asia, bodily mutilation was prescribed for certain types of crimes, and the consistent focus on the face, eyes, and nose may also have been intended to accord with the way in which shame, transgression, or a lack of fidelity was inscribed on the body of contemporary

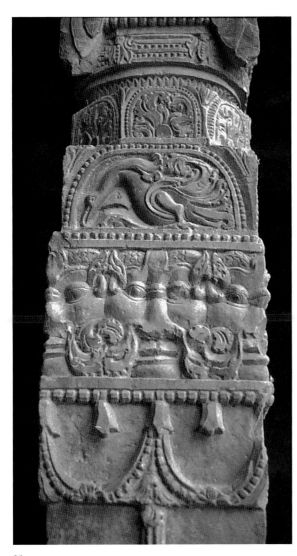

95
Chaurasi Khambha Mosque, Kaman, detail of reused pilaster with *haṁsa* (auspicious goose) and *kīrttimukha* (radiant lion face) motifs.

that birds and mythological creatures such as *makaras* (sea monsters) appear alongside headless torsos and noseless faces.[116] This is particularly evident in the northern porch of the Kaman mosque, the entrance to its royal chamber (*mulūk khāna*), which is richly embellished with reused figural sculpture that has been selectively altered, so that the zoomorphic carvings discussed above remain intact while anthropomorphic representations are defaced (figs. 95 and 101). Similarly, on the pillars of the Ajmir mosque and in the interiors of the corbeled domes found in Delhi and Khatu, paired birds or narrow friezes of *haṁsas* (auspicious geese) continue to exist unaltered (figs. 95 and 101). The preservation of these friezes in Khatu is particularly striking, for this is the most starkly aniconic of the mosques, a quality achieved by the sparing use of material bearing figural carving.

The reception of the radiant horned lion face (*siṁhamukha* or *kīrttimukha*), a ubiquitous figure in preconquest iconography, provides the most remarkable evidence for this selectivity. The continued existence of the lion face alongside defaced anthropomorphic imagery in the porch of the Kaman mosque conforms to a pattern found throughout the four Ghurid mosques discussed. In the Friday Mosque of Delhi alone, the image of the *kīrttimukha* appears more than thirty times on the trabeate lintels that still remain in place (roughly 50 percent of the original number), and innumerable more times on the reused columns that support them.[117] Not only the form but the logic of the image is preserved, for it often appears above windows and doors, as prescribed in Sanskrit treatises on architecture and witnessed in numerous surviving Buddhist stupas and Hindu temples in the Indus Valley and Gangetic Plain.[118] Myriad examples may be found of columns on which the face of the *kīrttimukha* remains untouched, while those of *apsarās* flanking the beast have been chiseled or hammered away (figs. 96 and 97). Although the corners of the pillars are more vulnerable to random damage, it is clear in many cases that this damage to the *apsarās* is the result of a deliberate blow, not casual wear.

Even in the mosques at Ajmir and Khatu, where the iconoclastic alterations are most extensive, numerous images of the beast are still intact. The proliferation of this figure contravenes both the spirit of the proscriptions on images in Islam and established

transgressors.[115] While the desire to deface was common, the mode of achieving this varied, ranging from total erasure to the ubiquitous gouging of the face, and from careful retooling to crude chiseling of facial features (figs. 93 and 119). Rather than a visceral response to the image, we are clearly dealing with an orchestrated program of transformation comparable to that which governed the collection and reassembly of existing architectural materials.

By contrast, zoomorphic imagery is occasionally altered but just as often left intact (figs. 91 and 92) so

96
Qutb Mosque, Delhi, reused pilaster showing untouched *kīrttimukha* face, with faces of corner *apsarā*s removed.

97
Chaurasi Kambha Mosque, Kaman, reused pilaster showing untouched *kīrttimukha* face, with faces of corner *apsarā*s removed.

98
Arhai-din-ka-Jhompra Mosque, Ajmir, detail of reused column with lizards and snakes set at entrance to prayer hall.

architectural practice, while adumbrating any notion of an essential and undifferentiated iconophobia.[119] More remarkable still is the contemporary appearance of both *haṁsa* and *kīrttimukha* in a small stone shrine at Larvand in central Afghanistan, which will be discussed below (figs. 142 and 157). It seems, therefore, that certain types of figural imagery were not only acceptable but desirable to Ghurid patrons, perhaps by virtue of their perceived apotropaic qualities. *Kīrttimukha*s do not appear in the pre-Ghurid monuments at Bhadreshvar in coastal Gujarat (figs. 15 and 17). These are strictly aniconic in their decoration, with the exception of *kīrttimukha* bands carved on the pillars flanking the entrance to the Solahkhambi

99
Detail of lion face on stucco fragment from Hulbuk, eleventh or twelfth century (after Anon. 1980).

100
Detail of lion face on fragments of stucco ornament from Termez, eleventh or twelfth century (after Deniké 1930).

Mosque, where the context suggests that the image was afforded an apotropaic or talismanic function.[120] Similarly, some of the zoomorphic imagery, including the lizards, snakes, and scorpions carved on reused columns from Hindu or Jain structures set at the entrance to the Friday Mosque of Ajmir (fig. 98) may have been intended to protect the mosques from the predations of the creatures that they represent; at least one fourteenth-century Indo-Persian text discussing the reuse of Ashokan pillars in sultanate mosques of the thirteenth and fourteenth centuries describes them as talismans designed to inhibit snakes, scorpions, and wasps.[121]

Studies of the "frontier cultures" of contemporary Anatolia have noted the "symbolic primacy of images" in processes of transculturation, a role that depended less on the attribution of singular identities than the ability to evoke a range of meanings simultaneously.[122] The proliferation of the *kīrttimuka* (face of glory) may, therefore, reflect its perception as a horned lion face and consequent assimilation to lion face friezes such as those that decorate eleventh- or twelfth-century palaces at Hulbuk, Sayyod, and Termez (figs. 99 and 100) in Transoxiana.[123] Similarly, the survival of single and regardant birds, or continuous friezes of auspicious geese (*haṃsa*s), in the corbeled domes of the mosques at Delhi, Ajmir, and even Khatu (where they are practically the only form of figural ornament in the prayer hall; fig. 101) recalls the decoration of contemporary Ghurid metalwork. A series of inlaid brass candlesticks produced in Herat in the second half of the twelfth century (and which may well have illuminated Ghurid mosques; fig. 102) is, for example, decorated with narrow files of birds or ducks comparable to those carved on the interior domes of Indo-Ghurid mosques, while regardant birds similar to those carved on the pillars reused in Indian mosques also appear on Khurasani metalwork of this period.[124]

A final factor confirming a selective approach to figuration is the differential deployment of figural material. In particular, the confinement of the reworked figural material to the upper registers of multitiered columns in the mosque at Ajmir points to a spatial hierarchy in which the most exuberantly iconic shafts are marginalized by deploying them in the obscurity of the superstructure, while the most aniconic are reserved for the lower and more visible sections (compare figs. 94 and 103). Many of the columns in

101
Shahi Masjid, Khatu, detail
of corbeled dome with inte-
rior frieze of *haṁsa*s (auspi-
cious geese).

102
Brass candlestick inlaid
with copper and silver,
Khurasan (probably
Herat), second half of
twelfth century (Paris,
Musée du Louvre, 6315,
Réunion des Musées Na-
tionaux/Art Resource, NY).

the upper levels of the prayer hall have had their figures retooled, leaving only a rhomboid outline that replicates the form of the diamond (*ratna*) designs of similar size that have been carved on the lower shafts of the same columns (figs. 103 and 104). Both newly carved members and those that have undergone iconoclastic transformations are thus aesthetically integrated in a manner that blurs the boundaries between figuration and geometric abstraction.

Similarly, in the Shahi Mosque at Khatu, the most starkly aniconic of any of the four mosques discussed here, the pavilion that faces the prayer hall is replete with images of the horned lion (*kīrttimukha*). These have been effaced on the trabeate beams reused in the construction of the prayer hall although, as at Ajmir, *kīrttimukha*s are still visible at points on the carved ceiling slabs hidden in the upper reaches of the superstructure. The careful erasure of the *kīrttimukha* figures carved on the columns that flank the mihrab of the Shahi Masjid (fig. 105) is particularly striking, and represents another point of similarity to the Arhai-din-ka-Jhompra Mosque at Ajmir. This reticence about the use of figural ornament in the *qibla* (Mecca-oriented) bay is common to other mosques in the group. In the Qutb Mosque in Delhi, for example,

103
Arhai-din-ka-Jhompra Mosque, Ajmir, detail of prayer hall showing lowest tier of plain columns with *ratna* (rhomboid or jewel) designs.

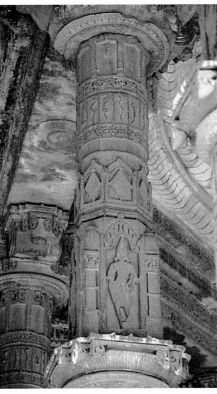

104
Arhai-din-ka-Jhompra Mosque, Ajmir, details of upper registers of columns carved with with *ratna* design and reworked figural carving altered to resemble a *ratna* design.

the pillars reused in the *qibla* bay contain fewer figural carvings than those found in many other areas of the mosque, and their figural capitals are more thoroughly defaced than those in other locations. However, even here there are exceptions: the pilaster closest to the mihrab (now lost) still bears cartouches carved with images of the *kīrttimukha* and *makara* (fig. 106; location visible in fig. 107).

This contextual approach to reuse finds parallels in other areas of the Islamic world. In the Azhar Mosque in Cairo (362/971), which made extensive reuse of Byzantine capitals, for example, the most lavish capitals were confined to the courtyard rather than the prayer hall, and Byzantine capitals avoided around the mihrab, which was provided with plain capitals especially carved for the purpose.[125] Conversely, exterior space could be differentiated by the massing of reused material richly carved with figural ornament, as is the case with the entrances to the royal enclosures (*mulūk khāna*s) of the mosques at Delhi and Kaman (figs. 85–90).

The complex dialectic between effacement and emphasis, obscurity and visibility of figural imagery in the Ghurid mosques of India distinguishes them from preconquest Indian mosques such as those at Bhadreshvar. Later architectural *shāstra*s (treatises) emphasize that figural ornament should be avoided in the decoration of mosques, implying that the image was perceived as an element of differentiation between distinct kinds of sacred space.[126] The treatment of figural imagery may therefore have played no less central a role in the construction and consolidation of a distinctive visual identity than the radical aniconism of earlier Indian mosques. The rewriting of visual space intrinsic to the formation of this identity reiterates on a smaller scale the rewriting of urban space to which the mosques themselves were integral. In both cases the phenomenon is characterized by a selective reception, erasing those features that were in some way incommensurate with the patron's values while preserving those that were more acceptable.[127] Like the appearance of Hindu deities on Indo-Ghurid coins (fig. 60), the selective interventions upon figural carving witnessed in the Ghurid mosques of India are indicative of a contextual evaluation of figuration rather than the uniformly proscriptive attitude of the chroniclers. Lion faces that were sought out in the decoration of royal entrances to the Indo-Ghurid

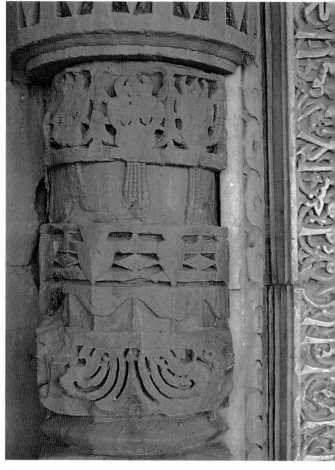

105
Shahi Masjid, Khatu, detail of mihrab visible in fig. 73 showing erased *kīrttimukha* band.

mosques were specifically erased in the area closest to their prayer niches. At the Qutb Mosque, the reuse of slabs carved with narrative figural scenes (including the birth of Krishna) as the exterior lintels of windows points in the same direction.[128] As Peter Jackson notes, "whatever the Muslim *literati* wanted people to think, the hallmark of [the Ghurid] years was not uncompromising iconoclasm."[129]

The hierarchization of space through the selective deployment of reused carvings was not confined to the realm of the figural: this was not only an appropriation of the past through its material traces but also an engagement with the present through its living traditions. To borrow a distinction coined in

REMAKING MONUMENTS

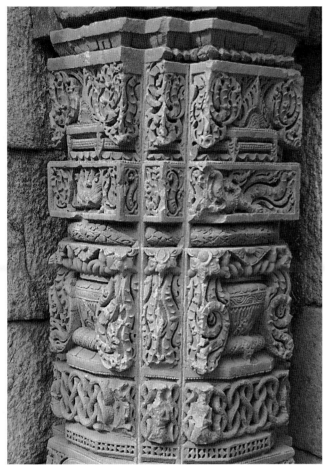

106
Qutb Mosque, Delhi, detail of surviving pilaster next
to the main mihrab (now lost) showing an unaltered
kīrttimukha image on one face and a *makara* (sea monster)
on the other.

studies of reuse in the medieval Mediterranean, the
monuments manifest both *spolia in se* (the reuse of
tangible objects) and *spolia in re* (the appropriation
and use of specific styles).[130] Evident in all the surviv-
ing Indo-Ghurid mosques, the phenomenon is mani-
fest in the creative reimagining of an aniconic vo-
cabulary to stratify sacred space, creating hierarchies
that provide potential insights into how these spaces
were conceived and how they functioned. The Chau-
rasi Khambha Mosque at Kaman in Rajasthan offers
a particularly clear example. As Michael Meister has
noted,

The pattern of re-use of pillars and other parts
suggests a defined attempt to create a hierarchy
of ornament within the new mosque. The north
colonnade, for example, primarily uses nearly
plain, square, pillars decorated with simple lo-
tus-medallions; the central pair, however, are or-
namented with *ghaṭapallavas* and are accentu-
ated by being offset. The four large pillars that
parallel the entry gate on the east are also offset,
with elaborately detailed ornamentation.[131]

The same phenomenon is manifest in the Qutb
Mosque in Delhi, where the reused pillars comprising
the *qibla* (Mecca-oriented) bay are the finest (and
least iconic), their surfaces adorned with a far greater
number of bell chains (*ghaṇṭāmālās*) than than those
used elswhere in the mosque (fig. 107).[132] The selec-
tive deployment of the bell motif in Delhi not only
establishes a hierarchy of space, but also adapts the
iconography and rituals of the temple for aniconic
worship: signs of the bell (fig. 108) ring the worship-
per's progression through the mosque and toward its
mihrabs even as the bell is sounded by worshippers
approaching the *garbhagriha* of the temple, the dwell-
ing place of the deity.[133]

At Kaman both reused and newly carved stones
are pressed into service to focus attention on the
mihrab and *qibla* bay of the mosque (figs. 109 and
110). At its most general level, this is seen in the com-
bination of carved stone palmettes similar to those
that occur in Ghurid stuccowork from Afghanistan
with the Indic *padmalatā* or vine motif to frame the
mihrab (see fig. 158). Similar vines occur on the *tōraṇa*s
framing Hindu icons, on the plinths supporting
them, and as devices to sacralize the temple threshold
(*udumbara*; see fig. 145).

The selective use of resonant elements to sacralize
the mihrab at Kaman extends to its elevation, for at
roof level the (re)use of full and partial lotus
(*padmashilā*) ceiling slabs describes a kind of proces-
sional axis that culiminates in the mihrab bay (visible
in plan in fig. 75). As one approaches the mihrab
along the central axis of the prayer hall, the transition
from court to hall is marked by a lintel carved with a
series of five lotus flowers. The first bay from the court
is covered by half of a flat lotus ceiling (*padmashilā*).
The following bay is covered by a full *padmashilā* sim-
ilar to those that often cover and precede the icon

173

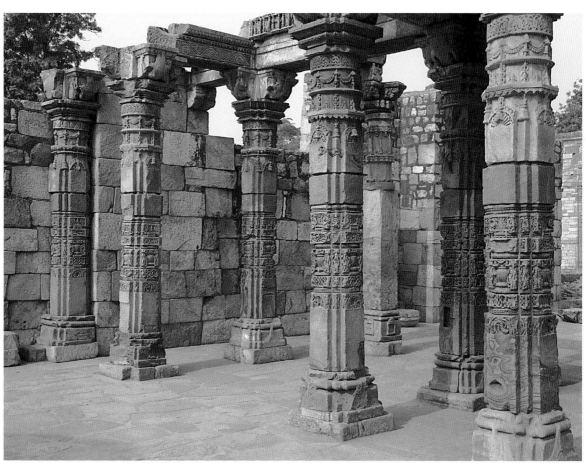

107
Qutb Mosque, Delhi, view of prayer hall with reused columns carved with bell chains.

108
Qutb Mosque, Delhi, prayer hall, detail of reused column carved with bell chain.

109
Chaurasi Khambha Mosque, Kaman,
red sandstone mihrab.

110
Chaurasi Khambha Mosque, Kaman,
detail of capital flanking mihrab.

111

Chaurasi Khambha Mosque, Kaman, view of ceilings along mihrab aisle showing a progression of flat half-lotus and full-lotus ceilings toward the mihrab dome (visible in plan in fig. 75).

112

Chaurasi Khambha Mosque, Kaman, concave ceiling above the exterior porch of the royal enclosure (see fig. 87).

chamber (*garbhagriha*) in medieval Rajasthani temples (fig. 111).[134] This progression in elaboration and scale reaches a crescendo in the final bay directly before the mihrab, where the ensemble of ceilings culminates in a monumental corbeled dome with internal lotus petal ornament (visible in plan in fig. 75). The corbeled *qibla* dome reproduces the *maqṣūra* dome integral to eastern Iranian mosques from the Seljuq period onward, in a local idiom: the deployment of the lotus motif in and around the *qibla* invests the focal point

of the Kaman mosque with iconographic qualities of radiance using an Indic vocabulary.

This differentiation of sacred space in the Kaman mosque is underlined by the restrictive (re)deployment of elaborate cusped domes in only two other locations, both iconographically significant: above the threshold of the exterior entrance to the *mulūk khāna* or royal box of the mosque (fig. 112), and in the stone canopy of the *minbar* or pulpit (the earliest surviving *minbar* in India), here constructed from reused *vēdikā* or railing elements. The honorific vocabulary of the *minbar* is particularly overdetermined, for its *nābhicchanda* (cusped) canopy with lotus ornament obscures a partial *padmashilā* set directly above (figs. 113 and 114). The use of the cusped lotus ceiling in this way recalls, among other things, the provision of *chatrs* in the form of lotuses to shelter the "lotus-faced" deities of northern Indian temples.[135] Here the purview of the idea is extended by its adaptation for use on a *minbar*, a reminder that the translation of forms and meanings witnessed in the Kaman mosque enhanced, not static space, but loci of ritual performance: the mihrab beside which the imam led the prayers, and the *minbar* upon which the *khuṭba* (the Friday sermon) would have been given to the assembled Muslim community, in close physical proximity to the

113

Chaurasi Khambha Mosque, Kaman, ceiling of *minbar* (pulpit) showing flat lotus ceiling above concave dome.

114

Chaurasi Khambha Mosque, Kaman, dome covering *minbar*.

royal chamber of the self-styled sultan, Baha' al-Din Tughril.

One further feature of the Kaman mosque that should be mentioned in this regard is the careful orchestration of horizontal sight lines connecting areas marked as iconographically significant by their distinctive ceiling decoration. If one stands in the entrance to the mosque, for example, the rectangular jamb of the doorway perfectly frames the mihrab bay of the mosque and the adjoining bay that houses the *minbar* (fig. 115). Stand at the opposite end of the mosque, within the mihrab bay, and the pillars of that bay precisely frame the entrance and the bay to the right of it. The significance of this bay is not obvious, but based on the provision of a full *padmashilā* ceiling above it (a feature otherwise confined to areas

of demonstrable iconographic significance; see fig. 75), this area of the mosque may have fulfilled a ceremonial role of some sort.

The coincidence between this framing of bays that are also distinguished by the content and nature of their ceiling decoration suggests that the orchestration of these sight lines is not random. In light of the adaptive use of honorific idioms elsewhere in the mosque, it is tempting to see this idiosyncratic emphasis on sight and vision as an adaptation inspired by the centrality to Hindu worship of *darśan*, the visual exchange between deity and devotee.[136] A relationship between the locus of an embodied iconic deity and the aniconic sign of geospatial sacrality may seem unlikely, but parallels in the treatment of icon, *garbhagriha,* and mihrab suggest that these represented another area of convergence between temple and mosque, at least in the eyes of the masons responsible for their carving.[137] The reservation of white marble for the mihrabs in the mosques at Ajmir and Khatu (figs. 71 and 73), despite the ubiquity of the stone in the region, points in a similar direction. There is some evidence that the use of white marble in the sultanate period was restricted to royal monuments, a tradition that may be germane to the sparing use of the medium here.[138] Equally relevant are the visual associations of the medium with purity and the use of white

115
Chaurasi Khambha Mosque, Kaman, view from main entrance showing framing of the bays housing the mihrab and *minbar*.

marble for the carving of religious icons—a point underlined both by finds of Hindu and Jain white marble icons in Afghanistan and by the reuse of a white marble *linga* in the court of the Ajmir mosque.[139]

In his work on the translation of religious texts in early modern Bengal, Tony Stewart has emphasized that attempts to translate between different sign systems (including verbal and nonverbal systems such as architecture and dress codes) are often characterized by an emphasis on a coherence of conception rather than a consistency of detail or precise one-to-one matches. In this case, translation is predicated on an act of *identification*, not a statement of *identity* be-

tween source and target cultures—one reason why a mihrab might be conceptualized as the locus of an aniconic deity.[140] The identification would not be unprecedented: Arab commentators often depict the mihrab as a cultural analog for the altar of the Christians and the fire altar of the Zoroastrians, one reason why the mihrab was targeted for destruction by revanchist Zoroastrian populations in Iran.[141] Accused of idolatry by a Muslim visiting Southeast Asia sometime before 1120, a devotee of a Hindu deity is said to have retorted that the idol was his equivalent of the *qibla* of a mosque, which is "but stones built and laid in tiers, and yet you worship them."[142]

Anecdotal though they are, such tales point to the operation of principles of analogy and homology in the cross-cultural reception of architecture that is well documented in other texts. They also provide a context for the reception of Indic idioms in the Indo-Ghurid mosques, which indicate a heuristic approach to mosque building later canonized as formal statements in medieval architectural treatises (*vāstu-shāstras*). Among the earliest of these to deal with the mosque are the eleventh-century *Jayāpṛcchā* and the *Vṛkṣār-ṇava*, a fifteenth-century Gujarati text, which refer to the mosque as the *Rehamāṇa-Prāsāda* (Temple of the Compassionate God), including it as one more temple type to be numbered among the temples of Shiva (*Shiva-Prāsāda*), Vishnu (*Viṣṇu-Prāsāda*), and Surya (*Sūrya-Prāsāda*).[143] As this suggests, references to Islamic sacred space and ritual practices in Sanskrit texts represent both using categories familiar from Hindu and Jain worship.[144] A bilingual (Persian and Sanskrit) foundation text from a mosque at Veraval on the coast of Gujarat, dated 662/1224, refers to the mosque as a *dharma-sthāna* (place of worship) and stresses the aniconic or formless nature of Islamic worship, invoking the deity worshipped there by the terms *Vishvanatha* (lord of the universe), *Shunyarūpa* (one whose form is of the void), *Lakshyālakshya* (visible and invisible), and *Vishavarūpa* (having various forms).[145] These conceptual and linguistic accommodations canonize processes of adaptation and translation encountered previously in the inscriptions on Sindi and Ghaznavid coins (figs. 12 and 14), and materialized in monumental form in Indo-Ghurid mosques.

The challenges posed by inscribing the mosque within the cognitive categories of Indic architectural

practice were by no means confined to Sanskrit texts. Analogous problems confronted medieval Arabic and Persian geographers and historians writing about Indian cultural forms unfamiliar to their audiences. These texts provide ample evidence for processes of analogic reasoning and categorical assimilation predicated on perceived formal, functional, or iconographic homologies. As early as the ninth century, for example, Arab writers refer to the *śikhara*s of Indian temples as *manāra*s (towers or minarets), a term also used for pre-Islamic commemorative pillars (*lat*s and *stambha*s) in later Persian texts.[146] In this case, equivalence was predicated on reflection, the perception of common isomorphic values (most obviously verticality). In other cases, we witness a process of refraction, an approximation based on a perceived functional homology. Writing of the Ghurid conquest of Bihar in 589/1193, for example, Juzjani refers to an ancient monastery, explaining that *bihār* (itself derived from *vihāra*, the Sanskrit term for a Buddhist monastery) is the term for *madrasa* in Hindavi.[147]

Cross-cultural representations of architecture in medieval texts thus offer abundant evidence for the finding of formal or functional homologies, offering a potential paradigm for comprehending the hermeneutical challenges posed by new patterns of architectural patronage after 588/1192. The heuristic nature of the reponse to these challenges has been recognized by several scholars, among them Michael Meister, who sees the mosques at Ajmir and Kaman as evidencing "a sort of empathetic response of local workmen, finding similes between elements in the local tradition and alien demands." Rejecting the traditional axes of "accommodation," "assimilation," "synthesis" that have structured even the most nuanced discussions, Meister offers "a different metaphor, that of permeability through a membrane, for the interaction between Islam and Hindu India; which cultural forms prove to be more permeable and which do not may provide a more interesting litmus for cultural interaction than a discussion of 'syncretism.'"[148]

Although acknowledging the inadequacy of syncretism as an explanatory trope—implying as it does an uneasy union of two essentially incommensurate entities—one problem with permeability is its tendency to occlude questions of agency, cognition, and power. If, as the anthropologist Alfred Gell has ar-

gued, the crafted artifact "is a congealed residue of performance and agency in object-form," then any attempt to account for both is perhaps not well served by the metaphor of osmosis with its deterministic and mechanistic overtones.[149] Rather than a passive or unidirectional reception, the mosques considered here attest to complex multifaceted processes of mediation and negotiation involving multiple agents. The phenomenon is truly one of transculturation for, although rarely acknowledged, the processes of translation and transformation witnessed in the Indian monuments of the Ghurids are confined neither to a stone medium nor to mosques erected from *spolia*. They are equally evident in brick shrines built contemporaneously for Ghurid patrons in the Indus Valley (fig. 66).[150] More significantly (and perhaps more surprisingly), the adaptive deployment of Indic architectural iconographies and vocabularies is not confined to regions east of the Indus but is equally manifest in a number of monuments built in the Afghan heartlands of the Ghurid sultanate during this period, as we shall see below.

In place of hybridity, permeability, or syncretism, it may therefore be more productive to take a lead from cross-cultural accounts of architecture found in contemporary texts and approach this hermeneutical dimension of architectural patronage through the frame of translation.[151] In their attempts to understand processes of translation, linguistic theorists have noted the centrality of translated texts as *primary* products of norm-regulated behavior rather than normative pronouncements about it. Similarly, Ajay Sinha's careful analysis of Vesara temples in medieval Karnataka—a style developed in response to the architectural traditions of both north and south—has demonstrated both a willingness on the part of medieval architects to rise to the challenge posed by mediating distinct architectural traditions, and the degree to which medieval monuments can serve as a source for reconstructing this process of mediation.[152] The process is manifest at its most basic level in a physical *translatio* witnessed in the basic procedures of harvesting and reuse. These find a conceptual counterpart in the deployment of familiar forms in unfamiliar contexts. Examples include the setting of corbeled domes at the entrances to the Delhi mosque (fig. 76), in positions similar (but not identical) to those in

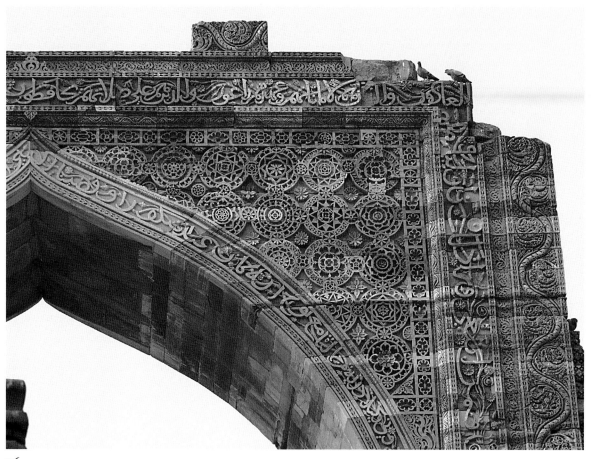

116

Carved stone ornament in the spandrels of the central arch of the screened
façade of the Qutb Mosque, Delhi (594/1198).

which vaulted *īwān*s appear in Iranian mosques, a
calque or refraction based on similarities in form and
function, which permit the innovative articulation of
a "dome concept" in regional media and techniques.[153]
Both phenomena reflect a search for dynamic equiva-
lence, a striving for equivalent effect rather than strict
formal or syntactic equivalence.[154]

In other cases, conventional modes of Indic or-
nament are present but deployed in a manner that
contravenes established syntax. Examples include the
creation of liturgical furnishings such as the *minbar*
(pulpit) of the Kaman mosque from *vēdikā* railings,
the vertical arrangement of decorative friezes derived
from the horizontal base moldings of temples on the
prayer hall screen of the Ajmir mosque (fig. 168),[155]

and the adaptation of concentric two-dimensional
geometrical patterns derived from the designs of
north Indian stone ceilings to fill the spandrels of the
screen added to the Qutb Mosque in 594/1198 (fig.
116), where they do service for the intersecting *hazār-
bāf* (thousand weave) brick patterns found in similar
positions in the brick architecture of Khurasan (fig.
117). The reconceptualization of an aniconic vocabu-
lary to sacralize the mihrab area represents a more
sophisticated (and less obvious) aspect of the same
phenomenon.

The notion of a translation between Iranian and
Indic architectural forms has in fact been invoked in
"foreignizing" approaches to Indo-Ghurid mosques.
These tend to view the mosques as second-rate ver-

REMAKING MONUMENTS

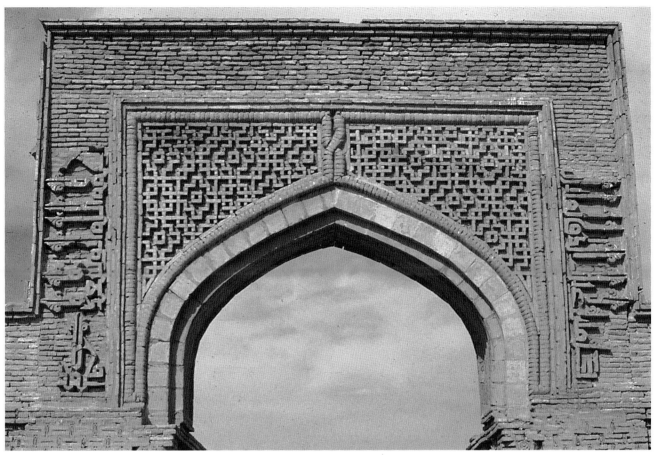

117
Hazār-bāf brickwork in the spandrels of an *īwān* Ribat-i Sharaf, Khurasan
(first quarter of twelfth century).

sions of arcuate Seljuq originals imperfectly remembered by Turkic patrons. Architectural form thus constitutes a sort of Platonic essence that travels with mobile Turks or in the hypothetical pattern books that they carry, divorced from media, techniques, and practices. With Turkic patrons dependent on the variable cognitive skills and stylistic predelictions of Indian masons for the implementation of ideal form, translation is invariably seen as deformation, as Anthony Welch's analysis of Indo-Ghurid mosques suggests:

> The architecture of this Turkish-dominated period is not eclectic: instead it is obsessed with imposing an aesthetic that carried comforting meaning for the conquerors. The attempt to rep-

licate the familiar from back home is overriding: it ignores north India's established building types and twists indigenous architectural techniques to accommodate it. The resulting torque is obvious, but not surprising. Without such mimetic references the Sultanate would have appeared adrift in an all too new and unfamiliar land.[156]

Here the appearance of the "mosque back home" entails a shift from the material or physical to the metaphysical, the Ur-mosque functioning as a kind of transcendental signified within a concept of translation as mimesis or replication. The mimetic paradigm of translation measures success by fidelity of reproduction, assuming the panoptic vision of the modern art

historian furnished with abundant comparanda rather than the more circumscribed view of the twelfth-century patron. Yet even those medieval Islamic monuments that are known to have made mimetic reference to earlier prototypes are marked by a degree of formal and stylistic variety associated with the "copy", its failure to reproduce the prototype exactly.[157]

Within the mimetic or reproductive model of translation, the deformation of an ideal form at the hands of Indian masons mirrors that of the temples whose materials were purloined to articulate it. The idea finds its clearest expression in the contrast (de rigeur in any text book on Islamic or Indo-Islamic architecture) between the "true" (four-centered) arch of Persian architecture and the corbeled (false) arch used to approximate it in the Indian mosques, a rare acknowledgment of hybridity in facture rather than form. With both conceptual mosque and material temple figured not only as temporally anterior but also culturally prior, architectural difference is correlated to cultural value, one reason why the mosques (like the "syncretistic" religious texts produced in South Asian vernaculars) have been marginalized by both Islamicists and South Asianists.[158]

In her work on cross-cultural translation in early modern China, Lydia Liu offers another way of thinking about the hermeneutical dimensions of cultural encounter. Instead of cultural particularity, with its implication of active and passive, influencing and influenced agents, Liu suggests that we employ the notion of competing universalisms. By acknowledging that the *particular circumstances* of the encounter determine the manner in which meaning acquires value in the process of translation, it follows that an original text may be 'rewritten,' 'parodied,' and 'manipulated' but not 'distorted'" by translation.[159]

Liu's analysis owes much to Walter Benjamin's conception of translation as a process that permits the "living-on" of a source text even in its absence: we might bear in mind here that the Delhi and Kaman mosques preserve refractions of architectural features (such as the *mulūk khāna*) known to have existed in contemporary Afghan congregational mosques that have long since vanished. In his contingent and contextual model of translation, Benjamin suggests that the relationship between target (translation) and source (translated) is not one of original and copy, for

translation is a process characterized by "continua of transformation, not abstract ideas of identity and similarity."[160] Building on this insight, poststructuralist theorists such as Jacques Derrida reject the idea of any stable essence that might be carried across between languages:

> Difference is never pure, no more so is translation, and for the notion of translation we would have to substitute a notion of *transformation*: a regulated transformation of one language by another, of one text by another. We will never have, and in fact have never had, to do with some 'transport' of pure signifieds from one language to another, or within one and the same language, that the signifying instrument would leave virgin and untouched.[161]

This offers a way of thinking about translation radically different from the more familiar notion of an export of meaning between two discrete languages, an idealist attempt at one-to-one mapping of meaning from one cultural form to another. In the latter case translation is measured by fidelity of reproduction, so that transformation necessarily entails deformation. In the former, the "original" is already heterogeneous and in process, so that there is no stable "original" against which to measure fidelity: translation thus entails a dynamic (and to some extent contingent) process of transformation. In its most radical expression, this approach even sees the original as *created* by the act of translation, not deformed by it.[162]

Although developed in relation to language and texts, the model of translation as transformation has potentially profound implications for the understanding of early Indo-Islamic architecture, challenging established conceptions of a one-to-one equivalence between the elements of alien Hindu and familiar Muslim "languages" (or vice versa).[163] Shifting the emphasis from the priority of architectural forms to the contingencies of cultural practice, translation as transformation has the advantage of displacing a backward-oriented (and often ideologically charged) source mongering with a more forward-looking emphasis on innovation and mediation.

Architecture is not text, however, but might be better compared to language, to the signifier (the term that denotes) rather than the signified (the term

denoted), to borrow a semiotic analogy. Like language, architecture is nonmimetic, yet capable of (re)structuring our experience of the world. Unlike language, architecture is apprehended *both* simultaneously and sequentially, and consequently marked by a strong polysemic quality.[164] The encounters discussed throughout this book suggest that ambiguity and polysemy played a central role to the cross-cultural reception of cultural forms and practices, including architecture.[165] The recycling of architectural materials heightens this quality, for as Dale Kinney has observed in another context, such materials "are signs of an artistic culture with a high tolerance, perhaps even a deep need, for ambiguity."[166] The value of ambiguity in smoothing the transition from Chauhan polity to Ghurid sultanate can hardly be doubted: it was in fact central to the hybrid political arrangements made in the aftermath of the conquest.

Viewed in this light, the preference for reused materials in Indo-Ghurid mosques might even be read as a radical critique within which rupture and reinscription were mutually constituting. Recent work on the role of architectural destruction and desecration during the French Revolution has, for example, noted the way in which physical alterations to existing monuments served not to erase the memory of the instantiated past but to co-opt and transcend it by employing practices of *détournement* to create new spaces out of old.[167] An observation made by Françoise Choay seems particularly appropriate to the context and content of the Indo-Ghurid mosques under consideration here: "To break with the past means neither to abolish its memory nor to destroy its monuments, but to conserve both in a dialectical movement that simultaneously assumes and transcends their original historical signification, by integrating it into a new semantic stratum."[168]

The semiotic qualities of this dialectic between past and present and its relationship to the construction of historical memory are implicit in Roland Barthes' notion of myth, a transformative process in which an existing sign (a compound of signifier and signified) is appropriated and transformed into a new signified, a partial component of a second sign generated from it.[169] Barthes' analysis has been productively deployed to describe the appropriation of material objects and the reconceptualizations and resignifica-

tions associated with the process.[170] That the notion lends itself to such usage is hardly suprising, given its close relationship to the anthropologist Claude Lévi-Strauss' discussion of mythical thought, in which he employs the metaphor of *bricolage*. This is a practice that refashions a heterogeneous assemblage of cultural materials derived from the accumulated remains of previous constructions and destructions in a manner congruent with both current needs and established practice.[171] In semiotic terms, *bricolage* constitutes an appropriation in which materials that once functioned as ends come to function as means, "evanescent links in a chain of Becoming," to borrow Anthony Cutler's poetic turn of phrase.[172]

Discussing Barthes' and Lévi-Strauss' texts, Hal Foster distinguishes between myth ("a one-way appropriation") and *bricolage* ("a process of textual play, of loss and gain").[173] In this sense, the appropriations and improvisations intrinsic to *bricolage* and its ability to generate new meanings from preexisting materials (and indeed vocabularies) exemplify the unstable and fluid nature of any sign, undermining the notion of a transcendental signified that is intrinsic to mimetic or reproductive models of translation.[174] Like the phenomenon of *bricolage*, the economy of translation is marked by both loss and gain, the excess of translation promoting creative transformations that expand the meaning or semantic range of borrowed terms. A good example is the use of the term *suratrāṅā*, not merely a Sanskritization of the Arabic *sulṭān* but a modification that imbued it with the Sanskrit meaning "savior of the gods."[175]

If the inscription of foreign terms can imbue them with additional connotations, translation can also set in motion changes in the cultural forms or practices of the recipient, introducing new terms or expanding the semantic range of preexisting terms in the language of inscription.[176] This dialogic aspect of translation is evident in the cross-cultural reception of architectural forms and vocabularies.[177] In the Indus Valley, for example, it has been noted that the architecture erected for Ghurid patrons attests to an "organic extension of local practice" in response to changing patterns of patronage.[178] Similarly, acknowledging the way in which the mosques under discussion here witness the reconceptualization of an existing visual language, Michael Meister sees the

novel patterns of patronage that developed in the late twelfth century not as the death knell of indigenous architectural traditions but as an opportunity seized on by Indian masons who "found stimulus from new requirements, bringing to fruition certain trends potential in their own tradition."[179]

| Patrons and Masons

The nexus between guild, ruler, and religion that was a pronounced feature of pre-Ghurid architectural patronage in India was undoubtedly disrupted by the conquest and the new conditions prevailing in its aftermath. However, the stone mosques and shrines of coastal Sind and Gujarat (figs. 17, 18, and 20) and the brick tombs constructed for Ghurid patrons in the Indus Valley (fig. 66) demonstrate that craftsmen were quite capable of adapting their repertoire to serve the needs of Muslim patrons, regardless of the medium in which they worked. Just as continuity in Indian coin issues indicates continuity in mint personnel, architectural and epigraphic evidence points to continuity in masons' guilds. Despite formal affinities with Khurasani mosques, there is for example a notable dearth of Persianate elements in the Ghurid mosques of India. The few instances that one can point to include the rigidly symmetrical palmettes carved around the mihrab of the Chaurasi Khambha Mosque at Kaman, a lithic reiteration of palmettes such as those found in the stucco decoration of the palaces at Lashkari Bazaar in southern Afghanistan (figs. 109 and 158a).

By contrast many of the formal, iconographic, and stylistic details of the mosques—raised plinths, corbeled domes and arches, or the fluid, organic forms of their vegetal ornament—suggest continuity with pre-Ghurid monuments. In addition, although some of the material used to construct the mosques may have been garnered from monuments targeted as symbols of the ancien régime, many of the compositional strategies governing its redeployment were firmly rooted in the idiom and syntax of preconquest architecture. These strategies are manifest, for example, in the desire to match adjoining columns in terms of color or carving, orchestrating bichromatic effects similar to those found in preconquest temples.[180] While it may seem paradoxical to suggest that Hindu masons were involved in constructing mosques partly constructed from *spolia*, the pattern was repeated later after the expansion of the Delhi sultanate into the Deccan. For example, the mosque of Karim al-Din at Bijapur, which was founded by the son of a Khalji general after the conquest of the city in the early fourteenth century, and constructed from *spolia*, was supervised by a Hindu master mason (*sūtradhāra*).[181]

Epigraphic evidence from northern India confirms continuity in workshop practices, for the names of the *shilpī*s (craftsmen or architects), carpenters (*dārukarmakāra*s), and masons (*sūtradhāra*s) preserved in the twelfth- to fourteenth-century graffiti on the Qutb Minar are all Hindu. A Sanskrit inscription datable to AD 1369 on the Qutb Minar invokes Vishvakarma, the divine architect of the universe and ultimate source of architectural knowledge.[182] The invocation is a standard element in mason's inscriptions on pre- and post-Ghurid Indian temples, and its appearance here underlines the degree of continuity in the working practices (and cognitive categories) of northern Indian masons.

Although it is often assumed that convenience or economic pragmatism underlay the reuse of architectural materials, the harvesting and reintegration of stones from heterogeneous sources raised a number of technical problems and demanded certain skills.[183] The numbering of the stones reused slightly later in the construction of Sultan Ghari (628/1231), the funerary complex of Sultan Iltutmish's son in Delhi, suggests that the quarrying of architectural materials was a streamlined operation.[184] The masons' marks on the columns reused in the Qutb Mosque in Delhi have never been studied, but some at least may derive from secondary rather than primary use.[185] Similarly, the recarving and recombination of stones, and the creation of new materials to fill structural lacunae, were skilled enterprises. The problem of integrating column shafts of different length to provide a unified support system is repeatedly raised in accounts of medieval mosques constructed from reused columns, one reason why descriptions of the wooden columns brought from Sind and al-Hind for the Friday Mosque of Ghazni (ca. 409/1018) emphasize that they were all of the same length and thickness.[186] All these activities suggest a preconquest tradition of recycling architectural materials, to which numerous surviving temples also attest.[187]

Despite the indications that masons' guilds continued to work for Muslim patrons in the postconquest period, the pragmatics of patronage are somewhat opaque. The processes of mediation through which the Indian mosques came into being are usually imagined (if at all) as a simple negotiation between Muslim patron or overseer and Hindu master mason (*sūtradhāra*). Exemplified by Fritz Lehmann's comments, one school of thought envisions a division of labor in which formal and decorative elements were assigned to different agents:

> The Turkish patrons clearly were firm on overall design, the fairly standardized layout of a mosque, the use of arches, mihrab niche and mimbar, but seem to have been free to local suggestions on decoration and execution, and perhaps did not know enough about building technology in the older Islamic centres to be able to provide instruction in the techniques of building the exotic Muslim forms.[188]

Seen in this light, the pragmatics of construction might be compared to those governing the commissioning of funerary monuments for British colonial officials several centuries later:

> Generally the interred person's relatives or friends provided the mason with a rough idea of what they wanted. Often they were people who had rather incoherent ideas of English architectural forms and were inspired by the oriental monuments around them but had little acquaintance with the architectural traditions of either. Consequently, details were left to the discretion of the mason who was of course a native. He had his own notions and preferences.[189]

This sort of scenario resonates with a recent variant of the indigenist paradigm, which emphasizes the agency of the Hindu craftsman while marginalizing the potential contribution of Muslim patrons, asserting the regional affinities of the monuments over their transregional filiations, as if these were incommensurate rather than complementary.[190] Both approaches depend on the a priori assertion of assumed norms rather than sustained analysis of the process and products of facture. Consequently, the relative agency of Muslim patron and Hindu mason varies in accordance with the predilections and sympathies of those representing the imagined exchange between them.

A less speculative middle ground between the polarities of foreignizing and indigenizing emphases might be sought by combining empirical analysis with an ethnographic approach to architectural patronage, drawing on studies undertaken in other contact zones. For example, studies of transcultural elites and their architectural patronage in the Deccan during the fourteenth century emphasize two points that are undoubtedly relevant here. First, that whether expansive or minimal, the masons' comprehension of the patron's brief was mediated by "cognitive filters" supplied by the conceptual categories of Indic architectural practice. Second, this process of mediation was dependent on the recognition of "fortuitous areas of convergence" between different cultural forms and practices, cognates for the similes that Meister suggests helped shape the reconfiguration of architectural forms in the Ghurid mosques of India.[191] The observation resonates with a point made in various ways throughout this book: medieval agents frequently attempted to understand the cultural terms and practices of "others" in terms of known categories, finding homologies between the familiar and the foreign.

Studies of architectural patronage in contemporary Anatolia, a frontier region between Byzantium and various emergent Turkic polities, are also useful for trying to conceptualize the division of labor that shaped Indo-Ghurid mosques. Comparisons between the impact of Turkic expansion into northern India and Anatolia during the twelfth and thirteenth centuries have frequently been made, and twelfth- through fourteenth-century stone monuments erected for Turkic patrons in Anatolia attest to similar continuities in workshop practices, with Muslim and Christian architects overseeing masons who were primarily Greek Christians.[192] Although reused materials were often redeployed in Anatolia according to the logic and syntax of their original setting, as in India there has been a tendency to identify the reuse of architectural members as an appropriation that constituted a language of power and domination wielded by the conquering Turks.

Recently, the familiar emphasis on architectural (and by extension cultural) purity that underlies this assumption has been questioned. It has been argued, for example, that the "hybrid" style of early Ottoman

mosques should be seen both as the product of continuities in regional workshop practices and as a reflection of the ethnically and religiously heterogeneous nature of the early Ottoman sultanate, "an expression of *integration* rather than domination."[193] Although there are significant differences between Seljuq or Ottoman Anatolia and early sultanate India—not least the scale and rapidity of Ghurid expansion, which took place within a decade rather than over a more extended time frame—this attempt to highlight a dialectical relationship between architectural innovation and continuities in workshop practices has an obvious relevance to the contemporary northern Indian context.

Texts reveal little about the organization of labor in Indo-Ghurid mosques, although the *Tāj al-Maʾāthir* describes how elephants were used for destroying the main temple of Delhi, after which materials were brought to Delhi to construct the mosque on the site; elephants were also used for constructing the Qutb Minar.[194] Although the inscription at the northern entrance to the Qutb Mosque in Delhi gives the name of the Ghurid sultan Muʿizz al-Din Muhammad ibn Sam, it is far from certain that the sultan was actively involved in the project. In Ghaznavid Afghanistan and Seljuq Anatolia patrons reportedly had some role in the process of design, although the major part of the burden usually fell to a royal agent acting as supervisor.[195] This was reportedly the case with Sultan Mahmud's Friday Mosque at Ghazni. According to al-ʿUtbi (ca. 1030), the sultan had selected a level site for the mosque before he departed on his campaign against Kanauj and Mathura in 409/1018:

> Now it happened that his return from this expedition coincided with the completion of the desired planning and widening for the area and the erection of walls around its four sides, and he immediately began to pour out thousands of dirhams for the craftsmen, just as he had poured out the blood of valiant men on the day of battle. And he appointed to oversee them one of the notables of his court, to circulate among them (each day), insisting on conscientious work and criticizing any hint of imperfection.[196]

The inscription on the northern entrance to the Qutb Mosque in Delhi states that the mosque was constructed on the order (*amr*) of Sultan Muʿizz al-Din, whose name also appears on the Qutb Minar, along with those of his older brother, a rare appearance of the older Ghurid sultan's name in Delhi.[197] However, the recurrence of Qutb al-Din Aybek's name throughout the foundation texts of the Qutb Mosque indicates that here (as at Hansi, Kaman, and elsewhere) the commissioning patron was usually a member of the elite cadre of manumitted Turkic slaves on whom the sultan depended for the administration of his Indian territories.

Inscriptions in the Arhai-din-ka-Jhompra Mosque at Ajmir and the Qutb Mosque in Delhi tell us that some or all of the work took place under the respective supervision of (*fī tawallīyyat*) Abu Bakr ibn Ahmad Khalu (?) al-Harawi and Fadl ibn Abiʾl-Maʾali. The latter individual is named on both the arched screen of the mosque and on the lowest story of the Qutb Minar.[198] The *nisba* (toponymic) of the former suggests that he may have hailed from Herat, a major artistic center within the Ghurid sultanate whose denizens also seem to have contributed to the decoration of Ghurid monuments around Multan (fig. 66). These were constructed from brick, however; the predominance of a stone medium in northern India presumably limited the contribution that any Herati craftsmen could make.

The formula used in these inscriptions is among the earliest occurrences of a cognate expression, *bi-tawallī*, that appears in twelfth- and thirteenth-century foundation texts from Anatolia, the central Islamic lands, and Syria, where it refers to individuals who occupied the position of *mutawallī* or supervisor of works.[199] In certain cases, the function of the *mutawallī* may have been similar to that of the *miʿmār*, a term that appears on the minaret of Jam (569/1174; figs. 51 and 52), and which is usually translated as architect but, depending on context, may be better rendered by supervisor.[200] The *mutawallī* was responsible for keeping accounts and finances, hiring labor, acquiring raw materials, and commissioning a master mason. Ibn Battuta's account of the mosque planned by ʿAlaʾ al-Din Khalji in his new capital of Siri (ca. 1311) suggests that the master mason was also responsible for estimating the cost of construction.[201] The *mutawallī* was usually a member of the *ʿulamāʾ* or religious class, often a *qāḍī* (religious judge) or *khaṭīb* (preacher).[202]

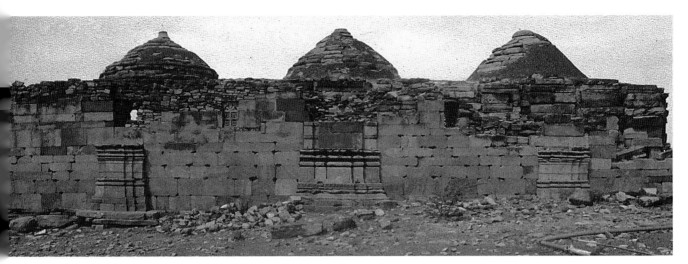

118

Shahi Masjid, Khatu, exterior of *qibla* wall showing three mihrab projections.

Taken together with the inscriptions in Ajmir and Delhi, this evidence for the modus operandi of patrons and masons in contemporary Anatolia enables us to establish a basic chain of command from the nominal patron (the Ghurid sultan, mentioned only in a few of the Delhi inscriptions), to his agent (the Turkic slave generals), and hence to the *mutawallī* or supervisor of works. Further specializations are suggested by an early thirteenth-century reference to the involvement of engineers (*muhandisān*) in constructing the Qutb Minar.[203] Similarly, the foundation text of an *ʿīdgāh* (place of prayer) at Jalor in Rajasthan dated 718/1318 names four individuals involved in the commission: the builder (*bānī*) or commissioning patron, the architect (*miʿmār*), the supervisor (*kārfarmān*), and the calligrapher (*kātib*).[204] The calligrapher and engraver were not necessarily identical: another fourteenth-century foundation text from Mangrol in Gujarat distinguishes between the *qāḍī* who wrote the text and the *sūtradhāra* (master mason) who engraved it.[205] This arrangement finds analogies in other regions of the Islamic world where the *qadī* often fulfilled the function of *mutawallī*, ensuring that the legal aspects of the project conformed to the Shariʿa, negotiating the linguistic divide between the language of the chancery (Persian) and foundation texts (generally Arabic) and often providing drafts of the latter.[206]

This chain of command is perfectly commensurate with what we know about the pragmatics of patronage in preconquest South Asia, which no doubt facilitated the adaptive restructuring necessitated by postconquest conditions. The involvement of military commanders as agents of the ruler is, for example, attested in preconquest temple construction, as is the role of the *sthāpaka* or *ācārya*, the priest who ensured conformity to religious norms and sometimes functioned as a superintendent of works, the equivalent of the *mutawallī*. Both *sthāpaka* and *mutawallī* dealt directly with a master mason (*sūtradhāra*) who could also function as designer/architect, a position comparable to that of *miʿmār* in the Islamic world. At the end of this chain stood the members of the guilds, the masons and sculptors (*shilpīs*) who executed the commands of the *sūtradhāra*.[207]

The epigraphic evidence can be supplemented by formal analysis, which provides further insights into the order in which the mosques were constructed. At both Ajmir and Khatu, for example, projections on the exterior of the *qibla* wall indicate that both mosques—which appear to be products of a single workshop—were originally planned with three mihrabs each preceded by a dome (figs. 72 and 118). In their final forms, however, both were provided with only a single mihrab, albeit a spectacular example in white marble (figs. 71 and 73). The discrepancy also suggests that the *qibla* wall was the first part of the mosque to be erected, as was the practice in other areas of the medieval Islamic world. The same pattern

is seen in sultanate architecture: the Friday Mosque ordered by the Delhi sultan 'Ala' al-Din Khalji for his capital of Siri (ca. 1311) was never constructed beyond the mihrab and *qibla* wall, while the Tughluqid Friday Mosque constructed in the Kakatiya capital of Warangal in the 1320s never proceeded beyond the *qibla* bay.[208] If the same sequence of construction was followed at Delhi, the gates would have been the last elements of the mosque to be completed, so that the foundation text over the eastern entrance to the Delhi mosque may have been set in place several years after 587/1191–92, the date that it cites for the erection of the mosque.[209]

Discrepancies between conception and execution in the Ajmir and Khatu mosques raise questions about agency and patronage that are perhaps ultimately unanswerable but that highlight the extent to which the mosques were shaped by a heuristic approach to construction. Despite their lowly position at the end of the chain of command, the masons working under a *sūtradhāra* seem to have had a certain leeway to exercise their initiative, as was the case with preconquest architectural projects.[210] The range and variation in alterations to figural imagery, for example, suggest that while the impetus for neutralizing it derived from the patrons of the mosques (or their perceived desires), the parameters of its implementation were left to the individual mason. A group of identical dwarf (*pramatha*) capitals reused together in the southeastern corner of the Qutb Mosque in Delhi makes the point. Despite their formal affinities and proximity, their facial features have been altered in various ways: while some display jagged irregular surfaces that are clearly the result of a blow, others display a careful retooling of the surface to produce an attractive smooth finish (fig. 119). The only common factor to the process of alteration is the attention paid to the face.

The adaptability and flexibility to which the monuments bear witness remind us that the choices made by the agents of architectural translation are in dialogue with the conventions within which they operate, so that the process of mediation is "socially embedded and historically contingent."[211] Based on what we know about the chain of command from patron to mason, we might therefore envisage an economy of translation that included functional requirements, the architectural acumen and desires of the patron or

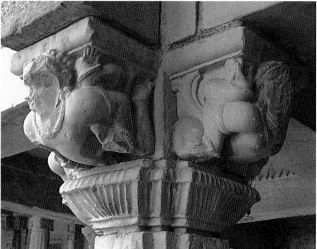
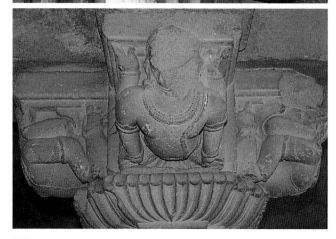

119

Qutb Mosque, Delhi, range of alterations to a group of reused capitals in the southeastern *riwāq*.

REMAKING MONUMENTS

his agent(s), the success of linguistic communication between different vernaculars, the cognitive and practical skills of the masons who worked on the project, and their consequent ability to rise to the challenge of inscribing what may have been new and alien modalities. The phenomenon is perhaps exemplified by the foundation text at the eastern entrance to the Qutb Mosque, the triumphant tone of its Persian text commemorating the act of foundation according to Indic conventions, and therefore necessitating subjective acts of cognition and communication inseparable from the conceptual and physical displacements witnessed in the mosque to which it is affixed and for which it constructs a context.

It is useful here to remember Roman Jakobson's distinction between intralingual translation (translation between different dialects of the same language), interlingual translation (translation between different languages), and intersemiotic translation (translation between different cultural signification systems, including verbal and nonverbal systems such as architecture and dress codes).[212] The Indo-Ghurid mosques presuppose all three modes of translation; a meta-architectural dialogue between craftsmen who spoke different Indic vernaculars, communicating with patrons who spoke Persian or Turkic languages about different architectural systems with their own morphemes, syntactic structures, registers, and regional dialects, either directly or through intermediaries and intermediate languages.[213]

| Markets, Mobility, and Intentional Hybridity

Scholarship on the Ghurid mosques of India has usually assumed a dichotomy between nomadic Turkic patrons and sedentary Hindu masons belonging to craft guilds whose architectural idioms and styles were deeply rooted in the soil of the conquered lands. By contrast, throughout this chapter I have tried to emphasize the need to consider the Indian mosques of the Ghurids in a transregional context, not only as elements of a larger program of architectural patronage designed to bolster the orthodox credentials of the Ghurid sultans, but also as corollaries to the contemporary circulation and reception of Indic artifacts and idioms in Afghanistan itself. Recognition of the cultural flows between these contiguous realms has

been stymied by an anachronistic tendency to envisage them as possessed of boundaries analogous to those of the modern nation-state. The rhetorical posturing of medieval Arabic and Persian histories affirms this impression by reifying cultural and religious difference, depicting the boundaries between the eastern sultanates of the *dār al-Islām* and the neighboring kingdoms of al-Hind as a kind of medieval iron curtain. Despite this, a number of what are generally treated as anomalies point to the recalcitrant nature of men and materials, their refusal to remain on either side of the hyphen dividing "Indo" from "Islamic," Iran from India.

In an important discussion of portability and its implications for artistic production in the medieval Mediterranean, Eva Hoffman has noted that "the fixed nature of architectural space stands in obvious contrast to the indeterminacy of the object and the vicissitudes of portability."[214] Architectural elements and forms can, however, travel either literally or through the mobility of craftsmen. Examples include the importation of (wooden?) beams or columns (*judhūʿ*) from Sind and al-Hind for the Friday Mosque of Ghazni built by Sultan Mahmud in 409/1018–19, or the wooden doors from the tomb of the same sultan (the infamous "Gates of Somnath"), which some scholars identify as the work of an itinerant Egyptian wood-carver operating in Afghanistan around 1100.[215] The role of mobile craftsmen in the multidirectional circulation of forms and techniques is again suggested by the employment of a peripatetic (and ultimately fraudulent) craftsman from the land of the Turks (*Turuṣkadeśa*) to gild a parasol (*chatr*) on a Shiva temple built by King Kalasha, the Hindu ruler of the Kashmir Valley between 1063 and 1089.[216] Gilding was rarely used on Kashmiri metalwork, and the context in which this commission occurs suggests that peripatetic artisans were particularly valued for their possession of uncommon skills. When it came to artistic patronage, cultural, ethnic, and religious boundaries were evidently permeable and porous; neither religion nor ethnicity was an impediment to the employ of a skilled artist on a royal project, even a religious monument.

However scattered, these references to the earlier circulation of artisans and architectonic elements provide a context for the reception of Indic elements and techniques in twelfth-century Afghanistan. Indic ele-

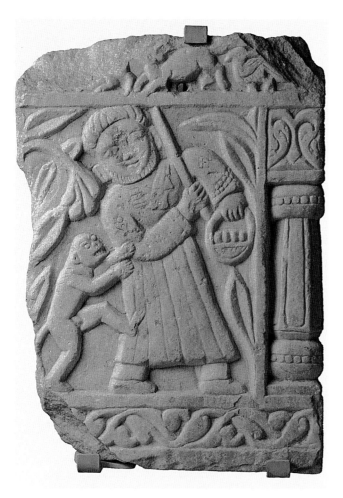

120

Carved stone relief from Ghazni, with stylized *pūrṇaghaṭa* (overflowing vase) capital, probably first quarter of twelfth century (courtesy of the Linden-Museum, Stuttgart).

ments are manifest in the art of Afghanistan from the early twelfth century, along with decorative and structural techniques that hint at the presence of Indian craftsmen. These include the use of cut brick on the minaret of Mas'ud III (d. 508/1115) at Ghazni, a technique that is rare in Afghanistan but common in the brick temples and tombs of the neighboring Indus Valley.[217] The white marble revetments found in the monuments of Ghazni from the early twelfth century might emulate the marble carvings favored in Rajasthani and Gujarati monuments, but they may also be

a more prosaic reflection of the abundant supply of marble in the vicinity of the city.[218] A more definitive relationship is attested by a relief of unknown provenance but related in content and style to a corpus of anthropomorphic and zoomorphic panels found at Ghazni, and likely to date from the early twelfth century. The scene illustrates a tale concerning the role of monkeys in the harvesting of beans, a rare example of a narrative scene in Ghaznavid art.[219] It is framed by a pilaster bearing a bifoliate capital clearly recognizable as a stylized variant of the overflowing vase (*pūrṇaghaṭa*) capitals common in northern Indian architecture of the eleventh and twelfth centuries (fig. 120; compare with the overflowing foliate vase visible in fig. 106). A series of terra-cotta colonnettes crowned with similar capitals was recovered from the palace of Sultan Mas'ud III at Ghazni (dated 505/1112), suggesting that Indic elements may have been more pervasive in Ghaznavid architectural decoration than has previously been thought.[220]

Despite these occasional appearances, it is only in the 1190s—when the Ghurid mosques in Ajmir, Delhi, and other Indian centers were under construction—that Indic ornament proliferates in Afghan stone carvings. This receptivity to Indic elements—which might be read against the contemporary appearance of the trident (*triśūl*) on coins minted in Firuzkuh (fig. 59)—is manifest in stone carvings from three sites: Sultan Mu'izz al-Din's capital of Ghazni in eastern Afghanistan (the second city of the Ghurid sultanate); the site of Bust in south-central Afghanistan, near the palace of Lashkari Bazar (possibly Sultan Ghiyath al-Din's winter residence); and the enigmatic site of Larvand in the Uruzgan province of central Afghanistan. The carvings from the first two sites are relatively small-scale marble funerary monuments. By contrast, at Larvand we are dealing with a unique stone shrine in which the forms and idioms of contemporary northern Indian architecture are transposed in toto. This receptivity to Indic architecture calls into question the assumption (common to both the indigenizing and foreignizing paradigms discussed above) that "influence" flows in the direction that traditional historiography consistently mandates: into India.

Although many of the Ghazni cenotaph fragments lack dates, on formal and stylistic grounds they

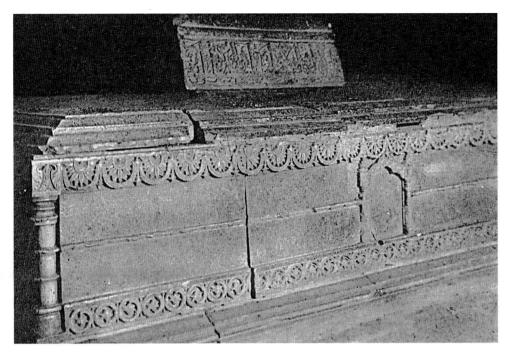

122
Ghazni, detail of cenotaph visible in fig. 121.

are datable to the second half of the twelfth century and the beginning of the thirteenth. A white marble cenotaph at Ghazni popularly identified as that of the Ghaznavid sultan Mas'ud I (r. 421–32/1031–41) is typical of the group as a whole (fig. 121). Despite the identification, recent research indicates that the cenotaph is composed of materials of at least two different periods, with the elements comprising the rectangular body datable to the late twelfth century.[221] Two horizontal friezes define the upper and lower edges of the cenotaph: an upper *padmajāla* (lotus chain) band, and a narrow lower band decorated with a *padmalatā* or lotus vine similar to that framing the mihrab in the mosque at Kaman (figs. 109 and 110) and to some of the friezes found in the Qutb complex in Delhi. The corners of the cenotaph are framed by ringed columns with bifoliate capitals bisected by a single *ardharatna* (half-diamond) motif (fig. 122): numerous parallels for all three elements can be found in the eleventh- and twelfth-century monuments of Gujarat and Rajasthan (see fig. 125).

The center of each side of the "Mas'ud" cenotaph is occupied by a lobed *tōraṇa* arch, a form also adapted for use in other Ghurid monuments, including the

123

Ghazni, undated marble cenotaph (by kind permission of the Istituto Italiano per l'Africa e l'Orient, IsIAO Dep CS No. 1766/1).

124

Ghazni, fragmentary marble cenotaph (by kind permission of the Istituto Italiano per l'Africa e l'Orient, IsIAO Dep CS No. R4726/7).

mihrabs in the mosques at Ajmir and Khatu (figs. 71 and 73). An interest in diverse arch forms is in fact a hallmark of Ghaznavid and Ghurid architecture, and the five- or seven-lobed *tōraṇa* arch seem to have been a standard element in the repertoire of the Ghazni masons. The form exists in several variants, supported on either ringed or baluster columns, the former being the case here. Both banded or ringed columns and the less common baluster columns (fig. 123) found on Ghazni cenotaphs have numerous Indic analogies. Baluster columns appear in the decoration of temples in eastern regions of India such as Bihar and Bengal; their earliest appearance at Ghazni occurs in a series of terra-cottas recovered from the pal-

REMAKING MONUMENTS

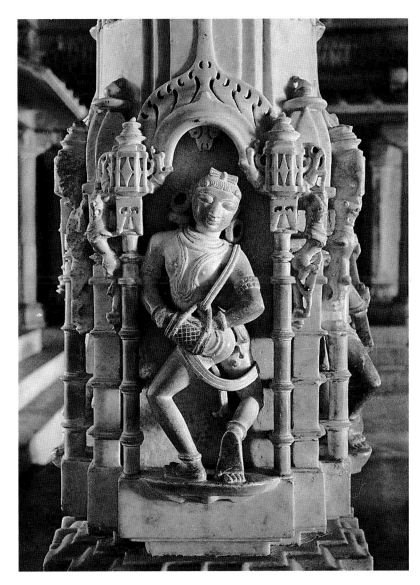

125
Detail of marble carving, Mahavira Temple, Kumbharia, Gujarat, AD 1062 (courtesy of AIIS, Neg. No. 211.35).

ace of Sultan Mas'ud III (505/1112), where they are found in association with Indic *pūrṇaghaṭa* capitals.[222] The ringed columns find numerous analogies in the eleventh- and twelfth-century stone monuments of Rajasthan and Gujarat (see fig. 125). The varied columns on the Ghazni carvings often rest on inverted petal bases and are provided with capitals in the form of *kalaśa*s or auspicious pots, or lanternlike capitals on which *ratna* (rhomboid jewel) designs are deeply undercut (fig. 124). Once again, these elements repli-

cate common details of Rajasthani and Gujarati marble carving (fig. 125).

Two of the Ghazni carvings are dated 600/1203, confirming that the proliferation of these features in Afghanistan coincides with the period of Ghurid expansion into northern India. The first is a fragmentary panel from a cenotaph carved with a repeated design of trilobed arches (fig. 126) similar to those carved on the marble dadoes in the palace of the Ghaznavid sultan Mas'ud III (dated 505/1112; fig. 127),

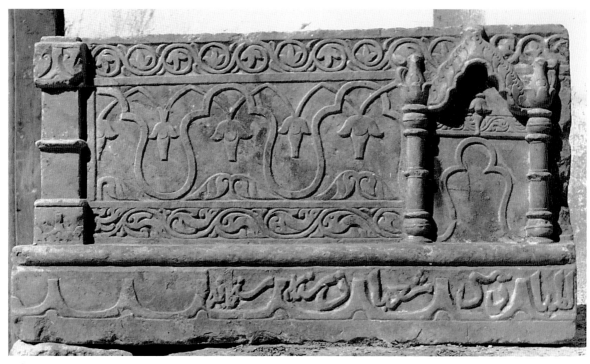

126
Ghazni, marble cenotaph dated 600/1203 (by kind permission of the Istituto Italiano per l'Africa e l'Orient, IsIAO Dep CS No. 1524/1).

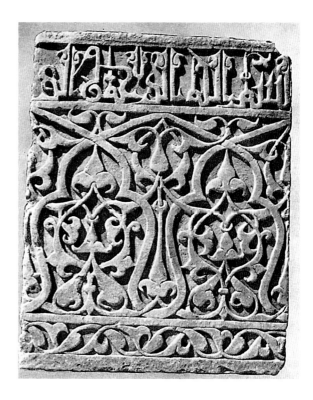

127
Fragment of a marble dado from the palace of Mas'ud III at Ghazni, 505/1112 (after Bombaci 1966, by kind permission of the Istituto Italiano per l'Africa e l'Orient).

REMAKING MONUMENTS

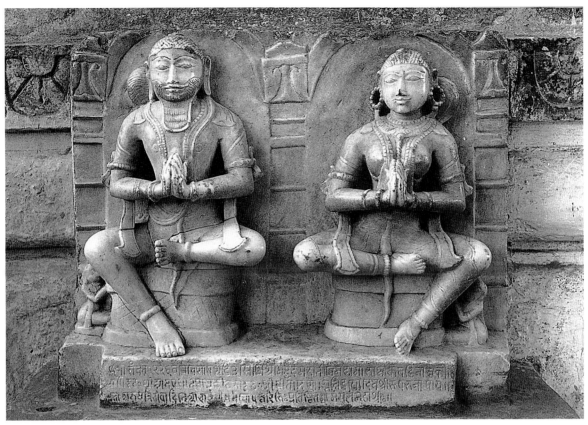

128

Jain relief showing the parents of Prime Minister Kapardi, dated VS 1226/1170 AD, with stylized *pūrṇaghaṭa* capitals, Mount Abu, Gujarat (courtesy of AIIS, Neg. No. 213.13).

but here overlain with a stem bearing inverted flower buds.[223] The surviving terminal of the panel is carved with a projecting pilaster surmounted by a *pūrṇaghaṭa* capital similar to those found on other Ghazni fragments, the leaves once again reduced to triangular abstractions. This abstraction is not a product of acculturation but faithfully echoes contemporary Indic stone carvings, where the triangular form preserves a "visual residue" of the fully representational vase-and-foliage capitals found in other contexts (fig. 128).[224] A *tōraṇa* arch appears at the center of the panel, the exterior of the arch lightly incised with petal patterns (fig. 126). On this, as on other more fragmentary cenotaphs from the site, a single flower is suspended from the summit of the projecting arch (apparently a stylized representation of a mihrab), in place of the

lamp found in other carvings of this period from Ghazni, a combination that was to enjoy a long history in Indo-Islamic stone carving.[225]

The second dated carving from Ghazni is a foundation text recording the construction of a mosque in 599/1203 during the reign of (*fi dawlat*) the Ghurid sultan Mu'izz al-Din Muhammad ibn Sam (fig. 129).[226] The polylobed arch of the foundation text is borne on twisted columns that stand on circular bases lightly incised with stylized inverted lotus petals and are surmounted by variants of the vase-and-foliage designs noted above. Like the baluster and ringed columns employed on other of the Ghazni carvings, the twisted columns employed here replicate a type of architectonic feature familiar from the stone temples of northern India. Among the few dated examples are

195

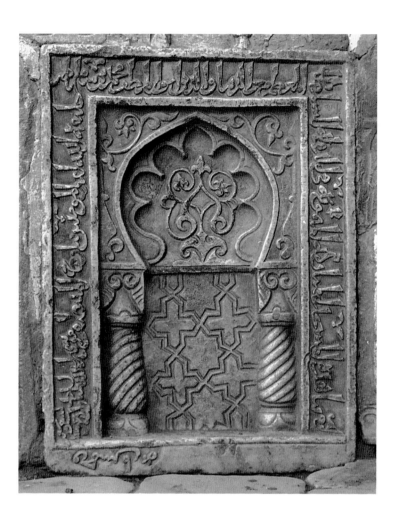

129
Ghazni, marble mihrab dated 599/1203 (by kind permission of the Istituto Italiano per l'Africa e l'Orient, IsIAO Dep CS No. 1524/8).

the columns flanking the entrance to the Sas Bahu Temple at Gwalior (1093 AD), but similar columns are also found in the eleventh- and twelfth-century temples of Rajasthan, among them the Vishnu temple at Chandravati (fig. 130).[227] The selection of a door frame carved with similar columns to frame the entrance to the royal chamber in the Qutb Mosque, Delhi, a decade or so earlier (fig. 86) underlines the need to consider the reception of such Indic elements in a transregional frame.

The lotus motifs, baluster, ringed, and spiral columns, *pūrṇaghaṭa* and *kalaśa* capitals, lotus bud finials, and lobed or *tōraṇa* arch forms employed on the Ghazni reliefs all recur on a series of smaller funerary stelae (measuring roughly 60 by 50 cm) from Bust in southern Afghanistan, which employ additional Indic

elements absent from the repertoire of the Ghazni masons.[228] The stelae are important complements to the Ghazni material, for they are dated, once again to the last decade of the twelfth century. They include a fragmentary tombstone dated 591/1195 on which a lobed arch is supported on baluster columns by a stylized vase-and-foliage capital (fig. 131).[229] On another relief dated 595/1199, a five-lobed *tōraṇa* arch similar to those found on some of the Ghazni cenotaphs is supported on *kalaśa* or auspicious pot capitals and twisted columns (fig. 132), both unknown in Persianate architecture but common in eleventh- and twelfth-century Indic stone carving (figs. 130, 133, and 156). The *tōraṇa* frame contains an Arabic epitaph, while lotus flower bosses are set in the spandrels of the arch. The arch form establishes an aesthetic

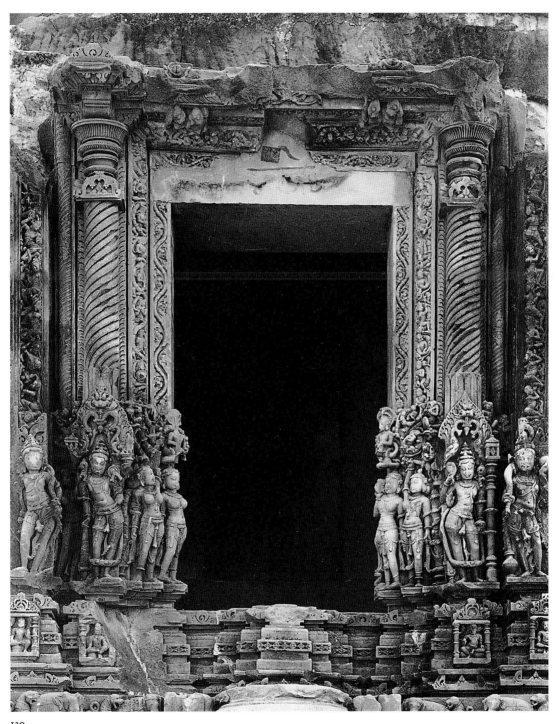

130
Vishnu Temple, Chandravati, Jhalawar District, Rajasthan, eleventh century, showing
twisted columns flanking the entrance (courtesy of AIIS, Neg. No. A5.52).

131
Bust, fragments of a funerary relief dated 591/1195
(courtesy of Bernard O'Kane).

132
Bust, funerary relief dated 595/1199
(courtesy of Bernard O'Kane).

REMAKING MONUMENTS

and formal relationship with the Ghurid mosques at Khatu and Ajmir, whose carved marble mihrabs reproduce similar lobed forms derived from *tōraṇa* arches (figs. 71 and 73). The latter is dated 595/1199 and is therefore exactly contemporary with the Bust stelae, underlining the common use of Indic forms and motifs throughout the Ghurid sultanate at this period.

Although it has been suggested that the cinquefoil arches of the mihrabs at Ajmir and Khatu derive from Afghan prototypes, these putative prototypes themselves attest to the reception of Indic forms in Afghanistan. The complex imbrications of Afghan and Indic architecture underline the transregional circulation of architectonic forms in the late twelfth century.[230] The proliferation of Indic architectural and decorative forms in Ghurid art is generally confined to stone carving, indicating a particular relationship with artisans skilled in this medium. Nevertheless, a series of terra-cotta colonnettes on which baluster columns were crowned with Indic *pūrṇaghaṭa* capitals in the palace of Sultan Masʿud III (505/1112) suggests that Indic elements permeated even the clay medium that was standard in Afghanistan. The brick mihrab of the Friday Mosque at Lashkari Bazar (dated by its excavators to the Ghurid period, but possibly earlier) was flanked by pilasters that rested on large rhomboid designs, the context and form of which recall the *ratna* designs employed in similar contexts on Indian stone pillars.[231] An earlier instance of the same motif in a different medium occurs on a tombstone from Ghazni dated 447/1055 (fig. 134), where the *ratna*s form both the bases and the capitals of the columns flanking the image of an arch in what appears to be the earliest dated evidence for the reception of Indic forms in Afghanistan.[232]

133
Detail of carved marble ceiling panel with *tōraṇa* arches, Vimala-Vasahi Temple, Mount Abu, Gujarat, Maru-Gurjara style, ca. AD 1150 (courtesy of AIIS, Neg. No. A31.37).

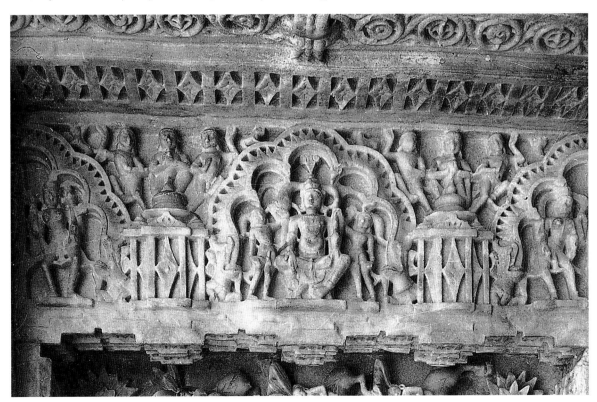

134

Ghazni, detail of tombstone dated 447/1055 with arch framed by columns with *ratna* capitals and bases (by kind permission of the Istituto Italiano per l'Africa e l'Orient, IsIAO Dep CS No. 4723.8).

The cenotaphs and stelae from Bust and Ghazni integrate modes of architectonic and vegetal ornament found in Afghanistan as early as the eleventh century with those derived from contemporary northern Indian sources. However, the carving on the Ghazni cenotaph is characterized by a flattened two-dimensionality alien to Indic carving but in keeping with the style of earlier twelfth-century stone carvings from Ghazni, which employ a similar overlay of architectonic and vegetal ornament (compare figs. 126 and 127). In other words, the reliefs witness the inscription of Indic forms according to the stylistic conventions established in Ghazni long before the Ghurid conquest of northern India.

The diverse genealogies of the carvings are often manifest in the distinct forms, idioms, and styles that

they employ. Of particular interest is the alternation between (or juxtaposition of) indigenous, tightly scrolling vegetation containing single palmettes with more organic, loosely scrolling vines that were standard in northern Indian carving. Witnessed on a small scale in the reliefs from Bust and Ghazni (fig. 126), this tendency to juxtapose distinct forms of homologous ornament is writ large in the Indian monuments of the Ghurids. A striking example can be found in the brick decoration of a Ghurid brick tomb near Multan (figs. 66, 135, and 136) and in the stone carving that surrounds the mihrab of the mosque at Kaman in Rajasthan (figs. 109 and 110): in one case the vegetation is loose, scrolling, organic; in the other, tighter, more symmetrical and stylized.[233]

The Ghazni reliefs demonstrate more than a paratactic approach to ornament, however, entailing a refraction that extends and expands the semantic domain of the Indic terms that they employ.[234] The most obvious example is the substitution of an inverted lotus flower—a motif redolent of radiance in Indic iconography—for the lamp suspended from the apexes of the arches or mihrabs carved on other cenotaphs (figs. 124 and 126). The displacement through which one cultural system is understood in terms of another is achieved through a process of identification, not identity, underlining the need to distinguish between *semantics*, the content understood by most or all members of a community, and *pragmatics*, the various connotations that attach to a given form or style and that may or may not be equally accessible to all members of that community.[235] This raises a number of questions about the nature of visual cognition in twelfth-century Afghanistan that are perhaps unanswerable but that are essential to understanding the broader cultural processes to which the Bust and Ghazni carving bear witness.

The striking juxtaposition of distinct styles of vegetal ornament in some of the monuments built for Ghurid patrons in the Indus Valley and northern India raises the possibility that the novelty of baluster, ringed, and twisted columns, bifoliate capitals, half-diamond designs, lotus friezes, and *tōraṇa* arches rendered them visible to varying degrees, depending on the visual acumen of the viewer. Adapting the terminology of sociolinguistics to the domain of medieval stone carving, the stelae from Bust and Ghazni are

REMAKING MONUMENTS

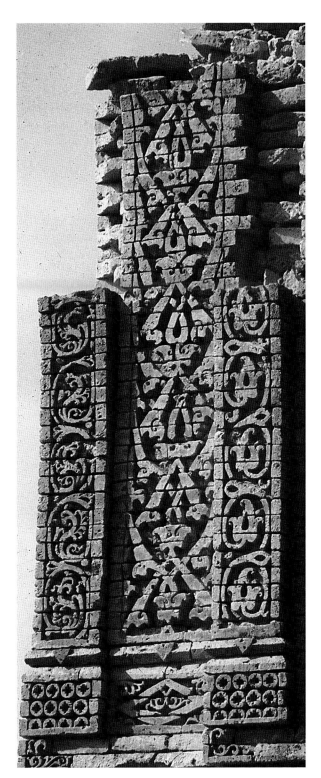

135
Tomb of Sadan Shahid near Multan, ca. 1200, detail of brick ornament with two distinct styles of vegetal ornament flanking a stylized vegetal frieze.

136
Drawing of the vegetal ornament visible in fig. 135 (drawing, Max Schneider).

characterized not only by code mixing, intersplicing words or phrases from one "language" into another, but also by relexicalization, reformulations of specific expressions that exploit the existence of homonyms or synonyms, the "fortuitous convergences" noted above.[236] Analyses of both phenomena suggest that among the determinants of the mix are the relative prestige of different languages and the extent to which they are considered distinct and recognizably separate.[237] Crudely put, code mixing is often characterized by an awareness of difference and the value that attaches to it.

The mixing of distinct regional terms and idioms in the Bust and Ghazni stelae might be compared to contemporary linguistic imbrications in the frontier cities of al-Hind: the proliferation of words drawn from Indic vernaculars in Ghaznavid poetry; the Persian peppered with Hindavi words written by Fakhr-i Mudabbir, a historian of the Ghurids who wrote in Lahore during the early thirteenth century; the appearance of Persianate words in Sanskrit texts of the thirteenth and fourteenth centuries.[238] On this model, however, the proliferation of Indic forms would appear as an organic outgrowth of the enhanced contacts between Afghanistan, the Indus Valley and northern India after the eastward expansion of the Ghurid sultanate.

Alternatively, to push the linguistic analogy a little further, the juxtaposition of homologous forms might be read in light of the prevalence of and preference for cognate doublets—paired homologous terms with distinct linguistic genealogies—in South Asian languages.[239] This would indicate a deliberate vogue for Indic elements recognized as such in twelfth-century Afghan stone carving, an idea implicit in a recent suggestion that the *pūrṇaghaṭa* capital in a Ghaznavid narrative relief (fig. 120) was intended to evoke the Indian milieu in which the tale that it illustrates is set.[240] A slightly earlier analogy can be found in the hybrid Vesara temples of south-central India, characterized by the juxtaposition of northern (Nagara) and southern (Dravida) forms, which contemporary inscriptions indicate were understood as belonging to distinct visual systems.[241] A contemporary model for the perception of idiomatic or stylistic difference might be sought in the sensitivity that Arab and Persian geographers and historians

display toward dress and its role in the visual articulation of ethnic, religious, and regional distinctions (see chapter 2).

The work of the literary theorist Mikhail Bakhtin provides a model for understanding what he terms "hybrid constructions" that may be useful in thinking through the broader practical and theoretical issues raised by the Ghurid stone carvings. For Bakhtin, a hybrid construction "belongs by its grammatical [syntactic] and compositional markers, to a single speaker, but actually contains mixed within it two utterances, two speech manners, two styles, two 'languages.'" Bakhtin distinguishes between "intentional hybridity," in which two distinct languages or linguistic styles are juxtaposed and placed in dialogue ("set against each other dialogically"), and "organic hybridity," in which both fusion and mixture occur but "the mixture remains mute and opaque, never making use of conscious contrasts and oppositions."[242] The notion of "intentional hybridity" is a useful one that, accounting for human agency, moves us beyond the all too ubiquitous "influence," which, like the influenza to which it is etymologically related, is catching rather than caught.[243]

Bakhtin's organic hybridity is akin to processes of *créolisation* or *métissage*, a mixing of previously distinct cultural or linguistic forms associated with novel patterns of contact and constellation,[244] whereas intentional hybridity comes close to the model of hybridity espoused by postcolonial theorists, in which self-conscious practices of merging and resistance to it are equally relevant to the emergence of new identities.[245] Seen in this light, the Afghan stone carvings might be seen as manifesting a premodern "visual biculturalism" similar to that embraced in the art of contemporary Chicano artists, which oscillates between multiple aesthetic modes, making and remaking the artistic traditions from which it is derived.[246] Parallels for the manipulation and mixing of distinct cultural forms exist in the arts of premodern contact zones: the ninth- and tenth- century bilingual coins from Multan, each face bearing a distinct language and script (fig. 12), are a case in point.[247] To extend this reading to the Afghan carvings is to presuppose, however, both a populace that was "architecturally polyglot" and a self-consciousness that is perhaps more relevant to minority artists competing in mod-

REMAKING MONUMENTS

ern globalized markets than medieval South Asian stonemasons.[248]

Nevertheless, the question of the market is germane. The twelfth century sees the rise of an urban "bourgeoisie" in the eastern Islamic world, with a palpable impact on the production and consumption of ceramics, metalwork, and manuscript painting.[249] The rise of an inlaid metalwork industry in the Ghurid territories (and Herat in particular) in the second half of the twelfth century may reflect increased contacts with northern India (where the use of inlay was well established), perhaps even the presence of Indian metalworkers in Herat and Khurasan, a possibility with an obvious relevance to the marble stelae from Bust and Ghazni.[250] The inscriptions on these inlaid metal objects indicate that they were bought and commissioned not by courtly elites but by members of an urban "middle class." The same is true of the stelae from Bust and Ghazni, none of which are royal monuments; the name of Sultan Muʿizz al-Din appears on a single example from Ghazni (fig. 129) but as a dating desideratum rather than a claim of personal involvement. The Bust stelae are inscribed with the names of *imāms*, *qāḍīs*, shaykhs, and in one case an amir: persons of status but not of royal rank. The heterogeneous constitution of the marbles might therefore be read in light of Terry Allen's suggestion that imported forms, decorative idioms, or techniques (in Allen's case those found in twelfth-century Syrian monuments) could be chosen for their "exotic" qualities, "a 'fashion statement' in the advertising language of today's mass market." Outside the paradigms of communalist historiography, there are few reasons to think that the "customer's preference," to borrow Pushpa Prasad's phrase, excluded artistic forms and techniques usually denied him by modern taxonomies.[251] As Allen notes, in situations where

> juxtaposition rather than synthesis was the intended effect . . . there would have been an incentive for architects and other artisans to cultivate their own regional styles rather than synthesize, in order to maintain these styles as marketable commodities, and there would have been a market for architectural design not unlike that for imported luxury articles but con-

strained by its smaller size and different business practices.[252]

The likelihood that the Bust and Ghazni carvings reflect what Allen dubs "style as consumer choice" is enhanced not only by the juxtaposition of homologous forms but also by the fact that this was not a phenomenon of the *longue durée*, of long-established patterns of contact and patronage. Rather, it was a sudden and short-lived phenomenon datable to the period between roughly 1190 and 1210, when contacts between Afghanistan and India increased in intensity and volume as a result of the eastward expansion of the Ghurid sultanate. The balance of probability thus points to a vogue for Indic ornament in late twelfth-century Afghanistan, a deliberate taste for visual novelty catered to by the westward migration of Indian masons working in the styles to which they were accustomed.

This impression is reinforced by the most monumental and spectacular expression of this vogue, the Masjid-i Sangi at the remote site of Larvand just south of the Ghurid heartlands in central Afghanistan (figs. 47 and 137).[253] The monument is a small cuboid structure usually identified as a mosque but assuming the form of a domed square, the dominant type of funerary monument in eastern Iran and central Asia, and one adopted by the Ghurids for tombs in Herat and the Indus Valley.[254] It is constructed from stone, itself an anomaly in a region where brick was the norm; the novelty is embodied in the structure's name, the Stone Mosque. On both historical and stylistic grounds, the shrine has been dated to the period of Ghurid ascendancy during the last decades of the twelfth century, but it is unusual among Ghurid monuments for its dearth of inscriptions. The popular name of the locality in which it stands, Ziyārat-i Malikān (the Pilgrimage Place of Chiefs), and reports that fragments of other monumental structures exist in its vicinity suggest that this elevated site was important to the Ghurids; it has been suggested that it was the summer quarters or hunting lodge of one of the Ghurid *maliks*.[255]

The building is entered through an arched screen applied to the structural walls of the monument, recalling the stone screens added to the façades of the prayer halls of the Ajmir and Delhi mosques. A cen-

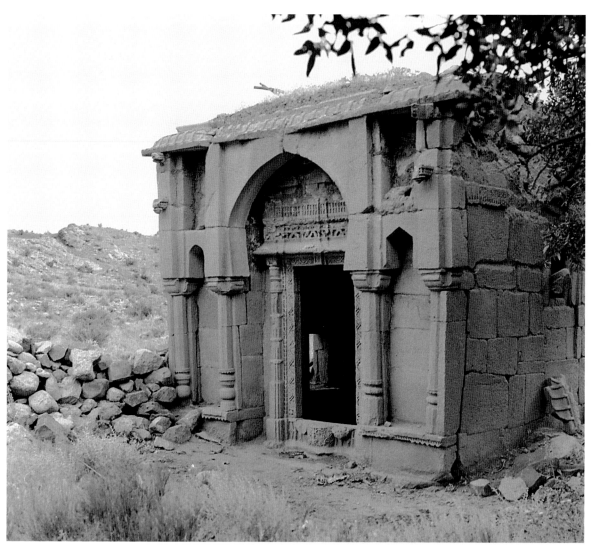

137

Masjid-i Sangi, Larvand, exterior view from the northeast (Josephine Powell
Photograph, courtesy of Photographic Collections, Fine Arts Library, Harvard
College Library).

tral angled, pointed arch carved from four separate
monoliths frames the entrance, its inward turning
form finding parallels in Ghaznavid and Ghurid mon-
uments.[256] This is flanked on either side by narrow
arched recesses, repeating an arrangement popular in
the twelfth-century brick Seljuq mosques and tombs of
Khurasan but using monolithic cut stones rather than
voussoired arches (figs. 137, 141, and 142). Although it
is not possible to reconstruct the original exterior ap-
pearance of the dome, photographs of the interior
confirm that it was corbeled (fig. 138) and crowned on

the exterior with a ribbed *āmalaka* finial (fig. 139), a
standard element in the roof ornaments of northern
Indian temples (fig. 154). In the nineteenth century,
the domes of the Arhai-din-ka-Jhompra mosque at
Ajmir were knowned with similar features, although it
is not clear that these were original.

The plain appearance of the exterior and façade
(figs. 139 and 140) stands in marked contrast to the
sculptural elaboration of the entrance (figs. 141 and
142), its door frame surrounded by at least four dis-
tinct moldings (*śākhā*s), the jambs and pilasters richly

REMAKING MONUMENTS

138
Masjid-i Sangi, Larvand, interior
view showing the remains of a
corbeled dome (Josephine Powell
Photograph, courtesy of Photo-
graphic Collections, Fine Arts
Library, Harvard College Library).

139
Masjid-i Sangi, Larvand, remains of
āmalaka and finial (Josephine
Powell Photograph, courtesy of
Photographic Collections, Fine Arts
Library, Harvard College Library).

140
Masjid-i Sangi, Larvand, exterior
of north wall (Josephine Powell
Photograph, courtesy of Photo-
graphic Collections, Fine Arts Li-
brary, Harvard College Library).

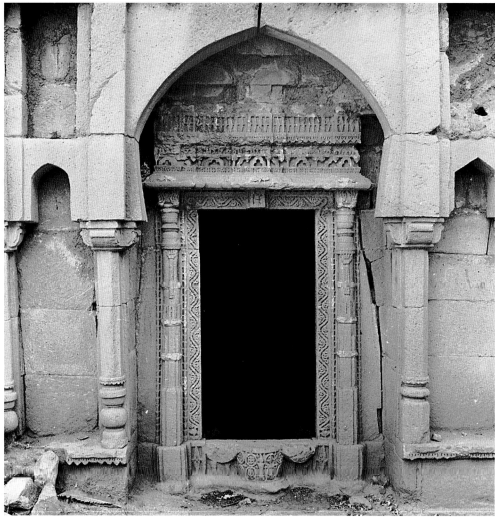

141
Masjid-i Sangi, Lar-
vand, entrance (Jose-
phine Powell Photo-
graph, courtesy of
Photographic Collec-
tions, Fine Arts Library,
Harvard College
Library).

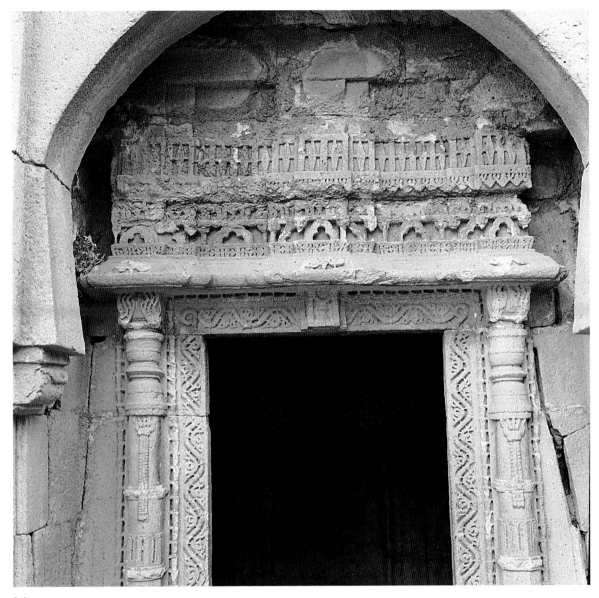

142
Masjid-i Sangi, Larvand, detail of entrance carvings (Josephine Powell Photograph,
courtesy of Photographic Collections, Fine Arts Library, Harvard College Library).

carved with creeper (*valli*), lotus vine (*padmalatā*), and lotus bud moldings. An array of Indic figural ornament adorns the *śākhā*s of the doorway and the overhanging eave above it. This includes three paired regardant birds perched on the eave (fig. 142), a single *kîrttimukha* (face of glory) on each pilaster, a single auspicious goose (*haṁsa*) on either side of the door at the base of the creeper that frames it (fig. 143), and a pair of projecting lion heads or *kîrttimukha*s (now

broken) flanking the lotus threshold (*udumbara*; fig. 144). The original appearance of the threshold can be reconstructed by comparison with those of eleventh- and twelfth-century Gujarati and Rajasthani temples, to which it is iconographically and stylistically related (fig. 145).

It has generally been assumed that the Masjid-i Sangi was constructed from *spolia* carried back from northern India. The sole reason for thinking this is its

143 (left)
Masjid-i Sangi, Larvand, detail of entrance carvings showing threshold, single *haṁsa* (auspicious goose) motif, and lotus bud beading (Josephine Powell Photograph, courtesy of Photographic Collections, Fine Arts Library, Harvard College Library).

144 (facing page, top)
Masjid-i Sangi, Larvand, detail of lotus threshold (*udumbara*) (Josephine Powell Photograph, courtesy of Photographic Collections, Fine Arts Library, Harvard College Library).

145 (facing page, bottom)
Kumbharia, Gujarat, threshold of Neminatha temple (twelfth and thirteenth centuries) with lotus threshold and projecting *kīrttimukha* faces similar to those now broken on the Larvand threshold (courtesy of AIIS, Neg. no. 632-57).

unusual stone medium and Indic idioms, but the misidentification of stone carvings found in early Indo-Islamic mosques as "Hindu" *spolia* is common. Moreover, the marbles from Bust and Ghazni suggest that Indian masons were working in Afghanistan during this period. Rather than the white marble that was easily available at Ghazni, the Larvand shrine is constructed from coarse, dark, pitted stone, probably of local origin. Since stone was an architectonic rather than an architectural medium in Afghanistan, used for small-scale carvings such as cenotaphs and stelae rather than monumental structures, it is likely that the Masjid-i Sangi is the work of northern Indian stonemasons. General parallels have been noted between the Larvand carvings and the stone carvings in the medieval temples of southern Gujarat.[257] The specific details of the carvings and the peculiarities of their syntax point, however, to a relationship with two distinct regions: the stone and wooden monuments of the Hindu Kush and the Maru-Gurjara temples of northern Gujarat.

The frieze of miniature trefoil arches on the entablature above the entrance to the Masjid-i Sangi (fig. 142) and the single trefoil arches inscribed around each interior window opening find few counterparts in contemporary Indian carvings but numerous analogies in carvings of the Hindu Shahi period (ninth to tenth centuries), including a Hindu temple from the Kunar Valley in eastern Afghanistan, where its presence reflects the contemporary popularity of the trefoil form in Indus Valley and Kashmiri architecture.[258] A handful of later wooden and stone monuments from the Hindu Kush attest to the persistence of the trefoil frieze as a decorative motif even after the demise of the Hindu Shahis.[259] The involvement of artisans from Swat or other areas of the Hindu Kush therefore seems likely, but these clearly played a minor role: the closest affiliation of the carving is with the Maru-Gurjara style that prevailed in western India during the eleventh and twelfth centuries. Maru-Gurjara style was itself a synthesis of the Maha-Maru architectural styles of Rajasthan and the Maha-Gurjara styles of Gujarat. It has been suggested that this was a "common style" that developed among the Hindu polities of the northwest as they came under increasing pressure from the Turko-Persian sultanates of Afghanistan.[260]

The debt to Maru-Gurjara architecture is most apparent in the carving of the door frame, not only the specific elements comprising it, but also the manner in which they are combined. Both find particular analogies in a series of Maru-Gurjara temple carvings from southern Rajasthan and northern Gujarat, including the Jain temples at Kumbharia (medieval Arasana) in the Banaskantha district of northern Gujarat, about thirty miles southeast of Mount Abu

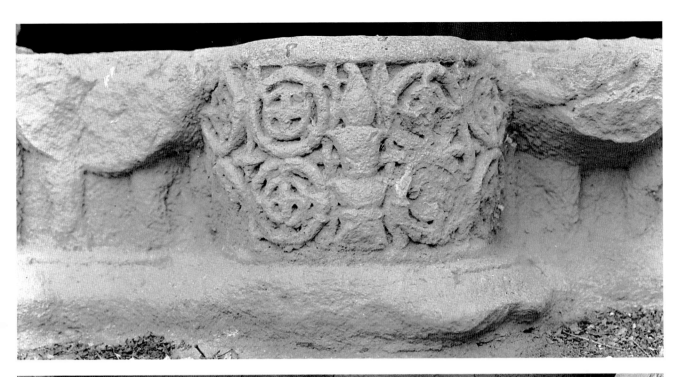

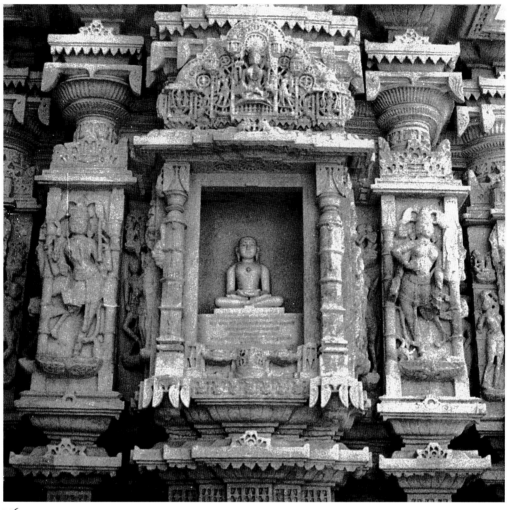

146

Mahavira Temple, Kumbharia, Gujarat, AD 1062, exterior shrine (courtesy of AIIS, Neg. no. 630-86).

(see fig. 47). The site lies at the confluence of trade routes leading from central India to Sind and northern Rajasthan to Gujarat. It contains six white marble temples (five Jain temples and a Shiva temple), which range in date from 1061 to ca. 1230 AD, coinciding with the zenith of the Solanki or Western Chalukya rajas, whose capital of Patan (Anahilavad) lay roughly fifty miles to the southwest.[261]

The details of the door carvings at Larvand (figs. 141 and 142)—the distinctive form of the curved "double-bell"-shaped capitals (similar to the fluted variants that flank the mihrab at Kaman in Rajast-

han, fig. 110), set with square bifoliate capitals, the precise relationship to the *kīrttimukha* (lion face) vomiting pearl strands below, the way in which these strands traverse the single band of this column section, the deep vertical incisions on the median section of the pilasters, the plain appearance of the lower section, and the transition of the pilaster from spherical to faceted octagonal and square section—all repeat a formula employed in the carved architectural frames of the Mahavira Temple at Kumbharia (Samvat 1118/AD 1062; fig. 146).[262] Also common to the Larvand doorway is the overhanging eave with pairs

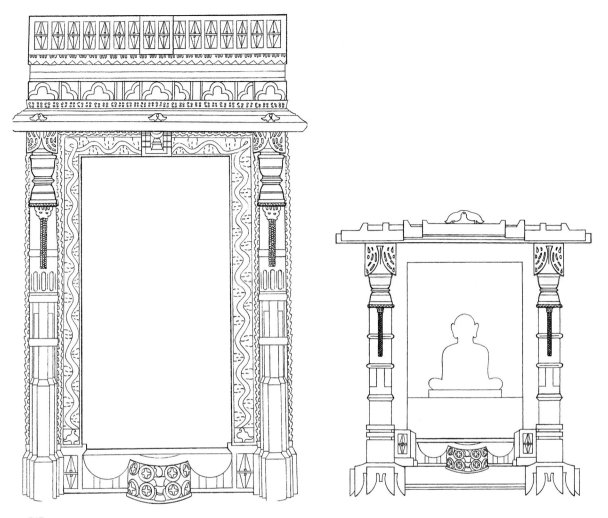

147

Masjid-i Sangi Larvand, schematic drawing of carvings surrounding the entrance compared with those framing the niche opening seen in fig. 146 (drawing, Max Schneider).

of *haṃsa*s (auspicious geese), the creeper carved upon the frame, the *lalāṭa* (shrine) at the center of the *uttaraṅga* (lintel), the lotus bud molding at the extremities, lotus threshold (*udumbara*) with flanking projecting lion heads, and the *ratna* (diamond) motifs set on either side of the threshold in the same location they occur in Larvand (fig. 147).[263]

The date of this particular temple precludes a direct relationship to Larvand, but analogous forms are found in similar combinations in other Maru-Gurjara carvings, including an eleventh-century relief from Mount Abu, on which a square capital with bifoliate ornament rests on the same form of double-bell-shaped capitals.[264] Other examples can be found in the *mūlaprāsāda* (main shrine) of the Kukkudesvara Mahadeva Temple in Chittorgarh, the Mahavira Temple in the hill fort at Jalor, and the Brahma Temple at Delmal in Gujarat.[265] The formal and structural parallels between these carvings and those at Larvand suggest that some of the masons responsible for the Masjid-i Sangi may have been Jains from this area of southern Rajasthan and northern Gujarat.

148

Masjid-i Sangi, Larvand, detail of entrance with crescent motif visible at the center of the lintel (after Scarcia and Taddei 1973).

149

Drawing of crescent motif visible in figs. 141, 142, and 148 (drawing, Max Schneider).

The adoption and adaptation of forms derived from Jain architecture in particular have been noted as characteristics of early mosques in this region, and contacts with Jain carvings are otherwise attested by the find of a near life-size eleventh- or twelfth-century white marble image of a *tīrthankara* (Jain prophet) near Kabul.[266]

In all these cases, it is *not*, however, the door frames of the temple that provide the closest comparanda with the Larvand portal, but the frames of the shrines set within the *bhadra*s, the exterior offsets of the temple. The latter are noticeably lacking in figural ornament, especially anthropomorphic imagery, unlike the lavishly carved temple doors. It thus seems likely that, under the demands of Muslim patrons with a selective taste for figural ornament, the Gujarati stonemasons working in Larvand transposed and monumentalized a familiar form of architectonic frame, adapting it for use around a doorway. This adaptive selectivity also reveals itself in subtle alterations to the iconographic content of the carving. For example, the *lalāṭa*, the rectangular shrine at the center of the *uttaraṅga* (lintel) directly above the entrance to the Larvand shrine (figs. 142 and 148), houses neither the Hindu or Jain icon that one would find in this position in contemporary Indian temples nor the aniconic *ratna* (diamond), which often substitutes for the

REMAKING MONUMENTS

image in Indian mosques, but a curious emblem that seems to represent a finial in the form of a crescent or a *hilāl* (fig. 149). The use of a crescent-shaped element of insignia, the *ḥāfir*, is documented in the eastern Islamic world from the tenth century, and crescent finials were used on Seljuq and Ghaznavid banners.[267] It therefore seems that this aniconic substitution preserves an element of contemporary Ghurid insignia, about which we know virtually nothing.

The adaptive dimension is most apparent in the interior carvings, which replicate the basic formal vocabulary of Maru-Gurjara temples while deploying some its component elements in novel ways; examples include the subsidiary decoration of the interior space, the narrow frieze of *ratnas* (diamonds) that surrounds the interior, and the sawtooth moldings (also found in the mud-brick fortifications of Ghur) just below the zone of transition (visible in figs. 150 and

151).[268] The focus of the interior carving is on the projecting rectangular mihrab at the center of the western wall, whose pointed arch is again carved from a single monolith. The carving of the mihrab is redolent of light, with lotus flower disks decorating the spandrels of the arch, *ardharatna* (half-diamond) decoration adorning its interior, and a partial lotus disk carved on the interior wall below the apex, recalling the flowers that hang in similar positions in the miniature mihrabs depicted on the carvings from Bust and Ghazni (fig. 126) or the protruding lotus flower bosses in the center of the marble mihrabs at Ajmir (fig. 71, now lost) and Khatu (fig. 73).

Above the apex of the Larvand mihrab, a globular vessel that once bore a triangular lid (still visible in outline) appears in relief (fig. 151), in a position where lamps are sometimes found inscribed on contemporary mihrabs (fig. 152). The lamp and its image

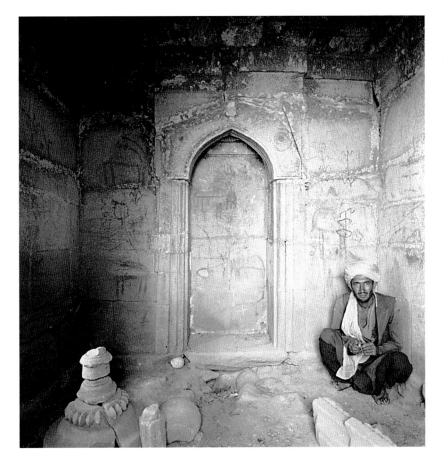

150
Masjid-i Sangi, Larvand, interior view (Josephine Powell Photograph, courtesy of Photographic Collections, Fine Arts Library, Harvard College Library).

151
Masjid-i Sangi, Larvand, mihrab showing remains of lamp/vase motif above its apex (Josephine Powell Photograph, courtesy of Photographic Collections, Fine Arts Library, Harvard College Library).

152
Detail of mihrab with lamp above apex, Kale Cami, Divriği, Anatolia, 576/1180–81.

had long been associated with mihrabs by this date, manifesting an extended image of light found in Qur'an 24:35, the *āyāt al-nūr* (verse of light), in which the Light of God is compared to that of a lamp contained within a niche or vessel.[269] The image of the lamp or vase is among a limited repertoire of pictograms chosen to appear on Ghurid coins, and a frieze of vase-lamps with emergent flames also appears on at least one of the marble cenotaph fragments from Ghazni (fig. 153).[270]

In Larvand, however, the form of the vessel above the mihrab differs from the globular lamp with triangular base and mouth that was standard in the contemporary Islamic world. What appears instead is the

REMAKING MONUMENTS

153
Ghazni, undated marble cenotaph with lamps in the interstices of arches (by kind permission of the Istituto Italiano per l'Africa e l'Orient, IsIAO Dep CS No. R477/4F).

familiar form of the *kalaśa*, the auspicious jar-shaped vessel often used as a crowning ornament of north Indian temples (fig. 154). Eleventh- and twelfth-century dedicatory inscriptions in north Indian temples frequently compare the gilded *kalaśa* to a golden sun, an association with light that may have facilitated its novel adaptation at Larvand.[271] A century or two later, representations of identical vessels, sometimes with flames emerging from them, can be found set above and within mihrabs in the mosques of Bengal and Gujarat.[272]

In its general tenor and the specific terms that it employs, the adaptive use of luminescent imagery at Larvand finds parallels in the Ghurid mosques of India. These include the use of the lotus flower ceilings to create an "axis of honor" leading to the mihrab in the Chaurasi Khambha Mosque at Kaman (figs. 75 and 111), and the carvings in the Shahi Masjid at Khatu in Rajasthan, where twin images of the *kalaśa* flank the entrance to the porch of the mosque (figs. 155 and 156). The form and context recalls the pillars topped by *kalaśa*s that flank niches sheltering deities

154
Sacciyamata Temple, Osian, Rajasthan, ca. AD 975, showing finials with terminal *kalaśa*s (courtesy of AIIS, Neg. No. 495.72).

155
Shahi Masjid, Khatu, entrance with
kalaśa motifs carved on either side.

on twelfth-century sculptures from western India, a form adapted for some of the Ghazni cenotaphs and for the Bust stela of 595/1199, on which the pillars supporting the mihrab arch are surmounted by vessels of similar form (fig. 132).[273]

Perhaps the most obvious parallels between the Larvand shrine and the contemporary Indian mosques of the Ghurids appear in the adaptive deployment of figural imagery, which reiterates in spirit and detail the

reception of an Indic figural vocabulary in the mosques being constructed contemporaneously in northern India. As noted above, zoomorphic carving of various sorts (including *haṁsa*s, lions, and *kīrttimukha*s) is massed around the entrance, recalling the massing of figural imagery around the entrances to the royal chambers in the mosques at Delhi and Kaman (figs. 88–90). In addition, the image of the *kīrttimukha* (face of glory) appears on the interior trabeate beams that

REMAKING MONUMENTS

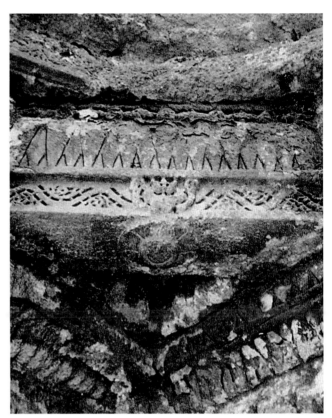

156
Lamp/vase motif above the apex of the Larvand mihrab compared with the *kalasha* motif flanking the entrance to the Shahi Masjid, Khatu.

157
Masjid-i Sangi, Larvand, interior showing *kīrttimukha* motif at center of beam supporting dome (after Scarcia and Taddei 1973).

once supported a corbeled dome (fig. 157). The reception of the *kīrttimukha* in the contemporary religious monuments of Afghanistan underscores a point made above: the survival of similar images on reused stone carvings in the Ghurid mosques of northern India is not fortuitous; even figuration was not a bar to the reception of Indic forms.

The proliferation of figural imagery in the Masjid-i Sangi should not, however, obscure the fact that its reception is quite selective, another aspect common to Ghurid mosques in India. The point is underlined by the omission of anthropomorphic imagery (the absence of the ubiquitous *apsarā*s, the divine nymphs, for example) from the rich array of figural carvings around the entrance and by the restriction of *interior* figural carving to the image of the *kīrttimukha*. Once again, this selectivity brings us back to the Indian mosques of the Ghurids, in which

Hindu (and sometimes Jain) anthropomorphic images on reused materials were altered by defacement and erasure, despite the more permissive attitude to zoomorphic carvings. Selective omission is frequently employed by those translating culturally problematic material, and this differential engagement with a figural vocabulary might be compared to the translation of an Islamicate rhetoric of power on the Indian coins of the Ghurid sultans, which, as we saw in chapter 3, was characterized not only by a carrying over from Arabic into Sanskrit but also by significant absences.

If, as stylistic analysis suggests, the majority of masons working in Larvand came from the northern Chalukya domains (probably the area around Mount Abu or the neighboring district of Chittorgarh), it is possible that they were carried off from these regions during Ghurid raids. In 574/1178–79, an army led by Sultan Muʿizz al-Din was repelled by the Chalukya

raja Mularaja II or his brother and successor Bhima Deva, an event commemorated in a royal inscription, which records the defeat of the army of *Garjaṇakadhirāja* (the raja of Ghazni) at Mount Abu.[274] The 1170s seem to have been an especially prolific decade for Ghurid architectural patronage, and it possible that Indian masons were taken westward after the campaign of 1178, dating the Larvand shrine a few decades earlier than has usually been assumed. A more likely date would be two decades later in 593/1197, when Qutb al-Din Aybek, the Turkic general of the sultan, defeated a Chalukya army near Mount Abu and sacked Anahilavad, the Chalukya capital. After the latter victory, Aybek is said to have dispatched a selection of booty, including jewels, elephants, and prisoners, to Sultan Mu'izz al-Din in Ghazni.[275] The numbers of Indian slaves amassed during raids into northern India is a topos of the chroniclers, and the relocation of crafted artifacts and skilled artisans after successful campaigns of military expansion was common in the medieval Islamic world. During this period, for example, Sultan al-Kamil of Egypt (d. 635/1238) is reported to have carried off the artisans of Edessa to Cairo after his sack of the city. Later examples include the carriage of masons and material back to Samarqand after Timur's sack of Delhi in 800/1398, and the raid mounted on the same city by the Persian ruler Nadir Shah in 1151/1739, when he carried off rich booty, including Indian masons and metalsmiths, who helped construct Kalat-i Nadiri, a marble monument in Khurasan that was used to house some of the Indian loot.[276]

The elaboration and location of the Masjid-i Sangi suggests that it was commissioned by a member of the Ghurid elite, but this is not true of the Bust and Ghazni stelae with Indic elements. It is therefore just as likely that the Indian stonemasons responsible for at least some of these Afghan carvings were not slaves but freemen who migrated westward seeking expanded opportunities for patronage in the newly ascendant Ghurid sultanate. The biography of Tilak, the Hindu migrant who sought employment at the Ghaznavid court as a translator in the eleventh century and rose to become a celebrated general, illustrates what was possible for an enterprising migrant.[277] Medieval Indian masons were more mobile than is sometimes assumed and could migrate in search of

patronage; the case of the Bhangoras, who rose to prominence as the chief royal architects of Mewar in Rajasthan, having moved there from Gujarat around 1389, is particularly well documented.[278] Artisanal migrations often accompanied shifts in the balance of power, including the territorial expansion of existing polities; examples include the southern migration of craftsmen from the Chalukya kingdom of the Deccan into the territories of the newly ascendant Hoysalas during the eleventh and twelfth centuries.[279] For some major projects, among them construction of the celebrated Sun Temple at Konarak (thirteenth century), agents were even sent to recruit suitable workmen from the regions.[280] Whether spontaneous or encouraged by potential patrons, these migrations often entailed a movement from peripheral areas to major cultural centers, where opportunities for patronage were more plentiful. Recent research has even demonstrated the presence of Gujarati marble carvers in East Africa and Indonesia during the fourteenth century, representatives of Gujarati marble workshops whose carved marble tombstones were then enjoying popularity across the Indian Ocean.[281]

There is therefore no reason to assume that Afghanistan lay beyond the purview of Gujarati stonemasons, whose ability to adapt Maru-Gurjara norms to serve the needs of Muslim patrons is attested by the mosques and shrines erected several decades earlier in the town of Bhadreshvar on the coast of Gujarat (figs. 17, 18, and 20).[282] The military expansion of the Ghurid sultanate in the late twelfth century was in any case far from a "first contact" situation. Despite the disruptions that it no doubt occasioned, Arabic and Persian sources attest to the continuation of commercial contacts with Muslim merchants living and trading in Anahilavad/Patan, the capital of the Chalukya rajas, and Hindu merchants from the same city operating contemporaneously in Ghazni.[283] The existence of a Gujarati diaspora in Ghazni might have encouraged and facilitated such migrations.

Considering the role of Arab artisans in Constantinople during this period, Anthony Cutler has argued that when it came to patronage and the production of luxury artifacts, the eastern Mediterranean constituted a realm of *ouvriers sans frontières*, even during periods of intermittent warfare between Byzantium and its Arab neighbors.[284] The same seems to

have been true of the Ghurid sultanate. While the small-scale carvings from Bust and Ghazni may represent the operation of contemporary market forces, the monumental scale and elaboration of the Masjid-i Sangi suggest that something more was at stake. As in other cases where craftsmen where imported— Byzantine mosaicists in Norman Sicily or Indian stonemasons in Timurid Samarqand—the intrusive stone medium and unusual style of the Masjid-i Sangi is likely to reflect the value (both aesthetic and cultural) invested in the Indic forms that it employs, while providing a very public affirmation of the ability to command resources on a transregional scale. As Ibn Khaldun (d. 808/1406) notes:

> The monuments of a dynasty are its buildings and large (edifices). They are proportionate to the original power of the dynasty. They can materialize only when there are many workers and united action and co-operation. When a dynasty is large and far-flung, with many provinces and subjects, workers are very plentiful and can be brought together from all sides and regions.[285]

After the conquest of Constantinople in 1453, for example, the Ottoman sultan Mehmed erected three pavilions in the ground of Topkapı Palace, each in a different style—Turkish, Persian, and Byzantine-Greek—as a sign of his dominion over each of these realms.[286]

Indeed, it may not be going too far to suggest that the import of artistic forms, media, and techniques that were "out of place" (to use Terry Allen's phrase) was integral to the self-fashioning of elites in twelfth-century contact zones. These included the Persianate forms and media (including glazed tiles, *muqarnas* or honeycomb vaulting, and Persianate royal scenes) favored in the palaces of Christian Constantinople in the second half of the twelfth century in emulation of the Seljuq Turks, whose rise posed a significant military threat to the Byzantine state, and whose palaces were sometimes named after those of their Byzantine adversaries.[287] During the same period, the architecture constructed by the Norman rulers of Sicily was marked by its combination of Byzantine, Islamic, and Latin elements, among them goldground mosaics and *muqarnas* vaulting, the products of craftsmen imported from Constantinople and

North Africa. Like the contemporary deployment of different languages and scripts in official texts, the adoption of distinct visual systems by the Norman rulers was part of a careful deployment of eclecticism comparable to Bakhtin's intentional hybridity. This simultaneous staging and disavowal of difference through its visual signs was designed to bolster the status and standing of the parvenu Norman rulers both among their Christian and Muslim subjects and, more importantly, in the wider world beyond the Mediterranean island.[288]

Like the skillfully crafted exotic objects discussed in chapter 4, intrusive forms and styles often functioned as "powerful symbolizations" conferring cultural and political capital on those associated with them.[289] In his discussion of what he calls "out of place" architectural forms and media, Terry Allen makes an interesting comparison between the transregional mobility of forms and styles (including architecture) and the circulation of exotic luxury goods that "can be imported and exported, and combined with other luxury goods to create whatever ensemble is in fashion at the moment."[290] Among the few extant examples of Ghurid and early sultanate objects from northern India, a pair of brass stirrups tentatively ascribed to late twelfth- or early thirteenth-century northern India shows strong formal affinities with Persianate stirrups but makes use of an Indic decorative vocabulary that includes cusped arches, parrots, lotuses, and the lion faces that proliferate in Indo-Ghurid mosques. As Melikian-Chirvani notes, the existence of such objects militates against the choice of visual "language" in contemporary mosques being determined by the contingencies of geography alone: "the combination of an Iranian plan . . . and Indian details found in architecture is not just down to some practical necessity of using what manpower happened to be available. It was at least as much, if not even entirely, the result of an aesthetic option."[291]

Rather than a grudging adaptation to local conditions, the Indian mosques of the Ghurids should be seen instead as indicative of a transregional phenomenon with multiple localized facets. The evidence presented here suggests that the mobility of artisans (and with them the regional idioms and styles of north Indian architecture) was as integral to this phenomenon as the circulation of artifacts.

158

a. Lashkari Bazar, South Palace, detail of carved stucco, after 1150 AD (drawing, Max Schneider, after Schlumberger and Sourdel-Thomine 1978, 1b, pl. 61e).

b. Kaman, Chaurasi Khambha Mosque, detail of stone inscription framing the mihrab visible in figs. 109 and 110, ca. 1200 AD (drawing, Max Schneider).

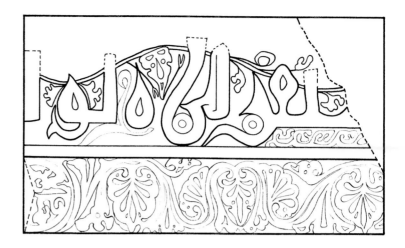

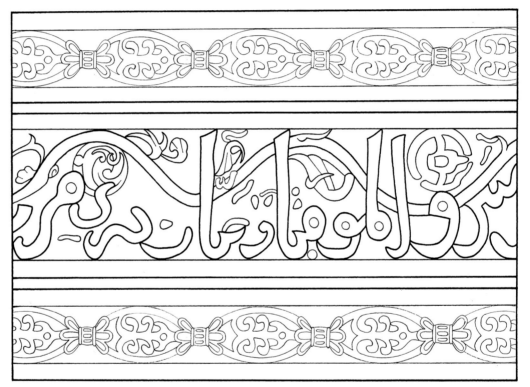

However, just as the reception of Indic idioms in Afghanistan belies the common assumption that the flow of "influence" was eastward and unidirectional, there is no reason to assume that north Indian stonemasons working in Afghanistan were permanently rooted there. On the contrary, certain features of Ghurid mosques in India are most easily comprehended as the products of Indian masons who, having previously worked for Muslim patrons in Afghanistan, returned to work on the Indian projects of the Ghurids in the wake of the Indian conquests. This mobility might account for the sudden appearance of monumental Arabic and Persian stone inscriptions absent from the repertoire of pre-conquest Indian masons. Some of these inscriptions replicate idiosyncratic features of Ghurid stucco inscriptions from Afghanistan on a monumental scale. Among these characteristics is a continuous undulating vine, which meanders through the background of the *naskh* inscriptions like a chain connecting the disparate letters comprising them. The form of

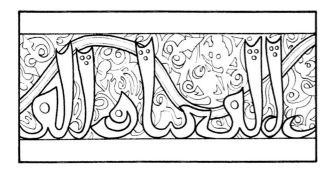

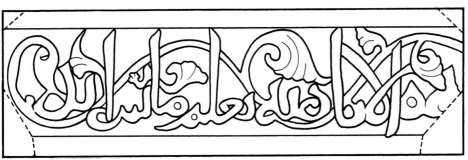

the vine is quite distinctive, a hallmark of Ghurid stucco inscriptions in the palace at Lashkari Bazar near Bust (after 1150; fig. 158a), the mausoleum at Chisht (562/1167; figs. 54 and 159a), and in the Shah-i Mash-had Madrasa in Gharjistan (571/1176; fig. 50), but rare in post-Ghurid inscriptions.[292] Absent from pre-Ghu-rid Indian inscriptions, the feature first appears east of the Indus in the inscriptions that surround the en-trance and mihrab of the Chaurasi Khambha Mosque at Kaman in Rajasthan around 1200 (fig. 158b) and on the screen added to the prayer hall of the Qutb Mosque at Delhi in 594/1198 (fig. 159b). In both cases, the for-mal relationship between script and undulating scroll is preserved, as is the morphology of the latter, but the idiom in which the vine is executed conforms to indig-enous norms.[293]

The presence of complex knotted elements in at least three locations amidst the inscriptions of the screen added to the Qutb Mosque in 594/1198 (fig. 160) also requires explanation. These are not part a preconquest Indic decorative repertoire but are ab-stracted instead from the knotted designs associated with Ghurid brick inscriptions from Afghanistan (fig. 161), a process of abstraction already witnessed in the decoration of contemporary Ghurid monuments in Afghanistan and the Indus Valley.[294] The complex heart-shaped knot integrated into the background or-nament of the fourth inscription band on the first story of the Qutb Minar at Delhi (fig. 162), the band containing the name of the Ghurid sultan, is particu-larly characteristic. Where noted, this has usually been described as a filling ornament, but its contem-porary appearance as a solitary device on Ghurid di-nars minted in Ghazni (fig. 163) suggests that it may be something more.[295]

In both cases, the origins of these features in the

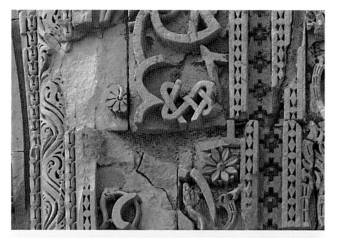

161

Chisht, Ghurid brick funerary monument of 562/1167, detail of inscription with knot motifs (courtesy of Bernt Glatzer).

160

Qutb Mosque, Delhi, details of screen added to the prayer hall in 594/1198 showing different types of knot motifs set amidst vegetal friezes.

contemporary brick and stucco decoration of twelfth-century Afghan monuments are clear (figs. 158, 159, and 164). Their replication and monumentalization in a stone medium thus raises significant questions about the mechanisms of transmission and translation, subjects that have been curiously neglected, despite consistent assertions that Indo-Ghurid mosques replicate the formal values of Khurasani mosques. Illustrated Qur'ans, depictions of mosques, and pattern books have all been mooted as media of transmission. Although there is little evidence for the use of paper notation in Islamic architecture before the thirteenth century, the complexity of the epigraphic program of the Jam minaret of 570/1174 (figs. 51 and 52) points in this direction.[296] It seems more likely, however, that the relationship to Afghan and Iranian mosques is the

162
Qutb Minar, Delhi, detail of Ghurid stone inscription on
fourth band of first story showing heart-shaped knot motif.

163
Obverse of dinar minted in the name of Sultan Muʻizz al-
Din, Ghazni, 568/1172, with prominent knot motif visible at
top (private collection).

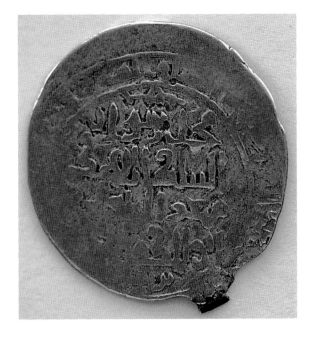

164
Drawing of knot
motifs visible in figs.
161–163 (drawing,
Max Schneider).

product of verbal transmission rather than graphic notation.

While it is easy to imagine basic formal features of a mosque—the combination of courtyard, pillared prayer hall, domes, and *iwāns*—or even the content of its inscriptions being communicated verbally or through textual means, it is less likely that specific decorative forms such as knots and undulating vines were transmitted in the same way. Since stone was not a structural medium in Afghanistan, it is difficult to imagine Afghan masons carving monumental Indian inscriptions. The replication of these diagnostic features and the manner of their execution in India thus presupposes artistic agents cognizant of contemporary Ghurid epigraphic styles, who were skilled stone carvers, capable of working in the contemporary idioms of northern India. The most logical explanation for translations between medium and region is that the diaspora migrating eastward in the decade following the Ghurid conquest was not confined to Herati brick carvers and supervisors but also included northern Indian masons who had previously worked in Afghanistan. This artisanal diaspora may also have been responsible for the "translation" of other forms of vegetal ornament associated with Ghurid brick architecture of Afghanistan, among them the rather stiff stone palmettes surrounding the Kaman mihrab (figs. 109 and 110), whose genealogy is

found in the stucco ornament of contemporary Afghan monuments (fig. 158).

One of the dated stone stelae from Bust can in fact help to bridge the chronological and material divide between the stucco inscriptions at Chisht and Lashkari Bazar and the Ghurid stone inscriptions found decades later in northern India.[297] The outer epigraphic band of the stela is carved with an inscription in *naskh* script executed against the characteristic undulating vine (figs. 131 and 159c). Dated 591/1195, the stela demonstrates the translation of the undulating vine into a minor stone medium in the years just prior to construction of the mosques at Delhi and Kaman. The diagnostic vine appears on a carving replete with Indic elements, including a lobed or *tōraṇa* arch form, lotus buds, and capitals derived from the *pūrṇaghaṭa* (vase and foliage) capital. If this is in fact the product of a northern Indian mason, the "Islamic" style of the undulating vine suggests that these masons were versed in multiple visual "languages," code-switching in accord with local norms or the demands of different patrons.[298]

Apart from the Manichaean strictures of traditional South Asian historiography, there is little reason to assume a division of labor into "Indic" and "Islamic" elements whether or not indigenous and migrant artisans collaborated in the creation of the Bust and Ghazni carvings, as they did in the construction of Ghurid monuments in the Indus Valley.[299] Nor can it be assumed that orthographic peculiarities point to the work of Indian masons. Mistakes proliferate in the texts on Bust and Ghazni carvings and on Ghurid metalwork from Herat—indeed the names of patrons and sultans are frequently misspelled on the very monuments that they commissioned—suggesting that exigencies of form rather than content governed their execution by artisans who were generally illiterate, whatever their ethnicity or religion.[300] A stone cenotaph dated 624/1227 from Bhadreshvar on the coast of Gujarat, whose mosques and shrines (figs. 17, 18, and 20) attest to the ability of Indian masons to adapt their repertoires for Muslim patrons, has an Arabic dating text carved in relief in angular Kufic script in the interstices of a foliated *ardharatna* (half-diamond) frieze (fig. 165), in precisely the same location that a cursive dating text appears on the cenotaph of 600/1203 from Ghazni (fig. 126).[301]

165
Rubbing showing a detail of a Kufic inscription on a cenotaph from Bhadreshvar,
Gujarat, dated 624/1227 (after Z. Desai, *EI* 1965, pl. IVb).

Whatever the division of labor within the marble workshops of Ghazni, there is therefore no reason to assume that Indian stonemasons operating in the city were incapable of carving Arabic texts using established styles and techniques.[302]

The fluidity of praxis and the mobility of both patrons and practitioners underline the multidirectional nature of the cultural flows between Afghanistan and northern India. Confounding any notion of a linear transumption between hypostatized figurations of temple and mosque, they also raise significant questions about cross-cultural architectural reception and aesthetic taste at the end of the twelfth century. While the Indian mosques of the Ghurids are constructed from a bricolage of heterogeneous materials according to prevailing architectural conventions, the newly carved funerary monuments from Bust and Ghazni are marked by the juxtaposition of distinct regional vocabularies in a single artifact.[303] The concerns of the *bricoleurs* responsible for the Indian mosques were both aesthetic and iconographic, creating a loose but legible hierarchy of space related to the content and quality of the reused elements.[304] The determination of equivalence that is central to this process is also evident in the Bust and Ghazni carvings, where, for example, the use of lotus flowers in place of the lamp constitutes a type of refraction premised on shared iconographic qualities of effulgence. This translation of an Indic vocabulary is writ large in the Masjid-i Sangi, where an adaptive use of Maru-Gurjara idioms manifests a Qur'anic simile in which the Light of God is compared to a lamp.

All these phenomena were informed by what Pierre Bourdieu defines as the *habitus*, a residue of repetitive practices that are shaped by, but not reducible to, cultural dispositions.[305] The adoption or perpetuation of different media, structural techniques, and styles in the monuments erected simultaneously in different regions of the Ghurid sultanate illustrates the operation of the *habitus*, while demonstrating the limitations of the dynastic rubrics under which Islamic architecture is often studied. Nevertheless, the *habitus* of the masons who worked for Ghurid patrons seems to have been quite heterogeneous in its makeup, shaped both by the regional architectural traditions in which the masons were first trained (primarily those of southern Rajasthan and northern Gujarat) and by the hybrid modes of stone carving that evolved in their work for Ghurid patrons in Afghanistan. The phenomenon reminds us of George Kubler's observation that "different styles can exist, like languages in one speaker,"[306] underlining a point made throughout this chapter: while locally situated, architectural idioms and styles were not necessarily rooted.[307]

Finally, as Lawrence Venuti reminds us, translation is a utopian endeavor, performed not only as an act of communication between cultures in the present, but also with an eye to future communities that will coalesce around its products.[308] While the collapse of the Ghurid sultanate shortly after 1206 and the Mongol invasions that followed in its wake seem to have stymied the cultural flows that marked the late twelfth century, the period also saw the emergence of a powerful independent sultanate based in

Delhi. Within this sultanate, the mosques discussed here continued to serve a Muslim community expanded by the eastward migrations of those fleeing the Mongol onslaught. Focusing on the Qutb Mosque in Delhi, the final chapter of this book will consider the nature of the community that formed around these early Indian mosques, the ways in which they figured in regional struggles for authority, and the manner in which they continued to mediate between Indic and Islamic cultural forms and practices in the emergent sultanate. In doing so, it will demonstrate the way in which the meaning of monuments could undergo dramatic shifts even over a relatively short period of time.

6 | Palimpsest Pasts and Fictive Genealogies

Communities are to be distinguished, not by their falsity/genuineness,
but by the style in which they are imagined.

—Benedict Anderson, *Imagined Communities* (1991), 6

| A World within a World

Today, eight centuries after its emergence as the cultural and political capital of northern India, the preeminent status of Delhi is a given. In the early thirteenth century this was not the case. Instead, the city was one of a number of regional centers whose governors competed for dominance in the internecine power struggles that took place after the assassination of the Ghurid sultan Mu'izz al-Din in 602/1206. During his lifetime, the sultan had effectively extended the horizontal clan system of the Shansabanids to the Indian *bandagān-i khaṣṣ*, the elite Turkic mamluks who administered his Indian territories. The historian Juzjani attributes the following explanation of these arrangements to the Ghurid sultan:

> Other monarchs may have one son, or two sons: I have so many thousand sons, namely, my Turk slaves, who will be the heirs of my dominions, and who, after me, will take care to prreserve my name in the khutbah [Friday sermon] throughout those territories.[1]

The division of territories after the sultan's death mirrored these aspirations, which Juzjani may have put in the sultan's mouth as a post hoc rationalization. Taj al-Din Yildiz acceded to the overlordship of Ghazni and its dependent territories while, in India, Qutb al-Din Aybek successfully asserted his authority over

the claims of the other mamluks and the regional centers that they controlled.[2] The difficulties associated with this transitional period are suggested by the fact that Yildiz was still issuing coins in his master's name (qualified as *al-sulṭān al-shahīd*, the martyred sultan) three years after the latter's death.[3]

In the decade after 1206, those territories that had formerly been under the control of the paramount Ghurid sovereign, Ghiyath al-Din, were increasingly threatened by the Central Asian Khwarazmshahs, who finally extinguished the last of the Shansabanid line in 612/1215, less than a decade before the region was devastated by the Mongols.[4] This effectively sundered the Ghurid territories to the west of Ghazni from those to the east, putting an end to the idiosyncratic transregional experiment that was the Ghurid sultanate.

In the east, the death of Qutb al-Din Aybek in 607/1210–11 saw the rivalries between the former mamluks of the Ghurids intensify. In the unsettled conditions that followed, several rival mamluks vied for supremacy, quickly pushing aside the claims of Qutb al-Din's son, Aram Shah, who had found some initial support among the mamluks of Lahore.[5] Among the leading contenders were Baha' al-Din Tughril in Bayana and Nasir al-Din Qubacha in Multan, both former mamluks of Sultan Mu'izz al-Din, and a new generation of mamluks who had been in service not to the Ghurid sultan but to his general, Qutb al-Din Aybek (and are hence often referred to

as *Quṭbī* as opposed to *Muʿizzī* mamluks). Chief among these was Shams al-Din Iltutmish, who had held the important governorships of Gwalior and Bada'un. After the death of his former master, Iltutmish was apparently invited to Delhi by a political faction there and conferred with insignia of authority by Taj al-Din Yildiz.[6]

Initially, Iltutmish was careful not to exceed his authority, styling himself *al-malik al-muʿaẓẓam* (the great chief) rather than sultan.[7] In 612/1215–16, however, after Yildiz suffered defeats at the hands of the Khwarazmshahs, Iltutmish met and defeated him at Tara'in, the very site of the Ghurid victory over a Rajput confederation that had opened up northern India to Ghurid arms two decades earlier. Twelve years later, in 625/1228, Nasir al-Din Qubacha, the last remaining of the Muʿizzi mamluks capable of posing a threat, was defeated and drowned.[8] Within two decades after the death of the Ghurid sultan, Iltutmish had thus established himself as the paramount ruler of a new Indian sultanate based in Delhi, eclipsing the claims of other sultans (and sultanates) in Ghazni, Lahore, Multan, and Bayana.

The emergence of Delhi as the preeminent power center of India led to a concentration of political authority in a single urban node that was unprecedented in India since the days of the Mauryan emperor Ashoka in the third century BC. It also marked a shift from the heterogeneous and polycentric modes of state formation favored by the Ghurids to a more centripetal model of kingship, a shift reflected in a number of significant alterations in the cultural and political life of northern India over the quarter century of Iltutmish's reign.

As we saw in chapters 3 and 5, architectural, numismatic, and textual evidence all suggest that the cultural life of northern India was marked by a dialectical interplay between continuity and discontinuity, tradition and innovation, in the last decade of the twelfth century. Ultimately, however, all three phenomena were ephemeral. The scions of Rajput royal houses ruling as Ghurid vassals disappear by the end of the twelfth century. Similarly, as the Turkic elites that administered the new Indian territories consolidated their rule, Sanskrit inscriptions and Hindu iconography became increasingly rare on the coins that they issued. The Lakshmi gold coins issued at Bayana

(fig. 60) and Kanauj are not minted after the death of Sultan Muʿizz al-Din. Coins with exclusively *devnagari* legends are uncommon from the mints of the Delhi sultans after 1250 or so, while bilingual (Arabic and Sanskrit) coins become increasingly rare and have all but disappeared by the 1350s.[9] The beginning of this process is already evident in the coinage of Iltutmish, whose reign witnesses the first appearance of Arabic on coins minted east of the Indus Valley.[10]

Contests for authority and shifts in the nature of its constitution and representation are also manifest in architecture. In the years between the demise of the Ghurid sultan and the triumph of Iltutmish, the patronage of congregational mosques designed to enhance competing claims to authority had been a marked feature of the rivalry between different mamluks, notably Qutb al-Din Aybek, the builder of the Qutb Mosque in Delhi, and Baha' al-Din Tughril, the governor of Bayana and patron of the Friday Mosque at Kaman in Rajasthan. In the foundation text carved upon the main entrance to his mosque at Kaman, Baha' al-Din styles himself *pādishāh* and *sulṭān*, usurping the titular authority invested in Aybek but also asserting a historical relationship to the Ghurid sultan by the use of the self-descriptor *al-sulṭānī* ([slave] of the sultan).[11] The presence of a royal chamber (*mulūk khāna*) at Kaman (figs. 87, 88, and 90), as in Aybek's mosque in Delhi (figs. 84–86), highlights the role of the mosque not only as a sign of Islamization but as a site for the public contestation and performance of authority, most obviously in the ritual affirmation of communal allegiances during the *khuṭba* (Friday sermon).

The instrumentality of architecture to the rivalry between Qutb al-Din Aybek and Baha' al-Din Tughril was not lost on the former's protégé. The architectural patronage of Iltutmish over the two and a half decades of his reign (607–33/1210–36) is an oddly neglected subject, but it is clear that he continued and expanded the ambitious architectural program undertaken by the Ghurids in the few short decades of their rule, embellishing sites associated with his rise to power. These included the city Bada'un, which he had governed before acceding to the sultanate, and which he endowed with a congregational mosque in 620/1223.[12] This occurred at the beginning of a decade that saw a proliferation of royal architectural

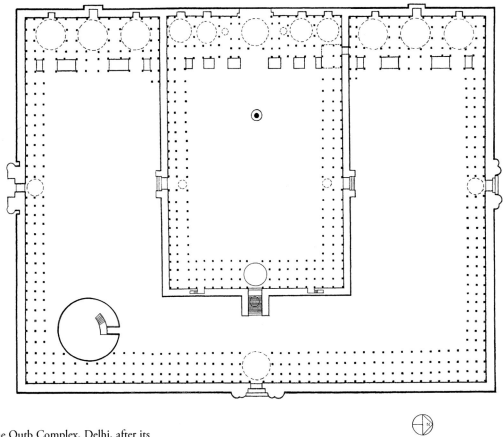

166
Schematic plan of the Qutb Complex, Delhi, after its
enlargement by Iltutmish (drawing, Max Schneider).

projects, the centerpiece of which was the enlarge-
ment of the Qutb Mosque, the first congregational
mosque of the new imperial capital.

Along with other thirteenth- and fourteenth-cen-
tury chroniclers, Juzjani portrays Delhi under Iltut-
mish not only as a regional center but as the epicenter
of the Islamic lands, a rival to Baghdad, Constantino-
ple, Egypt, and Jerusalem, and even the center of the
circle of Islam (*markaz-i dā'ira-i Islām*).[13] At the center
of the circle (and in close association with the city's
bazaars) stood the Friday Mosque of the new imperial
capital, a "world within a world" (*jahān dar jahān*), as
the early fourteenth-century writer Amir Khusrau re-
fers to it.[14] This idea of the Qutb complex as a micro-
cosm, a concatenated metonym of universal religious
and political dominion, is already implicit in its trans-
formation by Iltutmish, for whom the historical asso-
ciations of the site rendered it a valuable rhetorical
tool. Under Iltutmish, the mosque became the locus
for an agglomeration of signs that included architec-

tural form, color, scale, script, looted icons, and an
enigmatic iron column. The accumulation and ma-
nipulation of these signs attempted to legitimize Iltut-
mish's de facto usurpation of power, addressing the
dialectical nature of Indian Islamic identity in ways
that advertised and aggrandized the authority of both
sultan and sultanate. On the one hand, they asserted a
relationship to the ideals of the *umma*, the transhis-
torical and transregional community of Muslims, ob-
scuring contemporary divisions within that commu-
nity; on the other, they constructed a relationship to
an imagined Indian past of which idolatrous practices
and epic feats of kingship were equally characteristic.

If Iltutmish transformed the Delhi mosque into
the repository of a number of resonant relics, the great-
est of these was the original mosque built by Qutb al-
Din Aybek, his former overlord. This was now encased
and enshrined within a massive architectural frame
that almost tripled the area of the mosque (fig. 166).
The most famous feature of the original mosque, its

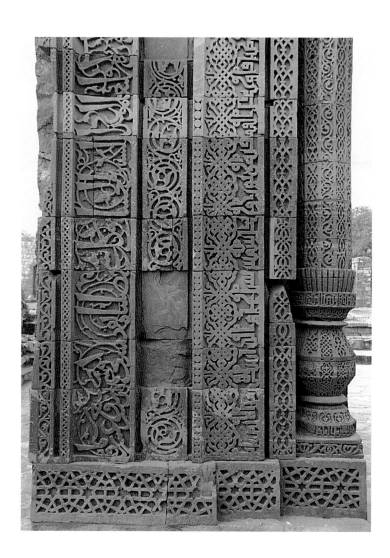

167
Qutb Mosque, Delhi, southernmost pier
of Iltutmish's extended screen inscribed
with the date 627/1229.

massive minaret known as the Qutb Minar (fig. 77),
which had originally stood outside its southwestern
corner, was now heightened by an additional three
stories (perhaps according to the original plan) and
enclosed within one of the courtyards of the newly
extended monument.[15] Thus did Iltutmish lay claim
to Aybek's legacy in a remarkably literal way, with the
earlier mosque both figuratively and literally integrated
into "a new semantic stratum."[16]

Iltutmish's program for the mosque entailed ap-
propriation, juxtaposition, and supersession. As part
of the massive enlargement of the complex, the screen
added to the prayer hall by Aybek and dated 20 *Dhū'l-
qāda* 594 (September 1198) was extended north and
south, the much higher arches of the extension dwarf-
ing those of Aybek's original screen. The foundation

text of Iltutmish's screen, which gives a date in the
months of 627/1229, is located at the base of the
southernmost pier of the extended colonnade (figs.
166 and 167).[17] In effect, this co-opts the epigraphic
program of Aybek's earlier screen, not only by fram-
ing it north and south with larger and more impres-
sive extensions, but also by producing the impression
that the epigraphic program of all three sections forms
a continuous text that begins and ends in those sec-
tions added by Iltutmish.

Despite the differences in scale between Aybek's
mosque and Iltutmish's additions, relationships be-
tween different parts of the complex were established
through reiteration and repetition. The entrance to
the palace of Iltutmish (which lay near the mosque,
as we shall see below) was, for example, embellished

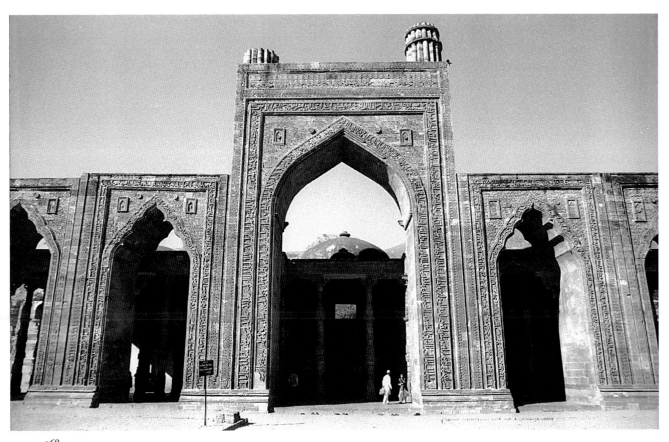

168
Arhai-din-ka-Jhompra, Ajmir, screen added to the façade of the prayer hall by Iltutmish.

with two marble lions, establishing a relationship with the lion sculptures set at the entrance of the royal enclosure in Qutb al-Din's mosque (fig. 89).[18] In addition, the tomb identified as that of the sultan (visible in fig. 178) was situated outside the northwestern corner of Aybek's mosque, in close proximity to its royal enclosure or *mulūk khāna* (figs. 84–86).[19] The reprise of specific Qur'anic verses—especially those found on the screen that Qutb al-Din Aybek had added to the mosque in 594/1198—also helped to relate the buildings of different eras. Around the exterior arch of the eastern entrance to the tomb of Iltutmish—the principal entrance facing the richly decorated *qibla* wall—we find Qur'an 17:1–4, which runs around the central arch of Aybek's screen. Similarly, Qur'an 71:1–5, which appears on Aybek's screen, reappears in the interior of Iltutmish's tomb.[20]

The formula employed in Delhi was replicated in Ajmir, the former capital of the Chauhan rajas. Here

a monumental arched screen similar to that erected by Qutb al-Din Aybek (fig. 78) and extended by Iltutmish in Delhi was added to the façade of the prayer hall (fig. 168). Inscriptions play a central role in the ornament of the screen; once again, the repetition of specific Qur'anic verses established a relationship with the original Ghurid work: Qur'an 9:18–19, which is inscribed on the mihrab of 595/1199, recurs on the central arch of Iltutmish's screen.[21]

As in Delhi, the original core of the Ghurid congregational mosque was enframed and enshrined within a monumental stone carapace consisting of massive outer walls provided with elaborate bastions. In fact, although the Ajmir mosque is assumed to have been built in the late 1190s (in keeping with the date on its mihrab), it is largely a creation of the 1220s. The faceted, flanged, and lobed bastions of two distinct kinds found at the corners of the outer walls (and often erroneously described as minarets; fig. 169)

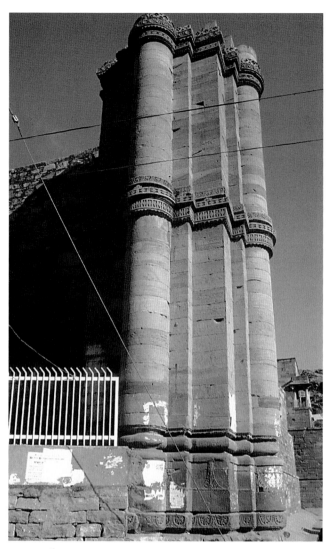

169
Arhai-din-ka-Jhompra Mosque, Ajmir, southeast corner
bastion.

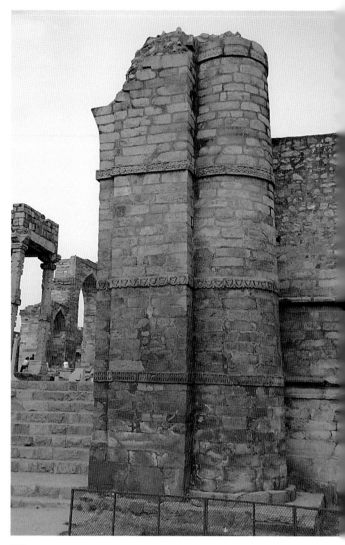

170
Bastion at south entrance to Iltutmish's extended Qutb
Mosque, Delhi (visible on the left side of fig. 166).

have antecedents in the twelfth-century monuments
of Khurasan (fig. 82) but are more closely related to
similar bastions that frame the north and south en-
trances to the perimeter wall of Iltutmish's extended
Qutb Mosque in Delhi (fig. 170). The core of the
Ghurid prayer hall may also have been altered when
the screen and retaining walls were added, since its
columns are of an unusual height (fig. 103), having
more in common with the tall multitiered engaged
columns of the main entrance (fig. 171), added in
the 1220s, than those found in other Indo-Ghurid
mosques.

The ornamenation of the main gate confirms that
the entire retaining wall of the Ajmir mosque was
added by Iltutmish, for its prominent knot designs
reiterate those of Iltutmish's screen (figs. 168 and 177)
and also reflect the ubiquity of knots and knot de-
signs in the epigraphic bands of the sultan's tomb in
Delhi. In both cases the knot motifs are afforded an
almost iconic status by virtue of their placement: in a
cartouche on the lintel directly above the entrance to
the Ajmir mosque (visible in fig. 172); at the apexes of
the interior arches framing the entrances to the Delhi
tomb (fig. 173). Similar heart-shaped knots occur

PALIMPSEST PASTS AND FICTIVE GENEALOGIES

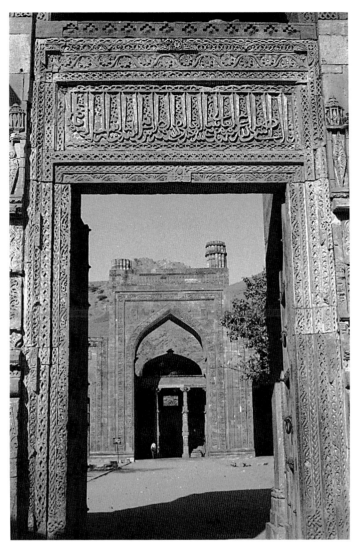

171
Main gateway to the Arhai-din-ka-Jhompra
Mosque, Ajmir.

172
Gateway to the Arhai-din-ka-Jhompra Mosque,
detail showing knot motifs at center of lintel.

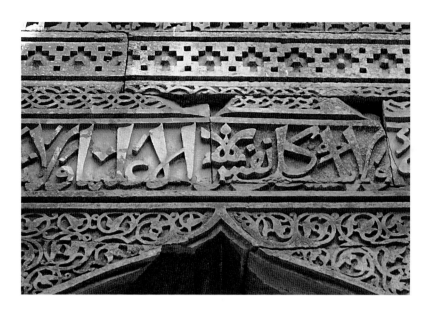

173
Iltutmish's tomb, Delhi, detail of
carved ornament with knot motif,
interior eastern façade.

among the Ghurid inscriptions on the Qutb Minar
(figs. 162 and 164) but gain more prominence in Iltut-
mish's tomb, and also occur in a prominent location
in the foundation text of the Friday Mosque commis-
sioned by Iltutmish in Bada'un (620/1223).[22] It has
been suggested that the abstract knotted motifs in the
Bada'un inscription functioned as "monograms" of
some kind, which seems likely in view of their promi-
nent appearance on contemporary coinage as far west
as the Turkoman polities of Anatolia and as far east
as Mongolia, where the difficulties of determining
whether they should be read as a design element (and
thus implicitly meaningless) or a *tamgha* (a brand or
tribal/personal sign) has recently been noted.[23] It is
tempting to identify the knot pattern as a "proto-
heraldic" device, but in the absence of further research
it may be safer to suggest that it belonged to "a con-
stellation of symbols of power"—figural, abstract, and
textual—that were widely dispersed in Central Asian
and Turkic cultures, and which could be deployed
singly or in combination.[24] We may in fact be dealing
with a nontextual sign system physically integrated
with but semantically distinct from the text with
which it is associated.

Comparison with the art and architecture of
Seljuq Anatolia (whose floruit was contemporary with
the reign of Iltutmish) reinforces this impression. In
his work on Seljuq epigraphy, Scott Redford has sug-
gested that "writing was one in a series of symbolic
systems: astrological, chromatic, religious, totemic,
figural and non-figural that operated separately and

together" as semiotic signifiers, especially in the east-
ern Islamic world.[25] The semiotic potential of color
has largely escaped the attention of modern scholars,
who have focused on script and text as bearers of
meaning, but it was clearly apparent to premodern
visitors to Delhi. In his description of the Qutb Com-
plex, for example, Ibn Battuta (b. 703/1304) noted
that the Qutb Minar (fig. 77) was distinguished from
the more heterogeneous constitution of the adjacent
mosque not only by its dressed stone construction but
also by the red color of the stone used to construct it.[26]
In a similar vein, the consistent use of dressed red
sandstone (rather than *spolia*) in Iltutmish's extensions
to the Delhi mosque distinguished them visually from
the original structure, which (constructed as it is from
reused materials) is chromatically and stylistically
more heterogeneous.

The associations of red in contemporary royal
ceremonial provide a context within which to con-
sider the visual distinction conferred on the minaret
by its builders. Red was the color of royal insignia:
Qutb al-Din Aybek was, for example, invested by the
Ghurid sultan of Firuzkuh with a red parasol (*chatr-i
la'l*), and Iltutmish similarly invested his son as gover-
nor of Bengal with a red canopy of state.[27] The choice
of color in both cases suggests that it had royal asso-
ciations, as it did in the contemporary Turkic polities
of Anatolia, where the word *al-sultān* was picked out
in red on court documents and perhaps even monu-
mental inscriptions.[28] In the fourteenth century at
least, the victories of the Delhi sultans were celebrated

PALIMPSEST PASTS AND FICTIVE GENEALOGIES

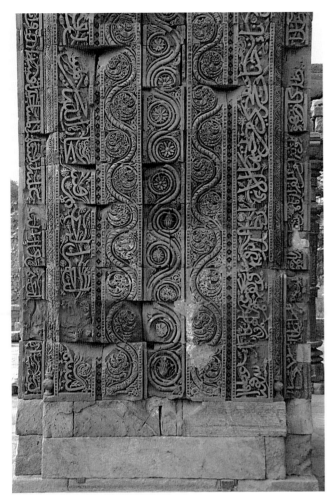

174
Qutb Mosque, Delhi, detail of screen added by Qutb al-Din
Aybek in 594/1198.

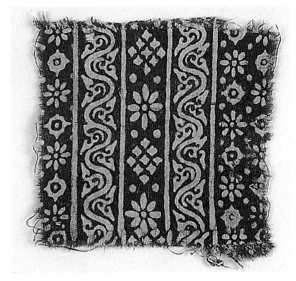

175
Fragment of stamped, resist-dyed blue cotton textile, north-
ern India, eleventh or twelfth century (courtesy of the Kelsey
Museum of Archaeology, Accession no. 22685).

by hanging the walls of the city with red cloth, thus
framing the entire city as a royal enclosure.[29] Like the
exclusive use of white marble to confer distinction on
the mihrabs of Ghurid mosques at Ajmir and Khatu
(figs. 71 and 73), the choice of red stone to construct
the Qutb Minar reflected its august associations.

These associations may have included ephemeral
structures and temporary displays that were no less
integral to the visualization of sovereignty than the
monumental forms that endure today. It is possible,
for example, that the arcaded screen of the Delhi
mosque (fig. 78) once evoked structures that were fa-
miliar to the residents of the city but have not sur-
vived. It is usually assumed that the screen was an
afterthought, for although the *qibla* (Mecca-oriented)

bays were normally the first part of a congregational
mosque to be constructed, the screen is dated 20
Dhū'l-qāda 594 (23 September 1198), between three
and six years after the foundation dates given in the
texts above the northern and eastern gates.[30] How-
ever, this assumption rests largely on the assertion of
the screen's "Islamic" character vis-à-vis the "Hindu"
appearance of the prayer hall (with its richly carved
reused columns), which the screen is assumed to have
masked, negated, or at least mitigated.[31] The meaning
of the screen may, however, also have been bound up
with the victory arches (s. *khūza*) that were part of
the ceremonial adornment of premodern urban cities
such as Delhi; we are told, for example, that on one
occasion the return of Qutb al-Din Aybek from Af-
ghanistan was marked by the adornment of the city
with textiles and beautiful lofty arches (*khūzahā*).[32]
These ephemeral structures have left more permanent
traces in a handful of extant monuments, among
them a brick arch flanked by superimposed rows of
blind arcades that survives at Bust in southern Af-
ghanistan, and which is believed to have formed part
of a Ghurid processional way leading to the royal
citadel.[33] Since the *khūzahā* were often adorned with
textiles, it is worth noting the formal relationship be-
tween the banded inscriptions and vine band orna-
ment of the Delhi screen (fig. 174) and contemporary
block-printed Indian cotton textiles (fig. 175).[34]

235

This banded quality is common to both Iltut-mish's extensions of the Delhi screen and the screen added to the Ajmir mosque (fig. 176 and 177). In contrast to the original Ghurid mosques with which they are associated, however, Iltutmish's additions make little obvious use of *spolia*. In addition, while their carved stone decoration integrates both Indic and imported Persianate forms, the latter now predominate, so that we see an emphasis on geometric ornament and knotted angular scripts, familiar from the brick and stucco ornament of Afghan and Khurasani architecture (fig. 161) but rare in Indo-Ghurid monuments of the 1190s.[35] The contrast in content and style between the stylized geometric ornament of Iltutmish's screens at Ajmir and Delhi (figs. 167, 176, and 177) and the more fluid, organic vegetation carved on Qutb al-Din Aybek's Delhi screen of 594/1198 (figs. 78 and 174) was bluntly but not inappropriately captured by Mohammad Mujeeb, who saw in the work of Iltutmish's day a "stiffness and austerity . . . something severely geometric" in place of the "exuberant naturalism" of Aybek's screen.[36] The flat two-dimensional style of the carving on Iltutmish's additions to the Delhi screen is a marked contrast to the exuberant high relief of its predecessor but is very much in keeping with the style of earlier stone carvings from Ghazni (fig. 127). In addition, the early thirteenth-century additions to the Qutb Complex are marked by their strictly aniconic character in contrast to the more liberal attitude to figuration demonstrated in the orginal mosque of Qutb al-Din Aybek.

The translation of Persianate brick and stucco ornament into stone in Indo-Islamic architecture of the 1220s, and the sudden appearance of formal features that reproduce the basic elements of Khurasani architecture—lobed bastions, four-centred arches (in the screen additions), stone squinches (in Iltutmish's tomb), and *muqarnas* or honeycomb vaulting on the sections of the Qutb Minar added by Iltutmish—probably reflect contemporary demographic shifts. A later Afghan history claims that Sultan Mu'izz al-Din encouraged migration from Ghur to Ghazni and the regions west of the Indus, a move that may have been intended to consolidate the frontiers of the sultanate.[37] Such movements can only have been intensified by the repeated Mongol incursions into eastern Iran and Afghanistan during the 1220s, when the Delhi sultan-

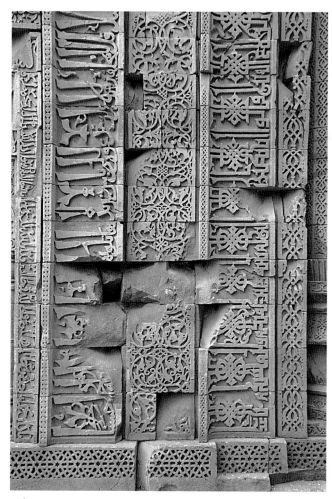

176

Qutb Mosque, Delhi, detail of screen extensions added by Iltutmish in 627/1229.

ate offered one of the few havens for military and political refugees; during this period the historian Juzjani fled from his ancestral home near Herat, first to the court of Nasir al-Din Qubacha at Uchch, then to the court of Iltutmish. We are told that during the reign of Iltutmish, people from all over (according to one contemporary source, "all the Muslims of the east") flocked to Delhi, among them artisans (*san'atgarān*) and workmen (*kasibān*) from Khurasan and other western centers seeking patronage.[38]

The newly ascendant Delhi sultan no doubt encouraged these developments. During the 1220s, at exactly the same time that Iltutmish was investing Delhi as an imperial capital, the Anatolian city of Konya was being endowed as the capital of the Rum

177
Arhai-din-ka-Jhompra
Mosque, Ajmir, detail of
screen added by Iltutmish
in the 1220s.

Seljuq Turks, benefiting from a westward flow of Iranian refugees just as Delhi did from those who fled eastward. Ibn Bibi, the court chronicler of the Seljuqs, celebrates the cosmopolitan nature of Konya in terms strikingly reminiscent of those that thirteenth- and fourteenth-century Indo-Persian writers bring to their description of Delhi:

> Men from all lands hasten
> to make in that city of happiness a
> homeland (*vaṭan*).
> Not a city, you were a complete world;
> You were a deep sea and a city of renown.[39]

Closer to home, Baha' al-Din Tughril's earlier foundation of the city of *sulṭānkōt* (sultanville), and his reported patronage of merchants from far-flung regions (including eastern Iran), had underlined the instrumental value of both cosmopolitanism (especially in its mercantile varieties) and urbanism in pressing rival claims to authority and projecting it on an "international" stage.[40]

 We have no firm statistical information that might permit us to estimate the size of postconquest Muslim communities in northern Indian cities, but despite the influx of refugees from the west, it is unlikely that the Muslim community of the 1220s would have required

a space almost three times as large as that deemed appropriate for the first generation of Delhi Muslims. There are historical parallels in postconquest contexts for the construction of large congregational mosques that do not necessarily reflect the scale and needs of the Muslim community that they served but, instead, inscribe both the Muslims' presence and their aspiration to endure on the landscape.[41] The size of Qutb al-Din's mosque at Delhi was relatively modest, however, comparable to or even smaller in scale than contemporary congregational mosques in medium-size eastern Iranian cities such as Gunabad in Khurasan (fig. 79).[42] Rather than the mosque, the adjoining minaret, the Qutb Minar (fig. 77), seems to have functioned as an indicator of presence, and the formula was later repeated in Bengal, in the massive minaret at Chotta Pandua (late thirteenth century).[43] In Iltutmish's expanded Delhi mosque, the Qutb Minar was itself appropriated and enframed (fig. 166).

 The precedent set by Iltutmish in both appropriating and superseding the ultimate sign of his master's authority was followed by subsequent claimants to the title of sultan, who sought to up the ante of this competitive discourse. The relationship between architectural scale and the relativization of political power is most dramatically illustrated in the changes

237

to the Qutb Complex undertaken around 710/1311 by 'Ala' al-Din Khalji (r. 695–715/1296–1316), whose megalomanic vision for the complex entailed a gigantism that defied realization (fig. 178). With a projected tripling of the size of the mosque, the construction of a screen that was wider and higher than that added by Iltutmish, and a minaret that would dwarf the most famous feature of the complex, the Qutb Minar, 'Ala' al-Din's intention was clearly, as Kumar has noted, "to detract, diminish, and effectively hegemonize Iltutmish's architectural contributions to the Delhi *masjid-i jāmiʿ*."[44] In his discussion of 'Ala' al-Din Khalji's expansion of the Qutb Complex, Amir Khusrau states that the sultan's intention was to enable the community of Islam (*jamaʿāt-i Islām*) to be accommodated within this "world within a world" (*jahān dar jahān*).[45] Later sultans might equally engage the genealogical potential of the Delhi complex (albeit in

less dramatic and hegemonic fashion) through renovation and restoration.[46]

For all its appeal to the universals of Islamizing rhetoric, the construction or renovation of sacred space was inseparable from the aggrandizement of specific aspirants to authority, perhaps even the consolidation of the sultanate itself. Iltutmish's dramatic threefold enlargement of the Delhi mosque may have helped accommodate newly arrived Muslims, but it also advertised the sultanate's role as a magnet for Muslims from all over the Islamic world, and the mosque's consequent function as a microcosmic sign of community. The context in which this occurred exemplifies a phenomenon noted by Henri Lefebvre in his work on the construction of space: "Monumental buildings mask the will to power and the arbitrariness of power beneath signs and surfaces which claim to express collective will and thought. In the

178

Reconstruction of the Qutb Mosque, Delhi, after its enlargement by 'Ala' al-Din Khalji in the early fourteenth century (after Burton-Page 1965a, courtesy of Brill).

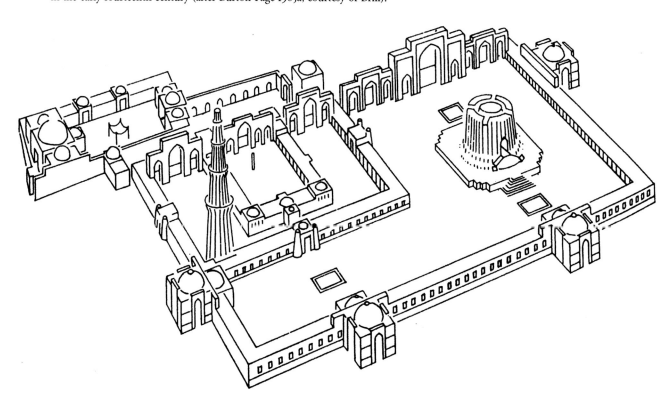

PALIMPSEST PASTS AND FICTIVE GENEALOGIES

process, such signs and surfaces also manage to conjure away both possibility and time."[47] The sheer magnitude of Iltutmish's work in the Qutb Complex naturalized the emergence and endurance of the Delhi sultanate, presenting as preordained (and hence not susceptible to other possibilities) what was plainly contingent. The enshrinement and incorporation of Aybek's mosque as a kind of relic at the center of this new ensemble was equally instrumental to an emphasis on dynastic continuity, occluding the fact that Iltutmish had come to power by defeating Qutb al-Din Aybek's son, then marrying his daughter.

These and other conflicts within the Muslim community are minimized and referred to only in passing in the thirteenth-century chronicles on which we depend for our knowledge of the period. In these, the sultan was eulogized, the precise circumstances of his rise to power obscured (or "spun," to use a modern term), the importance or viability of other contenders marginalized, and the Muslim community led by the Turkic elite presented as a unified monolith, despite contemporary ethnic, intrasectarian, and political tensions within it. The success of the endeavor can be measured from the fact that only recently has any attempt been made to deconstruct this monolith, and to reconstruct the complex histories of the intense rivalries out of which Iltutmish (and hence Delhi) emerged victorious.[48]

The emphasis on continuity and enhancement (a literal building upon the past) that is palpable in Iltutmish's manipulation of Aybek's architectural legacy may shed some light on the idiosyncrasies that characterize the earliest and most prominent foundation text found in the Qutb Mosque, that above its main (eastern) entrance (fig. 70). As noted in chapter 5, it is possible, likely even, that the Persian inscription, which records the reuse of temple materials in the mosque's construction and purports to date from 587/1191–92, was in fact set in place as part of this remaking of the Qutb Complex in the image of Iltutmish's sultanate. The text, which is carved upon the inner lintel, is preceded by another Persian inscription, carved on the outer tympanum of the entrance, identifying Qutb al-Din Aybek as the builder of the mosque.[49] The use of Persian is unique among the official texts found in the mosque, and unusual in foundation texts of the late twelfth century, although

not entirely without precedent: the Ghurid complex at Chisht (562/1167; fig. 54) has a Persian foundation text, for example, and Persian recurs in at least one of the less formal inscriptions of the Delhi mosque.[50] Persian foundation texts are, however, more common in the thirteenth century, occurring in congregational mosques built at Khatu in Rajasthan and Kol (Aligarh) during the reign of Iltutmish. Similarly, a gate of Gwalior fort is reported to have borne a Persian poetical text commemorating its capture by Iltutmish in 630/1232.[51] In addition, as we saw in chapter 5, the date of 587/1191–92 given in Arabic is at odds with that which the chronicles give for the capture of Delhi, which is usually put in 588 or 589.[52] Although it has been suggested that the text is a "maladroit Persian translation" of an Arabic original, with an original date of 589 misread as 587, why it might have been felt necessary to replace the orginal text is unclear.[53]

In his careful study of the inscription, undertaken a century ago, Horovitz noted that, in addition to these anomalies, the form of the script and the emphasis on Qutb al-Din Aybek rather than the Ghurid sultan suggest that the text may have been set in place by Qutb al-Din's successor, Shams al-Din Iltutmish.[54] The use of Persian in some of the foundation texts erected in this sultan's name supports this suggestion, as does the prominence afforded Iltutmish's former master, Qutb al-Din, which contrasts with the Arabic text at the northern entrance, which gives the date of 592/1197 and stresses the role of Sultan Mu'izz al-Din rather than Aykbek as the mosque's patron. In addition, a prominent knotted square motif occurs at the beginning of the Qur'anic text that precedes the Persian foundation text on the inner lintel, in precisely the same location as knot motifs in the foundation text of Iltutmish's mosque at Bada'un: the likelihood that such knot motifs acquired a particular iconographic significance in Iltutmish's public texts has been raised above.[55]

There is, moreover, an interesting contemporary parallel that points to the value of strategic anachronism in struggles for legitimacy: around 607/1210 'Ali Mardan, the Turkic commander who had usurped power in Bengal, issued gold coins dated Ramadan 600/May 1204, the date of the Ghurid conquest of Bengal six years previously.[56] In the disturbed conditions of the early thirteenth century, such emphases

on continuity served to smooth what were often turbulent transitions. The endeavor to perpetuate the memory of appropriation and transformation was evidently successful, for the fourteenth-century traveler Ibn Battuta tells us that the Delhi mosque stands on the site of an idol temple (*but-khāna*).[57]

The conceptual/textual reframing of the monument at its principal entrance would fit well with the physical reconfiguration undertaken at this time. Moreover, the dialectic between the connotative and denotative aspects of the foundation text discussed in chapter 5—its reiteration of the normative rhetoric of "Islamic" conquest according to pre-conquest "Hindu" conventions—finds a counterpart in the mosque to which it was affixed. Under Iltutmish, this became the repository of objects that indexed both the recent past of the Muslim community and, as we shall see shortly, the more distant past of Indian kings. Both were relevant to the construction of fictive continuities designed to obscure the discontinuities out of which the Delhi sultanate emerged.

If the inscription added to Aybek's mosque was intended to constitute it as a *lieu de mémoire*, in which the past was appropriated through its traces, incorporated, displayed, and set to work for Iltutmish and his successors, the enlargement of the complex was also intimately connected to the memorialization of Iltutmish's own successes. These included both the elimination of the last remnants of the Mu'izzi *bandagān* capable of posing a real threat to the sultan's authority, including Nasir al-Din Qubacha, the powerful ruler of Sind in 625/1228, and the defeat of the errant sultan of Bengal, an event that secured the sultan's control over the eastern regions of his dominion.[58] A more direct chronological relationship exists to the ultimate sign of the new sultan's ascendancy: his subsequent recognition as sultan of India by the 'Abbasid caliph in Baghdad, the nominal head of Sunni Islam.

The southern extension of the Delhi screen bears the date 627/1229 (fig. 167), which following the conventions of dating inscriptions is likely to be the date that the work was ordered rather than completed. The date falls just a short time after *Rābī'* 1 626/February 1229, when an ambassador from the 'Abbasid caliph in Baghdad brought the gift of a robe (*khil'a*) and diploma (*manshūr*) confirming the sultan's rule over this Indian territories. This was the crowning achievement of a series of contacts that had led two years earlier to Iltutmish receiving a patent (*'ahd*) and banner (*liwā*).[59] Eulogized by court poets, the events of 626/1229 were of no small significance, since they represented the first time since the zenith of the Ghurid sultanate that a ruler of the eastern regions had dealt directly with the caliphate. After this, Iltutmish assumed the royal privilege of having drums beaten (*naubat*) outside his palace (as indeed the Ghurid sultans had in similar circumstance) and began inscribing the name of the caliph al-Mustansir on his coinage, among them the *tanka*, the new silver coin that he introduced as part of a numismatic reform.[60]

Unfortunately, the date on the Ajmir screen has been lost, but since the titles used include *nāṣir amīr al-mu'minīn* (helper of the commander of the faithful, i.e., the 'Abbasid caliph), Horovitz concluded that it was ordered after Iltutmish's investiture by the caliph.[61] The royal titles inscribed around the central arch of the Ajmir screen refer to the sultan as "the subjugator of infidels and heretics, the vanquisher of transgressors and of polytheists,"[62] marking a departure in tone from earlier inscriptions: despite their use in other contexts, the absence of titles referring to the extirpation of polytheism from the few surviving monumental inscriptions of the Ghurid sultans in India (where one might reasonably expect them to be highlighted) is striking. Noting this, Horovitz suggested that the Ajmir inscription was erected to commemorate Iltutmish's victory over "Hindu princes." A likely event is the sultan's victory over the raja of Ujain in Malwa during 631/1233–34, which was commemorated by the installation of looted Hindu icons in the Delhi mosque, underlining the mosque's utility as a locus in which to commemorate and consolidate Iltutmish's usurpation of power.

The icons from Ujain included the stone *linga* of Mahakal (an incarnation of Shiva) and the metal icon of "Rai Vikramajit," which (along with other brass icons) were laid at the principal (eastern) entrance to the Qutb Mosque, to be trampled on by those entering it; the latter may have been among the two large brass images seen by Ibn Battuta lying prostrate at this entrance when he visited a century later.[63] The recontextualization of the looted icons within the Delhi mosque permitted the perpetual commemoration of a singular victory. It also harked back to earlier

precedents (recalling Mahmud of Ghazni's treatment of the Somnath *linga*, for example), while indexing the expanding frontiers of Iltutmish's empire very publicly in the first mosque of the imperial capital. It is also worth drawing attention to the strictly aniconic decoration of those sections of the Delhi mosque added by Iltutmish, a feature that contrasts with the orginal mosque of Aybek, in which certain kinds of images coexisted with Qur'anic scripture, the result of a deliberate process of selection outlined in chapter 5. Where figural carvings were used in Iltutmish's mosque, they were reversed and inscribed with Arabic text.[64]

Following Iltutmish's precedent, and especially following the demise of the Baghdad caliphate at the hands of the Mongols in 1258, Hindu icons captured during campaigns of expansion were no longer sent to Baghdad or Mecca but were now displayed within the Friday Mosque of Delhi, the symbolic center of the new world capital, where they provided a material counterpart to the admonitions against idolatry found in its inscriptions.[65] Indeed, the chroniclers give the impression that by the fourteenth century the mosque was cluttered with indexes of renunciation and trophies of conquest, lending a particular resonance to descriptions of Delhi as "the Ka'ba of the seven climes."[66]

There is little epigraphic or textual evidence for such displays of looted Indian icons by the Ghurids. Instead, their installation in the Delhi mosque by Iltutmish in the 1230s seems to have been part of a palpable ratcheting up of sectarian rhetoric, witnessed both in the titles by which the sultan is presented on public monuments and in the rhetorical gestures through which his victories over "pagan" rulers were materialized in Delhi. The rise of the Ghurids themselves had demonstrated the value of these types of claims to those seeking to sell the virtues of their rule and project authority on a transregional stage. Equally relevant in this respect is a new silver *tanka* of Iltutmish minted in Dehli in 632/1234–35 that bore the Arabic legend *min kharāj qanauj wa kufr* (from the land tax of Qanauj and unbelief). *Kharāj* was a land tax that in the early Islamic period was payable by non-Muslims, and which in India was often closely associated with *jizya*, the poll tax paid by non-Muslims. The content and context of the inscription thus implies an indexical relationship between the metal content of the coin and the fruits of victory over unbelievers.[67] This relationship between medium and message finds earlier precedents: an unusually large commemorative gold coin struck in the name of Mahmud of Ghazni in 397/1006–7 weighs almost three times more than contemporary dinars and states that it was minted in the land of the *dār al-ḥarb* (house of war), al-Hind, probably from Indian gold.[68] Once again, the timing of Iltutmish's gesture is telling, for the coin was struck in the imperial capital in the year following the sultan's successful campaign against the raja of Ujain in 631/1233–34, after which the looted stone and metal icons were installed in the Delhi mosque.

As the locus for communal prayer (the importance of which is repeatedly stressed in the Qur'anic inscriptions carved upon Iltutmish's additions to the Delhi mosque), the congregational mosque was the ideal venue in which to engage the Muslim community. Iltutmish's embellishment of the Qutb Mosque may have transformed it into an idealized sign of the north Indian Muslim community (or at least of sultanate rhetoric concerning it), but its audience was limited to those present in Delhi or who had access to the descriptions that proliferate in thirteenth- and fourteenth-century histories and travelogues. The audience for such gestures was, however, substantially expanded by the minting of a coin that circulated both the news and the fruits of the sultan's victories over unbelievers. The minting of the coin in Delhi and the installation of looted icons in its mosque (newly embellished and extended only two or three years earlier) should be seen as microfacets of a phenomenon that found its macro expression in the architectural frame within which these signs were displayed.

Like contemporary representations of Muslim Turks as destroyers of temples (or Brahmans as their protectors) in Sanskrit and vernacular texts, the palpable increase in the volume and tenor of rhetoric concerning idolatry, the epigraphic emphasis on its extirpation, and the enshrinement of its defunct objects within the Delhi mosque should probably be understood "as strategies aimed at consolidating community allegiance."[69] The proliferation of texts containing Qur'anic quotations, hadiths (traditions of the Prophet Muhammad), and the name and titles of Iltutmish in the newly built areas of the Delhi mosque

are no less relevant to processes of consolidation. If, as Benedict Anderson has argued, "the sacred silent languages were the media through which the great global communities of the past were imagined," then the prominent display of Arabic sacred texts within the mosque signified participation in a transregional "community of discourse."[70]

Although modern scholarship has fixated on the question of reused materials or the mosque's relationship to purported Iranian prototypes, for medieval observers who wrote about their experience of the Friday Mosque of Delhi, it was the extraordinary ubiquity of inscriptions that left the greatest impression. The earliest description of the Delhi mosque is found in Hasan Nizami's *Tāj al-Maʾāthir*, which was written during the reign of Iltutmish, to whom he attributes the mosque's construction. It describes how the temple of Delhi was demolished by elephants and and its stone images (*butān-i sangīn*) destroyed. Aside from the foundation text found on the eastern entrance to the mosque, it is the sole premodern text to refer to the reuse of architectural materials:

> One of the embroideries of the garment of glorious deeds and the heading of the letter of brilliant achievements of the king is the cathedral mosque of Delhi, the construction of which was started by him with great faith and perfect devotion. Its foundations were as firm as a mountain or as the basis of the empire with its incomparable wealth. Its rampart extended its hand to touch the girdle of the Gemini and had been strengthened with marble like Alexander's rampart (*ba-sān sadd-i Sikandar*) and the fortress of Heruman. Its *minbar* and mihrab had been embellished with exquisite calligraphy (*ba-laṭīf-i kitābat*) and subtle craftsmanship and covered with strange figures (*shakīl-i gharīb*) and marvelous engravings (*naqūsh*) executed with remarkable skill.
>
> Its skylike arch (*ṭāq*) and lofty roof were as fascinating as Paradise. Even the picture gallery of China was envious of its architectural charm. It acquired the additional elegance, having been inscribed with the divine commandment (*manshūr-i raḥmānī*) in *ṭughrā* (script), which further enhanced its splendor. On its battlements were placed the golden domes of the idol

temples (*qubbahā-yi zarīn-i but-khānahā*), looking like the glass parasol of the sun or the crown of Venus, set with pearls. By the blessings of the royal judgment, that delightful and sacred spot (*buqʿa-yi mutabarrak*) became the abode of men of purity, a place where prayers were granted.[71]

A more extensive description of the mosque after its enlargement by Iltutmish can be found amidst a paean to Iltutmish in the *Jawāmiʿ al-Ḥikāyāt*, a work dedicated to the sultan by Sadid al-Din Muhammad ʿAwfi (ca. 625/1228), who includes the Delhi mosque in a section on remarkable monuments, including the pyramids and the Iwan of Khusrau (the epitome of pre-Islamic Persian architecture).[72] In his description, ʿAwfi refers to the stone arches and marble paving of the mosque and the beauty of its *riwāqs* (arcades). Particular praise is reserved for the adjoining minaret, the Qutb Minar (fig. 77), which was built in stages, its construction extending over a century and a half. The first story was finished under the patronage of Qutb al-Din Aybek, probably before the death of the Ghurid sultan Muʿizz al-Din; storys two through four were added by Iltutmish. Although an inscription on the second story states that Iltutmish ordered the completion (*amāra bi-itmām*) of the minaret, the final, fifth story was built or rebuilt under Firuz Shah Tughluq in 770–71/1368–69.[73]

The iconic status afforded the minaret is reflected in the proliferation of thirteenth- and fourteenth-century structures that make reference to it, often by replicating its characteristic flanges and curves of its most famous feature.[74] The fame of the minaret had circulated well beyond Delhi at an early date, catching the imagination of Muslims living far from India: the Syrian writers Abuʾl-Fida (d. 731/1331), al-ʿUmari (d. 749/1349), and Sibṭ ibn al-ʿAjami (b. 818/1415) describe the Qutb Minar as a unique monument of red stone possessed of 360 steps, comparable in its scale and impact to the ancient lighthouse of Alexandria, another of the seven wonders of the ancient world.[75] These references, and ʿAwfi's description, suggest that the minaret was used for the *adhān*, the call to prayer, a function also alluded to in its Qurʾanic inscriptions.[76]

In ʿAwfi's description, the minaret is compared to a cypress tree (*dirakht-i sarv*, a common simile in Persian poetry) in which nightingales and doves sing. It is implicitly anthropomorphized by virtue of a com-

parison between the epigraphic bands encircling it and an amulet (*ta'wīẕ*) inscribed with Qur'anic verses strung around the neck of a believer. The structure is also compared both to one of the morally upright or righteous (*mustaqimān*) and to a living creature standing near the presence of the sultan (whose palace was evidently located nearby) and rewarded by him for its service with a rich belt or girdle (*band*), a reference to its richly carved ornament.[77] The spectacular appearance of the structure is represented as the result of royal beneficence, while the image of the belt (discussed in chapter 2) binds the minaret to the sultan as one who is his vassal and hence does his will. Similarly, the call to prayer (*adhān*) given from the minaret is compared to the orchestra (*naubat*) that sounded the hours of prayer at the gate of the sultan's palace.[78] In this way, 'Awfi's appropriation of the Qutb Complex for the glorification of the sultan provides a literary equivalent to Iltutmish's physical manipulation of architectural space for the same ends.

'Awfi goes on to develop his epigraphic metaphors at length, so that particular architectural forms and spaces within the mosque are equated with specific Arabic and Persian letter shapes inscribed on the tablet of the monument's surface:

> As the triumphing judgment of the king [that is, Iltutmish] suggested due to his good faith in the principles of Islam that the sound of the prayer call should reach the ears of all creatures, he fixed the size and the lofty height of the monument and consequently the wise engineers (*muhandisān*), in accordance with the royal command, constructed a minaret which was so to say an *alif* written on the tablet of the courtyard of the mosque (*lauḥ-i ṣaḥn-i masjid*) and the arches (*ṭāqhā*) of the mosque were given a curved shape like that of a *nūn* and thus they are like *alif* and *nūn* respectively, indicating *ān* [the combination of both letters].[79]

In this way, forms that bear an abundance of Arabic text are themselves transformed into letters under the weight of inscription. In addition to inscriptions on the entrances, screen, and minaret of the Qutb Mosque, its mihrab was originally carved with texts, now lost.[80]

The relationship between architecture, script (or perhaps scripture), and inscription evoked in 'Awfi's passage is prefigured by the resonant text chosen to adorn the mihrab of the Chaurasi Kambha Mosque at Kaman in Rajasthan a decade or so earlier (figs. 109 and 110):

> I call to witness the pen and what they inscribe:
> You are not demented by the grace of your
> Lord,
> There is surely reward unending for you,
> For you are verily born of sublime nature,
> So you will see, and they will realize [Qur'an
> 68:1–5][81]

The programmatic nature of the Qur'anic inscriptions on Ghurid and early sultanate monuments in Afghanistan and India has recently been demonstrated, suggesting that what was exported to India in the last decade of the twelfth century was not only a penchant for monumental epigraphy but also an established tradition of employing Qur'anic quotations discursively. Indeed, the inscription of all thirty verses of Surat al-Mulk, chapter 67 of the Qur'an, around the zone of transition in Iltutmish's tomb is a highly unusual gesture that finds it closes point of comparison in the minaret of Jam (figs. 51 and 52), on which all ninety-eight verses of Surat Maryam (Qur'an 19) were inscribed.[82]

Recent studies of Qur'anic epigraphy remind us that to those conversant with the Qur'an, verses cited out of scriptural context had a "pre-echo and a post-echo," constituting "the tip of an iceberg, of whose weight and mass contemporary readers would have been well aware."[83] It is therefore worth quoting the verses following those inscribed on the Kaman mihrab:

> Who is distracted.
> Verily your Lord knows those
> Who have gone astray from His path,
> And He knows those who are guided on
> the way [Qur'an 68:6–7]

Where the content of these following verses has been noted, it has been assumed that they were chosen as an allusion to the Hindu majority; given the context in which they appear, other referents are equally possible. That references to idolatry or unbelief in the Qur'anic inscriptions on Ghurid and early sultanate

monuments (and on the Qutb Minar in particular) constitute an address to those who stood outside the faith of Islam, or that references to paradise were oriented toward noncaste Hindus as an invitation to conversion, are axiomatic in modern scholarship.[84] Such interpretations acknowledge both diachronic and synchronic aspects of the Qur'anic text—the fact that "timeless truths" are deployed in specific historical circumstances—but they generally ignore questions of access (physical, linguistic, conceptual) central to understanding the discursive function of Qur'anic epigraphy. We know little about questions of physical access to these mosques, for example. The degree and nature of access to temples was often correlated to caste status, but although it has been suggested both that Hindus were prevented from entering the Delhi mosque and that converted *chandalas* or noncaste Hindus may have been among the congregation using it, there is little solid evidence for either suggestion.[85]

Even assuming that these spaces were accessible to the non-Muslim majority, the transformation of letters (assuming that they were recognized as such) into language requires a "socially transformative act" that is itself dependent on the possession of certain interpretive skills.[86] One would therefore have to assume an ability to read Arabic on the part of the Hindus whom the inscriptions are assumed to address. Equally relevant is the fact that the Turkic elite of the sultanate, who wielded political power far in excess of their numbers, were served by a Persian-speaking bureaucracy and, as in contemporary Seljuq Anatolia, may have read or spoken little Arabic.[87] In addition, the inscriptions are deployed in narrow, vertically rising bands of elaborate script entangled with (and obscured by) dense vegetal ornament, rotated through ninety degrees or hidden in the obscurity of entrance porches. They are thus quite difficult to decipher, even with all the advantages conferred by telephoto lenses.[88]

In an extremely influential article published over three decades ago, Richard Ettinghausen argued that the monumental inscription of Qur'anic texts functioned as a "symbolic affirmation" of the faith, and was not necessarily intended to facilitate strict legibility.[89] There are, however, a range of communicative strategies capable of mediating between the poles of total legibility and total neglect, as Oleg Grabar's distinction between monoptic perception—the recognition of script as such—and the decipherment of its semantic content suggests.[90] In addition to their denotative content, the context and manner in which monumental texts are inscribed also connotes, communicating something about their nature and meaning.[91] The failure of modern historians to engage this aspect of Ghurid and early sultanate inscriptions reflects their dependence on textual publications or scholarly compendia that obscure sensory dimensions of their material presence.[92] Along with certain formal features (the arched screen, for example), the scale and ubiquity of script distinguished the mosques from preconquest monuments, including Hindu temples.[93] In this sense, script may have functioned as a sign of identity much as the arches evoked by means of carving or corbeling (techniques at odds with the structural function of the arch) did in Indian mosques built for communities of Arabs and Persians even before the Ghurid conquest (fig. 20). It should also be stated that most Ghurid and early sultanate inscriptions from India are carved in relief rather than incised, the standard technique used for Indic public texts.

Modern scholars usually identify the script used in the Delhi mosque as *naskh*, a type of cursive that gained currency during the eleventh and twelfth centuries, but the medieval sources are unanimous in identifying it as *ṭughrā*, a script characterized by symmetrical arrangement of elongated verticals. The identification is significant, for the term designated both a composite device, a kind of imperial monogram common among the Turkic dynasties of the Islamic world, and a chancery script often used for royal orders, patents of investiture (the *manshūr* or *farmān*), and *fatḥnāmas* or victory missives.[94] Although the earliest surviving *farmān* of the Delhi sultanate was issued in the name of Muhammad ibn Tughluq (r. 725–51/1325–51), the document clearly belongs to a well-established tradition; it begins with a *ṭughrā* giving the sultan's name.[95] For informed viewers, the visual qualities of the scripts used in the Delhi mosque may therefore have lent the inscriptions additional connotations; this is in fact suggested by Hasan Nizami's reference to the divine commandment (*manshūr-i raḥmānī*) inscribed in *ṭughrā* script

on the walls of the Delhi mosque in the passage cited above.

Written words are a residue of oral practices, and the well-documented interrelationships between orality, textuality, and the construction of communal memory in Islamic societies suggest further dimensions to the function and meaning of monumental inscriptions such as those in the Delhi mosque.[96] Semantic content may have been familiar only to a learned few, susceptible of oral transmission to those for whom the specifics of the inscriptions remained literally obscure. Verbal explication or sermons and speeches given within the mosque may have further extended the audience for and understanding of the Qur'anic texts inscribed upon it.[97] As Kumar has noted, a relationship between inscription, performance, and representation within the space of the mosque is implied by a passage in Amir Khusrau's description of 'Ala' al-Din Khalji's massive (and uncompleted) extension to the Delhi mosque in 711/1311:

> Qur'ānic verses were engraved (in a manner) impossible to inscribe on wax (*keh bar mūm naqsh na-tawān bast*). [The inscribed pillars] were gradually elevated so that one would think that the Word of God was going to heaven and alighting on the other side in such a way to symbolize the descent of the Qur'ān on earth. Through the elevation of this inscription, a discourse was born between earth and heaven which could never be quenched.[98]

Although impossible to prove, a performative dimension to at least some of the thirteenth- and fourteenth-century inscriptions is likely. The popularity of the Sura of Victory (Qur'an chap. 48) on Ghurid and sultanate monuments (including the Qutb Minar, the screen at Ajmir, and the tomb of Iltutmish) may, for example, be related not only to its rhetorical value but to its talismanic potential, since these Qur'anic verses were often recited immediately before battle.[99] Their inscription as monumental text may therefore have reified contemporary verbal or recitational practices.

This assumes, however, that the primary audience for the texts inscribed on Ghurid and early sultanate monuments was the Muslim community using them.[100] As we saw in chapter 3, the deployment of resonant Qur'anic references to idolatry was the stock-in-trade of intra-Muslim (and even intra-Sunni) polemics. The evidence for the polemical role of Qur'anic epigraphy in contemporary Afghanistan suggests that the multiple allusions to error, falsity, and unbelief in the Qur'anic inscriptions of the Indian mosques constituted an address to audiences that probably included but also extended beyond the Hindu unbeliever.[101] With their reference to "those who have gone astray from His path," it is, for example, tempting to identify the verses following those inscribed on the Kaman mihrab as an allusion to the Hindu unbeliever, until one remembers that the construction of the mosque (with its royal pretensions) was part of a competitive discourse between its patron, Baha' al-Din Tughril, and his (eventually victorious) rival, Qutb al-Din Aybek. Similarly, allusive references to the rise of corruption (*al-fasād*) among the Children of Israel (the Chosen People) in Qur'an 17:1–6, the verses carved upon the central arch of Aybek's screen and upon Iltutmish's later extension, may be better understood in the context of tensions within the Muslim community than as a reference to the non-Muslim majority.[102]

The internecine religious disputes and sectarianism that wracked the cities of eastern Iran during the eleventh and twelfth centuries (see chapter 3) continued to be part of the cultural life of the Muslim communities of northern India well into the sultanate period. In 634/1236, for example, riots broke out at the Qutb Mosque in Delhi involving elements that Juzjani terms Isma'ilis and Shi'is (*mulāḥida wa qarāmiṭa*).[103] The centrality of Delhi's congregational mosque to these disputes lends further valences to the content of its inscriptions, a combination of hadiths and Qur'anic quotations that emphasize communal obligations (especially Friday prayer) and the need for both orthodoxy and orthopraxy.[104] The prominent use of hadiths in Ghurid and early sultanate mosques at Ajmir, Delhi, and Hansi is striking and merits further investigation: once again, it finds a counterpart in the contemporary architecture of Seljuq Anatolia.[105]

As the events of 634/1236 suggest, by the early thirteenth century the mosque was becoming the locus for contestations of authority between practitioners of different forms of piety. Tensions between the religious classes (*ulamā*) and the sufi saints who patronized the mosque were to become an increasingly

important part of northern Indian sacred and political topography through the course of the thirteenth century. These often reflected a contrast between notions of the mosque as sanctified by its role as the locus of communal prayer or blessed by the presence within it of sufis saints, "portable vessels of sanctity," through whom its architectural spaces acquired a more populist patina of sanctity.[106] Assertions about the sacrality of the Indo-Ghurid and early sultanate mosques permeate early thirteenth-century texts, in which the language of description sometimes echoes the epigraphic content of the monuments described. For example, the description of the Delhi mosque as a blessed spot (*buqʿa-yi mutabarrak*) in the passage from the *Tāj al-Maʾāthir* cited above resonates with cognate phrases included in the foundation texts of Ghurid mosques at Herat, Kaman in Rajasthan, and a mosque built at Kol (Aligarh) during the reign of Iltutmish, establishing a relationship between epigraphic and textual representations of sacred space.[107]

This emphasis on sacrality was apparently enhanced by less tangible signs that sought to enhance the sanctity and august associations of the Delhi mosque. According to a curious tale told by the fourteenth-century historian ʿIsami, when Iltutmish was constructing his monumental reservoir in Delhi, the Hauz-i Shamsi, a pilgrim or *ḥājj* arrived bearing a bottle of water from the sacred well of Zam-zam at Mecca, a common practice for pilgrims returning to their home countries. After being shown respect by the sultan, the *ḥājj* presented him with the precious bottle of water, inviting him to drink of its contents. Iltutmish demurred, however, preferring to pour its contents into the Hauz-i Shamsi, where they mixed with the profane waters of the reservoir lapping around the small mosque at its center. The remaining drops were sprinkled into the foundations of the congregational mosque of Delhi, presumably the portion that Iltutmish was extending at this time.[108] In the historian's narrative, the sacralization of both sites serves as an example of the sultan's selfless piety in wanting to share with his subjects the blessings (*baraka*) that the sacred water conveyed. The tale may be apocryphal, but the role played by Zam-zam water finds parallels in hadiths and legends concerning sites converted to Muslim worship after the Arab expansion of the early Islamic period and the Ottoman conquest of Istanbul in the fifteenth century.[109]

Iltutmish's endeavor is also curiously reminiscent of the ritual practices of kings from among three of the greatest imperial formations of medieval India—the Chalukyas, Rashtrakutas, and the Cholas—each of whom could claim to have brought the Ganges to his capital, either through symbolic means or through the literal transport of water drawn from the river.[110] Perhaps the most novel take on this idea was Rajendra Chola's construction of a "Liquid Pillar of Victory" in his capital in the second decade of the eleventh century, the largest man-made lake in India, into which was poured Ganges water ceremonially carried from the sacred river on the heads of vanquished rulers. The lake was subsequently known as Chola-Ganga, Ganga of the Cholas, but since it was sixteen miles long and three wide, it was clearly not filled with Ganges water alone. Rather the addition of the sacred water to its overall mass was intended as a ritual sacralization, a type of recentering intended to overcome the divergence between political and sacral geographies.[111] These or similar traditions seem to have provided the precedents for the use of Ganges water in the dedication of Daulatabad, the new Deccani capital of the Tughluqid sultans of Delhi in 1327, for which purpose it was carried across the country on a forty-day journey from the river.[112]

While the use of Ganges water in Daulatabad points to the emergence of transcultural dimensions to the articulation of sovereignty in the Delhi sultanate by the early fourteenth century, Iltutmish's antecedent use of Zam-zam water might be better explained as an example of homology, the "fortuitous convergences" between Indic and Islamic ritual practices that were often central to the articulation of political authority in premodern South Asia. These may also explain how the motif of a "chain of justice," a bell-hung chain set at a palace entrance to be rung by those seeking justice from the ruler within, is common to a twelfth-century Sanskrit description of the palace built by king Harsha of Kashmir (r. 1089–1101) and a fourteenth-century Arabic description of the palace built by Iltutmish in Delhi over a century later.[113] Nevertheless, more direct engagements with Indic royal ritual cannot be ruled out, since they are

in fact attested by Iltutmish's reerection of an antique iron pillar at the heart of the Delhi mosque.

| Monuments and Memory

The rhetoric of orthodoxy was integral to Iltutmish's self-fashioning, as it had been to his Ghurid predecessors, but like them the sultan was also faced with the need to negotiate between the transregional ideals of the *umma* and the local idioms and sites of their articulation. The epigraphic, textual (and perhaps ritual) emphasis on the sacrality of the new centers of

Islam that had lain within the *dār al-ḥarb* just a generation earlier is one result of this imperative. Another is seen in the manipulation of carefully selected relics of the pre-Islamic past, including the icons looted from Ujain. More complex engagements with more remote pasts are suggested by the reerection of a seven-meter-high antique iron pillar in the courtyard of Qutb al-Din's mosque, the physical heart of the massive complex that Iltutmish endowed as the symbolic omphalos (*quṭb*) of his capital, directly on axis with its main mihrab (fig. 179).

That the pillar was reused from an earlier context is clear, for a dedicatory text inscribed upon it tells us

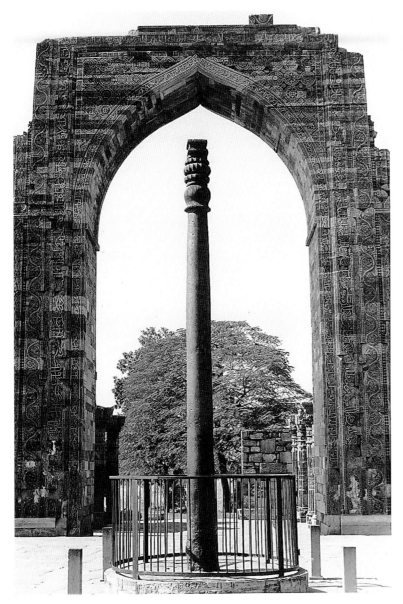

179
Qutb Mosque, Delhi, iron pillar erected by Iltutmish.

247

that it was originally dedicated as a standard (*dhvaja*) to a Vishnu temple by the fourth- or fifth-century ruler Chandra, whose military prowess the inscription celebrates.[114] The pillar is among a genre of commemorative columns referred to in inscriptions as pillars of fame (*kīrtistambha*s) or pillars of victory (*jayastambha*s), which were erected by medieval Indian rulers to memorialize their architectural patronage, donations to temples, or military victories.

Writing in the mid–fourteenth century, Shams-i Siraj ʿAfif attributes the reerection of the iron pillar to Iltutmish, explaining his motivation as follows: "Every great king took care during his reign to set up some lasting memorial of his power. So sultan Shams al-Din Altamsh (*sic*) raised the large pillar in the Masjid-i Jamiʿ at old Dehli, the history of which is well known."[115] ʿAfif is not always reliable as a historian, and it has been suggested that the pillar was already standing before a temple on this site, and was incorporated into the mosque as it stood. However, ʿAfif's insistence that the pillar was reerected on this site is supported by nineteenth-century forensic investigations of its base and support structure.[116]

The date at which the pillar was set in place is uncertain, but the most likely period is the late 1220s or early 1230s, when Iltutmish was accumulating other signs of authority within the mosque. The appropriation and reerection of the pillar is usually seen as reflecting its trophy value and consequent ability to memorialize the triumph of the "Muslim" present over the "Hindu" past, but (unlike the bronze images from Ujain) there is nothing to suggest that it was seized during one of Iltutmish's military campaigns. In the most extensive premodern account of the pillar, written by the traveler Ibn Battuta after a visit to the Delhi mosque in or around 1333, awe and mystery rather than triumph and victory are the keynotes:

In the center of the mosque is the awe-inspiring column of which [it is said] nobody knows of what metal it is constructed. One of their learned men told me that it is called *Haft Jūsh*, which means "seven metals" (*sic*), and that it is composed of these seven. A part of this column, of a finger's length, has been polished, and this polished part gives out a brilliant gleam. Iron makes no impression on it. It is thirty cubits high, and

we rolled a turban round it, and the portion which encircled it measured eight cubits.[117]

The palpable sense of marvel here renders the pillar a suitable counterpart for the Qutb Minar, whose form it evokes on a more modest scale, and which by this date was being celebrated as one of the wonders of the world. In keeping with the ascription of static identities to premodern artifacts, however, the iron pillar in Delhi is generally referred to as the "Hindu" iron pillar, an object placed in direct opposition to the adjacent "Islamic" minaret.[118] This ignores the fact that the terms *stambha* (pillar) and *minār* (minaret) were used interchangeably to refer to the same objects by medieval observers, Hindu and Muslim.[119] More tellingly, for all that the appropriation and reerection of the iron pillar have been depicted as "a symbol of the domination of Islam" memorializing a derogation of the pre-Islamic past,[120] the closest precedents for the gesture are in fact found in the ritual practices of preconquest Indian kings.

Evidence for these precedents can be found a few miles north of the Qutb Mosque, where an antique stone pillar still stands atop a unique pyramidal structure, the Kotla Firuz Shah. The monument was erected by the Delhi sultan Firuz Shah Tughluq (r. 752–790/1351–88) in the 1350s adjacent to the Friday Mosque of Firuzabad, the new urban foundation that bore his name. This was one of ten antique stone pillars incorporated into Firuz Shah's monuments, two of which were moved and reerected under the direct supervision of the sultan, reportedly in emulation of Iltutmish.[121] The pillar that crowns the Kotla bears two distinct sets of texts written in different scripts and languages (fig. 180). The first is an edict of the Buddhist emperor Ashoka inscribed in Prakrit using *brahmi* script in the third century BC, over a millennium and a half before Firuz Shah erected his pyramid. Of greater interest is a second inscription carved below and around Ashoka's edict. This is a Sanskrit text carved in clearly distinguishable *nagari* script in 1164, sixty years or so before Iltutmish erected the Gupta pillar in the Delhi mosque. The inscription records the conquests of Visala Deva, Vigraharaja IV of the Chauhan dynasty, which was still ruling over Delhi at the time of the Ghurid conquest in the 1190s, and his victories over a *Mlechha* (presumably Ghaz-

PALIMPSEST PASTS AND FICTIVE GENEALOGIES

180
Firuzabad, Delhi, detail of palimpsest inscriptions on an
Ashokan pillar reerected in the mid–fourteenth century.

navid or Ghurid) army.[122] It seems unlikely that the pillar remained in one spot for fifteen centuries, and we must instead assume that it was reerected (or at least reused) in the late twelfth century by Visala Deva to commemorate his military victories.[123]

The significance of this Chauhan (re)inscription can hardly be overstated, for it proves that antique stone pillars were being reused by the Hindu rulers of Delhi less than three decades before the Ghurid conquest of the city. Evidence from other sites indicates that this was by no means unusual. On the contrary, some of the antique pillars that survive in northern India are complex palimpsests whose multiple inscriptions indicate that they had acquired complex genealogies through repeated reuse by Indian kings of different eras and faiths.[124] The palimpsest nature of these artifacts was intrinsic to their role as sites for an ongoing process of "translating" the past, a process that frequently encompassed physical displacement and reinscription. The ability to move and reerect these extraordinary relics of ancient Indian rulers echoed the original act of creation, conveying significant messages about patronage and power in a manner determined by royal precedent.[125]

Writing several decades ago, Fritz Lehmann read Iltutmish's appropriation of the pillar as integral to the articulation of a "new imperium" in which the subject population was "included, not excluded, in a way that recognizes past great achievements of their civilization and so subtly underscores the power and magnificence of the new rulers."[126] More recently, William McKibben has noted that Iltutmish "may have appropriated the iron pillar for the Quwwat al-Islam mosque in part to glorify the achievements of past civilizations and affirm the ideological beginnings of Islamic rule in India by aligning himself with pre-Islamic sovereigns."[127]

However, both authors fail to historicize reuse itself. This was a past that inhered not only in objects but also in the practices and rituals associated with them. The act of physical appropriation might itself be palimpsest on earlier reuses of the same or similar objects, thus serving to construct a dynamic continuity between contemporary practices and their historical antecedents. The potential for legitimation resided therefore not just in the pillar itself but also in the very act of appropriation. If the iron pillar itself was a fragment of the distant past, the reuse of similar antique

pillars during the more recent Chauhan dispensation was conceivably within living memory when Iltutmish incorporated the pillar into the Delhi mosque in the early thirteenth century. Contemporary texts cite Iltutmish's erection of the iron pillar in the Ghurid Friday Mosque of Delhi a century earlier as the precedent for Firuz Shah's interest in antique pillars. However, the inscriptions on the Firuzabad pillar attesting to its appropriation by the Chauhan rulers of Delhi suggest that Iltutmish was following a precedent rather than establishing one. In short, this was no mere appropriation of *spolia* designed to suggest a *symbolic* continuity with pre-Muslim kingship but an *actual* continuation of a practice associated with Indian kings from the Gupta period onward. Objects that have been read as trophies at first glance appear, on closer inspection, to offer evidence for transculturation in the ritual practices of the first Delhi sultan.

No less than an "Islamization" of the Indic past, the appropriation and reerection of the iron pillar represented an "indigenization" of the Islamicate present, for the object used and the practices associated with it reveal a dependence on Indic models of legitimation,[128] a reminder that practices of reuse are themselves historically constituted and can therefore be instrumental in the construction of legitimizing genealogies that relate past and present. Seen in this light, Iltutmish's reerection of the iron pillar in the Friday Mosque of Delhi has little to do with cultural rupture and everything to do with the construction of fictive continuities, an endeavor that, as we saw above, characterizes the remodeling of the complex at whose center the iron pillar was reerected. The potential for legitimation inherent in these fragments of antiquity was no doubt obvious, for their association with earlier Indian kings (historical and mythical) is stressed in medieval Persian sources, and in some cases was literally legible. While the Prakrit inscriptions on the Firuzabad pillar remained elusive, connoting a generic mythologized antiquity, the Sanskrit inscriptions (fig. 180) were evidently read with a high degree of accuracy, for the fourteenth-century Persian text that records the removal and reerection of the pillar reports quite correctly that the writing on the column commemorates its reinscription by prince Visala Deva two centuries earlier.[129]

India was in fact associated with mysterious iron pillars long before the reign of Iltutmish: according to

a tale preserved in an eleventh-century Egyptian compendium of royal gifts, the 'Abbasid governor of Sind encountered an iron pillar seventy cubits long in the city of Kandahar during an attempt to conquer India in 151/768. The governor was told that the column was a victory monument erected by the celebrated pre-Islamic king Tubba' and fashioned from the metal of weapons used in gaining the victory that it commemorated.[130] The tale demonstrates the way in which familiar verbal or textual narratives could function as vectors for the reception (and appropriation) of local pre-Islamic pasts.

The valences of the iron medium itself may have further enhanced the column's mythohistorical associations and narrative potential, for reports that it was made of seven metals hint at cosmological dimensions to its perceived meaning.[131] In Arabic and Persian tradition a close relationship existed between marvelous iron structures and Alexander the Great, whose most famous work was the iron wall that he built to separate Gog from Magog, order from chaos. Hasan Nizami's analogy between Iltutmish's mosque and the *sadd-i Sikandar*, the fabled rampart of Alexander, in the passage from the *Tāj al-Ma'āthir* cited above may therefore have been more than a topos.[132] The comparison should be read in light of Iltutmish's titular claim (adopted from his Ghurid predecessor) to be a Second Alexander (*Sikandar al-thānī*), and contemporary literary comparisons of the sultan to Alexander.[133]

In addition to the likely associations with Alexander, the quintessential foreign-born "Indian" world conqueror, popular tradition also identified antique pillars such as those reused in Delhi with Bhim, one of the five legendary Pandava brothers, whose exploits are related in the *Mahābhārata*.[134] The fame of the brothers was known even in Iran, for sections of the *Mahābhārata* involving their exploits had been translated into Persian from Arabic as early as 417/1026–27, repackaged as *Ādāb al-Mulūk* (Etiquettes of Kings—a reminder that Indianness was less important than kingliness). In this translation, Alexander the Great keeps company with both the great warriors of the *Mahābhārata* and *Shāhnāma* (the Persian national epic), in a transcultural congeries of heroic personalities and deeds.[135] Around the same time, the great Indologist al-Biruni makes an explicit comparison between the Pandava brothers of the *Mahābhārata* and

the heroes of *Shāhnāma* (as indeed later Indo-Persian writers do).[136] The *Shāhnāma* had itself been produced on the eastern frontier of the Islamic world and was reportedly inspired by an ancient Indian king's patronage of historical and allegorical texts, a genealogy that may have facilitated its assimilation to the *Mahābhārata*.[137] Occasionally the textual and artifactual coincided in the articulation of genealogical claims, as when a throne that had reportedly belonged to the Pandavas was seized during Mahmud of Ghazni's raid on Nagarkot in 399/1008, or when passages from the *Shāhnāma* were quoted on the walls of Seljuq and Ilkhanid cities and palaces, in an endeavor "to legitimize the present through identification with the past."[138] Just as the *Mahābhārata* could "serve transhistorically as a medium for processing every historical present," the *Shāhnāma* and other epic tales often served as vectors for historical sultans to construct a genealogical relationship to epic pasts (including pre-Islamic pasts), reframing them within a narrative matrix that emphasized the shared experience of kingship.[139]

As we saw in chapter 3, the Ghurids had devised a lineage relating them to the kings of pre-Islamic Iran, the denizens of the *Shāhnāma*, and to the Arabic-Islamic past embodied in the caliphate, invoking material relics of the past to bolster their claims to a noble lineage.[140] Like the insignia discussed in chapter 4, or Mughal gems and jade cups bearing the accumulated names of illustrious predecessors, the iron pillar should be counted among the inalienable or "symbolically dense" objects that "act as vehicles for bringing past time into the present, so that the histories of ancestors, titles, or mythological events become an intimate part of a person's present identity."[141] The dual ability of such objects to function, on the one hand, as symbolic repositories of memory whose histories are "authenticated by fictive or true genealogies" and, on the other, to attract "new meanings, fictitious memories, altered genealogies, and imagined ancestors," renders them particularly valuable to those trying to construct legitimizing genealogies in conditions of social flux or political discontinuity. As the anthropologist Mary Helms notes:

attention to regenerating or recreating the past is neither random nor inconsequential. Historical consciousness is promoted; change is disguised.

Situations of political revolution or rebellion, when hierarchy is so developed that one segment of the society revolts, appear to be exceptions. Yet when the victors claim leadership, they immediately constitute their legitimation through the creation of symbols that stand for the past.[142]

In this sense, both the iron pillar and the mosque at the center of which it stands can be considered symbolically dense objects whose framing and remodeling engages aspects of distinct pasts that were equally intrinsic to the emergent identity of the Muslim community of Delhi in the early thirteenth century: the "Qutbi" phase of recent history and a more distant past of epic deeds and marvelous constructions.

By framing and subsuming carefully selected relics of the old orders into the chief Friday Mosque of the newly emergent capital, Iltutmish signaled the emergence of a new temporality, that of the Delhi sultanate. In this sense, the treatment of the iron pillar and Ujain icons mirrored the manipulation of Qutb al-Din Aybek's orginal mosque. The question of time looms large in both undertakings, not only in the likely retrojection of the foundation text of Qutb al-Din's mosque, with its attempt to cast the structural materials of the mosque as remnants from a past era of "paganism" pressed into the service of the "Islamic" present, or in the erection of the ancient pillar at its center, but also in the display of the images looted from Ujain. Their seizure and humiliating display in the Delhi mosque manifested the sultan's military prowess and ostentatious commitment to the extirpation of idolatry, but this would have been true of any looted icons. In this case, the specific connotations of the metal icon of "Rai Vikramajit" from Ujain lent it further resonances, for it was well known to Arab and Persian writers as an effigy of an ancient king of the city, from whose reign Hindus reckoned their time; as late as the sixteenth century, the Deccani historian Firishta translates *hijrī* (Islamic) dates into their Vikramajit equivalents.[143]

In its role as an agglomeration of signs that both addressed and sought to mold the nature of Muslim identity in the newly emergent capital of a triumphant Indian sultanate, the Delhi mosque provides a precocious example of what Michel Foucault termed a heterotopia. Heterotopias are spaces in which a va-

riety of sites, including those that are incompatible or incommensurate, "are simultaneously represented, contested, and inverted." They are often linked "to the accumulation of time," or what Foucault terms a heterochrony, a term that denotes the synchronous representation of different (and possibly incommensurate) eras or times within the same space. The best example is the modern museum, with its agglomeration of object lessons designed to construct a collective and usable past.[144]

As the case of the museum demonstrates, space itself is hardly devoid of narrative content, despite the temptation for art historians to approach it as a series of forms and dates. Narratives can be constructed by skillful arrangements of storied objects in space, a reminder of Peter Gottschalk's prescient observation that "calendars count years but narratives serve to describe the link between the past and the present."[145] Narrative was central to the discursive production of a usable past materialized in monuments such as the Qutb Mosque. As in a museum, the artifactual, chromatic, iconic, and textual signs accumulated within the Delhi mosque constituted microsites for the construction of communal memory, inscribing a series of narratives on its spaces.

While clearly intended to stress the skill of masons who operated on hard stone as if on wax, Amir Khusrau's image of incision and inscription in the passage cited above provides a serendipitous echo of the Platonic model of memory as comprising mental imprints similar to those made on a wax tablet.[146] The metaphor of the Qutb Mosque as an inscribed tablet permeates the thirteenth- and fourteenth-century descriptions of the mosque discussed above, finding an interesting contemporary resonance in Henri Lefebvre's distinction between histories of time, which parse the objects of their analysis synchronically (stratifying them in terms of discrete temporal fragments), and histories of space, in which "the historical and diachronic realms and the generative past are forever leaving their inscriptions upon the writing-tablet, so to speak, of space." In the latter case, space is imagined not as a discrete entity but as "a set of relations and forms" characterized by various interrelationships between (verbal and textual) representations of space and what Lefebvre calls *representational spaces*, "space as directly *lived* through its associated images and

PALIMPSEST PASTS AND FICTIVE GENEALOGIES

symbols, and hence the space of 'inhabitants' and 'users.'" This kind of space is characterized by the proliferation of "more or less coherent systems of non-verbal symbols and signs."[147] The complex inter-relationship between architectural space, representations of architecture, and the lived experience of it to which Lefebvre alludes permeates thirteenth- and fourteenth-century descriptions of the Delhi mosque. It is witnessed, for example, in the repetition of sacralizing epithets in both foundation texts and textual descriptions of the Delhi mosque. Similarly, 'Awfi describes the mosque as a palace (qaṣr) of the righteous, a term that evokes the language of a well-known hadith according to which the builders of mosques on earth will be rewarded with a qaṣr in paradise, a hadith that is in fact inscribed on the entrance gate that Iltutmish added to the Ajmir mosque (fig. 171).[148]

Writing in a different context, Kathleen Biddick has argued that "graphic systems of 'inscriptions,' in the broadest possible sense, are powerful tools for conscripting or mobilizing communities of viewers/users."[149] The "inscriptions" that Biddick has in mind are not necessarily textual—they might include the chromatic semiosis witnessed in the red color of the Qutb Minar, the defunct icons arranged at the entrances to the mosque, and the attempt to memorialize the reuse of temple materials in its foundation text—but all of them contribute to the construction of a spatial narrative in which past and present are implicated in the "concretion of identity."[150] In this sense, the series of inscribed spaces created within the Delhi mosque in the 1220s—the foundation text, the looted icons, and the enigmatic iron column—are less about history than about memory, specifically, the attempt to construct collective memories around which a community divided by ethnicity, political affiliation, and sectarian affinities could adhere and cohere. As Pierre Nora notes, unlike history (the attempt to reconstruct what is finished and past), "memory is a perpetually actual phenomenon, a bond tying us to the eternal present," distinguished from history by its attachment to sites rather than events.[151]

The role of objectivized culture in this process has been explored at length by social theorists, who note that the formation and propagation of collective or cultural memory is dependent on the memory of "fixed points" in the past, "whose memory is maintained through cultural formation (texts, rites, monuments) and institutional communication (recitation, practice, observance)," which necessarily admit of repetition, replication and reuse.[152] Collective memory is closely allied to the idea of a usable past: as Jacques Le Goff defines it, collective memory is "what remains of the past in the lived reality of groups, or what these groups make of the past." In this sense, the construction of collective memory can often function as "an instrument and objective of power."[153]

The idea of use and reuse is central to the concept of collective memory itself, for in his classic study Halbwachs compared the relationship between memories and the events that gave rise to them to that of the "stones one finds fitted in certain Roman houses, which have been used as materials in very ancient buildings: their antiquity cannot be established by their form or their appearance but only by the fact that they still show the effaced vestiges of old characters."[154] This image of the objectivized past embedded in the material present finds a ready point of comparison in medieval Arabic and Persian historical writing, "in which older texts were continually being reproduced or embedded in new ones" that encompassed and built on them.[155] In his analysis of this phenomenon, Stephen Humphreys sees the process of embedding, inclusion, and supersession as integral to the construction of historical memory, specifically collective memory. This textual paradigm could be extended to encompass the material correlates of valorized quotations by those engaged in the business of creating usable pasts and fictive genealogies in the thirteenth century. Quotations from the Shāhnāma were, for example, inscribed on the walls of the Anatolian Seljuq capital of Konya in the 1220s, in combination with excerpts from the Qur'an and hadiths, aphorisms of various sorts, reused antique sculpture, and contemporary figural sculpture. In this way, as Redford notes, the Seljuq sultans located themselves "in a mythic context, keeping company with the kings of yore, whether Caesar or Khusrau."[156]

As the case of Konya suggests, the construction of genealogical histories relating past and present often found a visual counterpart in the patronage of archaizing styles, or the reuse, recontextualization, and reworking of carefully selected relics of the past,

the "signs and surfaces" that, in Lefebvre's formulation, "conjure away both possibility and time" and in so doing obscure the contingent nature of power.[157] As a microcosm or heterotopia, a world within a world as Amir Khusrau would have it, the Delhi mosque of the early thirteenth century functioned as a *lieu de mémoire* in which the transition from one political order to the next was indexed in a manner that stressed continuity. To this end, Iltutmish's patronage engaged both the immediate Islamic past (thus obscuring the way in which the sultan had seized power, sidelining Qutb al-Din's heir) and those aspects of the Indic past that could be assimilated into a Perso-Islamic matrix. The appropriation and recontextualization of the iron pillar in Delhi facilitated the metonymic appropriation of the distant Indian past, even as the Chauhan ornaments integrated into the Ghurid palace in Firuzkuh three or four decades earlier alluded to the incorporation of a more recent history. The latter facilitated the transition from event to memory no less than the texts in which they were themselves inscribed, and the oral narratives that have not survived. Conversely, the commemorative value of the iron column lay not in its specific associations with the historical kings of India but in its ability to represent the mythic totality of Indian kingship, including perhaps the legacy of that other naturalized Indian potentate, Alexander the Great.

Iltutmish's engagement of a genealogical imaginary through the deployment of resonant forms, objects, practices, and texts in the early thirteenth-century mosque finds a counterpart in a series of thirteenth-century Sanskrit inscriptions acknowledging the sultan as the paramount ruler and presenting the Ghurids and early sultanate rulers of Delhi as just the latest in a long line of regional overlords. The best known of these is a Sanskrit foundation text dated VS 1333/AD 1276, inscribed during the reign of Sultan Ghiyath al-Din Balban and found in Palam, a suburb of Delhi:

The land of Hariyānaka was first enjoyed by the Tomaras and then by the Chauhānas. It is now ruled by the Śaka kings (i.e. the sultans). First came Sāhabadīna (i.e. Shihab al-Din Ghuri), then Khudavadīna (i.e. Qutb al-Din Aybek), master of the earth, Samusdīna (i.e. Shams al-Din Iltutmish), then Pherujsāhi (i.e. Rukn al-

Din Firuz), lord of the earth. After him Jalāldīna (Jalal al-Din), and then was born king Maujadīna (Mu'izz al-Din Bahram), [then] the glorious, and noble king Alāvadīna ('Ala' al-Din Mas'ud), and Nasaradīna (Nasir al-Din Mahmud), the lord of the earth.[158]

Enumerating the dynastic changes in the region during the eleventh to thirteenth centuries, the author of the inscription devises a genealogy reminiscent of those found in the *praśastis* (epigraphic panegyrics) of pre-conquest kings.[159] An identical genealogy is given in a Sanskrit inscription of VS 1347/AD 1291 found at Sonepat in Delhi, while an analogous inscription found at Ladnun in Rajasthan gives the genealogy of Delhi from the Tomars, through the Chauhans and Ghurids, down to the Delhi sultan 'Ala' al-Din Khalji, who was ruling Delhi at the time of the text's inscription in VS 1373/1316.[160] In a similar vein, an important numismatic treatise written by Thakkura Pheru, the Hindu mint master of 'Ala' al-Din Khalji, in VS 1375/AD 1318 provides a continuous chronological list of the coin types minted in Delhi from its foundation under the Tomars to the early fourteenth century, distinguishing royal coinage on the basis not of the sectarian affinities of the issuer but of weight and precious metal content.[161]

The thirteenth- and fourteenth-century genealogical texts in which the Ghurids and Delhi sultans keep company with the Tomar and Chauhan rajas illustrate one dimension of a phenomenon that was multidirectional and reciprocal. An inscription of AD 1369 from Kotihar in Kashmir presents Sultan Shihab al-Din (or Shāhabhadena) (r. 755–75/1354–73), one of the first Muslim rulers of the region, as born of the house of the Pandavas, the heroic protagonists of the *Mahābhārata*. This induction may have been facilitated by the widely acknowledged homologies between the heroic characters and epic deeds of this text and those of the *Shāhnāma*.[162]

Faced with such claims, a modern observer is invariably inclined toward skepticism—the failure to distinguish myth from history is after all one of the characteristics often assumed to distinguish modernity from premodernity—but even the historical (and the apparently factual documents on which it depends) is permeated by the genealogical, as the ret-

PALIMPSEST PASTS AND FICTIVE GENEALOGIES

rojective foundation text above the eastern entrance to the Delhi mosque and its reception in modern scholarship suggests. In this case the "facts of history" are inseparable from the active construction of memory, much as the chronicles of the period obscure and occlude as much as they preserve and reveal, in order to naturalize contingencies while minimizing the ruptures associated with them.

As with Ghurid claims to be descended from a stock figure of Persian myth or to possess an authority conferred by no less a figure than Harun al-Rashid, to insist on the truth or falsity (the historical accuracy) of such claims is to miss the point. The genealogical constructions just outlined are not historical in the sense that they attempt to reconstruct and represent past events and finished stories. On the contrary, they are attempts to inscribe the present into an ongoing continuum into which "the past" of historical inquiry is subsumed. Their significance lies therefore not in the accuracy of the "historical" representations that they offer but in the insights that they provide into the specific manner in which the past was imagined and integrated into the ongoing present.

Intention should not be conflated with reception, and it may indeed be true that, as one historian observes, "coins and inscriptions tell us nothing about how the users and readers responded to the claims made."[163] Nevertheless, the fact that such claims were made at all is significant, whether or not they were taken at face value: as Benedict Anderson, the great theorist of the modern nation-state, notes: "communities are to be distinguished, not by their falsity/genuineness, but by the style in which they are imagined."[164] In the imagining of community, the utility of a shared or common past can hardly be overestimated, especially in the absence of other commonalities.[165]

The seamless integration of Ghurids and Delhi sultans into South Asian cultural and political history betrays little sense of the religious, political, and cultural rupture so often highlighted by modern historians and art historians alike. This may be a product of a pragmatic urge to legitimize effective political authority, but it is surely just as much a reflection of the ability of the Ghurids and Delhi sultans to engage with existing traditions, to project their authority in the expected manner.[166]

Although rooted in the habitus of tradition, the grammar and terminology of legitimation were neither immutable nor static, however, but dynamic in their articulation. At the very moment that the Delhi sultans were being inscribed into king lists that emphasize continuous dominion, a remarkable innovation was taking place in the self-representations of Indic kings, many of whose territories were threatened by the expansion of the Delhi sultanate. In a striking instance of the fluid relationship between processes of transculturation and strategies of royal legitimation, from the late thirteenth century, the term *Hammīra* was increasingly adopted as a personal name by the scions of a number of prominent Indian Rajput houses. This was a Sanskritized variant of the Arabic title *amīr* (commander) that entered Indian usage by the early eleventh century, when it was used to denote the Turkic sultans who raided the northwestern regions. In less than a century after the Ghurid conquest, a term once used to connote the Turko-Persian "other" thus came to denote an Indic self often constructed in opposition to it.

| *The Fate of Hammīra*

The corollary of the inclusion of the Ghurids and Delhi sultans in Sanskrit king lists is their inscription into medieval lists of those vanquished by successful Indic rulers.[167] As we saw in chapter 3, in a series of inscriptions and texts dating from roughly 1000 to 1250, all the major ruling houses of northern India—the Chauhans, Chandellas, Gahadavalas, Chalukyas, and Yadavas—refer to *Hammīra* (or variants such as *Hamīra*, *Hambīra*, and *Hamvīra*) as their historical opponent.[168] These early uses refer to the Ghaznavid rulers, who are indeed referred to as amirs (or "the Amir") by Persian court historians before the title of sultan was commonly adopted on official texts around the middle of the eleventh century.[169] The origins of Sanskrit usage might equally lie in contact with the (self-described) amirs of Sind discussed in chapter 1, whom the rise and eastward expansion of the Ghaznavids eclipsed.[170]

A series of subsequent inscriptions use the term, or variants of it, to refer to the Ghaznavid and Ghurid sultans. *Hambīra* is, for example, mentioned in an eleventh- or twelfth-century inscription from Bada'un,

while several copperplate inscriptions issued in the name of the Gahadavala rajas of Kanauj between Vikrama 1165/AD 1109 and Vikrama 1232/AD 1175 refer to *Hammīra*.[171] Similarly, a Chauhan inscription of 1167 refers to Hansi fort being protected against *Hammīra*.[172] Over the following decades, an inscription in the name of the Chalukya raja Bhima II (1178–1239) at Veraval on the coast of Gujarat records the defeat of *Hammīra*; around the same time, a Yadava inscription from Patna dated ca. 1209–10 makes a similar claim.[173]

In addition to these copper and stone commemorative inscriptions and *praśasti*s (inscribed eulogies), the term *Hammīra* also appears in contemporary north Indian courtly literature. The earliest documented textual (as opposed to epigraphic) use is in Kalhana's *Rājataraṅgiṇī*, a Kashmiri royal chronicle of the mid–twelfth century; around the same time the Ghaznavid sultan is referred to as *Hammīra* in a series of Sanskrit plays penned and inscribed on stone tablets at the Chauhan court of Ajmir, and in the *Prithvīrājvijaya* of Jayanaka (ca. 1192), an account of the deeds of the last Chauhan raja of Ajmir.[174] In the following century, the term occurs in the title of the Jain writer Jayasimha Suri's Sanskrit play *Hammīra Mada Mardana*, an account of the victories of Viradhavala, the Vaghela raja of Dholka in Gujarat against the Delhi sultan in the late twelfth or early thirteenth century.[175]

All these occurrences suggest that by the second half of the thirteenth century the term *Hammīra* had come to denote a series of formidable Turko-Persian adversaries who had menaced the Rajput kingdoms for almost three centuries. The sense of admiration and dread inspired by *Hammīra* and his role as a worthy adversary is clear. The Chandella inscription that contains the earliest documented use of the term refers to the raja Dhaṅga as one "who, by the strength of his arms, equaled even the powerful Haṁvīra, who had proved a heavy burden for the earth." As Mitra notes, "to equate Dhaṅga with Haṁvīra in prowess and military achievements must have appeared to the *praśastikāra* [i.e., the genealogist and eulogist] as deserving of the highest reward."[176] Almost two centuries later, Mularaja II, the powerful Chalukya raja of Anahilavad (or Patan) who defeated a Ghurid army in 1178, is said to have "overcome in battle the ruler of *Garjaṇaka*s [denizens of Ghazni], who are difficult to

conquer."[177] In all these instances, *Hammīra* is portrayed as a ferocious opponent, an enemy by virtue of strength rather than religious affiliation. Conversely, the prowess of his Indic opponent is measured against the ability to deter or defeat the potential threat that *Hammīra* posed to the polity, and hence to the dharmic order.

As we saw in chapter 3, after the conquest of northern India in the 1190s, *Hammīra* was adopted as a self-descriptor on the Indian coins minted in the name of the Ghurid sultan Mu'izz al-Din. At the risk of laboring the point, the adoption of this title on Indo-Ghurid coinage is comprehensible only as the product of an act of mediated cognition that assumes the positive connotations of the term as a signifier of military strength and (consequently) political authority. The Delhi sultans were referred to as *Hammīra* on the base metal bull-and-horseman coins issued in their names until the reign of Sultan Mas'ud (639–44/1242–46), after which the term is rarely used.[178] By this time, however, Sanskrit inscriptions produced within the sultanate were routinely referring to the Delhi sultan using this or cognate terms: the Palam inscription of VS 1333/AD 1276 cited above refers to the Delhi sultan Balban (one of the last of the Delhi sultans to employ *Hammīra* as a self-descriptor on his coinage) as both *nāyaka* (military commander) and *hammīra*.[179]

The nature and usage of *Hammīra* differentiate it from other terms used to denote Muslims, which are often ethnic in nature (*Tājika, Turuṣka, Yavana*) or indicate a generic noncaste status (*Mleccha*). Unlike *suratrāṇa*, the Sanskritized rendering of the title sultan, in its earliest usage *hammīra* referred to Afghan rulers who were a class, but a restricted one, hence the ambiguity between the use of the term as a generic and as a personal name: Mahmud of Ghazni is, for example, referred to as *Hammīra* in several texts.[180] This slippage between the generic and specific led to confusion among nineteenth-century historians as to whether or not *Hammīra* was the personal name of a specific historical ruler.[181] In this sense, the meaning and usage of the term bears comparison to Kisra or Khusrau, a personal name—that of the celebrated Sasanian ruler who sent Burzuya on his mission to India—that came to serve as a generic for pre-Islamic kings in Arabic and Persian texts, and was often used to eulogize Muslim rulers, including Qutb al-Din Aybek.[182]

In the decades following the emergence of the Delhi sultanate, this referential ambiguity and the slippages that it engendered facilitated a remarkable transumption, in which the Sanskritized Arabic noun was adopted as a personal name by a myriad of northern Indian Hindu rulers. In an ironic twist, for example, the last scion of the Chauhan royal house was named Hammira. A descendant of the Ghurid vassal prince of Ajmir, Raja Hammira ruled at Ranthambhor (the Chauhan fort discussed in chapter 4) from 1283 until his defeat by the Delhi sultan 'Ala' al-Din Khalji in 1301; he is mentioned in an inscribed *praśasti* (eulogy) of the Chauhan kings of Ajmir and Ranthambor dated Samvat 1345/AD 1288, and his final confrontation with the Delhi sultan was memorialized in Rajasthani bardic epics, of which the fifteenth-century *Hammīra Mahākāvya* is the best known.[183]

Noting the irony that the last of the Chauhan rajas was named Hammira, Romila Thapar observes that "the currency of Hammira as a personal name among Rajputs suggests an admiration for the qualities associated with those referred to as Amirs."[184] The material culture of the period elaborates the irony that Thapar notes. For example, Hammira of Ranthambhor, the last Chauhan, struck silver and copper coins on which dates are given using the indigenous Vikrama Samvat dating system. Dates were not included on pre-Ghurid Indic coinage, however. Rather, their appearance is an innovation of the Delhi sultans, who issued coins dated according to the Vikrama Samvat era. Hammira Chauhan was not alone in being inspired by this innovative practice: the coins issued by the neighboring ruler of Narwar are dated in the same way.[185] The ironies associated with the circulation of an Indic dating system on sultanate coinage, from whence it was adopted for use on coins issued by indigenous elites, are self-evident and of the same magnitude and nature as those associated with the circulation of the term *hammīra* itself, or the reerection of an iron pillar inscribed with a Hindu text at the center of the main mosque of Delhi.

For most of the century before Hammira of Ranthambhor was born, *hammīra* had served as the title of the Delhi sultans, who continuously sought to expand the territories under their control. The military engagements on which expansion was predicated did not preclude other forms of contact: on the contrary,

sometimes it fostered them. In the decades before the eclipse of the Kakatiyas of Warangal in the Deccan, for example, they were reconstituted as tributaries of the sultanate, and the presence of Kakatiya envoys and nobles is reported at the imperial court in Delhi in the late thirteenth and early fourteenth centuries.[186] These diplomatic and military contacts undoubtedly enhanced the cumulative prestige of *hammīra*, whose use as a personal name was not confined to the raja of Ranthambhor but proliferated among the scions of minor Rajput houses in the second half of the thirteenth century and the first half of the fourteenth. Among the other examples are Hammiravarman, the Chandella raja of Kalinjar, who is mentioned in an inscription dated VS 1346/1289 (and is therefore an exact contemporary of his Chauhan namesake), which also refers to him as a *Sāhī Rāj* (a Shahi or Persian king). Hiralal suggests that this illustrates the "growing Muhammadan influence" on Rajput courts, but the popularity of such names suggests a more active reception than the model of influence suggests.[187] A Rana of Mewar ruling from Chittor around AD 1326 was, for example, named Hammira, while a Maharaj Hamiradeva of Lukasthana is mentioned on a memorial pillar from Bundelkhund dated S 1397/AD 1340. A reference on an inscription from Unstra near Jodhpur in Rajasthan to Hamira devi, a queen of the Gehlot clan displaced from Mewar by the Delhi sultans, attests to the circulation of the name even among the female elite of the late thirteenth century.[188]

It is possible that *Hammīra* or variants of it had been adopted as the personal name of Hindu rajas in "frontier" regions a century or more before the Ghurid conquest. Among the rajas of the Chudasama dynasty that ruled Saurashtra, that part of coastal Gujarat adjacent to Sind, local histories list a Hamiradeva, who is said to have reigned around the middle of the eleventh century. As late as the sixteenth century, the name Hammir is also attested to among the Jadeja rajas of Kachh, the coastal region between Saurashtra and Sind.[189]

All these examples are found in the contact zones between Rajput authority and Turko-Persian dominion in north and northwestern India, indicating a close relationship between the frequency with which the figure of *Hammīra* was encountered or invoked and his adoption as a model. The Chandella rajas of

Kalinjar are a case in point: that the last of the dynasty was named Hammiravarman is a reflection of more than two and a half centuries of contact with Turkic sultans and their mamluks.

With the southern expansion of the Delhi sultans in the early fourteenth century and the emergence of independent sultanates in the Deccan a few decades later, the zone within which *hammīra* circulated expanded southward. A trilingual text of S 1383/ AD 1461 inscribed in Sanskrit, Oriya, and Telugu refers to a Gajapati raja of Orissa named *Haṁvīra*, the founder of a city named Haṁbīrapura (Haṁbīra-ville). The raja in question, who is named in a series of copperplate and stone inscriptions, conspired with the Bahmanid sultans of Bidar against the Hindu rulers of the south, including his own brother.[190] The popularity of such names in the Deccan finds earlier parallels in the adoption of the title *suratrāṇa* (the Sanskritized *sultān*) by the ruling houses of northern India, a development echoed in the compound title *Hindurāyasuratrāṇa* (Sultans among the Hindu kings) adopted by the Hindu maharajas of Vijayanagara in the fourteenth and fifteenth centuries.[191] Earlier variants on this title include *Andhra suratrāṇa* (sultan of Andhra), associated with Kapaya Nayak, a Deccani rebel against the authority of the Delhi sultanate around 1367.[192] The tradition continued during the period of Vijayanagara supremacy in the Deccan: according to an inscription dated Samvat 1496/AD 1440, Rana Kumbha of Mewar in Rajasthan (who counted a Hammira among his ancestors) assumed the title of *hiṁdu suratrāṇa* (Hindu sultan), or had it conferred on him by the sultans of Gujarat of Dehli, whose territories he is said to have menaced; the claim implicit in the title was manifest in a parasol (*chatr*) conferred on the rana.[193]

The circulation of Islamicate names and terms among the Rajput rulers of both northern and southern India exemplifies what, following Mauss, I suggested in chapter 2 should be read as *prestigious imitation*. The trajectory of *Hammīra* is a complex one, however, not only because of the transcultural nature of the term, or because it translates an Arabic title that (after the adoption of "sultan" around the middle of the eleventh century) would have been considered beneath the dignity of those to whom it was applied, but also because of its oscillation between a personal iden-

tity and a generic identification. In the slippage between the generic and particular, a name that was both a translated title and a taxonomic category came to denote specific historical rulers, and eventually subjective identity. The "internalization" of the other (or "othering" of the self) implicit in this process exemplifies a phenomenon noted by Tony Stewart in his study of early modern textual translation in Bengal:

> [The process of translation] reveals a movement of accommodation by the receiving or target language and the culture that it represents, which when sufficiently pursued eventually becomes an act of appropriation. The target language incorporates fully the new terms and concepts that result from this encounter, a process that is patently different from syncretism. The act of incorporating what is alien ultimately changes its host.[194]

The appropriation of the translated term (and implicitly the qualities that it connoted) by minor Rajput rulers might be compared to the adoption of Islamicate modes of dress and public self-representation discussed in chapter 2. In both cases, the synchronic deployment of the name (or the robe) presupposes a diachronic history of engagement through which the appropriated term acquires its desirable qualities.

In this sense, the onomastic practices outlined above represent another facet of the genealogical imaginary within which Iltutmish's reerection of the iron pillar in the Delhi mosque, or the inclusion of the Ghurids and Delhi sultans in epigraphic genealogies alongside their Tomar and Chauhan predecessors, construct communities and continuities that emphasize shared qualities of kingship. The nature of the raw material employed in each case was determined neither by essential cultural pathologies nor a priori expressions of sectarian identity, but by pragmatic orientations to power expressed in particular cultural, historical, and regional contexts. Hence, the adoption of Indic dress by Arab elites or Turkic dress by Buddhist and Hindu elites was contingent on the prevailing (and shifting) balance of power in Sind and the western Himalayas during the tenth through twelfth centuries, as was the circulation of *Hammīra* as a personal name in northern India a century or so later. It would therefore be a mistake to think of premodern

modes of legitimation as fixed and unreflexive, insensitive to shifts in the broader political realities that they underpinned. As Brajadulal Chattopadhyaya notes, "The modes of legitimation [associated with premodern Indic kingship] underwent significant changes over time, and the Sanskrit sources of the early medieval period show us that current motifs could be combined with new elements, by suitably transforming such elements to adjust with recognizable cultural conventions. *Suratrāṇa*, transformed from sultan, would be an example of this."[195]

Returning to a point made in the introduction, I want to emphasize once again that the construction of legitimizing genealogies or transcultural modes of self-aggrandizement did not necessarily obscure or occlude difference. The sorts of genealogical constructs explored here offered frameworks for subsuming but not necessarily negating difference, which was often central to their operation. The adoption of the Sanskritized Arabic title as a personal name is, for example, an identification that operates through the simultaneous assertion and domestication of difference, an appropriation of qualities associated with the "other" that presupposes otherness itself. Indeed, what is most fascinating about the phenomenon is precisely its endeavor to bring into constellation what were formerly mutually oppositional categories, as Chattopadhyaya notes.

Interesting (and near contemporary) analogies can be found among the Seljuqs of Anatolia, whose complex cultural, diplomatic, mercantile, and military engagement with the Byzantine state mirror the entanglements of Rajputs, Turks, and sultans in thirteenth- and fourteenth-century India. Of particular interest is the name that the Seljuq sultan Kilij Arslan II (r. 551–88/1156–92) chose for his son, Muʿizz al-Din Qaysarshah. Qaysarshah ruled as governor of Malataya between 1186 and 1201, and coins struck in his name survive.[196] This use by a Muslim Turk of a proper name that combines Caesar (Qaysar) and Shah, the two paradigmatic titles of Roman-Greek and Persianate kingship, (past and present) is of a piece with the textual and visual collage through which Caesar, Khus-

rau, and the Seljuq sultan were brought into constellation on the walls of Konya.[197]

Terms like Hammira or Qaysarshah and the transcultural phenomena that they name are echoed in James Joyce's neologism *Jewgreek*, coined to denote the complex relationship between "Hebraism and Hellenism," the two historical poles of Mediterranean (and by extension, European) culture. In Joyce's formulation, "Jewgreek is greekjew. Extremes meet."[198] Implicit in both assertion and term is the idea of each as constituted by but not culturally prior to the other. Later exegesis of the Joycean term by Derrida emphasizes its ability to signify a meeting of apparently incommensurate identities, not an easy synthesis, rather an appropriation and assertion of identity constituted in and through difference but not reducible to it. Derrida poses a question that, with some terminological substitution, might equally refer to the problem of "Hindu-Muslim" identity: "Are we Greeks? Are we Jews? Are we (not a chronological but a prelogical question) *first* Jews or *first* Greeks?," concluding that "we live in the difference between the Jew and the Greek."[199] This notion of living through and in difference has, of course, been central to the "third space" of postcolonial theorists, the place between hegemonic cultural forms, rhetorical self-representations, and subjective identities, where cultural frontiers are expanded and "the superposition of cultural layers negotiates the appearance of a new hybrid subject."[200]

Whether or not this anachronism is useful for conceptualizing the onomastic transumption outlined above and the transculturation that it implies, we are clearly a very long way from the proscriptive "When in Rome" models of identity with which we began several hundred pages back. Rather than the "either or" prescriptions discussed in the introduction, the circulation of Hammira or the coining of Qaysarshah point to "both and" models of identity (or at least self-identification), exemplifying the very "mixedupness" denounced as a disruptive and unsettling effect of global modernity by anticosmopolitan intellectuals of our own age.

| *Conclusion: In and Out of Place*

The historians' contribution to the study of globalization should therefore be to remind us that we may be living amid only the latest (but probably not the last) of globalization's diverse and disconnected pre-histories.

—David Armitage, "Is There a Pre-history of Globalization?" (2004),

173–74

To enter the entangled worlds of Arab, Persian, Turkic, and Indic artisans, merchants, political elites, and soldiery living in the northwestern regions of South Asia during the ninth through thirteenth centuries is to enter a world that is incommensurate with sectarian historiographies, and inconceivable to purveyors of orthodoxies and purities of every sort. This is a world in which a tenth-century Muslim denizen of Siraf, a mercantile city in the Persian Gulf, administered a port city on the west coast of India in the name of the Rashtrakuta raja, granting permission for the construction of Hindu temples and monasteries. Just across the Indian Ocean in Sind, an Arab amir who claimed descent from the Prophet Muhammad and professed allegiance to the ʿAbbasid caliph in Baghdad, the titular head of Sunni Islam, adopted the dress and public rituals of contemporary north Indian kings. His Muslim neighbor in Multan, who was also descended from the Prophet's tribe and nominally loyal to Baghdad, presided over a city in which one of the most famous medieval Hindu icons was enshrined, and issued coins with Islamic slogans engraved in Arabic on one side and Sanskrit invocations of Hindu deities on the other.

During the same period, the ʿAbbasid caliph of Baghdad was striking gold and silver commemorative coins based on Afghan silver tokens that circulated westward as far as the Baltic, their circulation and imitation in no way impeded by the image that they bore

of Nandi, the mount of the Hindu deity Shiva. A century or two later saw the Hindu ruler of Kashmir calling on the services of a Turkic craftsman to gild the parasol covering the icon in a royal Shiva temple even as the Buddhist princes of a neighboring Himalayan kingdom were having themselves depicted in Turkic dress adorned with pseudo-Arabic inscriptions based on stylized repetitions of the word *Allāh*. Around the same time, north Indian stonemasons were working for Muslim patrons in Afghanistan, carving tombstones adorned with Arabic script. The products of these masons suggest that while locally situated, architectural idioms were not necessarily rooted: through the mobility of either artifacts or artisans they could travel surprising distances. Similarly, the contemporary import of fine Persian ceramics across the deserts and plains of Iran, and over the high mountain passes of central Afghanistan, to serve the Ghurid elite in their remote stronghold of Firuzkuh highlights the fact that geographic remoteness is not the same as cultural isolation.

Like the earlier reception and transformation of artistic forms derived from the heartlands of the ʿAbbasid caliphate in Arab Sind, the circulation of artisans and artifacts between twelfth-century Afghanistan and India raises significant questions about shifting patterns of cross-cultural patronage and aesthetic taste. In contrast to the Sindi bronzes and ivories discussed in chapter 1, for example, the Ghurid

carvings reflect the patronage of an urban "middle class" comprising merchants, princelings, and members of the clergy ('*ulamā*'). While artistic and cultural geography is not necessarily coincident with physical and political geography, both are relevant to these developments: just as maritime contacts with the Red Sea and Persian Gulf ensured that innovative scripts were accessible to the amirs of Sind, the common availability of marble in Ghazni and Rasjasthan was as integral to the emergence of hybrid modes of stone carving as the mobility of Gujarati stonemasons or the political reconfigurations that facilitated it.

The implications of these phenomena for notions of center, periphery, and influence that permeate discussions of premodern Islamic and South Asian art and architecture are significant. The center-periphery model has long been discredited by its association with diffusionism, the idea that culture diffuses from "high" centers to more culturally impoverished peripheries. The notion depends on the vector of influence that, like influenza, is catching rather than caught by recipients who are passive receptors rather than active consumers. Proponents of this model have often assumed the degeneration or distintegration of cultural forms and practices as they circulate away from the civilizing influences at their point of origin.[1] In this sense, they come close to the model of translation as reproduction/deformation criticized in relation to the "degenerate" forms and "false" arches discussed in chapter 5.

The processes of mediation, negotiation, and translation witnessed simultaneously in the Ghurid monuments of Afghanistan and India were constituted by neither an admixture of two stable cultures nor a unidirectional carrying over between temple and mosque, but by a dynamic condition in which signs and meanings were "appropriated, translated, rehistoricized and read anew."[2] The monuments therefore underline a point made by the authors of a recent study of circulation in early modern South Asia: "In circulating, things, men and notions often transform themselves. Circulation is therefore a value-loaded term which implies an incremental aspect and not the simple reproduction across space of already formed structures and notions."[3] Like the alternative imaginings of translation discussed in chapter 5, this approach acknowledges the transformations wrought through circulation as culturally productive, undermining the privilege afforded an original as culturally

(rather than temporally) prior to any subsequent works that it inspires.

Recent reimaginings of the relationships between centers and peripheries acknowledge the cultural and political power of artistic or political centers (the two are not necessarily coincident) but see peripheries as potentially more productive by virtue of their role as a nexus between different artistic and cultural networks, and the consequent availability of potential models that may not circulate in the center.[4] The material from Sind presented in chapter 1 is a case in point. In addition, the transformation of 'Abbasid cultural forms (from coins to script) in "Arab" Sind under the impact of Indic artistic and numismatic conventions reminds us that localism and particularism are by no means opposed to cosmopolitanism, both being implicit in the term itself.[5]

Theorists of cultural borderlands see them as "pregnant with possibilities" that find expression in the emergence of new cultural practices characterized by improvisation and recombination, by juxtaposition, syncretism, and translation.[6] The juxtaposition of different languages and scripts on the coins of Arab Sind (fig. 12), or of distinct vegetal idioms in the Ghurid monuments of Afghanistan and the Indus Valley (figs. 135 and 136), illustrates one aspect of this phenomenon. Equally relevant are strategies of translation, which, at the most basic level, entailed the identification of conceptual cognates in distinct languages; examples include Sindi and Ghaznavid coins upon which the basic tenets of Islam are rendered in Sanskrit and the Prophet Muhammad is presented as an avatar (fig. 14). As the epigraphic content of the coins demonstrates, the endeavor was often marked by selection and omission, and frequently exploited ambiguities associated with the practice and products of translation.

The search for equivalence was not, however, confined to linguistic, textual, or verbal practices. Monuments built for Ghurid patrons in India show evidence for the identification of analogies and homologies between distinct forms and idioms at the lexical and syntactical level, as well as processes of "deep" translation, a dynamic striving for equivalent effect that encompassed and transformed both architectural iconographies and idioms. The identification of golden sculptures looted from the Chauhan rajas of Ajmir to adorn the palace of the Ghurid sultans as *humā*s, signifiers of royalty in the Persianate world, and their treatment in

CONCLUSION: IN AND OUT OF PLACE

Afghanistan exemplifies a close relationship between strategies of translation and processes of transculturation, underlining the fact that practices of displacement and reconsolidation can be "*constitutive* of cultural meanings" rather than merely indexing a simple transfer or extension of them.[7]

Less tangible aspects of these phenomena include the earlier circulation of a poem eulogizing the military prowess of Sultan Mahmud of Ghazni, the "idol breaker," written by a Hindu raja in Hindavi, the precursor of Hindi. The reception of the poem indicates a degree of self-recognition among elites and raises interesting questions about both linguistic translation and literary cognition, since we are told that Mahmud had the poem disseminated to the Indian, Persian, and Turkish poets among his retinue, who certified its excellence. The consequent exchange of the raja's finger for a robe of honor gifted by Mahmud raises issues of translation of a different sort, concerning homologies in modes of ritual practice, in this case protocols of submission involving the royal body.

The exchange also reminds us that whether in the Arab amirates of Sind or the Buddhist kingdoms of the Himalayas, the body of the ruler was neither a biological given nor determined by ethnicity alone, but was culturally constructed according to considerations of piety, power, utility, and so forth that reflect both established cultural values and the choices made by medieval elites. As a consequence, neither social nor religious identity was immutable, but socially constructed and subject to categorical shifts according to an "orientation to power" that mandated pragmatism (if not opportunism) in the construction and representation of elite identities.[8] Hence, the anonymous Hindu rajas who submitted to the Arab amirs of Sind, converting to Islam and accepting Arab names, rejected them and apostasized when conditions were favorable to their reassertion of independence. Conversely, by the thirteenth century, the positive qualities associated with the military successes of *Hammīra*, the Delhi sultan, led his Rajput foes to adopt this Sanskritized Arabic term as a proper name.

Both phenomena suggest that political utility could be a more significant determinant of elite identity (or at least its public articulation) than essential ethnicities or religious affinities. Like the earlier adoption of Turko-Persian modes of dress by Buddhist or Hindu elites, this identification with the "other" (or

with the qualities denoted by his title) attests to the appeal of cultural forms that the historian Marshall Hodgson termed *Islamicate*, those associated with the broader realm of cultural production and practice rather than the more restrictive realm of religious adherence denoted by the adjective *Islamic*.[9] The choice of model appears anomalous only from a perspective that reduces the identity of medieval elites to their religious affiliations, but even the gods were not immune to the possibilities offered by participation in these Islamicate ecumenes: the *Sūrya Purāṅā*, a fifteenth- or sixteenth-century devotional tract from Bengal, represents the assimilation of Hindu deities to the divinity and prophets of Islam through the metaphor of reclothing and the adoption of Turko-Persian modes of dress.[10]

What is less often recognized is the reciprocal nature of what, following Mauss, I have dubbed prestigious imitation: the fact that we also find minor Arab potentates existing on the margins of powerful Indic imperial formations fashioning themselves after the court styles associated with their Hindu neighbors. The hybrid modes of self-representation adopted by the Ghurid sultan in northern India over two centuries later offers another example, although one more redolent of a desire for economic and political continuity in a postconquest situation.

Perhaps in recognition of this reciprocity, the historian Daud Ali has argued for the participation of the early medieval court cultures of South Asia in what he terms a "cosmopolitan ecumene," which transcended even the qualified particularities implied by "Islamicate":

> Numerous aspects of this cosmopolitan ecumene (banqueting, dress styles, manners and concepts of love) have yet to be explored, but an adequate understanding of them cannot be grasped simply through dichotomous religious categories like "Hindu" and "Muslim." Indeed, it would seem that the claims and practices of *both* "Hindu" and "Muslim" courts of this period related themselves in some way to this ecumene and the wider cosmopolitan world that it represented.[11]

The nature of this cosmopolitan ecumene, the specific terms that defined it, and the meanings that they accrued were dynamic in their constitution and contin-

gent in their expression, dependent on the balance of power in specific times and places. Consequently, if the agency of premodern elites was manifest in their adoption of linguistic, numismatic, or vestimentary codes that enabled their participation in cosmopolitan ecumenes, it is equally apparent in their rejection. The Chandella raja of Kalinjar's rejection of the robe conferred on him by Sultan Mahmud in 413/1023 (chapter 2) is one example, the resistance of the Ghurid chiefs and clerics to the "international turn" in the pietistic alignments of the Ghurid sultans around 595/1199 another (chapter 3).

In addition, cosmopolitanism was not necessarily an effect of intercultural contact. On the one hand, shifts from vernacular literary forms to Sanskrit then back again among premodern South Asian elites constitute modes of self-fashioning that, in Sheldon Pollock's view, amounted to nothing less than a "fundamental reconceptualization of the self and its identities."[12] On the other, Roxanne Euben notes a "literal and imaginative interaction among Muslims located in different cultural milieus, encounters that at moments articulate and occasion a reworking of racial, religious, and geographic frontiers."[13] Examples include the adoption of cosmopolitan modes of dress by the ancestor of the Ghurid sultans when he appeared before the ʿAbbasid caliph (at least according later genealogies), or the later embrace of cosmopolitan forms of Muslim pietism by his descendants at the apogee of their power, when contacts with the Baghdad caliphate increased in intensity (chapter 3). Much as a modern politician might "spin" his image, and in so doing make choices designed to maximize access to representational space, parvenu elites exploited contemporary information flows in their self-fashioning. The mutual self-awareness implied by the undertaking is apparent in contemporary comparisons between the Ghurid sultan Muʿizz al-Din (r. 569–602/1173–1206) and Salah al-Din (Saladin, r. 564–88/1169–93), the Ayyubid ruler of Syria, a comparison that may be reflected in the adoption of Ayyubid coin types in Ghazni around 599/1200 (figs. 56–57). Such comparisons are particularly marked in the self-representations of frontier elites: on the twelfth-century Anatolian frontier, a panegyric penned in favor of the Mengujekid Turkman ruler Fakhr al-Din Bahram Shah of Erzincan compares him to his namesake in the Pan-

jab, the Ghaznivid sultan Bahram Shah (511–46/1118–52).[14]

Cosmopolitanism was neither the preserve of amirs, sultans, and rajas nor confined to court cultures and institutionalized practices. It was also manifest in less formalized and more quotidian modes of encounter, and associated with individuals possessed of sufficient cognitive skills to circulate and translate between different verbal and social "languages."[15] Phillip Wagoner has, for example, drawn attention to the biography of ʿAin al-Mulk Gilani, a sixteenth-century Deccani nobleman mentioned in histories written in both Persian and the South Indian classical language of Telugu. ʿAin al-Mulk began his life in the service of the ʿAdil Shahi ruler of Bijapur, only to offend his Muslim master and seek service at the court of the Hindu rulers of Vijayanagara. A copperplate inscription survives in which ʿAin al-Mulk (appearing as the Sanskritized Ainanamalukka) petitions the Vijayanagara ruler to make a land grant to eighty Brahmins.[16] Having undertaken several campaigns for the raja of Vijayanagara (including some against his coreligionists), ʿAin al-Mulk ended his life back where he started, in the service of the sultan of Bijapur.

I have argued throughout this book that patterns of encounter and processes of transculturation well documented in the Deccan in the fourteenth through sixteenth centuries may in fact follow precedents established in the much earlier and more northerly encounters that form the subject of this book. Not surprisingly, therefore, ʿAin al-Mulk finds earlier counterparts in northwestern India, among them the Hindu generals and soldiery of the Ghaznivid sultans. The best documented of these is Tilak, a Hindu freeman who made his way from Kashmir to Ghazni to work as a translator at the court of Sultan Masʿud I (r. 422–32/1031–41) before rising to high office in the Ghaznavid army and conducting campaigns against both Hindu and Muslim foes of the sultan. Individuals like Tilak and ʿAin al-Mulk Gilani are clearly the tip of the iceberg. Rather than dismissing their biographies as anomalies that buck contemporary trends (exceptions that prove the rule), we might instead see the cultural and social mobility to which they attest as a relatively common limitrophe phenomenon. At the western extremity of the Islamic world, for example, we find an earlier counterpart for ʿAin al-Mulk

CONCLUSION: IN AND OUT OF PLACE

Gilani in Mahmud ibn ʿAbd al-Jabbar of Merida (d.ca. 230/845), who led a failed revolt against the Arab amir of Cordoba, defected to the service of King Alfonso II of Asturias, and later repented of his treason, dying under siege from his Christian overlord.[17]

The presence of subaltern Indian contingents in the Saffarid and Ghaznavid armies (the *sālār-i Hindūyān*), and their families who inhabited an Indian quarter in Ghazni, suggest that the geographic mobility and social mutability associated with rulers, generals, and noblemen was not exclusive to them. The same is true of the Indian stonemasons from Gujarat and Rajasthan who worked in Bust, Ghazni, and Ghur in the late twelfth century. There is no reason to assume that these were slaves: on the contrary, the presence of both contingents is likely to reflect the appeal of major cultural and political centers to those seeking to maximize their economic and social opportunities.[18]

The historical master narratives in which both these subjects have been inscribed are dominated by the idea of great (or lesser) civilizations, "a world of bounded spaces and identities, among which people may move but within which they live."[19] This invariably encourages the "vertical fallacy," the idea that the identity of human agents who act to shape such phenomena (and, by extension, the cultural forms and practices with which they are associated) can be adequately represented by oppositional tabulations.[20] The objects with which the identities and identifications of premodern subjects were imbricated and by which they were implicated have similarly been imbued with an identity that inheres in essence, form, and structure rather than agency, circulation, and use. With both subjects and objects subordinated to a "spatial incarceration" (to borrow Arjun Appadurai's term), the transcultural artifacts, individuals, spaces, and practices that form the subject of this book are necessarily marginal phenomena, "a kind of disorder that might suddenly scramble impeccably structured—and allegedly authentic—units."[21]

In her classic study of taboos concerning purity, the anthropologist Mary Douglas noted the threat that "things out of place" pose to the dominant categorical structures through which understanding of the world is ordered: "their half-identity still clings to them and the clarity of the scene in which they obtrude is impaired by their presence."[22] As if to under-

line the point, a recent police raid on an Islamic school in the south of England was reportedly occasioned by suspicions of non-Muslim neighbors, who felt that the stream of white-robed visitors to the school was "a little out of place" in the English countryside.[23] Whether white-robed Muslims studying in the modern English countryside or Hindu stonemasons carving Arabic tombstones for their medieval predecessors in Afghanistan, it appears that there is something inherently disruptive about people and things that refuse to stay in place.

Ironically, despite its preoccupations with cultural flows and global markets, this concern with displacement and mobility and their ability to undermine established orders and naturalized taxonomies may be a defining characteristic of modernity. In a provocative (if somewhat reductive) hypothesis, the sociologist Bruno Latour has characterized modernity as a perpetual tussle between practices of translation (broadly understood as a process of mixing and hybridization) that create hybrids (of culture and nature as much as culture and culture) and strategies of purification (broadly understood as the assertion or imposition of taxonomic difference).[24] Similarly, it has recently been claimed that premodern societies were marked by a "cosmopolitan cultivation of fragmentation" marked by "openness to alterities, to linguistic and cultural exchanges and hybridizations."[25]

A more nuanced version of the same appraisal is found in a recent volume of essays on cosmopolitanism, whose editors contrast the transhistorical prevalence of "mixed upness" with the purifying impulses of modernity: "In fact, modernity itself is just this contradictory, even duplicitous, attempt to separate and purify realms—the natural, social and empyrean realms, with their things and peoples and gods—that have never been separate and pure, and still are not."[26] Seen in this light, the origins of modernity might be sought in the "ethnic cleansing" of 1492, the expulsions and massacres of Jews and Muslims from a newly proclaimed "Christian" Spain, an act from which the more cosmopolitan and heterogeneous Ottoman Empire reaped rich rewards. Following the same logic, the birth of South Asian modernity might be located on the cusp of colonization, manifest in such acts of linguistic cleansing as the eighteenth-century Maratha ruler Shivaji's patronage of a San-

skrit thesaurus designed to reduce the use of Islamic terms for statecraft.[27]

However, while the purifying or stratifying impulses of modernity may say much about the contemporary situation, the attempt to cast premodernity as the utopian inverse of a dystopian present brings us back to the idea of *Convivencia* criticized in the introduction. Flattening the topography of highly contoured landscapes, notions of a lost heterogeneous, hybrid, or "multicultural" past are romantic fantasies that, no less than sectarian historiographies, deny the agency of premodern subjects and the consequently protean nature of their identities. In one case the premodern subject is a permanent prisoner of his or her "Hindu" or "Muslim" identity; in the other, bludgeoned into a perpetual performance of harmonious hybridity. Ahistorical notions of premodernity as a perpetual celebration or excoriation of cultural heterogeneity cannot account for the negotiation of difference that is central to the communicative strategies and translational gambits that have been outlined above. As Gauri Viswanathan notes, "the language of sharing . . . obscures the means by which competing groups negotiated their differences," occluding contestations of power, the violence that often accompanied them, and the ways in which both were implicated in modes and moments of coexistence and conflict.[28] These often presuppose awareness of ethnic, cultural, or regional difference, the ability to negotiate it, and the will to exploit it.

Like the adoption of Sanskritic modes of self-representation by Indic elites, the embrace of Indic modes of dress by Arab amirs, or Islamicate modes of dress and titulature by Hindu rulers, the peregrinations of 'Ain al-Mulk Gilani or Tilak and his Indian soldiery demonstrate that plucky individuals could reimagine or reinvent themselves through migration or mutation. The phenomenon challenges presentist orthodoxies according to which subjective agency, social mobility, and strategies of self-fashioning mark the advent of a modernity that emerges in a European milieu.[29] The chronological origins of modernity are something of a movable feast, but the claim to radical novelty that it entails occludes the ways in which it "remains continuous with its own prehistory."[30] If the identities of modern subjects are depicted as protean, subjective, and heavily inflected by personal choice

(or at least the perception that such choices exist), those of premodern subjects are represented as fixed and stable, reflecting subscription or submission to shared cultural norms.[31] This contrast between the mobile agentive actors of modernity and their immobile passive predecessors is typified by Francis Barker's representation of subjectivity in premodern Europe: "Subjects are profoundly implicated not because they 'know their place' (as in the modern form when it is effective) but because alterity of placement is always-already encoded as unthinkable."[32] While the notion of a sovereign self, the categorical distinction between subject and object that is central to it, and the rise of a public sphere may all have expanded the possibilities for self-fashioning and the self-conscious articulation of agency, "alterity of placement" was precisely the strategy employed by the premodern characters discussed above in their endeavors to better their lot.

In South Asian historiography, assumptions about caste and the anticosmopolitan nature of Islam have compounded this denial of premodern agency, despite the likelihood that, as Sheldon Pollock notes, "boundaries and cultural restrictions had far less salience in action than they may have had in representation."[33] This being so, it may be more accurate (and certainly more productive) to think in terms of strategies of identification rather than the reified identities of sectarian historiography and their more utopian (but no less immobilizing) counterparts. To do so would necessitate conceiving of alterity "not as ontologically given but as historically constituted," as Edward Said suggested in a different context.[34] The idea resonates with Homi Bhabha's observation on the performative nature of cultural difference, which could also characterize many of the encounters discussed above: "Terms of cultural engagement, whether antagonistic or affiliative, are produced performatively: 'difference' is not so much a reflection of pre-given ethnic or cultural traits set in the tablets of 'fixed' traditions as it is a complex on-going negotiation."[35]

Despite (or perhaps because of) the dynamic constitution of difference, contemporary attempts to assert the fixity of identity and its unsettling by the disruptive effects of global mobility are ubiquitous, as the quotation with which I began my introduction to this book suggests. Although rarely noted, these are the contemporary progeny of nineteenth-century dis-

courses that emphasized the singularity of identity and excoriated practices of crossing and mixing as potentially degenerative.[36] Writing in 1870s, the ethnologist George Campbell related his concerns about racial intermingling to the phenomenon of modernity and the global displacements that it had engendered, emphasizing familiar concerns then articulated around purities of race rather than culture:

> The world is becoming more and more one great country; race meeting race, black with white, the Arian with Turanian and the Negro, and questions of miscegenation or separation are very pressing.[37]

The recent resurgence of such anticosmopolitan sentiments and the imperial condescension to which they bear witness is directly related to contemporary anxieties regarding the displacements that have accompanied the myriad of phenomena and epiphenomena known as globalization. As Robert Young notes in his recent study of hybridity and its historiographies, "Fixity of identity is only sought in situations of instability and disruption, of conflict and change."[38]

In their contemporary manifestations, concerns about geographic displacement and cultural intermingling have often coincided with resurgent anxieties about Islam. Prominent among them is the specter of the great (and pristine) "European national cultures" giving way to Eurabia, "a new transnational Muslim identity that merges North African, Turkish, subcontinental, and other elements" and is manifest in the death of cathedrals or their transformation into mosques.[39] The transculturation conjured as specter by contemporary proponents of purity finds its inverse in a passage written by Théophile Gautier in 1845, during the heyday of European colonialism to which modern patterns of transnational mobility owe so much:

> How strange! We think we have conquered Algiers, and it is Algiers which has conquered us. — Our women are already wearing gold-threaded and multicoloured scarves which used to belong to the slaves of the harems. . . . If this continues, France will soon become Mahomedan and we shall see the white domes of mosques swell up in our cities, and minarets mingle with steeples, just as in Spain under the Moors. We would willingly live until that day, for quite frankly, we prefer Oriental fashions to English ones.[40]

Gautier's facetious comments anticipate a postmodern tendency to recuperate the notion of hybridity, not only by accepting it as a sign of the contemporary condition, but also by celebrating and valorizing practices of mixing and *métissage* that provide challenge and counterpoint to both apocalyptic anticosmopolitanisms and the hegemony of the melting pot.

Contemporary preoccupations with "Eurabia" are in many ways a pale shadow of those that conjured and maintain a Muslim specter at the center of a South Asian (and, now, global) history that has recently been mobilized by Hindu nationalists, Islamists, and neoconservatives. The demolition of the Baburi Masjid at Ayodhya in 1992, in order to reconstruct a temple that it was believed to have replaced in the sixteenth century, provided a violent illustration of how partitioned or purified histories could be pressed into the service of the present to dramatic effect.[41] Like the mobile subjects of postmodernity, the past it seems will no longer stay in its proper place.

Whether in Ayodhya or Eurabia, a dehistoricized and undifferentiated cultural-religious formation threatens the fictive purities that are fundamental to modern imaginings of identity. However, if, as Joan-Pau Rubiés has suggested with respect to cross-cultural encounters in early modern South India, and I have argued here in relation to their northern predecessors, histories of cultural translation are inseparable from "the histories of identities, of their creation and dissolution in a continuous process of reproduction and change," then the territorialized identities and imagined purities of the nation-state are themselves just the latest in series.[42] Presenting the contingencies of power as part of a preordained continuum, the founding myths and "eternal" verities of the nation-state bear comparison with the fictive genealogies developed by Indic and Islamic rulers to similar effect, even if the former have been rendered more plausible through naturalization and repetition.

Nineteenth- and twentieth-century histories of pre-Mughal South Asia may be heavily inflected by modern imaginings of empire and nation, but consid-

eration of the peculiarly contemporary resonances of the period—its transregional cultural flows, contingent cosmopolitanisms, subaltern diasporas, and transcultural elites—has been occluded by the hegemony of Manichaean taxonomies on the one hand, and the presentism that identifies these phenomena with Euro-American modernity on the other. Nevertheless, geographic mobility and the mutability of identity that often accompanies it have a variety of histories that include, but are not coincident with, the histories and effects of European colonialism, modernity, or global capital. If, therefore, postcolonial studies of Europe's former colonies can illuminate the study of premodern empires and the displacements, migrations, and transformations that they occasioned, the converse is no less true. [43] In this sense, the very pasts that have returned to haunt the present may also suggest new ways of negotiating its challenges.

Saffarids of Sistan

Yaq'ub ibn Layth al-Saffar (253–65/867–79)

'Amr ibn Layth (265–88/879–901)

Habbarids of Mansura

'Abd Allah ibn 'Umar (regnal dates unknown, ruling 270/883)

Ghaznavids

Mahmud ibn Sebuktegin (388–421/998–1030)

Mas'ud I (421–32/1031–41)

Mas'ud III (492–508/1099–1115)

Bahram Shah (512–47/1118–52)

Khusrau Shah (ca. 547–55/1152–60)

Khusrau Malik (555–82/1160–86)

Ghurids

'Ala' al-Din Husayn (ca. 544–56/1149–61)

Ghiyath al-Din Muhammad (558–99/1163–1203)

Mu'izz al-Din Muhammad (599–602/1203–6)

Delhi Sultans

Qutb al-Din Aybek (602–7/1206–10)

Aram Shah (607/1210–11)

Shams al-Din Iltutmish (607–33/1211–36)

'Ala' al-Din Khalji (695–715/1296–1316)

Firuz Shah Tughluq (752–90/1351–88)

Chauhans of Ajmir and Ranthambor

Prithviraj III (ca. 1165–92)

Govindaraja (ca. 1192–95)

Hammira (ruled at Ranthambhor ca. 1282–1301)

Chandellas of Kalinjar

Dhanga (ca. 990–1002)

Ganda (ca. 1002–19)

Vidyadhara (ca. 1019–29)

Chalukyas or Solankis of Gujarat

Mularaja II (ca.1176–ca. 1178)

Bhimadeva II (ca. 1178–1242)

| Notes

| Abbreviations

The following abbreviations have been used in the notes:

AIIS	The American Institute for Indian studies
EI	*Epigraphia Indica*, Delhi, 1892–
EIAPS	*Epigraphia Indica Arabic and Persian Supplement* (also Known as *Epigraphia Indo Moslemica*), Calcutta, 1909–
IA	*The Indian Antiquary*, Bombay, 1872–
RCEA	Répertoire chronologique d'épigraphie Arabe, Cairo, 1931–

| Introduction

1. Garton-Ash (2006).
2. Huntington (2003), 48. I am not, however, using *encounter* in the sense that Huntington understands it, as intermittent or sporadic contact between disparate politico-cultural entities.
3. Clifford (1988), 6.
4. Bennison (2002); Eaton (2003), 3, 9, 42–43; Euben (2005), 37.
5. On these general trends see Voll (1994), 217; Bentley (1996); Manning (1996). For South Asia see Ludden (1994), 6–7. See also Eaton's comments on the tendency when discussing premodern Islam to conflate culture, civilization, religion, and territory: Eaton (2003), 11.
6. Ludden (1994), 3, 6. For similar sentiments also related to South Asia see Gommans (1998).
7. Abu-Lughod (1989). See also Subrahmanyam (1997), 736–37.

8. Acknowledging this (explicitly or implicitly), some scholars have sought to locate the chronological origins of the world system as early as the eighth to tenth centuries, the period covered by chapter 1. In a more radical revisioning, others have argued the need to replace the narratives of rise and fall on which most proponents of "world system" histories have depended with a diachronic approach that emphasizes the development of a continuous world system that cuts across the divide between pre- and postmodernity: Frank (1990), 254–55; Pollock (2004), 265. While such approaches are helpful in moving us beyond the bounded cultures and a priori stasis of earlier analyses, they carry with them the dangers of ahistorical generalization and the consequent inability to account for cultural change: for a balanced critique see Pollock (2006), 482–85.
9. A lacuna noted by Richards (1974), 91; Pollock (2004), 264–65.
10. Duff (1876), 300.
11. For a flavor of these narratives and the role of scholarship within them see Goel (1993).
12. Bhandarkar (1930). For other examples see Srivastava (1965) and Richards (1974).
13. M.A. Ali (1990), 16; Veer (1994a), 152; Gottschalk (2000), 17; Inden (2000a), 8–17.
14. Awasthi (1962), 139.
15. On this point see M.A. Ali (1990), 16–17.
16. As the editors of a recent volume of essays that sought to reconceptualize essentialist notions of Muslim and Hindu identity noted, "Not local Indian rulers but Hindu norms were defeated in the period from the

Ghaznavids to the Mughals, and they were defeated not by certain Muslim rulers but by Islam itself": Gilmartin and Lawrence (2000), 3. See also Subrahmanyam (1996), 76; Gottschalk (2000), 17, 108–9.

17. Clifford (1988), 344.

18. Chattopadhyaya (1998), 29; Talbot (2001), 212.

19. Bühler (1892), 5; Sircar (1967), 1:74–97; Thapar (1971), 409–20; idem (1989), 223–24; Pingree (1981), 172–74; Parasher (1991); Sundermann (1993), 166; Chattopadhyaya (1998), 30–33.

20. Stuszkiewicz (1951–52); Wink (1992b); Prasad (1995).

21. Bühler (1892), 5, 22; R.S. Sharma (1961), 95. For a discussion of *Hammīra* see chapters 3 and 6. There are also suggestions of a distinction between Turkic rulers based on their military prowess and courage: the *Prithvīrājavijaya* (late twelfth century) laments the seizure of Ghazni by Mu'izz al-Din Ghuri in 1174, and his defeat of the Lord of Horses (*hayapati*), who is either the Ghaznavid sultan or, more likely, the leader of the Ghuzz Turks who held the city until then: Pollock (1993), 276.

22. M.A. Stein (1989), 1:353, book 7, verse 1095; Chattopadhyaya (1998), 90.

23. Ernst (1992), 23–24; Talbot (1995), 694, 701; Inden (2000a), 2; Gilmartin and Lawrence (2000), 4; Pollock (2004), 275. See also Grabar (1986), 444–45; Hall and Maharaj (2001), 41; Campbell and Milner (2004), 5–6.

24. See the 1992 exhibition catalog of the same named edited by Vivian B. Mann, Thomas F. Glick, and Jerilynn D. Dodds.

25. Amin (2004), 30, 42, emphasis original.

26. Pollock (1996), 246. Similarly, Stewart and Ernst note (2001, 586) that "if everything is syncretistic, nothing is syncretistic and the term loses its power to describe." See also Bhabha (1990), 211; Pollock (2002), 47; Subrahmanyam (2005), 20–21.

27. Clifford (1997), 7.

28. Dharwadker (1999), 129.

29. Meister (1993a), 445; idem (1994b); Wagoner (1999), 260.

30. Stepan (1985); Young (1995), 6–9; Coombes and Brah (2000), 10–11; T.K. Stewart (2001), 261–63, 269–74.

31. Shaw and Stewart (1994); Veer (1994b).

32. Dean and Leibsohn (2003), 11–12, 17; N. Thomas (1991), 106; Gruzinski (2002), 31. See also Summers (1994), 592.

33. See also chapter 6.

34. Hardy (1978), 147–48.

35. Sachau (1989), 2:246.

36. Said (1989), 32. The text of the *Mahābhārata* was translated into Persian as early as 417/1026–27: Reinaud (1976), 25–79.

37. Sachau (1989), 1:179. On the *dhoti* see Goswamy (1993), 11–12.

38. Cutler (1999a), 636–37. For a general discussion of commensurability in relation to the encounters between early modern South Asian elites and others see Subrahmanyam (2005).

39. Atil (1981); de Blois (1990); idem (1991a); Raby (1991).

40. Blois (1990), 42, 82; Gutas (1998), 36.

41. Salem and Kumar (1991), 13–14. Similarly, Amir Khusrau of Delhi (d. 725/1325) enumerates *Kalīla wa Dimna* among the many merits of India, citing the production of Arabic, Persian, Turkish, and other translations as proof of its excellence. A century later, an emissary from the court of Shah Rukh, the Muslim ruler of Herat, to the court of the Hindu rulers of Vijayanagara in southern India cited the Persian translation of the text as evidence of the wisdom of the Brahmans of that region, where he believed the tales to have originated: Thackston (1989), 307.

42. Sachau (1989), 1:159. For contemporary European debates regarding the possibility of an accurate translation of Arabic texts into Latin or European vernacular languages see Burnett (1997), 61–62, 71.

43. Amir Khusrau (1950), 169; Nath and Gwaliari (1981), 59.

44. De Blois (1990), 40–43, 58–60, 81–82.

45. Gutas (1998), 16, 30.

46. Lawrence (1976), 26–29.

47. Minorsky (1942), 125; Dodge (1970), 2:826–27; Gutas (1998), 36, 39. This possibility of invoking the authority of the text and claiming it as one's own is one reason why the acquisition of texts for translation was sometimes resisted in frontier regions of the medieval Islamic world: Burnett (2002).

48. Minorsky (1956), 167–68.

49. Munshi (1996), 371. Some illustrated versions of *Kalīla wa Dimna* depict Bahram Shah at the beginning of the manuscript: Cowen (1989), 40–42; Alam (2003), 148; B. O'Kane (2003), appendix B. Similarly, the Persian verses inscribed in the palace of the Ghaznavid sultan Mas'ud III at Ghazni (505/1112) refer to India, apparently in an attempt to cast Mas'ud's Indian exploits in an epic frame: Bombaci (1966), 14, 42; Bosworth (1977b), 89.

50. Moskva (1967); Humphreys (1991) 30, 129–47. Patronage of literature in the Persian vernacular developed during the tenth and eleventh centuries, with a flourishing literary production associated with Lahore, which was known as "Little Ghazni": S. Sharma (2000), 17; Alam (2003), 132–37.

51. Pollock (1996); Alam (2003), 133, 142.

52. Pollock (2004), 274. Where Islamic culture *has* made an appearance in discussions of vernacularization in both

Europe and South Asia, it has done so as a passive stimulus to these processes rather than a coeval manifestation of them. See, however, Pollock (1996), 240, 244, where both Europe and the Persianate polities of the northwest are mentioned as analogs. In Pollock's later work only the European analogy developed, without any discussion of Persian, although see the passing mention of "newly flourishing Persianate literary practices": idem (2006), 393. For a similar observation see Shulman (2007), 824–25.

53. Cohn and Marriott (1958).

54. Latour (1993), 3, 11, 121.

55. Niranjana (1992), 8; Carbonell (1996); Basnett (1998); Campbell and Milner (2004), 1–2. These developments were anticipated by the work of linguistic theorists such as Roman Jakobson (2000).

56. Manning (1996), 779; Hall and Maharaj (2001), 37.

57. Bhabha (1994), 37; idem (1996), 54, 58; Hall and Maharaj (2001), 42–43. See also Richard White's identification of a "middle ground" between cultures and its role in the colonization of North America: White (1991).

58. Eaton (2003), 3.

59. Pollock (1993), 285.

60. Wagoner (1996a); idem (1999).

61. For these critiques see B. Parry (1994), 8–12; Phillips (1998). A. Ahmad (1991, 136) criticizes a "shift from the political economy of production to the cultural complexes of representation" in Bhabha's work, although one wonders whether these are in fact as distinct as Ahmad seems to suggest.

62. Hay (1999), 6. See also Latour (2000), 20; Mignolo and Schiwy (2003), 10–11.

63. J. Hunt (1993), 297.

64. Glick and Pi-Sunyer (1969), 140; Lionnet (1989), 15–17; Pratt (1992); Ortiz (1995), 102–3; Dallmayr (1996), 14–18. See, however, Subrahmanyam (2005), 20–21.

65. On this point see Wagoner (1996b), 875; Cutler (1999a), 635.

66. Trautmann and Sinopoli (2002), 517. This is true even of monumental architecture: in colonial-era histories of South Asia, where medieval texts were lacking, medieval monuments were often figured as metaphorical books: Flood (2004), 26. On the textualization of India in colonial scholarship see Prakash (1990), 386.

67. This is the case with Cynthia Talbot's otherwise exemplary 2001 study. See also Morrison and Lycett (1997) and chapter 6 below.

68. See index under (kharāj, turuṣkadaṇḍa, and agriculture).

69. Summers (1991), 184–85; idem (1994), 592; idem (2003), esp. 15–61. On the inadequacies of the linguistic model to account for the visual see also McCracken (1988), 65–67; Crossley and Clarke (2000), 3; Pinney (2006), 132–34. For opposing views on the utility of translation as a metaphor for understanding the built environment see Rykwert (1998) and Freedberg (1998).

70. Cohn (1996), 4, 18, 29, 53. One might add that the production and reproduction of language itself entails a material dimension curiously absent from the abstractions of linguistics: as a social practice, language necessarily implies embodiment, either of the listener who repeats the words that he or she has heard or of an apparatus of reproduction, whether manuscript or CD-ROM. For a relevant discussion of Eurocentrism in universal histories of art see Rampley (2005), 528–29.

71. Atil (1981), 15.

72. On this general point see Allsen (1997); Hofmann (2001).

73. Gell (1998), 104.

74. Kopytoff (1986), 64; de Grazia, Qulligan, and Stallybrass (1996), 5.

75. Ortiz (1995), 102–3; Glick and Pi-Sunyer (1969), 140; Lionnet (1989), 15–17; Dallmayr (1996), 14–18.

76. B. Metcalf (1995), 959.

77. Tye (1996), 6. The same logic determines that medieval bilingual inscriptions are split into their component languages, their Arabic or Persian content published in compendia of "Islamic" texts, their Sanskrit or vernacular components published in books and journals intended for specialists with different training. Although acute in studies of premodern South Asia, the phenomenon is not peculiar to it: the disciplinary separation between Arabists and Latinists has been noted as a major reason for the centrality of political and religious frontiers to studies of the relationship between medieval "Christian" and "Muslim" states: Christys (2002), 35. See also Tronzo (1993), 212.

78. Wagoner (1996b); idem (1999); Rubiés (2000), 30, 33; D. Ali (2004), 267. As Grabar observes (1998, 127), "a culture of shared objects implies a certain commonality of court behavior and of court practices." Similarly, Linda Seidel notes apropos Christian-Muslim exchange in the arts of the Mediterranean during this period that "in order for there to be exchange between groups there has to be some degree of shared experience or expectation": Seidel (1986), 377. See also Redford (1993), 152.

79. Manning (1996), 780–81.

80. Bosworth (1995a).

81. See, for example, the rather parodic (but not uncommon) contrast between solid empirical approaches to premodern architecture and the dilettantism of "modern theorists . . . too bored with the bricks and mortar to

read a technical report or a primary source" in Ouster-hout (1995), 48. For a cogent critique of this idea of a "return to the object" as if it were preexistent see Camille (1996), 201.

82. Inden (2000a), 3. Among the scholars whose work attempts to straddle this divide, one might mention Daud Ali, Sheldon Pollock, and Phillip Wagoner.

83. Dirks (1996b), 277; idem (1996a), 31–34. See also Clifford (1988), 94; Patterson (1990), 90; Grondin (1994), 111. Both criticisms tend to conflate a notion of history as a series of events that have occurred in the past and the (predominantly textual) representation of those events in the present: de Certeau (1988), 21; Skinner (2002), esp. 8–26. For this question in relation to South Asian history see Kumar (2007), 45.

84. These problems are not of course peculiar to South Asian historiography. See Clunas (1991, 75) on writing cultural histories of premodern China.

85. Baxandall (1992), 343. As Hahn (1990, 15) notes, the historian "can only be in dialogue with an interpretive community that one imagines for now or for the future, or, more likely, for both." See also Asad (1986), 163; Dirks (1982), 658; Skinner (2002), 77–78.

86. Inden (2000a), 21.

87. R. Evans (1994), 36; N. Thomas (1991), 176.

1 | *The Mercantile Cosmopolis*

1. Collins and al-Tai (1994), 417; for the Arabic original see al-Muqaddasi (1967), 474.

2. Marshall (1928), 573.

3. Kervran (1993); idem (1999); Mughal (1990).

4. A. Watson (1983); Bonner (1996), 140.

5. The term was coined by Glick (1992b), 103. See also Pollock (2006), 484–85.

6. Ludden (1994), 7–9; Wink (1996), 25–65, 109–92.

7. Friedmann (1977), 318; Constable (1994), 36.

8. Marquart and de Groot (1915); Bosworth (1965); Habibi (1967), 75–76; Bosworth (1973c); idem (1984), 6–7; Wink (1996), 1:112–28; Kuwayama (1999), 29–35, 66–67, 72.

9. For the geography of the eastern frontier see Hamadani (1986), 6–17.

10. Anon. (1962), 103; Ibn Hawqal (1967), 450; al-Muqaddasi (1967), 304; Minorsky (1980), 88, 108, 110; Bosworth (1994), 63; Collins and al-Tai (1994), 268.

11. Anon. (1962), 103; Kramers and Wiet (1964), 435; Ibn Hawqal (1967), 450.

12. Ibn Ibrahim, (1886), 25–26, 49; Minorsky (1942) 47; Wiet (1955), 151; Bosworth (1995b), 945.

13. Fatimi (1963); Gabrieli (1964–65); Pathan (1974), 33–64; Blankinship (1994), 110–11, 131–34, 147–49, 186–90; Wink (1996) 201–9.

14. Creswell (1932–40), 1:263–64; Friedmann (1984).

15. Pathan (1964); idem (1969); Friedmann (1991); idem (1993).

16. Willetts (1960); Anon. 1964; Ashfaque (1969); A. Khan (1990).

17. The latter correspond to the "shatter zones" or "route areas" that Bernard Cohn has noted as constituting a type of historical region in South Asia: Cohn (1998), 109. See also Clark (1995), 55–56.

18. Wink (1996) 208–9. For a general history of Mansura see Pathan (1974). For a discussion of the textual sources for the Arabs of Sind see Bede (1973), 7–9.

19. Ramhurmuzi (1883–86); Sauvaget (1948). Several tenth-century eyewitness accounts of Sind and the west coast of India are preserved: Hourani (1995), 65–68. For a full discussion of the sources see Miquel (1967), 116–32. Among other important works that do not survive are the *Kitāb ʿummāl al-Hind* (The Book of the Governors of India) and the *Kitāb thaghr al-hind* (The Book of the Indian Frontier) by the Iraqi writer al-Madaʾini (d. 225/839): Friedmann (1984), 27.

20. Pellat (1991).

21. Al-Masʿudi (1861–77), 1:207, 376–77; Dodge (1970), 1:11.

22. Al-Muqaddasi (1967), 485; Hamdani (1967); Collins and al-Tai (1994), 425.

23. Ghafur (1966), 85–88; Ashfaque (1969), 90; Maclean (1989), 98. Renowned for their conservative piety, the Sindi *ʿulamāʾ* evidently supported the antirationalist reaction, for the chosen verses assert belief in a visible God and an uncreated Qurʾan, views espoused by the antirationalist faction then in the ascendant. On the background to the controversy and the religious life of Sind see Maclean (1989), 83–125; Tabbaa (2001), 12–13.

24. Nainar (1942), 161–63; Sauvaget (1948), 12; S. M. Ahmad (1960a); idem (1960b); al-Masʿudi (1962–), 150–51; Ibn Khurradadhbih (1967), 47; Bede (1973), 48–51. For a detailed discussion of the Rashtrakutas see J. Mishra (1992).

25. Al-Masʿudi (1962) 2:383, Bhandarkar (1930), 30–33; Avasthy and Ghosh (1936), 161–63; Pingree (1981), 172–74. Despite this antipathy, the raja of Kanauj, sometimes referred to as the "raja of the Indians" (*rāy az Hinduvān*), is a stock figure in medieval Arabic and Persian sources: Anon. (1962), 89; Minorsky (1980), 62, 238.

26. Friedmann (1977), 311–12; al-Qaddumi (1996), 174–75.

27. Al-Qaddumi (1996), 68.

28. Ibid., 188.

29. Fatimi (1963), 126–29.

30. Al-Qaddumi (1996), 76, 183. See also al-Mas'udi (1962), 192.

31. Dodge (1970), 2:583–84. On the diplomatic gifting of luxury manuscripts during the period see Lowden (1992).

32. Gabrieli (1932), 609–10; Minorksy (1948), 628; Salem and Kumar (1991), 12–13.

33. Pingree (1963), 243; von Grunebaum (1970), 51; Gutas (1998), 16, 24–25, 30, 58–59.

34. Minorsky (1948), 628; Dodge (1970), 2:827–28.

35. Cureton and Wilson (1841), 105–6, 116; Nadvi (1937), 178; Ibn al-Faqih (1967), 14; Pingree (1968), 98; Massé (1973), 17; Pingree (1978); idem (1997); Gutas (1998), 113–14.

36. Schimmel (1975), 110–11; Salem and Kumar (1991), 12; Deshpande (1993), 85–101.

37. Ramhurmuzi (1883–86), 157; Minorsky (1942), 47; Minorsky (1948), 629–30; Wiet (1955), 148; Al-Mas'udi (1962), 1:186; Ibn al-Faqih (1967), 15; Massé (1973), 18; Memon (1976), 259; Sachau (1989), 1:23; al-Azmeh (1992), 8, 17; Hawting (1997), 25.

38. Al-Mas'udi (1861–77), 6:265; Sauvaget (1933), 121; Thackston (1986), 3.

39. Hourani (1995), 70; Bosworth (1984), 7. Population transfers may also have played a role in disseminating Indic cults: communities of Zutt (Jatts) were, for example, sent to southern Iraq in the late seventh and early eight centuries: Murgotten (1969), 2:109, 250.

40. Thackston (1989), 300.

41. Pellat (1954), 157–59; al-Muqaddasi (1967), 481; Goitein (1983), 129, 134–35, 140; Collins and al-Tai (1994), 422; Y. Stillman (2000), 44, 46, 49.

42. These include the so-called further eye, which is documented in western Himalayan wall painting a century or two before it appears in some Iraqi manuscripts: Grabar (1984), 27.

43. Pingree (1981) 177.

44. Al-Mas'udi (1962), 1:187. See also Ramhurmuzi (1883–86), 142–44; Kay (1892), 88–89; Maclean (1989), 71.

45. Clark (1995), 59–60; Stern (1967), 10–11.

46. Al-Mas'udi (1861–87), 1:382; idem (1962), 1:154; al-Istakhri (1967), 173, 176; Anon. (1962), 66; Kramers and Wiet (1964), 313; Ibn Hawqal (1967), 320; Minorsky (1980), 88. For a full discussion of these communities see Lambourn (unpublished a).

47. EI 32 (1957–58), esp. 47, 50; Sircar (1967) 77–85; Pingree (1981) 176–77; Chakravarti (2001), 265–69. The patronage of Hindu institutions by the Muslim administrators of the Rashtrakutas finds counterparts in reports that the Chalukya raja Jayasimha Siddharaja (1094–1144) paid for the rebuilding of a mosque damaged in a sectarian riot in Cambay, or that a Jain merchant funded construction of a mosque in the town of Bhadreshvar on the coast of Gujarat, which has in fact preserved the remains of some of the earliest Indian mosques: Bühler (1892), 18; Elliot and Dowson (1990), 2:162.

48. Pingree (1981) 175; Gupta et al. (2004).

49. Sircar (1967), 77; Pingree (1981), 178.

50. Al-Muqaddasi (1967), 480. On Kanauj at this period see Wink (1992b).

51. Willis (1985).

52. Ramhurmuzi (1883–86), 142–44, 161; al-Mas'udi (1962), 1:187; Maclean (1989), 71.

53. Ramhurmuzi (1883–86), 143; Kautilya (1992), 488, 4.13.41.

54. Kramers and Wiet (1964), 435; Ibn Hawqal (1967), 450; al-Muqaddasi (1967), 480; Collins and al-Tai (1994), 421.

55. Peter Sahlins, cited in Ferguson and Mansbach (1996), 394. Benedict Anderson contrasts the sharp delineations of borders and boundaries in the "imagined communities" of the modern nation-state with premodern imaginings in which "states were defined by centers, borders were porous and indistinct, and sovereignties faded imperceptibly into one another." Anderson concludes that this very porosity enabled premodern rulers "to sustain their rule over immensely heterogeneous, and often not even contiguous populations for long periods of time": Anderson (1991), 19.

56. Minorsky (1980), 82.

57. Brauer (1995), 11–16.

58. Latham (2000), 446; Bonner (1994), 17.

59. Bonner (1994), 17; Brauer (1995), 21–24; Bonner (1996), 140.

60. Brauer (1995), 5–6, 26–30; Ellenblum (2002), 111–16; Abulafia (2002).

61. Al-Mas'udi (1861–77), 1:378; Kramers and Wiet (1964), 321; Ibn Hawqal (1967), 328.

62. This text also informs us that the Panjabi town of Jalhandar (Jullundur), which was included within the boundaries (ḥudūd) of the Pratihara kingdom of Kanauj, lay five days' journey to the northeast of Ramayan, an eastern outpost of the Arab amirs of Multan: Anon. (1962), 104; Minorsky (1980), 90, 111, 247. Similarly, the geographers describe Qamuhul (at the point of transition from Mansura to the Rashtrakuta territories) as the first city of the Indian frontier (ḥadd al-Hind) that one encounters en route to Saymur, a port city of the Rashtrakuta polity (Qamuhul min awal ḥadd al-Hind 'alay Saymur): al-Istakhri (1967), 180. See also Kramers and Wiet (1964), 316; Ibn Hawqal (1967), 323; Minorsky (1980), 88.

63. The southeastern gate of Mansura, the Bab Sandan, led toward the coastal emporium of Sandan, which lay within the territories of the Rashtrakutas: al-Muqaddasi (1967), 479; Collins and al-Tai (1994), 420.

64. Bourdieu (1991), 222.

65. Bushnell (2002), 18; Talbot (2001), 138. For a similar observation on the frontier between Christian and Muslim polities in medieval Andalusia see Abulafia (2002), 34.

66. Elton (1996), 127; Ellenblum (2002), 109.

67. Lambourn (unpublished b). I am grateful to Elizabeth Lambourn for providing me with a copy of her unpublished paper.

68. I owe this distinction to Stein (1977), 8–9.

69. Hoffman (2001), 17.

70. Miquel (1966), 1059; Deyell (1999), 56, 65; Beckett (2003), 57–58. For an overview of evidence for the circulation of Islamic coins in medieval Europe see Duplessy (1956).

71. Deyell (1999), 65–66.

72. Bykov (1965).

73. MacDowall (1968), 208–9; Bhatia (1973), 51.

74. Deyell (1999), 52–53. Rehman (1979), 105–7, 202–3, rejects the reading, but it is clear. The same formula is used later on Ghaznavid dinars from Afghanistan. Slightly later in 878, al-Muwaffaq, the brother of the ʿAbbasid caliph, defeated the Saffarids and struck Hindu Shahi copper coin types bearing his own name: Deyell (1999), 59, pl. 56.

75. Darke (1960), 226; Eaton (1993), 30.

76. That is, around 2.8 g compared with an average 3–3.5 g: MacDowall (1968), 198–99; Bhatia (1973), 55–58.

77. Altekar (1946); J. Walker (1946), 121–23. For an extremely rare example of the gold issue see Sotheby's, *Islamic Art*, Geneva, Tuesday 25 June, 1985, no. 116.

78. Thomas (1848), 187; MacDowall (1968), 199.

79. J. Walker (1946), 126; MacDowall (1968), 209; Ilisch (1984), 24. It is possible that they were struck using silver from the celebrated Panjhir silver mines of Afghanistan.

80. Bosworth (1984), 7.

81. Clark (1995).

82. Lawrence (1973), 76; Tien (1975), 178–80.

83. Tolan (1999); Hawting (1999), 85.

84. Christensen (1911–12); Minorsky (1948), 629–40; Dodge (1970) 2:827–36; Lawrence (1973); Friedmann (1975); Lawrence (1976), 16–17.

85. Jahn (1963), 186–87; Sachau (1989), 1:111–24.

86. Friedmann (1975), 214.

87. Al-Idrisi (1954), 23; S. Ahmad (1960), 37; Lawrence (1973), 69; Meisami (1991), 146; Waardenburg (2004), 213, 224.

88. Al-Baladhuri (1968), 235.

89. Al-Masʿudi (1861–77), 4:149.

90. Appadurai (1986), 38; Cutler (2001b), 273.

91. Davis (1997), 108.

92. Cutler (2001b), 250.

93. Hinds (1990), 194. The melting of gold and silver vessels and icons seized at Paykand later the same year was even more lucrative, yielding as much as 150,000 *mithqāls*: ibid., 137.

94. Bosworth (1960–61), 62, 74.

95. Dirks (1982) 100. Davis (1993), 27–28; idem (1994b), 166; idem (1994a), 301. As Davis points out, while the precedents followed by Indian kings were believed to be divine, Muslims followed the precedent of the Prophet as mandated in the Qurʾan (8:41) and later elaborated in histories, hadith, and legal lore. See, for example, Rehatsek (1892–93), 331–33; Fishbein (1997), 38–39, 130, among others.

96. *IA* 20 (1929–30), 88; Porter (1993), 18.

97. Davis (1997), 54. See also Dayalan (1985), 134–37; Davis (1993), 36; idem (1994b), 162–74.

98. Said (1989), 56; Gutas (1998), 42.

99. In this case, however, the concern derived not from the nature of the object but from its continued use for its original function: al-Qaddumi (1996), 186.

100. From the *Catalogue of the Missionary Museum, Austin Friars*, London: Anon. (1826), iii–iv.

101. Greenblatt (1991), 51; Helms (1994), 372.

102. Al-Azraqi (1858), 158, 169; al-Biruni (1958), 67; al-Yaʿqubi (1969), 2:544, 550; Bosworth (1984), 14–15; Sachau (1989), 1:57. *RCEA* nos. 100 and 116.

103. Madelung (1981), 337.

104. Wüstenfeld (1861), 190–91; Ibn al-Faqih (1967), 21; al-Yaʿqubi (1969), 2:544, 550; Barthold[-Bosworth] (2000), 576. Al-Biruni refers not to a crown and throne but to gold and silver idols: al-Biruni (1958), 67; Sachau (1989), 1:57.

105. A later narrative describing the surrender of the family icon of the Lawiks of Ghazni upon their conversion to Islam represents the icon as the embodiment of their kingly power: Bosworth (1965), 19. On the confusion between Turks and Tibetans see Wink (1992a), 761.

106. Breckenridge (1989), 205.

107. Wüstenfeld (1861), 191; al-Azraqi (1858), 156–58; Beckwith (1987) 161–62; Sachau (1989), 1:56–57. *RCEA* no. 119.

108. Wink (1996), 1:198.

109. Al-Yaʿqubi (1969), 2:544.

110. Ghafur (1965–66), 5–11.

111. As noted by Bloom (1989), 77.

112. Halm (1996), 389.

113. Stern (1949), 302; Stern (1955), 23–24. See also Sachau (1989), 1:116; Said (1989), 42.

114. Tabbaa (2001), 9. It should be noted, for example, that the Saffarids also sent to Baghdad choice items of booty seized during campaigns *within* the *dār al-Islām* and thus in theory already subject to the caliph's jurisdiction: Bosworth (1994), 146.

115. Saliba (1985), 27.

116. Ibn al-Zubayr (1959), 37; al-Qaddumi (1996), 83–4.

117. Tucci (1963), 172; Bosworth (1965), 22; idem (1968a), 35; Minorsky (1980), 347; Bosworth (1994), 219–20.

118. Al-Mas'udi (1861–77), 4:148–49; Ibn al-Zubayr (1959), 44–45; Waines (1992), 265; al-Qaddumi (1996), 88.

119. Gardizi (1928), 17.

120. Bourdieu (1997), 235.

121. M. Habib (1941), 151–53; Sachau (1989), 2:103; Davis (1997), 94. On the Thanesar campaign see Bosworth (1963), 116.

122. Scerrato (1959), 39–40, fig. 39. The faces of all the figures on the sculpture are worn equally, even though they would presumably have appeared at different levels had the image been set into a horizontal surface. It is therefore possible that the erasures were already present before the sculpture was set in place. Some of the Ghaznavid figural bas-reliefs from the site have had their faces carefully erased in what are clearly later iconoclastic interventions: Bombaci (1959), fig. 4.

123. Flood (2002), 644, 650. Accounts of Islamization in early Islamic Arabia refer to an idol named Dhū al-khalaṣa reused as the threshold of a mosque, and the image of the god Hubal, one of the major deities of the Meccan pantheon, was reportedly embedded in threshold of the Banu Shaibah Gate of the sanctuary at Mecca: Anon. (1985), Arabic 26, English 16; Faris (1952), 31.

124. M. Sarma (1948), 248–49; Choudhary (1964), 287; B. Sinha (1969); Blair (1992), 183–84.

125. Raverty (1970), 1:24; A. Husain (1966–77), 2:90; Davis (1997), 109. The list can even be extended further: to this day, an elongated stone bearing a twelfth-century Arabic inscription and set at what was once the threshold of the Imamzadeh Ahmad in Isfahan, thousands of miles to the west of Gujarat, is identified (anachronistically) as a fragment of the Somnath *linga*, the striations upon the stone taken as the marks of chains that were used to drag it: Honarfar (1971); Mihrabadi (1974), 744–45. Metaphorical variants on the same theme are apparent in the work of Ghaznavid court poets, who make use of simile in order to relate the palace of Ghazni to both the caliphal palace in Baghdad and the holy shrines at Mecca and Medina.

126. Raverty (1970), 1:24.

127. Hocart and Needham (1970), 248–49; Davis (1994a), 299; Mitchell (2005), 159–60.

128. Bosworth (1994), 101, 105–6, 216. Bamiyan had also been raided in the same year: Gardizi (1928), 11. Following a familiar pattern, the caliph reciprocated later in the same year by sending his brother as an envoy to Yaq'ub bearing patents, standards, and diplomas of investiture confirming Saffarid authority over Balkh, Tokharistan, Kirman, Sistan, and Sind: Waines (1992), 119. A century after this event, the Islamized Shir of Bamiyan was himself represented in the Meccan sanctuary by a taper inscribed with his name, which burned alongside others bearing the names of the rulers of Egypt and Yemen: al-Muqaddasi (1967), 74; Collins and al-Tai (1994), 73.

129. Anon. (1955), 216; Gold (1976), 171–72. Ibn al-Nadim states categorically that these were from Bamiyan: Dodge (1970), 2:829.

130. D. Chattopadhyaya (1970), 279; Maclean (1989), 54–55; Wink (1997), 310. For analogous critiques of hylotheism see Finney (1994), 47–48.

131. Mauss (1990), 74.

132. Bataille (1988), 68–69, 71, 75–76. On the interconvertibility of financial and symbolic capital see Bourdieu (1998), 179–80.

133. Kramers and Wiet (1964), 403; al-Istakhri (1967), 341; Ibn Hawqal (1967), 415.

134. Z. Desai (1961), 363; *EI* 34 (1961–62), 145.

135. B. Chattopadhyaya (1998), 74.

136. Hawting (1999), 106.

137. Ibn al-Athir (1965–67), 9:239; P. Walker (2003), 375–76. The tale has a coda: in 1059, the robe and turban of the 'Abbasid caliph were looted in Baghdad and forwarded to the Fatimid caliph in Cairo: Canard (1960), 1074.

138. Weir[-Zysow] (1995), 710.

139. 'Attar (1998), 280–81.

140. Al-Ghazali (n.d.), 96; Juynboll (1985), 110.

141. Meisami (1991), 143.

142. A. Watson (1967).

143. Algar (1982), 186.

144. Al-Ghazali (n.d.), 95–96. For similar ideas in early modern Europe see Zorach (2005), 90–91.

145. For the exegesis of these verses see Ghabin (1987) 85–86.

146. Memon (1976), 166; Ghabin (1987), 83; idem (1998), 195, 198.

147. Rehatsek (1878–80), 64; Lawrence (1976), 52; Hawting (1997), 25–26, 34–37. The idea finds its clearest expression in Psalm 115:3–7. "But our God is in the heavens: he hath done whatsoever he hath pleased. Their idols are silver and gold, the work of men's hands. They have mouths, but they speak not: eyes have they, but they see not: They have ears, but they hear not: noses have they, but they smell not: They have hands, but they handle

not: feet have they, but they walk not: neither speak they through their throat."

148. Rashid and Mokhdoomi (1949), 23; Lal (1967), 176; A. Husain (1966–77), 2:389.

149. I am indebted here to Goux (1990), 27, 36–37, 47.

150. Pagden (1993), 17–27.

151. Zorach (2005), 210.

152. Spies (1943), 63; Habib (1982), 99. For other examples see Richards (1983), 183–84, 189; Siddiqui (1992), 135. Similar critiques are common to modern political economists: Schneider (1977), 25.

153. Meisami (1991), 211 One need not necessarily preclude the other, however. Thus, according to a version of Mahmud's destruction of the Somnath icon first found in the poetry of 'Attar (1998, 280–81), Mahmud refused to ransom the icon for Brahmanical gold, and thus received both spiritual reward from his decisive repudiation of idolatry and financial remuneration when the icon proved to house a cache of jewels of far greater value than the gold offered as ransom.

154. Conversely, the mutability of materials that can change form while retaining their essential character could serve polemicists wanting to assert the ability of the infinite to manifest itself in an image: Zelliot (1982), 184.

155. Fredunbeg (1985), 190–91.

156. Bosworth (1965), 20. See also chapters 3 and 4 below.

157. I owe this translation to the generosity of Everett Rowson, who is currently preparing a definitive bilingual edition of the text. For the Arabic original see al-'Utbi (1869), 2:296–98.

158. Juynboll (1985), 113.

159. Shell (1982), 107; Kopytoff (1986), 75; Cutler (2001b) 260.

160. Davis (1992).

161. Davis (1997), 109. The association was sufficiently well acknowledged that a rabbi writing in twelfth-century Andalusia could refer to Indian practices in an attempt to explain why the Israelites had chosen the form of a calf for their golden idol: Bland (2001), 136.

162. M. Stein (1989), 1:187, book 5:16; Parashar (2000), 171. For the use of looted gold to embellish temples see Hultzsch (1891), 14; idem (1892) 236, 242–43; Altekar (1967), 303.

163. Dagens (1985), 339; Davis (1992), 53.

164. Mitchell (2005), 158.

165. Flood (2001c), 242.

166. Greenblatt (1991), 42; See also Davis (1997), 9.

167. Maclean (1989), 1–21.

168. Lohuizen de Leeuw (1981), 51.

169. Other temples stood in the town of Ramiyan or Rama-yan near Multan, at the entrance to which stood a temple containing a gold-inlaid copper idol that was the object of rites of veneration similar to those reported at Multan. Similarly, the town of Biruza or Biruda, an emporium within the amirate of Multan, is said to have possessed a number of Hindu temples: Minorsky (1942), 49, 52; idem (1980), 90.

170. Murgotten (1969), 2:221; Friedmann (1972), 181; Friedmann (1977), 328–29; Maclean (1989), 40–49; Wink (1996), 192.

171. The spire (śikhara) of the main Shiva temple at Daybul, damaged in the siege of the city by Muhammad ibn Qasim, was finally demolished by the 'Abbasid governor in the reign of al-Mu'tasim (833–42) and its stones used to rebuild the city: al-Baladhuri (1968), 437; Murgotten (1969), 2:218.

172. Anon. (1964), 53, pls. XVIB, XVIIA; Ashfaque (1969), 198–99.

173. Maclean (1989), 155. For the trampling of the crucifix, for example, see Ibn Jubayr (1907), 355; Broadhurst (1952), 355.

174. A. Khan (1966), 23.

175. Lohuizen de Leeuw (1981), 51–54.

176. Based on a pre-Islamic Sasanian design with a ruler bust on one side and an abstracted fire temple on the other: Marvazi correctly informs us that these bore the image (ṣūra) of the Gurjara-Pratihara king: Minorsky (1942), 47; Sauvaget (1948), 12; Murgotten (1969), 2:228; al-Idrisi (1954), 32; S. Ahmad (1960), 43; Kramers and Wiet (1964), 314; Ibn Hawqal (1967), 321; al-Istakhri (1967), 173; al-Baladhuri (1968), 443; Lowick (1990), 67–68, n. 7. See also Elliot and Dowson (1990), 1:13; Wiet (1955), 151–52; Ibn Khurradadhbih (1967), 47.

177. Deyell (1999), 127.

178. Vost (1909); M. Nath (1947).

179. Deyell (1999), 46–48; Tye (1996), 7–10. The term drama is used in a Rashtrakuta inscription of VS 1005/AD 947–48: EI 1 (1892), 168, l.21. Minting of such coins continued in Sind for several decades after the Ghaznavids ended the rule of the Multani amirs in 401/1010: M. Habib (1941), 138. They are not found however after the reign of the Ghaznavid sultan Ibrahim (1055–99): Deyell (1999), 73. For finds of similar coins in the western Indian Ocean see Horton (2004), 76, 81, fig. 4.6.

180. Shamma (1976), 560; Goron and Goenka (2001), xxii.

181. Vost (1909); Deyell (1999), 47–48.

182. Maclean (1989), 145. For examples see Thomas (1882), 91; Nasir (1969); Deyell (1999), 45.

183. This is Abu'l-Luhab al-Munabbih ibn Asad al-Qurayshi, a descendant of Usama ibn Lu'ayy ibn Ghalib (for whom

see Dodge [1970], 1:11), who was ruling in 300/912 when al-Mas'udi visited Sind: al-Mas'udi (1861–77), 1:207, 376–77.

184. Mirchandani (1968); Filigenzi (2006). The cult of Surya was itself an Iranian import into northern India: Wink (1992b), 101. I am extremely grateful to Dr. Joe Cribb, Dr. Shailendra Bhandare, and Dr. Stan Goron for sharing their insights on these coins with me.

185. *EI* 1 (1892), 167, l.11.

186. Deyell (1999), 28–29. In the later eighth and early ninth centuries, a minor dynasty ruling in Saurasthra, on the eastern fringe of the Arab territories of Sind, made use of *varaha* as a dynastic name: R. Majumdar (1993), 102.

187. Al-Muqaddasi (1967), 482; Lowick (1990); Collins and al-Tai (1994), 423.

188. The same Sanskritization is also used in a Rashtrakuta copper-plate inscription dated Śaka 848 (AD 926) that refers to an Arab governor of Samyana/Sanjan on the Karnataka coast: EI 32 (1957–58) 50; J. Mishra (1992), 41.

189. H. Sastri (1937), 495; Goron and Goenka (2001), xxvi–xxvii. The coins exist in four variant types. The fine quality of the engraving on both issues has led to suggestions that they were intended as fiduciary dirhams: Tye and Tye (1995), 49.

190. Dikshit (1935-36); Agarwala (1943); Bhattacharya (1953); idem (1954), 113–14; Ernst (1992), 52; Pollock (1993), 285; Goron and Goenka (2001), xxvi. Interestingly the marginal inscriptions show modifications over time: the earliest in the series states that "in the name of the Invisible (*avyaktīya nāme*) this *tanka* was struck at Mahmudpur in Samvat," whereas the latest state more simply: "this *tanka* was struck at Mahmudpur in the Arabic year (*tājikīyena samvatī*)."

191. Narayanan (2000), 91; T. Stewart (2001), 281; Behl (2002), 89, 96. Similarly, Chinese writers of a century or so later present Muhammad as the Buddha Ma-sia-wu (Muhammad): Hirth and Rockhill (1966), 125.

192. Raghavan (1956), 501–2; Kulke (1978) 129–31; Schnepel (2001), 290.

193. Minorsky (1942), 41, Arabic text 28; Friedmann (1975), 216, 219. For analogous translations between Indic and Islamic religious terms see Ernst (2003), 177. See also Assmann (1996).

194. Habibi (1954).

195. Goitein (1954), 186; Udovitch (2000), 682.

196. Al-Mas'udi (1861–77), 1:207; Kramers and Wiet (1964), 318; Ibn Hawqal (1967), 325; al-Muqaddasi (1967), 479–80; Collins and al-Tai (1994), 420–21.

197. Mayrhofer (1998), xii–xiii, 3.

198. Friedmann (1972), 178; idem (1993). In addition, when threatened by "Hindu" armies from the east or north, the amirs wielded the threat of destroying to the revered anthropomorphic icon of Surya until the aggressor receded. Sanskrit texts and inscriptions record several military encounters between the Arabs of Sind and their Indian neighbors: Wiet (1955), 152–53; al-Mas'udi (1962–), 1:151–52; Sircar (1967) 1:74–77.

199. For a discussion of Antonio Gramsci's idea of imperial cosmopolitanism see Brennan (2001a), 79–80; idem (2001b), 667–68. On the historical utility of cosmopolitanism to imperial formations see Ballinger (2004), 37.

200. Kramers and Wiet (1964), 315; Ibn Hawqal (1967), 322; Friedmann (1974).

201. Stern (1955), 11, 14–16; Halm (1996), 389.

202. Al-Muqaddasi (1967), 483; Collins and al-Tai (1994), 424.

203. Yaqut (1866), 1:348; Murgotten (1969), 2:225; al-Baladhuri (1968), 441; Esin (1977), 327; Friedmann (1977), 314–15, 323; Rehman (1979) 149–50. Similarly, in the exchanges between Byzantium and Baghdad during the ninth and tenth centuries, we encounter particularly mobile individuals who move between languages as easily as they oscillate between religious affinities: Dagron (1994), 232.

204. On this point see Bulliet (1979), 33; Veer (1994a), 41–42.

205. Edwards (1990), 91.

206. Friedmann (1977), 315; Bosworth (1965), 23–24. It has been suggested that the persistence of Zoroastrianism in Sistan as late as the tenth century facilitated the reception of heterodox strands of Islamic belief: Bosworth (1968b), 23. For campaigns against the heterodox Muslims of these borderlands see chapter 3.

207. For a preliminary overview see Edwards (1990), 81–91; Amin (2004). For analogous phenomena in medieval Anatolia see Kafadar (1995), 74.

208. Amir Khusrau (1953), 36.

209. Al-'Umari (1962), 82; Siddiqi and Ahmad (1972), 68–69. One might also mention the way in which taboos concerning the south (associated with Yama, the god of death) could influence the siting of medieval Muslim cemeteries in India or the way in which the south façade of tombs was treated: Burton-Page (1991b), 126; Flood (2001b), 149–53.

210. Kafadar (1995), 73, 76, 82. The fluidity of confessional identity that is such a marked characteristic of frontier regions of the Islamic world may reiterate a condition that marked the earliest decades of an emergent Islam, if one accepts Donner (2002–3).

211. Kafadar (1995), 72–73; Wolper (2003), 12.

279

212. Eaton (2003), 20–27.
213. Merrill (1993), 130, 153–54. Studies of Christian-pagan relations in the late antique Mediterranean have noted that taxonomies based on pietistic practice rather than religious belief alone tend to blur boundaries that contemporary Christian writers represent as well defined: Rothaus (1996), 299–305.
214. Gottschalk (2000), esp. chapter 1.
215. Halperin (1984), 447. See also Moreno (1994), 88, 92.
216. Brennan (2001), 76.
217. Pratt (1992), 7.
218. Ramhurmuzi (1883–86), 2–4. As Maclean notes, this exchange "indicates an aggressive interest in the propagation of the Qur'ān and Islam during the early Habbārid period and a belief in Manṣūrah (where the anecdote was current in 288/900) in the power of the Qur'ān to effect conversion": Maclean (1989), 122–23.
219. Mohan (1981), 291–97; Inden (2000b), 65. I am grateful to Tamara Sears for calling my attention to this.
220. V. Srivastava (1972), 268, 386–87.
221. The Siraf mosque measured 180 by 130 feet: Whitehouse (1980), 1–9. The Mansura mosque is, however, about half the size of the Friday Mosque built by Ibn Tulun in his Egyptian capital of al-Qata'i in 265/879.
222. Anon. (1964), 52; Ashfaque (1969); Pathan (1974), 65–79. For a recent unconvincing attempt to date the mosque to the tenth century see M. Khan (2002).
223. Al-Muqaddasi (1967), 479; al-Istakhri (1967), 173, 176.
224. Anon. (1964), 51–52; Ashfaque (1969), 187, 191, 204.
225. Creswell (1932–40), 2:257–58.
226. Defrémery and Sanguinetti (1914–26), 4:178–81; Lambourn (unpublished a and b).
227. Maclean (1989), 73.
228. Cousens (1903–4), 133–34; A. Khan (1990b), 26.
229. Kervran (1996), 46–47, figs. 9–12. For other early mosques of the Indus Delta see Ibrahim and Lashari (1993).
230. Allen (1988a), 79; King (1989); O'Kane (2006). See, for example, the mosque of similar size and plan excavated at al-Tur in Sinai: Kawatoko (2003), 1–3, 41–44, pls. 9–10.
231. Cousens (1929), 126–27; Kervran (1996), 46–47.
232. Meister (1996); idem (2000); Meister, Rehman, and Khan (2000).
233. Markovits, Ponchepadass, and Subrahmanyam. (2003), 11.
234. Ashfaque (1969), 193; Shokoohy (1988), 39–40.
235. Camille (1996), 200.
236. A. Khan (1990b), 42–55.
237. Zebrowski (1997), 30–31; Meyer and Northover (2003).
238. Al-Istakhri (1967), 174; Ibn Hawqal (1967), 321; Lohuizen de Leeuw (1981), 51, pl. XIII; Joshi (2007), 53, fig. 16.
239. Cousens (1908–9), pl. XXI; Chandra (1959–62), 18, figs. 7b, 11a, 11c, 12c, 13a. See also the recent finds of lion faces decorating a seventh- or eighth-century Vishnu temple in Swat, Upper Indus Valley: Filigenzi (2006), 6.
240. Thomas (1882), 92; Ramhurmuzi (1883–86), 2–3; Goron and Goenka (2001), xxii. 'Abd Allah appears to have been replaced by the following year, when his brother and apparent successor Musa ibn 'Umar ibn 'Abd al-'Aziz (described as ṣāhib al-Sind, the lord of Sind) sent gifts to the 'Abbasid caliph in Baghdad: Ibn al-Zubayr (1959), 37; al-Qaddumi (1996), 83.
241. Ghafur (1966), 81–84. In 300/913, al-Mas'udi reports that the ruler of Mansura was Abu'l-Mundhir 'Umar ibn 'Abd Allah: al-Mas'udi (1861–877), 1:377.
242. Grohmann (1957), 197, 203.
243. A. Khan (1990b), 103. Contacts between Yemen and Sind are documented as early as the 880s: Wink (1996), 1:214.
244. Grohmann (1957), 208–12, fig. 27; Blair (1998), 57–58; Tabbaa 2001, 55–57.
245. Constable (1994), 361. See al-Muqaddasi (1967), 485; Collins and al-Tai (1994), 425. On the associations of foliated scripts see Blair (1999).
246. Kalus and Guillot (2006), 18–24, nos. 1 and 2. I am grateful to Elizabeth Lambourn for drawing my attention to the existence of these inscriptions. On the Sindi seizure of the Muslim travelers, see Maclean (1989), 65.
247. Blair (1989), 391.
248. Al-Sabi' (1964), 95; Salem (1977), 76–77; Blair (1998), 149, 151, 215.
249. Deyell (1999), 342; Burgess (1991), 75; Goron and Goenka (2001), xxi–xxv.
250. Al-Ya'qubi (1969), 2:599; al-Baladhuri (1968), 446; Murgotten (1969), 2:232. According to al-Ya'qubi, the governor in question was Harun ibn Muhammad, who is named in a foundation text from Banbhore dated 239/853–54: Ghafur (1966), 77, 81. Al-Baladhuri erroneously identifies the governor as 'Imran ibn Musa al-Barmaki, who held the office two decades earlier: Maclean (1989), 47. See also Friedmann (1977), 310.
251. Anon. (1962), 67; Pathan (1974), 83–99; Minorsky (1980), 88. With the result he is referred to as *mutaghalliba* (having seized power): Wink (1996), 1:212.
252. Kraemer (1989), 96; Waines (1992), 119, 166, 205.
253. Ibn Hawqal (1967), 322; Kramers and Wiet (1964), 2:315. A report that the qadi Muhammad ibn Abi Shawarib was sent from Baghdad in 283/896 hints at more complex engagements with 'Abbasid Baghdad, but the report is ambiguous and the balance of probability mitigates against the veracity of this event: Friedmann (1974), 663; Maclean (1989), 663.

254. Ghafur (1966), 81, 83; al-Baladhuri (1968), 446; Murgotten (1969), 2:232.

255. Creswell (1932–40), 2:333; Bloom (1993), 22–23.

256. Barrett (1955), 51.

257. Ettinghausen, Grabar, and Jenkins-Medina (2001), 327.

258. Anon. (1971), no. 267; S. Welch (1985), no. 72; Louvre (1991), no. 18; Burjakov (1994), 70. Although Welch suggests that it may have been produced in Ghaznavid Afghanistan, the ivory bears little resemblance to Ghaznavid and Seljuq elephants: Contadini (1995), fig. 11; *Christie's Islamic Art, Indian Miniatures, Rugs and Carpets*, London, Tuesday, 26 April 1994, no. 337.

259. A point noted by Ghose (1927), 124.

260. The crown is vaguely reminiscent of the *kirīta* crown usually worn by Vishnu and Indra or the composite headgear depicted in the Rashtrakuta sculptures at El-lora: Berkson, Doniger O'Flaherty, and Michell (1983), pls. 45–46, 49; Malla (1990), pls. 67, 70, 77. See also Czuma (1989), fig. 11.

261. Kühnel (1971), 31; Pinder-Wilson (2005), 19. The script is less angular than the Kufic used on the silver coinage of Arab Sind but is broadly comparable to the more cursive scripts employed on Sindi copper coinage: Goron and Goenka (2001), xxii AGS5 and AGS6. Certain details (the rightward horizontal extension of the initial "alif," for example) also recur on the ninth- and tenth-century inscriptions from Banbhore: Ghafur (1966), pls. xxxvii and xxxix. Although the formula *min ʿamala* is unusual by comparison with the simpler and more common *ʿamal* used by Islamic artisans of the seventh through tenth centuries, the cognate formula *min ṣanʿat* is recorded as early as 67/686–86 or 69/688–89 on a bronze ewer from Basra: Mayer (1959), 22, 44, 48, 65, 85. See also Mayer (1958), 24, 40.

262. Al-Masʿudi (1861–77), 6:140; Caskel (1960). Among these were Qutayba ibn Muslim al-Bahili, who conquered Samarqand in the first decades of the eighth century.

263. Zambaur (1927), table 259; al-Baladhuri (1968), 442; al-Yaʿqubi (1969), 2:389; Murgotten (1969), 2:225, 232; Hinds (1990), 194; Islam (1996), 4.

264. Czuma (1989).

265. For the "Kashmiri crowns" see Agrawala (1968), 167, fig. 2; von Hinüber (2004), 31–32, 168–69; figs. 4, 35. The triple projections find numerous parallels in ivory, metal, and stone sculptures of the ninth and tenth centuries from Kashmir and other western Himalayan centers such as Chamba and Gilgit, in the western foothills of the Himalayas north of Sind, or in the fillets worn by the Turkic kings of the Kabul Valley on their coins: von Schroeder (1981), 22, 104, 164; Kuwayama (1999), 52; Pal

(2003), nos. 64, 67, 72, 85–88. The fleur-de-lis motifs on the crowns of the mounted warriors also find parallels on the robes worn by Buddist rulers depicted in medieval Himalayan frescoes, as do the peacocks adorning the heads of the mounts, and the circular shields decorated with rosettes (figs. 38–39).

266. A rare exception is a tenth-century reliquary now in the collections of the Metropolitan Museum of Art, New York (1985.392.1), which is cut from the diameter of a tusk and carved in the round.

267. Ramhurmuzi (1883–86), 2–3, 103; Goetz (1957), 19; al-Masʿudi (1962–), 1:150; Goetz (1969), 97; Pal (1988), 52; Maclean (1989), 103–4, 113–14, 122–23; Meister (1996), 43, figs. 4–5. For artistic contacts between Kashmir and Gujarat during the same period see Klimburg-Salter (1999–2000), 259–60.

268. Al-Muqaddasi (1967), 481; Collins and al-Tai (1994), 422.

269. *Bayn sūq al-ʿājiyyīn wa ṣaff al-ṣaffārīn*: al-Istakhri (1967), 174; Ibn Hawqal (1967), 321.

270. Barrett (1955), 50. See also Cousens (1908–9), 85–86; Chandra (1957–59), 49; A. Khan (1990b), 86–88, pls. 68–69.

271. Eder (1994); idem (2003), 53, no. 1. The ivory was acquired in 1967 from an Indian or Pakistani dealer. I am grateful to Drs. Rafael Gadebusch and Corinna Wessels-Mevissen for supplying images of the ivory and information about it. See also the fragmentary figure of a rider in the Hermitage Museum about 4.5 cm high, and thus comparable in scale to the rider on the Paris elephant with which it shares a common pose and dress: Burjakov (1994), 68, fig. 15.

272. Weichao (1997), vol. 3, no. 156. I am grateful to Jenny Liu for drawing my attention to this publication.

273. Rowan (1985), 282, and 260–61, for comparison with the elephant under consideration here.

274. Pastoureau (1990), 53–54; Eder (1994).

275. Al-Masʿudi (1861–77), 375, 379; al-Masʿudi (1962–), 1: 152–53. See also Kautilya (1992), 721, 10.5.10–11.

276. Kautilya (1992) 10.5.10–11, 72.

277. Blair (1992), 112; Wink (1992b), 104.

278. Kramers and Wiet (1964), 315; Ibn Hawqal (1967), 322; al-Istakhri (1967), 175.

279. Kautilya (1992), 547, 559; Wink (1984), 268–69. To some extent this identification depends on whether the mahout leaning from the head of the elephant is in the process of assisting the figure curled within the elephant's trunk or attacking him. The mutual enmity of the Arabs and Rashtrakutas toward the Gurjara-Pratihara rajas is congruent with the ideals of the *Arthashāstra*, which identifies an immediate neighbor as an enemy and a

neighbor's neighbor as a potential ally, a sentiment that
is reiterated in Kamandaka's *Nitisara* (eighth century):
Kautilya (1992), 555, 6.2.15.

280. Ibn al-Faqih (1967), 429; Massé (1973), 262; Salem and
Kumar (1991), 11.

281. Chandra (1957–59), 51.

282. Pinder-Wilson (2005), 19.

283. Zebrowski (1997), 31. Similarly, the tin content of the
heads and the plates to which they are attached differs,
leading to suggestions "that at least two hands, technol-
ogies and two traditions—local and foreign—were in-
volved in their manufacture": A. Khan (1990b), 51.

284. For an excellent treatment of an analogous problem in a
very different context see Elsner (2003).

285. Wasserstein (1993), 318.

286. Al-Mas'udi (1861–77), 1:207; Ramhurmuzi (1883–86),
165; Ibn Khurradadhbih (1967), 37–38.

287. Anon. (1962), 66; Kramers and Wiet (1964), 318; Ibn
Hawqal (1967), 325; Minorsky (1980), 88.

2 | *Cultural Cross-dressing*

1. The adjective *Islamicate* was coined by Marshall Hodg-
son to denote those forms associated with the broader
realm of cultural production and practice rather than
the more restrictive realm of religious adherence: Hodg-
son (1977), 1:57–60.

2. Wagoner (1996b), 853.

3. Jones and Stallybrass (2001), 2–3; Silverman (1986), 145.

4. Chaudhuri (1976), 55.

5. Al-Biruni (1958), 15; Sachau (1989), 1:20.

6. Hence the adoption of some of or all these character-
istics can allow one to "pass" as Indian. For examples
see Kay (1892), 89; Sachau (1989), 1:179–80; S. Sharma
(2000), 20.

7. Y. Stillman (1995); Sidem (2000), 39, 102–3.

8. Al-Muqaddasi (1967), 429; Tritton (1970), 115–26;
Vryonis (1971), 224–26; Budge (1976), 141; Y. Stillman
(2000), 108.

9. Canard (1973), 220–21; Dozy (1969), 420–21; Kraemer
(1989), 90; Y. Stillman (2000), 52; Noth (2004), 106,
115–17. Although not prescribed, the association between
dress and identity also operated intraculturally. In his
description of Zarang, the Saffarid capital in Sistan, for
example, the tenth-century geographer al-Muqaddasi
informs us that the populace wore robes cut in the fash-
ion of the Kharijites, a heterodox group that was present
in large numbers in the eastern frontier regions of the
Islamic world: al-Muqaddasi (1967), 305. Collins and al-
Tai (1994), 269, mistakenly translate *burdahum* as "their
turbans."

10. Kane (1930), 355; Friedmann (1977), 331–32; idem (1984),
33–34; Maclean (1989), 45–50; Wink (1992a), 766; Noth
(2004), 106, 115–16. For the association of dress and
hairstyles with ethnic difference in early medieval Eu-
rope see Pohl (1998), 51–61. See also medieval Chinese
attempts to prevent the adoption of Sinicizing modes of
dress by Muslims in China: Leslie (1987), 177.

11. Fakhr-i Mudabbir (1967), 405; Nizami (2002), 330.

12. Al-Biruni (1958), 145; Dozy (1969), 196–98; N. Ahmad
(1988), 10; S. Sharma (2000), 7. Similarly, twelfth- and
thirteenth-century Sanskrit texts look for "the descrip-
tive equivalent" of garments that are not indigenous to
northern India but are imports from eastern Iran or
Central Asia that find analogies among existing Indic
types: Goswamy (1993), 11.

13. Noth (2004), 119.

14. Hence, the inhabitants of Constantinople could be de-
scribed as wearing "the robe of Christianity," while the
donning or shedding of clothing could serve as a meta-
phor for gaining or losing power: Goitein (1983), 396;
Johns and Savage-Smith (2003), 21 n. 19.

15. Melville (1990), 171.

16. *Man tashabbaha bi-qawm fahuwa minhum*: Noth
(2004), 119. For a later reiteration seee Memon (1976),
166, 173.

17. Canard (1973), 220.

18. *lam yasumna 'l-tahannuda wa'l-intaqāla ilā rusūmihim*:
al-Biruni (1958), 15; Sachau (1989), 1:19–20.

19. Drory (1994), 78. For a critical discussion of linguistic
models in relation to the analysis of clothing see
McCracken (1988).

20. Jones and Stallybrass (2001), 4, 220–21.

21. Jones and Stallybrass (2001), 2. See also B. Brown
(2001).

22. Sauvaget (1948), 28; Thackston (1989), 305. European
visitors to the Vijayanagara court of the Deccan distin-
guish between common people who wear what is evi-
dently the *izār* and those of the elite who wear shirts and
turbans: Rubiés (2000), 149.

23. Ahsan (1979), 34–35.

24. Anon. (1962), 66; Kramers and Wiet (1964), 318; al-
Muqaddasi (1967), 480; Ibn Hawqal (1967), 325; al-
Istakhri (1967), 177; Minorsky (1980), 88; Collins and
al-Tai (1994) 290, 421; Noth (2004), 120–22.

25. Noth (2004), 120–22.

26. Al-Idrisi (1954), 31; S. M. Ahmad (1960), 43.

27. Al-Biruni (1958), 145; Kramers and Wiet (1964), 314; Ibn
Hawqal (1967), 321; Al-Istakhri (1967), 173; Sachau (1989),
1:180.

28. Chandra (1960), 29–30. According to the geographers,
the adoption of Iraqi and Persian modes of dress was the
norm in the mercantile emporia of Sind and Makran,

which lay to the west, en route to Iran: Kramers and Wiet (1964), 318; Ibn Hawqal (1967), 325.

29. M. Stein (1989) 1:339, book 7:922.

30. Al-Idrisi (1954), 31; S. M. Ahmad (1960), 43; Kramers and Wiet (1964), 318; Ibn Hawqal (1967), 325; al-Muqaddasi (1967), 482; al-Istakhri (1967), 177; Collins and al-Tai (1994), 423.

31. Sauvaget (1948), 12; Lowick (1990), 68n.

32. Sauvaget (1948), 12.

33. Kramers and Wiet (1964), 315; Ibn Hawqal (1967), 315; al-Istakhri (1967), 175.

34. Al-Idrisi (1954), 59; S. M. Ahmad (1960), 59. Although writing in the twelfth century, al-Idrisi refers to the Chalukyas as feudatories of the Rashtrakutas, indicating that his information refers to ninth- or tenth-century conditions, when the ritualized appearances of the Multani amirs and their Solanki neighbors were evidently marked by striking similarities. The spectacle of riding out was part of the alternation of seclusion and public revelation that characterized medieval Islamic court rituals, and recent research on the Norman court of Sicily suggests that such spectacles were a rich arena for cultural borrowings in other "frontier" courts on the margins of the Islamic world: Johns (2002), 82, 255, 287–88.

35. Chandra (1960), 10, 13–14, 18, 22.

36. Vohra (1995).

37. Although the fresco is often said to date from the mid-eleventh century, recent research indicates a later date: Goepper (1990), 165; Luczanits (2005), 74.

38. Snellgrove and Skorupski (1977), 1:31, pl. XVIII.

39. Dozy (1969), 352–62.

40. See, for example, the depiction of "Tokharian knights" in similar dress at Qizil in Chinese Turkestan, ca. 600–650: Sims (2002), 128–29, no. 47. See also Esin (1977), 328.

41. Levy (1935), 335; Serjeant (1972), 18, 23, 80, 91, 117, 99–100; Goetz (1981); Y. Stillman (1986), 733, 739; Wagoner (1996b), 860–61.

42. Chandra (1960), 22.

43. Al-Biruni (1958), 348; Sachau (1989), 2:10.

44. Melikian-Chirvani (1981), 62.

45. Rice (1969), 270–74; Allsen (1997), 91; Rabbat (2000); Stillman and Sanders (2000).

46. Kohzad (1951), 50–51; Bombaci (1959), 12–13; Rice (1969), fig. 3; Schlumberger and Sourdel-Thomine (1978), 63–64, pl. 123.

47. Klimburg-Salter (1987), 695.

48. M. Stein (1989), 1:310–11, book 7:527–31; Goepper (2003), 18–19, 22.

49. Wink (1992a), 767; Hangloo (1991), 105.

50. M. Stein (1989), 1:339, book 7:922–24.

51. Chandra (1960), 22.

52. The wide lapel variant is found on the robes depicted in the paintings of the Dunhuang caves from the period of Tibetan occupation (ninth to tenth centuries) and in the frescoes of the Tabo Monastery in the Spiti Valley (tenth to eleventh centuries): Karmay (1977), 71–74; figs. 5, 7–8; Klimburg-Salter (1997), fig. 121.

53. Goepper (1991–92); Luczanits (2004), 195. For the use of Persianate vocabulary in relation to Kashmiri dress and the possibility that it indicates the reception of Perso-Turkic modes of dress in the region see Chandra (1960), 7.

54. Flood (2001b), 152–53, fig. 40. See also the pseudoinscriptions framing roundels on an Afghan wooden box of this period, the decoration of which clearly emulates contemporary textiles: Folsach (2003), 79, figs. 2–3.

55. Ettinghausen (1984c), 31, 34–35, 41–42, figs. 1–2, 4–5, 16, 35, 113c. For Mediterranean *comparanda* see Soteriou (1935), figs. 3, 18–19, 25, 31, 41–42.

56. Pal (1982), 17, 28–29; Sims (2002), 24.

57. Soucek (1992), 93–96; idem (1995), 224.

58. Pal (1982), 29.

59. Goepper (2003).

60. Boer (1994), 212–14; idem (2002), 423–24; Tobin (1999), 88; Roberts (2005). See also Webb Keane on dress, identity, and "cultural tranvestism": Keane (2005), 5–6.

61. Boer (1994), 213.

62. See Bhabha (1994), 86, 90.

63. Wagoner (1996b), 858–59.

64. Eastmond and Jones (2001), 159–61, fig. 7.4. On the 'Abbasid medallion see Ilisch (1984), 28.

65. Mathews and Daskalakis (1997).

66. H. Evans (1997), 485.

67. Jones (2001), 226–27; Eastmond and Jones (2001), 175. A century or so later, the adoption of Greek modes of self-identification in the coins and inscriptions of the Turkman principalities that emerged on the eastern fringe of Byzantium offers a further example of the phenomenon, while underlining its relationship to political utility rather than religious affinity: Shukurov (2001), 259.

68. Braudel (1988), 1:318.

69. Ibn al-Athir (1965–67), 12:51; Gabrieli (1969), 242.

70. Mauss (1973), 73–74.

71. Wagoner (1996b), 854. The specific case with which Wagoner deals precludes his use of the term *Turkicization*. By contrast, the cultural ambience of the Himalayan kingdoms was heavily inflected by Turkic culture during the eleventh and twelfth centuries. I have, however, avoided the term because of its primary denotation of ethnic qualities that are not necessarily relevant.

72. Eastmond and Jones (2001), 150–51.

73. Hoffman (2001), 29; Johns (2002), 82, 255.

74. Heller (1995), 160; Rampton (1998), 300.

75. Raghavan (1956), 500; Pollock (1996); Wagoner (1996b), 872.

76. Pollock (2006), 123.

77. Sauvaget (1948), 28; Thackston (1989), 305.

78. Greenblatt (1980), 9.

79. Bhabha (1994), 90.

80. Gordon (2001a).

81. Y. Stillman (2000), 103.

82. Hardy (1998), 221, 226, 237. As Brand notes, "In India, the chatr may well have also played a role in the search for symbols of authority over their Hindu subjects by Muslim rulers": Brand (1986), 213.

83. Rosenthal (1967), 2:48–52; Inden (1981), 116; Talbot (2001), 172; D. Ali (2004), 120.

84. Schnepel (2001), 283. For a theoretical approach to political asymmetry see Orenstein (1980), 74.

85. Hardy (1998), 229.

86. Richards (1983), 196.

87. Talbot (2001), 149.

88. Dirks (1982), 672; Cohn (1996), 18–19, 114–18.

89. Amirsoleimani (2003), 223.

90. Sourdel (2001), 143. See also al-Sabi' (1964), 128–33; Salem (1977), 75–78; N. Stillman (1986); Springberg-Hinsen (2000); Hambly (2001), 196; Amirsoleimani (2003), 233–34.

91. Mauss (1990), 12, 20, 44, 46–48.

92. J. Parry (1986), 457.

93. A. Weiner (1985), 217.

94. Buckler (1928); idem (1985); Mayer (1952), 56; N. Stillman (1986).

95. Hambly (2001), 208–9; Sanders (2001), 225–27. As demand increased, courts developed imaginative ways of amplifying the number of "castoffs," producing these by brushing the robe across the shoulders of the donor for example: Minault (2003), 127. An early eighteenth-century Safavid administrative manual states that the robes tailored for the amirs of the court as *khil'at* have the same significance as the robe that has been worn by the Shah: Baker (1991), 31.

96. Allsen (1997), 90.

97. Above, p. 34. For similar uses of items of clothing in the context of 'Abbasid-Fatimid rivalry see P. Walker (2003). Similarly, by virtue of their ability to transmit the *baraka* (a type of blessing conceived of as physical emanation) of their donor, robes given by the Fatimid caliph were often used as funerary textiles by recipients, with the epigraphic bands containing the caliph's name placed across the eyes: Sokoly (1997), 75–77. The robe could thus play a role similar to that of secondary relics within medieval Christian tradition.

98. Gell (1998), 104.

99. Buckler (1928); idem (1985); Cohn (1996), 114; Cutler (2001a). For the sharing of food see note 152 below.

100. A. Weiner (1985), 210.

101. Paret (1928); Basset (1960); P. Walker (2003).

102. T. Weiner (2001). A similar idea was expressed recently when, upon being freed, a UN representative taken hostage in Afghanistan was presented with an elaborate robe taken from the president's own wardrobe: Walsh (2004).

103. In 567/1172, for example, the 'Abbasid caliph sent robes of honor to Nur al-Din Zangi, the de facto ruler of Syria, who put them on and then promptly dispatched them to his victorious general, Salah al-Din Ayyub (Saladin), to wear on his triumphal entry into Cairo after extirpating the rule of the Isma'ili Fatimids in Egypt: Broadhurst (1980), 39. Slightly later, the Delhi sultans invested certain of their own subordinates with robes that they themselves had received from the caliph, or that had been bestowed on them by the Ghurid sultans.

104. K. Gopal (1963–64), 85; Dirks (1982), 673; idem (1987), 42; Inden (1981), 116–17; idem (1998), 78.

105. Springberg-Hinsen (2000), 179–84; Hambly (2001), 195, 198, 201; Sourdel (2001), 140, 143.

106. "A fractal person is never a unit standing in relation to an aggregate, or an aggregate standing in relation to a unit, but always an entity with relationship integrally implied": Wagner (1991), 163–64. See Gell (1998), 137, 140.

107. For an overview of the history see Edwards (1990), 25–81.

108. Darke (1960), 103–4; Bosworth (1960–61), 44, 54; idem (1994), 278, 282. The armies of the rajas of Kashmir and the Hindu Shahis were equally ethnically and religiously heterogeneous: M. Stein (1989), 2:70, book 8:885–86; Hashmi (1958), 268.

109. Bayhaqi (1971), 522–33, esp. 523–24; Elliott and Dowson (1990), 2:125–34.

110. See, for example, his campaign against Ahmad Niyaltigin, the rebellious governor of Lahore: Hashmi (1958), 268; Bayhaqi (1971), 497.

111. Wormhoudt (1997), Arabic 317.

112. Kafadar (1995), 70–71, 82.

113. Glick and Pi-Sunyer (1969), 152; Halperin (1984).

114. Ibn Zafir (n.d.), fol. 149b; Ibn al-Athir (1965–67), 9:187, 309, 333.

115. Fagnan (1915), 268; idem (1921), 320; Løkkegaard (1950), 45–46; Inalcik (1965); Ben Shemesh (1967), 23; Lambton (1991), 210; de Epalza (1999), 209.

116. Al-Baladhuri (1968), 446; Murgotten (1969), 2:232.

117. Shalem (2005), 102. The specific source of the elephant is not specified, but it seems likely that his westward peregrinations began on the eastern frontier.

118. Ibn al-Athir (1965–67), 9:213; Rehman (1979), 155. In 376/986–87, the Hindu Shahi raja Jayapala had agreed to terms with Sebuktegin, Mahmud's father, in which he offered one million Shahi dirhams (silver bull and horseman coins), fifty war elephants, and the ceding of several frontier forts: ibid., 136.

119. M. Habib (1941), 143–45; Nazim (1971), 102.

120. *EI* 3 (1894–95), 69. In 351/962, for example, the Ghaznavid ruler Alptigin reportedly conferred a robe of honor on the Shir of Bamiyan after he capitulated and converted to Islam: Rehman (1979), 126. On the role of robing at the Ghaznavid court see Amirsoleimani (2003).

121. Gardizi (1928), 79–80; S. R. Sharma (1933), 940–41. Ibn al-Athir mistakenly gives the date of the encounter in question as 396/1005 but corroborates the details found in the other Arabic sources. Under the year 414/1023, he refers to an attack on an unnamed impregnable fort, which ended with submission and gift exchange: Ibn al-Athir (1965–67), 9:333. This coincides with the date given by other sources for the assault on Kalinjar, and it seems likely that the historian has confused several distinct encounters.

122. *EI* 1 (1892), 219; *EI* 2 (1894), 233; Smith (1908), 142–43; idem (1909), 277–80; S. R. Sharma (1933), 940–41; Dikshit (1965), 55–57; Nazim (1971), 113–14; Ray (1973), 1:604, 606; 2:687–88. Ray notes that this mutation may have been aided by the tendency to drop the *y* of Vidya in Bundelkhund dialect.

123. Smith (1909), 274; Sachau (1989), 1:202. Bar Hebraeus mistakenly locates these events in Kawakir (Gwalior), as does Ibn al-Athir, who refers to Bida as "lord of Kawakir" whose kingdom was Khajuraho: Ibn al-Athir (1965–67), 9:187, 308. During the period, the fort of Gwalior was in the possession of the Kacchwaha feudatory of the Chandellas, which no doubt accounts for the confusion: Smith (1909), 274.

124. Ahluwalia (1966), 145.

125. Gardizi (1928), 70–71; S. R. Sharma (1933), 940–41. On the history of Hindavi see Rai (1984).

126. Carbonell (1996), 91.

127. Adapted from Budge (1976), 190, and Nazim (1971), 207–8.

128. Baker (1991), 28; Gordon (2001b), 2; Hambly (2001), 210; Gordon (2003), 16–17; Maskiell and Mayor (2003), 116.

129. In 720/1321, Ghiyath al-Din Tughluq signaled his (ultimately successful) revolt against the Delhi sultan Khus-

rau Khan by throwing the robe of honor that the latter had sent him on the ground, and sitting on it: Gibb (1958–94), 3:648.

130. Allsen (2001), 307.

131. Bourdieu (1997), 237–38.

132. Cutler (2001a). On the belt and its symbolism see Widengren (1968), esp. 142; Allsen (1997), 85.

133. Bourdieu (1997), 237.

134. Ibn al-Athir (1965–67), 9:187.

135. Al-Qalqashandi (1913), 5:88; Spies (1936), 61.

136. Sanders (2001), 233.

137. Murra (1989), 292.

138. See, for example, Bhatnagar (1991), 16.

139. J. Parry (1998), 160.

140. Inden (1998), 78, 91; Dirks (1987), 41.

141. Gordon (1996), 231–32. In preconquest India, as in the Islamic world, certain types of imported and luxury textiles were associated with royalty, and specific textiles seem to have been associated with particular royal rituals. As a result of contact with Islamicate court cultures in which the gifting of robes played a central role, the use of cloth as a transactional symbol by the rajas of Vijayanagara "was modified in such a way that it came into closer conformity with Islamicate practice": Wagoner (1996b), 866.

142. Gordon (2001b), 14–15.

143. Bayly (1986), 287; Gordon (2001a); Maskiell and Mayor (2003), 98.

144. B. Chattopadhyaya (1998), 31. Similarly, in Safavid Iran carpets, garments, and vessels were held by some Muslims to be susceptible to pollution by the touch of a Christian. Thus a garment that came into contact with a Christian was carried off and washed: Matthee (1998), 227–28.

145. Chaudhuri (1976), 52; Tarlo (1996), 28–29. Thirteenth-century Sanskrit texts refer to the gifting of *divya-vāstra* by Gujarati kings at this period; the term *divya* is a Sanskritized version of the Persian *dībā* (Arabic *dībāj*), a brocade textile that was among the fabrics favored by the rich and cultured of 'Abbasid Iraq as early as the ninth century: Chandra (1960), 14, 17, 20–21.

146. Jones and Stallybrass (2001), 221.

147. N. Ahmad (1988), 10.

148. Adapted from Budge (1976), 190–91, and Nazim (1971), 208.

149. Ibn al-Athir (1965–67) 9:187.

150. Sibt ibn al-Jawzi (n.d.), fols. 219v–220r. I have followed the translation of Nazim ([1971], 3, 10, 208), correcting omissions and altering his generic "robe of honour" to the *qabā'* of the manuscript. The trope of wonderful ointments able to stem the blood flow from self-inflicted

wounds is found in earlier Arabic descriptions of India: M. Hasan (1994a), 33.

151. Ibn Zafir (n.d.), fol. 149b; Gardizi (1928), 79–80.

152. Freeman-Grenville (1981), 67; Ramhurmuzi (1883–86), 115; Siddiqui (1992a), 144. The same tale appears much later, in the description of India by Ibn Fadl Allah al-'Umari (d. 785/1384): Siddiqi and Ahmad (1972), 144, so it was current right through the Ghaznavid and Ghurid periods. For such oaths of loyalty at later Indian courts see Talbot (2001), 68.

153. Dirks (1982), 668, 678; G. Necipoğlu (1991), 19; Sanders (1994), 111; idem (1995), 54–55; Curley (2003), 53–54; Hambly (2003), 35; Gibb (1958–94), 3:669, 689. For analogies in the distributed body of premodern European kings see Bertelli (2001), 195, 211.

154. Among these is a Rashtrakuta copperplate inscription of Saka-Samvat 793 (AD 871) found at Sanjan in Maharashtra, which records that the king Amoghavarsha presented his left finger to the goddess Maha-Lakshmi in order to avert an impending calamity of an unspecified sort. A memorial stela erected in the Shikarpur District of Karnataka in 1050 refers to a devotional suicide preceded by the amputation of a finger, while a fourteenth-century inscription in the Kalabhairava Temple at Siti refers to "a regular staff . . . maintained . . . to cut off the finger, [and] dress the wound without much loss of blood": *EI* 18 (1925–26), 241–42; Altekar (1967), 88. The latter detail in particular is curiously reminiscent of Mahmud's encounter with the raja of Kalinjar as described in Arabic and Syriac sources.

155. M. Stein (1989), 2:125, 178, books 8:1594; 8:1738; 8:2272; 8:2300; 8:3300.

156. Minorsky (1942), ar. 38, tr. 51.

157. M. Stein (1989), 1:205, book 5:150.

158. Ibn al-Athir (1965–67), 9: 634. The gesture can be understood not only as an act of fealty but also as an endeavor to absorb the blessing (*baraka*) emanating from the caliphal body: see note 97 above.

159. Jackson (1999), 194. For later examples see Cohn (1996), 115; Subrahmanyam (2005), 1.

160. See Allsen (2001), 309; Cormack (1992), 229, 236. For two examples of ambiguity at the court of Norman Sicily, each with quite different implications, see Johns (2002), 146, 255–56.

161. Sewter (1966), 253; Cormack (1992), 227.

162. Lacan (1977), 5–7.

163. Babcock and Krey (1943), 2:321.

164. I owe the notion of the incarnated sign to Appadurai (1986), 38.

165. Rubiés (2000), xvii–xviii, 30.

166. Wagoner (1999), 249.

167. Similarly, in Norman Sicily, Muslims swearing oaths to their Christian overlords were expected to swear on the Qur'an: Johns (2004), 243–47.

168. Three years earlier, a *fathnāma* or victory dispatch recording Mahmud's exploits in the east had been received by the caliph, who reportedly ordered it to be read to the populace of Baghdad amidst much celebration: de Slane (1842–71), 3:333; Nazim (1971), 114; Briggs (1981), 1:36–37.

169. Hasan Nizami (n.d.), fol. 182b; Askari (1963), 91. Writing in the Ghurid sultanate, Nizami 'Arudi relates a tale concerning Mahmud's encounter with an Indian raja who submitted and was gifted a robe, which may preserve the memory of the Kalinjar encounter: 'Arudi (1927), 57. For a later Ghaznavid raid on Kalinjar, a century or so after that discussed here, see Bosworth (1977b), 86.

170 Kafadar (1995), 27.

171. On this point see Comaroff and Comaroff (1992), 76–77; Mayaram (1997), 37.

3 | *Accommodating the Infidel*

1. G. Khan (1949), 207–11; Raverty (1970), 1:353–54; Bosworth (1977a), 117; idem (1991b), 1100; Jackson (1999), 21. There is some dispute as to whether the marble revetments and wooden gates of Mahmud's tomb were contemporary features or later Ghurid embellishments. For contrary views see Sourdel-Thomine (1981) and Giunta (2003a), 27–44.

2. Bosworth (1977a), 120–21; Minorsky (1980), 110. For useful overviews of Ghurid history see Ghafur (1960); Kieffer (1962); Pazhwak (1966); Rawshanzamir (1978); Edwards (1990), 144–68; Wink (1997), 135–61; Nizami (1998).

3. Kieffer (1962), 19; Bosworth (1991b), 1101; Jackson (1999), 5–9; Hambly (2001), 206.

4. Kumar (1992), 7, 60; idem (2007), 55.

5. Raverty (1970), 1:449–55. For the Chauhans see *EI* 11 (1911), 16–79.

6. Bosworth (1991b), 1103; Edwards (1990), 144–68.

7. Hodgson (1977), 2:255–92; Voll (1994); Arjomand (2004); Pollock (2004), 265. The classic study of the post-Mongol world system is that of Abu-Lughod (1989).

8. Tabbaa (2001).

9. Ghafur (1960), 96–97, 119–20, 143, 148; Hodgson (1977), 2:284–85; Hartmann (1975), 75–80, 107. In the reign of al-Nasir's successor, al-Mustansir (r. 623–40/1226–42), this spirit of utopian ecumenism was given material form in the Mustansiriyya Madrasa in Baghdad, the first religious school designed to house adherents of all four

Sunni schools of jurisprudence (*fiqh*): Hodgson (1977), 2:282; Tabbaa (2001), 84–85.

10. Ghafur (1964), 112–15.

11. Bulliet (1994), 124, 173.

12. Meisami (1993), 250. As Bosworth (1973b, 56) observes, "where feasible connections could be made, a Persian dynasty might attempt to get the best of both worlds and establish links with both the Arab-Islamic past and the Iranian one."

13. Juzjani (1963–64), 1:320–21; Raverty (1970), 1:302, 304–5; Bosworth (1973b), 54–55.

14. For the historical background to this conflict see Bosworth (1977a), 126–27.

15. Juzjani (1963–64), 1:324–27; Raverty (1970), 1:311–16.

16. Turner (1967), 93–94.

17. Bosworth (1991b), 1099.

18. Fischel (1945), 38–40, 48; Sachau (1989), 1:206. The presence of Jews in Bamiyan, the seat of another branch of the Ghurid house, and their use as intermediaries in business enterprises is mentioned in the *Chahār Maqāla* (ca. 551/1156): 'Arudi (1927), 61.

19. Bruno (1963); Gnoli (1964); Fischel (1965). The earliest of these predates the date of ca. 543/1148 given for the foundation of Firuzkuh in the sources (e.g., Raverty [1970], 1:339, 341), hinting at commercial activity in the region even before it became the summer capital of the Ghurids.

20. Ramhurmuzi (1883–86), 107; Goitein (1954), 189; Goitein (1963), 201.

21. E. Ross (1922), 397; Fakhr-i Mudabbir (1927), 20. See also Juzjani (1963–64) 1:375; Raverty (1970), 1:405. For recent finds of such ceramics see Gascoigne (2006), 3. A fragmentary silk fabric of this period, apparently recovered in Afghanistan, recently appeared on the market: Bonham's, *Islamic Works of Art*, Wednesday 12th April 2000, lot no. 155.

22. See Abulafia (2002), 17.

23. Humphreys (1991), 156.

24. Kumar (2005), 5.

25. Pollock (1996), 243.

26. Maricq and Wiet (1959), 34–35. According to Juzjani (Raverty [1970], 1:439), Sayf al-Din Suri, the brother of 'Ala' al-Din, was the first of the Shansabanids to hold the title of sultan. See also Bosworth (1991b), 1100.

27. Juzjani (1963–64), 1:354; Raverty (1970), 1:368–70; Z. al Qazwini (1960), 787. The precise date at which this happened is unclear: for a full discussion see Flood (2005a), 266.

28. Juzjani (1963–64), 1:354; Raverty (1970), 1:368–70; Mirkhvand (1994), 2:787. See also Giunta and Bresc (2004).

29. Based on the numismatic evidence, the change can be dated later than 566/1170 and probably shortly before 569/1174: Spengler (1984), 113–14.

30. Mu'izz al-Din is further distinguished from his brother by his patronymic (*kunya*) Abu'l-Muzaffar as opposed to Ghiyath al-din, Abu'l-Fath. The distinction reiterates the earlier differentiation of the Seljuq sultans and their vassals: Shukurov (2001), 262–63. A series of silver coins issued from an unknown mint between 569/1174 and 581/1185 are exceptional in naming Mu'izz al-Din as *sulṭān al-aʿẓam*, hinting at divergences between the assumption and bestowal of royal authority: Spengler (1984), 114–15. Ghiyath al-Din retained the title *al-sulṭān al-muʿaẓẓam* among his other titles even in inscriptions that date late in his reign, among them the Friday Mosque of Herat and the Qutb Minar.

31. Kieffer (1962), 11–13; Bosworth (1991b), 1100.

32. Album (1998), M1754 and T1754 in the forthcoming revised edition; Morton and Eden, Auction of Coins and Medals, London, 25th May 2004, lot #533.

33. A brass candlestick dated 556/1161 bears an inscription that is said to refer to an unidentified Ghurid sultan, but the titles do not correspond to those of the Ghurids, and it seems more likely that the individual in question was a provincial governor, perhaps of Herat: Kalter (1993), 82–85, fig. 83.

34. The boxes measure 5.24 by 2.84 cm, and are housed in the al-Sabah Collection in Kuwait. They were exhibited as part of the Treasury of the World exhibition in the Metropolitan Museum of Art, New York, in 2001 (numbers INS 1890a and b), and are referred to in the publication of Giunta and Bresc (2004), 228, 231. I am grateful to Dr. Sue Kaoukji for supplying the details cited here. The use of the caliphal-sounding title *ẓil Allāh fi'l-bilād* (the shadow of God on earth) on the boxes, otherwise documented only in the tomb of Ghiyath al-Din at Herat, suggests that they should be dated to the 1190s. For the wooden fragments from Jam see Rugiadi (2006).

35. Anon. (1949), pt. 2, 16–17, 30–33. Bahrami (1949), 23, no. 52; Ettinghausen (1984a), 532; Afround (1996); Soucek (2000), 494, fig. 18.

36. Al-malik wa'l-sulṭān al-muʿaẓẓam shahanshāh al-ʿaẓam malik riqāb al-umam sulṭān al-salāṭīn fi'l-ʿālam ghiyāth al-dunyā wa'l-dīn muʿizz al-Islām wa'l-muslimīn qāhir al-kafara wa'l-mulḥidīn qāmiʿ al-bidʿa wa'l-mutamarridīn ʿaḍud al-dawla al-qāhira tāj al-milla al-zāhira jalāl al-umma al-bāhira niẓām al-ʿālam abū al-fatḥ Muḥammad ibn Sām, qasīm amīr al-muʾminīn: Iran Bastan Museum, manuscript no. 3507, fol. 198a. For a discussion of Ghaznavid and Ghurid titulature see Giunta and Bresc (2004), although with some errors; these include the

identification of the Ghiyath al-Din named on a bronze basin in the Great Mosque of Herat as the Ghurid sultan (217) when he is in fact the fourteenth-century Kartid ruler of the same name.

37. Maricq and Wiet (1959), 51–53; Lambton (1980), 129.

38. Jackson (1999), 4; Flood (2005a), 269.

39. Patronized during the reign of 'Ala' al-Din Jahan-suz (r. 544–56/1149–61), the Isma'ilis were persecuted by his son and successor, Sayf al-Din Muhammad ibn Husayn (r. 556–58/1161–63) and by subsequent Shansabanid sultans. As Juzjani puts it, the dispatch of the former "purified the territories of Ghur, which were a mine of righteousness and orthodoxy, from the pollution of the Qarmathian evil": Raverty (1970), 1:363–65; Juzjani (1963–64), 1:349, 351–52.

40. Malamud (1994), 42.

41. Al-Muqaddasi (1967), 41; Bosworth (1977c); idem (1977a); idem (1978); Collins and al-Tai (1994), 40; Massignon (1997), 175–83.

42. Al-Qazwini (1960), 430; Ibn al-Athir (1965–67), 12:151; Raverty (1970), 1:363, 365–66.

43. Bosworth (1978), 668; Sourdel (1976), 167–69.

44. On the subdivisions of the Karramiya see al-Shahrastani (1977), 111; Seelye (1966), 38; Bosworth (1978), 668.

45. Van Ess (2000), 341–44.

46. Van Ess (1980); Zysow (1988). I am grateful to Bernard Haykel for this reference.

47. Al-Qazwini (1960), 430; Ibn al-Athir (1965–67), 12:151.

48. Gilliot (1999), 146; Paket-Chy and Gilliot (2000), 107.

49. On Shah-i Mashhad see Glatzer (1973). For Jam see Sourdel-Thomine (2004), 31–32, fig. 14; Thomas, Pastori, and Cucco (2004), 92–93. The Karrami affiliations of the former are discussed in Flood (2005a) and idem (forthcoming b).

50. R. Stewart (2004), 168–78.

51. Al-Qazwini (1960), 430; Sourdel-Thomine (2004), 45–51.

52. Kumar (2007), 61.

53. Sourdel-Thomine (2004), 134.

54. Sourdel-Thomine (2004), 31–32; Flood (2005a), 272–73.

55. Fakhr-i Mudabbir (1927), 19–20.

56. Cahen (1965), 1107–8; Raverty (1970), 1:376–77. For a near-contemporary account of this event see Fakhr-i Mudabbir (1927), 18–19. A verse of the *Prithvīrājavijaya* (late twelfth cent. CE) laments the seizure of Ghazni by Mu'izz al-Din Ghuri and his defeat of the Lord of Horses (*hayapati*), who is either the Ghaznavid sultan or, more likely, the leader of the Ghuzz Turks who held the city until then: Pollock (1993), 276.

57. Pinder-Wilson (2001), 170–71.

58. Flood (2000). I owe the observation about the mihrab to Professor Doris Behrens-Abouseif.

59. Grabar (1959), 54–55.

60. Blair (1983b), 339; Edwards (1991b), 68–69. See also Ralph Pinder-Wilson (2001, 170) on the difficulties of accommodating the various prophetic references in Surat Maryam within an interpretative paradigm that emphasizes victory alone.

61. Madelung (1988), 41–42. The resulting implication of a limit on God's power (see chapter text) was especially abhorrent to the opponents of the Karramiya: Bosworth (1978), 667.

62. El-Galli (1970), 98, 104–6, 113–14, 118–20; al-Shahrastani (1977), 116; Bosworth (1978); Kazi and Flynn (1984), 93–94; Gimaret and Monnot (1986), 1:359.

63. Qur'an 2:117, 3:47, 3:59, 6:73, 16:40, 19:35, 36:82, 40:68. On the role of the phrase in *kalām* see Ceylan (1996), 143–44.

64. Wensinck [Johnstone] (1991), 629.

65. Qur'an 2:117, 3:47, 3:59, 19:35.

66. Al-Surabadi (2002–3), 2:1476–77.

67. These criticisms are found in the work of scholars such as Abu Mansur al-Baghdadi (d. 429/1037) and Abu'l-Muzaffar al-Isfara'ini (d. 471/1078): Bosworth (1978), 667; El-Galli (1970), 73.

68. Madelung (1991), 847.

69. Ibn al-Athir (1965–67), 12:151–52, 154; al-Qazwini (1960), 430. In their shifting affiliations, the Ghurids show the same religious eclecticism and equivocation as their Ghaznavid predecessors. Mahmud of Ghazni had, for example espoused the Karramiya before shifting his allegiances to the Shafi'is, while the Ghaznavids generally inclined toward the Hanafi *madhhab*: Bosworth (1977c). Favored by the Seljuq sultans, the Hanafis had a strong standing in Khurasan and were to eventually eclipse the Shafi'i presence: Chaumont (1997), 185–89. The citizenry of Ghur are reported to have adhered to Karrami doctrines in matters of religion (*dīn*) and Hanafi precepts in matters of law (*fiqh*). Madelung (1988), 40; idem (1985), 123; Bosworth (1977a), 8.

70. Bulliet (1972a), 28–47, 253; idem (1973), 90–91; Bosworth (1977c), 13; Madelung (1988), 36–37; Malamud (1994).

71. Raverty (1970), 1:371, 385. *Fitna* is a theologically charged term, which denotes "disturbances, or even civil war, involving the adoption of doctrinal attitudes which endanger the purity of the Muslim faith": Gardet (1965), 931.

72. Al-Qazwini (1960), 430; Juzjani (1963–64), 1:362; Ibn al-Athir (1965–67), 12:154; Raverty (1970), 1:384–85. The idea of conversion to a particular *madhhab* through the appearance of a vision or dream is a topos: Molé (1961), 113–14.

73. Anawati (1965), 751–55; al-Safadi (1931–), 4:249; Ibn al-Sa'i (1934), 4–6; Kraus (1937), 134–35; Ibn al-Athir

(1965–67), 12:154; El-Galli (1970), 24; Bosworth (1977a), 131. For al-Razi on the Karramiya see idem (1978), 101–2.

74. This was the *faqīh* Yahya ibn Rabiʿ: Ibn al-Saʿi (1934), 44. See also Ibn al-Athir (1965–67), 12:221; Raverty (1970), 1:243. Also relevant is Ibn Munavvar's dedication of the *Asrār al-Tawḥīd*, a biography of the sufi saint Abu Saʿid, who had clashed with the Karramiya, to sultan Ghiyath al-Din: Bosworth (1977c), 11. The author's emphasis on the fundamental unity of the Shafiʿi and Hanafi *madhhab*s may reflect the growing strength of both in the Ghurid domains in the second half of the twelfth century: J. O'Kane (1992), 588.

75. Blair (1985), 84; Potter (1992), 94.

76. Eaton (2001), 174.

77. Ibn al-Saʿi (1934), 5–6; Ibn al-Athir (1965–67), 12:152; Kholeif (1966), 19; El-Galli (1970), 58; Bosworth (1977a), 132.

78. Bosworth (1977a), 130–31.

79. Ibn al-Athir (1965–67), 12:154.

80. Malamud (1994), 50.

81. Noted by Deyell (1999), 196.

82. For pre-595 Ghurid issues from this mint see E. Thomas (1967), 12, nos. 1 and 2, pl. I, no. 2; Schwarz (1995), no. 539. Coins of traditional linear epigraphic form continued to be minted in both Ghazni and Firuzkuh after 595: ibid., nos. 539–57, nos. 812–14; Bates and Darley-Dorn (1985), no. 553.

83. E. Thomas (1967), 14, no. 4, pl. I, no. 3; Deyell (1999), 359, no. 239; Schwarz (1995), nos. 564–67. The type continued to be minted until the fall of the Ghurids and was later adopted by the Delhi sultans.

84. Bierman (1998), 62–70; Nicol (1988); Bacharach (2001), 9–11.

85. Balog (1980), 66–67, pls. III, nos. 33–35; Bates and Darley-Dorn (1985), 353, 372–74; Nicol (1988); Bresc (2001), 33, no. 3; 36, no. 8, 37, nos. 11–12.

86. Raverty (1970), 1:214; Flood (2001c), 6.

87. Cahen (1960), 802–3; C. Hillenbrand (2004), 282–84; Tabbaa (2001), 53–72.

88. Morton (1978); Spengler (1984), 115.

89. The same verse had appeared earlier on Samanid and Seljuq dirhams struck at Bamiyan and Balkh: Mitchiner (1973), 122, 133–34. After this date, the verse begins to appear on some Ghurid coins of "traditional" epigraphic type.

90. In 387/997, for example, Mahmud of Ghazni issued a silver dirham endowed with a Qur'anic verse associated with the theological position of the Hanafi-Muʿtazili faction then competing for political authority in the fractious city of Nishapur: Bulliet (1969). See also Bulliet (1978), 43.

91. Lambton (1980), essay 2, 131–31, 139. Some legal scholars go so far as to assert that the killing of heretics is more meritorious than campaigns against non-Muslims: Lambton (1991), 211, 213.

92. Fakhr-i Mudabbir (1967), 4. See also Wink's comments on the close relationship between *jihād* (holy war waged against an external non-Muslim foe) and *fitna* (civil war, waged against elements of the recalcitrant Muslim self) along the eastern frontier: Wink (1996), 127, 197.

93. Lambton (1980), essay 2, 139. See also Fakhr-i Mudabbir (1927), 16–18.

94. Blair (1985), 83.

95. Mirkhvand (1994), 2:787.

96. Juvayni, (1912–37), 2:62.

97. Glatzer (1980); Stuckert (1980); R. Hillenbrand (2000), 125; idem (2002).

98. Melikian-Chirvani (1970), 323–34. A similar formula occurs in the foundation text of a mosque built by a merchant at Cambay in Gujarat in 615/1218: *EIAPS* (1961), 6. Cognate terms used in contemporary Anatolian foundation texts emphasize personal expenditure rather than the use of a treasury grant: Rogers (1976), 89.

99. See chapter 4.

100. Kafadar (1995), 91.

101. Bosworth (1998), 105.

102. Hardy (1983), 169.

103. This is among Muʿizz al-Din's titles on the Qutb Minar and may be alluded to in one of his Indian coin issues: Wright (1936), 7 no. 15a; *RCEA* no. 3619. For later usage see Davidovich and Dani (1992), 415, and chapter 7. The rhetorical representation of Afghan sultans as new Alexanders by virtue of their Indian conquests is found already in Ghaznavid court poetry, in which sultan Mahmud is compared to or eulogized as a second Alexander: Bosworth (1973b), 61; idem (1994), 335.

104. Ganguly (1942); D. Sharma (1975), 69.

105. Raverty (1970), 1:110.

106. Ibn al-Athir (1965–67), 12:105; Elliott and Dowson (1990), 2: 251.

107. E. Ross (1922), 397; Fakhr-i Mudabbir (1927), 20. On the connotations of "Hindu" in pre-Mongol Persian literature see Ernst (1992), 24, 30–31.

108. Al-Qazwini (1910), 407; Bosworth (1977a), 125. Bosworth notes the uncertainty about whether any such Indian influences penetrated Ghur, but as Kieffer notes (1962, 4), the name may suggest a relationship with sun worship.

109. Ibn Ibrahim (1886), 25-26, 49; Goitein (1954), 193; al-Idrisi (1954), 60; S. M. Ahmad (1960), 60; Elliott and Dowson (1990), 2:201.

110. Raverty (1970), 1:557; Amin (2004). See also Nizami (2002), 82–83.

111. Bhatia (1978); Tye (1988), 6; Tye and Tye (1995), 51; Deyell (1999), 79.

112. On the mining of earlier Hindu Shahi types for the designs of Ghurid copper coinage see Tye and Tye (1995), 51.

113. Schwarz (1995), 70, no. 809.

114. Chapter 6.

115. Qur'an 17:18; Khadduri (1971), 180.

116. Ghafur (1960), 147.

117. Pollock (1993), 277. We are also told that the envoy wore a *choga*, a long robe related to the *qabā*, suggesting that dress was part of this inscription of difference: Sarda (1913), 279; Goswamy (1993), 87–88.

118. Pollock (1993), 276.

119. Thapar (1971), 409.

120. Elliott and Dowson (1990), 2:213; Saroop (1998), 53–54. The same individual appears later during the Ghurid campaigns in Rajasthan and seems to have ended up in the service of the Delhi sultan Iltutmish: Kumar (1992), 24–25; Jackson (1999), 41–42. See B. Chattopadhyaya (1998), 81.

121. Nizami (2002), 343.

122. *IA* 20 (1891); Pollock (1993), 276.

123. Hardy (1983), 169.

124. D. Sharma (1944), 65; Awasthi (1962), 140; Pollock (1993), 270, 273; Talbot (1995), 695–704.

125. Wink (1992a), 768.

126. Willis (1985), 245.

127. M. Habib (2001), 58; Davis (1994a), 303. The dichotomy inherent in the latter scenario is not only essentialist but anachronistic, entailing a peculiarly modern ambivalence about "political" violence and warfare, both of which were central to premodern state formation, whatever the model followed. On this point see Talbot (2001), 201.

128. Jackson (1999), 281. See also Hardy (1998), 229–31.

129. Hardy (1998), 217.

130. Ferguson and Mansbach (1996), 36.

131. Halperin (1984), 398, 465–66. Kafadar (1995), 79.

132. Jackson (1999), 12.

133. Sircar (1955); D. Sharma (1954)

134. P. Singh (1988). On the fate of Prithviraja see Hasan Nizami (n.d.), fols. 48b–49a; Askari (1963), 62; Elliott and Dowson (1990), 2:214–15. A manuscript of Rashid al-Din's *Jāmi' al-Tawārīkh* in the Rampur library reportedly states that Mu'izz al-Din intended to reinstate Prithviraja: Nizami (1997), 184. By contrast, Jain sources indicate that he was executed: Somani (1981), 81.

135. Hasan Nizami (n.d.), fols. 49a–b; Askari (1963), 62; Saroop (1998), 67. Elliott and Dowson (1990), 2:216. There has been some confusion over the name of the son, but a *praśasti* (inscribed eulogy) of the Chauhans of Rant-

hambor dated Samvat 1345/AD 1288 names Govindaraja as Prithviraja's son: *EIAPS* (1927–28), 47–48. See also IA 41 (1912), 88; Prabha (1976), 295.

136. Elliott and Dowson (1990) 2:216; Saroop (1998), 70. A permanent Muslim garrison was, however, installed in the nearby Indraprastha: Jackson (1999), 10.

137. Hasan Nizami (n.d.), fols. 157b–158a; Fakhr-i Mudabbir (1927), 23-24; Askari (1963), 84; Juzjani (1963–64), 1:421, 448; A. Husain (1966–77), 1:157–59; Raverty (1970), 1:546; Elliott and Dowson (1990) 2:227–28; Kumar (2007), 109.

138. Hasan Nizami (n.d), fols. 135a–b, 137a; Askari (1963), 75, 77n; Tripathi (1989), 333–35; Elliott and Dowson (1990), 2:223; Prasad (1990), 58–70; Kumar (2007), 110–13.

139. Hasan Nizami (n.d.), fols. 77b–80b, 142b; Askari (1963), 68–69, 80–82; Saroop (1998), 192. An inscription on an icon dedicated in Hariraja's name from Tantoli shows that the area was under his control in Vaisakh Vadi VS 1251/April AD 1194: Sarda (1913), 268, n. 16; *EI* 12 (1913–14), 223; Prabha (1976), 295, 309.

140. Hasan Nizami (n.d.), fol. 14b; Askari (1963), 81; Raverty (1970), 1:547; Prabha (1976), 151; Elliott and Dowson (1990) 2:219–20, 225–26; Saroop (1998), 184; Jackson (1999), 12.

141. See p. 119.

142. Talbot (2001), 209.

143. Lambton (1980), essay 6, 429; Dankoff (1983), 177; Meisami (1991), 301.

144. Most Sunni law schools are agreed on four basic modes of dealing with non-Muslim foes and their territories: acceptance of Islam and the retention of all lands without the requirement to pay *jizya* (poll tax) and *kharāj* (land tax); voluntary capitulation ('*anwatan*) with the requirement to pay *jizya* and *kharāj*; defeat by military means and the incorporation of conquered lands into the *dār al-Islām*; reconstitution as tributaries through treaty, so that the lands in question become part of the *dār al-'ahd* (land of the covenant), an intermediate space between the *dār al-Islām* and *dār al-ḥarb*, and its inhabitants pay *jizya* (poll tax) and *kharāj*: Fagnan (1915), 289; Ben Shemesh (1967), 30; Fakhr-i Mudabbir (1967), 404; Khadduri (1955); idem (1971), 180.

145. Fagnan (1915), 289; Lambton (1991), 216–17. On the question of whether *jizya* was acceptable from those who were not People of the Book (Christians, Jews, Zorastrians), the Hanafis, the major law school in India, tended to take a more liberal attitude than the Shafi'is. With the exception of Arabian idol worshippers (an extinct category), *jizya* was acceptable from nonbelievers: Hardy (1983), 168.

146. Kautilya (1992), 613; See also Inden (1981), 114.

147. Hardy (1998), 230.
148. L. Gopal (1963), 26–30.
149. Schnepel (2001), 289.
150. Ibn al-Athir (1965–67), 11:171–72; Raverty (1970), 1:449–51n. For precedents see Talbot (2001), 155–56. There is a possible confusion here with the daughter of Ghiyath al-Din, who is known to have been buried in Herat: Raverty (1970), 1:344.
151. Hardy (1998), 229–31.
152. Nainar (1942), 147.
153. See, for example, the deposition of Malik ʿAbbas, the tyrannical ruler of Ghur, by his Ghaznavid overlord sultan Ibrahim (r. 451–92/1059–99), after which the former's son was installed in his stead: Raverty (1970), 1:332.
154. Jackson (1999), 19; Hasan Nizami (n.d.), fol. 150a; Askari (1963), 82.
155. T. Hall (1986), 398; Ferguson and Mansbach (1996), 44.
156. Nizami (1966), 23; de Epalza (1999). See also Friedmann (1972), 182.
157. Cahen (1953); idem (1971); Lambton (1980), 358; idem (1988b), 104. For the Indian *iqṭāʿ* see I. Habib (1992), 11–12.
158. Jackson (1990); I. Habib (1992), 6–7. Members of the Afghan elite were active during the initial period of conquest and subsequent administration in areas west of the Gangetic Plain, but involvement east of the Indus appears to have marked a temporary interlude in administrative careers rooted in the Afghan heartlands. In fact the nobles of Ghur played a notable role in the administration of northern India only after the collapse of the Ghurid sultanate and the onslaught of the Mongols in the first decades of the thirteenth century: Jackson (1990), 344; Kumar (1992), 15–17; idem (2007), 63–77.
159. Kumar (1992), 44–45.
160. Jackson (1999), 12. Just as the Ghurid sultanate itself developed rapidly, the *cursus honorum* of the Muʿizzi *bandagān* was considerably accelerated compared with that of mamluks in other parts of the Islamic world: Kumar (1992), 43.
161. I. Habib (1992), 5–6.
162. Kumar (1992), 60–62.
163. Nizami (1983), 56.
164. M. Habib (1974–81), 1:104. See also K. Gopal (1963–64), 86–89, 91–92, 98–100; Nizami (2002), 34.
165. R. Sharma (1961), 73, 78–80; K. Gopal (1963–64), 80, 84; Jackson (1999), 9.
166. L. Gopal (1963), 27, 34–35; Lambton (1980), 233–34; idem (1988), 104.
167. These were the counterparts of the *rāīs* and *rānās* who served among the forces that defended the Ghaznavids from the Ghurid onslaught: E. Ross (1922), 402; Hardy (1998), 238. For the passage mentioning *rāuta*s and *thākur*s see Fakhr-i Mudabbir (1927), 33; Hardy (1998), 241; Jackson (1999), 21. In one case we hear of a tributary raja serving in the Ghaznavid army, an obligation that was also among the duties of a tributary within the Indic traditions of kingship: S. R. Sharma (1941), 144. See also B. Chattopadhyaya (1995), 227.
168. Cahen (1971), 1089. See also Kumar (2007), 99–100.
169. Lambton (1991), 216–17
170. Wagoner (1999); Talbot (2001), 279n.
171. Wagoner (1996a); Eaton (2001), 161, 163. On the technological dimensions of these interactions see I. Habib (1979), 158–60.
172. *EI* 4 (1900), 118, 120; *EI* 9 (1907–8), 321; Avasthy and Ghosh (1936), 170–71; Mazumdar (1960), 126; A. Ahmad (1999), 81.
173. Broadhurst (1952), 339–40; Johns (2004), 244–45.
174. Wagoner (1999). See also Kafadar (1995), 82. Cormack (1992), 229–30.
175. Hardy (1998), 219.
176. Hasan Nizami (n.d.), fol. 134b; Askari (1963), 75.
177. Bhattacharya (1954), 115–16; Gupta (1973); Deyell (1999), 195–206.
178. Fakhr-i Mudabbir (1967), 117. The conservatism of northern Indian numismatic tradition is attested by the fact that among the many complaints made against Harsha, the iconoclastic eleventh-century ruler of Kashmir, is that he adopted Deccani fashions at court, including a new coinage based on Deccani models: M. Stein (1989), 7:926.
179. Elliott and Dowson (1990), 2:201. By the thirteenth century, the Hindu merchants of Gujarat were being praised in Persian sources for their honesty, in contrast to their Muslim contemporaries: Siddiqui (1992b), 29.
180. Kumar (2007), 269.
181. Kumar (2001), 161.
182. It has, for example, been argued that the Sasanian coin types featuring a royal portrait continued to be issued after the Arab conquest of Iran in 652 because the portrait "had come to be associated with the concept of a valid silver coin to such a degree that the Muslim administrators feared that its adaptation or removal would have caused it to be rejected in the market-place": Treadwell (2000), 230. For the Crusader coins see Metcalf (1999), 166–69. See also Wasserstein (1993), 305.
183. On this question and for other examples see Ivir (1987), 44. For the Crusader coins and other examples of omission in the context of cross-cultural exchanges see A. Watson (1967), 10; Pym (1994), 54–55; Grabar (1998), 118, 126.
184. Gonda (1966), 21, 46; D. Ali (2004), 114. The term *śrī*

first appears on Hindu Shahi coins: Bhattacharya (1954), 117–18; Deyell (1999), 52–53.

185. See chapter 6, pp. 255–60.

186. *Islamic and Indian Art*, Thursday 29th April 2004, Bonham's, 115–17, no. 293.

187. See also Bühler (1892), 11; Elliott and Dowson (1990), 2:69.

188. Juzjani (1963–64), 1:388; Raverty (1970), 1:429.

189. Porter (1993), 105.

190. Pancaroğlu (2004), 156.

191. Shukurov (2001), 260–61, 269, 275–76. See also Whelan (1980); idem (2006), 50–72; Oikonomidès (1983); Wolper (2003), 9.

192. Kafadar (1995), 72.

193. Flood (2001c), 221.

194. Deyell (1999), 201–6.

195. Sachau (1989), 1:18.

196. Ibid., 207. On the issue of numismatic imitations, epigraphy, and medieval literacy, see Bulliet (1969), 123–24.

197. Hasan Nizami (n.d.), fol. 80b; Askari (1963), 68; Saroop (1998), 110; Raverty (1970), 1:517, n. 2. For examples of Mu'izz al-Din gifting items from the royal wardrobe see Raverty (1970), 1:366, 500.

198. Howell (1989), 422.

199. Nizami (2002), xxxvii. This practice continued under the sultans of Delhi. See, for example, 'Ala' al-Din Khalji's bestowal of a *durbash* (mace) and banners on the Kakatiya raja of Warangal: Elliott and Dowson (1990), 3:561.

200. Greenblatt (1980), 1.

201. Helms (1993), 180. See also Elias (1994), 466.

4 | Looking at Loot

1. Zamzama's checkered history is outlined in more detail by Latif (1892), 383–85.

2. Kipling (1989), 3. My attention was drawn to this passage by Gyan Prakash's provocative article on science and the museum in colonial India: Prakash (1992), 153. While Prakash is more interested in the museum than the gun, his discussion of the production and reception of histories articulated around the artifact is relevant to what follows here. Abe's ([1995], 64) interpretation of Zamzama as a "symbol of colonial power," while clearly true, is too reductive. The semiotic power of the gun in a colonial context is inextricably linked not just to the nature of the object but also to its precolonial history, if not the notion of history itself. The repositioning of the much-historied gun outside the colonial museum, where figurative and material constructions of Indian past coincide, is hardly fortuitous.

3. But see Shalem (1998); P. Walker (2003).

4. A. Weiner (1992), 36–37. See also Kopytoff (1986), 73.

5. Gell (1998), 68.

6. Raverty (1970), 1:418.

7. Hasan Nizami (n.d.), fol. 257a; R. Sastri (1920), 424; Geiger (1953), 44:18–20; Bosworth (1960–61), 74; idem (1986a), 197; Busse (1973), 69; Brand (1986), 212, 215; A. Weiner (1992), 6; Andrews (1993), 193; M. Hasan (1994b), 100.

8. N. Thomas (1991), 206.

9. Kopytoff (1986), 67.

10. A. Weiner (1992), 11.

11. Grierson (1959).

12. Redlich (1956), 15, 73, 78. By "looting" I mean the appropriation of objects valued for either their intrinsic properties or their symbolic significance during periods of warfare or social disorder.

13. Davis (1994a), 310–13; Hevia (1999), 192, 196. Although it came to designate a range of activities viewed in strictly negative terms, the topic of looting received little detailed attention in nineteenth-century writing on Indian history: the very act of naming seems to have precluded the need for any such analysis.

14. Skeat (1882), 406. In contrast to *booty*, which had entered into English usage by the fifteenth century, the earliest recorded passage of the term loot into English is in 1788: *Oxford English Dictionary* (1989), 2: 408; Yule and Burnell (1968), 519–20. In early usage *booty* is glossed by "plunder" and "pillage," a trend that has continued subsequently.

15. Davis (1994a), 311.

16. Flood (2004).

17. In fact, in certain nineteenth-century English dictionaries, *loot* is glossed by "rupture:" Skeat (1882), 302.

18. Flood (2007b) and (2008).

19. Anon., "Gold Diggers," *Outlook*, January 1 (1997), 3.

20. Richards (1983), 186–87.

21. Altekar (1967), 155. For numerous examples of medieval intra-Muslim royal looting in which vast quantities of precious metals were plundered see al-Qaddumi (1996), nos. 228–29, 237–38.

22. M. Hasan (1994b), 41. Such spectacles recall earlier displays of treasure to impress visitors to the 'Abbasid court in Baghdad and later descriptions of the Central Asian ruler Timur enthroned amidst his booty before an audience of subjects, foreign ambassadors, and the conquered: Manz (1988), 120–21.

23. Hultzsch (1899), 70.

24. Reynolds (1858), 342–43; Richards (1983), 189–90.

25. Bosworth (1963), 78; idem (1968a), 38.

26. Idem (1977b), 97; M. Hasan (1994b), 71.

27. Davis (1994b), 162–74, 297. See also Ariyapala (1956), 68–70; Dayalan (1985), 134–37.

28. *EI* 4 (1895–96), 239; Geiger (1953), 125–27; Chidanandamurthy (1973), 86–87; Davis (1993), 31, 37.

29. Davis (1994b), 167. See, for example, the lengths to which the Chola rulers of southern Indian went in the tenth century to recover the royal regalia of their enemies, the Pandyas, from the kings of Sri Lanka, with whom they had been deposited for safekeeping: Spencer (1976), 409.

30. Davis (1994a), 298. In the tenth century, the Rashtrakuta rajas boast of having taken Bengal's umbrellas of state: *EI* 9 (1907–8), 38–39. In the following century, the Ganga prince Marasimha II records his capture of the jeweled earrings, rutting elephants, and other possessions of the lord of the Vanavasi country: *EI* 5 (1898–99), 153. In the eleventh century, the Cholas record their capture of elephants, banners, conches, parasols, crowns, thrones, yak-tail fans, trumpets, drums, canopies, and ornamental arch (*makara-tōraṇa*) from their Chalukyan and Pandyan enemies (Hultzsch [1899], 37, 56), while the Chandellas record the seizure of banners and musical instruments from rival kings, along with elephants and gems: *EI* 9 (1907–8), 205–6.

31. See, for example, the golden image that came to rest in the Lakshmana Temple at Khajuraho after twice being looted and once given as a gift, facts recorded in the foundation inscription of the temple that housed it: *EI* 1 (1898–91), 134; Davis (1993), 29.

32. Davis (1994a), 302. These remarks address Ghaznavid campaigns in northern India—Davis does not discuss the Ghurid conquest of a century later that forms the focus of this chapter. However, even the Ghaznavid sultans may have been more aware of the semiotic capacity of looted objects and royal regalia than the primary and secondary sources would suggest. For example, the taking of golden chains from the necks of Rajput rulers is often mentioned in Ghaznavid sources. See, for example, the pearl necklace(s) taken from the Hindu Shahi raja Jaipal in 392/1001, which may be the *ekāvalī*, the pearl chain mentioned among of the royal regalia of certain South Asian rulers, suggesting that more than their monetary value may have been at stake: M. Habib (1941), 132; Geiger (1953), 1:86; Ariyapala (1956), 69–70; Ranking (1976), 1:18; Bhatnagar (1991), 139; Hasan (1994b), 34.

33. For example, the chapter on looting in Fakhr-i Mudabbir's *Ādāb al-Ḥarb*, written in Delhi in the early thirteenth century: Fakhr-i Mudabbir (1967), 398–407. In a history of the Ghurid conquest by the same author, we are told that livestock, textiles, gold, and silver were seized, but no details of specific objects are given: Fakhr-i

Mudabbir (1927), 28. Among rare exceptions see al-Biruni's description of especially valuable rubies looted from specific rulers and temples: H. Said (1989), 47, 65, 73.

34. Wink (1997), 124–26, 141–42. Of the booty seized during Mahmud of Ghazni's raid on Bhimnagar in 399/1009, al-'Utbi reports that "the clerks could not prepare an inventory and the imagination of the accountants failed to grasp it in their number." S. Sharma (1941), 141. Similarly, Ibn Athir reports that 1,400 camels were needed to transport the booty seized by the Ghurids in Benaras back to Ghazni: Hasan (1994), 86. While we should obviously be circumspect about taking such figures literally (as does Richards [1983]), they were clearly intended to impress on the reader the vast quantities in which booty was seized, and are therefore something more than a topos: Reuter (1985), 76. On the problem of calculating precise amounts of booty from figures given in medieval histories see Ferrard (1971).

35. Juzjani (1963–64), 1:408–9; Raverty (1970), 1:399, 488, 494.

36. Juzjani (1963–64), 1:375; Raverty (1970), 1:404. On Juzjani see Nizami (1983), 71–93. Both Raverty (1970, 1:404, n9 and 517n2) and Habibi (Juzjani[1963–64], 1:375n2) see the term *kharbūza* as a figurative reference to the kettledrums. At least one variant of this text has *jarīra* for *kharbūza*: Kieffer (1960), 50–51. As Habibi points out, this is almost certainly a corruption arising from the difficulties in distinguishing between the two in the absence of diacriticals. Depending on the value of the *mann*, the melons could have weighed 300 kilos or more. Raverty ([1970], 1:488n8) assumes that Juzjani is using the Tabrizi *mann*, which is just over 0.8 kilo. For alternative values of up to 6 kilos for the *mann* in various parts of medieval Iran and India see Hinz (1955), 17–27; Thackston (1999), 473.

37. Hasan Nizami (n.d.), fol. 80b; Askari (1963), 68; Saroop (1998), 110. On Hasan Nizami see Nizami (1983), 55–70.

38. Although the term *maqṣūra* usually refers to a royal enclosure, in South Asian usage it denotes the prayer hall itself: Flood (2007b), 105.

39. Fakhr-i Mudabbir (1927), 22–23. See also E. Ross (1922), 398.

40. Al-Isfizari (1961), 27–28. Since *ṭāq* is sometimes used as a synonym for *īwān* (al-Qazwini [1910], 1:229), the *ṭāq-i maqṣūra* was presumably the qibla *īwān*. For the Ghurid parts of the mosque see Melikian-Chirvani (1970); Stuckert (1980).

41. There is nothing implausible in the Great Mosque of Firuzkuh being destroyed by flooding; in 422/1031 the commercial center of Ghazni had been destroyed by a deluge of spring meltwaters: Bosworth (1963), 139.

42. Frye (1965); Bosworth (1999), 637.

43. See chapter 1 p.28 for a discussion of Islamic looting protocols.

44. Fagnan (1915), 268; Løkkegaard (1950), 45; idem (1965a) and (1965b); Ben Shemesh (1967), 29; S. Hasan (1979).

45. Hardy (1965), 566. In this sense, they bear comparison to *pīshkash*, the tribute offered as gifts by the vassals of later Persian rulers as a token of submission, which often elicited robes in return: Lambton (1994) and (1995). On the juridical implications of Muslim rulers accepting gifts from non-Muslims see Rosenthal (1990), 138–39.

46. As Spencer notes apropos the Chola economy, "we should envisage a taxation-plunder continuum in which taxation serves as the form of exaction imposed in areas where the dynastic power is strongest, tribute as the form imposed on more peripheral/powerful chiefs, and plunder as the irregular exaction taken from the most distant places which were ordinarily subject to rival dynastic centers": Spencer (1976), 406. On the rather fluid interrelationships between gifts, tribute, and tax in the medieval Mediterranean see Cutler (2001b), 256, 263.

47. Jackson (1999), 21.

48. See chapter 5.

49. Raverty (1970), 1:610–11.

50. See chapter 3.

51. According to Juzjani and other sources, Iltutmish is said to have been the first to capture the fort, in 623/1226: Raverty (1970), 1:610–11. By the middle of the thirteenth century the fort was apparently back in Rajput hands, its ruler being described as "the greatest of the kings of Hind": Wink (1997), 230. Its recapture by ʿAlaʾ al-Din Khalji in 700/1300 is recorded in Persian and Sanskrit sources: Bandyapadhyaya (1879); M. Habib (1931), 37–41. At some subsequent point Ranthambor was regained by the Rajputs, being taken by Akbar in 976/1569. For depictions of this event see Topsfield (1984), 15, fig. 7; Sen (1984), 54–55, pl. 5.

52. Iskandar (1981), 290. Such sketchy references to booty as one finds in the Islamic sources often serve to highlight the intersection between natural and man-made *ʿajāʾib* in India. See, for example, reports of a giant snake killed during Mahmud of Ghazni's expedition to Somnath and displayed in the citadel of Ghazni: Raverty (1970), 1:82n2.

53. See note 32 above. For a golden chain with bells in the temple at Somnath that weighed 200 manns see Elliott and Dowson (1990), 2:472; Hasan (1994b), 53. The Chola ruler Rajaraja I dedicated eight golden chains (*koḍi*) with golden flowers to the Thanjavur temple: Hultzsch (1891), 11.

54. *EI* 3 (1894–95), 11, 14.

55. Kramrisch (1996), 2:355–56. I owe this suggestion to Dr. Debra Diamond. In the Delhi sultanate at least, Central Asian melons were considered appropriate as royal gifts: Siddiqui (1992a), 125.

56. *EI* 15 (1919–20), 325; Choudhary (1964), 376. Such drums were usually paired, as was the case with the drums taken to Afghanistan. It has been suggested that the kettle drum was introduced to South Asia, as it was to Europe, by the Arabs: Dagens (1985), 282. See also see Blades and Anderson (1984), 379; Dick (1984a), 89.

57. Nazim (1927), 487, 491; Shafi (1938), 221, 223. In contrast to other parts of the medieval Islamic world, where drums seized as booty were silenced either by being inverted or cleft in two (Ayalon [1986], 189), the looted drums donated by Sultan Ghiyath al-Din to the Friday Mosque of Firuzkuh apparently remained intact. Their display within the *pīshṭāq* of the Firuzkuh mosque no doubt reflects an emphasis on visibility; several centuries later, the entrance was also the chosen location for a pair of kettledrums expropriated from Dawud Khan, the sultan of Bengal, in 1574 and donated by Akbar to the shrine of the sufi saint Muʿin al-Din Chishti at Ajmir: Sarda (1941), 87. At least in the sultanate period, the entrance to mosque, palace, or shrine was the traditional site of the *naqqāra-khāna* (drum house) which sheltered the *naubat* associated with both the notation of the hours and the call to prayer: Farmer (1929a), 154; N. Jairazbhoy (1970), 377, pl. 2; Baily (1980), 5; Lambton (1993); Farmer (1998), 34; Wade (1998), 7–8. Even here there is a clear link between the religious and political function of the drum, for the *naubat* could be ordered to fall silent in times of military defeat, only to be reprised when a ruler had gained victory: Farmer (1998), 36.

58. Bayhaqi (1971), 524; Elliott and Dowson (1990), 2:129.

59. Bhatnagar (1991), 10.

60. Nizami (1997), 54; Farmer (1998).

61. Al-Muqaddasi (1967), 315; Collins and al-Tai (1994), 277.

62. A. Siddiqi (1953), 71; Lambton (1993), 35; Farmer (1998), 35. On the devolution of honors see Ibn Khaldun: Rosenthal (1967), 2:50–52. The arrogation of the privilege of having drums sounded could be construed as an act of rebellion: Lambton (1993), 928. Conversely, drums could be reappropriated to signify a loss of status consequent on the recipient incurring the displeasure of his sovereign: Wade (1998), 130, figs. 84–85.

63. Juzjani (1963–64), 1:361; Raverty (1970), 1:383. The *naubat* was the orchestra, "by which the presence and sover-

eignty of the emperor was announced, enunciated, reiterated and symbolized": Wade (1998), 5–6, 11, fig. 9. Such orchestras were normally housed in pavilions above the entrances to city gates or princely residences. Ghurid reticence may have been part of a more widespread effort to reform the practice of distributing honors, for at the same period, at the opposite end of the Islamic world, the Almohad rulers of the Maghrib restored the use of banners and drums to the ruler alone: Rosenthal (1967), 2:51. Ghurid sultans, however, continued nonetheless the tradition of conferring drums and banners on their vassals: Askari (1963), 93; E. Ross (1922), 397.

64. See, for example, the reference to the gilded pinnacles of the Shiva temple at Shikar in Rajasthan: R. Mishra (1990), 57, 65.

65. N. Ahmad (1988), 13; Meisami (2001), 28.

66. Cited in Dirks (1982), 673.

67. Inden (1981), 105; Dubey (1987), 86; Meisami (2001), 28.

68. Bühler (1892), 17; Bhavnagar (1894), 84, 95, 191; *Annual Report on the Working of the Rajputana Museum, Ajmer* (1914–15), 3; *IA* 62 (1933), 41; Prabha (1976), 166; Somani (1982), 163; Shah (1990), 284; Kramrisch (1996), 2:355–56. Lesser kings were sometimes present as witnesses at such ceremonies, as when the *dhvaja* of a Jain temple at Ajmir was set in place by Vigraharaja IV in the presence of the rulers of Malwa and Arisingh: Somani (1981), 139.

69. Iyer (1987), 186 (chapter 43: 63).

70. The term used is *daqal* (mast): al-Baladhuri (1968), 437; Murgotten (1969), 2:217–18; al-Kufi (1983), 78–79; Fredunbeg (1985), 81–83.

71. Bhatnagar (1991), 10.

72. For the redistribution of booty among vassals in Sanskrit texts and medieval practice see Davis (1994a), 296. The practice was consonant with Islamic law and royal tradition governing the disposal of booty, and was continued by the sultans of Delhi: M. Habib (1931), 117–18, 120; Elliott and Dowson (1990), 3:541.

73. Raverty (1970), 1:402n, 519n; Boyle (1958), 1:332; Elliott and Dowson (1990), 2:251. White elephants appear to have been especially valued, for a Central Asian traveler describes one kept by the Hindu ruler of Vijayanagara in the fifteenth century: Thackston (1989), 309. White birds were among the rarities sent by the Byzantine emperors to the Fatimid caliphs of Cairo: Cutler (1999b), 638.

74. An analogous sentiment was expressed by the reported use of the battlements of a pre-Islamic Sasanian palace as the foundations of a palace built by the ʿAbbasid caliph al-Muktafi: Wendell (1971), 127.

75. Huart (1971).

76. Algar (1982), 395.

77. Nizami (1997), 51. On the association between kingship and bird in Central and East Asia see Waida (1978); Cammann (1957), 22. For depictions of the royal parasol surmounted by a golden bird from the fourteenth century onward see Andrews (1999) 817–18, fig. 156.

78. Nizami (1997), 51; Saroop (1998), 152.

79. Z. al-Qazwini (1960), 430.

80. Archer, Powell, and Skelton (1987), 134, no. 213.

81. Forrest (1970), 355, fig. 15a. On the British sack of Sri Rangapattan see Davis (1994a), 304–10.

82. Thomas (1991), 184. See also Davis (1994a), 294.

83. Pinder-Wilson (1985), 100.

84. Shalem (1998), 72–73.

85. See, among others, Irwin (1987), 135; idem (1989), 402.

86. Similarly, however exotic they appeared, the golden objects brought to Europe from the Americas in the early sixteenth century were assimilated to known categories of objects in contemporary descriptions: Greenblatt (1991), 52–53. See also Thomas (1991), 125.

87. Le Strange (1912), 26–27.

88. Minorsky (1948), 630n2.

89. Golden birds were also among royal donations to temples [Hultzsch (1891), 18], and an inscription mentions the gifting of a golden Garuda to the temple of Vishnu in S 1517/AD 1460 by the Rana Kumbha: *Annual Report on the Working of the Rajputana Museum, Ajmer* (1926), 3. Later Persian artists endowed the thrones of Indian kings that they depicted with golden birds, assuming a shared iconography of kingship: see, for example, Ettinghausen (1984b), 497, fig. 4.

90. Thomas (1991), 28, 123. On the role of naming see B. Brown (1998), 954; Mitchell (2005), 156.

91. Brand (1986), 223. For comparisons between the formal qualities of the crowns worn by Indian rulers and the domes with which they endowed royal temples see *EI* 3 (1894–95), 17.

92. The visual articulation of victory finds parallels in later Ghaznavid poetical descriptions of palaces, where there is a shift in the rhetorical function of the palace, so that it becomes "more a trophy than a locus of artistic achievements": Meisami (2001), 41. In this respect, it is noteworthy that the only information available on the Ghurid palace concerns neither its architectural form nor its decoration, but its role in the display of Indian booty.

93. *IA* (1885); Chidanandamurthy (1973); Inden (2000a), 250–52.

94. Inden (1981), 115.

95. See, for example, Spencer's appraisal of Chola expansion in southern India, which he attributes to economic and

strategic concerns, to the prospect of plunder and the desire to neutralize potential rivals: Spencer (1976), 419.

96. P. Walker (2003), 372–73.

97. The best example is the golden window grille in the caliphal palace in Baghdad, from behind which the ʿAbbasid caliph gave audiences. This was looted in 450/1058 by the renegade general al-Basasiri, who dispatched it to the Fatimid countercaliph al-Mustansir (r. 427–87/1036–94) in Cairo, along with other key items of the caliphal insignia. Once in Cairo, the grille was kept in the Fatimid palace, then incorporated into a series of buildings until, 250 years later, it finally came to rest in the funerary dome of the Mamluk sultan Baybars al-Jashankir (d. 709/1309): ibid., 377–78.

98. The use of the Kaʿba as a type of treasury predates Islam: Shalem (2002); Rubin (1986), 115–18. See also Grabar's discussion of the Dome of the Rock as a type of *tropaion*: Grabar (1959).

99. Chamberlain (1994), 58. There are early Islamic precedents for this practice, for ʿAli sent the booty gleaned in the Battle of the Camel in 35/656 to the Friday Mosque of Basra: Pedersen (1991), 669.

100. Dodds (1992), nos. 55, 58. See also the treatment of the Ottoman loot from Buda: while classicizing sculptures were displayed in the Hippodrome, the candelabra seized from that city's cathedral served to light the mosque into which Hagia Sophia had been transformed: Corvinus (1982), 313–4, no. 263; Török (1992), 265.

101. Davis (1997), 61–62. Silver and gold seized as booty could either be donated to temples, disposed of to pay for donations to temples, or melted down to produce objects or materials used to adorn temples: Hultzsch (1892), 236, 242–43; Venkayya (1913), 415–16.

102. See chapter 6, pp. 246–50.

103. I have suggested elsewhere that the commemorative traditions of contemporary Indian rulers may have inspired Ghaznavid use of the minaret as a victory monument: Flood (2001a).

104. See Kroeber (1940), 1. What I am calling "cultural borrowing" here might equally well be termed "cultural influence" according to Oleg Grabar's definition: "it is appropriate to talk of influences when the receiving organism adopts features from an alien source without being driven to them, without requiring them": Grabar (1986), 442.

105. The role of absence is noted by Jackson (1999), 237. See also P. Walker (2003), 371, 373, 381, on looting and the meaning of loss.

106. Eaton (2000), 262. See also Kumar (2007), 50.

107. Siddiqui (1992a), 35. See also Meisami (1993), 265.

5 | Remaking Monuments

1. Burton-Page (1965b), 441.

2. P. Brown (1944), 1:1. In other accounts, the temple features as the baroque excess of feudal hierarchy awaiting the cleansing modernist revolution effected by the introduction of the mosque with its airy, open, and democratizing aesthetics: Rajput (1963), 6.

3. Goetz (1953), 95. See also Willis (1985), 245.

4. *EIAPS* (1966), 12.

5. Sourdel-Thomine (1960).

6. Ibn Mahru (1965), 38; A. Khan (1991), 34, 51–53.

7. Edwards (1990), 168–214; idem (1991a); Flood (2001b).

8. *EI* 2 (1894), 429–30; *EIAPS* (1968); Shokoohy (1986), 29–31, 69, pls. 62b, 75–79; idem (1988b), 30–31, pls. 75–77; Shokoohy and Shokoohy (1988), 88–92. The Nagaur inscription is unusual among Ghurid inscriptions in being incised, a common practice in northern India.

9. In addition, it has been suggested that the congregational mosque at nearby Bayana (now known as the Ukha Mandir) dates from the same period: Shokoohy and Shokoohy (1987), 121-28. While it resembles the Kaman mosque in its formal aspects, the flat, two-dimensional, geometrized style of the mosque's stone carvings, especially around the mihrab, is quite different from those found at Kaman; there are analogies in the style of the carving on the screens added to the mosques at Ajmir and Delhi by sultan Iltutmish (d. 633/1236). Based on these analogies, it seems likely that at least parts of the Bayana mosque should be dated to the 1220s.

10. *EIAPS* (1911–12), 13–16; Page (1926), 29; Meister (1972); Shokoohy (1986), 12–13; R. Hillenbrand (1988).

11. Meister (1972); Shokoohy (1986), 55–56; Shokoohy and Shokoohy (1993), 107–110; Meister (1993a), 451–52; Patel (2000), 215–16. For the history of Khatu see Chaghtai (1968).

12. Z. Desai (1971), 96; Shokoohy (1986), 50–54; Shokoohy and Shokoohy (1987), 114 15; Meister (1993), 445 51.

13. *IA* 10 (1881), 34–36; Shokoohy and Shokoohy (1987); Shokoohy (1988b), 50 54; Meister (1994b), 292.

14. Page (1926), 39; Prasad (1990), 1–2; *RCEA*, no. 3619, where the sultan's *kunya* (damaged in the inscription) is erroneously given as Abūʾl-Muẓaffar rather than Abūʾl-Fath.

15. Chapter 6, p. 235.

16. *EIAPS* (1911–12), 23, 29–30, 33–34; Page (1926), 10–13; Hillenbrand (1988).

17. Differences in mihrab profile and the presence or absence of exterior mihrab projections in pre- and early sultanate Indian mosques have been correlated to ethnic

differences between Arab and Persian patrons, those of rectangular or square profile being identified as Khurasani or Persian, those of semicircular form as Arab style: Shokoohy and Shokoohy (1996), 349. However, the Ghaznavid mosque at Raja Giri in Swat had a semicircular mihrab when it was built in the early eleventh century, replaced around 440/1048–49 with a mihrab that was square in plan, confounding any simplistic equation of ethnicity with architectural form: Bagnera (2006), 210.

18. On the relationship to Siraf see Shokoohy (1988a), 58–59; Blair (1989).

19. Shokoohy and Shokoohy (1993), 8. See also Nizami (2002), 82–83.

20. Ibn al-Athir (1965–67), 12:105. See also B. Chattopadhyaya (1998), 28–60.

21. These include the presence of certain formal features (a pillared antechamber before the prayer halls at Bhadreshvar, for example) and the absence of others (the elevated royal enclosures found in Ajmir and Delhi).

22. Meister (1993a), 445–48.

23. Dikshit (1944); Cunningham (1972), 178–79, 262; Dhaky (1998), 205–10, pls. 504–5; Willis (1999), 177.

24. *IA* 20 (1891); Sarda (1941), 75–76.

25. Anon. (1902–3); Sarda (1941), 69; Jain (1972), 14; Prabha (1976), 166, 173–74. On the question of Jain materials see R. Hillenbrand (1988), 108–9; Patel (2000), 312–14.

26. For a fourteenth-century criticism of this practice see Rosenthal (1967) 2:270–71.

27. Ghafur (1966), 78.

28. Sastry (1975), 19; Dagens (1985), 350–51, 358–60: Dhaky (1998), 107, 127, 199, pls. 43–44, 499.

29. Wagoner and Rice (2001), 89–90.

30. Flood (2001d).

31. Tod (1829), 1:778.

32. Pandey (1998), 31. See also Elst (1990), 83: "The old Muslim records and temples-turned-mosques keep on testifying with one voice that the 'Muslim period' of Indian history was a blood-soaked catastrophe, a marathon of persecution and religious war, inciting thousandfold temple desecration."

33. Flood (2004), 33–38.

34. Tod (1829), 1:782.

35. Flood (2006a), 54–55, figs. 2.3–2.4.

36. Flood (2004).

37. Dirks (1996b), 292; Flood (2004), 28–30.

38. Napier (1870), 722. For the broader European debates on hybridity see Stepan (1985); Young (1995).

39. Kuban (1985), 15.

40. S. D. Sharma (1937), 63.

41. Flood (2007a), 46.

42. Draper (2000), 33.

43. Flood (2007b); idem (2008).

44. For a full discussion of these paradigms, their genealogies and impact on modern scholarship, see Flood (2007b) and (2008).

45. D. Hynes cited in Ben-Amos (1977), 128.

46. Hillenbrand (1988), 105–115.

47. Sauerländer (1987), 3. See also Draper (2000).

48. A. Sinha (2000), 23–24.

49. Juzjani (1963–64), 1:323; Raverty (1970), 1:310. See also a much later tale according to which the sufi saint Mu'in al-Din Chishti converts a local deity of Ajmir to Islam and moves into his former temple: Currie (1989), 86.

50. See, for example, Fakhr-i Mudabbir (1927), 26, fol. 17b.

51. On these convergences between the spatial organization of preconquest Delhi and that of contemporary Iranian cities see Asher (2000), 253.

52. Davis (1994a), 302; Chattopadhyaya (1997), 201; Flood (2008).

53. Siddiqui (1992a), 170.

54. Rosenthal (1967), 1;143; Trigger (1990), 128.

55. Grabar (1987), 43–72. See also Juneja (2005), 255.

56. *Hazār qaṣr cho Irān banā konī dar Hind*: S. Sharma (2000), 8.

57. See chapter 3.

58. Lambton (1991), 204; Jackson (1999), 20.

59. Hasan Nizami (n.d.), fols. 157a–158b; Elliott and Dowson (1990), 2:227–28; A. Husain (1966–77), 1:157–59; Raverty (1970), 1:546–47; Kumar (2007), 109.

60. Bulliet (1972a), 28–47, 253; Madelung (1988), 36–37.

61. Sachau (1989), 1:117. Around the same time, a mosque in the vicinity of Herat was destroyed by a marauding army from Ghur, then still largely pagan: Spuler (1968), 356.

62. Gold (1976), 291–92; Bosworth (1994), 277, 299, 382, 348–89.

63. Budge (1976), 1:210.

64. Juzjani (1963–64), 1:344; Raverty (1970), 1:353–54.

65. See, for example, Wink (1997), 301, 308–9, 321. For a contrary view see Thapar (1994), 17–18.

66. See Champakalakshmi (1978); Golzio (1990). For a full discussion of the evidence see Flood (2008).

67. For instances of such appropriation and reuse see Champakalakshmi (1978), 74; Dayalan (1985), 136; M. Stein (1989), 7:1095–99.

68. Granoff (1998). See also Davis (2001).

69. Thapar (1994), 34.

70. The classic studies are those of A. Ahmad (1963) and Pollock (1993). See also Granoff (1991–92), 567.

71. Eaton (2000), 270.

72. See, for example, *EI* 1 (1892), 61–66.

73. M. Stein (1989), 7:1095.

74. D. Sharma (1935), 780.

75. Granoff (1991); idem. (1998), 130–33.

76. Prasad (1990), 92–94.

77. Kumar (2001), 159; idem. (2007) 107–8.

78. *EIAPS* (1911–12), 13; Page (1926), 29; Welch, Keshani, and Bain (2002), 18. For a discussion of the grammatical peculiarities in this text see Patel (2000), 109–14.

79. As suggested by Horovitz in *EIAPS* (1911–12), 14. For a full discussion see chapter 6, p. 239.

80. Cunningham (1972), 177–78.

81. Meister (1989), 25.

82. Raverty (1970), 1:331. For other references to structures in the medieval Islamic world with 360 rooms, steps, or windows see Barthold (1984), 155, and chapter 6 below.

83. See, for example, al-'Utbi's account of Mahmud of Ghazni's expedition against the city of Mathura: Reynolds (1858), 455–56; al-'Utbi (1869), 2:274–75.

84. M. Stein (1989), 1:142.

85. Welch, Keshani, and Bain (2002), 18.

86. For empirical analyses of the Qutb Mosque in Delhi that emphasize this dialectic between continuity and discontinuity as well as the idea of the mosque as a space of mediation see Kumar (2001), 144–48, 157–62; Juneja (2005).

87. Duff (1876), 300. For further discussion see Flood (2005c).

88. Beglar (1994), 87; J. Marshall (1928), 576; Terry (1955), 7; Flood, (2007b).

89. Ernst (2000), 99.

90. Reynolds (1858), 455; al-'Utbi (1869), 2:274. I am very grateful to Everett Rowson for permitting me to use his unpublished translation of the text.

91. Al-'Utbi (1869), 2:292. In the Persian translation, the term is glossed by *dirakht* (tree): al-Jurfadiqani (1978), 387.

92. Dodds (1993), 29–30; idem (2000), 86; Ruggles (1997), 84–89.

93. Flood (2005c), 21–27.

94. See, for example, Nicklies (2004), 110.

95. Jacoby (1992), 22; Barrucand (2002), 52; Redford (forthcoming).

96. Cutler (1999c), 1073.

97. Mujeeb (1972), 115.

98. In southern India and Bengal, for example: Shokoohy (2003), 235; N. Banerji (2002), 17.

99. See, for example, the domed (but single-storyed) corner chambers in the madrasa of Shah-i Mashhad in Garjistan (571/1175–76): Casimir and Glatzer (1971), 54, fig. 1. Equally, in the early thirteenth century, the exterior

corners of the Friday Mosque of Cambay are reported to have been set with gilded domes: 'Awfi (1967), 207–8.

100. Shokoohy and Shokoohy (1987), 125.

101. Page (1926), 8; Burton-Page (1965b), 259; Shokoohy and Shokoohy (1988), 33–37. For a general discussion of the feature see Qadir (1981–82).

102. Al-'Utbi (1869), 2:296–97. For an early thirteenth-century Persian translation in which the Arabic term *bayt* is glossed as *khāna* see al-Jurfadiqani (1978), 387–88. I am very grateful to Everett Rowson for allowing me to use his translation of the Arabic text, which is taken from the bilingual edition that he is currently publishing. For other translations see Reynolds (1858), 466; Bombaci (1964), 25–26, 32.

103. Patel (2004a), 152–53; Flood (2007b).

104. S. Ahmad (1966), 113–14; Welch and Crane (1983), 130; Thackston (1999), 245; N. Banerji (2002), 66–67, 87–93.

105. At the entrance to the royal chamber in the Adina Mosque of 776/1374 at Pandua in Bengal, for example: N. Banerji (2002), 76.

106. Gibb (1958–94), 3:630.

107. Chapter 4, pp. 130–31.

108. Melikian-Chirvani (1992), 113–15; Pancaroğlu (2000), 24.

109. See for example, Scerrato (1962); Carboni (2001), 272–81.

110. Flood (2002). Rare exceptions include pre-Islamic monuments converted for use as mosques after campaigns of conquest in Iran and elsewhere, in which figural imagery continued to be visible: Juynboll (1989), 23, 30; Pedersen, (1991), 650.

111. Flood (2001b), 141–43.

112. Cunningham (1972), 187; Flood (2005c), 21–22. Lack of concern with the seminaked female form has been noted in the reuse of Crusader figural sculpture in the Islamic monuments of Jerusalem at approximately this time: Jacoby (1992), 18.

113. Flood (2005c), 16–24.

114. See, for example, Frye (1954), 49; Flood (2002), 644–45, 647. Where there is evidence of more recent damage, it lacks the characteristic patina of older alterations and tends to focus on the body rather than the face.

115. In addition to decollation and the amputation of limbs, these punishments included blinding and the amputation of noses. The latter punishment was often used as a means of incapacitating those who posed a threat to the dominant political order, or meted out to those who had demonstrated a lack of fidelity by conspiring against it. As Dario Gamboni notes in his recent book on Euro-

pean iconoclasm, "a work may be 'damaged' rather than 'destroyed' in order to make it a token of the violence it was subjected to and of the infamy of anything with which it is associated:" Gamboni (1997), 19.

116. As noted by Shokoohy and Shokoohy (1993), 109, and (1996), 335.

117. Flood (2005c), 24–25.

118. Zimmer (1962), 182; Kramrisch (1996), 322–31.

119. The disembodied nature of the *kīrttimukha* image might have facilitated its adoption, for the hadiths (prophetic traditions) on figuration prescribe decapitation as a means of rendering an image acceptable: Flood (2002), 644.

120. Misidentified in Shokoohy (1988a), 22, fig. 13, pl. 22b. The outline of some of the vegetal decoration carved on the capitals of the Bhadreshvar mosques resembles that of the creature, abstracted to a decorative device. A similarly ambiguous evocation of figural iconography by means of vegetation is found later in some of the earliest mosques of Bengal: Pinder-Wilson (1995), 253; N. Banerji (2002), 82, 118, fig. 19.

121. Page (1937), 34; Flood (2006b).

122. Pancaroğlu (2004), 158.

123. Deniké (1930); Field and Prostov (1938), figs. 14–15; Anon. (1980), pl. 81; Chmelnizkij (1992), 249.

124. For examples see Atil, Chase, and Jett (1985), 98–100.

125. Barrucand (2002), 54, fig. 34.

126. R. Nath (1977 and 1989).

127. My discussion here is indebted to Barber (1997), 1028.

128. Dikshit (1944).

129. Jackson (1999), 20.

130. Brilliant (1982). In his perceptive analysis of the Ghurid mosques at Kaman and Khatu, Michael Meister has noted the operation of four interrelated architectural processes: the reuse of preexisting or spoliated material, the creation of new materials according to prevailing aesthetic conventions, the creation of materials for novel purposes in a manner determined by local conventions, and material reconceptualized in a manner informed by the conventions of Persianate architecture: Meister (1993b), 344.

131. Meister (1993a), 448.

132. As noted by Beglar (1994), 43.

133. Similarly, in some of the eleventh- and twelfth-century Jain temples of Mount Abu, conches (*śankh*s) are carved in relief on either side of the steps leading to the sanctum (*garbhagriha*) of the temple, increasing in scale and number as one draws near.

134. See for example the Narasimha Temple at Kakoni in Uparamala: Dhaky (1998), 343–47 and pls. 773–75.

135. *IA* 15 (1886), 45–46.

136. Eck (1981).

137. For later parallels see P. Hasan (1993).

138. Al-ʿUmari reports that in Tughluqid Dehli only the sultan used it as a paving material: Brand (1986), 222.

139. Sarda (1941), 69; Goetz (1957); Fischer (1962); Agrawala (1968); Salomon and Willis (1990).

140. T. Stewart (2001), 284.

141. Minorsky (1950), 459–60; Gold (1976), 75; Meier (1948), 28. See also the role of Zoroastrians in the destruction of the Friday Mosque in Cambay in the early thirteenth century: Siddiqui (1992a), 24–25.

142. Minorsky (1942), 51.

143. Dhaky (1969); Nath (1977), 239–40; idem (1989), 199; Patel (2004a), 83–84.

144. Wagoner (1999), 249–60.

145. Bhavnagar (1894), 224–27; *EI* 34 (1961–62); Ernst (1992), 32–33; B. Chattopadhyaya (1998), 71–78.

146. Al-Baladhuri (1968), 437; Prasad (1990), xxx, 2–3, 18–19. Similarly, a ninth-century Arab traveler in Constantinople could identify the slender columns on which statues of the emperors stood as minarets or "like minarets," even as Venetian travelers in fifteenth-century Cairo might refer to the numerous minarets of the city as campanili: Berger (2002), 190; Howard (2000b), 47.

147. Juzjani (1963–64), 1:423; Raverty (1970), 1:552. On refraction see T. Stewart (2001), 280. Northern Indian usage conforms to more general trends. In the following century, the inveterate North African traveler Ibn Battuta found Islamic and Arabic equivalents for the non-Islamic institutions that he encountered on his peripatetic voyages, informing his reader, for example, that the Christian monastery (*mānistār*) is equivalent to the Muslim *zāwiya* or (usually sufi) convent: Rogers (1970), 128.

148. Meister (1972), 61; idem (1993a), 445.

149. Gell (1998), 68.

150. Flood (2001b).

151. See, for example, Wagoner (1999), 249–52

152. Toury (2000), 206–7; A. Sinha (2000), 27.

153. Nida (2000), 129–30; T. Stewart (2001), 280. My distinction between the "dome concept" and the manner of its articulation owes something to André Lefevere's suggestion that translation results from an interplay between "conceptual" and "textual" (or architectural) grids: Lefevere (1999), 75–76. A similar rendering of a "dome concept" in a regional idiom and medium can be found a few decades earlier in the tomb of Ibrahim at Bhadreshvar on the coast of Gujarat, where a corbeled stone dome sits atop a square chamber to re-create the most common form of Islamic funerary monument in an Indic idiom (see figs. 17 and 18). In both Bhadreshvar and

Delhi, the exterior of the domes was probably plastered smooth to produce the effect of a hemispherical dome. A more extreme expression of a similar idea is found a century or so later in the earliest Muslim shrines of southern India, where massive monolithic stone blocks were sometimes hollowed out to the same effect: Shokoohy (2003), 41–42.

154. On dynamic equivalence see Basnett-McGuire (1991), 26; Nida (2000), 129.

155. Meister (1972), 61.

156. A. Welch (1993), 314.

157. Bloom (1993), 27; Flood (1997). It is worth pointing out that the possibility of a literal translation was debated even among medieval translators: Burnett (1997), 61–62, 71.

158. On the marginalization of these texts see T. Stewart (2001), 264–66.

159. Liu (1999), 13–44, esp. 19–20.

160. Benjamin (1992), 71–72; idem (1978), 325.

161. Derrida (1978), 200; idem (1981), 20; Benjamin (1978), 325. In his work on hermeneutics, the philosopher Hans-Georg Gadamer has also argued that any translation is not a reproduction of an original but a re-creation, an interpretation rather than a reiteration: Gadamer (1995), 384–87. See also Venuti (1992), 7.

162. Gentzler (2001), 149–50. See also Bhabha (1990); R. Evans (1994), 32.

163. The potential of translation theories for conceptualizing textual production in medieval and early modern South Asia has been explored by T. Stewart (2001). For their application to architecture see Flood (2005c), 27–29.

164. Crossley and Clarke (2000), 14; Howard (2000b), 162.

165. Wagoner (1999), 258–59. On the importance of ambiguity in facilitating interpretation and translation see more generally Caws (1988), 12.

166. Kinney (1995), 58.

167. The strategy of *détournement* was developed as a radical critique of hegemonic ideologies and the role of images in promoting them. Guy Debord, who coined the term, explained that "détournement has a peculiar power which obviously stems from the double meaning, from the enrichment of most of the terms by the coexistence within them of their old and new senses": Debord (1956). Although inextricably linked to struggles over European modernity, the dialectical qualities associated with practices and products of *détournement* might be seen as a common characteristic of revolutionary attempts to rewrite architectural space.

168. Choay (2001), 75. See also Lefebvre (1981), 254; idem (1991), 167. In his work on iconoclasm during the French Revolution, Richard Wrigley suggests, that "in practice,

we find that acts of iconoclasm are commonly exercises in compromise, usually resulting in hybridized or synthetic results which succeed in making of the object concerned a vehicle for a message utterly different to its original meaning": Wrigley (1993), 185. In a similar vein, the anthropologist Alfred Gell has argued that as the product of a type of "artistic agency," the act of iconoclastic alteration follows the same conceptual structure as the act of creation, giving rise to a new work, related to but distinct from the original: Gell (1998) 62–65.

169. Barthes (1972), 114–17.

170. Nelson (2003), 162–63.

171. Lévi-Strauss (1966), 17–22; Ashley and Plesch (2002), 4–7.

172. Cutler (1999c), 1079.

173. H. Foster (1985), 63–64.

174. "The signified changes into the signifying and vice versa": Lévi-Strauss (1966), 21. See also Derrida (1992), 20, and Latour (1999), 92–110. I am grateful to Jonathan Hay for drawing my attention to Latour's text.

175. Pollock (1993), 285; B. Chattopadhyaya (1998), 53. Conversely, Latin Christians sometimes translated the same term as *tetrarcha*, a title associated with the exercise of Roman imperial authority and thus connotative of immoral despotism: Burnett (2002), 155.

176. Venuti (1995), 10. See also Lewis (2000), 273.

177. See, for example, Howard (2000a), 164.

178. Edwards (2006), 28.

179. Meister (1972), 62. See also Patel (2004a), 104, 106, 155–56. For parallels from al-Andalus see Dodds (1993), 28.

180. Meister (1993a), 449; Flood (2005c), 22. Among the many examples one might cite is the tenth-century Shiva Temple at Kera in Kachch. Once again, even if these components were plastered in the *post*-Ghurid period, the care taken to achieve such effects only makes sense if the pillars were seen and *not* obscured beneath a coat of plaster when the mosques were built in the twelfth century.

181. Cousens (1916), 42.

182. Page (1926), 39–41; Joshi (1974); R. Mishra (1983), 185–86; Prasad (1984); idem (1990), xxx, 21–22, 32–35; Ernst (1992), 32; B. Chattopadhyaya (1998), 64–65.

183. Saradi (1997), 422.

184. Beglar (1994), 59–60.

185. For these marks see Cunningham (1972), 179–80.

186. Al-'Utbi (1869), 2:292. For similar problems in the Great Mosque of Cordoba see de Gayangos (1840–43), 1:217–18, 493.

187. See note 28 above.

188. Lehmann (1978), 25. See also Page (1926), 9–10. For a

more recent speculative attempt to envisage the chain of command from patron to mason see Juneja (2005), 258.

189. B. Sharma (1975), 39.

190. Patel (2000), 40; idem (2004a), 8–11, 41.

191. Wagoner (1999), 259.

192. The superiority of these to their Turkic counterparts is noted by contemporaries, even as commentators such as Amir Khusrau boasted that the masons of Delhi were superior to those found in any other region of the Islamic world: Vryonis (1971), 235–37.

193. Ousterhout (1991), 87, 90–91; idem (1995), 60.

194. Hasan Nizami (n.d.), fol. 114a; Askari (1963), 71; Gibb (1958–94), 3:623.

195. Rogers (1976), 84; Crane (1993), 9–10; Necipoğlu (1995), 4.

196. Al-ʿUtbi (1869), 2:291–92; al-Jurfadiqani (1978), 386–87. Once again, I am grateful to Everett Rowson for permitting me to use his translation of the Arabic.

197. EIAPS (1911–12), 14, 16–18.

198. Ibid., 13, 15, 19.

199. Rogers (1976), 70, 91, 93, 95–96, 98–99.

200. Ibid., 99, 101–2; Sourdel-Thomine (2004), 134. In Seljuq Anatolia, the mi'mār was sometimes an amir of the court: Crane (1993), 43.

201. Gibb (1958–94), 3:624.

202. Rogers (1976), 71. The mutawallī of the mosque that the Ghurid sultan Muʿizz al-Din endowed at Multan was also the Shaikh al-Islam: Ibn Mahru (1965), 38; A. Khan (1991), 51. On the office of the Shaikh al-Islam see Bulliet (1972b).

203. ʿAwfi (n.d. 1), fol. 74b. See chapter 6.

204. EIAPS (1972), 14–17. In the case of at least one thirteenth-century inscription from Kambhat in Gujarat, the scribe seems to have been a jeweler or gem trader: Lambourn (2007), 115–16.

205. EIAPS (1962), 34.

206. Rogers (1976), 71–72.

207. Kramrisch (1958), 229; A. Boner (1970), 260; R. Mishra (1983), 185–90.

208. Gibb (1958–94), 3:624; Wagoner and Rice (2001), 90–91. For contemporary Anatolian parallels see Rogers (1976), 72.

209. See chapter 6, p. 239.

210. A. Boner (1970), 268.

211. Wagoner (1999), 259.

212. Jakobson (2000), 114–15. See also Basnett-McGuire (1991), 27; T. Stewart (2001), 282–86.

213. Premodern translation was often a multistepped process involving a range of actors and agents operating through multiple verbal and textual intermediaries. In 906, for example, a letter sent by Bertha Queen of the Franks to the ʿAbbasid caliph in Baghdad was first translated from the original Latin into Greek and thence into Arabic: Grabar (1998), 125. Similarly, in twelfth-century Spain, Arabic texts were read aloud and then translated verbally, word for word, into a vernacular Romance language; a fellow translator then committed the Latin translation of each vernacular term to paper: Glick (1992a), 4; idem (1992b), 101–2; Burnett (1997), 66. For a theoretical approach to architectural translation and the mediations that it entails see Rykwert (1998), 66.

214. Hoffman (2001), 38.

215. Al-ʿUtbi (1869), 2:292; Rogers (1969), 243–44.

216. M. Stein (1989), 7:528–31.

217. Bombaci (1958); Fischer (1966), 29; Pinder-Wilson (2001), 157; Flood (2001a), 111, pls. 10.5–6; idem (2001b).

218. For divergent views see Bombaci (1961), 67, and R. Hillenbrand (2000), 171–72. The availability of marble makes its reported importation from Nishapur for Mahmud of Ghazni's Friday Mosque all the more suprising.

219. Fontana (2005).

220. Museo Nazionale d'Arte Orientale, Rome, accession no. 7103.

221. Flury (1925), 84–87, pl. XX; Giunta (2003a), no. 74. The Indic affinities of the carving were recognized by both Flury and R. Jairazbhoy (1972), 285.

222. Koch (1982), 253. Museo Nazionale d'Arte Orientale, Rome, accession no. 7103. For further examples see Giunta (2003a), 445, C. 19.

223. Giunta (2003a), no. 58.

224. Patel (2000), 195–96; idem (2004a), 121. For other Indian examples see Pal (1994), 246, no. 111. For other examples on the Ghazni carvings see Giunta (2003a), C.11, C.16.

225. See, for example, Pinder-Wilson (1995), 255. For the lamp image in other Ghazni carvings see Giunta (2003a), nos. 25 and 39.

226. Giunta (2003b).

227. Examples of such twisted columns can be found at the following sites (negative numbers refer to the American Institute for Indian Studies [AIIS] photographic archive): Mahanaladeva Temple at Menal Chittorgarh District, ca. twelfth century, neg. no. 672.62; larger Sas Bahu Temple Gwalior AD 1093, neg no. A39.13; Undesvara Temple, Bijolia, Bhilwara District, Rajasthan, late twelfth century, neg. no. 638.35.

228. Sourdel-Thomine (1956); R. Hillenbrand (2000), 157, 164; Flood (2001b), 153–54.

229. Sourdel-Thomine (1956), 292–93, no. 2, pl. IV; R. Hillenbrand (2000), pl. 11.

230. Sourdel-Thomine (1956), 296–98, no. 3, pl. V; R. Hillen-

brand (2000), fig. 12. For the suggestion of an Afghan source see Hillenbrand (1988), 112.

231. Schlumberger and Sourdel-Thomine (1978), 1A 67–69, 1B pls. 95d, 96a.

232. Giunta (2001), figs. 3 and 5. For the recurrence of the same feature on a twelfth-century cenotaph from Ghazni see Giunta (2003a), no. 39.

233. Flood (2001b), 138.

234. T. Stewart (2001), 286.

235. Howard (2000b), 169.

236. Grosjean (1995), 263; Khubchandani (2002), 48.

237. Gardner-Chloros (1995), 70. See also Auer (1995), 116, and Gruzinski (2002), 31.

238. Prasad (1990), xvii; S. Sharma (2000), 202–3; Alam (2003), 142–47.

239. Khubchandani (2002), 48; Guha (2004).

240. Fontana (2005), 449.

241. A. Sinha (2000), 21–29, 167–81.

242. Bakhtin (2004), 75–76, 304–5, 360–61; Young (1995), 20–22.

243. See Grabar (1986), 442–43; Tartakov and Dehejia (1984). As Baxandall also points out, the model of influence also inverts the direction of agency (or negates it altogether). When we say that x has been influenced by y, we mean that y has acted upon x (who is therefore a passive agent) whereas in fact x has appropriated an artifact, form, or idea from y and is thus the active agent: Baxandall (1992), 58–61.

244. Gardner-Chloros (1995), 77–80; Glissant (1999), 50.

245. Gardner-Chloros (1995), 69; Bhabha (1994); Mignolo and Schiwy (2003), 12.

246. K. Turner (1996), 64.

247. Similarly, the Turkman dynasties of eleventh- and twelfth-century Anatolia struck copper coins on which Greek inscriptions and images of Christ are combined with Arabic texts, artifactual counterparts to the *mixobarbaroi* or *Tourkopouloi*, those born of intermarriage between Greek and Turkic parents: Vryonis (1971), 176, 228; Necipoğlu (1999–2000), 65–66.

248. The phrase is taken from Howard (2000b), 163, 167.

249. Grabar (1968a); idem (1968b), 641–48.

250. Pal (1988), 53; Ward (1993), 72–74, 79, fig. 57. See also the suggestion that Indian mint personnel worked in Ghurid mints in Afghanistan: Tye (1988), 6; Tye and Tye (1995), 51.

251. Prasad (1984), 15.

252. Allen (1988a), 108. See also Korn (2003), 238.

253. Scarcia and Taddei (1973), 89–108; Ball (1990), 105–10.

254. The orientation of the published plan in Ball appears to be erroneous. In their description of the structure, Scarcia and Taddei (1973) refer (p. 99) to the two windows on

the north and south walls, which would put the mihrab on the west wall, the standard *qibla* in the region.

255. Scarcia and Taddei (1973), 105; Ball (1990).

256. For example, in a wooden mihrab of the Ghaznavid or Ghurid period formerly in a small mosque at Charkh-i Logar: Melikian-Chirvani (1977).

257. Scarcia and Taddei (1973), 102–6.

258. Edelberg (1957), fig. 10; idem (1960); Lohuizen-de Leeuw (1959). The form also occurs in the Hindu Shahi Temple at Malot in the Salt Range: Meister (1996).

259. Scerrato and Taddei (1995). See also the Buddhist shrines at Alchi in Ladakh: Tucci (1973), figs. 134, 139.

260. Dhaky (1975); Meister (1994a), 161.

261. Dhaky (1961), 34–35, 40–41, 44; H. Singh (1975); idem (2001); Chanchreek and Jain (2004), 64–90.

262. H. Singh (1975), 300-306, pls. 1–7.

263. For other comparanda see the gate of Mandalgarh fort, Bhilwara District, Rajasthan (eleventh century), AIIS neg. no. 640.28, and the early twelfth-century temple at Arthuna in Banswara District, Rajasthan, AIIS neg. no. 601.23.

264. AIIS neg. no. 160.10. Several other features of the door frame also find more generic comparanda in the eleventh- and twelfth-century temples of northern Gujarat and the adjoining districts of southeastern Rajasthan, in particular those of Chittorgarh District (AIIS neg. nos. 632.50 and A35.74). These include the deployment of *ratna* or rhomboid motifs rather than images of deities on either side of the threshold: Mahanaladeva Temple at Menal (ca. twelfth century), AIIS neg. no. 672.62.

265. AIIS neg. nos. 595.20, 614.52, 630.75. See also the Somesvara Temple, Kiradu ca. 1020: AIIS neg. no. 544.58.

266. Fischer (1962); idem (1969), 339, pl. 9. On the adaptive use of Jain elements in the mosques of western India see Patel (2004a), 81–82.

267. G. Khan (1953), 113, 116; Redford (2005), 290.

268. The embrasures of the rectangular windows that open on the north and south walls are carved with entwined lotus stems, whose terminal lotus buds intersect directly above the window opening. Continuing the theme, the soffits are carved with a single lotus flower, a feature also found in the soffits of the windows in the Ghurid mosque at Khatu in Rajasthan.

269. Flood (2000).

270. Schwarz (1995), 70, no. 809.

271. Kramrisch (1996), 2:35. The triangular pinnacle (still visible in outline) may have suggested itself as the flame.

272. Pinder-Wilson (1995), 253; Burton-Page (1988), 57, fig. 10.

273. For examples of the northern Indian carvings see Pal

(1994), nos. 111–12. For the Ghazni material see Giunta (2003a), C.11, C.13.

274. Raverty (1970), 1:449; Jackson (1999), 10–12. The date coincides with that given in an inscription recording the destruction of a Jain icon in the temple at Kiradu in Rajasthan, which may be related: Somani (1982), 30. For other inscriptions recording Chalukya engagements with the Ghurids and discrepancies in the dates that they give see Patel (2004a), 4.

275. Fakhr-i Mudabbir (1927), 23; A. Majumdar (1956), 131–36; Raverty (1970), 1:516; Elliott and Dowson (1990), 2:226–31.

276. Lockhart (1938), 254; Vryonis (1971), 256; Budge (1976), 1:640; Haase (1982); Elliott and Dowson (1990), 3:447. See also Allsen (1997), 30–45.

277. Chapter 2, p. 78.

278. *EI* 24 (1937–38), 64; Kramrisch (1958). See also Dehejia (1988), 7.

279. Settar (1973), 419, 421.

280. A. Boner (1970), 261; Settar (1973), 419–20; Bolon (1988), 55–56.

281. Lambourn (2007), 124.

282. Shokoohy (1988a); Patel (2004a), 58.

283. Ibn Ibrahim, (1886), 25–26, 49; Goitein (1954), 193; al-Idrisi (1954), 60; S. M. Ahmad (1960a), 60; Elliott and Dowson (1990), 2:201. In the biography of the sufi saint Nizam al-Din, who flourished in the later thirteenth century, the honesty of the Gujarati traders is contrasted with that of the Muslim merchants of Lahore: Lawrence (1992), 215–16; Siddiqui (1992a), 29.

284. Cutler (1999a); idem (1999b), 640–42.

285. Rosenthal (1967), 1:143.

286. Redford (2004), 396.

287. L. Hunt (1984); Redford (2004), 390.

288. Zeitler (1996); Johns (2002), 266–67. Mallette (2003), 154–55, 158.

289. Cutler (2001b), 245.

290. Allen (1988a), 109. See also Korn (2003).

291. Melikian-Chirvani (1982) and (1982–83), 42. For a contrary view see R. Hillenbrand (1988), 115. Among the other likely examples of early sultanate metalwork are a group of inlaid bronze objects (including a casket and two tabletops) whose iconography and epigraphic content suggest that they were produced in northwestern India in the late twelfth or early thirteenth century: Barrett (1949), xxii, no. 9.

292. For one of its earliest occurrences see Giunta (2003a), no. 19, figs. 71, 73. The undulating band also occurs in the inscriptions on the marble cenotaph of Sultan Mahmud of Ghazni, the date of which is disputed: see chapter 3, note 1.

293. I am indebted here to Michael Meister's distinction between idiom (defined as "local traditions rooted in the work of local artisans, traditions which endure even as political authority shifts or declines") and style (defined as "an accumulation of general characteristics that reflect a broad cultural grouping"): Meister (1993b), 350. As Deborah Howard has noted in another context, architectural style is not dependent on vagaries of dialect or idiom: "arguably, a good translation could preserve the style": Howard (2000a), 171.

294. Flood (2001b), 145–46, figs. 19, 21, 23, 31.

295. For a fuller discussion, see chapter 6.

296. Havell (1913), 47; Meister (1993a), 450; Bloom (1993). It is reported that the Anatolian Seljuq sultan 'Ala' al-Din Kayqubad (d. 634/1236) drew the outlines of the palace that he designed at Kubadabad near Konya, the Anatolian Seljuq capital: Necipoğlu (1995), 4. References to fourteenth-century Indian mosque inscriptions being written by a *qāḍī* and engraved by a *sūtradhāra* appear to imply the use of graphic notation: *EIAPS* (1962), 34.

297. Sourdel-Thomine (1956), 292–93, no. 2, pl. IV; R. Hillenbrand (2000), pl. 11.

298. On code switching see the essays in Auer (1998).

299. Flood (2001b), 141. Conversely, while the movement of Indian masons to Afghanistan may have provided the initial impetus for the circulation of the Indic elements noted above, once these were established, the interrelationships between ethnicity, form, idom, and style may have been less pronounced.

300. For examples see Ettinghausen (1974), 304–5; Atil, Chase, and Jett (1985), 198; Blair (1983a), 312; Giunta (2003a), 306. Indian epigraphy had traditionally favored techniques of incision over carving in relief, the standard practice in the Islamic world. However, in some bilingual (Arabic or Persian and Sanskrit) texts from western India, the two languages are distinguished not only by the use of different scripts but also by distinct techniques of carving, indicating that Gujarati stone carvers were capable of "code switching," adapting their techniques to suit the needs of Muslim patrons. See, for example, *EIAPS* (1973), 13–20, pl. IIa.

301. *EIAPS* (1965), 7, l. IVb.

302. The best discussion of workshop practices among western Indian stonemasons is that of Lambourn (2007), who focuses on the Gujarati marble carvers of the thirteenth and fourteenth centuries, and whose research indicates a specialization of skills even within a single atelier. The complexity of the Ghazni cenotaphs, which comprise multiple separate carvings, points in the same direction.

303. The model of translation as transformation accounts for

multivocality, the heteroglossia (diversity of coexisting and competing languages) and heterophony (diversity of voices) within any text: Bakhtin (2004), 89.

304. The phenomenon is common to other historical instances of large-scale reuse: Hansen (2003), 121–35.

305. Bourdieu (1998). This is similar to what Wagoner (1999) terms the "cognitive filters" provided by the conceptual categories of regional architectural practice. As translation theorists remind us, "it is norms that determine the (type and extent of) equivalence manifested by actual translations": Toury (2000), 204. See also Clifford (1988), 92.

306. Kubler (1967), 854.

307. This is a truism not confined to South Asia. It has been convincingly demonstrated, for example, that formal and stylistic changes in the Mamluk monuments of Egypt (thirteenth to fifteenth centuries) were due to the migration of craftsmen and workshops between the Syrian and Egyptian centers of the Mamluk sultanate: Meinecke (1996).

308. Venuti (2000), 481–82.

6 | Palimpsest Pasts and Fictive Genealogies

1. Raverty (1970), 1:497; Kumar (1992), 61; idem (2007), 86–87, 166–77. See also chapter 3.

2. Raverty (1970), 1:500, 524–25; Jackson (1999), 28.

3. Lowick (1973), 206; Jackson (1999), 30; Kumar (2007), 123–24. The situation finds interesting parallels in Egypt, where the Mamluks assumed power around 1250, exercising power in the name of their dead Ayyubid masters for several years afterward. Similarly, after the murder of the ʿAbbasid caliph, the nominal head of Sunni Islam, by the invading Mongols in 1258, his name was retained on the coins of the Delhi sultans for three decades, until the time of Muʿizz al-Din Kayqubad (r. 686–89/1287–90): A. Ahmad (1999), 6–7.

4. Raverty (1970), 1:410–11; Jackson (2000).

5. Jackson (1999), 29; Kumar (2007), 132–33.

6. For Iltutmish's rise to power see Juzjani (1963–64), 1:440–58; Raverty (1970), 1:597–628.

7. Jackson (1999), 30.

8. Raverty (1970), 1:608; Jackson (1999), 30, 35; Kumar (2007), 138–43.

9. H. Sastri (1937), 495–96; Richards (1983) 198, 202; Davidovich and Dani (1992), 417. Among the very last examples are coins struck by Shams al-Din Mahmud in 718/1318: Wright (1936), 103.

10. Tye and Tye (1995), 147.

11. Shokoohy and Shokoohy (1987), 115. For the competi-

tion between Qutb al-Din Aybek and Bahaʿ al-Din Tughrul see Raverty (1970), 1:546–47; M. Shokoohy (1986b), 51–53; I. Habib (1992), 6–11; Jackson (1999), 26–41; Kumar (2007), 105.

12. Flood (2005b), 164–67.

13. Juzjani (1963–64), 1:440; Raverty (1970), 1:598–99; Fuller and Khallaque (1967), 149; Richards (1974), 107; Hardy (1998), 227.

14. Amir Khusrau (1953), 24; M. Habib (1931), 16.

15. Page (1926), 19; Prasad (1990), 18–19; Kumar (2007), 227.

16. Choay, (2001), 75. See chapter 5, p. 183.

17. EIAPS (1911–12), 23.

18. For this feature see Gibb (1958–94), 3:630.

19. A. Welch (1983), 261–67.

20. M. Husain (1936), 128–29, 135; A. Welch (1983), 262; Welch, Keshani, and Bain (2002), 29.

21. EIAPS (1911–12), 15, 30.

22. Flood (2005b), figs. 10.7 and 10.18.

23. Begley (1985), 28; Nyamaa (2005), 79, 197, no. 84.

24. Redford (2005), 297.

25. Ibid., 285; idem (forthcoming).

26. Gibb (1958–94), 3:623.

27. Juzjani (1963–64), 1:373; Raverty (1970), 1:398.

28. Redford (2005).

29. Mirza (1974), 123.

30. EIAPS (1911–12), 13–15.

31. For a full discussion see Flood (2007b).

32. Hasan Nizami (n.d.), fol. 106b; Askari (1963), 71.

33. Allen (1988b), 59–60; Tabbaa (1997), 68. For the architecture and decoration of the monument see Hardy-Guilbert and Djindjian (1980); R. Hillenbrand (2000), 142.

34. See Barnes (1997), 68–69, nos. 527–28; the closest parallels are found in idem (1993), Nos. 9–10.

35. As noted by Willis (1985), 245, although the idea that these modes of ornament displace indigenous modes of ornament actively rejected is too simplistic. For the knotted scripts in Iltutmish's extensions to the Delhi screen see Shafiqullah (1994), 65–66, figs. 1–4.

36. Mujeeb (1972), 121. See also Shafiqullah (1994), 65–66.

37. Dorn (1976), 40. Such migrations may account for the appearance of the nisba (toponymic) al-Ghūrī (of Ghur) in Indian inscriptions of the early fourteenth century: see, for example, EIAPS (1972), 17.

38. According to the fourteenth-century historian ʿIsami, cited in Digby (1967), 52. See also Raverty (1970), 1:598; I. Habib (1992), 14; Siddiqui (1992a), 32–33; Jackson (1999), 41; Kumar (2007), 143–44.

39. Cited in Redford (2005), 306.

40. Juzjani (1963–64), 1:321; Raverty (1970), 1:545; Kumar (2001), 155–57; idem (2007), 101–3, 146.

41. As part of the treaty concluded between the Kalbids of Sicily and the Byzantine emperor Constantine VII in 336/947–48, for example, a mosque of considerable size with a minaret at one of its corners was built in the Southern Italian town of Rhegium, with the stipulation that Muslims should be guaranteed freedom of access, Christians denied access and put under threat of demolishing all churches in Sicily and Africa should the fabric of the mosque be touched: Trombley (2004), 151. Similarly, the number of mosques built after the Ottoman conquest of Crete exceeded the number of Muslims available to fill them: Bierman (1991), 66. Conversely, after the Christian (re)conquest of cities like Valencia in the Iberian Peninsula, mosques were converted into churches even in the absence of congregations to make use of them: Burns (1975), 100.

42. The original Delhi mosque measured 147.5 by 47 feet compared with 259 by 57.5 feet for the Ajmir mosque after its remodeling in the 1220s: Cunningham (1972), 260. The congregational mosque at Gunabad measures 225 by 135 feet: Research Institute for Islamic Culture and Art (1997), fig. 128. Mujeeb estimates that the first Delhi mosque would have held 3,800 worshippers, that of Iltutmish 11,000, and the extended mosque planned by 'Ala' al-Din Khalji 20,000 to 30,000 souls: Mujeeb (1972). Similarly, it has been suggested that Iltutmish's remodeled mosque at Ajmir held 7,300 worshippers: Lehmann (1978), 22–23. The basis of these statistics is unclear.

43. Eaton (1993), 36–37.

44. Kumar (2000), 42. After this, the question of scale becomes central to a relativization of power: later in the fourteenth century, for example, the rebellious Ilyas Shahi rulers of Bengal built the Friday Mosque in their capital of Adina on a scale that far surpassed the monuments of their former overlords, the Tughluqid sultans of Delhi: Eaton (1993), 36–37; N. Banerji (2002), 69. 'Ala' al-Din's superlative reiteration of Iltutmish's appropriative gesture also seems to have inspired a palpable gigantism in congregational mosques erected subsequently in territories newly conquered by the Delhi sultanate, many of which replicate characteristic features of the Delhi mosque or its celebrated minaret. Lambourn ([2001], 138) attributes this increase in scale to 'Ala' al-Din Khalji's projects, but despite the enhanced scale of their ambition, these were clearly following an earlier precedent and were perhaps even part of a fourteenth-century transregional competitive discourse to which questions of scale were central: B. O'Kane (1996).

45. Amir Khusrau (1953), 24; M. Habib (1931), 16.

46. In his memoirs, for example, Firuz Shah Tughluq (d. 790/1388) refers to his restoration of the monuments built by earlier Delhi sultans, beginning with the Qutb Minar and Qutb Mosque (referred to as Sultan Mu'izz al-Din's mosque), along with monuments built by Iltutmish: Roy (1941), 459.

47. Lefebvre (1991), 143.

48. Jackson (1999), 31; Kumar (2007), 87–97, 105–25, 135.

49. *EIAPS* (1911–12), 13–14. For the text see p. 158 above. The style of both inscriptions is quite different, with the elongated verticals of the outer inscription finding more in common with the Ghurid texts from the mosque than those carved on Iltutmish's additions.

50. Blair (1985), 82. Persian foundation texts are known from at least three Central Asian monuments dated between 1055 and 1152: Bombaci (1966), 36–37; Blair (1992), 10, 153–54; idem (1998), 23–24. For the Persian inscriptions in Delhi see Horovitz in *EIAPS* (1911–12), 19, no. XII. Although it has been claimed that a Persian historical text appears on the Ghurid section of the Qutb Minar (Welch, Keshani, and Bain [2002]), the inscription in question is in fact in Arabic but contains a Persian title: Page (1926), 30. The mélange of Persian vocabulary and Arabic grammar or vice versa (most obviously in the use of Arabic numerals) is common to other Indo-Ghurid and sultanate inscriptions: *EIAPS* (1913–14), 14; *EIAPS* (1959–60), 1–3.

51. *EIAPS* (1911–12), 24–25; Halim (1949); Chaghtai (1968), 24, no. 3.

52. Juzjani (1963–64), 1:417; Raverty (1970), 1:515, 2:1297, and appendix A.

53. Pinder-Wilson (1985), 102n. In the absence of diacritical marks, the confusion between the reading of the Arabic for seven and nine is common. Repeated study of the text suggests that the former is the correct reading, however: E. Ross (1922), 412–13; M. Ahmad (1949), 129n; E. Thomas (1967), 22–23. In addition, Ibn Battuta claims to have seen the date of 584/1188 inscribed on the mihrab of the mosque, but this may be a misreading of *arba'a* (four) for *saba'a* (seven): Gibb (1958–94), 3:628.

54. *EIAPS* (1911–12), 14.

55. Ibid., l. XI; R. Nath (1979), drawing of inscription 4; Flood (2005b), figs. 10.7 and 10.18.

56. Eaton (1993), 32–33. Similarly, the date given on thirteenth-century Indian tombs is sometimes the date of the death of the individual that they commemorate, even if the inscription was carved decades later: Lambourn (2007), 115.

57. Gibb (1958–94), 3:622.

58. Raverty (1970), 1:618.

59. R. Nath (1979), 32n8. See also *EIAPS* (1911–12), 23; Page (1926), 30; Jackson (1999), 37–38. Welch, Keshani, and

Bain (2002 [28]) refer to an inscription dated 1223–24 on the screen, but I have found no record of such an inscription, and this seems to be an error.

60. Raverty (1970), 1:616; Digby (1970), 64; Richards (1983), 198.

61. *EIAPS* (1911–12), 30.

62. *Qāma' al-kafira wa'l-mulahidīn qāhir al-zalama wa'l-mushrikīn*: ibid. For the use of similar titles by the Ghurid sultans see chapter 3.

63. Raverty (1970), 1:623, 628; Ranking (1976), 120; Gibb (1958–94), 3:622. Nineteenth-century archaeological excavations found two black slate images of an unspecified kind at the north gate of the Delhi mosque: Stephens (1876), 68.

64. Page (1926), 9, pl. 9d–e; Sain (1934), illus. 3a–b.

65. In 1290, for example, two bronze images of Brahma captured at Jhain were broken into pieces and distributed to the officers of the sultan with instructions that the fragments should be thrown down at the gates of the Delhi mosque: A. Husain (1966–77), 2:389. Similarly, in 698/1298 following a Khalji raid on the temple of Somnath in Gujarat, we are told that fragments of the icon were conveyed to Delhi and the Friday Mosque of the city paved with them: Elliott and Dowson (1990), 3:44.

66. 'Awfi (n.d. 1), 74a; A. Husain (1966–77), 3:22.

67. Wright (1936), 71–72; Goron and Goenka (2001), 19–29. This is an early reference to the imposition of *kharāj*, which appears to have been introduced only gradually following the Ghurid conquest: I. Habib (1978), 295.

68. Deyell (1999), 74. This was evidently a commemorative issue, perhaps related to the defeat of the Hindu Shahi ruler Anandpal and the Isma'ili ruler of Multan in the preceding year: Gardizi (1928), 67; M. Habib (1941), 136–39. Even here, however, the relationship to India was a complex one, for the Ghaznavid coin was struck to an Indian *tola* weight standard: Singhal (1954), 123–26; Goron and Goenka (2001), xxvi. In similar vein, it has been suggested a gold *tanka* struck in 601/1204–5 in the name of the Ghurid sultan after the conquest of Bengal was minted from booty seized at this time: Lowick (1973), 198–203; Eaton (1993), 33–34. These coins exemplify what Mary Helms refers to in an important essay on objects as "distance made tangible," as the desire to keep indexes of territorial expansion "literally in hand": Helms (1994), 355.

69. Talbot (2001), 720.

70. Anderson (1991), 13–14. Voll (1994), 219–20.

71. Adapted from Saroop (1998), 141–42, using Hasan Nizami (n.d), fols. 114a–b. See also Askari (1963), 71–72.

72. Nizamu'd-Din (1929), 250. On 'Awfi see Browne (1964), 2:478–79.

73. *EIAPS* (1911–12), 16–17, 26–28; Page (1926), 19–20, 30–34; *RCEA* nos. 3618–19.

74. Among them, the *'idgāh* at Jalor in Rajasthan (718/1318), which had corner buttresses with alternating angular and circular flutings, and the congregational mosque built in 725/1325 after the conquest of Cambay, some eight hundred kilometers south of Delhi, but replicating the basic forms of the Qutb Mosque, including an arched screen tacked on to a trabeate façade: *EIAPS* (1972), 13; Lambourn (2001), 133–35. See Koch (1991).

75. Reinaud and Guyard (1848–53), 2.2:120; Sauvaget (1950), 23; Siddiqi and Ahmad (1972), 36.

76. Kumar (2007), 230.

77. Parkash (1967), 55–56.

78. 'Awfi (n.d. 1), fol. 74b.

79. Adapted from the partial synopses given in Parkash (1967), 55–56 and Siddiqui (1992a), 35, using the manuscripts in London and Paris: 'Awfi (n.d. 1), fols. 74a–b; 'Awfi (n.d. 2), fols. 342a–b. This text requires a study in its own right, which I hope to undertake in the near future.

80. Described by Ibn Battutta: Gibb (1958–94), 3:628.

81. Z. Desai (1971), no. 304, 96; Meister (1993a), 446–47.

82. A. Welch (1983), 265; Flood (2005a). See also the comments of R. Hillenbrand (1991), 182.

83. C. Hillenbrand (2004), 288.

84. A. Welch (1983); R. Hillenbrand (1988), 109; Edwards (1991b), 72; Meister (1993a), 446–48; Asher (2000), 255; Welch, Keshani, and Bain (2002). The latter distinguish between the tone and content of Qur'anic verses on the exterior of the Delhi mosque "that refer to the non-Muslims" and those of the interior that "address the Muslims who enter the mosque": ibid., 18.

85. Asher (2000), 255; Kumar (2001), 157–58. On the question of access to premodern Hindu temples see Filliozat (1975).

86. Nelson (2005); Redford (forthcoming). See also Grabar's distinction between monoptic perception — the recognition of script as such—and the decipherment of its semantic content: Grabar (1999), 103.

87. E. Ross (1922), 405; Fakhr-i Mudabbir (1927), 43–44; Redford (forthcoming).

88. As noted by Ettinghausen (1974), 300–303. See also R. Hillenbrand (1991), 178; Asher (2000), 255; Patel (2004a), 44–45.

89. Ettinghausen (1974).

90. Grabar (1999), 103.

91. Bowman and Woolf (1994), 8. Wasserstein (1993), 312.

92. See Introduction. For similar points made about the inscriptions found in Byzantine churches see Papalexandrou (2001).

93. For contemporary parallels in Sicily, another contact zone between Muslims and non-Muslims, see Johns (2002), 299.

94. Siddiqui (1992a), 171; Siddiq (2000). For the former usage, the best discussion is that of Redford (2005), 294–97. For references to patents and so forth employing the script see Juvayni (1912–37), 2:63; Boyle (1958), 1:329.

95. B. Robinson (1976), pl. 150; B. O'Kane (forthcoming), chap. 3.

96. Ong (1986), 11; Messick (1993), 24–29. On writing as an adjunct to memory rather than its replacement see Fentress and Wickham (1992), 9.

97. Ettinghausen (1974), 308; Edwards (1991b), 65, 70. For a discussion of the question of legibility in relation to Ghurid and early sultanate inscriptions in India see Kumar (1992), 223–24; idem (2007), 230–31.

98. After Kumar (2000), 47–48, with slight modifications. For the Persian text see Amir Khusrau (1953), 23.

99. Bosworth (1986a), 196; Trombley (2004), 150. For the usage of these verses in Ghurid monuments see Flood (2001b), 139–40; A. Welch (1983), 260, 262.

100. Similarly, Irene Bierman has suggested that Qur'anic inscriptions in the early Islamic monuments of Syria and Palestine were addressed to believers who would understand their semantic content, despite their emphasis on points of doctrinal differences between Islam and Christianity: Bierman (1998), 58–59.

101. See Kumar (2001), 157.

102. Welch, Keshani, Bain (2002), 25. This is especially true since the content of the screen inscriptions suggests that they addressed the community using the mosque: A. Welch (1983).

103. Juzjani (1963–64), 1:461, 623–24n; Raverty (1970), 2:829–31; Nizami (1983), 78; idem (2002), 309–10; Kumar (2007), 204–9.

104. Kumar (2007), 226–29. Similarly, the inscriptions on the Ajmir screen stress the importance of communal prayer and proper conduct: Welch, Keshani, and Bain (2002), 38. The hadiths carved on the main entrance to the Ajmir mosque, part of the renovation undertaken by order of Iltutmish in the 1220s or 1230s, emphasize Friday prayer (whose merits are compared to that of pilgrimages) and of constructing mosques, which will earn the patron a place in paradise: Sarda (1941), 81–82.

105. See note 156 below.

106. Digby (1986), esp. 64, 68; Kumar (2000), 61. The biography of Nizam al-Din Awliya, the celebrated sufi saint of Delhi, refers to the mosque as sanctified by the feet of sufis and relates an incident in which a sufi holy man was seen circling the colored pinnacles (*kangūrhā-yi mu-*

lamma') and the mihrab arches (*ṭāqhā-yi miḥrāb*, presumably the arches of the prayer hall screen) of the mosque, an unusually explicit sanctification of specific architectural spaces: Awliya (1966), 14; Lawrence (1992), 24; Kumar (2001), 168.

107. The Kaman mosque is described in its foundation text as "the agreeable place" (*al-buqʿat al-laṭīf*): Shokoohy and Shokoohy (1987), 114. The phrase recalls al-Isfizari's description of the Ghurid *maqṣūra* of the Herat Mosque as a *buqʿat maʿmūr*, amidst a discussion of the mosque's inscriptions: al-Isfizari (1961), 27. For the Kol inscription see Halim (1949), 3; *EIAPS* (1966), 9–11.

108. A. Husain (1966–77), 2:228–29. For a fourteenth-century description of the reservoir see Gibb (1958–94), 3:624.

109. A hadith related by al-Nasa'i reports that water used for ablutions by the Prophet Muhammad was diluted and sprinkled on the site of church in order to prepare the site for construction of a mosque: Siddiqi (1994), no. 704, 443. See also the Ottoman tradition regarding the rebuilding of the Hagia Sophia by means of a mortar consisting of sand from Mecca, Zam-zam water, and the saliva of the Prophet Muhammad, prophesying its future conversion into a mosque: Necipoğlu (1992): 200.

110. Eaton (2000), 268–69. For the role of Ganges water in earlier royal ceremonial see Dehejia (1990), 79; Davis (1993), 38–42: Inden (1998), 69.

111. Dehejia (1990), 79.

112. Eaton (2000), 279–81.

113. M. Stein (1989), 7:879; Gibb (1958–94), 3:630.

114. Burt (1838), 629–31; de Tassey (1860), 226–29; Stephens (1876), 17–24; Page (1926), 44–45; Fleet (1970), 139–42; Cunningham (1972), 170–74. There is some debate as to whether the Chandra mentioned on the pillar is Chandragupta I or II, or indeed any Gupta ruler: Smith (1897); Shastri (1913); *EI* 14 (1917–18); Sircar (1939). The pillar was originally surmounted by a Garuda (eagle) figure, which most scholars have assumed was removed when it was placed in the mosque.

115. Elliott and Dowson (1990), 3:353. For the Persian text see 'Afif (1888), 314.

116. The column is supported by a series of iron bars soldered with lead, which rest upon the surface of a floor assumed to be that of the temple that previously stood on the site: Smith (1897), 4–5.

117. Gibb (1958–94), 3:622.

118. Welch and Crane (1983), 134; Irwin (1987), 134

119. Prasad (1990), xxx, 2–3, 18–19. As R. Nath ([1970], 29) remarks, "the idea is more symbolic than functional," with the *lat* acquiring a role as the "conceptual equivalent" to the *minār*: McKibben (1994), 112. It is likely that the formal similarities between pillar and minaret en-

abled these to be identified in the eyes of contemporaries.

120. See, for example, Digby (1986), 58, among many others.

121. Briggs (1981), 1:270. For a full list of Firuz Shah's pillars see Flood (2003), 100.

122. Colebrooke (1808); *IA* 19 (1890); Hultzsch (1925), xv–xvi, 119; Irwin (1973), 709. On the identity of Visala Deva and Vigraharaja IV see D. Sharma (1975), 67; Deyell (1999), 167. In an irony of history, plays concerning Visala Deva's battles against the *Turuṣka*s, including one written by the raja himself, were inscribed on stones later reused in the Ghurid Friday Mosque at Ajmir: *IA* 20 (1891); Sarda (1941), 76–78.

123. The precise context from which the Firuzabad pillar was brought to Delhi in the fourteenth century is not entirely clear, even if we know that it came from somewhere near Topra. The *Sirāt-i Firūz Shāhī* states that Visala Deva found the pillar standing in front a temple there: Page (1937), 29, 34.

124. Flood (2003).

125. Such heroic endeavors were memorialized in fourteenth-century texts, which prefigure European treatises on similar topics by several centuries: Page (1937), 33–42.

126. Lehmann (1978), 25.

127. McKibben (1994), 113.

128. The later "Islamization" of the Firuzabad pillar through its removal from a temple and reuse as a *minār* of a mosque is celebrated at in the *Sirāt-i Firūz Shāhī*: Page (1937), 34. However, not all the pillars reused by Firuz Shah were set up in mosques, and it is not clear how widespread such attitudes regarding the "Islamization" of pre-Islamic relics were, or if one can project them back into the early thirteenth century. Moreover, even the secondary association with religious architecture may have earlier Indian precedents if (as seems likely) some of the pillars reused by earlier Indian rulers had been reerected in temple precincts: see also Irwin (1987), 134; idem (1989), 397, fig. 3.

129. Elliott and Dowson (1990), 3:352; Page (1937), 34

130. Al-Qaddumi (1996), 180–81; Beeston (1999).

131. In this sense, Ibn Battuta's identification of the pillar as *haft jūsh*, an alloy of seven metals, is surely significant. Although recorded among modern Muslim communities, folkloric beliefs concerning the primordial nature of iron and the consequent ascription of apotropaic or magical properties to the medium of iron itself are also worth noting, especially since some of these beliefs relate to the understanding of specific Qur'anic passages: Bowen (1993), 90–93.

132. Eulogies of later Delhi sultans also compare their monuments to the iron wall of Alexander: Kumar (2000), 46. For fourteenth-century depictions of the iron wall and iron warriors of Alexander see Komaroff and Carboni (2002), nos. 48, 52, figs. 160, 191.

133. See Juzjani's comparison of the sultan's dominion (*dawlat*) to that of Alexander: Juzjani (1963–64), 1:440–41; Raverty (1970), 1:598. While Mughal sources preserved the memory that the *lat* reused in Firuzabad was once associated with Hindu rajas (Colebrooke [1808], 177; Prinsep [1837], 566), seventeenth-century popular opinion had it that the pillars at Allahabad and Delhi were erected by Alexander the Great: W. Foster (1921), 177, 248; Cunningham (1972), 163–64.

134. Burt (1834), 106; *EI* 9 (1907–8), 248; Hultzsch (1925), xviii, xxiii; Kejariwal (1988), 170; Elliott and Dowson (1990), 3:350; Willis (1993), 75.

135. Reinaud (1976), 28–39, 44–45; Ernst (2003), 178.

136. H. Said (1989), 32; Briggs (1981), 1:lvi–lxxii.

137. Bombaci (1966), 42. Minorsky (1956), 167. On the impact of the text on Persianate historiography in India see M. Ali (1998), 295.

138. Blair (1993), 243–44. For the throne see Nazim (1971), 90.

139. Hardy (1998), 230; Pollock (2006), 555. See also Bosworth (1973b); Meisami (1999), 285–86, on the importance of the "great man" paradigm of Persian historiography, and idem (1993), 250: "The role of history in linking present rulers with past ones (whether with those of ancient Iran or with the caliphate) and thereby legitimizing the transfer of power to the current incumbents is clearly crucial."

140. Bosworth (1973b), 54–55, 66.

141. A. Weiner (1985), 210. For Mughal palimpsests such as gems and jade cups inscribed by each of a series of celebrated rulers as they passed through their hands in turn see Blair (1996), 571–72.

142. Weiner (1992), 7, 11, 33, 42; idem (1985), 224; idem (1994), 394–95.

143. Raverty (1970), 1:622–23; Briggs (1981), 1:lix–lx.

144. Foucault (1986).

145. Gottschalk (2000), 6.

146. Carruthers (1998), 42; Marshall and Fryer (1978), 3–4.

147. Lefebvre (1991), 39, 110.

148. 'Awfi (n.d. 1), 74b; 'Awfi (n.d. 2), 342b; Sarda (1941), 82. For the Arabic text of the hadith see Wensinck (1927), 155.

149. Biddick (1996), 595–96.

150. This is a consciousness of unity from which formative and normative impulses are derived in such a way as to

permit their own ongoing reproduction: Assmann (1995), 130.

151. Nora (1989), 8–9.

152. Assmann (1995), 128–29, 132. See also Thapar (2001), 213–15.

153. Le Goff (1992), 95, 98.

154. Halbwachs (1992), 47.

155. Meisami (1999), 287–88; Humphreys (2004), 75.

156. Redford (1993), 154. See also Bombaci (1969); Crane (1993), 10.

157. For premodern examples from South Asia entailing the appropriation of earlier objects or styles see Williams (1973); Michell (1994), 192–93.

158. Prasad (1990), 3–11. *EIAPS* (1913–14), 35–45, gives a slightly different date. As early as the 1220s, Sanskrit inscriptions recognize Iltutmish as the paramount ruler of northern India: Kumar (2007), 113.

159. As Yazdani observes, "the poet extols the greatness of the Mlēchchha king in no less flattering terms than are used in the panegyrics of the Hindu period": *EIAPS* (1913–14), 37. See also B. Chattopadhyaya (1997), 197; idem (1998), 48–54.

160. Prasad (1990), 15–18; *EI* 12 (1913–14), 18–20.

161. Agarwala (1966), 96–99.

162. Deambi (1982), 114–15; M. Khan (1986). Elsewhere, Hindu deities might be called on to bestow sanctity on Kashmiri sultans: Granoff (1998), 128. As Brajadulal Chattopadhyaya ([1997], 197) notes: "If temporal power needed 'legitimization' from 'spiritual' authority, so did the human agents of 'spiritual' authority require sustenance from temporal power. Viewed from this perspective, it should not be surprising that priestly validation of temporal power continued beyond the period of 'Hindu' dynasties; the brāhmaṇa, in a situation of reciprocal relationship, could continue to prepare the *praśastis* of the rule of a Sultan and Sanskritize his titles to *Suratrāṇa*."

163. Hardy (1986), 38.

164. Anderson (1991), 6.

165. Talbot (2000), 282.

166. The phenomenon exemplifies Jonathan Hay's observation regarding claims of transdynastic continuity: "For here—especially in the realm of dynastic style—syncretism often gives way to synthesis, and so to the playing out in art of relations of cultural power: the foreign is exoticized, domesticated": Hay (1999), 7.

167. Talbot (1995), esp. 701.

168. The earliest documented use of the term occurs in an inscription of the Chandella ruler Dhanga (ca. 998–1002), whose prowess is said to equal that of *Haṁvira*: *EI* 1 (1892), 221.

169. Bosworth (1962), 223.

170. Ray (1973), 2:681–82.

171. *IA* 15 (1886), 7–13; *IA* 18 (1889), 133, 130; *EI* 1 (1892), 64; *EI* 4 (1900), 119.

172. *IA* 41 (1912), 19.

173. *EI* 1 (1892), 344; *EI* 2 (1894), 439.

174. M. Stein (1989), 7:53; *IA* 20 (1891), 202; Sarda (1913).

175. Suri (1920); Sandesara (1953), 122–25; Bhattacharya (1954), 116; Prabha (1976), 292.

176. Mitra (1957), 153. See also *EI* 1 (1892), 218; Ahluwalia (1970), 163; D. Sharma (1975), 61, 68–69.

177. Jackson (1999), 10–12; Patel (2004a), 4.

178. For a late example see Tye and Tye (1995), no. 404. See also Deyell (1999), 152.

179. *EIAPS* (1913–14), 37; Prasad (1990), 5, 13. For convenient lists of the titles afforded the Delhi sultans in Sanskrit inscriptions see Prasad (1990), appendix B; B. Chattopadhyaya (1997), appendix 1.

180. B. Chattopadhyaya (1998), 30.

181. Wilson, and Masson (1846), 431–32; E. Thomas (1967), 50–51.

182. Among the many references to Aybek as Khusrau in the *Tāj al-Ma'āthir* see Hasan Nizami (n.d.), fol. 106.

183. *IA* 8 (1879); *EIAPS* (1927–28); A. Ahmad (1963), 473–74; Prabha (1976), 291–319. For a modern history of Hammīra see Sarda (1921).

184. Thapar (2001), 125, 131.

185. Deyell (1999), 223, 369. For the use of VS dates on the coins of the Delhi sultans from the time of Iltutmish onward see ibid., 366, nos. 315, 320. On the absence of dates on pre-Ghurid Indian coinage see Richards (1983).

186. *EI* 32 (1957–58), 246.

187. *EI* 20 (1929–30), 134–35; Mazumdar (1960), 130–31. On the term *Śāha* or *Śāhī* see B. Chattopadhyaya (1998), 54.

188. Bhandarkar (1983), nos. 615, 702; *EI* 24 (1937–38), 59.

189. Burgess (1991), 164, 200.

190. *EI* 34 (1961–62), 178–82.

191. Wagoner (1996b), 861–63.

192. Eaton (2001), 164. For other instances of the use of *suratrāṇa* see Bhandarkar (1983), nos. 919–920.

193. Bhavnagar Archaeological Department (1894), 114–17; Thapar (1989), 224.

194. T. Stewart (2001), 276.

195. B. Chattopadhyaya (1998), 84.

196. Ibn Bibi (1971), 10, 390, 403; Album (1998), 62, no. 1196; Necipoğlu (1999–2000), 71.

197. Redford (1993), 154.

198. *Ulysses*, chap. 15.

199. Derrida (1978), 153.

200. Carbonell (1996), 91.

1. DaCosta Kaufmann (2004), 221, 225.
2. Bhabha (1994), 37; S. Ross (1990), 38; Carbonell (1996), 90–93.
3. Markovits, Pouchepadass, and Subrahmanyam (2003), 2–3.
4. DaCosta Kaufmann (2004), 233–34.
5. Pollock (1996), 246. In a similar vein see Bulliet (1994).
6. Lugo (1997), 51, 57; McMaster (1995), 82; Hay (1999), 7. See also Abulafia (2002), 5.
7. Clifford (1997), 3.
8. The phrase is that of Tony Stewart ([2000], 24), discussed at length by Gilmartin and Lawrence (2000), 6.
9. Hodgson (1977), 1:57–60.
10. Raghavan (1956), 502.
11. D. Ali (2004), 268.
12. Pollock (1996), 234; idem (2002), 17; idem (2004), 249.
13. Euben (2005), 179, 182.
14. Shukurov (2001), 269.
15. Mayaram (1997). Studies of Christian-Muslim interaction in medieval Andalusia note that cultural innovations were more frequently the product of nonformal mechanisms of circulation than institutionalized contacts: Glick (1979) 284–86.
16. Wagoner (1999), 242–49.
17. Christys (2002).
18. Wagoner (1996b), 875.
19. Ludden (1994), 6.
20. B. Metcalf (1995), 952.
21. Appadurai (1988), 46–47; Gruzinski (2002), 25–27; Gupta and Ferguson (1992), 6–7; Dean and Leibsohn (2003), 6. See also Wagoner (1996b), 852.
22. Douglas (1966), 160.
23. Adam and Cowell (2006).
24. Latour (1993), 10–11.
25. Stone (1996), 156, 160. See also Eaton (2001), 160; Pollock (2004), 262; Menocal (2005).
26. Pollock et al. (2002), 12.
27. Guha (2004)
28. Viswanathan (1996). For similar points see also Glick (1992), 7; Kafadar (1995), 84; Subrahmanyam (1996), 51–52, 55–58; Mayaram (1997), 42; G. Desai (2004).
29. The classic study is that of Greenblatt (1980). See Bentley's comments on the prevalence of "'modernocentrism' —an enchantment with the modern world and the processes of modern history that has hindered many historians from recognizing the significance of cross-cultural interactions in earlier times": Bentley (1998), 239. See also Patterson (1990); Subrahmanyam (1997), 740; Talbot (2001), 10; Euben (2005), 177; Pollock (2004), 248; idem (2006), 10–11.
30. Ferguson (2000), 189.
31. Ferguson (2000), 3, 9, 13; DaCosta Kaufmann (2004), 112. A further aspect of this presentism is the preeminence of the colonial and postcolonial periods in the study of South Asia and the tendency to disaggregate both from the premodern pasts out of which they emerged, assuming a "profound epistemic rupture" with the advent of European colonialism. This has the paradoxical effect of privileging colonial discourse above the indigenous discourses that it supplanted and sometimes suppressed: B. Miller (1991), 785; Eaton (2000), 145–46; Wagoner (2003), 784.
32. Barker (1984), 10–11. For a critical assessment see Patterson (1990), 97. See also Subrahmanyam (1997), 740; Pollock (2006), 8–10.
33. Pollock (2002), 26. See also Inden (2000a), 264.
34. E. Said (1989), 225.
35. Bhabha (1993), 22.
36. Stepan (1985), 99, 109–110; Lionnet (1989), 10; Pagden (1995), 144–45. Young (1995), 16–19, 26–28. Mayaram (1997), 41; Coombes and Brah (2000), 4–5; Pollock (2002), 47.
37. Quoted in Prakash (1992), 159.
38. Young (1995), 2, 4. As Sanjay Subrahmanyam notes: "a national culture that does not have the confidence to declare that, like all other national cultures, it too is a hybrid, a crossroads, a mixture of elements derived from chance encounters and unforeseen consequences, can only take the path to xenophobia and cultural paranoia": Subrahmanyam (2001).
39. Pipes (2004). See also Buruma (2007).
40. Cited in Lionnet (1989), 11.
41. For these events see Veer (1994a), 152–62, and Guha-Thakurta (1997) among many others.
42. Rubiés (2000), 391.
43. D. Robinson (1997), 16. As Euben notes, consideration of continuities and discontinuities in the history of cross-cultural encounter can "help restore a broader historical and cultural field for recognizing the mobility of theorizing and theorizing mobility across and within epochs and cultures": Euben (2005), 17, 174–75. See also Bennison (2002).

| Bibliography

For the sake of convenience the bibliography has been subdivided into three sections:
1. Primary Sources
2. Secondary Sources
 (a) History and Material Culture
 (b) Conceptual and Theoretical

| Primary Sources

INSCRIPTIONS, MANUSCRIPTS, PUBLISHED
RECENSIONS, AND TRANSLATIONS

'Afif, Shams Siraj. 1888. *The Tarikh-i-Firoz Shahi*. Ed. Maulavi Vilayat Husain. Calcutta: Asiatic Society.

Ahmad, S. Maqbul. 1960. *India and the Neighbouring Territories in the* Kitāb Nuzhat al-Mushtāq fi Khtirāq al-'Afāq *of al-Sharīf al-Idrīsī*. Leiden: E. J. Brill.

Algar, Hamid. 1982. *The Path of God's Bondsmen from Origin to Return (Mersad al-'ebad men al-mabda' ela'l-ma'ad): A Sufi Compendium by 'Abd Allah ibn Muhammad Najm al-Din Razi*. Delmar, N.Y.: Caravan Books.

Amedroz, H. F., and D. S. Margoliouth. 1921. *The Eclipse of the 'Abbasid Caliphate*. Vol. 4. Oxford: Basil Blackwell.

Amir Khusrau. 1950. *The Nuh Sipihr of Amir Khusrau*. Ed. Mohammed Wahid Mirza. Oxford: Oxford University Press.

———. 1953. *Khazā'in al-Futuh of Hazrat Amīr Khusrau Dihlawī*. Ed. Mohammed Wahid Mirza. Calcutta: Asiatic Society.

Anon. 1955 [1314]. *Tārīkh-i Sistān*. Ed. Malik al-Shu'ara Taqi Bahar. Tehran: Muhammad Ramazani.

———. 1962. *Ḥudūd al-'Ālam*. Ed. Manuchihr Sutudeh. Tehran: Intisarat-i Danishgah-i Tehran.

———. 1985. *Kitāb al-istibsār fi 'ajā'ib al-amsār: wasf Mekka wa'l-Madīna wa Misr*. Al-Dar al-Bayda: Dar al-Nashr al-Maghribiyya.

al-'Arudi, Nizami al-'Arudi al-Samarqandi, Ahmad b. 'Umar b. 'Ali. 1927. *Chahār Maqāla*. Berlin: Iranschähr.

Askari, Syed Hasan. 1963. "Taj-ul-Maasir of Hasan Nizami." *Patna University Journal* 18/3: 49–127.

'Attar, Farid al-Din. 1998. *The Speech of the Birds Concerning Migration to the Real, the* Manṭiqu't-Ṭair. Trans. P. W. Avery. Cambridge: Islamic Texts Society.

Avasthy, Rama Shankar, and Amalananda Ghosh. 1936. "References to Muhammadans in Sanskrit Inscriptions in Northern India c. A.D. 730 to 1320." *Journal of Indian History* 15:161–74.

Awasthi, A. B. L. 1962. "Garuḍa Purāṇa on the Turkish Conquest of India." *Journal of the Uttar Pradesh Historical Society* 10/1–2: 139–42.

'Awfi, Sadid al-Din. 1967. *Jawāmi' al-Ḥikāyāt fi Lawāmi' al-Riwāyāt*. Ed. M. Nizamud-din. Hyderabad: Dairatu'l-Ma'arif-il-Osmania Press.

———. N.d. 1. *Jawāmi' al-Ḥikāyāt fi Lawāmi' al-Riwāyāt*. Manuscript, British Library, London, Or. 2676.

———. N.d. 2. *Jawāmi' al-Ḥikāyāt fi Lawāmi' al-Riwāyāt*. Manuscript, Bibliothèque nationale, Paris, Sup. Pers. 906.

Awliya, Nizam al-Din. 1966. *Favā'id al-Fu'ād*. Ed. Muhammad Latif Malik. Lahore: Malik Siraj al-Din.

al-Azraqi, Abu'l-Walid Muhammad b. 'Abdullah b. Ahmad.

1858. *Kitāb Akhbār Makka.* Ed. F. Wüstenfeld. Leipzig: F. A. Brockhaus.

Babcock, Emily Atwater, and A. C. Krey. 1943. *A History of Deeds Done Beyond the Sea.* 2 vols. New York: Columbia University Press.

al-Baladhuri, Ahmad ibn Yahya ibn Jabir. 1968 [1866]. *Kitāb futuḥ al-buldān.* Ed. M. J. de Goeje. Bibliotheca Geographorum Arabicorum, vol. 5. Leiden: E. J. Brill.

Bandyapadhyaya, Brajanātha. 1879. "Hamīr Rāsā, or a History of Hamīr, Prince of Ranthambor." *Journal of the Royal Asiatic Society of Bengal* 48:186–252.

Bayhaqi, Abu'l-Fazl Muhammad b. Hosayn. 1971. *Tārīkh-i Bayhaqī.* Ed. ʿAli Akbar Fayyaz. Mashhad: Danishgah-i Mashhad.

Ben Shemesh, A. 1967. *Taxation in Islam I: Yaḥyā ben Ādam's Kitāb al-Kharāj.* Leiden: E. J. Brill.

Beveridge, Annette Susannah. 1922. *The Bābur-Nāma in English.* 2 vols. London: Luzac.

Beveridge, H. 1986. *The Tārīkh-i-Mubārakshāhī of Yāḥya bin Aḥmad bin ʿAbdullah Sirhindi.* Delhi: Durga Publishers.

Bhandarkar, D. R. 1983. *A List of Inscriptions of Northern India in Brahmi and Its Derivative Scripts, from about 200 AC.* Appendix to *Epigraphia Indica* vols. 19–23. New Delhi: Director General of the Archaeological Survey of India.

Bhatnagar, V. S. 1991. *Kānhaḍade Prabandha (India's Greatest Patriotic Saga of Medieval Times).* New Delhi: Aditya Prakashan.

Bhavnagar Archaeological Department. 1894. *A Collection of Prakrit and Sanskrit Inscriptions.* Bhavnagar: State Printing Press.

al-Biruni, Abu Rayhan Muhammad ibn Ahmad. 1958. *Kitāb fī tahqīq-i-ma li'l-Hind.* Hyderabad: Osmania Oriental Publications Bureau.

———. 1980. *Kitāb al-jamāhir fī maʿrifat al-jawāhir.* Cairo: Maktabat al-Mutanabbi.

Boyle, John Andrew. 1958. *The History of the World-Conqueror by ʿAlā al-Dīn Aṭā Malek Joveynī.* 2 vols. Cambridge, Mass.: Harvard University Press.

Briggs, John. 1981 [1829]. *History of the Rise of the Mahomedan Power in India through the Year A.D. 1612, Translated from the Original Persian of Mahomed Kasim Ferishta.* 4 vols. New Delhi: Oriental Books Reprint Corp.

Broadhurst, R. J. C. 1952. *The Travels of Ibn Jubayr.* London: J. Cape.

———. 1980. *A History of the Ayyubid Sultans of Egypt Translated from the Arabic of al-Maqrizi.* Boston: Twayne Publishing.

Budge, Ernest A. Wallis. 1976 [1932]. *The Chronography of Gregory Abû'l-Faraj 1225–1286.* 2 vols. Amsterdam: APA-Philo Press.

Bühler, Georg. 1892. "The Jagḍûcharita of Sarvânanda, a Historical Romance from Gujarât." *Sitzungsberichte der Philosophisch-Historischen Classe der Kaiserlichen Akademie der Wissenschaften* 126:1–74.

Chattopadhyaya, Debiprasad. 1970. *Tāranātha's History of Buddhism in India.* Simla: Indian Institute of Advanced Study.

Colebrooke, Henry. 1808. "Translation of one of the Inscriptions on the Pillar at Dehlee, called the Lat of Feeroz Shah." *Asiatick Researches* 7:175–82.

Collins, B. A., and M. H. al-Tai. 1994. *Al-Muqaddasi, The Best Divisions for Knowledge of the Regions.* Reading: Garnett Publishing.

Cureton, W., and H. H. Wilson. 1841. "Extract from the Work Entitled Fountains of Information Respecting the Classes of Physicians by Muwaffik-uddīn Abú-'l abbás Ahmad ibn Abú Usaibiâh." *Journal of the Royal Asiatic Society* 6:105–119.

Dagens, Bruno. 1984. *Architecture in the Ajitāgama and the Ravravāgama (a Study of two South Indian Texts).* Pondichery: Institut Française d'Indologie.

———. 1985. *Mayamata (an Indian Treatise on Housing, Architecture and Iconography).* New Delhi: Sitaram Bhartia Institute of Scientific Research.

Dani, Ahmad Hasan, Helmut Humbach, and Robert Gobl. 1964. "Tochi Valley Inscriptions in the Peshawar Museum." *Ancient Pakistan* 1:125–35.

Dankoff, Robert. 1983. *Yūsuf Khāṣṣ Ḥājib, Wisdom of Royal Glory (Kutadgu Bilig), a Turko-Islamic Mirror for Princes.* Chicago and London: University of Chicago Press.

Darke, Hubert, trans. 1960. *The Book of Governors or Rules for Kings: the Siyāsat-nāma or Siyar al-mulūk of Niẓām al-Mulk.* New Haven: Yale University Press.

de Gayangos, P. 1840–43. *The History of the Mohamedan Dynasties in Spain.* 2 vols. London: W. H. Allen & Co.

de Slane, William MacGuckin Baron. 1842–71. *Ibn Khallikan's Biographical Dictionary.* 4 vols. London: Oriental Translation Fund of Great Britain and Ireland.

Defrémery, C. 1843-44. "Histoire des Sultans Ghourides." *Journal Asiatique* iv série 2 and 3: 167–200 and 258–91.

Defrémery, C., and B. R. Sanguinetti. 1914–26. *Voyages d'Ibn Batoutah.* 5 vols. Paris: Imprimerie Nationale.

Desai, Ziyaud-Din A. 1961. "Muslims in the 13th Century Gujarat, as Known from Arabic Inscriptions." *Journal of the Oriental Institute MS University of Baroda* 10/3: 353–64.

———. 1971. *Published Muslim Inscriptions of Rajasthan.* Jaipur: Directorate of Archaeology and Museums, Government of Rajasthan.

———. 1985. *Corpus of Arabic and Persian Inscriptions in the Museums of Gujarat.* Vadodara: Government of Gujarat Department of Museums.

Dhaky, M. A. 1969. "Māru-Gurjara Vāstu-Śāstra mān masjid-Nirmāṅa Vidhi." *Swadhyaya* 8:64–79.

Dodge, Bayard, trans. 1970. *The Fihrist of al-Nadīm: A Tenth-Century Survey of Muslim Culture.* 2 vols. New York: Columbia University Press.

Dorn, Bernhard. 1976. *History of the Afghans, Translated from the Persian of Neamet Ullah.* Karachi: Indus Publications.

Dubey, Lal Mani. 1987. *Aparājitapṛcchā—a Critical Study.* Allahabad: Lakshmi Publications.

Elliott, H. M., and John Dowson. 1990 [1867–77]. *The History of India as Told by Its Own Historians.* 4 vols. Delhi: Low Cost Publications.

Fagnan, E. 1915. *Abū'l-Hasan ʿAlī Mawardī, Les statuts gouvernementaux ou règles de droit public et adminstratif.* Algiers: Librairie de l'université.

———. 1921. *Abu Yusuf Yaʿqub, Le Livre de l'impot foncier (Kitāb El-Kharādj).* Paris: P. Geuthner.

Fakhr-i Mudabbir, Muhammad b. Mansur. 1927. *Taʾrīkh-i Fakhr al-Dīn Mubārakshah.* Ed. E. Denison Ross. London: Royal Asiatic Society.

———. 1967 [1346s]. *Adāb al-Ḥarb waʾl-Shujāʿa.* Ed. Ahmad Suhayli Khwansari. Tehran: Intisharat-i Iqbal.

Faris, Nabih Amin. 1952. *The Book of Idols.* Princeton: Princeton University Press.

Fatimi, S. Q. 1963. "Two Letters from the Mahārājā to the Khalīfah." *Islamic Studies* 2/1: 121–40.

Fishbein, Michael. 1997. *The History of Ṭabarī.* Vol. 8: *The Victory of Islam.* Albany: SUNY Press.

Fleet, John Faithful. 1970. *Inscriptions of the Early Gupta Kings and Their Successors.* Corpus Inscriptionum Indicarum, vol. 3. Varanasi: Indological Book House.

Foster, William. 1921. *Early Travels in India, 1583–1619.* Oxford University Press, Oxford.

Fredunbeg, Mirza Kalichbeg. 1985 [1900]. *The Chachnamah an Ancient History of Sind.* Karachi: Vanguard Books.

Freeman-Grenville, G.S.P. 1981. *The Book of the Wonders of India.* London and The Hague: East-West Publications.

Frye, Richard, N. 1954. *The History of Bukhara.* Cambridge, Mass.: Mediaeval Academy of America.

Fuller, A. R., and Khallaque, A. 1967. *The Reign of ʿĀlāuddīn Khiljī Translated from Zia-ud-din Barani's Tarīkh-i-Firūz Shāhī.* Calcutta: Pilgrim Publishers.

Gabrieli, Francesco. 1932. "Un antico Trattato Persiano di storia delle Religioni—Il *Bayān al-Adyān* di Abū'l-Maʿālī Muḥammad ibn ʿUbaydallāh." *Rendiconti della Reale Accademia Nazionale dei Lincei,* Classe di Scienze Morali, Storiche e Filologiche 6th series 8:587–644.

Gardizi, Abu Saʿid ʿAbd al-Hayy ibn al-Dahhak ibn Mahmud. 1928. *Kitāb Zāyn al-Akhbār.* Ed. Muhammad Nazim. London: Luzac & Co.

Geiger, Willhelm. 1953. *Cūlavamsa, Being the More Recent Part of the Mahavamsa.* Colombo: Ceylon Government Information Department.

Ghafur, Muhammad Abdul. 1965–66. "Two Lost Inscriptions Relating to the Arab Conquest of Kabul and the North-West Region of West Pakistan." *Ancient Pakistan* 2:4–12.

———. 1966. "Fourteen Kufic Inscriptions of Banhore the Site of Daybul." *Pakistan Archaeology* 3:65–90.

al-Ghazali, Muhammad ibn Muhammad. N.d. *Iḥyaʾ al-ʿUlūm-ud-Din (The Revival of Religious Learnings).* Trans. al-Haj Maulana Fazal-ul-Karim. Book 3: *The Book of Destructive Evils.* Lahore: Kazi Publications.

Gibb, H.A.R. 1958–94. *The Travels of Ibn Baṭṭūṭa, A.D. 1325–1354.* 4 vols. Cambridge: Cambridge University Press.

Gimaret, Daniel, and Guy Monnot. 1986. *Livre des religions et des sectes.* 2 vols. Paris: UNESCO.

Gold, Milton. 1976. *The Tārīkh-e Sistān.* Rome: Istituto Italiano per il Medio ed Estremo Oriente.

Habib, Muhammad. 1931. *The Campaigns of ʿAlāʾ ud-Dīn Khiljī Being the Khaẓāʾinul Futūh (Treasures of Victory) of Hazrat Amīr Khusrau.* Madras: D. B. Taraporewala, Sons & Co.

Habibi, Abdul Hai. 1954. "The Oldest Muslim Inscription in Middle Asia." *Museums Journal* 6/1–2: 70–75.

Halim, A. 1949. "Kōl Inscription of Sultān Altamash." *Journal of the Royal Asiatic Society of Bengal, Letters* 16:1–3.

Hasan, Mahmudul. 1994a. *Religion and Society in India of the 10th Century as Described by the Arab Scholar al-Masʿudi (d. 956).* The Arabs Discover India II. Patna: Khuda Bakhsh Oriental Public Library.

———. 1994b. *Religion and Society in India of the 13th Century as Described by the Arab Scholar Ibn al-Athir (d. 1232).* The Arabs Discover India II. Patna: Khuda Bakhsh Oriental Public Library.

Hasan Nizami, Taj al-Din Hasan ibn Nizami Nishapuri. N.d. *Tāj al-Maʾāthir.* Manuscript, British Library, London, India Office Library, ms. 15 (Ethé no. 210).

Hinds, Martin. 1990. *The History of al-Ṭabarī.* Vol. 23: *The Zenith of the Marwānid House.* Albany: State University of New York Press.

Hirth, Friedrich, and W. W. Rockhill. 1966. *Chau Ju-Kua: His Work on the Chinese and Arab Trade in the Twelfth and Thirteenth Centuries Entitled Chu.-Fan-Chï.* Amsterdam: Orient Press.

Hoernle, Rudolf A. F. 1881. *The Prithvirāja Rāsau of Chand Bardai.* Part 2, fasiculus 1. Bibliotheca Indica n.s. no. 452. Calcutta: Asiatic Society of Bengal.

Hultzsch, E. 1891. *South-Indian Inscriptions.* Vol. 2, part 1. Madras: Archaeological Survey of India.

———. 1892. *South-Indian Inscriptions.* Vol. 2, part 2. Madras: Archaeological Survey of India.

———. 1895. *South-Indian Inscriptions.* Vol. 2, part 3. Madras: Government Press.

———. 1899. *South-Indian Inscriptions.* Vol. 3, part 1. Madras: Government Press.

———. 1903. *South-Indian Inscriptions.* Vol. 3, part 2. Madras: Government Press.

———. 1925. *Inscriptions of Ashoka*. Corpus Inscriptionum Indicarum, vol. 1. Oxford: Clarendon Press.

Husain, Agha Mahdi. 1966–77. *Futūhu's Salāṭīn or Shāhnāmah-i Hind of 'Iṣāmī*. 3 vols. Bombay and Calcutta: Asia Publishing House.

Husain, Maulvi Muhammad Ashraf. 1936. *Record of All the Qur'anic and Non-historical Epigraphs on the Protected Monuments in the Delhi Province*. Memoirs of the Archaeological Survey of India no. 47. Calcutta: Government of India Central Publications Branch.

Ibn al-Athir, 'Izz al-Din. 1965–67. *Al-Kāmil fī'l-Ta'rīkh*. Ed. C. J. Tornberg. Beirut: Dār Sadr.

Ibn Bibi, Nasir al-Din Husayn ibn Muhammad. 1971. *Akhbār-i Salajiqah-i Rūm bā matn-i kāmil-i Saljūqnāmah-i Ibn Bibi*. Tehran: Kitabfurushi-i Tihran.

Ibn al-Faqih, Abu Bakr Ahmad ibn Muhammab al-Hamadhani. 1967. *Kitāb al-buldān*. Ed. M. J. de Goeje. Bibliotheca Geographorum Arabicorum, vol. 5. Leiden: E. J. Brill.

Ibn Hawqal, Abu'l-Qasim. 1967 [1873]. *Kitāb ṣūrat al-arḍ*. Ed. J. H. Kramers. Bibliotheca Geographorum Arabicorum, vol. 3. Leiden: E. J. Brill.

Ibn Ibrahim, Muhammad. 1886. *Tārīkh-i Saljūqiyān-i Kirmān*. Ed. M. T. Houtsma. Recueil de texts relatives à l'histoire des Seljoucides I. Leiden: E. J. Brill.

Ibn Jubayr, Abu'l-Husayn Muhammad ibn Ahmad. 1907. *Rihla*, Ed. W. Wright. Leiden: E. J. Brill.

Ibn Khurradadhbih, 'Ubayd ibn Allah ibn 'Abd Allah. 1967 [1889]. *Kitāb al-masālik wa'l-mamālik*. Ed. M. J. de Goeje. Bibliotheca Geographorum Arabicorum, vol. 6. Leiden: E. J. Brill.

Ibn Mahru, 'Ain al-Din 'Ain al-Mulk Abdullah. 1965. *Inshā'-i-Māhrū (Letters of 'Ain ud-Din 'Ain al-Mulk Abdullah bin Mahru)*. Ed. 'Abdur Rashid and Muhammad Bashir Hussain. Lahore: Research Society of Pakistan.

Ibn al-Sa'i, Ali ibn Anjab. 1934. *Al-jāmī' al-mukhtaṣar fī 'unwān al-tawārīkh wa 'uyūn al-siyar*. Baghdad: al-Matba'ah al-siryaniyah al-kathulikiyah.

Ibn Zafir, Jamal al-Din Abu'l-Hasan. N.d. *Akhbār al-duwali 'l-munqaṭi'a* Manuscript, British Library, India Office Library, Or. 3685.

Ibn al-Zubayr, Aḥmad ibn al-Rasīd. 1959. *Kitāb al-dhakā'ir wa'l-tuḥaf*. Kuwait: Dar al-matbu'at wa'l-nashr.

al-Idrisi, Abu 'Abd Allah Muhammad. 1954. *Wasf al-Hind*. Ed. S. Maqbul Ahmad. Aligarh: Aligarh Muslim University.

al-Isfizari, Mu'in al-Din Muhammad al-Zamji. 1961. *Rawḍāt al-Jannāt fī awṣāfi madīnat-i Harāt*. Aligarh: Aligarh Muslim University.

Iskandar, Albert Z. 1981. "A Doctor's Book on Zoology: Al-Marwazī's Ṭabā'i' al-Ḥayawān (Nature of Animals) Reassessed." *Oriens* 27–28:266–312.

al-Istakhri, Abu Ishaq al-Farisi. 1967 [1870]. *Kitāb masālik wa'l-mamālik*. Ed M. J. de Goeje. Leiden: E. J. Brill.

Iyer, N. C. 1987. *The Bṛhat Saṃhitā of Varāha Mihira*. Delhi: Sri Satguru Publications.

Joshi, M. C. 1974. "Some Nagari Inscriptions on the Qutb Minar." In *Proceedings of Seminar on Medieval Inscriptions (6–8th Feb. 1970)*, pp. 22–26. Aligarh: Centre of Advanced Study, Aligarh Muslim University.

al-Jurfadiqani, Abu'l-Sharaf Nasih ibn Zafar. 1978. *Tarjuma-yi Tārīkh-i Yamīnī*. Ed. Ja'far Sha'ār. Teheran: Bahman Press.

Juvayni, 'Ala' al-Din 'Ata Malik Juvayni. 1912–37. *The Ta'rīkh-i-Jahān-Gushā*. Ed. Mirza Muhammad. 3 vols. E. J. Gibb Memorial Series, vol. 16. London: Luzac & Co.

Juynboll, Gautier H. A. 1989. *The History of al-Ṭabarī*. vol. 23: *The Conquest of Iraq, Southwestern Persia, and Egypt*. Albany: State University of New York Press.

Juzjani, Minhaj al-Din Abu 'Umar al-Uthman. 1963–64 [1342–43s]. *Ṭabaqāt-i Nāṣirī*. Ed. 'Abd al-Hayy Husayni Habibi. 2 vols. Kabul: Anjuman-i Tarikh-i Afghanistan.

Kalus, Ludvik, and Claude Guillot. 2006. "Réinterprétation des plus anciennes stèles funéraires Islamiques nousantariennes. III: Sri Lanka." *Archipel* 72:15–68.

Kautilya. 1992. *The Arthashastra*. Trans. L. N. Rangarajan. New Delhi: Penguin Books.

Kay, Henry Cassels. 1892. *Yaman, Its Early Medieval History*. London: Edward Arnold.

Kazi, A. K., and J. G. Flynn. 1984. *Muslim Sects and Divisions, the Section on Muslim Sects in Kitāb al-Milal wa'l-Niḥal*. London: Kegan Paul International.

Kraemer, Joel L. 1989. *The History of al-Ṭabarī*. Vol. 34: *Incipient Decline*. Albany: State University of New York Press.

Kramers, J. H., and G. Wiet. 1964. *Configuration de la terre (Kitāb surat al-arḍ)*. Vol. 2. Paris: Éditions G. P. Maisonneuve & Larose.

al-Kufi, 'Ali ibn Hamid ibn Abi Bakr. 1983. *Fatḥnāmah-yi Sind (Chachnāma)*. Ed. N. A. Baloch. Islamabad: Institute of Islamic History, Culture and Civilization, Islamabad University.

Kuraishi, Muhammad Hamid. 1925–26. "A Kufic Sarada Inscription from the Peshawar Museum." *Epigraphia Indica Arabic and Persian Supplement*, 27–28.

Lawrence, Bruce B. 1973. "Shahrastānī on Indian Idol Worship." *Studia Islamica* 38:60–73.

———. 1976. *Shahrastānī on the Indian Religions*. The Hague and Paris: Mouton.

———. 1992. *Nizam al-Din Awliya, Morals for the Heart*. New York: Paulist Press.

Le Strange, Guy. 1912. *Description of the Province of Fars in Persia*. London: Royal Asiatic Society.

Lunde, Paul, and Caroline Stone. 1989. *The Meadows of Gold*.

Vol. 1: *The 'Abbasids*. London and New York: Kegan Paul International.

Massé, Henri. 1973. *Abrégé du livre des pays*. Damascus: Institut Français de Damas.

al-Mas'udi, Abu'l-Hasan 'Ali. 1861–77. *Murūj al-dhahab wa mada'adin al-jawhar*. 9 vols. Ed. and trans. C. Barbier de Meynard and Pavet de Courteille. Paris: Imprimerie impériale.

———. 1962–. *Les prairies d'or*. Trans. C. Barbier de Meynard, Pavet de Courteille, and Charles Pellat. Paris: Société asiatique.

Mayrhofer, C. M. 1998. *The Saṁdeśarāsaka of Abdul Rahman*. Delhi: Motilal Banarsidas Publishers Private.

Meier, Friedrich Max. 1948. Abu Bakr Muhammad Mahmud ibn 'Uthman, *Die Vita das Scheich Abu Ishaq al-Kazaruni in der persischen Bearbeitung*. Leipzig: F. A. Brockhaus.

Meisami, Julie Scott. 1991. *The Sea of Precious Virtues (Baḥr al-Favā'id): A Medieval Islamic Mirror for Princes*. Salt Lake City: University of Utah Press.

Minorsky, V. 1942. *Sharaf al-Zamān Ṭāhir Marvazī on China, the Turks and India*. London: Royal Asiatic Society.

———. 1948. "Gardīzī on India." *Bulletin of the School of Oriental and African Studies* 12/2: 625–39.

———. 1950. "Marvazi on the Byzantines." *Annuaire de l'institut de philologie et d'histoire orientales et slaves* 10:454–69.

———. 1980 [1937]. *Ḥudūd al-'Ālam, "The Regions of the World": A Persian Geography, 372 A.H.–982 A.D.* Karachi: Indus Publications.

Miquel, André. 1966. "L'Europe occidentale dans la relation Arabe d'Ibrâhîm b. Ya'qûb (Xe s.)." *Annales* 21:1048–64.

Mirkhvand, Muhammad ibn Khavandshah. 1994 [1358s]. *Rawḍat al-ṣafā*. 2 vols. Tehran: Intisharat-i 'Ilmi.

Mishra, Ratan Lal. 1990. *Epigraphical Studies of Rajasthan Inscriptions*. Delhi: B. R. Publishing Corporation.

Munshi, Abu'l Ma'ali Nasr Allah. 1996. *Nasrollah Monschi: Kalila und Dimna. Fabeln aus dem klassischen Persien*. Trans. Siegfried Weber. Munich: Verlag C. H. Beck.

al-Muqaddasi, Muhammad ibn Ahmad. 1967. *Kitāb Aḥsan al-Taqāsīm fī ma'rīfat al-aqālīm*. Ed. M. J. de Goeje. Bibliotheca Geographorum Arabicorum, vol. 3. Leiden: E. J. Brill.

Murgotten, Francis Clark. 1969 [1924]. *The Origins of the Islamic State*. Part 2. New York: AMS Press.

Nainar, Muhammad Husayn. 1942. *Arab Geographers' Knowledge of Southern India*. Madras: Madras University Islamic Series, no. 6.

Nath, Ram. 1977. "*Rehmāṇa-Prāsāda*—a Chapter on the Muslim Mosque from the *Vṛkṣārṇava*." *Vishveshvaranand Indological Journal* 15:239–40.

———. 1989. "On the Theory of Indo-Muslim Architecture." In Anna Libera Dallapiccola, ed., *Shastric Traditions in Indian Art*, vol. 2: *Texts*, pp. 187–201. Stuttgart: Steiner Verlag.

Nath, Ram, and Faiyaz Gwaliari. 1981. *India as Seen by Amir Khusrau (in 1318 A.D.)*. Jaipur: Historical Research Documentation Programme.

Nöldeke, Theodor. 1857. "Über das Kitâb Jamînî des Abû Naṣr Muḥammad ibn 'Abd al-ğabbâr al-'Utbî." *Sitzungsberichte de Kaiserlichen Akademie der Wissenschaften, Philosophisch-Historische Classe* 23:15–102.

O'Kane, John. 1992. *The Secret of God's Mystical Oneness or the Spiritual Stations of Shaikh Abu Sa'id*. Costa Mesa: Mazda.

Parashar, Sadhana. 2000. *Kāvyamīmaṁsā of Rājaśekhara*. New Delhi: D. K. Printworld (P).

Parkash, Ved. 1967. "The Qutb Minar from Contemporary and Near Contemporary Sources." In *Indian History Congress, Proceedings of the Ranchi Session 1964*, 2:52–57.

Pellat, Charles. 1954. "Ğāḥiẓiana, I. Le *kitāb al-tabaṣṣur bi'l-tiğāra* attribué à Ğāḥiẓ." *Arabica* 1:153–65.

Pingree, David. 1981. "Sanskrit Evidence for the Presence of Arabs, Jews, and Persians in Western India: ca. 700–1300." *Journal of the Oriental Institute M.S. University of Baroda* 31/1: 172–82.

Prasad, Pushpa. 1990. *Sanskrit Inscriptions of the Delhi Sultanate 1191–1256*. New Delhi: Oxford University Press.

———. 1995. 'The *Turuska* or Turks in Late Ancient Indian Documents.' In *Proceedings of the Indian History Congress, 55th Session, Aligarh 1994*, pp. 170–75. Delhi.

Prinsep, James. 1837. "Interpretation of the Most Ancient of the Inscriptions on the Pillar Called the lát of Feroz Sháh, near Delhi, and That of the Allahabad, Radhia and Matthia Pillar, or lát, Inscriptions Which Agree Therewith." *Journal of the Asiatic Society of Bengal* 6:566–609.

al-Qaddumi, Ghada al-Hijjawi. 1996. *Book of Gifts and Rarities, Kitāb al-Hadāyā wa al-Tuḥaf*. Cambridge, Mass: Harvard University Press.

al-Qalqashandi, Ahmad ibn 'Ali. 1913 [1333]. *Kitāb ṣubḥ al-a'shā*. 14 vols. Cairo: Al-Matba'ah al-Amiriyah.

al-Qazwini, Hamd' Allah Mustawfi. 1910. *The Ta'rīkh-i-Guzīda*. Ed. and trans. Edward G. Browne. 2 vols. London: Luzac & Co.

al-Qazwini, Zakariya ibn Muhammad. 1960. *Āthār al-bilād wa-akhbār al-'ibād*. Beirut: Dār Sadr.

Quatremère, Etienne Marc. 1811. *Mémoires géographiques et historiques sur l'Égypte*. 2 vols. Paris: F. Schoell.

Ramhurmuzi, Buzurg ibn Shahriyar. 1883–86. *Kitāb 'ajā'ib al-Hind (Livre des merveilles de l'Inde)*. Ed. P. A. van der Lith and L. Marcel Devic. Leiden: E. J. Brill.

Ranking, George S. A. 1976. *Muntakhab-ut-Tawārīkh by*

'Abdul Qādir bin Mulūk Shāh Known as al-Badāonī. Karachi: Karimsons.

Rashid, Abdur, and M. A. Mokhdoomi, 1949. *Futuhat-i-Firoz Shahi.* Aligarh: Aligarh Muslim University.

Raverty, H. G. 1970 [1881]. *Ṭabaḳāt-i-Nāṣirī: A General History of the Muhammedan Dynasties of Asia, Including Hindustan.* 2 vols. New Delhi: Oriental Books Reprint Corporation.

al-Razi, Fakhr al-Din Muhammad ibn 'Umar. 1978. *I'tiqādāt firaq al-muslimīn wa'l-mushrikīn.* Cairo: Maktabat al-kulliyat al-Azhariyah.

Rehatsek, E. 1878–80. "Early Moslem Accounts of the Hindu Religion." *Journal of the Bombay Branch of the Royal Asiatic Society* 14:29–70.

———. 1892–93. *The Rauzat-us-safa; or, Garden of Purity.* Vol. 1, parts 1 and 2. London: Royal Asiatic Society.

Reinaud, Joseph Toussaint. 1976 [1845]. *Fragments arabes et persans inédits relatifs à l'Inde antérieurement au XIe siècle.* Amsterdam: Oriental Press.

Reinaud, Joseph Toussaint, and Stanislas Guyard. 1848–53. *Géographie d'Aboulféda.* 2 vols. Paris: Imprimerie Nationale.

Reynolds, James. 1858. *The Kitab-i-Yamini.* London: Oriental Translation Fund of Great Britain and Ireland.

Rosenthal, Franz. 1967. *The Muqaddimah, an Introduction to History.* 2nd ed., 3 vols. Princeton: Princeton University Press.

Ross, E. Denison. 1922. "The Genealogies of Fakhr-ud-dīn Mubārakshāh." In T. W. Arnold and Reynold A. Nicholson, eds., *Ajab Nāma: A Volume of Oriental Studies,* pp. 392–413. Cambridge: Cambridge University Press.

Roy, N. B. 1941. "The Victories of Sulṭān Fīrūz Shāh of Tughluq Dynasty (English Translation of Futūḥāt-i-Fīrūz Shāhī.)" *Islamic Culture* 15:449–64.

al-Sabi', Hilal. 1964. *Rusūm dār al-Khilāfah.* Ed. Mikha'il 'Awad. Baghdad: Matba'a al-'Ani.

Sachau, Edward C. 1989 [1910]. *Al-Beruni's India.* 2 vols. Delhi: Low Price Publications.

al-Safadi, Salah al-Din Khalil ibn Aybak. 1931–. *Kitāb al-wāfī hi'l-wafayāt.* 29 vols. Leipzig: F. A. Brockhaus.

Said, Hakim Mohammad. 1989. *Al-Beruni's Book on Mineralogy: The Book Most Comprehensive in Knowledge on Precious Stones.* Islamabad: Pakistan Hijra Council.

Salem, Elie A. 1977. *Hilāl al-Ṣābi', Rusūm dār al-Khilāfah (The Rules and Regulations of the 'Abbāsid Court).* Beirut: American University of Beirut.

Salem, Sema'an I., and Alok Kumar. 1991. *Science in the Medieval World: Book of the Category of Nations by Ṣā'id al-Andalusī.* Austin: University of Texas Press.

Saliba, George. 1985. *The History of al-Ṭabarī.* Vol. 35: *The Crisis of the 'Abbasid Caliphate.* Albany: SUNY Press.

Sami, Nizamuddin. 1937. *Ẓafarnāma.* Ed. Felix Tauer. Prague: Oriental Institute.

Sarda, Har Bilas. 1913. "The Prithviraja Vijaya." *Journal of the Royal Asiatic Society,* 259–81.

———. 1985 [1935]. *Prithviraja Vijaya: The Great Epic Poem on Prthviraja the Last Chauhan Emperor.* Ajmir: Vedic Yantralaya.

Saroop, Bhagwat. 1998. *Tajud Din Hasan Nizami's Taj ul Ma'athir [The Crown of Glorious Deeds].* Delhi: Saud Ahmad Dehlavi.

Sastri, Rao Sahil K. Krishna. 1920. *South-Indian Inscriptions.* Vol. 3, part 3. Madras: Government Press.

Sauvaget, Jean. 1933. *"Les Perles Choisies" d'Ibn ach-Chihna.* Matériaux pour server a l'histoire de la ville d'Alep, vol. I. Beirut: Institut Français de Damas.

———. 1941–46. "Glanes Épigraphiques." *Revue des Études Islamiques* 14–18:17–29.

———. 1948. *Aḫbār aṣ-Ṣīn wa l-Hind. Relation de la Chine et de l'Inde.* Paris: Société d'édition "les belles lettres."

———. 1950. *"Les trésors d'or" de Sibṭ Ibn al-'Ajami.* Beirut: Institut Français de Damas.

Seelye, Kate Chambers. 1966. *Moslem Schisms and Sects (Al-Farḳ Bain al-Firaḳ).* New York: AMS Press.

Sewter, E.R.A. 1966. *Fourteen Byzantine Rulers: The Chronographia of Michael Psellus.* London: Penguin.

Shah, Priyabala. 1990. *Shri Vishnudharmottara (a Text on Ancient Indian Arts).* Ahmedabad: P. Shah.

al-Shahrastani, Muhammad ibn 'Abd al-Karim. 1977. *Al-Milal wa'l-niḥal.* Cairo: Maktabat al-Anjlu al-Misriyah.

Sharma, Shri Ram. 1933. "An Almost Contemporary Account of Mahmud's Invasion of India." *Indian Historical Quarterly* 9/4: 934–42.

———. 1941. "A Contemporary Account of Sultan Mahmud's Indian Expedition." *Journal of the Aligarh History Research Institute.* 1/2–3: 127–63.

Shokoohy, Mehrdad. 1986. *Rajasthan* I. Corpus Inscriptionum Iranicarum (CII), part 4: Persian Inscriptions down to the Safavid Period. London: Lund Humphries.

———. 1988b. *Haryana I: The Column of Fīrūz Shāh and Other Islamic Inscriptions from the District of Hisar.* Corpus Inscriptionum Iranicarum, part 4: Persian Inscriptions down to the Early Safavid Period. Vol. 47: India, State of Harayana. London: Lund Humphries.

Sibt ibn al-Jawzi, Abu'l-Muzaffar. N.d. *Mir'at al-Zamān.* Manuscript, British Library, London, India Office Library, ms. Or. 4619.

Siddiqi, Iqtidar Hussain, and Qazi Mohammad Ahmad. 1972. *A Fourteenth Century Arab Account of India under Sultan Muhammad bin Tughluq.* Aligarh: Siddiqi Publishing House.

Siddiqi, Muhammad Iqbal. 1994. *Sunan Nasā'i* (English

translation with Arabic text). Vol. 1. Lahore: Kazi Publications.

Somani, Ram Vallabh. 1982. *Jain Inscriptions of Rajasthan*. Jaipur: Rajasthan Prakrit Bharati Sansthan.

Spies, Otto. 1936. *An Arab Account of India in the 14th Century Being a Translation of the Chapters on India from al-Qalqashandi's Ṣubḥ ul-A'shā*. Stuttgart: Verlag von W. Kohlhammer.

———. 1943. *Ibn Fadlallah al-Omari's bericht über Indien*. Leipzig: Otto Harrassowitz.

Stein, M. A. 1989 [1900]. *Kalhaṇa's Rājataraṅgiṇī: A Chronicle of the Kings of Kaśmīr*. 3 vols. Delhi: Motilal Banarsidass Publishers.

al-Surabadi, Abu Bakr 'Atiq b. Muhammad. 2002–3 [1381s]. *Tafsīr-i Sūrābādī*. 5 vols. Tehran: Farhang-i Nashr-i Naw.

Suri, Jayasimha. 1920. *Hammīra Mada Mardana*. Ed. Chimanlal Dahyabhai. Baroda: Central Library.

Tawney, C. H. 1982 [1899]. *The Prabandhacintāmaṅi or Wishing-Stone of Narratives*. Reprinted, Indian Book Gallery, New Delhi.

Thackston, Wheeler M. 1986. *Nāṣer-e Khosraw's Book of Travels (Safarnāma)*. Albany: Bibliotheca Persica.

———. 1989. "Kamaluddin Abdul-Razzaq Samarqandi: Mission to Calicut and Vijayanagar." In *A Century of Princes: Sources on Timurid History and Art*, pp. 299–321. Cambridge, Mass.: The Aga Khan Program for Islamic Architecture.

———. 1999. *The Jahangirnama: Memoirs of Jahangir, Emperor of India*. New York: Oxford University Press.

Tien, Anton. 1975. "'Abd al-Masīḥ Ibn Isḥāq al-Kindī: The Apology of al-Kindī Translated from the Arabic." Typescript, London, School of Oriental and African Studies.

al-'Umari, Ibn Fadl Allah. 1962. *Tārīkh-i Hind par na'i raushanī*. Delhi: Nadvat al-Musaniffin.

al-'Utbi, Muḥammad b. 'Abd al-Jabbār. 1869. *Al-Ta'rīkh al-Yamīnī*, printed in the margin of Aḥmad ibn 'Alī al-Manīnī, *Al-Fatḥ al-wahabī 'alā ta'rīkh Abī Naṣr al-Utbī*. 2 vols. Bulaq: al-Matba'ah al-wahabiyah.

Venkayya, Rai Bahadur. 1913. *South-Indian Inscriptions*. Vol. 2, part 4. Madras: Archaeological Survey of India.

Waines, David. 1992. *The History of al-Ṭabarī. Vol. 36: The Revolt of the Zanj*. Albany: SUNY Press.

Wiet, Gaston. 1955. *Les atours précieux*. Cairo: Publications de la société de Géographie d'Égypte.

Wormhoudt, Arthur. 1997. *Risalat al-Gufran, the Letter of Forgiveness by Abu 'Ala al-Ma'arri*. Oskaloosa: William Penn College.

Wüstenfeld, Ferdinand. 1861. *Die Chroniken der Stadt Mekka*. Vol. 4: *Geschichte der Stadt Mekka*. Leipzig: F. A. Brockhaus.

al-Ya'qubi, Ahmad ibn Abi Ya'qub. 1969 [1883]. *Ta'rīkh*. Ed. T. Houtsma. 2 vols. Leiden: E. J. Brill.

Yaqut, Ibn 'Abd Allah al-Hamawi. 1866. *Kitāb mu'jam al-buldān*. Ed. Ferdinand Wüstenfeld. 6 vols. Leipzig: F. A. Brochaus.

———. 1990. *Mu'jam al-Buldān*. 7 vols. Beirut: Dar Sadr.

Secondary Sources

HISTORY AND MATERIAL CULTURE

Abe, Stanley, K. 1995. "Inside the Wonder House: Buddhist Art and the West." In Donald S. Lopez Jr., ed., *Curators of the Buddha: The Study of Buddhism under Colonialism*, pp. 63–106. Chicago and London: University of Chicago Press.

Abulafia, David. 2002. "Introduction: Seven Types of Ambiguity, c. 1100–c.1500." In David Abulafia and Nora Berend, eds., *Medieval Frontiers: Concepts and Practices*, pp. 1–34. Aldershot: Ashgate.

Abu-Lughod, Janet L. 1989. *Before European Hegemony: The World System, A.D. 1250–1350*. New York: Oxford University Press.

Adam, Karla, and Adam Cowell. 2006. "Police Search Islamic School in South Britain." *New York Times*, September 4.

Afround, Qadir. 1996 [1375s]. "Qur'ān-i mauqūfah-i Turbat-i Shaykh Aḥmad Jāmī." *Mīrāth-i Farhangī* 15:4–14.

Agrawala, R. C. 1968. "Ūrdhvaretas Gaṇeśa from Afghanistan." *East and West* 18:166–68.

Agarwala, V. S. 1943. "The Sanskrit Legend on the Bilingual Ṭankas of Mahmūd Ghaznī." *Journal of the Numismatic Society of India* 5/2: 155–61.

———. 1966. "A Unique Treatise on Medieval Indian Coins." In H. K. Sherwani, ed., *Dr. Ghulam Yazdani Commemoration Volume*, pp. 87–101. Hyderabad: Maulana Abul Kalam Azad Oriental Research Institute.

Ahluwalia, M. S. 1966. "The Sultanate's Penetration into Rajasthan and Central India—a Study Based on Epigraphic Evidence." In *Indian History Congress 1966, 28th Session Mysore*, pp. 144–52. Aligarh.

———. 1970. "References to the Muslims in Sanskrit Inscriptions from Rajasthan during the Sultanate Period." In *Indian History Congress, Proceedings of the 31st Session, Varanasi 1969*, pp. 162–71. Patna.

Ahmad, Aziz. 1963. "Epic and Counter-epic in Medieval India." *Journal of the American Oriental Society* 83:470–76.

———. 1999 [1964]. *Studies in Islamic Culture in the Indian Environment*. Delhi: Oxford University Press.

Ahmad, Imtiaz. 1976. "Exclusion and Assimilation in Indian Islam." In Attar Singh, ed., *Socio-cultural Impact of Islam*

on India, pp. 85–105. Chandigarh: Chandigarh-Publication Bureau, Punjab University.

Ahmad, Muhammad Aziz. 1949. *Political History and Institutions of the Early Turkish Empire of Delhi, 1206–1290*. Aligarh: Aligarh Muslim University.

Ahmad, Nazir. 1988. "A Reference to the Agra Fort in an 11th-Century Persian Codex." *Indo-Iranica* 41:1–23.

Ahmad, S. Maqbul. 1957–58. "Arabic Source Materials on Indo-Arab Relations." *Medieval India Quarterly* 3:100–08.

———. 1960a. "Balharā." In *The Encyclopaedia of Islam*, 1: 991. Leiden: E. J. Brill.

———. 1960b. "Al-Mas'ūdī on the Kings of India." In S. Maqbul Ahmad and A. Rahman, eds., *Al-Mas'ūdī Millenary Commemoration Volume*, pp. 97–112. Aligarh: Institute of Islamic Studies.

Ahmad, Shamsuddin Ahmad. 1966. "An Outline of Muslim Architecture in Bengal." In *Studies in Indian Culture: Dr. Ghulam Yazdani Commemoration Volume*, pp. 113–14. Hyderabad: Maulana Abul Kalam Azad Oriental Research Institute.

Ahsan, Muhammad Manazir. 1979. *Social Life under the Abbasids, 170–289 AH 786–902 AD*. London and New York: Libraire du Liban.

Alam, Muzaffar. 2003. "The Culture and Politics of Persian in Precolonial Hindustan." In Sheldon Pollock, ed., *Literary Cultures in History: Reconstructions from South Asia*, pp. 131–98. Berkeley: University of California Press.

Album, Stephen. 1998. *A Checklist of Popular Islamic Coins*. Santa Rosa, Calif.: Stephen Album.

Ali, Daud. 2004. *Courtly Culture and Political Life in Early Medieval India*. Cambridge: Cambridge University Press.

Ali, M. Athar. 1990. "Encounter and Effloresence: Genesis of the Medieval Civilization." *Social Scientist* 18/1–2:13–28.

———. 1998. "Ta'rīkh. 4. In Muslim India." In *The Encyclopaedia of Islam*, new ed., 10:295–97.

Allan, James W. 1979. *Persian Metal Technology, 700–1300 AD*. London: Ithaca Press.

Allen, Terry. 1988a. *Five Essays on Islamic Art*. Manchester, Mich.: Solipsist Press.

———. 1988b. "Notes on Bust." *Iran* 26:55–68.

Allsen, Thomas T. 1997. *Commodity and Exchange in the Mongol Empire: A Cultural History of Islamic Textiles*. Cambridge: Cambridge University Press.

———. 2001. "Robing in the Mongolian Empire." In Stewart Gordon, ed., *Robes and Honor: The Medieval World of Investiture*, pp. 305–14. New York: Palgrave.

Altekar, Anant Sadashiv. 1946. "A Bull and Horseman Type of Coin of the Abbasid Caliph al-Muqtadir Billah Ja'afar." *Journal of the Numismatic Society of India* 8:75–78.

———. 1967. *Rāshtrakūṭas and Their Times*. Poona: Oriental Book Agency.

Amin, Shahid. 2004. "On Retelling the Muslim Conquest of North India." In Partha Chatterjee and Anjan Ghosh, eds. *History and the Present*, pp. 24–43. Delhi: Permanent Black.

Amirsoleimani, Soheila. 2003. "Clothing in the Early Ghaznavid Courts: Hierarchy and Mystification." *Studia Iranica* 32:213–42.

Anawati, G. C. 1965. "Fakhr al-Dīn al-Rāzī." In *The Encyclopaedia of Islam*, new ed., 2:751–55.

Anderson, Benedict. 1991. *Imagined Communities*. London and New York: Verso.

Andrews, Peter Alford. 1993. "Miẓalla 4. In the Persian, Indian and Turkish Lands." In *The Encyclopaedia of Islam*, new ed. 7: 192–94. Leiden: E. J. Brill.

———. 1999. *Felt Tents and Pavilions: The Nomadic Tradition and Its Interaction with Princely Tentage*. 2 vols. London: Melisende.

Anon. 1826. *Catalogue of the Missionary Museum, Austin Friars*. London: W. Phillipps.

———. 1902–3. "Restoration Work in Ajmīr." *Archaeological Survey of India Reports*, 80–81.

———. 1949 [1328s]. *Rahnāma-yi Ganjīnah-i Qur'ān dar Mūzah-i Irān-i Bāstān*. Tehran: Chapkhanah-i Bank-i Milli-yi Iran.

———. 1964. "Excavations at Banbhore." *Pakistan Archaeology* 1:49–55.

———. 1971. *Arts de l'Islam des origines à 1700 dans les collections publiques Françaises*. Paris: Réunion des musées nationaux.

———. 1980. *The Central Asian Art of Avicenna Epoch*. Dushanbe: "Irfan" Publishing House.

Archer, Mildred, Christopher Powell, and Robert Skelton. 1987. *Treasures from India: The Clive Collection at Powis Castle*. London: National Trust.

Ariyapala, M. B. 1956. *Society in Mediaeval Ceylon*. Colombo and Kandy: K.V.G. de Silva.

Arjomand, Said Amir. 2004. "Transformation of the Islamicate Civilization: A Turning Point in the Thirteenth Century." *Medieval Encounters* 10/1–3: 213–45.

Asher, Catherine B. 2000. "Delhi Walled: Changing Boundaries." In James D. Tracy, ed., *City Walls: The Urban Enceinte in Global Perspective*, pp. 247–81. Cambridge: Cambridge University Press.

Ashfaque, S. M. 1969. "The Grand Mosque of Banbhore." *Pakistan Archaeology* 6:182–209.

Atil, Esin. 1981. *Kalila wa Dimna: Fables from a Fourteenth-Century Arabic Manuscript*. Washington, D.C.: Smithsonian Institution Press.

Atil, Esin, W. T. Chase, and Paul Jett. 1985. *Islamic Metalwork in the Freer Gallery of Art*. Washington, D.C.: Smithsonian Institution Press.

Ayalon, David. 1986. "Ḥarb—iii. The Mamlūk Sultanate." In

The Encyclopaedia of Islam, 2nd ed., 3:184–90. Leiden: E. J. Brill.

al-Azmeh, Aziz. 1992. "Barbarians in Arab Eyes." *Past and Present* 134:3–18.

Bacharach, Jere L. 2001. "Thoughts about Pennies and Other Monies." *Middle East Studies Association Bulletin* 35:2–13.

Bagnera, Alessandra. 2006. "Preliminary Note on the Islamic Settlement of Udegram, Swat: The Islamic Graveyard (11th–13th Century A.D.)." *East and West* 56/1–3: 205–28.

Bahrami, Mehdi. 1949. *Iranian Art: Treasures from the Imperial Collections and Museums of Iran*. New York: Metropolitan Museum of Art.

Baily, John. 1980. "A Description of the Naqqarkhana of Herat." *Asian Music* 11/2: 1–10.

Baily, John, and Alastair Dick. 1984. "Naqqāra-khāna." In *The New Grove Dictionary of Musical Instruments*, 2: 748–49. London: Macmillan Press.

Baker, Patricia L. 1991. "Islamic Honorific Garments." *Costume* 25:25–35.

Ball, Warwick. 1989. "The Buddhists of Sind." *South Asian Studies* 5:119–31.

———. 1990. "Some Notes on the Masjid-i Sangi at Larwand in Central Afghanistan." *South Asian Studies* 6:105–10.

Balog, Paul. 1980. *The Coinage of the Ayyūbids*, London: Royal Numismatic Society.

Banerji, Naseem Ahmed. 2002. *The Architecture of the Adina Mosque in Pandua, India: Medieval Tradition and Innovation*. Mellen Studies in Architecture, vol. 6. Lewiston: Edwin Mellen Press.

Banerji, R. D. 1917–18. "A Note on King Chandra of the Meharauli Inscription." *Epigraphia Indica* 14:367–71.

Barber, Charles. 1997. "The Truth in Painting: Iconoclasm and Identity in Early-Medieval Art." *Speculum* 72:1019–36.

Barker, Francis. 1984. *The Tremulous Private Body: Essays on Subjection*. London and New York: Methuen.

Barnes, Ruth. 1993. *Indian Block-Printed Cotton Fragments in the Kelsey Museum: The University of Michigan*. Kelsey Museum Studies 8. Ann Arbor: University of Michigan Press.

———. 1997. *Indian Block-Printed Textiles in Egypt: The Newberry Collection in the Ashmolean Museum, Oxford*. Oxford: Clarendon Press.

Barrett, Douglas. 1949. *Islamic Metalwork in the British Museum*. London: Trustees of the British Museum.

———. 1955. "A Group of Medieval Indian Ivories." *Oriental Art* n.s. 1–2:47–51.

Barrucand, Marianne. 2002. "Les chapiteaux de remploi de la mosquée al-Azhar et l'émergence d'un type de chapiteau medieval en Égypte." *Annales Islamologiques* 36:37–55.

Barthold, W. 1913. "Bāmiyān." In *The Encyclopaedia of Islam*, vol. 1, part 2: 643–44.

———. 1984. *An Historical Geography of Iran*. Trans. Svat Soucek. Princeton: Princeton University Press.

———. [Bosworth, C. E.]. 2000. "Tubbat." In *The Encyclopaedia of Islam*, new ed. 10:576–78.

Basset, R. 1960. "Burda." In *Encyclopaedia of Islam*, 2nd ed. 1:1314–15. Leiden: E. J. Brill.

Bates, Michael L., and Robert E. Darley-Dorn. 1985. "The Art of Islamic Coinage." In Toby Falk, ed., *Treasures of Islam*, pp. 350–95. London: Sotheby's.

Baudinet, Marie-José. 1989. "The Face of Christ, the Form of the Church." In Michel Feher, ed., *Fragments for a History of the Human Body*, part 1, pp. 148–56. New York: Zone Books.

Baxandall, Michael. 1992. *Patterns of Intention: On the Historical Explanation of Pictures*. New Haven: Yale University Press.

Bayly, C. A. 1986. "The Origins of Swadeshi (Home Industry): Cloth and Indian Society, 1700–1930." In Igor Kopytoff and Arjun Appadurai, eds., *The Social Life of Things: Commodities in Cultural Perspective*, pp. 284–321. Cambridge: Cambridge University Press.

Beckett, Katharine Scarfe. 2003. *Anglo-Saxon Perceptions of the Islamic World*. Cambridge.

Beckwith, Christopher I. 1987. *The Tibetan Empire in Central Asia: A History of the Struggle for Great Power among Tibetans, Turks, Arabs, and Chinese during the Early Middle Ages*. Princeton: Princeton University Press.

Bede, John Jehangir. 1973. "The Arabs in Sind, 712–1026." D.Phil. thesis, University of Utah.

Beeston, A.F.L. 1999. "Tubbaʿ." In *The Encyclopaedia of Islam*, new ed. 10:575–76.

Beglar, J. D. 1994. "Report on Delhi." In *Archaeological Survey of India Reports*, vol. 4: *Report for the Year 1871–72*, pp. 1–91. Delhi: Rahul Publishing House.

Begley, Wayne. 1985. *Monumental Islamic Calligraphy from India*. Villa Park, Ill. Islamic Foundation.

Behl, Aditya. 2002. "Premodern Negotiations: Translating between Persian and Hindavi." In Rukmini Bhaya Nair, ed., *Translation, Text and Theory: The Paradigm of India*, pp. 89–100. New Delhi: Sage.

Bennison, Amira K. 2002. "Muslim Universalism and Western Globalization." In A. G. Hopkins, ed., *Globalization in World History*, pp. 73–98. New York: W. W. Norton and Company.

Bentley, Jerry H. 1996. "Cross-cultural Interaction and Periodization in World History." *American Historical Review* 101/3: 749–70.

———. 1998. "Hemispheric Integration, 500–1500 C.E." *Journal of World History* 9/2: 237–54.

Berger, A. 2002. "Sightseeing in Constantinople: Arab Travellers, c. 900–1300." In Ruth Macrides, ed., *Travel in the Byzantine World*, pp. 179–92. Aldershot: Ashgate.

Berkson, Carmel, Wendy Doniger O'Flaherty, and George Michell. 1983. *Elephanta, the Cave of Shiva*. Princeton: Princeton University Press.

Bertelli, Sergio. 2001. *The King's Body: Sacred Rituals of Power in Medieval and Early Modern Europe*. Trans. R. Burr Litchfield. University Park, Pa. Pennsyylvania State University Press.

Bhandarkar, D. R. 1930. "Indian Studies No. I: Slow Progress of Islam Power in Ancient India." *Annals of the Bhandarkar Oriental Research Institute* 10:25–44.

Bhatia, Pratipal. 1973. "Bull/Horseman Coins of the Shahis, c. A.D. 650–1026." In *Proceedings of the Indian History Congress*, pp. 50–61.

———. 1978. "Bull/Horseman Coins of the Sultans of Ghazna, AD 1030–1186." In *Proceedings of the Indian History Congress, 38th Session*, pp. 765–73.

Bhattacharya, Asoke Kumar. 1953. "Bilingual Coins of Maḥmūd of Ghazni—a Re-study." *Journal of the Asiatic Society of Calcutta, Letters* 19/2: 133–36.

———. 1954. "Hindu Elements in Early Muslim Coinage in India." *Journal of the Numismatic Society of India* 16/1: 112–21.

Bierman, Irene A. 1991. "The Ottomanization of Crete." In Irene A. Bierman, Rifa'at Abou-El-Haj, and Donald Preziosi, eds., *The Ottoman City and Its Parts: Urban Structure and Social Order*, pp. 53–75. New Rochelle: A. D. Caratzas.

———. 1998. *Writing Signs: The Fatimid Public Text*. Berkeley: University of California Press.

Blades, James, and Robert Anderson. 1984. "Kettledrum." In *The New Grove Dictionary of Musical Instruments*, 2:379. London and New York: Macmillan.

Blair, Sheila S. 1983a. "The Coins of the Later Ilkhanids: A Typological Analysis." *Journal of the Economic and Social History of the Orient* 26/3: 295–317.

———. 1983b. Review of Erika Cruikshank Dodd and Shereen Khairallah, *The Image of the Word: A Study of Quranic Verses in Islamic Architecture*. *Arabica* 31/3: 337–42.

———. 1985. "The Madrasa at Zuzan: Islamic Architecture in Eastern Iran on the Eve of the Mongol Invasions." *Muqarnas* 5:75–91.

———. 1989. Review of Mehrdad Shokoohy and Natalie H. Shokoohy, *Ḥiṣār-i Fīrūza and Bhadreśvar: The Oldest Islamic Monuments in India*. *Journal of the Society of Architectural Historians* 48/4: 390–91.

———. 1992. *The Monumental Inscriptions from Early Islamic Iran and Transoxiana*. Leiden: E. J. Brill.

———. 1993. "The Ilkhanid Palace." *Ars Orientalis* 23:239–48.

———. 1996. "Timurid Signs of Sovereignty." *Oriente Moderno* 76/2: 551–76.

———. 1998. *Islamic Inscriptions*. New York: New York University Press.

———. 1999. "Floriated Kufic and the Fatimids." In Marianne Barrucand, ed., *L'Égypte Fatimide son art et son histoire*, pp. 107–16. Paris: Presses de l'Université de France.

Bland, Kalman P. 2001. *The Artless Jew: Medieval and Modern Affirmations and Denials of the Visual*. Princeton: Princeton University Press.

Blankinship, Khalid Yahya. 1994. *The The End of the Jihād State: The Reign of Hishām Ibn 'Abd al-Malik and the Collapse of the Umayyads*. Albany: State University of New York.

Blois, François de. 1990. *Burzōy's Voyage to India and the Origin of the Book of Kalīlah wa Dimnah*. London: Royal Asiatic Society.

———. 1991a. "Burzoy's/Burzuyah's Voyage to India." *Marg* 43/1: 8–9.

———. 1991b. "The *Panchatantra*: From India to the West—and Back." *Marg* 43/1: 10–15.

Bloom, Jonathan M. 1989. *Minaret: Symbol of Islam*. Oxford Studies in Islamic Art, vol. 7.

———. 1993. "On the Transmission of Designs in Early Islamic Architecture." *Muqarnas* 10:21–28.

Bolon, Carol Radcliffe. 1988. "Evidence for Artists of the Early Calukya Period." In Michael W. Meister, ed., *Making Things in South Asia: The Role of Artist and Craftsman*, pp. 52–66. Philadelphia: Department of South Asia Regional Studies, University of Pennsylvania.

Bombaci, Alessio. 1958. "Ghaznavidi." In *Enciclopedia Universale dell'Arte* 6:5–16.

———. 1959. "Introduction to the Excavations at Ghazni." *East and West* 10:3–22.

———. 1961. "Les Turcs et l'art Ghaznavide." In *First International Congress of Turkish Art, Ankara 19th–24th October, 1959*, pp. 67–70. Ankara: Türk Tarih Kurumu Basimevi.

———. 1964. "La 'Sposa del Cielo'." In *A Francesco Gabrieli: Studi orientalistici offerti nel sessantesimo compleanno dei suoi colleghi e discepoli*, pp. 21–34. Rome: G. Bardi.

———. 1966. *The Kūfic Inscription in Persian Verses in the Court of the Royal Palace of Mas'ūd III at Ghazni*. Rome: Istituto Italiano per il medio ed estreme oriente.

———. 1969. "Die Mauerinschriften von Konya." In *Forschungen zur Kunst Asiens in Memoriam Kurt Erdmann*, pp. 67–73. Istanbul: Istanbul Üniversitesi Edebiyat Fakültesi.

Boner, Alice. 1970. "Economic and Organizational Aspects of the Building Operations of the Sun Temple at Koṇārka." *Journal of the Economic and Social History of the Orient* 13/3: 257–72.

Bonner, Michael. 1994. "The Naming of the Frontier: 'Awāṣim, Thughūr and the Arab Geographers." *Bulletin of the School of Oriental and African Studies* 57/1: 17–24.

———. 1996. *Aristocratic Violence and Holy War: Studies in the Jihad and the Arab-Byzantine Frontier.* New Haven: American Oriental Society.

Bosworth, Clifford Edmund. 1960–61. "Ghaznevid Military Organization." *Der Islam* 36:37–77.

———. 1962. "The Titulature of the Early Ghaznavids." *Oriens* 15:210–33.

———. 1963. *The Ghaznavids: Their Empire in Afghanistan and Eastern Iran, 994–1040.* Edinburgh: Edinburgh University Press.

———. 1965. "Notes on the Pre-Ghaznavid History of Eastern Afghanistan." *Islamic Culture* 9:12–24.

———. 1966. "Mahmud of Ghazna in Contemporary Eyes and in Later Persian Literature." *Iran* 4:85–92.

———. 1968a. "The Development of Persian Culture under the Early Ghaznavids." *Iran* 6:33–44.

———. 1968b. *Sīstān under the Arabs from the Islamic Conquest to the Rise of the Ṣaffārids (30–250/651–864).* Rome: IsMEO.

———. 1971. "Hiba i. The Caliphate." In *The Encyclopaedia of Islam,* new ed., 3:344–46. Leiden: E. J. Brill.

———. 1973a. "Barbarian Incursions: The Coming of the Turks into the Islamic World." In D. S. Richards, ed., *Islamic Civilisation 950–1150,* pp. 1–6. Oxford: Bruno Cassirer (Publishers).

———. 1973b. "The Heritage of Rulership in Early Islamic and the Search for Dynastic Connections with the Past." *Iran* 11:51–62.

———. 1973c. "'Ubaidallāh b. Abī Bakra and the 'Army of Destruction' in Zābulistan (79/698)." *Der Islam* 50:268–83.

———. 1977a. "The Early Islamic History of Ghūr." Essay 9 in *The Medieval History of Iran, Afghanistan, and Central Asia,* pp. 116–33. Aldershot: Variorum.

———. 1977b. *The Later Ghaznavids: Splendour and Decay; The Dynasty in Afghanistan and Northern, India 1040–1186.* Edinburgh: Edinburgh University Press.

———. 1977c. "The Rise of the Karāmiyyah in Khurasan." Essay 1 in *The Medieval History of Iran, Afghanistan, and Central Asia,* pp. 5–14. Aldershot: Variorum.

———. 1978. "Karrāmiyya." In *The Encyclopaedia of Islam,* new ed., ed., 4:667–69.

———. 1984. "The Coming of Islam to Afghanistan." In Yohanan Friedmann, ed., *Islam in Asia,* vol. 1: *South Asia,* pp. 1–22. Boulder, Colo.: Westview Press.

———. 1986a. "Ḥarb v.-Persia." In *The Encyclopedia of Islam,* 2nd ed., 3:194–98.

———. 1986b. "Laḳab." In *The Encyclopaedia of Islam,* 5:618–31. Leiden: E. J. Brill.

———. 1991a. "Farrukhī's Elegy on Maḥmūd of Ghazna." *Iran* 29:43–49.

———. 1991b. "Ghūrids." In *The Encyclopedia of Islam,* 2nd ed. 2:1099–1104.

———. 1994. *The History of the Saffarids of Sistan and the Maliks of Nimruz (247/861 to 949/1542–3).* New York and Costa Mesa: Mazda.

———. 1995a. "Ṣaffārids." In *The Encyclopaedia of Islam,* new ed., 8:795–98. Leiden: E. J. Brill.

———. 1995b. "Saldjūḳids." In *The Encyclopaedia of Islam,* 8:936–59. Leiden: E. J. Brill.

———. 1998. "The Ghaznavids." In C. E. Bosworth and M. S. Asimov, eds., *History of Civilizations of Central Asia,* vol. 4: *The Age of Achievement: A.D. 750 to the End of the Fifteenth Century,* part 1: The History, Social and Economic Setting, pp. 95–118. Paris: UNESCO Publishing.

———. 1999. "Fīrūzkūh." In *Encyclopaedia Iranica,* 9:636–38.

———. 2000. "Tahirids." In *The Encyclopedia of Islam,* new ed., 10:104–5. Leiden: E. J. Brill.

Bowen, John R. 1993. *Muslims through Discourse, Religion and Ritual in Gayo Society.* Princeton: Princeton University Press.

Bowman, Alan K., and Greg Woolf. 1994. "Literacy and Power in the Ancient World." In idem, *Literacy and Power in the Ancient World,* pp. 1–16. Cambridge: Cambridge University Press.

Brand, Michael. 1986. "The Khalji Complex in Shadiabad Mandu." D.Phil. thesis, Harvard University.

Branfill, B. R. 1882. "Vijnôṭ and Other Old Sites in NE Sind." *Indian Antiquary* 11:1–9.

Brass, Paul R. 2003. *The Production of Hindu-Muslim Violence in Contemporary India.* Seattle and London: University of Washington Press.

Braudel, Fernand. 1988. *Civilization and Capitalism 15th–18th Century,* Vol. 1: *The Structures of Everyday Life, the Limits of the Possible.* New York: Harper and Row.

Brauer, Ralph W. 1992. "Geography in the Medieval Muslim World: Seeking a Basis for Comparison of the Development of the Natural Sciences in Different Cultures." *Comparative Civilizations Review* 26:73–110.

———. 1995. "Boundaries and Frontiers in Medieval Muslim Geography." *Transactions of the American Philosophical Society* 85/6: 1–73.

Breckenridge, Carol A. 1989. "The Aesthetics and Politics of Colonial Collecting: India at World Fairs." *Comparative Studies in Society and History* 31/2: 195–216.

Brend, Barbara. 1999. *Islamic Art.* Cambridge, Mass.: Harvard University Press.

Bresc, Cécile, 2001. "Les monnaies des Ayyoubides." In *L'Orient de Saladin l'Art des Ayyoubides,* pp. 31–63. Paris: Gallimard.

Brilliant, Richard. 1982. "I piedistalli del giardino di Boboli: spolia in se, spolia in re." *Prospettiva* 31:2–17.

Brown, Percy. 1944. *Indian Architecture [The Islamic Period]*. Bombay: Taraporevala Sons.

Browne, Edward G. 1964. *A Literary History of Persia*. Cambridge: Cambridge University Press.

Bruno, Andrea. 1963. "Notes on the Discovery of Hebrew Inscriptions in the Vicinity of the Minaret of Jām." *East and West* n.s. 14:206–8.

Buckler, F. W. 1928. "The Human Khilʿat." *Near East and India* 34:269–70.

———. 1985 [1928]. "The Oriental Despot." In M. N. Pearson, ed., *Legitimacy and Symbols: The South Asian Writings of F. W. Buckler*, pp. 176–87. Ann Arbor: Center for South and South East Asia Studies, University of Michigan.

Bulliet, Richard W. 1969. "A Muʿtazilite Coin of Maḥmūd of Ghazna." *American Numismatic Society Museum Notes* 15:119–29.

———. 1972a. *The Patricians of Nishapur: A Study in Medieval Islamic Social History*. Cambridge, Mass.: Harvard University Press.

———. 1972b. "The Shaikh al-Islam and the Evolution of Islamic Society." *Studia Islamica* 35:53–67.

———. 1973. "The Political-Religious History of Nishapur in the Eleventh Century." In D. S. Richards, ed., *Islamic Civilisation 950–1150*, pp. 71–91. Oxford: Cassirer.

———. 1978. "Local Politics in Eastern Iran under the Ghaznavids and Seljuks." *Iranian Studies* 11:35–56.

———. 1979. *Conversion to Islam in the Medieval Period: An Essay in Quantitative History*. Cambridge, Mass.: Harvard University Press.

———. 1994. *Islam: The View from the Edge*. New York: Columbia University Press.

Burgess, James. 1991 [1876]. *Report on the Antiquities of Kâthiâwâd and Kachh*. Jam Sharo, Sind: Sindhi Adabi Board.

Burjakov, Jurij F. 1994. "Zur Bestimmung und Datierung einiger der ältesten Schachfiguren." *Antike Welt* 25:62–71.

Burnett, Charles S. F. 1997. "Questiones de Traduction: Translation from Arabic into Latin in the Middle Ages; Theory, Practice, and Criticism." In Steve G. Lofts and Philipp W. Rosemann, eds., *Éditer, traduire, interpréter: essays de méthodologie philosophique*, pp. 55–78. Louvain and Paris: Éditer.

———. 2002. "The Translation of Arabic Science into Latin: A Case of Alienation of Intellectual Property." *Bulletin of the Royal Institute for Interfaith Studies* 4/1: 145–57.

Burns, Robert I. 1975. "Spanish Islam in Transition: Acculturative Survival and Its Price in the Christian Kingdom of Valencia, 1240–1280." In Speros Vryonis Jr., ed., *Islam and Cultural Change in the Middle Ages*, pp. 87–109. Wiesbaden: Otto Harrasowitz.

Burt, T. S. 1834. "A description, with drawings, of the Ancient Stone Pillar at Allahabad called Bhim Sén's Gadá or Club, with accompanying copies of four inscriptions engraved in different characters upon its surface." *Journal of the Asiatic Society of Bengal* 3:105–21.

Burt, T. S., and Alexander Cunningham. 1838. "Lithographs and translations of inscriptions taken in Ectype by Captain T. S. Burt, Engineers: and of one, from Ghosí taken by Captain A. Cunningham, of the same Corps." *Journal of the Asiatic Society of Bengal*, 629–36.

Burton-Page, J. 1965a. "Dihlī." In *The Encylopaedia of Islam*, new ed., 2:255–66.

———. 1965b. "Hind. Ii. Architecture." In *The Encyclopaedia of Islam*, new ed., 2:440–52.

———. 1988. "Mosques and Tombs." In George Michell and Snehal Shah, eds., *Ahmedabad*, pp. 30–119. Bombay: Marg Publications.

———. 1991a. "Dūrbāsh." In *The Encyclopedia of Islam*, new ed., 2:627–28.

———. 1991b. "Maḵbara 5. India." In *The Encyclopedia of Islam*, new ed., 16:125–28. Leiden: E. J. Brill.

Bushnell, Amy Turner. 2002. "Gates, Patterns, and Peripheries: The Field of Frontier Latin America." In Christine Daniels and Michael V. Kennedy, eds., *Negotiated Empires: Centers and Peripheries in the Americas, 1500–1820*, pp. 15–28. New York: Routledge.

Busse, Heribert. 1973. "The Revival of Persian Kingship under the Būyids." In D. S. Richards, ed., *Islamic Civilisation, 950–1150*, Papers on Islamic History 3, pp. 47–69. Oxford: Bruno Cassirer (Publishers).

Bykov, A. A. 1965. "Finds of Indian Medieval Coins in Eastern Europe." *Journal of the Numismatic Society of India* 27:146–55.

Cahen, Claude. 1953. "L'évolution de l'iqtaʿ du IXe au XIIIe siècle." *Annales ESC* 8:25–52.

———. 1960. "Ayyūbids." In *The Encyclopaedia of Islam*, new ed., 1:796–807. Leiden: E. J. Brill.

———. 1965. "Ghuzz." In *The Encyclopaedia of Islam*, new ed., 2:1106–10. Leiden: E. J. Brill.

———. 1971. "Iḳṭāʿ." In *The Encyclopaedia of Islam*, new ed., 3:1088–91. Leiden: E. J. Brill.

Cammann, Schuyler. 1957. "Ancient Symbols in Modern Afghanistan." *Ars Orientalis* 2:5–34.

Canard, Marius. 1960. "Al-Basāsīrī." In *The Encyclopaedia of Islam*, new ed., 1:1073–1075. Leiden: E. J. Brill.

———. 1973. "Coiffure Européenne et Islam." Essay 3 in idem, *Miscellanea Orientalia*, pp. 200–229. London: Variorum Reprints.

Carboni, Stefano. 2001. *Glass from Islamic Lands*. New York: Thames and Hudson.

Carruthers, Mary. 1998. *The Craft of Thought: Meditation, Rhetoric and the Making of Images, 400–1200*. Cambridge: Cambridge University Press.

Casimir, Michael J., and Bernt Glatzer, 1971. "Šāh-i Mašhad, a Recently Discovered Madrasah of the Ghurid Period in Ġargistān (Afghanistan)." *East and West* n.s. 21:53–68.

Caskel, W. 1960. "Bāhila." In *The Encyclopaedia of Islam*, new ed., 1:920–21.

Ceylan, Yasin. 1996. *Theology and Tafsīr in the Major Works of Fakhr al-Dīn al-Rāzī*. Kuala Lumpur: International Institute of Islamic Theology and Civilization.

Chaghtai, M. A. 1968. *Khatū, Rājasthān kī ek qadīm bastī*. Lahore: Kitab-Khana Nur.

Chakravarti, Ranabir. 2001. "Monarchs, Merchants and a Maṭha in Northern Konkan (c. AD 900–1053)." In idem, ed., *Trade in Early India*, pp. 257–81. New Delhi: Oxford University Press.

Chamberlain, Michael. 1994. *Knowledge and Social Practice in Medieval Damascus, 1190–1350*. Cambridge: Cambridge University Press.

Champakalakshmi. 1978. "Religious Conflict in the Tamil Country: A Re-appraisal of Epigraphic Evidence." *Journal of the Epigraphic Society of India* 5:69–81.

Chanchreek, K. L., and Mahesh K. Jain. 2004. *Jaina Art and Architecture: Western and South India and Jaina Bronzes in Museums*. New Delhi: Shree Publishers and Distributors.

Chandra, Moti. 1957–59. "Ancient Indian Ivories." *Bulletin of the Prince of Wales Museum of Western India* 6:4–63.

———. 1959–62. "A Study in the Terracotta from Mirpurkhas." *Prince of Wales Museum Bulletin* 7:1–22.

———. 1960. "Indian Costumes and Textiles from the Eighth to the Twelfth Century." *Journal of Indian Textile History* 5:1–41.

Chattopadhyaya, Brajadulal. 1995. "Political Processes and the Structure of Polity in Early Medieval India." In Hermann Kulke, ed., *The State in India 1000–1700*, pp. 195–232. Delhi: Oxford University Press.

———. 1997. *The Making of Early Medieval India*. Delhi: Oxford University Press.

———. 1998. *Representing the Other? Sanskrit Sources and the Muslims (8th to 14th Century)*. New Delhi: Manohar.

Chaudhuri, Nirad C. 1976. *Culture in the Vanity Bag*. Bombay: Jaico Publishing House.

Chaumont, E. 1997. "Al-Shāfi'iyya." In *The Encyclopaedia of Islam*, new ed., 9:185–89.

Chidanandamurthy, M. 1973. "The Meaning of 'Palidhvaja,' a Reinterpretation." In *Śrīkaṇṭhikā, Dr. S. Srikantha Sastri Felicitation Volume*, pp. 85–88. Mysore: Geetha Book House.

Chmelnizkij, S. 1992. *Mezhdu Arabami i Tiurkami: Ranne Islamskaia Arkitektura Srednei Azii*. Berlin: Izdvo "Continent."

Choudhary, Gulab Chandra. 1964. *Political History of North India from Jain Sources (c. 650 AD to 1300 AD)*. Amritsar: Sohanlal Jaindharma Prachant Samiti.

Christensen, A. 1911–12. "Remarques critiques sur le *kitāb bayāni-l-adyān* d'Abu'l-Ma'āli." *Le Monde Orientale* 5–6:205–16.

Christys, Ann. 2002. "Crossing the Frontier of Ninth-Century Hispania." In David Abulafia and Nora Berend, eds., *Medieval Frontiers: Concepts and Practices*, pp. 35–53. Aldershot: Ashgate.

Clark, Hugh R. 1995. "Muslims and Hindus in the Culture and Morphology of Quanzhou from the Tenth to the Thirteenth Centuries." *Journal of World History* 6/1: 49–74.

Clunas, Craig. 1991. *Superfluous Things: Material Culture and Social Status in Early Medieval China*. Cambridge: Polity Press.

Cohn, Bernard, S. 1996. *Colonialism and Its Forms of Knowledge: The British in India*. Princeton: Princeton University Press.

———. 1998. "Regions Subjective and Objective: Their Relation to the Study of Modern Indian History and Society." In idem, *An Anthropologist among the Historians*, pp. 100–135. New Delhi: Oxford University Press, India.

Cohn, Bernard S., and Marriott McKim. 1958. "Networks and Centers in the Integration of Indian Civilisation." *Journal of Social Research* 1/1: 1–9.

Constable, Olivia Rennie. 1994. *Trade and Traders in Muslim Spain: The Commercial Realignment of the Iberian Peninsula, 900–1500*. Cambridge: Cambridge University Press.

Contadini, Anna. 1995. "Islamic Ivory Chess Pieces, Draughtsmen and Dice." In James W. Allan, ed., *Islamic Art in the Ashmolean Museum*. 2 vols. *Oxford Studies in Islamic Art* 10/1: 111–54.

Cormack, Robin. 1992. "But Is It Art?" In Jonathan Shepard and Simon Franklin, eds., *Byzantine Diplomacy*, pp. 219–33. Brookfield Vt.: Ashgate.

Corvinus. 1982. *Matthias Corvinus und die Renaissance in Ungarn 1458–1541*. 8. Mai–1. November 1982, Schallaburg. Vienna: Niederösterreichisches Landesmuseum.

Cousens, Henry. 1903–4. "Brāhmanābād-Manṣūra in Sind." *Archaeological Survey of India Annual Reports* 4:132–44.

———. 1908–9. "Excavations at Brāhmanābād-Manṣūra, Sind." *Archaeological Survey of India Annual Reports*, 79–87.

———. 1909–10. "Buddhist Stūpa Mīrpur-khās, Sind." *Archaeological Survey of India Annual Reports*, 80–92.

———. 1914–15. "Buddhist Stūpa at Saidpur in Sind." *Archaeological Survey of India Annual Reports*, 89–95.

———. 1916. *Bijapur and Its Architectural Remains*. Bombay: Bombay Government Central Press.

———. 1929. *The Antiquities of Sind with Historical Outline*. Calcutta: Government of India Central Publications Branch.

Cowen, Jill Sanchia. 1989. *Kalila wa Dimna: An Animal Allegory of the Mongol Court*. Oxford: Oxford University Press.

Crane, Howard. 1993. "Notes on Saldjūq Architectural Patronage in Thirteenth Century Anatolia." *Journal of the Economic and Social History of the Orient* 36:1–57.

Crane, Howard, and William Trousdale. 1975. "Helmand-Sistan Project: Carved Decorative and Inscribed Bricks from Bust." *Afghanistan* 28/2: 25–45.

Creswell, K.A.C. 1932–40. *Early Muslim Architecture*. 2 vols. Oxford: Clarendon Press.

Cunningham, Alexander. 1972 [1871]. *Four Reports Made during the Years 1862–63–64–65*. Archaeological Survey of India Reports, vols. 1–2. Delhi and Varanasi: Indological Book House.

Curley, David L. 2003. "'Voluntary' Relationships and Royal Gifts of Pān in Mughal Bengal." In Stewart Gordon, ed., *Robes of Honor: Khil'at in Pre-colonial and Colonial India*, pp. 50–79. New Delhi: Oxford University Press.

Currie, P. M. 1989. *The Shrine and Cult of Mu'in al-Dīn Chishtī of Ajmer*. Delhi: Oxford University Press.

Cutler, Anthony. 1999a. "A Christian Ewer with Islamic Imagery and the Question of Arab *Gastarbeiter* in Byzantium." In Robert Favreau and Marie-Hélène Debiès, eds., *Iconographica: Mélanges offerts à Piotr Skubiszewski*, pp. 63–69. Poitiers: Université de Poitiers.

———. 1999b. "The Parallel Universes of Arab and Byzantine Art (with Special Reference to the Fatimid Era)." In Marianne Barrucand, ed., *L'Égypte Fatimide son art et son histoire*, pp. 635–48. Paris: Presses de l'Université de France.

———. 1999c. "Reuse or Use? Theoretical and Practical Attitudes Towards Objects in the Early Middle Ages." *Settimane di Studi del Centro Italiano di Studi Sull'alto Medioevo* 46:1055–79.

———. 2001a. "Exchanges of Clothing in Byzantium and Islam: Assymetrical Sources, Symmetrical Practices." In *20th International Congress of Byzantine Studies, College de France, Sorbonne*, pp. 19–25.

———. 2001b. "Gifts and Gift Exchange as Aspects of the Byzantine, Arab, and Related Economies." *Dumbarton Oaks Papers* 55:245–76.

———. 2004. "Everywhere and Nowhere: The Invisible Muslim and Christian Self-fashioning in the Culture of Outremer." In Daniel H. Weiss and Lisa Mahoney, eds., *France and the Holy Land: Frankish Culture at the End of the Crusades*, pp. 253–81. Baltimore: Johns Hopkins University Press, 2004.

Czuma, Stanislaw. 1989. "Ivory Sculpture." In Pratapaditya Pal, ed., *Art and Architecture of Ancient Kashmir*, pp. 57–76. Bombay: Marg Publications.

Dagron, Gilbert. 1994. "Formes et functions du pluralisme linguistique à Byzance (IXe–XIIe siècles)." *Travaux et Memoires* 12:219–40.

Davidovich, E. A. and A. H. Dani. 1992. "Coinage and the Monetary System." In M. S. Asimov and C. E. Bosworth, *History of Civilizations of Central Asia*, vol 4: *The Age of Achievement*, part 1: The History, Social and Economic Setting, pp. 391–419. Paris: UNESCO.

Davis, Richard H. 1992. "Loss and Recovery of Ritual Self among Hindu Images." *Journal of Ritual Studies* 61/1: 43–61.

———. 1993. "Indian Art Objects as Loot." *Journal of Asian Studies* 52/1: 22–48.

———. 1994a. "Three Styles in Looting India." *History and Anthropology (Great Britain)* 6/4: 293–317.

———. 1994b. "Trophies of War: The Case of the Chalukya Intruder." In Catherine B. Asher and Thomas R. Metcalf, eds., *Perceptions of South Asia's Visual Past*, pp. 161–77. New Delhi: Oxford & IBH Publishing Co. Pvt.

———. 1997. *Lives of Indian Images*. Princeton: Princeton University Press.

———. 2001. "Indian Image-Worship and Its Discontents." In Jan Assmann, Moshe Barasch, and Albert I. Baumgarten, eds., *Representation in Religion: Studies in Honor of Moshe Barasch*, pp. 107–32. Leiden: Brill.

Dayalan, D. 1985. "The Role of War-Trophies in Cultural Contact." *Tamil Civilisation* 3/2–3: 133–37.

Deambi, B. K. Kaul. 1982. *Corpus of Śāradā Inscriptions of Kashmir with Special Reference to Origins and Development of Śāradā Script*. Delhi: Agam Kala Prakashan.

Debord, Guy-Ernest. 1956. "Methods of Détournement." http://library.nothingness.org/articles/all/en/display/3.

Dehejia, Vidya. 1988. "Patron, Artist and Temple." In idem, ed., *Royal Patrons and Great Temple Art*, pp. 2–8. Bombay: Marg Publications.

———.1990. *Art of the Imperial Cholas*. New York: Asia Society.

Deniké, B. 1930. "Les nouvelles découvertes au Turkestan: la décoration en stuc sculpté de Termez." *Cahiers d'Art* 5:41–44.

Desai, Z. A. 1966. *Mosques of India*. Delhi: Publications Division, Ministry of Information and Broadcasting.

Deshpande, Madhav M. 1993. *Sanskrit and Prakrit: Sociolinguistic Issues*. Delhi: Motilal Banarsidass Publishers.

Deyell, John S. 1999. *Living without Silver: the Monetary History of Early Medieval North India*. New Delhi: Oxford University Press.

Dhaky, M. A. 1961. "The Chronology of the Solanki Temples of Gujarat." *Journal of the Madhya Pradesh Itihasa Parishad* 3:1–83.

———. 1975. "The Genesis and Development of Māru-Gurjara Temple Architecture." In Pramod Chandra, ed., *Studies in Indian Temple Architecture*, pp. 114–65. Varanasi: American Institute of Indian Studies.

———. 1998. *Encyclopaedia of Indian Temple Architecture*. Vol. 2.3: *North India Beginnings of Medieval Idiom c. AD 900-1000*. New Delhi: American Institute of Indian Studies.

Dick, Alistair. 1984a. "The Earlier History of the Shawm in India." *Galpin Society Journal* 38:80–98.

———. 1984b. "Mahvarī." In *New Grove Dictionary of Musical Instruments*, 2:597–98.

Digby, Simon. 1967. "The Literary Evidence for Painting in the Delhi Sultanate." *Bulletin of the American Academy of Benares* 1:47–58.

———. 1970. "Iletmish or Iltutmish? A Reconsideration of the Name of the Delhi Sultan." *Iran* 8:57–64.

———. 1986. "The Sufi Shaikh as a Source of Authority in Medieval India." *Puruṣārtha* 9:57–77.

Dikshit, R.B.K.N. 1935–36. "A Note on the Bilingual Coins of Sultan Mahmud of Ghazni." *Journal of the Asiatic Society of Bengal* n.s. 46:29.

———. 1944. "A Panel Showing the Birth of Lord Kṛishna from the Qutb Mosque." *Journal of the United Provinces Historical Society* 17/1: 84–86.

———. 1965. "The Chandellas and the Yaminis." *Journal of the Uttar Pradesh Historical Society* 11–13:47–65.

Dirks, Nicholas B. 1982. "The Pasts of a Pālaiyakārar: The Ethnohistory of a South Indian Little King." *Journal of Asian Studies* 41/4: 655–83.

———. B. 1987. *The Hollow Crown: Ethnohistory of an Indian Kingdom*. Cambridge: Cambridge University Press.

Dodds, Jerrilynn, D. 1992. *Al-Andalus, the Art of Islamic Spain*. New York: Harry N. Abrams.

———. 1993. "Islam, Christianity and the Problem of Religious Art." In idem, ed., *The Art of Medieval Spain, AD 500-1200*, pp. 27–37. New York: Metropolitan Museum of Art.

———. 2000. "Spaces." In María Rosa Menocal, Raymond P. Scheindlin, and Michael Sells, eds., *The Literature of al-Andalus*, the Cambridge History of Arabic Literature, pp. 83–95. Cambridge: Cambridge University Press.

Donner, Fred M. 2002-3. "From Believers to Muslims: Confessional Self-identity in the Early Islamic Community." *Al-Abhath* 50–51:9–53.

Dozy, R.P.A. 1969 [1845]. *Dictionnaire détaillé des noms des vêtements chez les Arabes*. Beirut: Librairie du Liban.

Draper, Peter. 2000. "English with a French Accent: Architectural *Franglais* in Late-Twelfth-Century England?" In Georgia Clarke and Paul Crossley, eds., *Architecture and Language: Constructing Identity in European Architecture, c. 1000–c. 1650*, pp. 21–35. Cambridge: Cambridge University Press.

Drory, Rina. 1994. "Al-Ḥarīzī's *Maqāmat*: A Tricultural Literary Product." In Roger Ellis and Ruth Evans, eds., *The Medieval Translator* 4:66–85. Binghamton: State University of New York.

Duff, Grant. 1876. "Address to the Archaeological Section." *Transactions of the Second Session of the International Congress of Orientalists*, pp. 298–301. London: Trübner & Co.

Duplessy, Jean. 1956. "La circulation des monnaies Arabes en Europe occidentale du VIIIe au XIIIe siècle." *Revue Numismatique* 18:101–63.

Eastmond, Anthony, and Lynn Jones. 2001. "Robing, Power, and Legitimacy in Armenia and Georgia." In Stewart Gordon, ed., *Robes, and Honor: The Medieval World of Investiture*, pp. 147–92. New York: Palgrave.

Eaton, Richard M. 1993. *The Rise of Islam and the Bengal Frontier, 1204–1760*. Berkeley and Los Angeles: University of California Press.

———. 2000. "Temple Desecration and Indo-Muslim States." In David Gilmartin and Bruce Lawrence, eds., *Beyond Turk and Hindu: Rethinking Religious Identity in Islamicate South Asia*, pp. 246–81. Gainesville: University Press of Florida.

———. 2001. *Essays on Islam and Indian History*. New Delhi: Oxford University Press.

———. 2003. *India's Islamic Traditions, 711–1750*. New Delhi: Oxford University Press.

Eck, Diana, L. 1981. *Darśan: Seeing the Divine Image in India*. Chambersburg, Pa. Anima Books.

Edelberg, L. 1957. "Fragments d'un stûpa dans la vallée du Kunar en Afghanistan." *Arts Asiatiques* 4/3: 199–207.

———. 1960. "An Ancient Hindu Temple in Kunar." *Afghanistan* 15/3: 11–15.

Eder, Manfred A. J. 1994. "Ist der 'Elefanten-König' doch (ke)ein 'Schack-König.'" *Schach-Journal* 1:45–51.

———. 2003. "Bagdad-Bergkristall-Benediktinerzum Ex-Oriente des Schachspiel." In *Ex Oriente Isaak und der Weisse Elefant*. Austellung 30.6.-28.09.2003. Aachen: Druck & Verlagg.

Edwards, Holly. 1990. "The Genesis of Islamic Architecture in the Indus Valley." D.Phil. thesis, New York University.

———. 1991a. "The Ribāt of 'Alī b. Karmakh." *Iran* 29:85–94.

———. 1991b. "Text, Context, Architext: The Qur'an as Architectural Inscription." In Carol Garret Fisher, ed., *Brocade of the Pen: The Art of Islamic Writing*, pp. 63–75. East Lansing: Kresge Art Museum.

———. 2006. "Centralizing the Margins: Commemorative Architecture in the Indus Valley." In Abha Narain Lambah and Alka Patel, eds., *The Architecture of the Indian Sultanates*, pp. 19–29. Bombay: Marg Publications.

El-Galli, Ahmad Muhammad. 1970. *The History and Doctrines of the Karrāmiyya Sect with Special Reference to ar-Rāzī's Criticism*. M.Litt. thesis, University of Edinburgh.

Ellenblum, Ronnie. 2002. "Were There Borders and Borderlands in the Middle Ages? The Example of the Latin Kingdom of Jerusalem." In David Abulafia and Nora Berend, eds., *Medieval Frontiers: Concepts and Practices*, pp. 105–119. Aldershot: Ashgate.

Elsner, Jaś. 2003. "Archaeologies and Agendas: Reflections on Late Ancient Jewish Art and Early Christian Art." *Journal of Roman Studies* 93:114–28.

Elst, Koenraad. 1990. *Ram Janmabhoomi vs. Babri Masjid: A Case Study in Hindu-Muslim Conflict*. New Delhi: Voice of India.

Elton, Hugh. 1996. "Defining Romans, Barbarians and the Roman Frontier." In Ralph W. Mathisen and Hagith S. Sivan, eds., *Shifting Frontiers in Late Antiquity*, pp. 126–35. Aldershot: Variorum.

Epalza, Míkel de. 1999. "Ahd: Muslim/Mudejar/Morisco Communities and Spanish-Christian Authorities." In Robert I. Burns and Paul E. Chevedden, eds., *Negotiating Cultures: Bilingual Surrender Treaties in Muslim-Christian Spain under James the Conqueror*, pp. 195–212. Leiden and Boston: E. J. Brill.

Ernst, Carl W. 1992. *Eternal Garden: Mysticism, History, and Politics at a South Asian Sufi Center*. Albany: State University of New York Press.

———. 2000. "Admiring the Works of the Ancients: The Ellora Temples as Viewed by Indo-Muslim Authors." In David Gilmartin and Bruce B. Lawrence, eds., *Beyond Turk and Hindu: Rethinking Religious Identity in Islamicate South Asia*, pp. 98–120. Gainesville: University Press of Florida.

———. 2003. "Muslim Studies of Hinduism? A Reconsideration of Arabic and Persian Translations from Indian Languages." *Iranian Studies* 36:173–95.

Esin, E. 1977. "Tarkhan Nizak or Tarkhan Tirek? An Enquiry Concerning the Prince of Badghis Who in A.H. 91/A.D. 709–10 Opposed the 'Omayyad Conquest of Central Asia." *Journal of the American Oriental Society* 97/3: 323–32.

Ettinghausen, Richard. 1955. "Interaction and Integration in Islamic Art." In Gustave E. von Grunebaum, ed., *Unity and Variety in Muslim Civilization*, pp. 17–37. Chicago: University of Chicago Press.

———. 1962. *Arab Painting*. New York: Skira.

———. 1974. "Arabic Epigraphy: Communication or Symbolic Affirmation." In Dickran K. Kouymjian, ed., *Near Eastern Numismatics, Iconography, Epigraphy and History, Studies in Honor of George C. Miles*, pp. 297–317. Beirut: American University of Beirut.

———. 1984a. "The Cover of the Morgan Manāfi' Manuscript and Other Early Persian Bookbindings." In Myriam Rosen-Ayalon, ed., *Islamic Art and Archaeology, Collected Papers*, pp. 521–44. Berlin: Bebr. Mann Verlag.

———. 1984b. "An Illuminated Manuscript of Hāfiz-i Abrū in Istanbul. Part 1." In Myriam Rosen-Ayalon, ed., *Islamic Art and Archaeology, Collected Papers*, pp. 494–509. Berlin: Bebr. Mann Verlag.

———. 1984c. "Kufesque in Byzantine Greece, the Latin West and the Muslim World." In M. Rosen-Ayalon, ed., *Islamic Art and Archaeology: Collected Papers of Richard Ettinghausen*, pp. 752–72. Berlin: Gebt. Mann Verlag.

———. Grabar, Oleg, and Marilyn Jenkins-Madina. 2001. *Islamic Art and Architecture 650–1250*. New Haven and London: Yale University Press.

Euben, Roxanne L. 2005. *Journeys to the Other Shore: Muslim and Western Travelers in Search of Knowledge*. Princeton: Princeton University Press.

Evans, Helen. 1997. "Kings and Power Bases: Sources for Royal Portraits in Armenian Cilicia." In J.-P. Mathé and R. W. Thomson, eds., *From Byzantium to Iran: Armenian Studies in Honour of Nina G. Garsoïan*, pp. 561–75. Atlanta: Scholars Press.

Farmer, Henry George. 1929a. *A History of Arabian Music to the 13th Century*. London: Luzac & Co.

———. 1929b. "Meccan Musical Instruments." *Journal of the Royal Asiatic Society*, 489–505.

———. 1937. *Turkish Instruments of Music in the Seventeenth Century*. Glasgow: Civic Press.

———. 1941a. "Music in Muslim India." *Islamic Culture* 15:331–40.

———. 1941b. "Oriental Influences on Occidental Military Music." *Islamic Culture* 15:235–42.

———. 1998. "Ṭabl-khāna." In *The Encyclopedia of Islam*, 2nd ed., 10:34–38. Leiden: E. J. Brill.

Fatimi, S. Q. 1963. "First Muslim Invasions of the N.W. Frontier of the Indo-Pakistan Sub-continent, 44 AH 664–5 AD." *Journal of the Asiatic Society of Pakistan* 8:37–45.

Fentress, James, and Chris Wickham. 1992. *Social Memory*. Oxford: Blackwell.

Fergusson, James. 1876. *History of Indian and Eastern Architecture*. London: John Murray.

Ferrard, Christopher C. 1971. "The Amount of Constantinopolitan Booty in 1204." *Studi Veneziani* 13:95–104.

Field, Henry, and Eugene Prostov. 1938. "Archaeological Investigations in Central Asia, 1917–37." *Ars Islamica* 5:233–71.

Filigenzi, Anna. 2006. "Surya, the Solar Kingship and the Turki Šāhis, New Acquisitions on the Cultural History of Swat." *East and West* 56/1–3: 195–203.

Filliozat, Pierre-Sylvain. 1975. "Le droit d'entrer dans les temples de Śiva au XIᶜ siècle." *Journal Asiatique* 263:103–17.

Finney, Paul Corby. 1994. *The Invisible God: The Earliest Christians on Art.* Oxford: Oxford University Press.

Fischel, Walter J. 1945. "The Jews of Central Asia (Khorasan) in Medieval Hebrew and Islamic Literature." *Historia Judaica* 7:29–50.

———. 1965. "The Rediscovery of the Medieval Jewish Community at Fīrūzkūh in Central Afghanistan." *Journal of the American Oriental Society* 85/2: 148–53.

Fischer, Klaus. 1962. "A Jaina Tīrthankara in Afghanistan." *Voice of Ahimsa* 121:1.

———. 1966. "Indo-Iranian Contacts as Revealed by Mud-Brick Architecture from Afghanistan." *Oriental Art* 12 (Spring): 25–29.

———. 1969. "Preliminary Remarks on Archaeological Survey in Afghanistan." *Zentralasiatische Studien* 3:327–408.

Flood, Finbarr Barry. 1997. "Umayyad Survivals and Mamluk Revivals: Qalawunid Architecture and the Great Mosque of Damascus." *Muqarnas* 14:57–79.

———. 2000. "Light in Stone: The Commemoration of the Prophet in Umayyad Architecture." In Jeremy Johns, ed., *Bayt al-Maqdis Part Two: Jerusalem and Early Islam,* Oxford Studies in Islamic Art 9, part 2, pp. 311–59. Oxford: Oxford University Press.

———. 2001a. "From Ghazna to Delhi: Lahore and Its Lost *Manâra.*" In Warwick Ball, ed., *Cairo to Kabul: Afghan and Islamic Studies Presented to Ralph Pinder-Wilson,* pp. 102–12. London: Melisende.

———. 2001b. "Ghurid Architecture in the Indus Valley: The Tomb of Shaykh Sadan Shahid." *Ars Orientalis* 36:129–66.

———. 2001c. *The Great Mosque of Damascus: Studies on the Makings of an Umayyad Visual Culture.* Leiden: E. J. Brill.

——— 2001d. "The Medieval Trophy as an Art Historical Trope: Coptic and Byzantine 'Altars' in Islamic Contexts." *Muqarnas* 18:41–72.

———. 2002. "Between Cult and Culture: Bamiyan, Islamic Iconoclasm and the Museum." *Art Bulletin* 84/4: 641–59.

———. 2003. "Pillars, Palimpsests and Princely Practices: Translating the Past in Sultanate Delhi." *Res* 43:95–116.

———. 2004. "Signs of Violence: Colonial Ethnographies and Indo-Islamic Monuments." *Australian and New Zealand Journal of Art* 5/2: 20–51.

———. 2005a. "Ghurid Monuments and Muslim Identities: Epigraphy and Exegesis in Twelfth-Century Afghanistan." *Indian Economic and Social History Review* 42/3: 263–94.

———. 2005b. "Persianate Trends in Sultanate Architecture: The Great Mosque of Bada'un." In Bernard O'Kane, ed., *The Iconography of Islamic Art,* Studies in Honour of Robert Hillenbrand, pp. 159–95. Edinburgh: Edinburgh University Press.

———. 2005c. "Refiguring Iconoclasm in the Early Indian Mosque." In Anne Maclanan and Jeffrey Johnson., eds., *Negating the Image: Case Studies in Iconoclasm,* pp. 15–40. Aldershot: Ashgate.

———. 2006a. "Correct Delineations and Promiscuous Outlines: Envisioning India at the Trial of Warren Hastings." *Art History* 29/1: 47–78.

———. 2006b. "Image against Nature: *Spolia* as Apotropaia in Byzantium and the Dar al-Islam." *Medieval History Journal* 9/1: 143–66.

———. 2007a. "From the Prophet to Postmodernism? New World Orders and the End of Islamic Art." In Elizabeth Mansfield, ed., *Making Art History,* pp. 31–53. New York: Routledge.

———. 2007b. "Lost in Translation: Architecture, Taxonomy, and the Eastern 'Turks.'" *Muqarnas* 24: 79–116.

———. 2008. "Introduction." In *Piety and Politics in the Early Indian Mosque.* Debates in Indian History and Society Series. New Delhi: Oxford University Press, India.

———. Forthcoming a. "An Ambiguous Aesthetic: Crusader *Spolia* in Ayyubid Jerusalem." In Sylvia Auld and Robert Hillenbrand, eds., *Ayyubid Jerusalem.* London: World of Islam Festival Trust.

———. Forthcoming b. "Islamic Identities and Islamic Art: Inscribing the Qur'an in Twelfth-Century Afghanistan." In *Studies in the History of Art.* Washington, D.C.: National Gallery of Art.

———. Unpublished. "*Linga*s in Latin: Classicism and Censorship in Colonial Translation." Paper delivered to the Annual Symposium of the American Council for Southern Asian Art, Peabody Museum, Salem, Massachussetts, May 2004.

Flury, Samuel. 1925. "Le décor épigraphique des monuments de Ghazna." *Syria* 6:61–90.

———. 1981. "Ornamental Kūfic Inscriptions on Pottery." In Arthur Upham Pope and Phyllis Ackermann, eds., *A Survey of Persian Art,* 6:1743–69. Ashiya: Sopa Ashiya.

Folsach, Kjeld von. 2003. "A Number of Pigmented Wooden Objects from the Eastern Islamic World." *Journal of the David Collection* 1:73–98.

Fontana, Maria Vittoria. 2005. "La fortuna di un 'ajā'ib?" In M. Bernardini and N. L. Tornesello, eds., *Studi in onore di Giovani M. D'Erme*, pp. 441–56. Naples: Università di Napoli "L'Orientale," Series Minor 68.

Forrest, Denys. 1970. *Tiger of Mysore: The Life and Death of Tipu Sultan*. London: Chatto & Windus.

Frank, Andre Gunder. 1990. "The Thirteenth-Century World System: A Review Essay." *Journal of World History* 1/2: 249–56.

Freedberg, David. 1977. "The Structure of Byzantine and European Iconoclasm." In Anthony Bryer and Judith Herrin, eds., *Iconoclasm: Papers Given at the Ninth Spring Symposium of Byzantine Studies, University of Birmingham, March 1975*, pp. 165–77. Birmingham: Centre for Byzantine Studies, University of Birmingham.

Friedmann, Yohanan. 1972. "The Temple of Multān: A Note on Early Muslim Attitudes to Idolatry." *Israel Oriental Studies* 2:176–82.

———. 1974. "The Beginnings of Islamic Learning in Sind—a Reconsideration." *Bulletin of the School of Oriental and African Studies* 37:659–64.

———. 1975. "Medieval Muslim Views of Indian Religions." *Journal of the American Oriental Society* 95:214–21.

———. 1977. "A Contribution to the Early History of Islam in India." In Myriam Rosen-Ayalon, ed., *Studies in Memory of Gaston Wiet*, pp. 309–33. Jerusalem: Hebrew University of Jerusalem.

———. 1984. "The Origins and Significance of the Chach Nāma." In Yohanan Friedmann, ed., *Islam in Asia*, vol. 1: *South Asia*, pp. 23–37. Jerusalem: Magnes Press.

———. 1991. "Al-Manṣūra." In *The Encyclopaedia of Islam*, 2nd ed., 6:439–40.

———. 1993. "Multān. 1. History." In *The Encyclopaedia of Islam*, 2nd ed., 7:548–49.

Frye, Richard N. 1965. "Fērōzkōh." In *The Encyclopaedia of Islam*, 2nd ed., 2:928.

Gabrieli, Francesco. 1964–65. "Muḥammad ibn Qāsim ath-Thaqafī and the Arab Conquest of Sind." *East and West*, n.s. 15:281–95.

———. 1969. *Arab Historians of the Crusades*. Berkeley and Los Angeles: University of California Press.

Gamboni, Dario. 1997. *The Destruction of Art: Iconoclasm and Vandalism since the French Revolution*. New Haven: Yale University Press.

Ganguly, D. C. 1942. "The Historical Value of Dīwān-i-Salmān." *Islamic Culture* 16:423–28.

Gardet, L. 1965. "Fitna." *The Encyclopaedia of Islam*, new ed., 2:930–31.

———. 1978. "Kalām." *The Encyclopaedia of Islam*, new ed., 4:468–71.

Gascoigne, Alison. 2006. "Archaeological Investigations at Jam, Afghanistan." *Fondation Max van Berchem Bulletin* 20:1–3.

Gätje, Helmut. 1996. *The Qur'an and Its Exegesis: Selected Texts with Classical and Modern Muslim Interpretations*. Rockport, Maine: Oneworld Publications.

Ghabin, Ahmad. 1987. "Jewellery and Goldsmithing in Medieval Islam: The Religious Point of View." In Na'ama Brosh, ed., *Jewellery and Goldsmithing in the Islamic World, International Symposium the Israel Museum*, pp. 83–92. Jerusalem: Israel Museum.

———. 1998. "The Quranic Verses as a Source for the Legitimacy of the Arts in Islam." *Der Islam* 75/2: 193–225.

Ghafur, Muhammad Abdul. 1960. The Gorids: History, Culture and Administration, 543–612/1148–1215–16. Ph.D. dissertation, University of Hamburg.

———. 1964. "The Relations of the Ghurids with the Caliph." *Journal of the Asiatic Society (Pakistan)* 9/2: 109–20.

———. 1966. "Fourteen Kufic Inscriptions of Banbhore, the Site of Daybul." *Pakistan Archaeology* 3:65–90.

Ghose, Ajit. 1927. "Some Old Indian Ivories." *Rupam* 29–32:22–29.

Gilliot, Claude. 1999. "L'exégèse du Coran en Asie centrale et au Khorasan." *Studia Islamica* 89:129–164.

Gilmartin, David, and Bruce B. Lawrence. 2000. "Introduction." In idem, eds., *Beyond Turk and Hindu: Rethinking Religious Identity in Islamicate South Asia*, pp. 1–20. Gainesville: University Press of Florida.

Giunta, Roberta. 2001. "The Tomb of Muḥammad al-Harawī (447/1055) at Ġaznī (Afghanistan) and Some New Observations on the Tomb of Maḥmūd the Ġaznavid." *East and West* 51:109–26.

———. 2003a. *Les inscriptions funéraires de Ġaznī (IVe–IXe/Xe–XVe siècles)*. Naples: Università degli Studi di Napoli.

———. 2003b. "Un texte de construction d'époque Ġūride a Ġaznī." In Maria Vittoria Fontana and Bruno Genito, eds., *Studi in Onore di Umberto Scerrato per il suo Settantacinquesimo Compleanno*, pp. 439–55. Naples: Istituto Italiano per l'Africa et l'Oriente.

Giunta, Roberta, and Cécile Bresc. 2004. "Listes de la titulature des Ghaznavides et des Ghurides à travers les documents numismatiques et épigraphiques." *Eurasian Studies* 3/2: 161–244.

Glatzer, Bernt. 1973. "The Madrasah of Shah-i-Mashhad in Badgis." *Afghanistan* 25/4: 46–68.

———. 1980. "Das Mausoleum und die Moschee des Ghoriden Ghiyāth ud-Dīn in Herat." *Afghanistan Journal* 7/1: 6–22.

Glick, Thomas F. 1979. *Islamic and Christian Spain in the Early Middle Ages*. Princeton: Princeton University Press.

———. 1992a. "Convivencia: An Introduction." In Vivian B. Mann, Thomas F. Glick, and Jerrilynn D. Dodds, eds., *Convivencia: Jews, Muslims and Christianity in Medieval Spain*, pp. 1–9. New York: George Braziller.

———. 1992b. "Science in Medieval Spain: The Jewish Contribution in the Context of *Convivencia*." In Vivian B. Mann, Thomas F. Glick, and Jerrilynn D. Dodds, eds., *Convivencia: Jews, Muslims and Christianity in Medieval Spain*, pp. 83–111. New York: George Braziller.

Glick, Thomas F., and Oriol Pi-Sunyer. 1969. "Acculturation as an Explanatory Concept in Spanish History." *Comparative Studies in Society and History* 11/2: 136–54.

Gnoli, Gherardo. 1964. *Le Iscrizioni Giudeo-Persiane del Ġūr (Afghanistan)*. Rome: Istituto Italiano per il Medio ed Estreme Oriente.

Godard, André. 1949. "Khorāsān." *Āthār-é Īrān* 4:7–150.

Goel, Sita Ram. 1993. *Hindu Temples: What Happened to Them?* Vol. 2: *The Islamic Evidence*. 2nd enlarged ed. New Delhi: Voice of India.

Goepper, Roger. 1990. "Clues for the Dating of the Three-Storeyed Temple (Sumtsek) in Alchi, Ladakh." *Asiatische Studien* 2:159–69.

———. 1991–92. "Early Kashmir Textiles? Painted Ceilings in Alchi." *Transactions of the Oriental Ceramics Society* 56:47–74.

———. 2003. "More Evidence for Dating the Sumtsek in Alchi and Its Relations with Kashmir." In Ingrid Kreide-Damani, ed., *Dating Tibetan Art: Essays on the Possibilities and Impossibilities of Chronology from the Lempertz Symposium*, Cologne, pp. 18–22. Wiesbaden: Dr. Ludwig Reichert Verlag.

Goetz, Herman. 1953. "Persia and India after the Conquest of Maḥmūd." In A. J. Arberry, ed., *The Legacy of Persia*, pp. 89–115. Oxford: Clarendon Press.

———. 1957. "Late Gupta Sculpture in Afghānistan: The 'Scorretti Marble' and Cognate Sculptures." *Arts Asiatiques* 4:13–19.

———. 1969. *Studies in the History and Art of Kashmir and the Indian Himalayas*. Wiesbaden: Otto Harrasowitz.

———. 1981. "The History of Persian Costume." In Arthur Upham Pope and Phyllis Ackermann, eds., *A Survey of Persian Art from Prehistoric Times to the Present*, 5:2227–56. Ashiya: SoPA.

Goitein, S. D. 1954. "From the Mediterranean to India: Documents on the Trade to India, South Arabia, and East Africa from the Eleventh and Twelfth Centuries." *Speculum* 29:181–97.

———. 1963. "Letters and Documents on the India Trade in Medieval Times." *Islamic Culture* 37:188–205.

———. 1980. "From Aden to India: Specimens of the Correspondence of India Traders of the Twelfth Century."

Journal of the Economic and Social History of the Orient 23:43–66.

———. 1983. *A Mediterranean Society: The Jewish Communities of the Arab World as Portrayed in the Documents of the Cairo Geniza*. Vol. 4: *Daily Life*. Berkeley: University of California Press.

Golzio, Karl-Heinz. 1990. "Das Problem von Toleranz in Indischen Relgionen anhand epigraphischer Quellen." In Helmut Eimer, ed., *Frank-Richard Hamm Memorial Volume, October 8, 1990*, pp. 89–102. Bonn: Indica et Tibetica Verlag.

Gommans, Jos. 1998. "The Silent Frontier of South Asia, c. A.D. 1100–1800." *Journal of World History* 9/1: 1–23.

Gonda, J. 1966. *Ancient Indian Kingship from the Religious Point of View*. Leiden: E. J. Brill.

Gopal, Krishna Kanti. 1963–64. "Assignment to Officers and Royal Kinsmen in Early Medieval India (c. 700–1200 A.D.)." *University of Allahabad Studies, Ancient History Section*, 75–103.

Gopal, Lallanji. 1963. "Sāmanta—Its Varying Significance in Ancient India." *Journal of the Royal Asiatic Society*, 21–37.

Gordon, Stewart. 1996. "Robes of Honour: A 'Transactional' Kingly Ceremony." *Indian Economic and Social History Review* 33/3: 225–42.

———. 2001a. "Robes, Kings, and Semiotic Ambiguity." In idem, ed., *Robes and Honor: The Medieval World of Investiture*, pp. 379–86. New York: Palgrave.

———. 2001b. "A World of Investiture." In idem, ed., *Robes and Honor: The Medieval World of Investiture*, pp. 1–22. New York: Palgrove.

———. 2003. "Introduction: Ibn Battuta and a Region of Robing." In idem, ed., *Robes of Honor: Khil'at in Pre-colonial and Colonial India*, pp. 1–30. New Delhi: Oxford University Press.

Goron, Stan, and J. P. Goenka. 2001. *Coins of the Indian Sultanates Covering the Area of Present-Day India, Pakistan and Bangladesh*. New Delhi: Munshiram Manoharlal.

Goswamy, B. N. 1993. *Indian Costumes in the Collection of the Calico Museum of Textiles*. Ahmedabad: Calico Museum of Textiles.

Gottschalk, Peter. 2000. *Beyond Hindu and Muslim: Multiple Identities in Narratives from Village India*. Oxford: Oxford University Press.

Grabar, Oleg. 1959. "The Umayyad Dome of the Rock in Jerusalem." *Ars Orientalis* 3:33–62.

———. 1968a. "Les arts mineurs de l'Orient Musulman à partir du milieu du XIIe siècle." *Cahiers de Civilization Médiévale* 11/2: 181–90.

———. 1968b. "The Visual Arts, 1050–1350." In *The Cambridge History of Iran*, vol. 5: *The Saljuq and Mongol Pe-*

riods, pp. 626–58. Cambridge: Cambridge University Press.

———. 1984. *The Illustrations of the Maqamat*. Chicago and London: University of Chicago Press.

———. 1986. "Patterns and Ways of Cultural Exchange." In Vladimir P. Goss and Christine Verzar Bornstein, eds., *The Meeting of Two Worlds: Cultural Exchange between East and West during the Period of the Crusades*, pp. 441–45. Kalamazoo: Medieval Institute Publications.

———. 1987. *The Formation of Islamic Art*. New Haven: Yale University Press.

———. 1998. "The Shared Culture of Objects." In Henry Maguire, ed., *Byzantine Court Culture, 829 to 1204*, pp. 115–29. Cambridge, Mass.: Harvard University Press.

———. 1999. *The Mediation of Ornament*. Princeton: Princeton University Press.

Granoff, Phyllis. 1991. "Tales of Broken Limbs and Bleeding Wounds: Responses to Muslim Iconoclasm in Medieval India." *East and West* 41:189–204.

———. 1991–92. "When Miracles Become Too Many: Stories of the Destruction of Holy Sites in the Tāpī Khaṇḍa of the Skanda Purāṇa." *Annals of the Bhandarkar Oriental Research Institute* 72–73:549–70.

———. 1998. "The Jina Bleeds: Threats to the Faith in Medieval Jain Stories." In Richard Davis, ed., *Images, Miracles and Authority in Asian Religious Traditions*, pp. 121–41. Boulder, Colo.: Westview Press.

Grierson, Phillip. 1959. "Commerce in the Dark Ages: A Critique of the Evidence." *Transactions of the Royal Historical Society* 5th series 9:123–40.

Grohmann, Adolf. 1957. "The Origin and Early Development of Floriated Kufic." *Ars Orientalis* 2:183–213.

Guha, Sumit. 2004. "Speaking Historically: The Changing Voices of Historical Narration in Western India, 1400–1900." *American Historical Review* 109/4: 1084–1103.

Guha-Thakurta, Tapati. 1997. *Archaeology as Evidence: Looking Back from the Ayodhya Debate*. Calcutta: Centre for Studies in Social Sciences.

Gupta, Parmeshwari Lal. 1973. "Nāgarī Legend on Horseman Ṭankah of Muhammad bin Sām." *Journal of the Numismatic Society of India* 35:209–12.

Gupta, S. P., Kurush F. Dalal, Abhijit Dandekar, Rukshana P. Nanji, and Suresh Bomble. 2004. "On the Footsteps of Zoroastrian Parsis in India: Excavations at Sanjan on the West Coast–2003." *Journal of Indian Ocean Archaeology* 1:93–106.

Gutas, Dimitri. 1998. *Greek Thought, Arabic Culture, the Graeco-Arabic Translation Movement in Baghdad and Early 'Abbāsid Society (2nd–4th/8th–10th Centuries)*. New York: Routledge.

Haase, C. P. 1982. "Probleme des Künstlerkonzentrationen unter Timur in Zentralasien." In Adalbert J. Gail, ed., *Künstler und Werkstatt in den Orientalistischen Gesellschaften*, pp. 61–73. Graz: Akademische Druck-u. Verlagenstadt.

Habib, Irfan. 1978. "Economic History of the Delhi Sultanate—an Essay in Interpretation." *Indian Historical Review* 4/2: 287–303.

———. 1979. "Technological Changes and Society in 13th– and 14th–Century India." In *Indian Historical Congress, Proceedings of the 31st Session, Varanasi 1969*, pp. 139–61. Patna.

———. 1982. "Northern India under the Sultanate." In Tapan Raychaudhuri and Irfan Habib, eds., *The Cambridge Economic History of India*. Vol. 1: *c. 1200–c.1750*, pp. 45–101. Cambridge: Cambridge University Press.

———. 1992. "Formation of the Sultanate Ruling Class of the Thirteenth Century." In *Medieval India 1: Researches in the History of India, 1200–1750*, pp. 1–21. New Delhi: Oxford University Press.

Habib, Mohammad. 1941. "Indian Culture and Social Life at the Time of the Turkish Invasions." *Journal of the Aligarh Historical Research Institute* 1/2–3: 1–125.

———. 1974–81. *Collected Works of Professor Mohammad Habib*, ed. K. A. Nizami, 2 vols. Aligarh: People's Publishing House.

———. 2001. "The Urban Revolution in Northern India." In Jos. J. L. Gommans and Dirk H. A. Kolff, eds., *Warfare and Weaponry in South Asia, 1000–1800*, pp. 45–65. New Delhi: Oxford University Press.

Habib, Mohammad, and Afsar Umar Salim Khan. 1960. *The Political Theory of the Delhi Sultanate (Including a Translation of Ziauddin Barani's Fatawa-i Jahandari, circa, 1358–9 A.D.)*. Allahabad, Bombay, and Delhi: Kitab Mahal.

Habibi, Abdul Hai. 1967. "The Temple of Sunagir, Zoon or Zoor in Ancient Afghanistan." In *Yādnāme-ye Jan Rypka, Collection of Articles on Persian and Tajik Literature*, pp. 75–78. Prague: Academia Publishing House.

Hall, Thomas D. 1986. "Incorporation in the World-System: Toward a Critique." *American Sociological Review* 51/3: 390–402.

Halm, Heinz. 1996. *The Empire of the Mahdi: The Rise of the Fatimids*. Leiden: E. J. Brill.

Halperin, Charles J. 1984. "The Ideology of Silence: Prejudice and Pragmatism on the Medieval Religious Frontier." *Comparative Studies in Society and History* 26/3: 442–66.

Hamadani, Agha Hussain. 1986. *The Frontier Policy of the Delhi Sultans*. Islamabad: National Institute of History and Cultural Research.

Hambly, Gavin R. G. 2001. "From Baghdad to Bukhara, from Ghazna to Delhi: The *khil'a* Ceremony in the Transmission of Kingly Pomp and Circumstance." In

Stewart Gordon, ed., *Robes and Honor: The Medieval World of Investiture*, pp. 193–224. New York: Palgrave.

———. 2003. "The Emperor's Clothes: Robing and 'Robes of Honor' in Mughal India." In Stewart Gordon, ed., *Robes of Honor: Khil'at in Pre-colonial and colonial India*, pp. 31–49. New Delhi: Oxford University Press.

Hamdani, Abbas. 1967. "The Fāṭimid-ʿAbbāsid Conflict in India." *Islamic Culture* 41:186–91.

Hangloo, R. L. 1991. "Accepting Islam and Abandoning Hinduism: A Study of Proselytization Process in Medieval Kashmir." *Islamic Culture* 71/1: 91–110.

Hansen, Maria Fabricius. 2003. *The Eloquence of Appropriation: Prolegomena to an Understanding of Spolia in Early Christian Rome*. Rome: "L'Erma" di Bretschneider.

Hardy, Peter. 1960. *Historians of Medieval India: Studies in Indo-Muslim Historical Writing*. London: Luzac and Company.

———. 1962. "Mahmud of Ghazna and the Historians." *Journal of the Panjab University Historical Society* 14:1–36.

———. 1965. "Djizya III—India." In *The Encyclopaedia of Islam*, new ed., 2:566–67.

———. 1978. "The Duty of the Sultan (in the Sultanate Period) to Further the Material Welfare of His Subjects." In Wendy O'Doniger Flaherty, J. Duncan, and M. Derrett, eds., *The Concept of Duty in South Asia*, pp. 147–65. New Delhi: Vikas Publishing House Pvt.

———. 1983. "Force and Violence in Indo-Persian Writing on History and Government in Medieval South Asia." In Milton Israel and N. K. Wagle, eds., *Islamic Society and Culture, Essays in Honour of Professor Aziz Ahmad*, pp. 165–208. Delhi: Manohar.

———. 1986. "The Authority of Muslim Kings in Mediaeval South Asia." *Puruṣārtha* 9:37–55.

———. 1998. "Growth of Authority over a Conquered Political Élite: Early Delhi Sultanate as a Possible Case Study." In J. F. Richards, ed., *Kingship and Authority in South Asia*, pp. 216–41. Delhi: Oxford University Press.

Hardy-Guilbert, Cl., and F. Djindjian. 1980. "Oganisation des decors de stuc sur l'arc du portail de la mosquée de Bust." *Dossiers d'archéologie* 42:88–93.

Hartmann, Angelika. 1975. *An-Nasir li-Din Allah (1180–1225): Politik, Religion, Kultur in der späten ʿAbbasidenzeit*. Berlin: de Gruyter.

Hasan, Perween. 1993. "Temple Niches and Miḥrābs in Bengal." In Anna Libera Dallapiccola and Stephanie Zingel-Avé Lallemant, eds., *Islam and Indian Regions*, pp. 87–94. Stuttgart: Franz Steiner Verlag.

Hasan, Sheikh Abdel Rahman. 1979. "Financial Resources in Islam." *Al-Azhar Magazine* 51/3: 132–42.

Hashmi, Yusuf Abbas. 1958. "Society and Religion under the Ghaznawids." *Journal of the Pakistan Historical Society* 6:254–68.

Havell, E. B. 1913. *Indian Architecture: Its Psychology, Structure and History from the first Muhammedan Invasion to the Present Day*. London: J. Murray.

Hawting, Gerald R. 1997. "The Literary Contexts of the Traditional Accounts of Pre-Islamic Arab Idolatry." *Jerusalem Studies in Arabic and Islam* 21:21–41.

———. 1999. *The Idea of Idolatry and the Emergence of Islam: From Polemic to History*. Cambridge: Cambridge University Press.

Hevia, James. 1999. "Looting Beijing, 1860, 1900." In Lydia H. Liu, ed., *Tokens of Exchange: The Problem of Translation in Global Circulations*, pp. 192–213. Durham and London: Duke University.

Hillenbrand, Carole. 2004. "Some Reflections on the Use of the Qur'ān in Monumental Inscriptions in Syria and Palestine in the Twelfth and Thirteenth Centuries." In Robert G. Hoyland and Philip F. Kennedy, eds., *Islamic Reflections Arabic Musings: Studies in Honour of Professor Alan Jones*, pp. 279–89. London: E.J.W. Gibb Memorial Trust.

Hillenbrand, Robert. 1988. "Political Symbolism in Early Indo-Islamic Mosque Architecture: The Case of Ajmīr." *Iran* 26:105–17.

———. 1991. "Qur'anic Epigraphy in Medieval Islamic Architecture." *Revue des Études Islamiques* 59:171–87.

———. 1999. *Islamic Art and Architecture*. London: Thames and Hudson.

———. 2000. "The Architecture of the Ghaznavids and Ghurids." In Carole Hillenbrand, ed., *Studies in Honour of Clifford Edmund Bosworth*, vol. 2: *The Sultan's Turret: Studies in Persian and Turkish Culture*, pp. 124–206. Leiden: E. J. Brill.

———. 2002. "The Ghurid Tomb at Herat." In Warwick Ball and Leonard Harrow, eds., *Cairo to Kabul: Afghan and Islamic Studies Presented to Ralph Pinder-Wilson*, pp. 123–43. London: Melisende.

Hinz, Walther. 1955. *Islamische Masse und Gewichte*. Leiden: E. J. Brill.

Hodgson, Marshall G. S. 1977. *The Venture of Islam: Conscience and History in a World Civilization*. 3 vols. Chicago and London: University of Chicago Press.

Hoffman, Eva. 2001. "Pathways of Portability: Islamic and Christian Interchange from the Tenth to the Twelfth Century." *Art History* 24/1: 17–50.

Honarfar, L. 1971. *Historical Monuments of Isfahan*. Tehran: Ziba Press.

Horton, Mark C. 2004. "Islam, Archaeology, and Swahili Identity." In Donald Whitcomb, ed., *Changing Social Identity with the Spread of Islam: Archaeological Per*

spectives, pp. 67–88. Chicago: University of Chicago Press.

Hourani, George F. 1995. *Arab Seafaring in the Indian Ocean in Ancient and Early Medieval Times*. Rev. and ed. John Carswell. Princeton: Princeton University Press.

Howard, Deborah. 2000b. *Venice and the East: the Impact of the Islamic World on Venetian Architecture, 1100–1500*. New Haven: Yale University Press.

Huart, C. 1971. "Humā." In *The Encyclopaedia of Islam*, new ed., 3:572.

Humbach, Helmut. 1994. "The Tochi Inscriptions." *Studien zur Indologie und Iranistik* 19:137–56.

Humphreys, R. Stephen. 1991. *Islamic History: A Framework for Inquiry*. Princeton: Princeton University Press.

———. 2004. "Borrowed Lives: The Reproduction of Texts in Islamic Cultures." In Irene A. Bierman, ed., *Text and Context in Islamic Societies*, pp. 69–85. Reading: Ithaca Press.

Hunt, Lucy-Anne Hunt. 1984. "Comnenian Aristocratic Palace Decoration: Descriptions and Islamic Connections." In Michael Angold, ed., *Byzantine aristocracy, IX to XIII Centuries*, pp. 138–56. Oxford: British Archaeological Reports Internation Series, 221.

Ibrahim, Asma, and Kaleem Lashari. 1993. "Recent Archaeological Discoveries in the Lower Deltaic Area of Indus." *Journal of Pakistan Archaeologist's Forum* 2/1–2: 1–44.

Ilisch, Lutz. 1984. "Münzgeschenke und Geschenkmünzen in der mittelalterlichen islamischen Welt II." *Münzenhandlung Holger Dombrowski Intermünz-Kurier* III (11 September): 15-24; (30 November): 27–34.

Inalcik, Halil. 1965. "Dār al-'Ahd." In *The Encyclopaedia of Islam*, new ed. 2:116. Leiden: E. J. Brill.

Inden, Ronald. 1981. "Hierarchies of Kings in Early Medieval India." *Contributions to Indian Sociology* 15:99–125.

———. 1998. "Ritual, Authority and Cyclic Time in Hindu Kingship." In J. F. Richards, ed., *Kingship and Authority in South Asia*, pp. 41–91. Delhi: Oxford University Press.

———. 2000a. *Imagining India*. Bloomington and Indianapolis: Indiana University Press.

———. 2000b. "Imperial Purāṇas: Kashmir as Vaiṣṇava Center of the World." In Ronald Inden, Jonathan S. Walters, and Daud Ali, eds., *Querying the Medieval: Texts and the History of Practices in South Asia*, pp. 29–95. Cambridge: Cambridge University Press.

———. 2000c. "Introduction: From Philological to Dialogical Texts." In Ronald Inden, Jonathan S. Walters, and Daud Ali, eds., *Querying the Medieval: Texts and the History of Practices in South Asia*, pp. 3–28. Cambridge: Cambridge University Press.

Irwin, John. 1973. "'Aśokan' Pillars: A Reassessment of the Evidence." *Burlington Magazine* 115:706–20.

———. 1987. "Islam and the Cosmic Pillar." In *Investigating Indian Art: Proceedings of a Symposium on the Development of Early Buddhist and Hindu Iconography Held at the Museum of Indian Art, Berlin, May 1986*, pp. 133–44. Berlin.

———. 1989. "Islam and the Cosmic Pillar." In *South Asian Archaeology 1985*, pp. 397–406. London.

Islam, Arshad. 1996. "Arab Rule in Sindh after the Umayyads." *Pakistan Journal of History and Culture* 17/1: 1–10.

Jackson, Peter. 1990. "The Mamlūk Institution in Early Medieval India." *Journal of the Royal Asiatic Society* 2:340–58.

———. 1999. *The Delhi Sultanate: A Political and Military History*. Cambridge: Cambridge University Press.

———. 2000. "The Fall of the Ghurid Dynasty." In Carole Hillenbrand, ed., *Studies in Honour of Clifford Edmund Bosworth, II: The Sultan's Turret: Studies in Persian and Turkish Culture*, pp. 207–37. Leiden: E. J. Brill.

Jacoby, Zehava. 1992. "Ideological and Pragmatic Aspects of Muslim Iconoclasm after the Crusader Advent in the Holy Land." In Michalski, Sergiusz, ed., *L'Art et les révolutions*, Section 4: *Les iconoclasmes*, Actes du XXVIIe congrès international d'histoire de l'art, Strasbourg, 1–7 septembre 1989, pp. 13–24. Strasbourg: Société alsacienne pour le dévelopment de l'histoire de l'art.

Jahn, K. 1963. "On the Mythology and Religion of the Indians in the Mediaeval Moslem Tradition." In *Mélanges d'Orientalisme offerts a Henri Massé*, pp. 185–97. Tehran: Imprimerie de l'Université.

Jain, Kaliash Chand. 1972. *Ancient Cities and Towns of Rajasthan*. Delhi: Motilal Banarsidass.

Jairazbhoy, Nazir A. 1970. "A Preliminary Survey of the Oboe in India." *Ethnomusicology* 14/3: 375–88.

Jairazbhoy, R. A. 1972. *An Outline of Islamic Art*. New York: Asia Publishing House.

Janaki, V. A. 1969. *Gujarat as the Arabs Knew It (a Study in Historical Geography)*. Geography Research Papers series no. 4. Baroda: Maharaja Sayajirao University of Baroda.

Johns, Jeremy. 2002. *Arabic Administration in Norman Sicily: The Royal Dîwân*. Cambridge: Cambridge University Press.

———. 2004. "The Boys from Mezzoiuso: Muslim *jizya*-payers in Christian Sicily." In Robert G. Hoyland and Phillip F. Kennedy, eds., *Islamic Reflections Arabic Musings: Studies in Honour of Professor Alan Jones*, pp. 243–55. Cambridge: Gibb Memorial Trust.

Johns, Jeremy, and Emilie Savage-Smith. 2003. "The *Book of Curiosities*: A Newly Discovered Series of Islamic Maps." *Imago Mundi* 55:7–24.

Jones, Lynn. 2001. "The Visual Experience of Power and Piety in Medieval Armenia: The Palace and Palace Church at

Aghtamar." In Anthony Eastmond, ed., *Eastern Approaches to Byzantium*, pp. 221–41. Aldershot: Ashgate.

Joshi, M. C. 2007. "Introduction à l'art Gupta." In *L'Age d'or de l'Inde classique, l'empire des Guptas*, pp. 29–57. Paris: Éditions de la réunion des musées nationaux.

Juneja, Monica. 2005. "Spaces of Encounter and Plurality: Looking at Architecture in Pre-colonial North India." In Jamal Malik and Helmut Reifeld, eds., *Religious Pluralism in South Asia and Europe*, pp. 245–67. New Delhi: Oxford University Press.

Juynboll, G.H.A. 1985. "The Attitude towards Gold and Silver in Early Islam." In Michael Vickers, ed., *Pots and Pans: A Colloquium on Precious Metals and Ceramics in the Muslim, Chinese and Graeco-Roman Worlds*, pp. 107–16. Oxford Studies in Islamic Art 3. Oxford: Oxford University.

Kafadar, Cemal. 1995. *Between Two Worlds: The Construction of the Ottoman State*. Berkeley: University of California Press.

Kalter, Johannes. 1993. "Die Höfe-Zentren der Macht-Zentren der Kunst-Verbreite des Glaubens." In Johannes Kalter, ed., *Die Gärten des Islam*, pp. 77–105. Stuttgart: Hansjörg Mayer.

Kane, P. V. 1930. "The Pahlavas and Pārasīkas in Ancient Sanskrit Literature." In *Dr. Modi Memorial Volume*, pp. 354–56. Bombay: Fort Printing Press.

Karmay, Heather. 1977. "Tibetan Costume, Seventh to Eleventh Centuries." In Ariane MacDonald and Yoshiro Imaeda, eds., *Essai sur l'art du Tibet*, pp. 64–81. Paris: Librairie d'Amérique et d'Orient.

Kawatoko, Mutsuo. 2003. *Archaeological Survey of the Rātay/at-Ṭūr Area of the Sinai Peninsula, Egypt*. Tokyo: Middle Eastern Culture Centre in Japan.

Kejariwal, O. P. 1988 *The Asiatic Society of Bengal and the Discovery of India's Past*. New Delhi: Oxford University Press.

Kervran, Monik. 1993. "Vanishing Medieval Cities of the North-West Indus Delta." *Pakistan Archaeology* 28:3–54.

———. 1996. "Le port multiple des bouches de l'Indus: Barbariké, Dêb, Daybul, Lâhorî Bandar, Diul Sinde." *Res Orientales* 8:45–92.

———. 1999. "Caravansérails du Delta de l'Indus: Réflexions sur l'origine du caravansérail Islamique." *Archéologie Islamique* 8–9:143–76.

Khadduri, Majid. 1955. *War and Peace in the Law of Islam*. Baltimore: Johns Hopkins University Press.

———. 1971. "Ḥarb." In *The Encyclopaedia of Islam*, 3: 180–81. Leiden: E. J. Brill.

Khan, Ahmad Nabi. 1966. "Bhambore, a Probable Site of Debul." *Islamic Review* 54:19–23.

———. 1990a. *Islamic Architecture of Pakistan: An Analytical Exposition*. Islamabad: National Hijra Council.

———. 1990b. *Al-Mansurah: A Forgotten Arab Metropolis in Pakistan*. Karachi: Department of Archaeology and Museums, Government of Pakistan.

———. 1991. *Development of Mosque Architecture in Pakistan*. Islamabad: Lok Virsa Publishing House.

Khan, Ghulam Mustafa. 1949. "A History of Bahram Shah of Ghazni." *Islamic Culture* 23:62–91, 199–235.

———. 1953. "The Islamic and Ghaznavide Banners." *Nagpur University Journal* 9:106–17.

———. 1977. "The Ghaznawid Heritage in Pakistan." *Journal of the Research Society of Pakistan* 14/1: 24–37.

Khan, Iqbal. 1993. "Views of Abul Fazl on the 'Birth' of Metals." In Ahsan Jan Qaisar and Som Prakash Verma, eds., *Art and Culture: Felicitation Volume in Honour of Professor Nurul Hasan*, pp. 105–9. Jaipur: Publication Scheme.

Khan, Muhammad Ishtiaq. 1986. "The Impact of Islam on Kashmir in the Sultanate Period (1320–1586)." *Indian Economic and Social History Review* 23:187–205.

———. 2002. "The Grand Mosque of Banbhore: A Reappraisal." *Ancient Pakistan* 15:1–7.

Kholeif, Fathalla. 1966. *A Study on Fakhr al-Dīn al-Rāzī and His Controversies in Transoxiana*. Beirut: Dār al-Mashriq.

Kieffer, Charles M. 1960. "Le minaret de Ghiyath al-Din a Firuzkoh." *Afghanistan* 15/4: 16–60.

———. 1962. *Les Ghorides: Une grande dynastie nationale*. Kabul: Historical Society of Afghanistan.

King, Geoffrey R. D. 1989. "The Nine Domed Mosque in Islam." *Madrider Mitteilungen* 30:332–90.

Kinney, Dale. 1995. "Rape or Restitution of the Past? Interpreting Spolia." In Susan C. Scott, ed., *The Art of Interpreting*, pp. 53–67. University Park: Department of Art History, Pennsylvania State University.

Kipling, Rudyard. 1989. *Kipling: A Selection of His Stories and Poems*. Ed. John Beechcroft. New York: Garden City.

Klimburg-Salter, Deborah E. 1987. "Reformation and Renaissance: A Study of Indo-Tibetan Monasteries in the Eleventh Century." In G. Gnoli and L. Lanciotti, eds., *Orientalia Iosephi Tucci Memoriae Dicata*, 2:683–702. Rome: Istituto Italianio per il medio ed Estremo Oriente.

———. 1989. *The Kingdom of Bāmiyan: Buddhist Art and Culture of the Hindu Kush*. Naples: Istituto Universitario Orientale & IsMEO.

———. 1997. *Tabo: A Lamp for the Kingdom; Early Indo-Tibetan Buddhist Art in the Western Himalayas*. Milan: Thames and Hudson.

———. 1999–2000. "The Buddhist Art of Gujarat: On Tāranātha's Old Western Indian Style." *Silk Road Archaeology* 6:253–67.

Koch, Ebba. 1982. "The Baluster Column—a European Motif

in Mughal Architecture and Its Meaning." *Journal of the Warburg and Courtauld Institutes* 45:251–62.

———. 1991. "The Copies of the Quṭb Minār." *Iran* 29:95–107.

Kohzad, Ahmad ʿAli. 1951. "Uniformes et armes des gardes des sultans de Ghazni." *Afghanistan* 6/1: 48–53.

Komaroff, Linda, and Stefano Carboni. 2002. *The Legacy of Genghis Khan: Courtly Art and Culture in Western Asia, 1256–1353.* New Haven: Yale University Press.

Korn, Lorenz. 2003. "Iranian Style 'Out of Place'? Some Egyptian and Syrian Stuccos of the 5th–6th/11th–12th Centuries." *Annales Islamologiques* 37:237–60.

Kramrisch, Stella. 1958. "Traditions of the Indian Craftsman." *Journal of American Folklore* 71:224–30.

———. 1996 [1946]. *The Hindu Temple.* 2 vols. Delhi: Motilal Banarsidas Publishers.

Kraus, Paul. 1937. "The "Controversies" of Fakhr al-Dîn al-Râzî." *Islamic Culture* 12:131–53.

Kuban, Doğan. 1985. *Muslim Religious Architecture.* Part 2: *Development of Religious Architecture in Later Periods.* Leiden: E. J. Brill.

Kühnel, Ernst. 1971. *Die islamischen Elfenbeinskulpturen VIII.–XIII. Jahrhundert.* Berlin: Deutscher Verlag für Kunstwissenschaft.

Kulke, Hermann. 1978. "Royal Temple Policy and the Structure of Medieval Hindu Kingdoms." In Anncharlott Eschmann, Hermann Kulke, and Gaya Charan Tripathi, eds., *The Cult of Jagannath and the Regional Tradition of Orissa*, pp. 127–37. Delhi: Manohar.

———. 1993. *Kings and Cults: State Formation and Legitimation in India and Southeast Asia.* New Delhi: Manohar.

Kumar, Sunil. 1992. "The Emergence of the Delhi Sultanate, 588–685/1192–1286." Ph.D. dissertation, Duke University.

———. 2000. "Assertions of Authority: A Study of the Discursive Statements of Two Sultans of Delhi." In Muzaffar Alam, Françoise "Nalini" Delvoye, and Marc Gaborieau, eds., *The Making of Indo-Persian Culture, Indian and French Studies*, pp. 37–65. New Delhi: Manohar.

———. 2001. "Qutb and Modern Memory." In Suvir Kaul, ed., *The Partitions of Memory: The Afterlife of the Division of India*, pp. 140–82. New Delhi: Permanent Black.

———. 2005. "Politics, the Muslim Community and Hindu-Muslim Relations Reconsidered: North India in the Early Thirteenth Century." *Annales: Économies, Sociétés, Civilizations*, 1–27.

———. 2006. "Service, Status or Military Slavery in the Delhi Sultanate of the 13th and Early 14th Centuries." In Indrani Chatterjee and Richard M. Eaton, eds., *Slavery and South Asian History*, pp. 83–114. Bloomington: Indiana University Press.

———. 2007. *The Emergence of the Delhi Sultanate 1192–1286.* New Delhi: Permanent Black.

Kuwayama, Shoshin. 1999. "Historical Notes on Kapisi and Kabul in the Sixth–Eighth Centuries." *Zinbun* 34/1: 25–77.

Lal, Kishoni Saran. 1967. *History of the Khaljis, AD 1290–1320.* New Delhi: Asia Publishing House.

Lambourn, Elizabeth. 2001. "'A Collection of Merits…' Architectural Influences in the Friday Mosque and Kazaruni Tomb Complex at Cambay, Gujarat." *South Asian Studies* 17:117–49.

———. 2007. "Carving and Communities: Marble Carving for Muslim Patrons of Khambhāt and around the Indian Ocean Rim, Late Thirteenth–Mid-fifteenth Centuries." *Ars Orientalis* 34:99–133.

———. Unpublished a. "Community, Khutba, Port and Polity—Reflections on the Political Geographies of Muslim Mercantile Communities in Pre-modern South Asia."

———. Unpublished b. "*Khutba* and *daʿwa al-sultan*: Networks of Mercantile Allegiance in the Indian Ocean World, 9th–10th Centuries CE."

Lambton, Ann K. S. 1980. *Theory and Practice in Medieval Persian Government.* Aldershot: Variorum.

———. 1988a. "Concepts of Authority in Persia: Eleventh to Nineteenth Centuries A.D." *Iran* 26:95–103.

———. 1988b. *Continuity and Change in Early Medieval Persia: Aspects of Administrative, Economic, and Social History, 11th–14th Century.* Albany: Bibliotheca Persica.

———. 1991 [1981]. *State and Government in Medieval Islam.* Oxford: Oxford University Press.

———. 1993. "Naḳḳāra-Khāna." In *The Encyclopaedia of Islam*, 2nd ed. 7:927–30. Leiden: E. J. Brill.

———. 1994. "Pīshkash: Present or Tribute?" *Bulletin of the School of Oriental and African Studies* 57/1: 144–58.

———. 1995. "Pīshkash." In *The Encyclopaedia of Islam*, 2nd ed. 8:312–13. Leiden: E. J. Brill.

Latham, J. D. 2000. "Al-Thughūr." In *The Encyclopaedia of Islam*, 10:446–49. Leiden: E. J. Brill.

Latif, Syad Muhammad. 1892. *Lahore: Its History, Architectural Remains and Antiquities.* Lahore: "New Imperial Press."

Lehmann, Fritz. 1978. "Architecture of the Early Sultanate Period and the Nature of the Muslim State in India." *Indica* 15/1: 13–31.

Leslie, Donald Daniel. 1987. "Living with the Chinese: The Muslim Experience in China, T'ang to Ming." In Charles le Blanc and Susan Blader, eds., *Chinese Ideas about Nature and Society: Studies in Honour of Derk Bodde*, pp. 175–93. Hong Kong: Hong Kong University Press.

Levy, Reuben. 1935. "Notes on Costume from Arabic Sources." *Journal of the Royal Asiatic Society*, 319–38.

Lockhart, Laurence. 1938. *Nadir Shah: A Critical Study Based*

Mainly upon Contemporary Sources. London: Luzac & Co.

Lohuizen de Leeuw, J. E. van. 1959. "An Ancient Hindu Temple in Eastern Afghanistan." *Oriental Art* 5:61–69.

———. 1981. "The Pre-Muslim Antiquities of Sind." In Hamida Khuhro, ed., *Sind through the Centuries: Proceedings of an International Seminar Held in Karachi in Spring 1975 by the Department of Culture, Government of Sind*, pp. 43–58. Karachi. Oxford University Press.

Løkkegaard, Frede. 1950. *Islamic Taxation in the Classical Period.* Philadelphia: Porcupine Press.

———. 1965a. "Fay'." In *The Encyclopaedia of Islam*, 2nd ed., 2:869–70.

———. 1965b. "Ghanīma." In *The Encyclopaedia of Islam*, 2nd ed. 2:1005–6. Leiden: E. J. Brill.

Louvre. 1991. *Le Trésor de Saint-Denis: Musée du Louvre, Paris, 12 mars–17 juin 1991.* Paris: Musée du Louvre.

Lowden, John. 1992. "The Luxury Book as Diplomatic Gift." In Jonathan Shepard and Simon Franklin, eds., *Byzantine Diplomacy*, pp. 249–60. Brookfield, Vt.: Variorum.

Lowick, Nicholas W. 1973. "The Horseman Type of Bengal and the Question of Commemorative Issues." *Journal of the Numismatic Society of India* 35:196–208.

———. 1990. "Fātimid Coins of Multan." Essay 19 in Joe Cribb, ed., *Islamic Coins and Trade in the Medieval World*, pp. 62–69. Aldershot: Variorum.

Luczanits, Christian. 2004. *Buddhist Sculpture in Clay: Early Western Himalayan Art, Late Tenth to Early Thirteenth Century.* Chicago: Serindia Publications.

———. 2005. "The Early Buddhist Heritage of Ladakh Reconsidered." In John Bry, ed., *Ladakhi Histories: Local and Regional Perspectives*, pp. 65–96. Boston: Brill.

Ludden, David. 1994. "History Outside Civilisation and the Mobility of South Asia." *South Asia* 17/1: 1–23.

MacDowall, David W. 1968. "The Shahis of Kabul and Gandhara." *Numismatic Chronicle* 8:189–224.

Maclean, Derryl N. 1989. *Religion and Society in Arab Sind.* Leiden: E. J. Brill.

Madelung, Wilferd. 1981. "New Documents Concerning al-Ma'mūn, al-Faḍl b. Sahl and 'Alī al-Riḍā." In Wadad al-Qaḍi, ed., *Studia Arabica et Islamica: Festschrift for Iḥsān 'Abbās on His Sixtieth Birthday*, pp. 333–46. Beirut: American University of Beirut.

———. 1985. "The Spread of Māturīdism and the Turks," In idem *Religious Schools and Sects in Medieval Islam*, pp. 109–68. Aldershot: Variorum.

———. 1988. *Religious Trends in Early Islamic Iran.* Albany: Persian Heritage Foundation.

———. 1991. "Māturīdiyya." In *The Encyclopaedia of Islam*, new ed., 6:847–88.

Majumdar, Asoke Kumar. 1956. *Chaulukyas of Gujarat.* Bombay: Bharatiya Vidya Bhavan.

Majumdar, R. C. 1961. "Ideas of History in Sanskrit Literature." In C. H. Phillips, ed., *Historians of India, Pakistan, and Ceylon*, pp. 13–27. Oxford: Oxford University Press.

———, ed. 1966 [1957]. *The Struggle for Empire.* Vol. 5 of *The History and Culture of the Indian People.* Bombay: Bharatiya Vidya Bhavan.

———, ed. 1993 [1955]. *The Age of Imperial Kanauj.* Vol. 4 of *The History and Culture of the Indian People.* Bombay: Bharatiya Vidya Bhavan.

Malamud, Margaret. 1994. "The Politics of Heresy in Medieval Khurasan: The Karramiyya in Nishapur." *Iranian Studies* 17/1–4: 37–51.

Malla, Bansi Lal. 1990. *Sculptures of Kashmir (600–1200 A.D.).* Delhi: Agam Kala Prakashan.

Mallette, Karla. 2003. "Translating Sicily." *Medieval Encounters* 9/1: 140–63.

Manning, Patrick. 1996. "The Problem of Interactions in World History." *American Historical Review* 101/3: 771–82.

Manz, Beatrice Forbes. 1988. "Tamerlane and the Symbolism of Sovereignty." *Iranian Studies* 21/1–2: 105–22.

Maricq, André and Gaston Wiet. 1959. *Le minaret de Djam: La découverte de la capitale des sultans Ghourides XIIe–XIIIe siècles.* Mémoires de la délégation archéologique française en Afghanistan, vol. 16. Paris: Librairie C. Klincksieck.

Markovits, Claude, Jacques Pouchepadass, and Sanjay Subrahmanyam. 2003. "Introduction—Circulation and Society under Colonial Rule." In Claude Markovits, Jacques Pouchepadass, and Sanjay Subrahmanyam, eds., *Society and Circulation: Mobile People and Itinerant Cultures in South Asia, 1750–1950*, pp. 1–22. Delhi: Permanent Black.

Marquart, J., and Johann Jakob Maria de Groot, 1915. "Das Reich Zābul und der Gott Žūn vom 6.–9. Jahrhundert." In Gotthold Weil, ed., *Festschrift Eduard Sachau zum Siebzigsten Geburtstage*, pp. 248–92. Berlin: G. Reimer.

Marshall, John. 1928. "The Monuments of Muslim India." In Wolseley Haig, ed., *Cambridge History of India.* Vol. 3: *Turks and Afghans*, pp. 568–640. Cambridge: Cambridge University Press.

Maskiell, Michelle, and Adrienne Mayor. 2003. "Early Legends of Poison *Khil'at*s in India." In Stewart Gordon, ed., *Robes of Honor: Khil'at in Pre-colonial and Colonial India*, pp. 95–124. New Delhi: Oxford University Press.

Massignon, Louis. 1997. *Essay on the Origins of the Technical Language of Islamic Mysticism.* Trans. Benjamin Clarke. Notre Dame, Ind.: University of Notre Dame Press.

Mathews, Thomas F., and Annie-Christine Daskalakis. 1997.

"The Portrait of Princess Marem of Kars, Jerusalem 2556, fol. 135b." In J.-P. Mahé and R. W. Thomson, eds., *From Byzantium to Iran: Armenian Studies in Honour of Nina G. Garsoïan*, pp. 475–84. Atlanta: Scholars Press.

Matthee, Rudi. 1998. "Between Aloofness and Fascination: Safavid Views of the West." *Iranian Studies* 31/3: 225–46.

Mayer, L. A. 1952. *Mamluk Costume*. Geneva: Albery Kundig.

———. 1958. *Islamic Woodcarvers and Their Works*. Geneva: A. Kundig.

———. 1959. *Islamic Metalworkers and Their Works*. Geneva: A. Kundig.

Mazumdar, Bhakat Prasad. 1960. *Socio-economic History of Northern India (1030–1194 A.D.)*. Calcutta: K. L. Mukhopahdyay.

McKibben, William Jeffrey. 1994. "The Monumental Pillars of Fīrūz Shāh Tughluq." *Ars Orientalis* 24:105–18.

Meinecke, Michael. 1996. *Patterns of Stylistic Changes in Islamic Art: Local Traditions versus Migrating Artists*. New York: New York University Press.

Meisami, Julie Scott. 1989. "Dynastic History and Ideals of Kingship in Bayhaqi's Tarikh-i Mas'udi." *Edebiyât* n.s. 3/1: 57–77.

———. 1993. "The Past in the Service of the Present: Two Views of History in Medieval Persia." *Poetics Today* 14/2: 247–75.

———. 1998. "Place in the Past, the Poetics/Politics of Nostalgia." *Edebiyât* n.s. 8:63–106.

———. 1999. *Persian Historiography to the End of the Twelfth Century*. Edinburgh: Edinburgh University Press.

———. 2001. "Palaces and Paradises: Palace Descriptions in Medieval Persian Poetry." In Oleg Grabar and Cynthia Robinson, eds., *Islamic Art and Literature*, pp. 21–54. Princeton: Markus Wiener Publishers.

Meister, Michael W. 1972. "The 'Two-and-a-Half-Day' Mosque." *Oriental Art* 18/1: 57–63.

———. 1989. "Mystifying Monuments." *Seminar* 364 (December): 24–27.

———. 1993a. "Indian Islam's Lotus Throne: Kaman and Khatu Kalan." In Anna Libera Dallapiccola and Stephanie Zingel-Avé Lallemant, eds., *Islam and Indian Regions*, pp. 445–52. Stuttgart: Franz Steiner Verlag.

———. 1993b. "Style and Idiom in the Art of Uparāmala." *Muqarnas* 40:345–54.

———. 1994a. "Art Regions and Modern Rajasthan." In Karine Schomer, Joan L. Erdman, Deryck O. Lodrick, and Lloyd I. Rudolph, eds., *The Idea of Rajasthan: Explorations in Regional Identity*, vol. 1: *Constructions*, pp. 143–71. Delhi: Manohar.

———. 1994b. "The Membrane of Tolerance—Middle and Modern India." In B. N. Saraswati, S. C. Malik, and Madhu Khanna, eds., *Art and the Integral Vision: A Vol-*

ume of Essays in Felicitation of Kapila Vatsyayan, pp. 289–98. New Delhi: D. K. Printworld.

———. 1996. "Temples along the Indus." *Expedition* 38/3: 41–54.

———. 2000. "Chronology of Temples in the Salt Range, Pakistan." In *South Asian Archaeology 1997*, pp. 1321–39. Rome: Istituto Italiano per l'Africa e l'Oriente.

Meister, Michael W., Abdur Rehman, and Farid Khan. 2000. "Discovery of a New Temple on the Indus." *Expedition* 42/1: 37–46.

Melikian-Chirvani, Assadullah Souren. 1970. "Eastern Iranian Architecture: Apropos of the Ghūrid Great Mosque of Herāt." *Bulletin of the School of Oriental and African Studies* 33:322–27.

———. 1977. "Un chef d'oeuvre inconnu dans une vallée afghane." *Conaissance des arts*, 76–79.

———. 1981. "The Buddhist Ritual in the Literature of Early Islamic Iran." *South Asian Archaeology: Proceedings of the 6th International Conference of the Association of South Asian Archaeologists in Western Europe*, pp. 272–79. Cambridge: Cambridge University Press.

———. 1982. "Studies in Hindustani Metalwork I—on Some Sultanate Stirrups." In Chahriyar Adle, ed., *Art et Société dans le monde Iranien*, pp. 177–95. Paris: Editions recherche sur les civilisations, A.D.P.F.

———. 1982–83. "Islamic Metalwork as a Source on Cultural History. *Arts and the Islamic World* 1/1: 36–44.

———. 1992. "The Iranian Bazm in Early Persian Sources." In R. Gyselen, ed., "Banquets d'Orient," *Res Orientales* 4:95–120.

Melville, Charles. 1990. "Padshah-i Islam, the Conversion of Ghazan Khan to Islam." *Persian and Islamic Studies in Honour of P. W. Avery*, Pembroke Papers 1:159–77. Cambridge: University of Cambridge Centre of middle East Studies.

Memon, Muhammad Umar. 1976. *Ibn Taimīya's Struggle against Popular Religion*. The Hague: Mouton.

Menocal, María Rosa. 2005. "The Culture of Translation." *Words without Borders: The Online Magazine for International Literature. www.wordswithoutborders.org/article.php?lab=culture*.

Messick, Brinkley. 1993. *The Calligraphic State: Textual Domination and History in a Muslim Society*. Berkeley: University of California Press.

Metcalf, Barbara D. 1995. "Presidential Address: Too Little, Too Much; Reflections on Muslims in the History of India." *Journal of Asian Studies* 54:951–67.

Metcalf, D. M. 1999. "Islamic, Byzantine, and Latin Influence in the Iconography of Crusader Coins and Seals." In Krijnie Ciggaar and Herman Teule, eds., *East and West in the Crusader States: Context-Contacts-Confrontations*, pp. 163–75. Leuven: Vitgeverij Peeters.

Meyer, Joachim, and Peter Northover. 2003. "A Newly Acquired Islamic Lion Door Knocker in the David Collection." *Journal of the David Collection* 1:48–71.

Michell, George. 1994. "Revivalism as the Imperial Mode: Religious Architecture during the Vijayanagara Period." In Catherine B. Asher and Thomas R. Metcalf, eds., *Perceptions of South Asia's Visual Past*, pp. 187–97. New Delhi: Oxford and IBH Publishing Co. Pvt.

Mihrabadi, Abu'l-Qasim Rafi'i. 1974 [1352]. *Āthār-i Melli-yi Isfahān*. Tehran: Intisharat-i Anjuman-i Athar-i Milli.

Miller, Barbara Stoller. 1991. "Presidential Address: Contending Narratives—the Political Life of the Indian Epics." *Journal of Asian Studies* 50/4: 783–92.

Minault, Gail. 2003. "The Emperor's Old Clothes: Robing and Sovereignty in Late Mughal and Early British India." In Stewart Gordon, ed., *Robes of Honor: Khil'at in Precolonial and Colonial India*, pp. 125–39. New Delhi: Oxford University Press.

Minorsky, Vladimir. 1956. "The Older Preface to the Shāh-Nāma." In *Studi Orientalistici in onore di Giorgio Levi della Vida*, 2:159–79. Rome: Istituto per l'Oriente.

Miquel, André. 1967. *La géographie humaine du monde musulman jusqu'au milieu du 11e siècle*. Paris: La Haye, Mouton & Co.

Mirchandani, B. 1968. "Sun-Temple of Multan." *Journal of Indian History* 46:209–16.

Mirza, M. Wahid. 1974 [1935]. *Life and Works of Amir Khusrau*. Delhi: Idarah-i Adabayat-i Delli.

Mishra, Jayashri. 1992. *Social and Economic Conditions under the Imperial Rāshṭrakuṭas circa A.D. 750–973*. New Delhi: Commonwealth Publishers.

Mishra, R. N. 1983. "Artists of Ḍāhala and Dakṣina Kosala: A Study Based on Epigraphs." In Frederick M. Asher and G. S. Gai, eds., *Indian Epigraphy: Its Bearing on the History of Art*, pp. 185–90. New Delhi: Oxford University Press and IBH Publishing Co.

Misra, S. C. 1971. "Indigenisation and Islamization in Muslim Society in India." *Transactions of the Indian Institute of Advanced Study* 6:366–71.

Mitchiner, Michael. 1973. *The Multiple Dirhems of Medieval Afghanistan*. London: Hawkins Publishing.

Mitra, Sisir Kumar. 1957. "Chandella Dhaṅga and the Muslim Invasions of His Time." *Indian Historical Quarterly* 33:152–55.

Mohan, Krishna. 1981. *Early Medieval History of Kashmir (with Special Reference to the Loharas A.D. 1003–1171)*. New Delhi: Meharchand Lachhmandas Publications.

Molé, M. 1961. "Les Kubrawiya entre sunnisme et shiisme aux huitième et neuvième siècles de l'hégire." *Revue des Études Islamiques* 29:61–142.

Moreno, Eduardo Manzano. 1994. "Christian-Muslim Frontier in Al-Andalus: Idea and Reality." In Dionisius A. Agius and Richard Hitchcock, eds., *The Arab Influence in Medieval Europe*, pp. 83–99. Reading: Ithaca Press.

Morony, Michael G. 1989. "Teleology and the Significance of Change." In F. M. Clover and R. S. Humphreys, eds., *Tradition and Innovation in Late Antiquity*, pp. 21–26. Madison: University of Wisconsin Press.

Morrison, Kathleen D., and Mark T. Lycett. 1997. "Inscriptions as Artifacts: Precolonial South India and the Analysis of Texts." *Journal of Archaeological Method and Theory* 4/3–4: 215–37.

Morton, A. H. 1978. "Ghūrid Gold en route to England." *Iran* 16:167–70.

Moskva, Mikhail Zand. 1967. "Some Light on Bilingualism in Literature of Transoxiana, Khurasan and Western Iran in the 10th Century AD." In *Yādnāme-ye Jan Rypka, Collection of Articles on Persian and Tajik Literature*, pp. 161–64. Prague: Academia Publishing House.

Mughal, Rafique. 1990. "Bhiro Bham: An Early Medieval Settlement in Central Sindh." *Journal of Central Asia* 13/2: 95–112.

Mujeeb, M. 1972. *Islamic Influence on Indian Society*. Meerut: Meenakshi Prakashan.

Murra, John V. 1989. "Cloth and Its Function in the Inka State." In Annette B. Weiner and Jane Schneider, eds., *Cloth and Human Experience*, pp. 275–303. Washington, D.C., and London: Smithsonian Institution Press.

Nadvi, Syed Sulayman. 1937. "The Early Relations between Arabia and India." *Islamic Culture* 11:172–79.

Napier, Lord. 1870. "Modern Architecture in India." *Builder* 28:680–82.

Narayanan, Vasudha. 2000. "Religious Vocabulary and Regional Identity: A Study of the Tamil Cirappuranam." In David Gilmartin and Bruce Lawrence, eds., *Beyond Turk and Hindu: Rethinking Religious Identity in Islamicate South Asia*, pp. 74–96. Gainesville: University Press of Florida.

Nasir, Pervin T. 1969. "Coins of the Early Muslim Period from Banbhore." *Pakistan Archaeology* 6:117–81.

Nath, Mahamahipadhyaya Pandit Bisheshwar. 1947. "Coins Struck by the Early Arab Governors of Sind." *Journal of the Numismatic Society of India* 9:124–27.

Nath, Ram. 1970. "The Minaret vs. the Dhvajastambha." *Indica* 7/1: 19–31.

———. 1979. *Monuments of Delhi: Historical Survey*. New Delhi: Ambika.

———. 1984. *Antiquities of Chittorgadh*. Jaipur: Historical Research Documentation Programme.

Nazim, Muhammad. 1927. "The Hindu Shāhiya Kingdom of Ohind." *Journal of the Royal Asiatic Society*, 485–95.

———. 1971 [1931]. *The Life and Times of Sultān Maḥmūd of Ghazna*. New Delhi: Munshriam Manoharlal.

Necipoğlu, Gülru. 1991. *Architecture, Ceremonial and Power: The Topkapi Palace in the Fifteenth and Sixteenth Centuries.* Cambridge, Mass.: MIT Press.

———. 1992. "The Life of an Imperial Monument: Hagia Sophia after Byzantium." In Robert Mark and Ahmet Ş. Çakmak, eds., *Hagia Sophia from the Age of Justinian to the Present*, pp. 195–226. Cambridge: Cambridge University Press.

———. 1995. *The Topkapı Scroll: Geometry and Ornament in Islamic Art.* Oxford: Oxford University Press.

Necipoğlu, Nevra. 1999–2000. "The Co-existence of Turks and Greeks in Medieval Anatolia (Eleventh–Twelfth Centuries)." *Harvard Middle Eastern and Islamic Review* 5:58–76.

Nelson, Robert S. 2005. "Letters and Language/Ornament and Identity." In Irene A. Bierman, ed., *The Experience of Islamic Art on the Margins of Islam*, pp. 61–88. Reading: Ithaca Press.

Nicklies, Charles E. 2004. "Builders, Patrons and Identity: The domed Basilicas of Sicily and Calabria." *Gesta* 43/2: 99–114.

Nicol, Norman P. 1988. "Islamic Coinage in Imitation of Fāṭimid Types." *Israel Numismatic Journal* 10:58–70.

Nizami, Khaliq Ahmad. 1966. *Studies in Medieval Indian History and Culture.* Allahabad: Kitab Mahal.

———. 1983. *On History and Historians of Medieval India.* Delhi: Munshiram Manoharlal Publishers Pvt.

———. 1997. *Royalty in Medieval India.* New Delhi: Munshiram Manohralal.

———. 1998. "The Ghurids." In C. E. Bosworth and M. S. Asimov, eds., *History of Civilizations of Central Asia*, vol. 4: *The Age of Achievement, A.D. 750 to the End of the Fifteenth Century*, part 1: The History, Social and Economic Setting, pp. 177–90. Paris: UNESCO Publishing.

———. 2002 [1961]. *Religion and Politics in India during the Thirteenth Century.* New Delhi: Oxford University Press.

Nizamu'd-Din, Muhammad. 1929. *Introduction to the Jawāmiʿ u'l-Ḥikāyā wa Lawāmiʿ u'r-Riwāyāt of Sadīdu'd-Dīn Muḥammad al-ʾAwfī.* London: Luzac & Co.

Noth, Albrecht. 2004. "Problems of Differentiation between Muslims and Non-Muslims: Re-reading the 'Ordinances of 'Umar' (al-Shurūṭ al-ʿUmariyya)." In Robert Hoyland, ed., *Muslims and Others in Early Islamic Society*, pp. 103–24. Aldershot: Ashgate.

Nyamaa, Badarch. 2005. *The Coins of Mongol Empire and Clan Tamgha of Khans (XIII–XIV).* Ulaan Baator.

Oikonomidès, Nicolas. 1983. "Les Danishmendides, entre Byzance, Bagdad, et le sultanat d'Iconium." *Revue Numismatique* 6th series 25:189–207.

O'Kane, Bernard. 1996. "Monumentality in Mamluk and Mongol Architecture." *Art History* 19/4: 499–522.

———. 2003. *Early Persian Painting: Kalila wa Dimna Manuscripts of the Late 14th Century.* London: I. B. Tauris.

———. 2006. "The Nine-Bay Plan in Islamic Architecture: Its Origin, Development and Meaning." In Abbas Daneshvari, ed., *A Survey of Persian Art*, vol. 18: *Islamic Period: From the End of the Sasanian Empire to the Present*, pp. 189–244. Costa Mesa, Calif.: Mazda.

———. Forthcoming. *The Appearance of Persian on Islamic Works of Art.* New York: Encyclopaedia Iranica.

Ousterhout, Robert. 1991. "Constantinople, Bithynia, and Regional Developments in Later Palaeologan Architecture." In Slobodan Ćurčić and Doula Mouriki, eds., *The Twilight of Byzantium: Aspects of Cultural and Religious History in the Late Byzantine Empire*, pp. 75–91. Princeton: Princeton University Press.

———. 1995. "Ethnic Identity and Cultural Appropriation in Early Ottoman Architecture." *Muqarnas* 12:48–62.

Page, J. A. 1926. *An Historical Memoir on the Qutb: Delhi.* Memoirs of the Archaeological Survey of India, no. 22. Calcutta: Government of India Central Publication Branch.

———. 1937. *A Memoir on Kotla Firoz Shah.* Memoirs of the Archaeological Survey of India, no. 52. Delhi: Manager of Publications.

Paket-Chy, A., and C. Gilliot. 2000. "Works on *hadīth* and Its Codification, on Exegesis and on Theology." In C. E. Bosworth and M. S. Asimov, eds., *History of Civilizations of Central Asia*, vol. 4: *The Age of Achievement, A.D. 750 to the End of the Fifteenth Century*, part 2: The Achievements, pp. 31–91. Paris: UNESCO.

Pal, Pratapaditya. 1981. *Elephants and Ivories in South Asia.* Los Angeles: Los Angeles County Museum of Art.

———. 1982. *A Buddhist Paradise: The Murals of Alchi, Western Himalayas.* Basel: Ravi Kumar.

———. 1988. *Indian Sculpture: A Catalogue of the Los Angeles County Museum of Art Collection.* Vol. 2: *700–1800.* Berkeley, Los Angeles, and London: Los Angeles County Museum of Art.

———. 1994. *The Peaceful Liberators: Jain Art from India.* Los Angeles: Los Angeles County Museum of Art.

———. 2003. *Himalayas: An Aesthetic Adventure.* Chicago: Art Institute of Chicago.

Pancaroğlu, Oya. 2000. "'A World unto Himself:' The Rise of a New Human Image in the Late Seljuq Period (1150–1250)." D.Phil. thesis, Harvard University.

———. 2004. "The Itinerant Dragon-Slayer: Forging Paths of Image and Identity in Medieval Anatolia." *Gesta* 43/2: 151–64.

Papalexandrou, Amy. 2001. "Text in Context: Eloquent Monuments and the Byzantine Beholder." *Word and Image* 17:259–83.

Parasher, Aloka. 1991. *Mlecchas in Early India: A Study in Attitudes Towards Outsiders up to AD 600*. Delhi: Munshiram Manoharlal Pvt.

Paret, Rudi. 1928. "Die Legende von der Verleihung des Propheten-mantels (burda) an Kaʿb ibn Zuhair." *Der Islam* 17:9–14.

Pastoureau, Michel. 1990. *L'Échiquier de Charlemagne, un jeu pour ne pas jouer*. Paris: A. Biro.

Patel, Alka Arvind. 2000. "Islamic Architecture of Western India (mid-12th–14th Centuries): Continuities and Interpretations." D.Phil. thesis, Harvard University.

———. 2004a. *Building Communities in Gujarat: Architecture and Society during the Twelfth through Fourteenth Centuries*. Leiden: E. J. Brill.

———. 2004b. "Toward Alternative Receptions of Ghurid Architecture in North India (Late Twelfth–early Thirteenth Century CE)." *Archives of Asian Art* 54:35–61.

Pathak, K. B. 1885. "The Explanation of the Term Palidhvaja." *Indian Antiquary*, 104–5.

Pathan, Mumtaz Husain A. 1964. "Foundation of al-Manṣūrah." *Islamic Culture* 38:183–94.

———. 1969. "Multan under the Arabs." *Islamic Culture* 43:13–20.

———. 1974. *Arab Kingdom of al-Mansurah in Sind*. Hyderabad: Institute of Sindhology.

Pazhvak, ʿAtiq Allah. 1966 [1345s]. *Ghūriyan*. Kabul: Anjuman-i Tarikh-i Afghanistan.

Pedersen, J. 1991. "Masdjid." In *The Encyclopaedia of Islam*, new ed. 6:644–77.

Pellat, Ch. 1991. "Al-Masʿūdī." *The Encyclopaedia of Islam*, 6:784–89. Leiden: E. J. Brill.

Pinder-Wilson, Ralph. 1985. *Studies in Islamic Art*. London: Pindar Press.

———. 1995. "Stone Sculpture of Gaur." In John Guy, ed., *Indian Art and Connoisseurship: Essays in Honour of Douglas Barrett*, pp. 251–61. New Delhi: Mapin Publishing Pvt.

———. 2001. "Ghaznavid and Ghūrid Minarets." *Iran* 39:155–86.

———. 2005. "Ivory Working in the Umayyad and Abbasid Periods." *Journal of the David Collection* 2/1: 13–23.

Pingree, David. 1963. "Astronomy and Astrology in India and Iran." *Isis* 54/2: 229–46.

———. 1968. "The Fragments of the Work of Yaqʿūb ibn Ṭāriq." *Journal of Near Eastern Studies* 27/2: 97–128.

———. 1978. "Islamic Astronomy in Sanskrit." *Journal for the History of Arabic Science* 2:315–30.

———. 1997. "Sindhind." In *The Encyclopaedia of Islam*, new ed. 10:640–41.

Pohl, Walter. 1998. "Telling the Difference: Signs of Ethnic Identity." In Walter Pohl and Helmut Reimitz, eds., *Strategies of Distinction: The Construction of Ethnic Communities, 300–800*, pp. 17–69. Leiden: E. J. Brill.

Pollock, Sheldon. 1993. "Rāmāyaṇa and Political Imagination in India." *Journal of Asian Studies* 52/2: 261–97.

———. 1996. "The Sanskrit Cosmopolis, 300–1300: Transculturation, Vernacularization, and the Question of Ideology." In Jan E. M. Houben, ed., *Ideology and Status of Sanskrit: Contributions to the History of the Sanskrit Language*, pp. 197–247. Leiden: E. J. Brill.

———. 1998. "India in the Vernacular Millenium: Literary Culture and Polity, 1000–1500." *Daedalus* 127:41–73.

———. 2002. "Cosmopolitanism and Vernacularization in History." In Carol A. Breckenridge-Appadurai, ed., *Cosmopolitanism*, pp. 17–53. Durham and London: Duke University Press.

———. 2004. "The Transformation of Culture-Power in Indo-Europe, 1000–1300." *Medieval Encounters* 10/1–3: 247–78.

———. 2006. *The Language of the Gods in the World of Men: Sanskrit, Culture, and Power in Premodern India*. Berkeley: University of California Press.

Pollock, Sheldon, Homi K. Bhabha, Carol A. Breckenridge, and Dipesh Chakrabarty. 2002. "Cosmopolitanism." In Carol A. Breckenridge-Appadurai, ed., *Cosmopolitanism*, pp. 1–14. Durham and London: Duke University Press.

Porter, Barbara Nevling. 1993. *Images, Power, and Politics: Figurative Aspects of Esarhaddon's Babylonian Policy*. Philadelphia: American Philosophical Society.

Potter, Lawrence Goddard. 1992. "The Kart Dynasty of Herat: Religion and Politics in Medieval Iran." D.Phil. thesis, Columbia University.

Prabha, Chandra. 1976. *Historical Mahākāvyas in Sanskrit (Eleventh to Fifteenth Century A.D.)* New Delhi: Shri Bharat Bharati Pvt.

Prasad, Pushpa. 1984. "Hindu Craftsmen in the Delhi Sultanate." *Indica* 21:11–15.

Prinsep, James. 1971. *Essays on Indian Antiquities*. Vol. 1. Varanasi: Indological Book House.

Pym, Anthony. 1994. "Twelfth-Century Toledo and Strategies of the Literalist Trojan Horse." *Target: International Journal of Translation Studies* 6/1: 43–66.

Qadir, Muhammad Abdul. 1981–82. "The So-Called Ladies' Gallery in the Early Mosques of Bangladesh." *Journal of the Varendra Research Museum* 7:161–72.

Rabbat, Nasser. 2000. "Ṭirāz." In *The Encyclopaedia of Islam*, 10:534–38. Leiden: E. J. Brill.

Rabe, Michael D. 1995. "Royal Temple Dedications." In Donald S. Lopez Jr., ed., *Religions of India in Practice*, pp. 235–43. Princeton: Princeton University Press.

Raby, Julian. 1991. "The Earliest Illustrations to *Kalilah wa Dimna*." *Marg* 43/1: 16–31.

Raghavan, V. 1956. "Variety and Integration in the Pattern of Indian Culture." *Far Eastern Quarterly* 15/4: 497–505.

Rai, Amrit. 1984. *A House Divided: The Origin and Development of Hindi/Hindavi*. Delhi: Oxford University Press.

Rajput, A. B. 1963. *Architecture in Pakistan*. Karachi: Pakistan Publications.

Rawshanzamir, Mahdi. 1978. *Tārīkh-i Siyāsī wa Nizāmī-yi Dūdmān-i Ghūri*. Tehran: Danishgah-i Milli-yi Iran.

Ray, H. C. 1973 [1931–36]. *The Dynastic History of Northern India (Early Mediaeval Period)*. 2 vols. New Delhi: Munshiram Manoharlal Publishers Pvt.

Redford, Scott. 1993. "The Seljuqs of Rum and the Antique." *Muqarnas* 10:148–56.

———. 2004. "Byzantium and the Islamic World, 1261-1557." In Helen C. Evans, ed., *Byzantium: Faith and Power (1261–1557)*, pp. 389–96. London and New Haven: Yale University Press.

———. 2005. "A Grammar of Rūm Seljuk Ornament." *Mesogeios* 25–26:283–310.

———. Forthcoming. "Words, Books, and Buildings in Seljuk Anatolia." In Karl Barbir and Bakri Tezcan, eds., *Identity and Identity Formation in the Ottoman Middle East and the Balkans: A Volume of Essays in Honor of Norman Itzkowitz*.

Redlich, Fritz. 1956. *De Praeda Militari: Looting and Booty 1500–1815*. Wiesbaden: Franz Steiner Verlag GMBH.

Rehman, Abdur. 1979. *The Last Two Dynasties of the Śāhis (an Analysis of Their History, Archaeology, Coinage and Paleography)*. Islamabad: Quaid-i Azam University, Center for the Study of the Civilizations of Central Asia.

Reinders, Eric. 2005. "Recycling Icons and Bodies in Chinese Anti-Buddhist Persecutions." *Res* 48:61–68.

Research Institute for Islamic Culture and Art. 1997 [1378s]. *An Encyclopedia of the Iranian Historical Monuments in the Islamic Era*. Vol. 2: *Mosques*. Tehran: Hawzah-i Hunari-i Sazman-i Tablighat-i Islami.

Reuter, Timothy. 1985. "Plunder and Trade in the Carolingian Empire." *Transactions of the Royal Historical Society* 5th series 35:75–94.

Rice, Tamara Talbot. 1969. "Some Reflections on the Subject of Arm Bands." In *Forschungen zur Kunst Asiens in Memoriam Kurt Erdmann*, pp. 262–77. Istanbul: Istanbul Üniversitesi Edebiyat Fakültesi.

Richards, J. F. 1974. "The Islamic Frontier in the East: Expansion into South Asia." *South Asia* 4:91–109.

———. 1983. "Outflows of Precious Metals from Early Islamic India." In J. F. Richards, ed., *Precious Metals in the Later Medieval and Early Medieval World*, pp. 183–205. Durham: Carolina Academic Press.

Robinson, B. W. 1976. "Unillustrated Manuscripts." In idem, ed., *Islamic Painting and the Arts of the Book*, pp. 285–300. London: Faber & Faber.

Rogers, J. Michael. 1969. "The Eleventh Century—a Turning Point in the Mashriq?" In D. S. Richards, ed., *Islamic Civilisation 950–1150*, pp. 211–49. Oxford: Bruno Cassirer (Publishers) Ltd.

———. 1970. "The Genesis of Safawid Religious Painting." *Iran* 8:125–40.

———. 1976. "Waqf and Patronage in Seljuk Anatolia: The Epigraphic Evidence." *Anatolian Studies* 26:69–103.

Rosenthal, Franz. 1968. *A History of Muslim Historiography*. 2nd rev. ed. Leiden: E. J. Brill.

———. 1990. "Gifts and Bribes: The Muslim View." Essay 14 in idem, *Muslim Intellectual and Social History: A Collection of Essays*, pp. 135–44. Aldershot: Variorum.

Rothaus, Richard. 1996. "Christianization and De-paganization: The Late Antique Creation of a Conceptual Frontier." In Ralph W. Mathisen and Hagith S. Sivan, eds., *Shifting Frontiers in Late Antiquity*, pp. 299–305. Aldershot: Variorum.

Rowan, Diana P. 1985. "Reconsideration of an Unusual Ivory Diptych." *Artibus Asiae* 46/4: 251–304.

Roxburgh, David J. 2005. *Turks: A Journey of a Thousand Years, 600–1600*. London: Royal Academy of Arts.

Rubiés, Joan-Pau. 2000. *Travel and Ethnology in the Renaissance: South India through European Eyes, 1250–1625*. Cambridge: Cambridge University Press.

Rubin, Uri. 1986. "The Ka'ba: Aspects of its Ritual Functions and Position in Pre-Islamic and Early Islamic Tradition." *Jerusalem Studies in Arabic and Islam* 8:97–132.

Ruggles, Dede Fairchild. 1997. "Representation and Identity in Medieval Spain: Beatus Manuscripts and the Mudejar Churches of Teruel." In Ross Bran, ed., *Languages of Power in Islamic Spain*, pp. 77–106. Bethesda, Md.: CDL Press.

Rugiadi, Martina. 2006. "A Carved Wooden Door from Jam—Preliminary Remarks." *Iran* 44:363–66.

Sain, Kanwar. 1934. "Who Built the Kutub Minar?" *Journal of the Punjab Historical Society* 3/2: 89–118.

Salomon, Richard, and Michael D. Willis. 1990. "A Ninth-Century Umāmaheśvara Image." *Artibus Asiae* 50/1–2: 148–55.

Sanders, Paula. 1994. *Ritual, Politics and the City in Fatimid Cairo*. Albany: State University of New York Press.

———. 1995. "Writing Identity in Medieval Cairo." In Irene A. Bierman and Paula Sanders, eds., *Writing Identity in Medieval Cairo*, pp. 24–78. Los Angeles: Center for Near Eastern Studies, UCLA.

———. 2001. "Robes of Honor in Fatimid Egypt." In Stewart Gordon, ed., *Robes and Honor: The Medieval World of Investiture*, pp. 225–40. New York: Palgrove.

Sandesara, Bhogilal J. 1953. *Literary Circle of Mahāmātya Vastupāla and Its Contribution to Sanskrit Literature*. Bombay: Singhi Jain Shastra Sikshapith.

Saradi, Helen. 1997. "The Use of Ancient Spolia in Byzantine Monuments: The Archaeological and Literary Evidence." *International Journal of the Classical Tradition* 3:395–423.

Sarda, Har Bilas. 1921. *Hammira of Ranthambhor*. Ajmer: Scottish Mission Industries Company.

———. 1941. *Ajmer: Historical and Descriptive*. Ajmer: Fine Art Printing Press.

Sarma, Mallampalli Somasekhara. 1948. *History of the Reddi Kingdoms (circa 1325 A.D. to circa 1448 A.D.)*. Waltair: Andhra University.

Sastri, Hirananda. 1937. "Devanāgarī and the Muhammadan Rulers of India." *Journal of the Bihar and Orissa Research Society* 23:492–97.

Sastry, T.V.G. 1975. "A Bhūmija Temple from a Chaitya Gṛha at Cezerla." *Itihas* 3/1: 19–41.

Sauerländer, Willibald. 1987. "Style or Transition? The Fallacies of Classification Discussed in the Light of German Architecture, 1190–1260." *Architectural History* 30:5–13.

Scarcia, Gianroberto, and Maurizio Taddei. 1973. "The Masǧid-i sangī of Larvand." *East and West* n.s. 23:89–108.

Scerrato, Umberto. 1959. "The First Two Excavation Campaigns at Ghazni, 1957–1958." *East and West* n.s. 10:22–55.

———. 1962. "Islamic Glazed Tiles with Moulded Decoration from Ghazni." *East and West* n.s. 13:263–87.

Scerrato, Umberto, and Maurizio Taddei. 1995. "A Possible Hindu-Shahi Lintel from Swat." In John Guy, ed., *Indian Art and Connoisseurship: Essays in Honour of Douglas Barrett*, pp. 52–56. New Delhi: Mapin Publishing Pvt.

Schimmel, Annemarie. 1975. "Turk and Hindu: A Poetical Image and Its Application to Historical Fact." In Speros Vryonis Jr., ed., *Islam and Cultural Change in the Middle Ages*, pp. 107–26. Wiesbaden: Harrassowitz.

Schlumberger, Daniel, and Janine Sourdel-Thomine. 1978. *Lashkari Bazar: Une residence royal ghaznévide et ghoride*, Mémoires de la Délégation archéologique français en Afghanistan, vol. 18. Paris: Diffusion de Boccard.

Schneider, Jane. 1977. "Was There a Pre-capitalist World-System?" *Peasant Studies* 6/1: 20–29.

Schnepel, Burkhard. 2001. "Kings and Rebel Kings: Rituals of Incorporation and Dissent in South Orissa." In Hermann Kulke and Burkhard Schnepel, ed., *Jagannath Revisited: Studying Society, Religion and the State in Orissa*, pp. 271–95. Delhi: Manohar.

Schwarz, Florian. 1995. *Ġazna/Kabul, XIVd Ḫurāsān IV. Sylloge numorum arabicorum*. Tübingen: E. Wasmuth.

Seidel, Linda. 1986. "Images of the Crusades in Western Art: Models as Metaphors." In Vladimir P. Goss, ed., *The Meeting of Two Worlds: Cultural Exchange between East and West during the Period of the Crusades*, pp. 377–91. Kalamazoo: Medieval Institute Publications, Western Michigan University.

Sen, Geeti. 1984. *Paintings form the Akbarnama: A Visual Chronicle of Mughal India*. Varanasi: Lustre Press Pvt.

Senac, Philippe. 1999. "L'Islam et chrétienté dans l'Espagne du haut Moyen Age: la naissance d'une frontière." *Studia Islamica* 89:91–108.

Serjeant, R. B. 1972. *Islamic Textiles: Material for a History up to the Mongol Conquest*. Beirut: Librairie du Liban.

Settar, S. 1973. "Peregrination of Medieval Artists: A Study of the Nature and Range of the Activity of the Hoysala Artists." *Journal of Indian History*, 419–35.

Shafi, M. (Miss). 1938. "Fresh Light on the Ghaznavids." *Islamic Culture* 12:189–234.

Shafiqullah, Shah Muhammad. 1994. "Calligraphic Ornamentation of the Quwwat al-Islam Mosque: An Observation on the Calligraphy of the Screens of Qutb al-Din and Iltutmish." *Journal of the Asiatic Society of Bangladesh, Humanities Volume* 39/2: 61–70.

Shalem, Avinoam. 1998. *Islam Christianized: Islamic Portable Objects in the Medieval Church Treasuries of the Latin West*. Frankfurt am Main: Peter Lang.

———. 2002. "Made for the Show: The Medieval Treasury of the Ka'ba in Mecca." Paper presented at the annual meeting of the College Art Association.

———. 2005. "Objects as Carriers of Real or Contrived Memories in a Cross-cultural Context." *Mitteilungen zur Spätantiken Archäologie und Byzantinischen Kunstgeschichte* 4:101–20.

Shamma, Samir. 1976. "The Political Significance of Religious Slogans on Coins." In *8th International Congress of Numismatics, 1973, New York and Washington, D.C.*, pp. 559–65. New York.

Sharma, Brij Bhushan. 1975. "European Sepulchral Architecture in India." *Indica* 12:36–40.

Sharma, Dasharatha. 1935. "The Kharataragaccha Paṭṭāvalī Compiled by Jinapāla." *Indian Historical Quarterly* 11:779–81.

———. 1944. "Pṛthvīrāja III, the Last Hindu Emperor of Delhi." *Indian Culture* 11/1: 57–73.

———. 1954. "Coin of Muhammad bin Sām and Pṛthvīrāja." *Journal of the Numismatic Society of India* 16/1: 122.

———. 1975 [1959]. *Early Chauhān Dynasties*. 2nd rev. ed. Delhi: Motilal Banarsidas.

Sharma, R. S. 1961. "Land Grants to Vassals and Officials in Northern India (c. A.D. 1000–1200)." *Journal of the Economic and Social History of the Orient*. 4:70–105.

Sharma, S. D. 1937. *The Crescent in India: A Study in Medieval History*. 3rd ed. Bombay: Karnataka Publishing House.

Sharma, Sunil. 2000. *Persian Poetry at the Indian Frontier: Mas'ūd Sa'd Salmān of Lahore*. New Delhi: Permanent Black.

Shastri, M. M. Havaprasad. 1913. "King Chandra of the

Meharauli Iron Pillar Inscription." *Indian Antiquary* 42:217–19.

Sherwani, H. K. 1963. "Cultural Synthesis in Mediaeval India." *Journal of Indian History* 41/1: 239–59.

Shokoohy, Mehrdad. 1988a. *Bhadreśvar, the Oldest Islamic Monuments in India*. Leiden: E. J. Brill.

———. 2003. *Muslim Architecture of South India: The Sultanate of Ma'bar and the Traditions of the Maritime Settlers on the Malabar and Coromandel Coasts [Tamil Nadu, Kerala, and Goa]*. London and New York: Routledge.

Shokoohy, Mehrdad, and Natalie H. Shokoohy. 1987. "The Architecture of Baha al-Din Tughrul in the Region of Bayana, Rajasthan." *Muqarnas* 4:114–32.

———. 1988. *Ḥiṣār-i Fīrūza: Sultanate and Early Mughal Architecture in the District of Hisar, India*. London: Monographs on Art, Archaeology and Architecture, South Asian Series.

———. 1993. *Nagaur: Sultanate and Early Mughal History and Architecture of the District of Nagaur, India*. London: Royal Asiatic Society.

———. 1996. "Indian Subcontinent III, 6(iii)(b): 11th–16th Century Indo-Islamic Architecture: North and West." In *Dictionary of Art*, 15:338–51. New York: MacMillan Publishing.

Shukurov, Rustam. 2001. "Turkoman and Byzantine Self-Identity: Some Reflections on the Logic of the Title-Making in Twelfth- and Thirteenth-Century Anatolia." In Anthony Eastmond, ed., *Eastern Approaches to Byzantium, Papers from the 33rd Spring Symposium of Byzantine Studies*, pp. 259–76. Aldershot: Ashgate.

Shulman, David. 2007. Review of Sheldon Pollock's *The Language of the Gods in the World of Men*. *Journal of Asian Studies* 66/3: 819–25.

Siddiq, Muhammad Yusuf. 2000. "Tughra. 2(d) History. In Indo-Muslim Usage." In *The Encyclopaedia of Islam*, new ed. 10:598. Leiden: E. J. Brill.

Siddiqi, Amir Hasan. 1942. *Caliphate and Kingship in Medieval Persia*. Lahore: Shaikh Muhammad Ashraf.

———. 1953. "Insignia of Sovereignty during the Caliphate." In *Proceedings of the Pakistan History Conference, 3rd Session, Dacca*, pp. 67–75.

Siddiqui, Iqtidar Husain. 1992a. *Perso-Arabic Sources of Information on the Life and Conditions in the Sultanate of Delhi*. New Delhi: Munshiram Manoharlal.

———. 1992b. "Social Mobility in the Delhi Sultanate." In *Medieval India 1: Researches in the History of India, 1200–1750*, pp. 22–48. Delhi: Oxford University Press.

Sims, Eleanor. 2002. *Peerless Images: Persian Painting and Its Sources*. New Haven: Yale University Press.

Singh, Harihar. 1975. "The Jaina Temples of Kumbhāriā." In U. P. Shah and M. A. Dhaky, eds., *Aspects of Jaina Art and Architecture*, pp. 299–318. Ahmedabad: Shantilal Harjiva Shah.

———. 2001. "The Jaina Temples of Kumbhāriā." *Encyclopaedia of Jainism*, 12:3407–24.

Singh, P. N. 1988. "Coins Bearing the Names of Muhammad bin Sam and Prithviraja III: A Reappraisal." *Israel Numismatic Journal* 10:113–16.

Singhal, C. R. 1954. "Rare and Unique Gold Coins of the Early Muslim Rulers." *Journal of the Indian Numismatic Society* 16:123–29.

Sinha, Ajay J. 2000. *Imagining Architects: Creativity in the Religious Monuments of India*. Newark: University of Delaware Press.

Sinha, B. P. 1969. "Some Reflections on Indian Sculpture (Stone or Bronze) of Buddhist Deities Trampling Hindu Deities." In *Dr. Satkari Mookerji Felicitation Volume*, pp. 97–107. Varanasi: Chowkhamba Sanskrit Series Office.

Sircar, Dines Chandra. 1939. "Digvijaya of King Chandra of the Meharauli Pillar Inscription." *Journal of the Asiatic Society of Bengal, Letters* 5:407–15.

———. 1955. "A Coin of Muhammad bin Sām and Prithvirāja." *Journal of the Numismatic Society of India* 15/2: 229–35.

———. 1967. *Studies in the Society and Administration of Ancient and Medieval India*. Vol. 1: *Society*. Calcutta: Firma K. L. Mukppadhyay.

Skeat, Walter W. 1882. *A Concise Etymological Dictionary of the English Language*. Oxford: Clarendon Press.

Smith, Vincent A. 1897. "The Iron Pillar of Delhi (Mihraulí) and the Emperor Candra (Chandra)." *Journal of the Royal Asiatic Society*, 1–18.

———. 1908. "The History and Coinage of the Chandel (Chandella) Dynasty of Bundelkhand (Jejakabhukri) from 831 to 1203 A.D." *Indian Antiquary* 37:114–48.

———. 1909. "The Gurjaras of Rajputana and Kanauj." *Journal of the Royal Asiatic Society*, 273–81.

Snellgrove, David N., and Tadeusz Skorupski. 1977. *The Cultural Heritage of Ladakh*. 2 vols. Boulder: Prajña Press.

Sokoly, Jochen A. 1997. "Between Life and Death: The Funerary Context of Ṭirāz Textiles." *Islamische Textilkunst des Mittelalters: Aktuelle Probleme. Riggisberger Berichte* 5:71–78.

Somani, Ram Vallabh. 1981. *Prithviraj Chauhan and His Times*. Jaipur: Sharan Book Depot.

Soteriou, G. 1935. "Arabikai diakosmaiseis eis ta byzantina mnemeia tais hellados." *Byzantinisch-Neugriechische Jahrbücher* 11/3–4: 233–69.

Soucek, Priscilla p. 1992. "Ethnicity in the Islamic Figural Tradition: The Case of the 'Turk.'" *Tarīh* 2:73–103.

———. 1995. "Ethnic Depictions in Warqah ve Gulshah." In

9th International Congress of Turkish Art, 23–27 September 1991, pp. 223–33. Ankara.

———. 2000. "The Development of Calligraphy." In C. E. Bosworth and M. S. Asimov, eds., *History of Civilizations of Central Asia*, vol. 4, *The Age of Achievement, A.D. 750 to the End of the Fifteenth Century*, part 2: The Achievements, pp. 485–505. Paris: UNESCO.

Sourdel, Dominique. 1976. "Réflexions sur la diffusion de la madrasa en Orient du XIe au XIIIe siècle." *Revue des Études Islamiques* 44:165–84.

———. 2001. "Robes of Honor in 'Abbasid Baghdad during the Eighth to Eleventh Centuries." In Stewart Gordon, ed., *Robes and Honor: The Medieval World of Investiture*, pp. 137–46. New York: Palgrave.

Sourdel-Thomine, Janine. 1956. "Stèles Arabes de Bust (Afghanistan)." *Arabica* 3:285–306.

———. 1960. "L'Art Ġuride d'Aghanistan à propos d'un livre récent." *Arabica* 7:273–80.

———. 1981. "A propos du cenotaphe de Mahmud a Ghazna (Afghanistan)." In Abbas Daneshvari, ed., *Essays in Honor of Katharina Otto-Dorn*. Malibu: Undena Publications.

———. 2004. *Le Minaret Ghouride de Jām: Un chef d'oeuvre du XIIe siècle*. Mémoires de l'académie des inscriptions et belles-lettres, vol. 29. Paris: Diffusion de Boccard.

Spencer, George W. 1976. "The Politics of Plunder: The Cholas in Eleventh-Century Ceylon." *Journal of Asian Studies* 35/3: 405–19.

Spengler, William F. 1984. "Some New Numismatic Evidence Regarding Royal Nomenclature and Titulature in the Ghurid Period." In *Numismatics and History*, Indian Institute of Research in Numismatic Studies, Inaugural Seminar 8–10 January 1984, pp. 106–16. Maharashtra: P. O. Anjaneri.

Springberg-Hinsen, Monika. 2000. *Die Ḫilʿa: Studien zur Geschichte des geschenken Gewandes in islamischen Kulturkreis*. Würzburg: Ergon Verlag.

Spuler, Bertold. 1968. "Afghanistans Geschichte und Verwaltung in Früh-Islamischer Zeit." In Erwin Gräf, ed., *Festschrift Werner Caskel*, pp. 351–59. Leiden: E. J. Brill, 1968.

Srivastava, Ashirbadi Lal. 1965. "A Survey of India's Resistance to Medieval Invaders from the North-West—Causes of Eventual Hindu Defeat." In C. D. Chatterjee, ed., *Itihāsa-Chayanikā (Dr. Sampurnanand Felicitation Volume)*, pp. 21–40. Lucknow: UP Historical Society.

Srivastava, V. C. 1972. *Sun-Worship in Ancient India*. Allahabad: Indological Publications.

Stein, Burton. 1977. "Circulation and the Historical Geography of Tamil Country." *Journal of Asian Studies* 37/1: 7–26.

Stephens, Carr. 1876. *The Archaeology and Monuments of Delhi*. Simla and Calcutta.

Stern, S. M. 1949. "Ismaili Propaganda and Fatimid Rule in Sind." *Islamic Culture* 23:298–307.

———. 1955. "Heterodox Ismāʿīlism at the Time of al-Muʿizz." *Bulletin of the School of Oriental and African Studies* 17/1: 10–33.

———. 1967. "Rāmish of Sīrāf, a Merchant Millionaire of the Twelfth Century." *Journal of the Royal Asiatic Society*, 10–14.

Stewart, Peter. 1999. "The Destruction of Statues in Late Antiquity." In Richard Miles, ed., *Constructing Identities in Late Antiquity*, pp. 159–89. London and New York: Routledge.

Stewart, Rory. 2004. *The Places In Between*. London: Picador.

Stewart, Tony K. 2000. "Alternative Structures of Authority: Satya Pīr on the Frontiers of Bengal." In David Gilmartin and Bruce Lawrence, eds., *Beyond Turk and Hindu: Rethinking Religious Identity in Islamicate South Asia*, pp. 21–54. Gainesville: University Press of Florida.

———. 2001. "In Search of Equivalence: Conceiving Hindu-Muslim Encounter through Translation Theory." *History of Religions* 40/3: 260–87.

Stillman, N. A. 1986. "Khilʿa. The Caliphate." In *The Encyclopaedia of Islam*, new ed., 5:6–7. Leiden: E. J. Brill.

Stillman, Yedida Kalfon. 1986. "Libās. 1. In the Central and Eastern Islamic Lands." In *The Encyclopaedia of Islam*, new ed., 5:732–47. Leiden: E. J. Brill.

———. 1995. "Costume as Cultural Statement: The Esthetics, Economics, and Politics of Islamic Dress." In Daniel Frank, ed., *The Jews of Medieval Islam: Community, Society and Identity*, pp. 127–35. Leiden: E. J. Brill.

———. 2000. *Arab Dress: A Short History from the Dawn of Islam to Modern Times*. Leiden: E. J. Brill.

Stillman, Yedida K., and Paula Sanders. 2000. "Ṭirāz." In *The Encyclopaedia of Islam*, new ed., 10:534–38. Leiden: E. J. Brill.

Stone, Gregory B. 1996. "Review Article: The Age of Others." *Medieval Encounters* 2/3: 155–63.

Stuckert, Ruedi. 1980. "Die Grosse Moschee und das Mausoleum des Ghiyāt ud-Dīn in Herat." *Afghanistan Journal* 7/1: 3–5.

Stuszkiewicz, Eugeniusz. 1951–52. "Indo-AryaREEn Turuṣka (Tourouchka)." *Rocznik Orientalistyczny* 17:295–305.

Subrahmanyam, Sanjay. 1996. "Before the Leviathan: Sectarian Violence and the State in Pre-colonial India." In Kaushik Basu and Sanjay Subrahmanyam, eds., *Unravelling the Nation—Sectarian Conflict and India's Secular Identity*, pp. 44–80. New Delhi: Penguin Books.

———. 1997. "Connected Histories: Notes toward a Recon-

figuration of Early Modern Eurasia." *Modern Asian Studies* 31/3: 735–62.

Sundermann, W. 1993. "An Early Attestation of the Name of the Tajiks." In Wojciech Skalmowski and Aloiss van Tangerloo, eds., *MedioIranica: Proceedings of the International Colloquium Organized by the Katholieke Universiteit Leuven from the 21st to the 23rd of May, 1990*, pp. 163–71. Leuven: Peeters.

Tabbaa, Yasser. 1997. *Constructions of Power and Piety in Medieval Aleppo*. University Park: Pennsylvania State University Press.

———. 2001. *The Transformation of Islamic Art during the Sunni Revival*. Seattle and London: University of Washington Press.

Talbot, Cynthia. 1995. "Inscribing the Other, Inscribing the Self: Hindu-Muslim Identities in Pre-colonial India." *Comparative Studies in Society and History* 37/4: 692–722.

———. 2000. "The Story of Prataparudra: Hindu Historiography on the Deccan Frontier." In David Gilmartin and Bruce Lawrence, eds., *Beyond Turk and Hindu: Rethinking Religious Identity in Islamicate South Asia*, pp. 282–99. Gainesville: University Press of Florida.

———. 2001. *Precolonial India in Practice: Society, Region and Identity in Medieval Andhra*. Oxford: Oxford University Press.

Tartakov Gary Michael Tartakov and Vidya Dehejia. 1984. "Sharing, Intrusion, and Influence: The Mahisasuramardini Imagery of the Calukyas and Pallavas." *Artibus Asiae* 45/4: 287–345.

Tassey, Garcin de. 1860. "Descriptions des monuments de Delhi en 1852 d'après le texte Hindustani de Saïyid Ahmad Khan." *Journal Asiatique* 5th series 15–16 (August–September): 238–50.

Terry, John. 1955. *The Charm of Indo-Islamic Architecture: An Introduction to the Northern Phase*. London: A. Tiranti.

Thapar, Romila. 1971. "The Image of the Barbarian in Early India." *Comparative Studies in Society and History* 13/4: 408–36.

——— 1989. "Imagined Religious Communities? Ancient History and the Modern Search for a Hindu Identity." *Modern Asian Studies* 23/2: 209–31.

———. 1994. *Cultural Transaction and Early India: Tradition and Patronage*. Delhi: Oxford University Press.

———. 2001. *Somanatha: The Many Voices of a History*. Delhi: Penguin, Viking.

Thomas, David, Giannino Pastori, and Ivan Cucco. 2004. "Excavations at Jam, Afghanistan." *East and West* 54:87–120.

Thomas, Edward. 1848a. "On the Coins of the Dynasties of the Hindú Kings of Kábul." *Journal of the Royal Asiatic Society* 9:177–98.

———. 1848b. "On the Coins of the Kings of Ghazni." *Journal of the Royal Asiatic Society*, 275–76.

———. 1882. "Coins of the Arabs of Sind." *Indian Antiquary* 11:88–95.

———. 1967 [1871]. *The Chronicles of the Pathan Kings of Delhi*. Delhi: Munshiram Manoharlal.

Tod, James. 1829–32. *Annals and Antiquities of Rajast'han, or the Central and Western Rajpoot States of India*. 2 vols. London: Smith, Elder & Co.

Tolan, John V. 1999. "Muslims as Pagans and Idolaters in Chronicles of the First Crusade." In David R. Blanks and Michael Frassetto, eds., *Western Views of Islam in Medieval and Early Modern Europe: Perception of the Other*, pp. 97–117. New York: St. Martin's Press.

Topsfield, Andrew. 1984. *An Introduction to Indian Court Painting*. London: Her Majesty's Stationery Office.

Török, Gyöngyi. 1992. "Bilderstürme durch die Türken in Ungarn." In Sergiusz Michalski, ed., *L'Art et les révolutions*, section 4: *Les iconoclasmes*, Actes du XXVIIe congrès international d'histoire de l'art, Strasbourg, 1–7 septembre 1989, pp. 261–74. Strasbourg: Société alsacienne pour le dévelopment de l'histoire de l'art.

Trautmann, Thomas R. 1997. *Aryans and British India*. Berkeley: University of California Press.

Trautmann, Thomas R., and Carla M. Sinopoli. 2002. "In the Beginning Was the Word: Excavating the Relations between History and Archaeology in South Asia." *Journal of the Economic and Social History of the Orient* 45/4: 492–522.

Treadwell, Luke. 2000. "The 'Orans' Drachm of Bishr ibn Marwan and the Figural Coinage of the Early Marwands." In Jeremy Johns, ed., *Bayt al-Maqdis*, part 2: *Jerusalem and Early Islam*, Oxford Studies in Islamic Art, 9, part 2, pp. 223–270. Oxford: Oxford University Press.

Tripathi, Rama Shankar. 1989. *History of Kanauj to the Moslem Conquest*. Delhi: Motilal Banarsidass.

Tritton, A. S. 1970. *The Caliphs and Their Non-Muslim Subjects: A Critical Study of the Covenant of 'Umar*. London: Frank Cass & Co.

Trombley, Frank R. 2004. "The Arabs in Anatolia and the Islamic Law of War (*fiqh al-jihād*), Seventh–Tenth Centuries." *Al-Masāq* 16/1: 147–61.

Tronzo, William. 1993. "The Medieval Object-Enigma and the Problem of the Capella Palatina in Palermo." *Word and Image* 9/3: 197–228.

Tucci, Giuseppe. 1963. "Oriental Notes II: An Image of a Devi Discovered in Swat and Some Connected Problems." *East and West* n. s. 14:146–82.

———. 1973. *Transhimalaya*. London: Barrie and Jenkins.

Tye, Robert. 1988. "Headhunting in Medieval Punjab?" *Oriental Numismatic Society Newsletter* 114 (September–October): 6–8.

———. 1996. "Dammas, Daniqs and 'Abd al-Malik." *Oriental Numismatic Society Newsletter* 148 (Spring): 6–10.

Tye, Robert, and Monica Tye. 1995. *Jitals: A Catalogue and Account of the Coin Denomination of Daily Use in Medieval Afghanistan and North West India.* Isle of South Uist.

Udovitch, Abraham L. 2000. "Fatimid Cairo: Crossroads of World Trade—From Spain to India." In Marianne Barrucand, ed., *L'Égypte Fatimide son art et son histoire, Actes du colloque organisé à Paris, les 28, 29 et 30 mai 1998,* pp. 681–91. Paris: Presses de l'Université de France.

van Ess, Josef. 1980. *Ungenützte Texte zur Karrāmīya.* Heidelberg: C. Winter Universitätverlag.

———. 1992. "'Abd al-Malik and the Dome of the Rock: An Analysis of Some Texts." In J. Raby and J. Johns, eds., *Bayt Al-Maqdis: 'Abd al-Malik's Jerusalem,* part 1, pp. 89–104. Oxford: Oxford University Press.

———. 2000. "Tashbīh wa-Tanzīh." In *The Encyclopaedia of Islam,* new ed., 10:341–44.

Veer, Peter van der. 1994a. *Religious Nationalism: Hindus and Muslims in India.* Berkeley: UCLA Press.

Vohra, Rohit. 1995. "Arabic Inscriptions of the Late First Millenium AD from Tangtse in Ladakh." In Henry Osmaston and Philip Denwood, eds., *Recent Research on Ladakh,* pp. 419–29. London: School of Oriental and African Studies.

Voll, John Obert. 1994. "Islam as a Special World-System." *Journal of World History* 5/2: 213–26.

von Grunebaum, G. E. 1970. "The Sources of Islamic Civilisation." *Der Islam* 46:1–54.

von Hinüber, Oskar. 2004. *Die Palola Ṣāhis ihre Steinschriften, inschriften auf Bronzen, Handschriften Kolophone und Scutzzauber: materialen zur Geschichte von Gilgit und Chilas.* Mainz: Verlag Philipp von Zabern.

von Schroeder, Ulrich. 1981. *Indo-Tibetan Bronzes.* Hong Kong: Visual Dharma Publications.

von Sivers, Peter. 1982. "Taxes and Trade in the 'Abbāsid Thughūr, 750–962/133–351." *Journal of the Economic and Social History of the Orient* 25/1: 71–99.

Vost, W. 1909. "Governors of Sind." *Journal of the Asiatic Society of Bengal, Calcutta* 5:308–90.

Vryonis, Speros, Jr. 1971. *The Decline of Medieval Hellenism in Asia Minor and the Process of Islamization from the Eleventh through the Fifteenth Century.* Berkeley: University of California Press.

Waardenburg, Jacques. 2004. "Muslim Studies of Other Religions: The Medieval Period." In Robert Hoyland, ed., *Muslims and Others in Early Islamic Society,* pp. 211–39. Aldershot: Ashgate.

Wade, Bonnie C. 1998. *Imaging Sound: An Ethnomusicological Study of Music, Art, and Culture in Mughal India.* Chicago: University of Chicago Press.

Wagoner, Phillip B. 1996a. "'Iqṭā' and Nāyaṃkara: Military Service Tenures and Political Theory from Saljuq Iran to Vijayanagara South India." Paper presented at the Twenty-fifth Annual Conference on South Asia, Madison, Wisconsin, 18–20 October.

———. 1996b. "'Sultan among Hindu Kings': Dress, Titles, and the Islamicisation of Hindu Culture at Vijayanagara." *Journal of Asian Studies* 55/4: 851–80.

———. 1999. "Fortuitous Convergences and Essential Ambiguities: Transcultural Political Elites in the Medieval Deccan." *International Journal of Hindu Studies* 3/3: 241–64.

———. 2003. "Precolonial Intellectuals and the Production of Colonial Knowledge." *Comparative Studies in Society and History* 45/4: 783–814.

Wagoner, Phillip B., and John Henry Rice. 2001. "From Delhi to the Deccan: Newly Discovered Tughluq Monuments at Warangal-Sulṭānpūr and the Beginnings of Indo-Islamic Architecture in Southern India." *Artibus Asiae* 31/1: 77–117.

Waida, Manabu. 1978. "Birds in the Mythology of Sacred Kingship." *East and West* n.s. 28:283–89.

Walker, John. 1946. "Islamic Coins with Hindu Types." *Journal of the Numismatic Society of India* 6th series 6:121–28.

Walker, Paul E. 2003. "Purloined Symbols of the Past: The Theft of Souvenirs and Sacred Relics in the Rivalry between the 'Abbasids and the Fatimids." In Farhad Daftary and Josef W. Meri, eds., *Culture and Memory in Medieval Islam: Essays in Honour of Wilferd Madelung,* pp. 365–89. London: I. B. Tauris.

Walsh, Declan. 2004. "Freed Hostage Tells of Afghan Ordeal." *Guardian,* November 25.

Wandel, Lee Palmer. 1994. *Voracious Idols and Violent Hands: Iconoclasm in Reformation Zurich, Strasbourg, and Basel.* Cambridge: Cambridge University Press.

Ward, Rachel. 1993. *Islamic Metalwork.* London. British Museum Press.

Wasserstein, David. 1993. "Coins as Agents of Cultural Definition in Islam." *Poetics Today* 14/2: 303–22.

Watson, Andrew M. 1967. "Back to Gold and Silver." *Economic History Review* 20/1: 1–34.

———. 1983. *Agricultural Innovation in the Early Islamic World (the Diffusion of Crops and Farming Techniques, 700–1100).* Cambridge: Cambridge University Press.

Watson, Oliver. 1985. *Persian Lustre Ware.* London: Faber & Faber.

———. 2004. *Ceramics from Islamic Lands.* London: Thames and Hudson.

Weekley, Ernest. 1967. *An Etymological Dictionary of Modern English.* 2 vols. New York: Dover Publications.

Weichao, Yu. 1997. *A Journey into China's Antiquity: National Museum of Chinese History.* 4 vols. Beijing: Morning Glory Publishers.

Weiner, Tim. 2001. "Seizing the Prophet's Mantle: Muhammad Omar." *New York Times*, December 7th.

Weir, T. H. [Zysow, A.]. 1995. "Ṣadaka." In *The Encyclopaedia of Islam*, 18:708–16. Leiden: E. J. Brill.

Welch, Anthony. 1983. "Qur'an and Tomb: The Religious Epigraphs of Two Early Sultanate Tombs in Delhi." In Frederick M. Asher and G. S. Gai, eds., *Indian Epigraphy: Its Bearing on the History of Art*, pp. 257–67. New Delhi: Oxford University Press and IBH Publishing Co.

———. 1993. "Architectural Patronage and the Past: The Tughluq Sultans of Delhi." *Muqarnas* 10:311–22.

Welch, Anthony, and Howard Crane. 1983. "The Tughluqs: Master Builders of the Delhi Sultanate." *Muqarnas* 1:123–66.

Welch, Anthony, Hussein Keshani, and Alexandra Bain. 2002. "Epigraphs, Scripture, and Architecture in the Early Delhi Sultanate." *Muqarnas* 19:12–43.

Welch, Stuart Cary. 1985. *India: Art and Culture, 1300–1900*. New York: Holt, Rhinehart, and Winston.

Wendell, Charles. 1971. "*Baghdād: Imago Mundi*, and Other Foundation-Lore." *International Journal of Middle Eastern Studies* 2:99–128.

Wensinck, A. J. 1927. *A Handbook of Early Muhammedan Tradition*. Leiden: E. J. Brill.

Wensinck, A. J. [Johnstone, Penelope]. 1991. "Maryam." In *The Encyclopaedia of Islam*, new ed., 6:628–32.

Whelan, Estelle J. 1980. "Contribution to Dānishmendid History: The Figured Copper Coins." *Numismatic Society Museum, Notes* 25:133–66.

———. 2006. *The Public Figure: Political Iconography in Medieval Mesopotamia*. London: Melisende.

White, Richard. 1991. *The Middle Ground: Indians, Empires and Republics in the Great Lakes Region, 1650–1815*. Cambridge: Cambridge University Press.

Whitehouse, David. 1980. Siraf III: *The Congregational Mosque and Other Mosques from the Ninth to the Twelfth Centuries*. London: British Institute of Persian Studies.

Widengren, Geo. 1968. "Le symbolisme de la ceinture." *Iranica Antiqua* 8:133–55.

Willetts, William. 1960. "Excavations at Bhambore near Karachi, Possible Site of the Medieval Seaport of Debal in Sind." *Oriental Art* 6/1: 25–28.

Williams, Joanna. 1973. "A Recut Aśokan Capital and the Gupta Attitude Towards the Past." *Artibus Asiae* 35:225–40.

Willis, Michael D. 1985. "An Eighth Century Miḥrāb in Gwalior." *Artibus Asiae* 46/3: 227–46.

———. 1993. "Religious and Royal Patronage in North India." In Vishaka N. Desai and Darielle Mason, eds., *Gods, Guardians, and Lovers: Temple Sculptures from North India, A.D. 700–1200*, pp. 49–65. New York: Asia Society.

———. 1997. *Temples of Gopakṣetra*. London: British Museum Press.

———. 1999. Review of Cynthia Packert Atherton, *The Sculpture of Early Medieval Rajasthan*. *South Asian Studies* 15: 175–77.

Wilson, H. H. and Charles Masson. 1846. *Ariana Antiqua: A Descriptive Account of the Antiquities and Coins of Afghanistan*. London: East India Co.

Wink, André. 1984. "Sovereignty and Universal Dominion in South Asia." *Indian Economic and Social History Review* 21/3: 265–302.

———. 1992a. "India and Central Asia: The Coming of the Turks in the Eleventh Century." In A. W. van den Hoek, D. H. A. Kolff, and M. S. Oort, *Ritual, State and History in South Asia in Honour of J. C. Heesterman*, pp. 747–73. Leiden. E. J. Brill.

———. 1992b. "Kanauj as the Religious and Political Capital of Early Medieval India." In Hans Bakker, ed., *The Sacred Centre as the Focus of Political Interest*, pp. 101–17. Groningen: Egbert Forster.

———. 1996. *Al-Hind: The Making of the Indo-Islamic World*. Vol. 1: *Early Medieval India and the Expansion of Islam, 7th–11th Centuries*. New Delhi: Oxford University Press.

———. 1997. *Al Hind, the Making of the Indo-Islamic World*. Vol. 2: *The Slave Kings and the Islamic Conquest, 11th–13th Centuries*. New Delhi: Oxford University Press.

Wolper, Ethel Sara. 2003. *Cities and Saints: Sufism and the Transformation of Urban Space in Medieval Anatolia*. University Park: Pennsylvania State University Press.

Wright, H. Nelson. 1936. *The Coinage and Metrology of the Sulṭāns of Delhi*. Delhi: Manager of Publications.

Wrigley, Richard. 1993. "Breaking the Code: Interpreting French Revolutionary Iconoclasm." In Alison, Yarrington and Kelvin Everest, eds., *Reflections of Revolution, Images of Romanticism*, pp. 182–95. New York and London: Routledge.

Yule, Henry, and A. C. Burnell. 1968 [1903]. *Hobson-Jobson, a Glossary of Colloquial Anglo-Indian Words and Phrases, and of Kindred Terms, Etymological, Historical, Geographical and Discursive*. Delhi: Munshiram Manoharlal.

Yusuf, S. M. 1955. "The Early Contacts between Islam and Buddhism." *University of Ceylon Review* 13/1: 1–28.

Zambaur, E. de. 1927. *Manuel de geneologie et de chronologie pour l'histoire de l'Islam*. Hanover: Librairie Orientalisten Heinz Lafaire.

Zand, Mikhail. 1967. "Some Light on Bilingualism in the Literature of Transoxiana, Khurasan and Western Iran in the 10th Century AD." In *Yādnāme-ye Jan Rypka, Collection of Articles on Persian and Tajik Literature*, pp. 161–64. Prague: Academia Publishing House.

Zebrowski, Mark. 1997. *Gold, Silver and Bronze from Mughal India*. London: Alexandria Press.

Zeitler, Barbara. 1996. "'Urbs Felix Dotata Populo Trilingui': Some Thoughts about a Twelfth-Century Funerary Memorial from Palermo." *Medieval Encounters* 2/2: 114–139.

Zelliot, Eleanor. 1982. "A Medieval Encounter between Hindu and Muslim: Eknath's Drama-Poem *Hindu-Turk Saṃvād*." In Fred R. Clothey, ed., *Images of Man: Religious and Historical Process in South Asia*, pp. 171–95. Madras: New Era Publishing.

Zimmer, Heinrich. 1962. *Myths and Symbols in Indian Art and Civilization*. New York: Harper Torch.

Zorach, Rebecca. 2005. *Blood, Milk, Ink, Gold: Abundance and Excess in the French* Renaissance. Chicago and London: University of Chicago Press.

Zysow, Aron. 1988. "Two Unrecognized Karrāmī Texts." *Journal of the American Oriental Society* 108/4: 577–87.

———. 2002. "Zakāt." In *The Encyclopaedia of Islam*, 11: 406–22. Leiden: E. J. Brill.

CONCEPTUAL AND THEORETICAL

Ahmad, Aijaz. 1991. "Between Orientalism and Historicism: Anthropological Knowledge of India." *Studies in History* 7:135–63.

Appadurai, Arjun. 1986. "Introduction: Commodities and the Politics of Value." In idem, ed., *The Social Life of Things: Commodities in Cultural Perspective*, pp. 3–63. Cambridge: Cambridge University Press.

———. 1988. "Putting Hierarchy in Its Place." *Cultural Anthropology* 3/1: 36–47.

Armitage, David. 2004. "Is There a Pre-history of Globalization?" In Deborah Cohen and Maura O'Connor, eds., *Comparison and History: Europe in Cross-national Perspective*, pp. 165–76. New York and London: Routledge.

Asad, Talal. 1986. "The Concept of Cultural Translation in British Social Anthropology." In James Clifford and George E. Marcus, eds., *Writing Culture: The Poetics and Politics of Ethnography*, pp. 141–64. Berkeley: University of California Press.

Ashley, Kathleen, and Véronique Plesch. 2002. "The Cultural Processes of 'Appropriation.'" *Journal of Medieval and Early Modern Studies* 32/1: 1–16.

Assmann, Jan. 1995. "Collective Memory and Cultural Identity." *New German Critique* 65:125–33.

———. 1996. "Translating Gods: Religion as a Factor of Cultural (Un)translatability." In Sanford Budick and Wolfgang Iser, eds., *The Translatability of Cultures: Figurations of the Space Between*, pp. 25–36. Stanford: Stanford University Press.

Auer, Peter. 1995. "The Pragmatics of Code-Switching: A Sequential Approach." In Lesley Milroy and Pieter Muysken, eds., *One Speaker, Two Languages: Cross-disciplinary Perspectives on Code-Switching*, pp. 115–35. Cambridge: Cambridge University Press.

———. 1998. *Code-Switching in Conversation, Language, Interaction and Identity*. New York: Routledge.

Bakhtin, M. M. 2004. *The Dialogic Imagination*. Ed. Michael Holquist, trans. Coryl Emerson and Michael Holquist. Austin: University of Texas Press.

Ballinger, Pamela. 2004. "'Authentic Hybrids' in the Balkan Borderlands." *Current Anthropology* 45/1: 31–49.

Bann, Stephen. 1995. "Shrines, Curiosities, and the Rhetoric of Display." In Lynne Cooke and Peter Wollen, eds., *Visual Display: Culture beyond Appearances*, Dia Center for the Arts Discussions in Contemporary Culture no. 10, pp. 15–29. Seattle: Bay Press.

Barthes, Roland. 1972. *Mythologies*. Trans. Annette Lavers. New York: Hill and Wang.

Basnett, Susan. 1998. "The Translation Turn in Cultural Studies." In Susan Basnett and André Lefevere, eds., *Constructing Cultures: Essays on Literary Translation*, pp. 123–40. Clevedon: Multilingual Matters.

Basnett-McGuire, Susan. 1991. *Translation Studies*. New York and London: Routledge.

Bataille, Georges. 1988. *The Accursed Share, an Essay on General Economy*. Vol. 1: *Consumption*. Trans. Robert Hurley. New York: Zone Books.

Ben-Amos, Paula. 1977. "Pidgin Languages and Tourist Arts." *Studies in the Anthropology of Visual Communication* 4/2: 128–39.

Benjamin, Walter. 1978. *Reflections: Essays, Aphorisms, Autobiographical Writings*. Trans. Edmund Jephcott. New York: Harcourt, Brace, Jovanovich.

———. 1992. *Illuminations*. Trans. Harry Zohn. London: Fontana Press.

Bhabha, Homi K. 1990. "The Third Space." In Jonathan Rutherford, ed., *Identity: Community, Culture, Difference*, pp. 207–21. London: Lawrence & Wishart.

———. 1993. "Beyond the Pale: Art in the Age of Multicultural Translation." In Ria Lavrijsen, ed., *Cultural Diversity in the Arts: Art, Art Policies, and the Facelift of Europe*, pp. 21–30. Amsterdam: Royal Tropical Institute.

———. 1994. *The Location of Culture*. London and New York: Routledge.

———. 1996. "Culture's In-Between." In Stuart Hall and Paul du Gay, eds., *Questions of Cultural Identity*, pp. 53–60. London: Sage.

Biddick, Kathleen. 1996. "Paper Jews: Inscription/Ethnicity/Ethnography." *Art Bulletin* 78/4: 594–99.

Boer, Inge E. 1994. "This Is Not the Orient: Theory and Postcolonial Practices." In Mieke Bal and Inge E. Boer, eds.,

The Point of Theory: Practices of Cultural Analysis, pp. 211–19. New York: Continuum.

———. 2002. "Just a Fashion? Cultural Cross-dressing and the Dynamics of Cross-cultural Representations." *Fashion Theory* 6/4: 421–40.

Bourdieu, Pierre. 1991. *Language and Symbolic Power*. Cambridge, Mass.: Harvard University Press.

———. 1997. "Marginalia: Some Additional Notes on the Gift." In A. D. Schrift, ed., *The Logic of the Gift: Toward an Ethic of Generosity*, pp. 231–41. New York: Routledge.

———. 1998. *Outline of a Theory of Practice*. Trans. Richard Nice. Cambridge: Cambridge University Press.

Brennan, Timothy. 2001a. "Cosmopolitanism and Internationalism." *New Left Review* 7:75–84.

———. 2001b. "Cosmo-Theory." *South Atlantic Quarterly* 100/3: 659–91.

Brown, Bill. 1998. "How to Do Things with Things (a Toy Story)." *Critical Inquiry* 24:935–64.

———. 2001. "Thing Theory." *Critical Inquiry* 28/4: 1–22.

Buruma, Ian. 2007. "Tariq Ramadan Has an Identity Issue." *New York Times*, February 4.

Camille, Michael. 1996. "Prophets, Canons and Promising Monsters." *Art Bulletin* 78/2: 198–201.

Campbell, Stephen J., and Stephen J. Milner. 2004. "Art, Identity, and Cultural Translation in Renaissance Italy." In Stephen J. Campbell and Stephen J. Milner, eds., *Artistic Exchange and Cultural Translation in the Italian Renaissance City*, pp. 1–13. Cambridge: Cambridge University Press.

Carbonell, Ovidio. 1996. "The Exotic Space of Cultural Translation." In Román Álvarez and M. Carmen-África Vidal, eds., *Translation, Power, Subversion*, pp. 79–98. Clevedon: Multilingual Matters.

Caws, Mary Ann. 1988. *The Art of Interference: Stressed Readings in Visual and Verbal Texts*. Princeton: Princeton University Press.

Certeau, Michel de. 1988. *The Writing of History*. Trans. Tom Conley. New York: Columbia University Press.

Choay, Françoise. 2001. *The Invention of the Historic Monument*. Cambridge: Cambridge University Press.

Clifford, James. 1988. *The Predicament of Culture: Twentieth-Century Ethnography, Literature, and Art*. Cambridge, Mass.: Harvard University Press.

———. 1997. *Routes: Travel and Translation in the Late Twentieth Century*. Cambridge, Mass.: Harvard University Press.

Comaroff, John, and Jean Comaroff. 1992. *Ethnography and the Historical Imagination*. Boulder, San Francisco, and Oxford: Westview Press.

Connerton, Paul. 1994. *How Societies Remember*. Cambridge: Cambridge University Press.

Coombes, Annie E., and Avtar Brah. 2000. "Introduction: The Conundrum of 'Mixing.'" In idem, eds., *Hybridity and Its Discontents: Politics, Science, Culture*, pp. 1–16. London and New York: Routledge.

Crossley, Paul, and Georgia Clarke. 2000. "Introduction." In idem, eds., *Architecture and Language: Constructing Identity in European Architecture c. 1000–c. 1650*, pp. 1–20. Cambridge: Cambridge University Press.

Crow, Thomas. 1999. *The Intelligence of Art*. Chapel Hill: University of North Carolina Press.

DaCosta Kaufmann, Thomas. 2004. *Toward a Geography of Art*. Chicago: University of Chicago Press.

Daftari, Fereshteh. 2006. *Without Boundary: Seventeen Ways of Looking*. New York: Museum of Modern Art.

Dallmayr, Fred. 1996. *Beyond Orientalism: Essays on Cross-cultural Encounter*. Albany: SUNY Press.

Dean, Carolyn, and Dana Leibsohn. 2003. "Hybridity and Its Discontents: Considering Visual Culture in Colonial Spanish America." *Colonial Latin American Review* 12/1: 5–35.

Derrida, Jacques. 1978. *Writing and Difference*. Trans. Alan Bass. Chicago: University of Chicago Press.

———. 1981. *Positions*. Trans. Alan Bass. London and New York: Continuum.

———. 1992. *Given Time: I, Counterfeit Money*. Trans. Peggy Kamuf. Chicago: University of Chicago Press.

Desai, Gaurav. 2004. "Old World Orders: Amitav Ghosh and the Writing of Nostalgia." *Representations* 85:125–48.

Dharwadker, Vinay. 1999. "A. K. Ramanujan's Theory and Practice of Translation." In Susan Basnett and Harish Trivedi, eds., *Post-colonial Translation, Theory and Practice*, pp. 114–40. New York: Routledge.

Dirks, Nicholas B. 1996a. "Is Vice Versa? Historical Anthropologies and Anthropological Histories." In T. McDonald, ed., *The Historic Turn in the Human Sciences*, pp. 17–51. Ann Arbor: University of Michigan Press.

———. 1996b. "Reading Culture: Anthropology and the Textualization of India." In E. Valentine Daniel and Jeffrey M. Peck, eds., *Culture/Contexture: Explorations in Anthropology and Literary Studies*, pp. 275–95. Berkeley: University of California Press.

Douglas, Mary. 1966. *Purity and Danger*. London: Routledge.

Elias, Norbert. 1994. *The Civilizing Process: The History of Manners & State Formation and Civilization*. Trans. Edmund Jephcott. Oxford and Cambridge, Mass.: Blackwell.

Evans, Ruth. 1994. "Translating Past Cultures?" In Roger Ellis and Ruth Evans, eds., *The Medieval Translator*, 4:20–45. Binghamton: State University of New York.

Ferguson, Harvie. 2000. *Modernity and Subjectivity: Body, Soul, Spirit*. Charlottesville and London: University Press of Virginia.

Ferguson, Yale H., and Richard W. Mansbach. 1996. *Polities: Authorities, Identities, and Change.* Columbia: University of South Carolina Press.

Foster, Hal. 1985. "The 'Primitive' Unconscious of Modern Art." *October* 34:45–70.

Foucault, Michel. 1986. "Of Other Spaces." *Diacritics* 16:22–27.

Freedberg, David. 1998. "The Limits of Translation." *Res* 34:71–74.

Gadamer, Hans-Georg. 1995. *Truth and Method.* New York: Continuum.

Gardner-Chloros, Penelope. 1995. "Code-Switching in Community, Regional and National Repertoires: The Myth of the Discreteness of Linguistic Systems." In Lesley Milroy and Pieter Muysken, eds., *One Speaker, Two Languages: Cross-disciplinary Perspectives on Code-Switching*, pp. 68–89. Cambridge: Cambridge University Press.

Garton-Ash, Timothy. 2006. "Our Media Must Give Muslims the Chance to Debate with Each Other." *Guardian*, February 9.

Geertz, Clifford. 1973. *The Interpretation of Cultures.* New York: Basic Books.

Gell, Alfred. 1995. "The Technology of Enchantment and the Enchantment of Technology." In Jeremy Coote and Anthony Shelton, eds., *Anthropology and Aesthetics*, pp. 40–63. Oxford: Clarendon Press.

———. 1998. *Art and Agency: An Anthropological Theory.* Oxford: Clarendon Press.

Gentzler, Edwin. 2001. *Contemporary Translation Theory.* 2nd rev. ed. Clevedon: Multilingual Matters.

Glissant, Edouard. 1999. "Métissage et Créolisation." In Sylvie Kandé, ed., *Discours sur le métissage: identités métisses: En quête d'Ariel*, pp. 47–53. Montreal and Paris: L'Harmattan.

Goux, Jean-Joseph. 1990. *Symbolic Economies: After Marx and Freud.* Ithaca: Cornell University Press.

Grazia, Margreta de, Maureen Qulligan, and Peter Stallybrass. 1996. "Introduction." In Margreta de Grazia, Maureen Qulligan, and Peter Stallybrass, eds., *Subject and Object in Renaissance Culture*, pp. 1–13. Cambridge: Cambridge University Press.

Greenblatt, Stephen. 1980. *Renaissance Self-fashioning from More to Shakespeare.* Chicago: University of Chicago Press.

———. 1991. "Resonance and Wonder." In Ivan Karp and Steven D. Lavine, eds., *Exhibiting Cultures: The Poetics and Politics of Museum Display*, pp. 42–56. London and Washington, D.C.: Smithsonian Institution Press.

Grondin, Jean. 1994. *Introduction to Philosophical Hermeneutics.* Trans. Joel Weinsheimer. New Haven and London: Yale University Press.

Grosjean, François. 1995. "A Psycholinguistic Approach to Code-Switching: The Recognition of Guest Words by Bilinguals." In Lesley Milroy and Pieter Muysken, eds., *One Speaker, Two Languages: Cross-disciplinary Perspectives on Code-Switching*, pp. 259–75. Cambridge: Cambridge University Press.

Gruzinski, Serge. 2002. *The Mestizo Mind: The Intellectual Dynamics of Colonization and Globalization.* Trans. Deke Dusinberre. New York: Routledge.

Gupta Akhil, and James Ferguson. 1992. "Beyond 'Culture': Space, Identity and the Politics of Difference." *Cultural Anthropology* 7/1: 6–23.

Hahn, Thomas. 1990. "The Premodern Text and the Postmodern Reader." *Exempleria* 2/1: 1–21.

Halbwachs, Maurice. 1992. *On Collective Memory.* Trans. Lewis A. Coser. Chicago and London: University of Chicago Press.

Hall, Stuart, and Sarat Maharaj. 2001. "Modernity and Difference: A Conversation." *Modernity and Difference, IV Annotations* 6:36–57.

Hannerz, Ulf. 1996. *Transnational Connections: Culture, People, Places.* Routledge: London and New York.

Hay, Jonathan. 1999. "Toward a Theory of the Intercultural." *Res* 35:5–9.

Heller, Monica. 1995. "Code-Switching and the Politics of Language." In Lesley Milroy and Pieter Muysken, eds., *One Speaker, Two Languages: Cross-disciplinary Perspectives on Code-Switching*, pp. 158–74. Cambridge: Cambridge University Press.

Helms, Mary, W. 1993. *Craft and the Kingly Ideal: Art, Trade, and Power.* Austin: University of Texas Press.

———. 1994. "Essay on Objects: Interpretations of Distance Made Tangible." In Stuart B. Schwartz, ed., *Implicit Understandings: Observing, Reporting, and Reflecting on the Encounters between Europeans and Other Peoples in the Early Modern Era*, pp. 355–77. Cambridge: Cambridge University Press.

Hocart, A. M. and Rodney Needham. 1970. *Kings and Councillors: An Essay in the Comparative Anatomy of Human Society.* Chicago: University of Chicago Press.

Howard, Deborah. 2000a. "Languages and Architecture in Scotland, 1500–1660." In Georgia Clarke and Paul Crossley, eds., *Architecture and Language: Constructing Identity in European Architecture, c. 1000–c. 1650*, pp. 162–72. Cambridge: Cambridge University Press.

Howell, Signe. 1989. "Of Persons and Things: Exchange and Valuables among the Lio of Eastern Indonesia." *Man* 24/3: 419–38.

Hunt, John Dixon. 1993. "The Sign of the Object." In Steven Lubar and W. David Kingery, eds., *History from Things: Essays on Material Culture*, pp. 293–98. Wash-

ington, D.C., and London: Smithsonian Institution Press.

Huntington, Samuel P. 2003. *The Clash of Civilizations and the Remaking of World Order*. New York and London: Simon & Schuster.

Ivir, Vladimir. 1987. "Procedures and Strategies for the Translation of Culture." *Indian Journal of Applied Linguistics* 13/2: 35–46.

Jakobson, Roman. 2000. "On Linguistic Aspects of Translation." In Lawrence Venuti, ed., *The Translation Studies Reader*, pp. 113–18. London and New York: Routledge.

Jones, Ann Rosalind, and Peter Stallybrass. 2001. *Renaissance Clothing and the Materials of Memory*. Cambridge and New York: Cambridge University Press.

Keane, Webb. 2001. "Money Is No Object: Materiality, Desire, and Modernity in an Indonesian Society." In Fred R. Myers, ed., *The Empire of Things: Regimes of Value and Material Culture*, pp. 65–90. Santa Fe: School of American Research Press.

———. 2005. "The Hazard of New Clothes: What Signs Make Possible." In Susanne Küchler and Graeme Were, eds., *The Art of Clothing: A Pacific Experience*, pp. 1–16. London: UCL Press.

Khubchandani, Lachman M. 2002. "Sources and Targets: Translation as a Cultural Filter." In Rukmini Bhaya Nair, ed., *Translation, Text and Theory: The Paradigm of India*, pp. 46–54. New Delhi: Sage Publications.

Kopytoff, Igor. 1986. "The Cultural Biography of Things: Commoditization as Process." In Arjun Appaduri, ed., *The Social Life of Things: Commodities in Cultural Perspective*, pp. 64–94. Cambridge: Cambridge University Press.

Kroeber, A. L. 1940. "Stimulus Diffusion." *American Anthropologist* n.s. 42/1: 1–20.

Kubler, George. 1967. "Style and the Representation of Historical Time." *Annals of the New York Academy of Sciences* 138:849–55.

Lacan, Jacques. 1977. *Écrits, a Selection*. New York: Norton.

Latour, Bruno. 1993. *We Have Never Been Modern*. Trans. Catherine Parker. Cambridge, Mass.: Harvard University Press

———. 1999. *Pandora's Hope: Essays on the Reality of Science Studies*. Cambridge, Mass.: Harvard University Press.

———. 2000. "The Berlin Key or How to Do Words with Things." In P. M. Graves-Brown, ed., *Matter, Materiality and Modern Culture*, pp. 10–21. London and New York: Routledge.

Lefebvre, Henri. 1981. *La production de l'espace*. Paris: Éditions anthropos.

———. 1991. *The Production of Space*. Trans. Donald Nicholson-Smith. Oxford: Blackwell.

Lefevere, André. 1999. "Composing the Other." In Susan Bas-

nett and Harish Trivedi, eds., *Post-colonial Translation, Theory and Practice*, pp. 75–79. New York: Routledge.

Le Goff, Jacques. 1992. *History and Memory*. Trans. Steven Rendall and Elizabeth Claman. New York: Columbia University Press.

Lévi-Strauss, Claude. 1966. *The Savage Mind (La pensée sauvage)*. London: Wiedenfeld and Nicolson.

Lewis, Philip E. 2000. "The Measure of Translation Effects." In Lawrence Venuti, ed., *The Translation Studies Reader*, pp. 264–83. London and New York: Routledge.

Lionnet, Françoise. 1989. "Introduction: The Politics and Aesthetics of Métissage." In idem, ed., *Autobiographical Voices: Race, Gender, Self-Portraiture*, pp. 1–29. Ithaca and London: Cornell University Press.

Liu, Lydia H. 1999. "The Question of Meaning-Value in the Political Economy of the Sign." In Lydia H. Liu, ed., *Tokens of Exchange: The Problem of Translation in Global Circulations*, pp. 1–12. Durham and London: Duke University Press.

Lugo, Alejandro. 1997. "Reflections on Border Theory, Culture, and the Nation." In Scott Michaelsen and David E. Johnson, eds., *Border Theory: The Limits of Cultural Politics*, pp. 43–67. Minneapolis: University of Minnesota Press.

Maharaj, Sarat. 2001. "Perfidious Translation: The Untranslatability of the Other." *Modernity and Difference*, Annotations 6:26–35.

Marshall, John C., and David M. Fryer. 1978. "Speak, Memory! An Introduction to Some Historic Studies of Remembering and Forgetting." In Michael M. Gruneberg and Peter E. Morris, eds., *Aspects of Memory*, pp. 1–25. London: Methuen.

Mauss, Marcel. 1973. "Techniques of the Body." *Economy and Society* 2:70–88.

———. 1990. *The Gift (the Form and Reason for Exchange in Archaic Societies)*. Trans. W. D. Halls. New York and London: W. W. Norton.

Mayaram, Shail. 1997. "Rethinking Meo Identity: Cultural Faultline, Syncretism, Hybridity or Liminality?" *Comparative Studies of South Asia, Africa, and the Middle East*, 17/2: 35–45.

McCracken, Grant. 1988. "Clothing as Language: An Object Lesson in the Study of the Expressive Properties of Material Culture." In idem, *Culture and Consumption: New Approaches to the Symbolic Character of Consumer Goods and Activities*, pp. 57–70. Bloomington and Indianapolis: Indiana University Press.

McMaster, Gerald R. 1995. "Border Zones: The 'Injun-uity' of Aesthetic Tricks" *Cultural Studies* 9/1: 74–90.

Merrill, William L. 1993. "Conversion and Colonialism in Northern Mexico: The Tarahumara Response to the Je-

suit Missionary Program, 1601–1767." In Robert W. Hefner, ed., *Conversion to Christianity: Historical and Anthropological Researches on a Great Transformation*, pp. 129–63. Berkeley: University of California Press.

Mignolo, Walter D., and Freya Schiwy. 2003. "Double Translation: Transculturation and the Colonial Difference." In Tullio Maranhão and Bernhard Streck, eds., *Translation and Ethnography: The Anthropological Challenge of Intercultural Understanding*, pp. 3–29. Tucson: University of Arizona Press.

Miller, Daniel. 1998. "Why Some Things Matter." In idem, ed., *Material Cultures: Why Some Things Matter*, pp. 3–21. Chicago: University of Chicago Press.

Mitchell, W.J.T. 2005. *What Do Pictures Want? The Lives and Loves of Images*. Chicago: University of Chicago Press.

Nelson, Robert S. 2003. "Appropriation." In Robert S. Nelson and Richard Shiff, eds., *Critical Terms for Art History*, 2nd ed., pp. 160–73. Chicago and London: University of Chicago Press.

Nida, Eugene. 2000. "Principles of Correspondence." In Lawrence Venuti, ed., *The Translation Studies Reader*, pp. 126–40. London and New York: Routledge.

Niranjana, Tejaswini. 1992. *Siting Translation: History, Poststructuralism and the Colonial Context*. Berkeley and Los Angeles: University of California Press.

Nora, Pierre. 1989. "Between Memory and History: Les Lieux de Mémoire." *Representations* 26:7–24.

Ong, Walter. 1986. *Orality and Literacy: The Technologization of the Word*. London and New York: Methuen.

Orenstein, Henry. 1980. "Asymmetrical Reciprocity: A Contribution to the Theory of Political Legitimacy." *Current Anthropology* 21/1: 69–91.

Ortiz, Fernando. 1995. *Cuban Counterpoint, Tobacco and Sugar*. Trans. Harriet de Onís. Durham: Duke University Press.

Pagden, Anthony. 1993. *European Encounters with the New World: From Renaissance to Romanticism*. New Haven: Yale University Press.

———. 1995. "The Effacement of Difference: Colonialism and the Origins of Nationalism in Diderot and Herder." In Gyan Prakash, ed., *After Colonialism: Imperial Histories and Postcolonial Displacements*, pp. 129–52. Princeton: Princeton University Press.

Pandey, Gyanendra. 1998. "The Culture of History." In Nicholas B. Dirks, ed., *In Near Ruins: Cultural Theory at the End of the Century*, pp. 275–93. Minneapolis: University of Minnesota Press.

Parry, Benita. 1994. "Signs of Our Times: Discussion of Homi Bhabha's *The Location of Culture*." *Third Text* 28–29:5–24.

Parry, Jonathan P. 1986. "The Gift, the Indian Gift and the 'Indian Gift.'" *Man* 21/3: 453–73.

———. 1998. "Mauss, Dumont, and the Distinction between Status and Power." In Wendy James and N. J. Allen, eds., *Marcel Mauss, a Centenary Tribute*, pp. 151–72. New York and Oxford: Berghahn Books.

Patterson, Lee. 1990. "On the Margin: Postmodernism, Ironic History, and Medieval Studies." *Speculum* 65/1: 87–108.

Pels, Peter. 1997. "The Spirit of Matter: On Fetish, Rarity, Fact, and Fancy." In Patricia Spyer, ed., *Border Fetishisms: Material Objects in Unstable Spaces*, pp. 91–120. New York: Routledge.

Phillips, Lawrence. 1998. "Lost in Space: Siting (Citing) the In-between of Homi Bhabha's *The Location of Culture*." *scrutiny* 2–3/1: 16–25.

Pinney, Christopher. 2006. "Four Types of Visual Culture." In Chris Tilley et al., *The Handbook of Material Culture*, pp. 131–44. London: Sage Publications.

Pipes, Daniel. 2004. "Muslim Europe." *New York Sun*, May 11, available at *www.danielpipes.org* as article 1796.

Poulot, Dominique. 1995. "Revolutionary 'Vandalism' and the Birth of the Museum: The Effects of a Representation of Modern Cultural Terror." In Susan Pearce, ed., *Art in Museums: New Research in Museum Studies* 5, pp. 192–214. London and Atlantic Highlands, N. J.: Athlone.

Prakash, Gyan. 1990. "Writing Post-orientalist Histories of the Third World: Perspectives from Indian Historiography." *Comparative Studies in Society and History* 32/2: 383–408.

———. 1992. "Science 'Gone Native' in Colonial India." *Representations* 40:153–78.

———. 1999. *Another Reason: Science and the Imagination of Modern India*. Princeton: Princeton University Press.

Pratt, Mary Louise. 1992. *Imperial Eyes: Travel Writing and Transculturation*. New York: Routledge.

Rampley, Matthew. 2005. "Art History and Cultural Difference: Alfred Gell's Anthropology of Art." *Art History* 28/4: 524–55.

Rampton, Ben. 1998. "Language Crossing and the Redefinition of Reality." In Peter Auer, ed., *Code-Switching in Conversation*, pp. 290–320. London: Routledge.

Roberts, Mary. 2005. "Cultural Crossings: Sartorial Adventures, Satiric Narratives, and the Question of Indigenous Agency in Nineteenth-Century Europe and the Near East." In Jocelyn Hackforth-Jones and Mary Roberts, ed., *Edges of Empire: Orientalism and Visual Culture*, pp. 70–94. Oxford: Blackwell Publishers.

Robinson, Douglas. 1997. *Translation and Empire: Postcolonial Theories Explained*. Manchester: St. Jerome Press.

Ross, Stephen David. 1990. "Translation as Transgression." In Dennis J. Schmidt, ed., *Hermeneutics and the Poetic Motion, Translation Perspectives*, 5:25–42. Binghamton: Center for Research in Translation.

Rykwert, J. 1998. "Translation and/or Representation." *Res* 34:65–70.

Said, Edward. 1989. "Representing the Colonized: Anthropology's Interlocutors." *Critical Inquiry* 15/2: 205–25.

Sarangi, Srikant. 1994. "Intercultural or Not? Beyond Celebration of Cultural Differences in Miscommunication Analysis." *Pragmatics* 4/3: 409–27.

Shaw, Rosalind, and Charles Stewart. 1994. "Introduction: Problematizing Syncretism." In Charles Stewart and Rosalind Shaw, eds., *Syncretism/Anti-syncretism: The Politics of Religious Synthesis*, pp. 1–26. London and New York: Routledge.

Shell, Marc. 1982. *Money, Language, and Thought: Literary and Philosophical Economies from the Medieval to the Modern Era*. Berkeley and London: University of California Press.

Silverman, Kaja. 1986. "Fragments of a Fashionable Discourse." In Tania Modleski, ed., *Studies in Entertainment: Critical Approaches to Mass Culture*, pp. 138–52. Bloomington and Indianopolis: Indiana University Press.

Skinner, Quentin. 2002. *Visions of Politics*. Vol. 1: *Regarding Method*. Cambridge: Cambridge University Press.

Stallybrass, Peter, and Allon White. 1986. *The Politics and Poetics of Transgression*. Ithaca: Cornell University Press.

Stepan, Nancy. 1985. "Biological Degeneration: Races and Proper Places." In J. Edward Chamberlain and Sander L. Gilman, eds., *Degeneration: The Dark Side of Progress*, pp. 97–120. New York: Columbia University Press.

Stewart, Tony K., and Carl W. Ernst. 2001. "Syncretism." In Peter J. Claus and Margaret Mills, eds., *South Asian Folklore: An Encyclopedia*, pp. 586–88. New York: Routledge.

Subrahmanyam, Sanjay. 2001. "Golden Age Hallucinations." *Outlook India Magazine*, August 20. *www.outlookindia.com*.

———. 2005. "Beyond Incommensurability: Understanding Inter-imperial Dynamics." Department of Sociology, UCLA, Theory and Research in Comparative Social Analysis paper 32. *http://www.repositories.cdlib.org/uclasoc/trcsa/32*

Summers, David. 1991. "Conditions and Conventions: On the Disanalogy of Art and Language." In Salim Kemal and Ivan Gaskell, eds., *The Language of Art History*, pp. 181–212. Cambridge: Cambridge University Press.

———. 1994. "On the Histories of Artifacts." *Art Bulletin* 76/4: 590–92.

———. 2003. *Real Spaces: World Art and the Rise of Western Modernism*. New York: Phaidon.

Tarlo, Emma. 1996. *Clothing Matters: Dress and Identity in India*. Chicago: University of Chicago Press.

Thomas, Nicholas. 1991. *Entangled Objects: Exchange, Material Culture, and Colonialism in the Pacific*. Cambridge Mass., Harvard University Press.

Tobin, Beth Fowkes. 1999. *Picturing Imperial Power Colonial Subjects in Eighteenth-Century British Painting*. Durham and London: Duke University Press.

Toury, Gideon. 2000. "The Nature and Role of Norms in Translation." In Lawrence Venuti, ed., *The Translation Studies Reader*, pp. 198–212. London and New York: Routledge.

Trigger, Bruce G. 1990. "Monumental Architecture: A Thermodynamic Explanation of Symbolic Behaviour." *World Archaeology* 22/2: 119–32.

Turner, Kay. 1996. "*Hacer Cosas*: Recycled Arts and the Making of Identity in Texas-Mexican Culture." In Charlene Cerny and Suzanne Seriff, eds., *Recycled Re-seen: Folk Art from the Global Scrap Heap*, pp. 60–71. New York: Harry N. Abrams.

Turner, Victor. 1967. *The Forest of Symbols: Aspects of Ndembu Ritual*. Ithaca and London: Cornell University Press.

Veer, Peter van der. 1994b. "Syncretism, Multiculturalism and the Discourse of Tolerance." In Charles Stewart and Rosalind Shaw, eds., *Syncretism/Anti-syncretism: The Politics of Religious Synthesis*, pp. 196–211. London and New York: Routledge.

Venuti, Lawrence. 1992. *Rethinking Translation—Discourse, Subjectivity, Ideology*. Routledge: London and New York.

———. 1995. "Translation and the Formation of Cultural Identities." In Christina Schäffner and Helen Kelly-Holmes, eds., *Cultural Functions of Translation*, pp. 3–25. Clevedon: Multilingual Matters.

———. 1996. "Translation, Philosophy, Materialism." *Radical Philosophy* (September–October): 24–34.

———. 2000. "Translation, Community, Utopia." In Lawrence Venuti, ed., *The Translation Studies Reader*, pp. 468–88. London and New York: Routledge.

Viswanathan, Gauri. 1996. "Beyond Orientalism: Syncretism and the Politics of Knowledge." *Stanford Humanities Review* 5/1: 19–34.

Wagner, Roy. 1991. "The Fractal Person." In Maurice Godelier and Marilyn Strathern, eds., *Big Men and Great Men: Personifications of Power in Melanesia*, pp. 159–73. Cambridge: Cambridge University Press.

Weiner, Annette B. 1985. "Inalienable Wealth." *American Ethnologist* 12:210–27.

———. 1992. *Inalienable Possessions: The Paradox of Keeping-While-Giving*. Berkeley: University of California Press.

———. 1994. "Cultural Difference and the Density of Objects." *American Ethnologist* 21/2: 391–403.

Young, Robert J. C. 1995. *Colonial Desire: Hybridity in Theory, Culture and Race*. London and New York: Routledge.

Žegarac, Vladimir, and Martha C. Pennington. 2000. "Pragmatic Transfer in Intercultural Communication." In Helen Spencer-Oatey, ed., *Culturally Speaking: Managing Rapport through Talk across Cultures*, pp. 165–90. London and New York: Continuum.

Index

elephants used by amirs of, 57, 65
Friday Mosque, 137–38, 155
Isma'ili Shi'ism in, 51, 107, 155
ivory production in, 52, 55
palace of amirs of, 65
piety of inhabitants of, 42
Sun Temple, 19, 30, 42, 43, 55, 155
Surya Temple, 38, 39
Tomb of Shaykh Sadan Shahid, 138, 200, 201
and trade, 16, 18
use of Arabic and Persian at, 59
mulūk khāna. See royal chamber (*mulūk khāna*)
al-Muqaddasi, 15, 23, 42, 282n9
muqarnas vaulting, 219, 236
al-Muqtadir Billah, 'Abbasid caliph, 26, 72, 73
mūrti, 165
Musa ibn 'Umar ibn 'Abd al-'Aziz, Habbarid amir, 31, 280n240
Musalamāna, 3
mushrikūn, 101, 104, 154
al-Mustadi', 'Abbasid caliph, 91
al-Mustansir, 'Abbasid caliph, 286n9, 296n97
mustaqimān, 243
al-Mu'tadid, 'Abbasid caliph, 31, 32
al-Mu'tamid, 'Abbasid caliph, 31, 33, 52
al-Mutawakkil, 'Abbasid caliph, 19
mutawallī, 186, 187
al-Muti'lillah, 'Abbasid caliph, 26
al-Muwaffaq, 'Abbasid caliph, 276n74
mūza, 92

nabob, 151
Nadir Shah, 218
nafal, 28
Nagara temples, 47, 152
nagari script. See *devnagari* script
Nagarkot, fort of, 124
Nagaur fort, Rasjasthan, 107, 138
tombstone, 148
Nahrwara, ruler of, 65
Najm al-Din Razi, 105, 130

nakṣatra, 157
Nanda, 80
Nandi, 25, 108, 115
Napier, Lord, 151
naqqāra-khāna, 294n57
Narayanpur
raja of, 79
al-Nasa'i, 307n109
al-Nasir, 'Abbasid caliph, 91, 101
Nasir al-Din Mahmud, 254
Nasir al-Din Qubacha, 227, 228, 236, 240
Nasir-i Khusrau, 21
naskh script, 220, 224, 244
Nasr Allah Munshi, 7
naubat, 129, 240, 243, 294nn57, 63
nāyaka, 256
nāyaṃkara, 114
networks, 8
al-Nisaburi, 'Ali ibn Ibrahim, 97
nisba, 54, 186
Nishapur, 90, 97
Nizam al-Din Awliya, 303n283, 307n106
Nizami, Khaliq Ahmad, 113
Nizami 'Arudi, 286n169
Nora, Pierre, 253
Nur al-Din Zangi, 284n103

Oman, 21
Orenstein, Henry, 89
Oriental despotism, 123
orthodoxy, 35
and architectural patronage, 138
and Ghurids, 105, 107
and Iltutmish, 247
and sectarian strife, 245
See also heterodoxy
Osian, Rajasthan
Sacciyamata Temple, 215
Otnes, Per, 1
Ottomans, 185–86, 219, 296n100

padmajāla (lotus chain), 191. *See also* lotus motif
padmalatā (lotus vine), 173, 191, 204
padmashilā (lotus ceiling), 173, 176, 177
Pal, Pratapaditya Pal, 71
Palam, Sanskrit foundation text, 254, 256

Pala rulers, 115
Palestine, 50, 91
palidhvaja, 133
palmettes, 173, 184, 200, 224
Panchatantra, 6, 7, 8, 20
Pandavas, 6, 251, 254
Pandua, Bengal
royal mosque at, 162
Pandyas, 129, 293nn29, 30
Panjab, 71, 90, 98
Panjim, 23
Pārasīka, 3, 22, 83
parasol. See *chatr* (parasol)
Parihars, 110, 111
Paris, Bibliothèque nationale
Chessman of Charlemagne, 52–56
Parmaldeva, Chandella raja, 87
Parry, Jonathan, 76–77
Pashupata Shaivites, 37
Patan, 107, 210, 218. *See also* Anahilavad (Patan)
patent of investiture (*manshūr* or *farmān*), 240, 244
patrons, 137, 184–89, 203, 212, 218, 261
dependence on Indian stonemasons, 181
Ghurid, 105
Hindu, 165
Jain, 165
memorialization of, 157
of mihrabs, 296n17
of mosques and shrines, 138
preferences of, 148
rivalry among, 228
as spoilers of art, 150
and stonemasons, 148, 225
and translation, 262
peqīd, 93
Persepolis, Achaemenid palace, 131
Persian Gulf, 16, 19, 21, 23
Persian language, 42, 239
pillars, 247–51. *See also* columns
pīshkash, 294n45
pīshṭāq, 126, 294n57
Pollock, Sheldon, 5, 8, 75, 93, 264, 266, 272n52
polyglossia, 42
polytheism, 27, 34, 38, 96
postcolonial studies, 72, 75, 82, 202
potlatch, 28, 34
pradakshiṇā, 43
pramatha, 165, 188

praśasti, 109, 256–57
Prasad, Pushpa, 203
Pratiharas. *See* Gurjara-Pratiharas
prayer halls, 44, 144, 145, 149, 150, 161, 169, 174, 203, 224, 231, 232, 235, 297n21
prestigious imitation, 74, 75, 102, 263
Prithviraja II, Chauhan raja, 109
Prithviraja III, Chauhan raja, 108–9, 110–11, 117, 127, 128, 154
coins of, 118
Prithvīrājavijaya, 109, 119, 256, 272n21, 288n56
Psellus, Michael, 86
pūrṇaghaṭa capitals, 190, 193, 195, 196, 202, 224

qabā', 66, 67, 68, 69, 71, 72, 73–74, 84, 92, 290n117
qāḍī, 23, 102, 187, 203
al-Qadir Billah, 'Abbasid caliph, 34, 77, 78
qal'a, 97
qalansuwa, 63, 67
al-Qalqashandi, 76, 83
qamīṣ, 65, 66, 67
Qamuhul, 275n62
al-Qazwini, 130
qibla, 162, 171–72, 173, 176, 178, 187–88, 231, 235
al-Qiqan in Sind, 20
qiṣāṣ, 96
Qiwam al-Mulk Rukn al-Din Hamza, 109
Qubacha. *See* Nasir al-Din Qubacha
Qur'an, 19, 243
as forbidding hoarding of gold and silver, 35
Ghurid (584/1189), 94–96, 97, 100
on Ghurid coins, 103, 104
gilding of, 36
gold in, 36
and inscriptions, 100, 222, 245
and Karramiya, 96
and lamp motif, 214
and Mansura bronzes, 52
and Minaret of Jam, 98–101, 243
and monumental inscriptions, 98–100, 244–45
and Qutb Minar, 245

Qur'an (cont.)
 and Qutb Mosque, 231, 241,
 245
 and sectarian strife, 245
 Surat Maryam, 98–100, 243
 Surat al-Mulk, 243
 and tomb of Iltutmish, 243
Quraysh, 65
Qusayr ʿAmra
 royal bathhouse at, 18
quṭb, 247
Qutb al-Din Aybek, 254, 256
 authority of, 227
 and Bahaʾ al-Din Tughril,
 245
 and Gahadavalas, 149
 and Gwalior, 111
 and Indian vassals, 111, 113
 and loot, 127, 130
 and Parmaldeva, 87
 as patron, 218, 228
 and Qutb Mosque, 139, 186,
 229–30, 241, 243, 252
 use of color red by, 234
 victory celebration of, 235
Quṭbī mamluks, 227–28

rāis, 112
Rai Vikramajit, metal icon of,
 240, 252
Raja Giri, Swat
 Ghaznavid mosque, 296n17
Rajasthan, 19, 128, 130, 139, 141,
 144, 210
 Maha-Maru architectural
 styles of, 208
 and marble carving, 190
 Muslims in before Ghurid
 conquest, 148–49
 Naugar fort, 138
 Surya cult, 44
 temples of, 196
Rājataraṅgiṇī, 85, 157, 256
rājaturuṣka, 155, 156
Rajendra Chola, 246
Rajputs, 90, 108–9, 258, 294n51
 chiefs of, 83
 as clients and vassals of
 Ghaznavids and
 Ghurids, 79, 111–13,
 135, 228
 defeat of, 110
 dynasties of, 25
 kingdoms of, 13
 and land assignments, 113
 Muslims in, 148

rākṣasas, 109
Ramāyāna, 7
Ramisht, 21
Ramiyan/Ramayan, 278n169
Rana Kumbha, 258, 295n89
Rana of Mewar, 257
rānās, 111, 112, 113, 117, 291n167
Ranthambhor, 111, 128, 257,
 294n51
Rashid al-Din, 290n134
Rashtrakuta rajas
 Amoghavarsha, 286n154
 Indra III, 22, 281n260
 Krishna II, 22
Rashtrakutas, 16, 19, 20, 21,
 23, 38, 65, 85, 133, 246,
 283n34, 293n30
 coastal cities of, 23
 copper-plate inscriptions,
 21–22, 279n188,
 286n154
 and dress, 64
 and Kadamba rajas, 21
 and mosques, 26
 ports, 23
 and Qamuhul, 275n62
ratna designs, 171, 193, 200, 211,
 212, 213, 302n264
rāutagān, 113
Rayy, 34, 124
Redford, Scott, 234, 253
Red Sea, 16, 19, 51
red stone, 144, 175, 234–35, 242,
 253
Rehamāṇa-Prāsāda, 178–79
ribāṭs, 154
Richards, J. F., 124, 125
ridāʾ, 65
ring(s)
 inscribed with the sultan's
 name, 84, 117
 signet, 117
riwāq, 144, 188, 242
robes
 gifting of, 11–12, 13, 75, 77, 83,
 284n95
 See also khilʿa (robe of honor)
Roman emperors, 28
Rowan, Diana, 56
royal chamber (*mulūk khāna*)
 Chaurasi Khambha Mosque,
 160, 163–64, 164,
 165, 167, 172, 176,
 177, 228
 Qutb Mosque, 160–63, 172,
 196, 228, 231, 297n21

Rubiés, Joan-Pau, 86, 267
Rukn al-Din Firuz, Delhi sultan,
 254

Śaka kings, 254
sadd-i Sikandar, 251
Sadid al-Din ʿAwfi, 135
 Jawāmiʿ al-Ḥikāyāt, 242–43,
 253
Safavids, 285n144
Saffarids, 13, 16, 25, 27, 28, 31,
 34, 52, 57, 78, 134, 155,
 277n114
 ʿAmr ibn Layth al-Saffar, 13,
 28, 31–34
 Yaʿqub ibn Layth al-Saffar,
 13, 31, 33
ṣafiyya, 28, 31, 127
*Ṣafwat al-Adhhān (The Cream of
 Intellect),* 20
ṣāhib al-Sind, 31
Sāhī Rāj, 257
Said, Edward, 266
Saʿid al-Andalusi, 7
śākhās, 204
Salah al-Din Ayyub (Saladin),
 74, 91, 103, 104, 264,
 284n103
sālār-i Hindūyān, 78, 155, 265
Salt Range, 47, 48
Samanids, 289n89
sāmantas, 57, 111, 112, 113, 116, 118
Samarqand, 28, 218, 219
Samarra, 33, 44
ṣanam, 30, 31, 36, 153
Sanjan (Samyana), Maharashtra,
 21, 22, 279n188, 286n154
Sanjar, Seljuq sultan, 125
Sankaravarman, raja of Kashmir,
 85
śaṅkh, 299n133
Sanskrit, 11, 75, 109, 115
 on coins, 25, 26, 39, 41, 44, 59,
 115, 116, 118, 228
Sanskrit epics, 155
Sanskrit Vidya, 80
Śāradā script, 41
satī, 78
Sauerländer, Willibald, 152
Saurashtra, 257
Sayf al-Dawla Mahmud,
 Ghaznavid prince, 84
Sayf al-Din Muhammad ibn
 Husayn, Ghurid *malik,*
 288n39
Saymur (Ceymulya), 21, 59

Sayyod, palace at, 169
scorpions, 169
script, 137, 236, 262. *See also
 brahmi* script; devnagari
 script; Kufic script; *naskh*
 script; Śāradā script;
 ṭughrā script
Seidel, Linda, 273n78
self-fashioning, 7, 61, 64, 72, 264
self-representation, 75, 103, 266
Seljuqs of Iran, 86, 89, 90, 105,
 125, 155
 architecture of, 137, 181, 234,
 245
 coins of, 104, 108, 118, 289n89
 and dress, 66
 mosques of, 162, 176, 204
 names of, 259
 and *Shāhnāma* (Book of
 Kings), 253
 Tughril Beg, 86, 155
Seljuqs of Rum
 ʿAlaʾ al-Din Kayqubad,
 303n296
 Kilij Arslan II, 259
 and Konya, 236–37, 253
 Qaysarshah, 259
semantics *vs.* pragmatics, 200
Sepoy Revolt, 123, 150
Shafiʿis, 101, 102, 105, 127,
 288n69, 289n74
 madrasas of, 105
Shahis, 62
Shāhnāma (Book of Kings), 6, 7,
 92, 106, 251, 253, 254
Shaivites, 149, 155
Shajara-i ansāb, 127
Shakambhari, 108
Shams al-Din Iltutmish. *See*
 Itutmish, Shams al-Din
Shams-i Siraj ʿAfif, 248
Shansabanids. *See* Ghurids
sharbūsh, 74
Shariʿa, 23, 24, 25, 187. *See also*
 Islam
Sharma, S. D., 151
shāstra, 37, 112, 172
Shiʾis, 19, 30, 42, 43, 50, 91, 96,
 107
Shikarpur District of Karnataka,
 memorial stela, 286n154
shilpīs, 184, 187
shirk, 27
Shir of Bamiyan, 16, 33,
 277n128
Shiva, 25, 42, 108, 178, 240

linga of, 32, 38, 45, 149
temples of, 68–69, 178, 189
shugl, 32, 37
Shunyarūpa, 178
Sibt ibn al-ʿAjami, 242
Sibt ibn al-Jawzi, 82, 84
Sicily, 27, 114, 219, 305n41
Sikandar al-thānī, 106, 251. *See also* Alexander the Great
śikhara, 129, 130, 179, 278n171
sikka, 76, 116. *See also* coins
simha, 50, 58
simhamukha, 167
simurgh, 131
Sind, 48, 144
Arab amirates of, 13, 59, 111
and caliphal control, 52
coins of, 39–41
conquest of, 2
as distinct entity, 24–25
economy of, 19
frontier of, 24
and idols, 27–28
ivory in, 55
mercantile emporia of, 37
mosques, 149
religiously heterogeneous population of, 38
stupas and temples of, 38, 50
and trade, 16, 17, 19
Sinha, Ajay, 152, 179
Siraf, 4, 16, 21, 148
Friday Mosque, 44, 280n221
Siri
Friday Mosque, 188
Sistan, 16, 17, 34, 155
snakes, 168, 169
Solanki rajas. *See* Chalukya rajas
Somnath
Gates of, 189
linga, 32, 241, 277n125, 278n153
temple of, 43, 130, 294n53, 306n65
Sonepat, Sanskrit foundation text, 254
Soucek, Priscilla, 71
sovereignty, 122, 129, 130, 133
Spiti Valley, 283n52
spolia, 47, 133, 150, 173, 179, 184, 207, 208, 234, 236, 250
śrī, 116–18
Sri Lanka, 293n29
funerary inscriptions, 51
Sri Rangapattan, 131
Stallybrass, Peter, 64, 84

stambha, 179, 248
statecraft, manuals on, 114
Stein, Aurel, 69
Stewart, Susan, 121
Stewart, Tony, 178, 258
sthāpaka, 187
stirrups, 53, 114, 219
stone, medium of, 149, 186
stone carving, 41, 134, 137, 159, 164, 189–203, 190, 224, 236
and Masjid-i Sangi, 203–8, 211–17, 218, 219
reuse of, 166
Sanskrit plays written in, 149
stonemasons, 134, 150, 181, 208, 225
circulation of, 261, 265
and inscriptions, 225
labor of, 187
in Larvand, 217–18
mobility of, 220
negotiation of forms by, 152
and patrons, 148
See also craftsmen/artisans
stucco, 137, 220, 224, 236
stupas, 38, 50, 54, 167
stūpika, 129
Subrahmanyam, Sanjay, 310n38
Sufis/Sufism, 43, 101–2, 245–46
sulh, 79
sulhan, 154
Summers, David, 11
Sunan of Abu Daʾud, 61, 63
Sunni Revival, 91–92
Sunnis, 19, 31, 43, 65
civil strife among, 101
and coins, 104
and heresy, 124
law schools of, 92, 96, 101, 102, 104
and mosques, 138
orthodoxy of, 78
royal rhetoric of, 96
and self-fashioning, 107
and Shiʿis, 91
al-Surabadi, Abu Bakr ʿAtiq ibn Muhammad, 96, 100
suratrāṇa, 183, 256, 258, 259
Surya, 39, 44, 178
bronze image of, 38
icon of, 279n198
temples of, 38, 40, 178
Sūrya Purāṇā, 263
sūtradhāra, 184, 185, 187, 188
Swat, 208, 297n17

syncretism, 4, 5, 42, 42, 179, 258
Syria, 63, 91, 103

Ṭabaqāt-i Nāṣirī, 126, 134. *See also* Juzjani
Tabo Monastery, 283n52
tafsīr, 44, 96
Taj al-Din Yildiz, 227, 228
Tājika, 3, 21, 22, 23, 256
Tāj al-Maʾāthir, 109, 111, 127, 242
talismans, 169. *See also* amulets
tamgha, 234
Tang-i Azao, Judeo-Persian rock inscription, 93
tankas, 41, 240, 241
ṭāq, 127, 242, 243, 293n40
Taʾrīkh al-Yamīnī of al-ʿUtbi, 161. *See also* al-ʿUtbi
tawḥīd, 100
taxes, 23
jizya (poll tax), 20, 31, 38, 79, 81, 114, 121, 127, 241, 290nn144, 145
kharāj (land tax), 79, 111, 113, 127, 241, 290n144
Turk tax (*Turuṣkadaṇḍa*), 114
Tāyika, 23
temples, 21
aesthetic values shared with mosques, 158
architecture of, 153
baluster columns in, 192–93
bell chains in, 173
and booty, 130
brick, 190
Buddhist, 47
conversion into mosques, 153
destruction of, 154–56
Hindu, 38, 43, 55, 178, 244
icon chamber of, 173, 176
images in, 167
Jain, 148, 178, 208
and mosques, 46, 137, 153, 158, 159, 164–65, 167, 169, 172, 173, 176, 177–78, 179
and political authority, 153
of Rajasthan, 196
roof ornaments of Hindu, 204
and sacral kingship, 153
of Salt Range, 55
*śikhara*s (spires) of, 129, 130, 179, 278n171
and twisted columns, 195–96, 197
Vesara, 152, 179, 202

Termez
lion face on stucco ornament from, 169
textiles, 11, 65, 76, 83, 93, 235, 285n141
thagr/thughūr, 24, 28
Thakkura Pheru, 254
thākur, 117
thākurān, 113
Thambo Wari (Thuman Jo), mosque of, 45–47
Thanesar, 32
Thomas, Nicholas, 122–23, 131
throne, 30
Tilak, 4, 78, 129, 218, 264, 266
tiles, 71, 165, 219
Timur, 218, 292n22
Tipu Sultan
jeweled *humā* bird from throne of, 131, 132
ṭirāz, 67–68, 72, 74
tīrthankara, 32, 212
Tochi Valley, Waziristan, foundation text dated 243/857, 42
Tod, James, 150–51, 158
tolas, 157
Tomars, 25, 108, 149, 254, 258
tombs, 190
tombstones, 51, 52. *See also* funerary stelae
Tonelli, Anna, 132
torāṇa, 173, 191, 192, 195, 196, 199, 200, 224
trabeate structures, 45, 46, 137, 144, 145, 149
trade, 17–19, 21, 25, 38, 61, 107, 123
and Ghurids, 93, 118
in idols, 27–28
and Jewish merchants, 93
and Ladakh, 65
and sculptural motifs, 208, 209
See also merchants
transculturation, 4, 5, 7, 36, 78, 84, 87, 264
and coins, 39
and mosque imagery, 169
and mosques and temples, 179
and names, 258, 259
and royal ceremonial, 246
as transformation, 9
translation, 3, 6, 7, 9, 299n153, 301n213
and ʿAbbasids, 20

translation (cont.)
 and accommodation, 258
 between architectural forms,
 180–82
 of booty, 131
 and circulation, 12
 and coins, 38–39, 178
 and culture, 5, 8–9
 as dialogic, 183
 and dress, 63
 and figural carving, 217
 and history, 14
 and identity, 267
 and inscriptions, 222
 Jakobson, Roman on, 189
 and modernity, 12
 and mosques, 178, 179, 188–89
 of Qur'an, 96
 and reinscription of artifacts,
 250
 and religious beliefs, 42
 strategies of, 262
 as transformation, 182,
 303n303
treaties, 79, 81
tribute, 20, 31, 79, 82, 87, 127,
 154, 294n45. *See also* taxes
triśūl, 26, 108, 190
tropaion, 131
Tughluqid sultans, 246, 305n44
ṭughrā script, 242, 244–45
Tughril Beg, Seljuq sultan, 86,
 155
Turner, Victor, 93
Turuṣka, 3, 66–68, 109, 155, 156,
 256, 308n122
Turuṣkadaṇḍa, 114
Turuṣkadeśa, 68, 189

al-Uballa, 26
Uchch, 98, 112, 236
udumbara, 173, 207, 208, 211

Ujain, 107
 icons from, 240, 241, 247,
 248, 252
'ulamā', 37, 186, 245, 262, 274n23
'Umar, Umayyad caliph, Code
 of, 63
al-'Umari, 242
'Umar ibn 'Abd al-'Aziz,
 Habbarid amir, 52–53, 54
Umayyad caliphs
 Hisham, Umayyad caliph, 20
 Mu'awiya b. Abi Sufyan, 20,
 27–28
 'Umar, 63
Umayyads, 15, 20, 31, 65
umma, 1, 30, 158, 229, 247
Unstra, inscription from, 257
upavita, 63
urban centers, 23, 24, 25, 139
Usama ibn Lu'ayy ibn Ghalib,
 19, 278n183
al-'Utbi, 36, 80, 107, 161, 186
uttaraṅga (lintel), 211, 212
Uttar Pradesh, 80

Vaghelas, 34, 256
Vaishnavites, 38, 155
 temples of, 149
Vajrasana
 temple of, 34
Vallabha-rāja, 20, 85
valli, 207
vandal, 150
Varaha, 39
Vasantagadh in Rajasthan
 Hindu temples in, 149
vase, overflowing. See
 pūrṇaghaṭa
vāstu-shāstras, 178–79
Vasudeva, 42
vaulting, 152, 162, 180, 219, 236
vēdikā railings, 180

vegetal motifs, 137, 165, 200, 201,
 236, 244, 262
Venuti, Lawrence, 225
Veraval, 256
 foundation text from mosque
 at, 34, 178, 256
Vesara temples, 152, 179, 202
victory missives (*fatḥnāma*s),
 244
Vidyadhara, Chandella raja of
 Kalinjar, 80, 84, 87
Vigraharaja IV, Chauhan raja,
 108, 109, 248, 250,
 295n68, 308n122
vihāra, 179
Vijayanagara, 61, 72, 73, 74, 86,
 87, 285n41
vine motifs, 173, 200, 210–11,
 220, 224, 235. *See
 also* creeper motifs;
 padmalatā (lotus vine)
Virarajendra, Chola raja, 124
Visala Deva, Chauhan raja. *See*
 Vigraharaja IV
Vishnu, 39, 40, 41, 42, 131, 155,
 157, 178, 281n260
 temples of, 178, 295n89
Vishnu Cakraswamin, bronze
 idol of, 32
Vishvakarma, 184
Viswanathan, Gauri, 266
Vrkṣārṇava, 178

Wagoner, Phillip, 8, 61, 87, 114,
 264, 304n305
wakīl, 93
Wall of Alexander, 80
waqf, 34, 96, 138
Warangal, 292n199
 Kakatiya rajas of, 292n199
 Tughluqid Friday Mosque, 188
Wasserstein, David, 58

al-Wathiq, 'Abbasid caliph, 50
Welch, Anthony, 181
White, Allon, 15
William of Tyre, 86
Windsor Castle
 jeweled *humā* bird, 131
Wink, André, 30
Wrigley, Richard, 300n168

Yadavas, 114, 115, 255, 256
Yahya ibn Khalid al-Barmaki,
 7, 20–21
Yahya ibn Rabi', 289n74
Yama, 279n209
Ya'qub ibn Layth al-Saffar, 13, 33
Yasser Tabbaa, 31
Yavana, 3, 256
Yemen, 21
Young, Robert, 267
Yusuf al-Bahili, 54, 58

Zabul, 16
Zabulistan, 17, 26
Zahak, 92, 106
Zamindawar, 16, 28, 31
zamīn-i zar, 128
Zamzama, 121, 125, 128
Zangids, 284n103
Zarang, 16, 34, 59
 Friday Mosque of, 155
zenāna, 161
Zhun, 26
Zij al-Sindhind, 21
Ziya' al-Din, Ghurid sultan, 122
Ziya' al-Din Barani, 119
ziyy, 64, 67
zoomorphism, 48, 58, 163, 165,
 169, 190, 216–17
Zoroastrianism, 29, 63, 178,
 279n206
Zunbil of Zamindawar, 16
zunnār, 63